FIGURES OF SPEECH

FIGURES OF SPEECH

MEN AND MAIDENS IN ANCIENT GREECE

GLORIA FERRARI

THE UNIVERSITY OF CHICAGO PRESS
CHICAGO & LONDON

GLORIA FERRARI is professor of classical archaeology and art at Harvard University. She is the author, most recently, of *Materiali del Museo Archeologico di Tarquinia XI: I vasi attici a figure rosse del periodo arcaico.*

The University of Chicago Press, Chicago 60637
The University of Chicago Press, Ltd., London
© 2002 by The University of Chicago
All rights reserved. Published 2002
Printed in the United States of America

10 09 08 07 06 05 04 03 02 1 2 3 4 5
ISBN: 0–226–24436–9 (cloth)

Library of Congress Cataloging-in-Publication Data
Ferrari, Gloria, 1941–
 Figures of speech : men and maidens in ancient Greece / Gloria Ferrari
 p. cm.
Includes bibliographical references and index.
 ISBN 0-226-22436-9 (cloth : alk. paper)
 1. Vases, Greek—Themes, motives. 2. Women in art. 3. Male nude in art.
4. Man-woman relationships in art. I. Title.
NK4645 .F47 2002
738.3′82′0938—dc21
 2002002849

♾ The paper used in this publication meets the minimum requirements of the American National Standard for Information Sciences—Permanence of Paper for Printed Library Materials, ANSI Z39.48–1992.

CONTENTS

ACKNOWLEDGMENTS

It became apparent only at the end of the project how profound an impact Angelo's Brelich's study of initiation rituals in ancient Greece had on my thinking about the construction of gender in ancient Greece. *Paides e parthenoi* was the model that made a comparative analysis of the construction of masculine and feminine identities seem both legitimate and feasible and was as well a source unmatched for wealth and erudition, to which I turned time and again. I would like nothing better than to believe that here I have good answers to the questions he posed about the relationship of the kouroi to initiations and about the nature of the Arkteia.

A debt of a more personal and specific nature is owed many people and several institutions whose contributions significantly shaped my research and made this book possible. The initial phase of my research took place in 1989–90, during a sabbatical leave as a fellow of the National Humanities Center, supported by a fellowship from the National Endowment for the Humanities. An Ailsa Mellon Bruce Senior Fellowship at the Center for Advanced Study in the Visual Arts in 1990–91 allowed me to complete a first draft of the book. This phase greatly profited from Alice A. Donohue's incisive criticism, as well as from comments from John Tagg, Guy Hedreen, Stephen Lonsdale, Sarah M. Peirce, Joan Reilly, and Ann Steiner. Among my fellow fellows at the NHC, I am especially grateful to Harriet Guest for many useful conversations about notions of gender and approaches to literary and visual interpretation. Mark Turner imparted the project a decisive turn by introducing me to the theory of metaphor as interaction. I thank two of the readers for the University of Chicago Press, who revealed their identity to me, Andrew Stewart and James Redfield, for their thoughtful criticism and invaluable suggestions for revision of the manuscript.

The task of revising entailed a new phase of research, largely about initiation rituals and marriage. I owe more than I can say to Laura Slatkin's insightful comments and creative suggestions throughout this process. I thank Joel Snyder for his comments on my reading of Aristotle's *Politics* in chapter 6; Bruce Lincoln for a helpful discussion of marriage and female initiations; Brunilde Ridgway for a thorough review of my treatment of the kouroi and male initiations; and Christopher Rowe for help with Plato's *Symposium*.

In these long twelve years the following scholars generously extended help in the form of advice, information, or access to materials: Irène Aghion, Diliana Angelova, Lenore Auslander, Elke Böhr, Ann B. Brownlee, Norman Bryson, W. R. Connor, David B. Dodd, Casey Dué, Mary Ebbot, Roger G. Edwards, Christopher Faraone, Françoise Frontisi-Ducroux, Robert Garland, Richard Hamilton, Marie-Christine Hellman, Albert Henrichs, Donna C. Kurtz, François Lissarrague, Nino Luraghi, Claire L. Lyons, Irad Malkin, Mary McGettigan, Maureen McLane, Joan Mertens, David Mitten, Gregory Nagy, Fred Naiden, J. Michael Padgett, R. J. Penella, Carlos A. Picón, Alain Schnapp, Ellen Reeder, Martin Robertson, J. Penny Small, Philip Stadter, and Dimitrios Yatromanolakis.

For assistance in research, editing, and the thankless job of obtaining illustrations I am grateful to Christine Cummings Milbank, Jon Berkin, Kelly Olson, Melissa Haynes, Valentine Chaudet, and Bryce Sady. Finally, I thank Eileen Markson of Bryn Mawr College and Catherine Mardikes of the University of Chicago for their aid in matters of bibliography and access to library resources. I gratefully acknowledge two grants from the Loeb Classical Library Projects Fund, which helped to pay for photographs and reproduction rights.

After all, we do have these inscriptions and these artefacts.
They are there. We cannot disregard them. What then are we
to say about them?

Arnaldo Momigliano [1]

One only has to turn to the subject index of John Boardman's *Athenian
Black Figure Vases* and to his *Athenian Red Figure Vases* to gain a sense
of how rich is the treasury of images these objects offer.[2] The pictures range
from epic and myth, to theater, to sundry activities that are not obviously
attached to a story. There are rituals and dances, combat scenes, erotic en-
counters, symposia, athletes, carpenters, girls bathing, olive pickers, and
dandies with a panther on a leash. The corpus has grown by leaps and
bounds thanks to licit and illicit excavations over the past century and a
half, and it has generated a voluminous body of scholarship.[3] By the 1950s,
the study of the painted vases was a highly specialized subfield of classical
archaeology, in which the study of their iconography had become largely
divorced from the mammoth task of classification and attribution. The sub-
division of the corpus into scenes of myth, on the one hand, and scenes of
reality, on the other, gained something close to the status of self-evident
truth near the end of the nineteenth century and further added to the frag-
mentation.[4] The identification of artists on the basis of Morellian analysis
came to dominate the study of the painted vases, particularly in England
and North America. The work of J. D. Beazley, spanning over sixty years,
was most influential in keeping the focus on the search for masters and on
authorship as the ultimate explanation for the vase paintings.[5]

In the past thirty years, the construction of the history of ancient art as a developmental continuum anchored to figures of great masters has all but collapsed. In the case of the painted vases, the crisis became apparent in the wake of Beazley's death in 1970, which brought about the reappraisal of attribution in terms of useful knowledge produced as well as the realization of his tremendous personal accomplishment. Attacks were directed not, or not primarily, at Beazley himself but at the way in which connoisseurship had come to dominate the field and had imposed constraints on approaches that took their point of departure from anything other than the fact of authorship.[6] It came sharply to the fore that Morellian analysis indeed made it possible to classify the vases with great precision, according to artistic pedigrees. But it became clear as well that the point of view it imposed had made it difficult to use the vases as witnesses of the society that had produced them. The aim of connoisseurship, after all, is to identify not the social and historical context of an artifact but the point at which, in Ginzburg's words, "the artist's subordination to cultural traditions gives way to a purely individual streak."[7]

As much as scholars in other fields of art history, archaeologists searched for a different interpretive paradigm. The first proposals for a structuralist approach to the images came from Herbert Hoffmann and Christiane Sourvinou-Inwood.[8] The exhibition entitled *La cité des images*, organized in 1984 by the scholars at the Centre Louis Gernet in Paris and the University of Lausanne, was a landmark event. The essays in the book that accompanied the exhibition all shared an approach to the images as a symbolic language that gave access to the imaginary of ancient Greek society.[9]

This is the background against which the research that produced this book took shape. It began as an investigation of approaches to the interpretation of objects and images and the use that we make of archaeological evidence in our reconstruction of ancient realities and conceptual models. Gender initially was not a central concern, although now it seems to claim the lion's share, at least in terms of space, of this work. It became one when I choose to work on a particular figure that appears on hundreds of vases, a veritable emblem of femininity: the woman working wool. These two topics — interpretive method and the representation of gender, masculine as well as feminine — are interdependent and closely interwoven throughout the book.

It is my premise that visual evidence will lead to an understanding of ancient culture that would be beyond reach on the basis exclusively of texts. This involves claiming for archaeological materials a larger measure of authority than they have hitherto enjoyed in classical archaeology. The disci-

pline has grown in the shadow of a rich body literature, which has been continuously reinterpreted since antiquity, with the result that it has remained, up to now, an integral part of modern culture. The weight of centuries of historical scholarship founded upon the authority of the texts has largely determined the ancillary status of the discipline: ancilla to history — whether political history or the cultural histories of art, literature, ideas, technology, and the like.[10] It may be excessive to say that the archaeologist's task has been viewed as that of handing over to the historian the raw material out of which the latter fashions history in the light of the written sources. But situating archaeology as a field of study within history has placed severe constraints on the ways in which the material record might be interpreted.[11] The issues of the relevance and value of the material record are bound up with those of the authority of archaeological sources with respect to literary sources and of the autonomy of the project of archaeology with respect to history.

The terms of the question may be briefly examined through an importunate ancestor whom modern archaeologists would prefer to forget: the antiquarian. Discredited as a collector of useless knowledge, the antiquarian became in this century an elusive figure toward whom Momigliano directed his attention in a masterly article of 1950.[12] There he traced the antiquarian's past — a long history of subordination to the historian interrupted by occasional rebellion. Momigliano's depiction of their relationship, which stressed the differences between the two, throws into relief two important aspects of antiquarian research. The first concerns the object of study:

> The whole modern method of historical research is founded upon the
> distinction between original and derivative authorities. By original authorities we mean either statements by eye-witnesses, or documents,
> and other material remains, that are contemporary with the events
> which they attest. . . . We praise original authorities — or sources — for
> being reliable, but we praise non-contemporary historians — or derivative authorities — for displaying sound judgment in the interpretation
> and evaluation of the original sources.[13]

The distinction made here is crucial in a definition of the archaeologist's task, because, like the antiquarian, he deals with the raw material of history, the nonliterary sources that are qualified as reliable evidence. The notion that "original authorities" — "coins, statues, vases, and inscriptions" — are somehow solid, straightforward, and transparent to the understanding is not, of course, one to which Momigliano subscribes, but it has survived

repeated attacks on the part of skeptics and still has many adherents. It is
the foundation for the "common sense," unproblematic reading of the mon-
uments as it is still widely practiced.

The second defining trait of the antiquarian is his preoccupation with
systematic description:

> I assume that to many of us the word "antiquary" suggests the notion
> of a student of the past who is not quite an historian because: (1) his-
> torians write in a chronological order; antiquaries write in a systematic
> order: (2) historians produce those facts which serve to illustrate or ex-
> plain a certain situation; antiquaries collect all the items that are con-
> nected with a certain subject, whether they help to solve a problem
> or not.[14]

A more positive light may be cast on this undeniable penchant for classifi-
cation that the archaeologist shares with the antiquarian. The historian,
short of a radical redefinition of his task, deals with events and change; the
antiquarian, with assemblages and categories and relationships among cat-
egories. Where the one asks *why*, the other asks *how*, or, as the founding
father of *antiquitates* puts it, "who, where, when, and what men do."[15] The
antiquarian may be rightfully chastised for his fondness for irrelevant de-
tail, but defining his main concern as "mere description" carries no stigma,
mere description being no small feat. This systematic character of an anti-
quarian's erudition is his distinguishing mark; it sets him on a search for
patterns and consistencies within apparent randomness and on the look-
out for meaningful connections. It is here that one may doubt both the
wisdom of subsuming the archaeologist's mission under a new definition
of history, as Momigliano proposed, and the truth of Morris's dictum, "ar-
chaeology is cultural history or it is nothing."[16] Rather than the course of
change, the purview of the archaeologist is the cultural space in which rep-
resentations operate and across which they stretch in a network to be ex-
posed and mapped. That is what makes "archaeology" such an apt meta-
phor for the project Foucault described as one of tracing discursive practices
in culture's "archive."[17]

The task then, to paraphrase Vernant, is to define the conditions that al-
low artifacts, epigraphical documents, and literary texts to throw light upon
one another in reciprocal fashion.[18] A premised shared with the structural-
ist approach is the fundamental tenet of the Durkhemian school, that so-
cial practices are representations, which bring into play with one another
modes of expression that otherwise lend themselves to different taxono-

mies: myth and history, sculptures and rituals, gestures and institutions, literary imagery and visual imagery. It is more than a historiographic curiosity that, through a different route, the notion of "collective representations" has a long tradition in studies of ancient Greek art, where it has been particularly influential in the work of Nikolaus Himmelmann and of Anthony Snodgrass.[19] On the whole, however, it has remained confined to debates about visual narrative and has proved less productive than it might have been, because its connection to the broader conceptual structure from which it issued was never acknowledged. This notion made its appearance in Carl Robert's *Bild und Lied*, published in 1881. As Durkheim would sixteen years later, Robert proposed the existence of a *Volksbewusstein*, or collective consciousness of the social group, and a *Volksvorstellung*, a collective system of representations, from which both the poet and the painters drew and which, in turn, they enriched and modified.[20] Presumably Robert drew, like Durkheim, upon the earliest formulation of what may be called the structuralist paradigm, put forward by Lazarus and Steinthal in Berlin in the first issue of the *Zeitschrift für Völkerpsychologie und Sprachwissenschaft* in 1860.[21] There one finds full-blown the proposal of a collective consciousness that informs and confronts that of the individual. Its "elements" are, first of all, language, a thesaurus of concepts, and mythology, religion, poetry, customs, monuments, and the visual arts.

It is in the perspective of language as representation that the adoption of the linguistic model for the interpretation of visual representations acquires legitimacy. As a means of communication, imagery may be thought of as a system analogous to language and, like language, as a social construct that is not readily accessible to outsiders to the social group. As signs, images are subject to two forms of organization: syntagmatic association or a chain of signs; and paradigmatic associations, which take effect in the consciousness of the viewers, connecting a given sign with certain others on the basis of similarity, dissimilarity, or equivalence.[22] The way in which images are deployed is here considered along the lines of the diagram of the communication event proposed by Roman Jakobson.[23] Each constitutes an exchange between an *addresser* (the artist, an institution, a patron through the artist) and an *addressee* (a customer, the citizens, an age class), in which a *message* in reference to something (the *context*) is conveyed through some *channel* ("physical and psychological," the vase with its image) in a form that is intelligible to both sender and receiver (the *code*). To the definition of the imagery as system, Jakobson's diagram adds the important notion of the context, what the message is about and the frame of reference in which it is exchanged. To consider the circumstances of its making and the purpose of

the image forces one onto the social and historical terrain of practices of discourse to contemplate the conditions that make the exchange both possible and meaningful. This ground is not solely verbal or solely visual but the place of intersection of the many modes of expression of a culture.

As regards the painted vases, which are the focus of chapters 1, 2, and 7, determining the content of an image and its frame of reference remains a particularly thorny problem. This is made worse by the widespread assumption that the pictures can be divided into myth and "genre" and that we can tell the difference between the two.[24] The problem may be examined by means of an example. In the interior of a cup painted by in the 470s B.C. (fig. 1) are two elaborately dressed female figures, one making roves of wool over her knee, work basket at her side, the other standing by, her own basket on a chair.[25] There are no inscriptions to tell us who they are and no texts that can be connected with the picture and explain it as part of a story or link it to any context, narrative or otherwise. The fail-safe measure applied in such cases, in a tradition of scholarship that is very much alive, is to take the scene as "genre," a representation of daily life. This kind of reading does more than gloss over the question What is the sense of this picture? It contains one central interpretive hypothesis: in greater or smaller measure, images are natural symbols, and they are, in this respect, radically different from the elements of language, which signifies in an entirely artificial conventional manner. The distance between the interpreter, who stands outside the culture, and the monument, which is a cultural construct, is bridged by the conceit that the picture says something about wool-working as it was practiced in fifth-century Athens. That is, while the connotations of an image are not to be recovered at a glance, its content is immediately available at the level of denotation. One may not know what these figures *are about*, but one can see what they *are:* two women, one making roves. It is important to realize that what passes for self-evident truth is instead an interpretive construct in which the image has been collapsed into the thing that it seems to us it represents: the picture of women making roves becomes women making roves. Thus freed from the frame of reference in which it was embedded—the heroic past, a paradigm of virtues, the lure of the brothel (all possibilities currently entertained)—the representation is available for a variety of modern scholarly discourses, from gender to technology. But by alienating the image in this manner we lose its sense and its purpose, the background against which it acquires resonance, and in the end, any value it might have as a source, historical or otherwise. The notion of the natural symbol ultimately brings visual representations into the fold of reality as it is perceived, which then becomes both the point of its origin

and its ultimate justification.[26] It is only by placing in question the objective reality of those allegedly natural facts that allow us to label the picture "two women"—their age and gender—that one may gain the proper distance and begin to question just how "natural" natural symbols are.[27]

A different view of the matter is held by scholars who believe that pictures such as this give access not to the way women lived in fifth-century Athens but to ways in which they are imagined. In this perspective, the division of the imagery into mythical and nonmythical becomes irrelevant as regards the study of the themes and formulas that constitute the common patrimony of the imagery. In practice, this means that the specific content of an image is subsumed under an overarching category, such as hero or woman, functioning in shifting frames of reference. For example, in the figures of a warrior carrying the body of his dead comrade on his shoulders one recognizes Ajax and Achilles if their names are inscribed. If there are no inscriptions or telling attributes, one is free to interpret the same figures either in reference to the heroic world or in reference to contemporary practice.[28] And one may read the figures on an Early Classical pyxis (fig. 2), who have the names of Argive heroines, as an "ordinary" scene that concerns female beauty.[29] Although one is often at a loss as to what its content is, I argue that the content of an image is important[30] and that it matters whether the scene refers not to the present but to the past, to the world as it is thought to be or the world reversed, to Penelope or a courtesan.[31]

The first two chapters explore specific questions of method, namely, how can visual signs be identified, if at all? and how are figures constructed? Rather than disparate subject matter, I use as a kind of laboratory scenes that have a common denominator: representations of females working wool. My analysis shows that these feature a finite number of figures, which are used repeatedly, like formulas, in a narrow thematic range: scenes of work and play, toilet, and courtship. The same imagery occurs as well in literary texts, where it is apparent that it fits into a coherent discourse concerning the requisites and behavior of the ideal maiden.

I apply the model of language to the interpretation of images more literally than others have done. In fact, the central hypothesis of the book concerns the relationship between these two domains. Moving from the premise that visual figures, like words, are projections of thought, I argue that metaphor is where the two different modes of representation intersect and, in the case of images that are the vehicle of metaphors, are linked. Chapter 3 attempts to bring out the play of metaphors in the construction of the image of the wool worker. The way in which images make concepts apparent is demonstrated through an analysis of the powerful notion of *aidos*,

which entails shame and respect, modesty and honor. This concept, I argue,
is structured by the image of the cloak in both verbal and visual expressions.
The hypothesis that certain visual figures have metaphoric valence is fur-
ther developed in the interpretation of the Greek nude given in chapter 5,
and of the bride as buried treasure, in chapter 8. Chapter 3, that is, is the
 hinge joining the first part of the book to the second, which deals with the
role of metaphor in the definition of male and female identities.

The representation of gender, which was the subtext of the first three, is
the dominant theme of chapters 4 – 8. The focus is on the imagery of rites of
passage, the crucial stage at which a boy becomes a man and a girl becomes
nubile. Stated rather narrowly, my interest lies in uncovering normative
gender roles and sexual practices in the polis and is confined, therefore, to
the citizen body. The very use of the word gender marks my approach as
feminist in a general way,[32] but I am in no position to take a particular
stance vis à vis the rich literature of the past twenty years in classical stud-
ies on the subject. It was difficult to identify a model that would accom-
modate the patterns that the comparative analysis of texts and images was
throwing into relief. In much of the scholarship on gender, one is con-
fronted with totalizing categories such as "patriarchal societies" in refer-
ence to both the Greek and Roman culture, or "Mediterranean societies,"
which collapses distinctions between several ancient cultures, not to men-
tion a dozen modern nations, profoundly diverse in their sexual mores.[33]
But—as I argue in chapters 6 and 8—notions about sex and gender in the
polis are closely tied to the polis's culturally and historically specific con-
stitution as an exclusive society of men, that is, anything but a patriarchal
society.[34] Just as troubling is the prevailing use of the term "women" to des-
ignate a socially meaningful category of adult females. I use the word myself
in an unmarked sense and to avoid the awkward "female." But the formal-
ities of female rites of passage and the conception of marriage insistently
suggest that an adult is what she must never become.[35]

The comparative analysis of coming of age rituals begins in chapter 4
with a look at the ostensible symmetry between young men and young
women that is both proposed, then belied, in the sources. A key text on the
establishment of difference is Plato's *Symposium*, in which Aphrodite Ura-
nia and Aphrodite Pandemos serve to define two separate and unequal
erotic and political spheres. Chapter 5 traces the metaphor of transsexual
metamorphosis, which articulates the transition from nonman to man,
through initiatory rites and their attendant legends to archaic statues of
nude young men, the kouroi. I argue that their nudity, and the Greek nude
in general, propose a metaphor of *andreia*, manhood itself. This figure also

brings into focus the crucial issue of age with respect to the social and sex-
ual identities of the young citizen. In chapter 6, I reexamine the rules that
govern *paiderastia*, the normative practice of homoerotic relationship be-
tween men, and its function as a political institution. The last two chapter
return to the representation of femininity through an analysis of the osten-
sible symmetry of the processes by which males and females are thought to
acquire adult social status. At issue is the existence of women's "initiations."
Chapter 7 deals with Spartan customs and the Athenian ritual of the Ark-
teia, which identify the segment of the female population that alone has
the capacity to produce citizens. Chapter 8 is devoted to the wedding rite.

The reader will be aware of at least two methodological difficulties. The
first concerns the treatment of the painted vases. Throughout, I refer to the
figural scenes on the vases, leaving out of consideration the geometric and
floral patterns that frame the scenes, the question of why different subjects
—which often seem utterly unrelated—are joined on the same vase, and
most important, the vase itself in terms of its function and context of use.
It is apparent that there is some correlation between shape and imagery.
The list of vases in appendix 2 clearly shows that scenes of females working
wool are found predominantly, but not exclusively, on certain vases—pyx-
ides, lekythoi, alabastra, hydriae—which may plausibly be said to be used
by women. But the exceptions are too many and their nature too poorly
understood to speculate based on a tentative correlation of shape to imag-
ery. Therefore, although I believe that the vase itself is an important part of
the message of the image and I have taken that into account in my analy-
sis, I have chosen not to make it part of the discussion, in an attempt to
avoid the practice of explaining the obscure by the uncertain. Like the pat-
terns and the thematic congruence of the several representations that may
be found on the same vase, this is a complex problem, which deserves to
be looked at on its own.[36]

A more serious charge will be that I combine evidence from different his-
torical periods. In my selection of archaeological sources, particularly vases,
I have marked off a certain period, the broader limits of which are about
520–400 B.C., with most falling between 470 and 430, because it offers the
richest selection. The literary sources from which I draw comparable imag-
ery, on the other hand, range from the eighth century, with Hesiod and the
epic, to the Hellenistic period, with Theocritus and Erinna. Moreover, the
mythographers, and the lexicographers who give evidence of customs and
ritual practices, take us all the way to late antiquity. Several lines of defense
are possible, such as that the clichés of gender I attempt to identify are
so basic and pervasive in a culture that they are less amenable than other

notions to fast and radical change throughout the lifespan of that culture. And I could point out that literary and political historians and, most frequently, historians of institutions and religion, routinely use evidence spanning the very same chronological range, albeit appealing to lost sources and postulating continuity of traditions, as appropriate. Although I have in each case carefully weighed the risks and implications, no explanations of this kind are provided. With characteristic perspicuity, Momigliano saw my predicament all too well:

> Often the nature of the evidence is such that one has to combine items
> belonging to different historical periods in order to obtain the pic-
> ture of an institution. Where the historian is reluctant to tread lest
> he may offend against the proper chronological sequence, the anti-
> quarian is ready to introduce himself. Classification can dispense with
> chronology.[37]

Antiquarian habits die hard.

CHAPTER 1

The Thread of Ariadne

> First let us distinguish between sentences and words. A sentence I will call every complete sign in a language game, its constituent signs are words.
>
> Wittgenstein, *The Blue and Brown Books*

Hector's words to Andromache upon his departure to fight Achilles are the earliest extant mention of a way of life that bound the women of the Greeks to the house, tethered to their looms and work baskets:

> Go then to your chamber and tend your own realm, the loom and the distaff, and see that your handmaids perform their tasks; for war is the concern of men, of all men but most of all mine, of all born in Ilios. (Homer *Iliad* 6.490–93)

The formula rings again in Telemachus's reply to his mother, who had complained that the singer's lay about the bitter homecomings of the Achaeans had stirred her sorrow:

> Go then to your chamber and tend your own realm, the loom and the distaff, and see that your handmaids perform their tasks; for speech is the concern of men, of all men but most of all mine, for mine is the power in the house. (Homer *Odyssey* 1.356–59)

Denied the right to speak and fight, the women of myth are represented doing their best at the only skill they are taught and allowed to practice.

Penelope's inalienable right to weave becomes the tool of her resistance against the men who are closing in on her and on the rest of her husband's property. Spinning and weaving in their chambers is the form of the rebellion of the daughters of King Minyas, who refuse to celebrate the rites of Dionysus.[1] Textiles become a girl's voice in the case of Philomela, who managed to tell the story of her rape by weaving it into a tapestry.[2] The woven fabrics are a woman's weapon of choice—the robe soaked in centaur's blood with which Deianira tries to win back her faithless husband, the beautiful poisoned dress with which Medea murders her rival, the web in which Clytemnestra traps Agamemnon before she kills him, an "evil wealth of cloth."[3]

Spinning and weaving—the distaff and the loom—are an essential feature of the ancient Greek representation of femininity, one that far exceeds utilitarian connotations of domesticity.[4] While it is plausible that, in practice, wool-working was a homely task, the pictures of females carding, twisting yarn, and spinning on the painted vases of the Late Archaic and Classical periods display an unexpected trait of the wool-worker: glamour.[5] Invariably young and comely, in fancy dress and adorned with jewelry, the spinner receives men who bring her gifts and counts Eros as her servant and companion. More explicitly than literary texts, these images show that wool-work imparts important connotations to the definition of a certain kind of femininity, but the nature of these connotations and of this kind of femininity is at present unclear and controversial. The problem of the spinner is taken up in this first chapter as a case study through which I examine methodological issues in the interpretation of the images of Greek painted vases.

THE HETAIRA AND THE HOUSEWIFE

The issues of who a spinning female may be and what her image means surfaced sixty years ago as a minor scholarly controversy. Debate centered on scenes such as the one represented on an alabastron of the 470s B.C. (figs. 3, 4): a young man holds out a pouch to a veiled female who sits spinning. She is invariably described as a "woman" rather than a "girl," which glosses over the fact that her appearance offers no indication of her age or marital status. The vignette conforms to an iconographic scheme labeled "courtship scene," in which a man hovers around or brings a gift to a younger male or to a female of undetermined age.[6] In the particular version of this theme that appears on the alabastron, the gift is a small pouch. While Beazley held firmly that the "woman" must be a respectable matron, Rodenwaldt argued that she is a high-priced courtesan, one of the *megalomisthoi*

hetairai affecting the manner of the respectable woman.[7] The key to Roden-
waldt's reading was precisely the bag the man holds, which was identified
as a money purse. The subject, then, must be love for money; the woman
(or the adolescent male or boy with whom she is interchangeable) is not
what she seems. This is how Rodenwaldt's article of 1932 brought into ex-
istence the "spinning hetaira," who has cast her shadow since over every
nameless spinster on the vases.[8]

Carried now to its logical extreme, Rodenwaldt's hypothesis has pro-
duced results that test the limits of an informed viewer's credulity. A prim
figure enthroned and spinning (fig. 5) is labeled the madam of a brothel.[9]
A scene of men and boys approaching, bag in hand, a female wrapped like
a mummy and holding a mirror can be described as "a hetaira seated in the
porch of what is surely a brothel."[10] (fig. 6) A sense of the grotesque makes
a fugitive appearance in Keuls's remark on this vase: "Is the whole family
on an excursion to the neighborhood whorehouse? Surely not, not even in
Classical Athens."[11] But spinning and textile activity have become synony-
mous with prostitution in a certain vein of writings on the vases, leading to
the idea that brothels doubled as textile factories: "[T]hat spinning and the
production of small textiles went on in the brothels of Athens seems emi-
nently likely."[12] Indeed, the presence of a large number of loom-weights
in the deposits of its third phase is the chief piece of evidence for the cur-
rent identification of Bau Z, a building excavated in the Athenian Cerami-
cus as inn, textile workshop, and brothel, all at once.[13] It is important to
note that this view represents a significant twist of the Rodenwaldt hypoth-
esis, one that turns the high-rank courtesan into a prostitute, the hetaira
into the *porne.*[14] This effectively undermines the construct of the "spinning
hetaira." For, if wool-work has any function in these representations of am-
orous encounter, it is to give the illusion of virtue, thus placing the women
worlds apart from the creatures who sat naked in the brothels of Athens
and could be had for two obols.[15]

As is well known and as Davidson and Kurke most recently pointed out,
there exists a divide in Greek thought between the *porne* and the hetaira.[16]
Briefly, the former is goods for sale: one pays cash in an exchange that is
impersonal and finite. But a man's engagement with a courtesan is a per-
sonal one over time, and the exchange of goods for services takes the form of
gift-giving.[17] Xenophon provides a notorious portrait of such a courtesan
in his *Memorabilia* (3.11), which relates Socrates' visit to Theodote.[18] Love-
liness personified, she is a woman who will consort with whomever "per-
suades" her to do so (τῷ πείθοντι, 3.11.1), her mother at her side, both
exquisitely dressed in their well-appointed house among their servants.

Socrates leaves no doubt as to her meretricious nature when he says that her body is an engulfing hunting net, animated by a soul that knows how to please men and have men please her (3.11.10). But the question of her source of income is a delicate subject. Eventually it transpires that she depends upon the generosity of her friends for gifts that, of course, are reciprocated in an exchange based on goodwill and gratitude, in a word, on *kharis*.[19] Indeed, the very sight of her is a gift that calls for favors in return. In this picture, the image of coins, or a coin purse, would be either inappropriate or highly charged. To quote Davidson: "The hetaira goes to great lengths to avoid having herself and the relationship with men made explicit. Otherwise she would not be a hetaira."[20] The same may be said of the scenes of "spinning hetairai." If these females are hetairai, the bags of money in the men's hand have the effect of shattering the pretense of gentility that the act of spinning, the elaborate clothes and jewels, and the courtly gestures create, by making the sordid nature of the transaction painfully clear. And if they are prostitutes, why the travesty? But are there moneybags in these pictures?

Attempts to refute the prevailing interpretation have tackled the alleged proof of the argument, the infamous bag, by proposing that it holds not coins but the favorite game of children and like-minded adults: *astragaloi* or knucklebones.[21] Inevitably, this leads into a discussion of the taxonomy of bags in vase painting. My point of departure was the study by Roland Hampe on a Thessalian stele of the Early Classical period. On it Hampe saw two girls finishing up a game of knucklebones. One displays her last, winning throw, holding the pieces she has won in her left; the other shows the losing side of her knucklebone and, in her left hand, the empty pouch.[22] The identification of such pouches on vases is not easy, since depictions of the game itself are rare and, as knucklebones varied in size and material, so too did the size and aspect of the satchels in which they were carried. With Hampe, one can identify as knucklebone bags those that have an opening on the side; these correspond to models of such objects, some of which have the flap lifted to reveal four *astragaloi* inside.[23]

On the plain satchels that appear in the scenes of courtship, Hampe remained uncommitted. On the basis of the shape of the bags alone, it is impossible to decide whether they are money purses. In a few cases, the admirer holds one of the pieces contained in the bag out to his beloved, but it is far from clear that the object is a coin.[24] Indeed, a lekythos in Athens shows clearly an object with two ends that can be held in the middle.[25] But there are other scenes in which these plain, small, rounded bags appear, and the way they are employed in these different situations gives strong in-

dications that they are not likely to hold coins. With few possible exceptions of doubtful interpretation, the bags do not appear in the scenes, admittedly few, of commercial transactions, and they are all but absent from the explicit and sometimes brutal depictions of lovemaking that are frequent on vases of this period.[26] On the other hand, plain satchels as well as satchels with the side opening occur in "music lesson" scenes, either hanging on the wall or offered as prizes;[27] in "school scenes," where they hang on the wall together with writing tablets and other trinkets;[28] and in "palaestra scenes," where they keep company on the wall with aryballos, sponge, and strigil for the bath.[29] Together with sandals and sashes, the bags hang on the wall in scenes of "women in the house," which are thought to represent the women's quarters or *gunaikonitis*, discussed below.[30] In all these cases, an identification of the object as a money purse is improbable, to say the least, and as a matter of fact in such settings the bags are normally called bags of knucklebones without further ado.

The context of the courtship scenes is no less revealing. In pictures that include more than one couple or several suitors for one girl- or boy-love, the little bag is but one of several possible gifts an admirer may bring to the beloved.[31] For instance, on an alabastron in the Cabinet des Médailles, in the same iconographic scheme as the scene on the Pan Painter's alabastron (figs. 3, 4), a young man offers a patterned sash instead of a bag to the female seated at her wool basket and holding a garland in her hands. The painted inscription next to her calls her *he numphe kale*, "the fair bride."[32] The range of tokens of love consists of flowers, pet animals for the boys—such as a hare or a cockerel, or rarely, an exotic cat—simple lyres, and garlands.[33] It is of the essence that these gifts be pretty things that have little or no value, that they should fall under the category of treats rather than payments. That is the sense of Aristophanes' satire of the mercenary *eromenos*, one who accepts presents such as horses and hunting dogs that are technically not payments but are substantial enough to being seen as compensation.[34] In romantic pursuits, where a bag of money would be out of place, *astragaloi* make a perfect gift, because they are charged with erotic connotations. In a much quoted line, Anacreon calls them the passion and battle of Eros,[35] a cliché, as one suspects from the phrase attributed to Polycrates of Samos and the Spartan Lysander, that one seduces men by means of oaths, and boys, with knucklebones.[36] Pausanias allows us to recover the connotations of these objects in his description of statues of the Graces in their sanctuary in Elis, one of whom held a rose, the second an *astragalos*, and the third a dainty branch of myrtle. The rose and the myrtle, says Pausanias, are connected to Aphrodite, but the *astragalos* refers to youth and *kharis*:

The *astragalos* of youths and maidens, whose grace is unblemished by
the touch of old age, the *astragalos* is their toy. (*Description of Greece*
6.24.7)

Finally, there are cases in which the knucklebones are out of the bags. On a
cup by Makron (fig. 7), the crucial pair is at the center, where the *erastes*, the
lover, holds a handful of small *astragaloi* to his beloved, with the same ges-
ture of the cupped hand as a girl depicted on a vase fragment from the Athe-
nian Acropolis, or the knucklebones-player on a Classical stele.[37] On a hy-
dria by the Kleophrades Painter, the man offers his sweetheart a single large
astragalos.[38]

 This explanation of the bag as an innocent gift restores the respectabil-
ity of the spinner. Let us now return to the alternatives posed by the ques-
tion either the hetaira or the housewife.[39] Both sides of the debate read the
spinner as a figure drawn from life and depicted with the features of the
housewife, although the one saw it as a counterfeit, the other as the real
thing.[40] Like folk etymologies, the divergent answers given—"she is being
offered money" on the one hand; "he brings home the bacon," on the other
—are based on the interpreter's common sense. Beazley's remark, however,
that prostitutes may well have done spinning in real life but would not be
represented doing so, puts some distance between fact and picture and points
us in the right direction.[41] What makes the figure of the spinner problem-
atic is the context in which she frequently finds herself, that of the amorous
encounter. Erotic connotations are hard to reconcile with notions of duties
and chores and with the ancient as well as the modern conception of the
housewife. While in real life, no doubt, many husbands felt passionately
about their wives, could a wife be viewed as the object of passion? Not to
judge from what may be gathered from literary accounts of the way men
thought about categories of love objects:[42]

 We have hetairai for pleasure, concubines for the day-to-day care of our
 body, and wives in order to procreate lawfully and to have a trusted
 guardian of the household. ([Demosthenes] 59.122)

This notorious statement in the Demosthenic speech against Neaera is a
clear expression, however overstated, of a way of thinking that viewed plea-
sure in marriage as a rare and dangerous thing. Love as erotic play involves
certain categories of females—maidens and hetairai—but excludes the
wife, who is kept for the work of procreation.[43] The question then becomes,
while in real life some wives may have received gifts and done spinning,

would they be *represented* doing so? Neither the prostitute nor the wife, it
seems, is a likely candidate for the enigmatic spinner. The problem will
now be tackled by redefining the terms of the question, widening the in-
quiry, and employing a different set of interpretive assumptions.

WAYS AND MEANS

The first step must be to make distinctions: between reality and representa-
tion and between the representation of reality and that of fiction. The
analyses of the courtship scenes considered so far, including mine, have re-
lied on the current classification of the vase paintings into mythological
and nonmythological scenes. The former are read following the text of a
story that has survived in written form; the latter are labeled "genre scenes"
and read as "everyday life" in reference to the material and social reality of
fifth-century B.C. Athens, as it can be recovered from written sources.[44] Let us
look at the way this distinction is made in some specific instances. A cup by
the Triptolemos Painter depicts a feast (fig. 8): men reclining on couches,
drinking, and making music. This scene is read as a staple of contemporary
Athenian life, the symposium of men. In its essential features, it corresponds
to hundreds of other representations on Attic vases of the same period.[45]
The very repetitiveness of the imagery seems to furnish some guarantee of
its realism. But on a rhyton by the same painter (fig. 9) one sees a very simi-
lar cast of characters—men reclining and drinking with musical instru-
ments—who are identified by inscriptions as the mythical kings of early
Athens.[46] A Classical bell krater by the Dinos Painter presents an analogous
case.[47] The picture shows a young warrior, nude except for a short mantle,
helmet, sword, and shield, pouring a libation at a primitive-looking altar.
He is assisted by a girl, who holds the oinochoe, while a bearded man looks
on, leaning on a walking stick. Further to the right is a young couple hold-
ing or shaking hands. Before the inscriptions were read, the scene had been
taken as an "everyday" departure scene. But the men turn out to be the
eponymous heroes of three Attic tribes—Pandion, Acamas, and Oineus.
Beazley recognized eponymous heroes in another picture that had been la-
beled "ephebes and courtesans" because it depicts men in cordial exchange
with women.[48]

Even interpretations that discount the realism of the image maintain the
distinction of myth versus nonmyth, with the effect that the representations
that are taken to be nonmythical are seen as lacking a specific content. In
the fine analysis of the representation of the dead hero by Schnapp and Lis-
sarrague, for instance, the unlabeled representations of the transport of the

corpse are taken to be anonymous and generic. Only the labeled ones are taken to be representations that have their referent in the epic past—pictures of Ajax carrying the corpse of Achilles.[49] One last example: on one cup by the Calliope Painter the tondo shows a youth holding a lyre and a woman offering him a garland; they are, the inscriptions say, the legendary poet Musaeus and the Muse Clio.[50] On the exterior are young men with lyres and women, again identified by inscriptions as Muses, Musaeus, and Apollo. Another cup by the same painter has very similar imagery: in the tondo, the youth with lyre sits, the woman stands with oinochoe and phiale; on the exterior, young men, one with a lyre, and women, two with oinochoe and phiale.[51] On this second cup the figures are not labeled and therefore lend themselves to be interpreted as characters from daily life.

It is common knowledge that what determines the classification of a scene as genre is not the presence of figural elements that can be recognized as nonmythological but the absence of elements that identify it as myth or fiction to our eyes. Identification depends upon inscriptions labeling the personages or features that the modern interpreter is able to recognize as fictional. While a sphinx triggers disbelief in the truth-value of the picture, the sexy spinner does not. There is, in fact, no credible way to distinguish between myth and nonmyth in the depictions on the vases. Indeed, the fact that the two may be represented in manners that are so alike as to generate confusion has not escaped the notice of scholars. The coincidence is explained, when an explanation is given, either way: by postulating that the painter has "dressed up" representations of everyday activities by the addition of inscriptions and attributes, or that he has "elevated" daily life to a superior realm. In this way, the picture on a Classical pyxis (fig. 2), where Helen is depicted at her wool basket, together with her sister Clytemnestra, Iphigenia, and Danae engaged in the toilet, is explained as a domestic scene to which the names of Argive heroines have been added.[52] The reverse case is assumed by the current interpretation of the figures on a Meidian pyxis showing females in an outdoor setting (rocks, vegetation) at their toilet, with erotes. The picture follows the same iconography as the toilet of Aphrodite, represented, for instance, on a lekanis lid in Mainz (figs. 40, 41). The correspondence is acknowledged without qualms: "Many of these scenes are practically indistinguishable from those that show Aphrodite and her retinue: only inscriptions can differentiate the goddess and her attendants from the anonymous women who may, provisionally at least, be assumed mortal."[53] The depiction of allegedly ordinary women in gardens surrounded by erotes is explained as an adaptation of the representation of Aphrodite to real wives: "[T]he gardens are Aphrodite's meadows of love, into which

the women of Athens, in idealized form, have been allowed to enter." [54] The remarkable assumption underlying this view is that, where the imagery is concerned, it makes no difference whether the representation articulates a discourse about the imaginary and the divine or about the here and now. [55]

This failure to acknowledge the significance of our inability to distinguish between representations of the real and the imaginary on the vases has far-reaching consequences. Consider, for instance, the picture of women reclining nude and drinking at a symposium on a psykter of about 510 B.C. (fig. 10). [56] Their names are inscribed, and the words "I toss this wine for you, Leagros," in Doric dialect (*tin tande latasso, Leagre*), issue from Smikra's mouth. She plays *kottabos*, a postprandial game men played at symposia, which consisted of tossing the lees of the wine at a target on a stand. [57] This scene now is taken as an illustration of factual matters in two ways. First, the fact that the figures speak Doric and play *kottabos* is explained by noting that the game was reportedly invented in Sicily, where Doric was spoken. [58] Second, the scene is interpreted as the illustration of an actual event, an occasion in which women were present at the banquet not on the menu as entertainment, for a change, but as participants. Because written sources make it clear that in Greece reputable women did not take part in symposia, and certainly not naked — like men — it is assumed that these are hetairai holding their own symposium. [59] This line of reasoning is taken further: in order to allow themselves the luxury of a symposium, these must be *rich* hetairai or prostitutes. This picture then takes us some way toward the reappraisal of the condition of prostitutes in the ancient world. [60]

The possibility should be allowed — and in principle everyone will agree — that pictures represent fiction, things that are thought not to exist but may be imagined. [61] In fiction, things may be represented as they are not, even as the contrary of what they are thought to be; impossible things may be shown but not without a sense and a purpose, that is, not outside a given discourse. If it is imaginary, the representation of the women at the banquet will not tally with what we are told really went on in ancient Greece; it should correspond, however, to what was represented or imagined in ancient Greece. [62] The scene reproduces the iconography of the symposium in all details — the rich cushions, the game of *kottabos*, the single-sex cast of guests entitled to recline, their partial or total nudity — in all details but one: women instead of men. And there is something decisively manly about the dress and physique of these women. [63] Against the set of conventions to which it belongs, the picture stands out as a perversion, of the contrary-to-fact sort, of the representation of the symposium, and the perversion consists of women having taken the place of men. [64] In the

literary texts, the same conceit is found in various sources, primarily in comedy, such as *Lysistrata,* and pseudoethnography, in which both real and imaginary barbarian females (the Etruscan women, for instance, and the Amazons) usurp masculine roles.[65] In philosophical and historical writings as well as in comedy, that kind of excess is characteristic as well of the Spartan females, who behaved like men in a number of ways, from displaying their bodies to managing property.[66] Spartan women, of course, spoke a Doric dialect, Laconian.[67] The Athenian picture showing manly Dorian women obviously is one more instance of the parody of Spartans. The discourse to which it belongs addresses the prerogatives of gender through that well-known paradox: women in charge. In this case at least, whether the scene is understood to depict real events or to offer a parody of the fabulous Spartans makes a substantive difference as to its meaning and value as a historical source.

Let us consider as a second example the picture on a Classical column krater. A woman sits on a chair within an architectural frame established by a column and holds out her hands to accept the gifts brought by the four men who stand before her: jewels in a chest, a dress, a phiale, a mirror. The men wear mantles and two have walking sticks, as in the "everyday" courtship scenes.[68] The scene has all the earmarks of pictures that are now understood as representations of courtesans and their clients. That an honest woman should find herself among men who offer her gifts is unthinkable in Athens of the fifth century B.C.[69] But this picture can be connected to a text. It was seen from the moment the vase came to light that the scene matches closely the description of the courtship of Penelope.[70] The Syracuse krater, because it is a representation of Penelope, by unspoken general consent never enters discussions of the image of the hetaira receiving clients, yet there are obvious shared features between the two. Should we believe that an "everyday" iconographic scheme has been dressed up to yield a depiction of myth such that the image of the hetaira has been projected upon Penelope? Or, as in the case of the "idealized" toilet scenes, do we think that the image of Penelope is the paradigm of the hetaira? The current definition of genre leads into a quandary that admits no facile solution. For this reason, I reject the premise that the image of the woman working wool belongs, to begin with, to the context of everyday life in fifth-century Athens and that it migrates from there into epic or myth. For all we know, in the eyes of the vase painters and their customers, the glamorous spinner was as real as Atlantis.

In either case—whether a representation of fiction or of reality—the image is a representation. Its task is to depict not what exists but what is con-

ceivable, the notions according to which reality takes shape in a given society. For this reason, the range of the imagery is not unbounded. As Bérard and others have observed, for all the variety that the repertoire of the painted vases offers, there is much that is never represented:

> Here we touch on one of the enigmas of this world of representations. In describing and analyzing this highly structured system of extremely rich and complex imagery, the lacunae, the gaps, and absences are even harder to explain than the isolated images themselves. Are those deliberate choices and rejections, censures, taboos, religious prohibitions, an order of values different from our own?[71]

The silences speak to the ways in which the pictures are both produced and controlled by the discursive practices dictated by the culture no less than other forms of expression. It is beside the point, therefore, to speculate whether in actuality courtesans worked wool or wives received gifts, because the fact that they did, if it were true, would not explain why they are represented doing so. The question to ask is what purposes it served to represent a woman (or a girl) as both laborer and object of desire. To ask why and how something may be represented takes us onto the terrain of the social reality of conventions and institutions rather than that of perception as objective apprehension of the world. We confront questions concerning the audience to whom the picture was directed, fixed rules of usage that insured the image would be read correctly, the particular discourses within which the picture circulated, and the norms and authorities regulating those discourses.

The idea that an image "resembles" or is "inspired by" and eventually depends upon what the painter actually saw is deeply ingrained in studies of visual representations and in studies of Greek vase paintings in particular.[72] But to speak of conventions, rules, and norms establishing what may be shown and where and when an image may come into being and be viewed implies that the image is an artificial creation whose relationship to actual reality is indirect and immensely complex. In chapter 3, I attempt to explain one of the mechanisms by which images are constructed. Here I state my position in general terms, taking my start from Nelson Goodman:

> Realistic representation . . . depends not upon imitation or illusion or information but upon inculcation. Almost any picture may represent almost anything; that is, given picture and object there is usually a *system of representation*, a plan of correlation, under which the picture

represents the object. How correct the picture is *under that system* de-
pends upon how accurate is the information about the object that is
obtained by reading the picture according to that system. *But how literal
or realistic the picture is depends upon how standard the system is.* If repre-
sentation is a matter of choice and correctness a matter of information,
realism is a matter of habit.[73]

I have introduced italics in this passage of *Languages of Art* in order to high-
light the conditions under which images convey meaning and the nature of
our predicament as interpreters of an alien culture. The imagery is a system
that forms part of the broader network of representations, visual and oth-
erwise, by means of which the ideas and values of the ancient commu-
nity were conveyed and that relied upon sets of conventions that were stan-
dard for that community. We, of course, have no direct access to the system
because it is not standard for us. We are, in other words, denied the direct,
intuitive understanding of the pictures that has been so lightly assumed.[74]
Understanding the imagery as a system of communication also allows for
the investigation of its meaning through semiotic analysis and through the
principles of structural linguistics upon which semiotics relies.[75] Like the
signs of language, visual signs may be thought of as subject to two forms of
organization: the "utterance" or picture—the syntagmatic chain in which
several signs are combined in a particular message; and paradigmatic as-
sociation, present in the mind of the members of the community of view-
ers, where a sign is connected to the ones that may be substituted for it.[76]
It becomes then conceivable that, given an image whose sense is obscure,
one may reconstruct its associations and recover its meaning by tracing it
through the pictures in which it occurs.[77]

Any attempt to put these principles into practice will bring back the re-
alization that one's own structure of knowledge is inescapable, working
against one's will to impose extraneous patterns on the evidence. The very
first step, choosing which image to investigate, is a decision made on the
basis of the researcher's experience and of the realities that inform his in-
terest, marking a point of forced entry into the system, an aperture that af-
fords only a partial and distorted perspective. What should be traced? The
figure of the "spinner" may appear to stand out naturally as a well-defined,
self-contained unit of meaning, but only if one does not look at the pic-
tures. The difficulties begin when one must decide which elements of the
many combinations involving females and wool are necessary and suf-
ficient to produce a certain meaning, which elements may be changed or
suppressed with little consequence, and which determine a perversion or

inversion of that meaning. Does it matter where she is located, whether she stands or sits, and whether she wears a headscarf? Does the act of spinning by itself provide the common denominator on which meaning rests, and does it have a meaning different from holding a distaff, with no spindle given, or having a wool basket by the side? How can we isolate visual signs? The analogy with language suggests a metaphor for our condition, if a picture may represent a text in an unknown language, with few clues as to word division and syntax but deceptively familiar in its script and disposition on the writing surface.[78]

Several proposals informed by semiotic theory have been made for the definition of the meaningful "unit" under these conditions, most notably by Morgan and Bérard. Morgan defined the irreducible elements of the picture as the equivalent of a morpheme in language, which cannot be broken down further without loss of meaning. In the depiction of the eye, for instance, one may not dispense with the inscription of the eyeball in the outline because that would result in a circle, no longer recognizable as part of the eye.[79] The figures, then, would be composed of such "minimal formal units," each having in itself a certain meaning, and the sense of an image would be the result of the association of units.[80] The problem with this proposal is that an interpreter who stands outside the culture that produced the pictures has no way of knowing how far the dismemberment of the figure can be taken before its elements are no longer identifiable for what they are—unless "natural symbols," which the modern viewer would interpret much the way the ancient viewer would have, are taken as the basis for the representations.[81] But if we scrutinize the assumption that the minimal formal units are ultimately meaningful intrinsically, outside of discourse, as natural symbols, it becomes doubtful as well that there is anything to be gained by breaking down the image into component parts.

Bérard's proposal also relies on the concept of the "minimal formal units" but as attributes in the conventional sense—man, club, lion skin for Heracles, for example—or as anatomical features such as beards or horns.[82] These units are granted only "reference" function. Signification occurs only when they are combined to yield a complex figure, a "minimal syntagm," whose meaning becomes clear when that figure is viewed in the context of all of the imagery. It is difficult to accept the notion of an image (the minimal formal unit) that has a referent and yet has no meaning, as well as the idea that such a purely denotative level of expression was accessible either to the artist or to past and present viewers. But the notion of the minimal syntagm as a unit of signification is important because it establishes the level at which interpretation is carried out. This level is not that of morphemes

or signs, which belong to the formal structure of the system as it may be abstractly thought of, but that of discourse, which belongs to the fabric of society.

My understanding of the notion of "level" relies on Benveniste's essay on linguistic analysis. Benveniste distinguishes the level of the sounds, the phonemes, which do not signify, from that of the word, or sign, which has meaning. He also distinguishes the level of the word from that of the sentence:

> The sentence is realized in words, but the words are not simply segments of it. A sentence constitutes a whole which is not reducible to the sum of its parts; the meaning inherent in this whole is distributed over the ensemble of the constituents.[83]

The sentence, which is the final integrative level of language, is a unit not of language but of discourse:

> [W]ith the sentence we leave the domain of language as a system of signs and enter into another universe, that of language as an instrument of communication, whose expression is discourse.[84]

Benveniste further develops this definition of the sentence, or syntagm, as the point at which signs enter the network of communication:

> The sentence is a unit insofar as it is a segment of discourse and not as it could be distinctive with respect to other units of the same level— which it is not as we have seen. But it is a complete unit that conveys both meaning and reference; meaning because it is informed by signification, and reference because it refers to a given situation. Those who communicate have precisely this in common: a certain situational reference, in the absence of which communication as such does not operate, "meaning" being intelligible but "reference" remaining unknown.[85]

To take the syntagm as the unit of meaning means that analysis must take place at the level of discourse. That involves postulating a situation, specific and concrete, where communication takes place; a context, or what the sentence is about; and a discourse to which it is relevant.[86] While in theory there is no limit to the number of possible combinations of images, in fact not all possible combinations occur. The conditions for their existence are dictated by the occasions that social life makes available and the discourses that are allowed to take place, both of which are limited.[87] In these

terms, the context against which an image on the painted vases becomes intelligible is not that of the totality of the imagery itself. It is broader, because in the field of reference many forms of communication besides the visual intersect. The image of a satyr-player, for instance, belongs in the same area as drama and ritual, together with poetry and myth. At the same time, the range of a given syntagm within the imagery of the painted vases themselves is restricted, because the image belongs to certain contexts and not to others. The figure of the satyr easily recognized by the combination of male body and horse's ears and tail, belongs to the realm of Dionysus — whether myths of Dionysus or plays for the Dionysia. But the image does not have free range in the Dionysiac context: it does not figure, for instance, in the Theban saga of Pentheus. The satyr, Hedreen has proposed, belongs to a Naxian cycle of myths of Dionysus that is connected to the Athenian festival of the Oschophoria.[88] The image, that is, is tied to specific contexts that, in turn, feed into particular discourses. The task of the interpreter, therefore, is to trace the image, or "minimal syntagm," through its possible contexts, connecting it with comparable expressions in other media, and to expose the discourse to which it belongs. The problem remains, once a meaningful figure is thus defined as a unit of discourse, of how to go about identifying it — precisely how many elements are required in each case to anchor a figure to a context. The make-up of an image cannot be determined before tracing that image through a number of scenes. But one will not know which scenes to choose unless one has a pretty good idea at the outset either of the features of his minimal syntagm or of the contexts in which it is likely to occur. The satyr can be immediately recognized as a construction of features — however much rooted in "reality" each feature might be. No such point of departure is available for the spinner.

MEANINGFUL FIGURES

The decision of where to begin is crucial because it will determine the "cut" of the project. Of necessity, this is also an arbitrary decision, dictated, at best, by informed common sense born of familiarity with the material. Here the selection of the corpus of images through which to explore the questions posed by the spinning woman was made on an explicitly pragmatic basis: as many as possible of the Athenian vases made between 500 and 400 B.C. were collected that show any indication of wool-working activity. In principle, no phase of the textile process was excluded, from sheepshearing to dyeing to the making of a garment.[89] It will come as no surprise to specialists in Greek vase painting, but it is remarkable nevertheless, that

among these objects none depict either sheep or dyeing vats. The corpus as a whole is internally coherent and presents several striking characteristics. To begin with, the wool-working operations depicted are restricted to a narrow range, from carding to spinning, with many examples showing handling of skeins and spinning or holding spinning implements. On the vast majority of examples, evidence of wool-working is limited to the presence of the wool basket. Representations of weaving on the upright loom are all but nonexistent; those of working with portable frames, rare.[90] Second, typically wool-working is not at all the point of the picture. Wool baskets, spindles, and spinners feature in scenes that now are classified as courtship, rape, toilet, and "domestic." Europa holds her wool basket aloft as she is transported by Zeus, who has transformed himself into a bull, and so does Aethra as she runs from Poseidon. Danae receives Zeus in the form of golden rain sitting by her wool basket.[91]

What transpires within the so-called domestic scenes is not work but play. The female who sits by her basket or handles wool keeps company with others who play a game of knucklebones or smell flowers and toss balls (fig. 46). In the form of work baskets or spinners, wool-working is, somehow, an appropriate standard connotation for the toilet, together with attendants bringing perfumes in alabastra, jewelry chests, and mirrors (fig. 44). The subjects that wool strings together—courtship (but never sex), toilet, feminine work, and play—are not obviously connected by a story line or by a logic to be recovered by looking at the way Athenian women "really" lived. Nevertheless, they are connected, undeniably. The same cast of characters occurs over and over as the same figures appear in the different but overlapping contexts. For instance, the female moving or standing by a wool basket occurs alone (fig. 30) as well as in scenes of courtship or in a group of females who hold sashes, make garlands, or work wool (figs. 57, 58). The standing girl holding a sash also appears by herself (fig. 33), as well as in multifigured scenes (fig. 46). The girl who sits in a chair and juggles balls or apples is sometimes an isolated figure (fig. 22), sometimes one of a number of girls who are seated, with the others holding a garland, a mirror, or a flower.[92] The standing spinner to whom men bring gifts also appears alone (fig. 14) as well as with other girls who spin or otherwise work wool (fig. 46) and, rarely, in representations where another is being dressed. The girl who sits by her wool basket and looks at herself in a mirror (fig. 18) may tend to her own toilet (fig. 42) or keep company with other girls.

The simpler vignettes thus appear to be the means by which more complex scenes are built. The fact that they occur by themselves indicates that

they are capable of signification, that is, of conveying to the viewer a message in reference to something pertaining to a certain discourse. These isolated figures, I suggest, are syntagms as minimal as we will be able to recover without subjecting the scenes to arbitrary segmentation. No doubt the contemporary viewer would have been able, effortlessly, indeed subliminally, to parse these figures into simpler meaning-laden elements. We, on the other hand, are not privy to the requisite insider knowledge. A different way of analyzing the pictures presents itself at this point. Rather than trying to relate the representations to real life in the sense of customs and material conditions and before making recourse to the texts, I will attempt to describe the way in which the simpler figures are employed like formulas in the composition of multifigured scenes.[93] The richer pictures will define the range within which the notion of wool-working operates. I have identified twenty-six such "meaningful figures" (figs. 13–38). They are each labeled with a letter and all are listed in appendix 2, where each is followed by a list of variants and of the composite scenes where it appears. The scenes themselves are expediently grouped according to ostensibly dominant themes: toilet scenes, scenes of females by themselves at work and play, and courtship or reception scenes where men are present. What follows is a morphology of these themes.

Toilet

The toilet scenes, which include a variety of activities, can be identified as such by the fact that the emphasis is on dressing up, from allusions to the bath to putting on accessories such as scarves and jewelry. They fall into two main types, one giving the collective toilet of several girls together, the other focusing attention on one, who is normally seated. A squat lekythos in Chapel Hill (figs. 11, 12) offers a splendid example of the collective toilet.[94] The representation is in two registers. Above, a seated girl with the mirror (F, fig. 18) is addressed by a girl who is standing (R, fig. 30) and is surrounded by three more girls, the first holding a wreath of leaves (I, fig. 21), the second bringing a box (W, fig. 35), the third (behind the chair) a chest. Next to this scene is another of a seated girl, her hair loose on her shoulders, receiving a chest; a mirror hangs on the wall. The lower register repeats the same alternation of seated and standing figures, the latter apparently bringing objects to the former. A girl sits holding a perfume flask, the alabastron (O, fig. 27), while another rushes by, carrying a wool basket (E, fig. 17). A girl who sits holding a ball (Q, fig. 29) is brought a box (W, fig. 35). Two stand, the first with a chest, the second holding a mirror (G, fig. 19) behind

the chair of a girl who makes a garland (H, fig. 21) and is brought a box (W). Two more standing figures hold, respectively, a scarf (V, fig. 34) and a mirror (G, fig. 20).

This type of composition is the model followed for the representation of the toilet of the Nereids on a Classical pyxis (fig. 39).[95] Thetis sits, mirror in her right hand, with her hair loose—wet or simply undressed, while her sisters bring her the chest, the unguent jar, or the plemochoe (X, fig. 36) and hover around her (R, fig. 30). Glauke hands the chest to a sister; Aura ties the belt of the chiton she has just put on, holding the overfold of thin fabric up and out of the way with her teeth, as Theo brings her the alabastron (P, fig. 28) and Chryseis, the plemochoe (X, fig. 36). This is also how the toilet of Aphrodite is represented on the lekanis lid mentioned above (figs. 40, 41).[96] Aphrodite is labeled Paphia and is seated, holding the alabastron (O, fig. 27); there is a second seated female, called Eunomia. The scene is set outdoors—the two sit on rocks amidst flowers and a ducklike fowl. Each is being brought the box (W) and the plemochoe (X); between the two groups sits an oversize wool basket.

The single toilet presents much the same cast of characters, the difference being one of emphasis. A good example is on a hydria in Brussels (fig. 42).[97] The protagonist is seated in the center, holding the mirror (F, fig. 18). Around her are five standing female figures, who bring the plemochoe (X, fig. 36), the wool basket (E, fig. 17), the alabastron (P, fig. 28), or just stand by (R, fig. 30). In such a way in another picture (fig. 43), Aphrodite, seated by her wool basket, is attended by Peitho, who carries the chest; Hygieia, with the chest and the plemochoe (X); Eudaimonia, who has a necklace; Paidia, who juggles a short staff; Euklea, who has the box (W); and Eunomia.[98] On a lebes gamikos in Basel (fig. 44) the central figure has an open chest on her lap (N, fig. 26) and pauses, hand lifted, before taking something out of it.[99] She is surrounded by standing females (R), but the ones who bring things are winged, one with the wool basket (E) and a scarf, the other with the alabastron (P) and a scarf. These fuller representations coexist with abridged ones. On a small hydria, the seated girl holds the alabastron (O), the standing one chest and mirror (G, fig. 19).[100] In another picture the seated figure is not depicted (fig. 45): the standing girl with a mirror (G) gestures toward a chair elaborately prepared with a tapestry spread over the seat, with a footstool, a wool basket to the side, and an alabastron hanging above.[101]

The figures that appear consistently in both types of toilet scenes are the one seated with a mirror (F) and the seated one with an alabastron (O), the standing girl bringing the alabastron (P) or the plemochoe (X), and the

ubiquitous girl standing by (R). The attendant who brings the scarf (V) and the seated girl holding the chest (N), on the other hand, are more frequent in the single toilet scenes. This cast of characters is what one would expect in representations of dressing, which requires scents for the body and for the hair, a scarf for the head, and ornaments of gold. But these figures are joined by others that, on the one hand, depart from the theme of the toilet into both "women's activities" and "courtship" and, on the other, resist explanation according to the logic of the occasion, thus bringing into the foreground the symbolic import of the imagery. Among them, the most remarkable is the standing figure who brings the wool basket (E).

Work and Play

The girl at the wool basket and the girl who juggles belong primarily to the cast of the women-at-home or "domestic" scenes. These often include elements of setting, such as a column, as on a pyxis (fig. 46) where six female figures are engaged in various, apparently unrelated actions.[102] One stands, holding up a sash (U, fig. 33) to another, who sits lifting a bloom, wool basket at her side; the third moves away, bloom in hand (S, fig. 31) toward one who sits making a garland (H, fig. 20). Following are a standing spinner (B, fig. 14) and a girl making roves of wool on her knee. Another, slightly earlier pyxis shows again six girls and a column, but here they all are seated. The first holds a ball (Q, fig. 29) and a bloom, next to another who sits by a wool basket, also holding a flower, followed by a third who ties her sandals in front of another who holds a mirror (F, fig. 18). There follow the girl who makes a garland (H, fig. 20) and the one who tosses balls (J, fig. 22).[103] The seated girl holding a large ball of wool (C, fig. 15) may be placed between two columns (figs. 47–49), facing the one who stands with the mirror (G, fig. 19).[104] Next, one finds the seated girl who holds her wool basket (D, fig. 16), followed by a group, in which a girl standing enveloped in her mantle is offered a wool basket (E, fig. 17). The girl encased in her cloak from head to toes is a frequent character in these scenes. On a pyxis in Boston (figs. 50–52) she stands facing another girl who holds out a ball (K, fig. 23), or she sits in front of another who plucks at the sleeve of her dress. The third group on this vase consists of two standing figures, one holding out a ball (K), the other lifting yarn from a wool basket (M, fig. 25).[105] On a Classical pyxis all three females represented in a setting that includes a door are muffled in their mantles, and one of them is endowed with wings.[106]

Although wool baskets are in view, little actual work ever takes place.

Scenes such as the one on a Stanford hydria (fig. 53),[107] with a seated spin-
ner (A, fig. 13), the girl holding wool (C, fig. 15) and another working on
a portable textile frame, are uncommon. Like the preceding ones, the rep-
resentations of women at home may be sharply abridged, as in the picture
showing one girl sitting muffled in her mantle while two others rush about
(R), in a setting that includes a door, three columns, and several wool bas-
kets (figs. 54, 55).[108] They may be elliptical, as on an alabastron showing
only a standing spinner (B, figs. 14, 56) and a standing girls holding a wool
basket (E, fig. 17) and fillet, or another where the latter is joined by a girl
standing with a garland (I, fig. 21).[109] The figures that occur more fre-
quently in these "domestic" scenes than in those of toilet or courtship are
the garland makers, both seated (H, fig. 20) and standing (I, fig. 21), the
girls lifting yarn from the wool basket, again both seated and standing (L,
fig. 24; M, fig. 25), and the sitting girl playing with balls (J, fig. 22).[110] The
standing figure moving or looking on (R, fig. 30) is ubiquitous. Of the fig-
ures most typical of the dressing scenes, the girl seated and holding the ala-
bastron (O), and the one who brings the plemochoe (X, fig. 36) are absent.
There are, however, noticeable overlaps: on the exterior of a Classical cup
(figs. 57, 58), four seated garland-makers (H, fig. 20) are joined by a stand-
ing spinner (B, fig. 14), on one side, and by a standing girl with an alabas-
tron in her hand (P, fig. 28) on the other.[111] The last figure is most common
in toilet scenes. The seated and standing figures with the mirror (F, fig. 18;
G, fig. 19) that stock the "domestic" scenes also allude to the last phase of
the toilet. The variant given by the standing girl at the wool basket with a
mirror in one hand and a flower in the other was found, so far, only in iso-
lation (fig. 32).

Reception Scenes

Men join the company of females working wool in what may be labeled
"reception scenes." For instance, a seated spinner is present in the depiction
of Paris's return to his father's palace in Troy, accompanied by Artemis and
greeted by his mother. In this case the spinner should be one of Priam's
daughters, perhaps Polyxena.[112] A picture that has been plausibly inter-
preted as the encounter of Paris and Helen (fig. 59) shows Helen seated by
her wool basket, with an attendant who brings a box (W, fig. 35) and, facing
her, Paris, in the dress of the traveler—boots, cloak, and broad-brimmed
hat. Behind him another attendant brings an oinochoe and phiale (Z,
fig. 38).[113] Often it is explicit that the purpose of the visit is courtship. In
the sparer representations, the girl is seated or stands by her wool basket, a

bloom in her hand, while a man approaches with a present, such as a bag of knucklebones, or a flower (fig. 60),[114] a garland, or a hare. There may be more than one suitor. The seated spinner (A, fig. 13) on the exterior of a Late Archaic cup is surrounded by three men.[115] The standing spinner (B, fig. 14) and the girl standing and holding her wool basket (E, fig. 17) painted on either side of another cup (figs. 61, 62) are each flanked by two young men, one leaning on his walking stick, the other offering a bloom.[116] The girl, whose companions follow carrying her boots and distaff, lets herself be admired by a number of young men, as she stands in her mantle framed by two columns (fig. 64).[117]

The most frequent figures in the courtship scenes are the seated spinner (A), the standing spinner (B), the seated girl who makes a garland (H) and the one who holds the mirror, both standing (G) and sitting (F). Here, too, there are frequent overlaps with the "domestic" scenes, on the one hand, and with the toilet, on the other. For instance, the modest pyxis discussed above (figs. 54, 55) shows a minimal version of the women-at-home theme: a girl sits, wrapped, between two columns, surrounded by wool baskets, while another moves in her direction, turning her head back toward a closed door. This is the scenario for courtship represented on another pyxis (figs. 65–67) in which a young man offers a ball to the seated girl, who thrusts a hand out of her wraps to present another ball; the attendant rushes toward the door carrying a bag and a mirror.[118] Characters typical of the toilet scenes also occur in those of courtship: the seated girl may hold the chest on her lap (N, fig. 26), a standing figure may carry the chest, box (W, fig. 35), or even the alabastron (P, fig. 28) or plemochoe (X, fig. 36).

Combinations

A few general observations may be made at this point. First, the way in which a figure is integrated into the scenes reveals its role and something about its identity. Let us focus on the girl in motion holding a mirror. She appears in representations such as that on a pyxis in Berlin (figs. 74–76) in an architectural setting together with other girls, two sitting idly, three more in motion. In another picture on a pyxis, which includes a group of a standing girls, all wrapped, being offered a wool basket and another female sitting holding her wool basket, this figure (figs. 47–49) holds out the mirror to a girl who sits holding wool. In the same way the mirror is offered to a female who sits wrapped in her mantle and is also accompanied by another standing girl who holds a sash.[119] This girl with the mirror also appears in scenes of courtship in which the center of attention is the seated girl, as on

the alabastron by the Pan Painter (figs. 3–4) and the pyxis (fig. 67) cited above. In other words, the standing girl in motion who holds out the mirror has the function of attendant. As such, she appears in the rich imagery of a lekythos in Chapel Hill (figs. 11–12) in which several seated girls are being brought things as they complete their toilet. She maintains her identity of attendant not only when she appears by herself but also in elliptical scenes from which the object of her action is missing (fig. 45). On an alabastron she moves away from a young man, depicted on the other side, who leans on his stick (figs. 68, 69).[120] It is only scenes like the ones on alabastron by the Pan Painter that allow us to restore to the picture the missing central figure of the seated beauty. The seated girl who holds the mirror, on the other hand, addresses no one: she receives suitors, she is brought chests of various shapes, sashes, and scents. She may look at herself in the mirror or just hold it. By the same means, other figures can be recognized as attendants: the standing girl with the alabastron (P, fig. 28), the one with the plemochoe (X, fig. 36), the ones who bring the sash (U, fig. 33) and scarf (V, fig. 34), the girl in motion, wool basket on the ground (R, fig. 30), and the less frequent standing figures with the staff (Y, fig. 37) and the oinochoe and phiale (Z, fig. 38). Confirmation of their function of handmaids comes from the fact that, sometimes, imaginary creatures take their place. Eros offers the seated girl a sash, or stands by the basket, or brings her a garland; winged females bring the alabastron or the wool basket; and a satyr lifts yarn from the basket.[121]

These observations also reveal the limits of this kind of reading. Among the elements that constitute the "minimal syntagm" are not only attributes but also less tangible factors, such as pose (standing or sitting) and movement, which are much more difficult to gauge. The significance of variations in dress is also problematic. Given that chiton and himation are the norm, one may take the fact that a chiton is decorated with a star pattern as a variant that does not radically change the sense of the figure. But does the presence or the absence of a headscarf or of a veil or the absence of the mantle make a difference? To return to the standing figure with the mirror, she appears on a Late Archaic alabastron in a picture in which she cannot function as an attendant (fig. 70). She has a gauzy veil on her head and faces two other girls, one of whom holds a bloom, the other, who has no mantle, a pair of castanets—an allusion to the dance to come.[122] There is a good reason, as we will see in chapter 2, why the division between the attendants and the girls around whom they hover is as porous as it seems. But these uncertainties also warn of a gray area in which our inability to recover the associations of each element may result in serious misunderstandings.

This caveat notwithstanding, it is apparent that in general the simpler, single figures are meaningful when they are given in isolation because they maintain, in the mind of the viewer, their connection to the richer multi-figured scenes. The constraints thus placed on the possible readings of the pictures are considerable. Let us take, for instance, the three figures on a small hydria (fig. 71): [123] a girl, wrapped, stands holding an alabastron, another holds out a wool basket, and a third holds with an elaborate blooming tendril. An interpretation of this picture open to the possibility that it is complete in itself allows that each of the three holds the "attribute" that belongs to her and that no particular action is represented—they are simply "women." If, on the other hand, one seeks the context to which the figures belong, it will be found to be the toilet, where the three figures function as attendants. On another hydria of the same date, the figure with the alabastron and the one with the wool basket are part of a large cast of attendants serving the girl with the mirror who is seated in the center.[124] The figure with the flower has the same role on a very similar picture on yet another small Classical hydria.[125] A "common sense" reading of the figures on the alabastron in Adolphseck (figs. 68, 69) admits the possibility that the girl who rushes away holding the mirror is the one the young man leaning on his stick, depicted on the other side, has come to see. A reading in which the picture is seen as part of a fuller narrative, however, reveals that the two figures are excerpts, and that the context from which they come includes at least a second female who is the object of their attention.

This elliptical form of representation has long been recognized in cases in which it is used for a story that is well known to us in its details. There is general agreement, for instance, that a well-dressed woman swinging an ax is an excerpt from a scene of the murder of Aegisthus and that a disheveled and tattooed one likewise armed comes from the representation of the dismemberment of Orpheus.[126] The isolated figure stands for an action involving several characters; it comes loaded with connotations. This principle is crucial for understanding how and why the three main themes in which the wool-working females appear overlap—that is, for exposing the discourse to which the figures belong.

Regarding the morphology of the scenes, there are apparent concentrations of figures according to subject, but no firm boundaries separating the three themes. The point may be made again by means of specific examples. The seated girl who tosses three balls in the air (J, fig. 22) typically belongs in scenes of women at home. Her habitual companions are the standing spinner (B), the girl who makes a garland, both sitting (H) and standing (I), the girls who lift yarn out of the wool baskets—again, both sitting (L)

and standing (M)—and wrapped girls. It is this cast of characters and ambience that the figure trails, with a tinge of incongruity, into the picture of the toilet on a vase, now lost (fig. 72), where she is surrounded by attendants who bring her a plemochoe, chest, alabastra, and a box.[127] The standing girl with the alabastron (P), a fixture of the toilet scenes both alone and in a group occurs in representations of girls making garlands (figs. 57, 58), spinning, and receiving men (figs. 3, 4), where she introduces references to baths and perfumes. The seated spinner is a standard character not in "domestic" scenes but in scenes of courtship. She also appears, however, in the former, although seldom, and in the toilet scenes,[128] where her incongruity is more easily perceived, if not her erotic overtones. In her hands, mirror and distaff are interchangeable and often indistinguishable from one another.[129]

The freshly bathed and scented spinner belongs to the so-called domestic scenes, and the allusion to her beautification and sexual allure produce connotations that are pertinent to the context of the "domestic" pictures. In this case, however, the ground upon which the apparently jarring elements become congruent is not a story like that of Orpheus, because the woolworking women belong to several different stories: there is Helen of Sparta, Europa, Aphrodite, and the Nereids.[130] If the various representations do not refer to the same story, however, they do share the same reference: a certain kind of femininity. This is a discourse that is carried out not only through pictures but also by other means of representation circulating within that society. The imagery of females working wool runs through other kinds of visual and in verbal expressions, such as ritual performances, poetry, and the paradigmatic examples proposed by myths. Under many guises, a definition of gender is laid out in which wool-work serves primarily as the connotation of a creature who is as blameless as Penelope but, for the time being, also as seductive and dangerous as Pandora: *he pais kale*, that is to say, *la jeune fille en fleur*.

The Spinners

"But I will give men as the price for fire an evil thing in which they may all be glad of heart while they embrace their own destruction." So said the father of men and gods, and laughed aloud. And he bade famous Hephaestus make haste and mix earth with water and to put in it the voice and the strength of human kind, and fashion a sweet, lovely maiden-shape, like to the immortal goddesses in face; and Athene to teach her needlework and the weaving of the varied web; and golden Aphrodite to shed grace upon her head and cruel longing and cares that weary the limbs.

Hesiod, *Works and Days* 57–66 (trans. Evelyn-White)

We saw in the preceding chapter that, lacking firm boundaries, the three themes involving wool-working flow one into the other as the same figures move in and out of each. Erotic connotations pervade the women-at-home scenes, and connotations of industriousness, within reason, qualify both the beautifying operations and the courtship. In order to define the grounds upon which these associations make sense, in this chapter I locate comparable imagery in other realms of representation, such as poetry and myth.

GUNAIKES EPI PROTHUROISIN

The setting in which the figures are placed provides one principle unifying element among the scenes. In a few cases the scene is outdoors, the land-

scape briefly sketched by means of rocky outcrops on which the girls may sit or of wispy flowering tendrils and dainty fauna, such as small birds, cranes, and hares.[1] Most pictures, however, show the girls in a built structure indicated by column, door, and wall in varying combinations. The fullest version (figs. 54, 55, 73) includes the door and one or more columns,[2] but the architecture may be reduced to the door alone (figs. 74–76),[3] to two columns framing a figure as if in a porch (figs. 47–49),[4] or to just one column.[5] When neither columns nor door are present, one understands that a wall is depicted by objects that hang on pegs — scarves and sashes, sandals, bags of *astragaloi*, hand-looms, mirrors, and alabastra.

The consistency with which these elements of architecture occur has encouraged the notion that they signify a particular place and a real place, the interior of the women's quarter, *gunaikonitis*, of an Athenian house.[6] That the setting is an interior has been assumed because of the items of furniture, chairs and stools, and of the objects hanging in the background. The furniture does not include couches or beds. The bed, however, is sometimes visible through the half-open door (fig. 77). We are, therefore, shown a place from which one gains access to a bedroom, the *thalamos*.[7] Such a place may be a room or it may be a space open on one or more sides, that is, either a porch or a portico. There are some indications that the space in front of the columns is an open area. On a Classical pyxis (figs. 78, 79), a man in traveling gear placed between two columns, another young man, and a woman wearing a crown all stand looking at a passer-by, who is a traveler on horseback.[8] Moreover, a Boeotian pyxis of the late fifth century, which imitates the Attic type, shows an altar occupying a place somewhere in front of the door (figs. 80–82). The place of an altar is in the open but not necessarily in a sanctuary: the altar of Zeus Herkeios is a standard feature of the representation of ancient palaces, where it is located in the court.[9]

The possibility that the portico of a court is where the women in the scenes spend their day in virtuous pursuits and within the reach of men affords the means to resolve the ambiguity scholars have seen in these representations. The well-documented seclusion in which respectable females were kept from their adolescent years onward stands in apparent contradiction to what the pictures show: men of various ages freely approaching girls who are pointedly demure, beautiful, and soigné.[10] It is hard to believe that these encounters are part of the everyday life of the Athenians, but it is just as difficult to believe that our figures represent hetairai making use of such strong connotations of virtue. It is worth considering the possibility that what we see on the vases is not everyday life. Indeed, if door and col-

umn signify a porch or a portico, we can locate the ambiance where the young women appear—not in the here and now of Athens in the fifth century, but in the imaginary world of myth and epic, and give this place a name: the *prothura* of a palace.

Prothura means the space before or incorporating the passageway from one domain to another, normally from public street to private house and, in metaphors, from land to sea or from life to death.[11] No single image corresponds to all nonmetaphorical uses of the word, which is used for epic palaces as well as for ordinary houses. The image evoked depends on connotations that the context provides The place and time of the action represented determine the relationship of imaginary *prothura* to *prothura* of which a fifth-century Athenian had experience, some recently built, others ancient by his time. The *prothura* of fiction must resemble these real buildings enough to be recognizable as *prothura* and be dissimilar enough to suit the context that houses them. In other words, the *prothura* of Circe's palace may have been pictured as different, in some respect, from the porch of Agathon's neighbor where Socrates was seen to stand for some time before joining the party in Plato's *Symposium*.[12] It is precisely the literary representations of *prothura* that match the features found in the vase paintings.

Pindar opens his sixth Olympic ode with a metaphor that corresponds to the key elements in our scenes. The beginning of the song is cast as the front of a splendid hall, *thaeton megaron*: a well-walled *prothuron* on golden columns set before the chamber.[13] This flashing image, compounding entrance and recesses of the house, seems to match several pictures on the vases. The house of Peleus on the François vase consists of a porch *in antis* before the half-open door of the *thalamos*, where Thetis, his unwilling bride, can be seen sitting on the bed (fig. 83).[14] Porch and door are again the essential elements of the house of the nameless groom on a lekythos by the Amasis Painter (fig. 102).[15] The same shorthand notation of *prothura* and *thalamos* describes the heavenly dwelling of Hephaestus in the *Odyssey*. After laying a snare for Ares and his own faithless wife, Aphrodite, Hephaestus pretends to leave for Lemnos, then returns to catch the lovers, now trapped and unable to move:

> He took his way back to his own house (*pros doma*), heart grieved
> within him,
> and stood there in the forecourt (*en prothuroisi*), with the savage anger
> upon him,
> and gave out a terrible cry and called to all the immortals:

. .

The gods, the givers of good things, stood there in the forecourt (*en prothuroisi*),
and among the blessed immortals uncontrolled laughter
went up as they saw the handiwork of subtle Hephaistos.
(*Odyssey* 8.303–305, 325–327 [trans. Lattimore 1967])

Here, as in Pindar's metaphor, the forecourt (*prothura*) is what stands in front of the *megaron*, but is it a gateway or front porch, as the word is often translated? The latter meaning may be appropriate in some cases, as in the instance of the *prothura* where Miltiades sat watching the Dolonci go by.[16] But the adjective by which Pindar qualifies his imaginary *prothuron* (well-walled, *eutoikhos*) suggests that here, and probably in the episode of the jealousy of Hephaestus, the word means not just the entranceway but the entire complex of exterior gate, court, and porticos, just as *thalamos* stands for a number of chambers having various functions—dining hall, store-rooms, and, of course, bedrooms.

The most complete description of a palace is that of the palace of Alcinous in the *Odyssey*. This is what Odysseus sees as he stands on the threshold of the outer gate: walls with a coping of lapis lazuli stretching from the brazen threshold to the inner part of the house. In front of the gates, made of gold with posts of silver, two dog-automata stand guard, wonders made by Hephaestus:

Within, seats were placed along the wall (*toikhon*) on either side, from
the threshold to the inner part of the house, and on them were spread
fine cloths, the work of women. There the leaders of the Phaeacians
used to sit, drinking and eating. (Homer *Odyssey* 7.95–99)

Probably because it would have been self-evident to the ancient audience, it remains unspecified for thirty-one lines that we are looking not into a room but into a court, *aule*, which apparently included a fountain.[17] If the *toikhos* here is the enclosure of the *aule*, in the lines of Pindar cited above *eutoikhos* may also refer to the wall delimiting the court rather than to the front wall of the house. In that case, the metaphor can be seen to occur again in Plutarch's life of Solon.[18] Plato's introduction of the theme of Atlantis in the unfinished dialogue *Critias* is pictured as a grandiose beginning of porches, enclosures, and courts, *prothura men megala kai peribolous kai aulas*, laid out as the preamble to the work.

One more detail supports the hypothesis that *prothura* is sometimes used to mean forecourt. The Homeric expression *stesen en prothuroisin* is sometimes translated as "halted at the outer gate"—for Nausicaa returning on her mule-drawn wagon or Nestor and Telemachus arriving at the palace of Menelaus in Sparta.[19] This implies that the chariot is housed outside the palace and that the horses are fed and watered in stalls that are on the outside as well. But the often-used formula for departures of gods and heroes from the palace is "drove away from the *prothuron* and the echoing portico," *elase prothuroio kai aithouses epidromou*.[20] If it is legitimate to assume that these words evoked images in the minds of the people who heard them recited, it is also reasonable to expect this imagery to be coherent and so to represent arrivals and departures in the same setting, within the court.[21]

Gateway and court form the complex through which one reaches the rooms of the house, as Odysseus's description to Eumaeus of his own house implies: "building upon building, preceded by a court with wall and coping, and double doors secure the enclosure."[22] He follows Eumaeus into the compound and sits on a wooden threshold; it is there that Irus the beggar finds him and challenges him to a fight. The polished threshold in front of high doors, *proparoithe thuraon*, on which the two stand arguing, must belong to the *megaron* because, when he drags out the beaten Irus, Odysseus follows a path through the *prothuron* to the court and the gates of the portico.[23] *Prothuron* here is the area in front of the doors of the room in which the Suitors are dining, not the porch of the external gate. The latter is the point of arrival where Irus is propped up against the external wall to scare away other beggars and dogs.

The same meaning should be given to the word *prothura* at lines 194–95 of Euripides' *The Trojan Women*, spoken by Hecuba as she looks ahead to her situation as slave of some Achaean, "keeping watch in the *prothura* or nursing children." She does not imagine herself guarding the outer gate, but in the same role as, for instance, Nausicaa's maid.[24] When Nausicaa returns from the beach and her encounter with Odysseus, she leaves her team of mules to her brothers' care and heads straight for her room. It is there that Eurymedusa, once her nurse and now her chambermaid, *thalamopolos*, waits for her, warms her room, brings her supper. Like Hecuba, Eurymedusa was a spoil of war. Hecuba laments that she will end her days a servant, *prospolos* (275), at the door of her lady's chamber.

If the word always has the general meaning of "area before an entrance," the context in which *prothura* is employed determines in each case which of four possible specific meanings is the appropriate one. The four mean-

ings of *prothura* are the following: forecourt (comprising outer gate, walled court, and porticoes); front porch;[25] porch on the inner side of the front gate (*aithousa aules*);[26] or the area in front of the doors giving access to inner part of the house (*prodomos*).[27] Two characteristics of *prothura* in the first sense of "forecourt" are important in the task of connecting verbal to visual imagery. First, although it is part of the house, the forecourt is readily accessible. Dogs guard the gates—Odysseus's Argus, Alcinous's splendid automata—but the doors are open: standing on the threshold, Odysseus can see inside the court. Irus wanders in unimpeded. Nestor and Odysseus, at the outer gate of Peleus's house, observe the old man roasting meat at the altar in the court and are promptly recognized by Achilles.[28] The walled court is open to the outside and functions as a place of transition between the recesses of the palace and the street.

Moreover, the court is not just an area of transit but also the place where the inhabitants of the house come together and where guests receive their first welcome and may be put up for the night.[29] In Alcinous's palace, the Phaeacian chieftains are represented gathering sociably in the court, taking the seats provided along the walls. The description of Athena's arrival at the house of Odysseus, under the guise of the Taphian Mentes, gives a clear idea of what kind of activities went on in the forecourt. As she stands on the threshold of the court, she is presented with the spectacle of the Suitors shooting craps, eating, and drinking, seated "in front of the doors," *proparoithe thuraon*. Among them is Telemachus, who sees the false Mentes standing at the gate and rushes to greet him. The doors in front of which the suitors and Telemachus sit can only be the doors of the chambers that form the inner recesses of the house—dining halls, bedrooms, storage rooms—and they should be located in the wall opposite the entrance.[30] One gathers from Penelope's remark,"[L]et them [the Suitors] entertain themselves sitting either at the doors or down here in the house," that the Suitors divide their time between the *megaron* and the court. In the palace of Eumaeus's father, tables and cups were also set out in the *prodomos*.[31]

The landscape of the court that can be sketched out on the basis of the literary imagery consists of doors (those of *thalamoi, megara,* and court), of a circuit wall, and of columns supporting the portico, *aithousa*. There are chairs and stools to sit on and, at least in a few cases, an altar in the center. These are also the features one sees in the pictures of women working wool as well as in many other representations of women on vases of the fifth century. A few paintings show what may be a front porch: on a pyxis in Athens, for instance, a mantled girl sits between two columns supporting an archi-

trave as a young man approaches.[32] The scene on the Tampa hydria from the Noble collection (fig. 6) seems at first glance closely comparable, particularly in the form of the building. There is, however, a curious detail: outside the porch, in the background of the space through which the men advance, hang a sponge and a strigil, which are part of the standard equipment of the athlete. Unless one assumes that the painter has made a mistake—which is possible but, methodologically, a desperate measure—the area *outside* the porch is represented as bounded by a wall. That is as it should be if the porch area in which the girl sits is the *prothuron* of a particular chamber, *thalamos* or *megaron*, that is, the place *proparoithe thuraon*, which may also be called *prodomos*.[33] Sponges and aryballoi hanging on the wall are a reference to the *gymnasion* and the manly world of athletics. They are out of place in the feminine environment that our scenes depict. If, however, the vases depict not fifth-century Athens but the imagined world of the epic, the sponge and aryballos and the lady on the porch easily coexist. In the *Odyssey*, the court is the place where the Suitors eat and drink; there they entertain themselves with music and dance and also with sports, throwing the discus and the javelin.[34]

It is tempting to see in the principal feature of the structure, the two columns, a reference to the two columns of the porch of actual Mycenaean palaces.[35] As a rule, the imaginary palaces of the epic should not be used as blueprints for the reconstruction of buildings that actually existed either in the Late Bronze Age or in the Early Iron Age. One should expect, however, that a few highly visible features of the real palaces would be invested with particular significance and retained, albeit in stereotyped form, in the visual memory of the culture and in the imagery of poetry and the visual arts.[36] It may then be possible that the two columns in vase-scenes signify "ancient palace," much in the way that a drawbridge over a moat means "medieval castle" to most people nowadays. The pair of columns is sometimes used as a frame setting off a particular girl, sometimes industrious, sometimes glamorous. In other cases, and probably in most pictures, we are shown the space outside the girls' *thalamos* (fig. 77). For that reason, the door receives significant emphasis,[37] but often the columns are enough to identify the setting as the court. Other features indicate that the location is open to the outdoors and somewhat accessible. The girls are encased in the enveloping mantle, a garb suiting the reserved behavior appropriate in public circumstances, and the men, who may also be wrapped in the mantle, are invariably equipped with a walking stick, as though they had just come in from the road.

The *prothura* is precisely the place where the women of the house come into public view, beginning with the description of the peaceful city on the shield of Achilles:

> On it he wrought in all their beauty two cities of mortal
> men. And there were marriages in one, and festivals.
> They were leading the brides along the city from their maiden cham-
> bers (*ek thalamon*)
> under the flaring of torches, and the loud bride song was arising.
> The young men followed the circles of the dance, and among them
> the flutes and lyres kept up their clamor as in the meantime
> the women standing each at the door of her court (*epi prothuroisin*) ad-
> mired them. (Homer *Iliad* 18.490–96 [trans. Lattimore 1951])[38]

Women are represented in the *Odyssey* sitting in the porch, like Penelope when she overhears the Suitors who are feasting in the *megaron*, or Helen when she receives Telemachus in Mycenae together with Menelaus.[39] Helen's epiphany has many remarkable points of correspondence with the vase paintings:

> Helen came out of the fragrant high-roofed bedchamber,
> looking like Artemis of the golden distaff. Adreste
> followed and set the well-made chair in place for her,
> and the coverlet of soft wool was carried in by Alkippe,
> and Phylo brought the silver workbasket which had been given
> by Alkandre, the wife of Polybos, who lived in Egyptian
> Thebes, where the greatest number of goods are stored in the houses.
> Polybos himself gave Menelaus two silver bathtubs,
> and a pair of tripods, and ten talents of gold, and apart from
> these his wife gave her own beautiful gifts to Helen.
> She gave her a golden distaff and a basket, silver,
> with wheels underneath, and the edges were done in gold. Phylo,
> her maidservant, now brought it and set it beside her
> full of yarn that had been prepared for spinning. The distaff
> with the dark-colored wool was laid over the basket. Helen
> seated herself on the chair, and under her feet was a footstool.
> (Homer *Odyssey* 4.121–36 [trans. Lattimore 1967])

On the vases one sees the preparation of the chair (fig. 45), the cortege carrying the beauty's accoutrements, such as boots and distaff (fig. 63), wool

baskets full of crimson wool with distaff at the ready (fig. 20), and important wool baskets — ceremoniously carried (figs. 61, 84) or monumental in size (fig. 85).[40] Like the Suitors, the girls too may dance (fig. 86) around the altar and the wool basket within the walled enclosure (sash on the wall).[41]

When they come out in the *prothura*, the young women can be accosted by more or less desirable men. The Suitors' behavior — their camping out in Penelope's court and *megaron*— represents a perversion by excess of this custom. Aegina was carried off by Zeus from her father's *prothura*. The picture on a pyxis in Cambridge illustrates that particular version of the tale by showing Aegina's father, Asopus, seated between the two columns of the *prodomos* (figs. 87, 88).[42] The image of the beauty with a porch full of suitors is a cliché that occurs again and again in the epigrams of the *Greek Anthology*. The once beautiful Lais dedicates her mirror to Aphrodite, Lais who in her youth had a swarm of young lovers at her doors. The blaze from Cleophon's eyes as she stands *epi prothuroisi* effaces the mild charm of Nicarete, who shows herself at an upper window. A disappointed lover's dream of revenge is to have the girl pining at his door, *para prothurois*.[43]

Columns and doors identify one of the few places in which a respectable female might be seen and even approached. This is the reason why in these scenes of wool-working the actual weaving, that is to say, the upright loom, is almost never represented. The loom is inside, in the chamber, where the girls are inaccessible.[44] Because of its transitional nature the court is akin to other circumstances under which a respectable maiden may come into contact with men. Like a trip to the fountain-house, such as that taken by Amymone, for instance, or an outing to gather flowers, as those taken by Europa or Persephone, sitting in the porch and in the court sets up the right conditions for courtship and rape.[45]

HELIKES HETAIRAI

Another pervasive feature of the imagery of the wool-working females is the ambiguity marking the relationship of one character to another. As each figure was traced through several scenes, some were identified as "attendants" of other girls around whom the action revolved. The most characteristic trait of the attendant is that she stands and brings objects. It is not always clear, however, whether the object a standing figure holds is her own or is being carried or fetched for another. In other words, the standing pose is not in itself enough to qualify someone as an attendant.[46] The same is true of dress. With few exceptions, the seated girls wear a mantle over their dress and often something on their head — a snood, a diadem, or less frequently,

a short veil. When a figure lacks a mantle, she is normally one who stands. A sort of hierarchy of dress is displayed on the Athens alabastron considered above (fig. 70). The girl who holds the mirror is the most elaborately decked in mantle and veil; the second one, with the rose, has the mantle but no headdress; the third, with the castanets, stands in her dress alone (but wears a diadem in her hair). There are many instances of this kind of subtle differentiation. The scenes on the exterior of a cup in Florence (figs. 57, 58) suggest that dress indicates some distinction of rank, because all five seated girls have a mantle, while only two of the five who stand have one. On the Basel lebes gamikos with a scene of individual toilet (fig. 44), only the seated woman has a mantle; none of her six attendants, not even the winged figures, are represented wearing mantles.

But the distinction is so inconsistently employed that it is an unreliable means for the identification of figures. On a small hydria in St. Petersburg, for example, the two figures standing in front of one who sits, all wrapped with her head bent, both have mantles. One wears a diadem, as does the seated girl; the other, a snood.[47] Some confirmation that dress by itself does not indicate a radical difference in status comes from the pyxis depicting the Argive heroines (fig. 2), where all wear chiton and mantle except for Iphigenia, who is getting dressed, and Danae, who brings the chest. In this fashion, the imagery both suggests and denies distinctions among the woolworkers. Indeed, many pictures propose an equivalence of all figures depicted, such as the pyxis with six seated girls or present more than one female as the focus of attention. This is so in the case, among many, of the representation on a vase in the shape of a wool basket, the kalathos in Durham (fig. 89) where one sees a girl weaving on a portable frame together with a standing figure dressed only in her peplos and carrying a wool basket and a seated girl looking in a mirror who is being brought an alabastron and a plemochoe. Between these two groups are positioned two females, one crowned and swathed in a voluminous mantle, the other tying her belt. In a similar way, the figures on a white-ground pyxis in Boston (figs. 50–52) confront one another but do not noticeably fall into the categories of "protagonists" and "attendants." The relationship of one wool-worker to another is analogous to that among the females depicted on the contemporary Attic white-ground lekythoi, the so-called "mistress and maid" scenes, in which several women tend to the toilet of one who is seated. There, too, as Reilly has shown, the perceptible division of roles is counterbalanced by shared attributes so that "mistresses" and "maids" fade one into the other.[48]

This ambiguity is in itself a telling feature. It expresses one important aspect of the spinner: she belongs to the group of her peers. No less than their

elegant clothes and conspicuous jewelry and the fact that they are at home in a palace, the articulation of the figures into main characters and attendants is the visual equivalent of the way in which the image of a girl outstanding for beauty and rank is cast in poetry and in myth. In Greek myth, girls come in packs: the Nereids, the Minyads, the Proetids, and the Danaids, to name only a few.[49] Precisely such a brood appears on the Athenian pyxis described above (fig. 39), decorated with the toilet of the Nereids. Thetis, the maiden wooed by all the gods, is given the place of honor and is the only one seated. But two of her sisters as well are the focus of attention on the part of more sisters; some wear mantles, some do not. The picture gives the model of the sisterly band of maidens all of an age, all noble, beautiful, and virtuous, led by the one who is the most beautiful, noble, and virtuous of all. This model, which also structures the representation of choruses of maidens, was painstakingly uncovered by Calame. In his study of Alcman's *Partheneion* he carefully defined in the essential traits.[50] In poetry, a detailed representation of the *thiasos helikon*, the "company of coevals," is found in Moschus's *Europa*. The princess is surrounded by her companions (*hetairai*), girls of her same age (*helikes, homelikes*), dear to her (*philai*) and, like her, of noble birth. Each carries a basket as they set off to gather flowers. But Europa's is no ordinary basket: it is gold, made in Hephaestus's forge and, like other wonderful objects, has its own distinguished history. Europa herself stands out among her peers "as the foam-born goddess shines among the Graces."[51] An analogous relationship is voiced by the chorus of maidens of Theocritus's *Wedding Song for Helen*. The chorus claims Helen as one of its own (*paida sun paisi*) but also says how different she is: "Fair, Lady Night, is the face that rising Dawn discloses, or radiant spring when winter ends; and so amongst us did golden Helen shine."[52]

The band of companions, such as Helen's *thelus neolaia*, is the setting for the image of the beautiful maiden who is the object of desire of men and gods. The same flashes of light and precious metals set Hagesichora apart from her companions in Alcman's *Partheneion:* her face is silver, and her hair, gold.[53] Likewise, Nausicaa has the beauty of a goddess, and her companions have charms obtained from the Graces (Homer *Odyssey* 6.15–19) The notion of the group of industrious maidens all of an age is also at the core of a few mannered votive epigrams in the *Greek Anthology*. Demo, Arsinoe, and Bacchylis, who dedicate to Pallas, respectively, wool basket, spindle, and weaving comb, call themselves "three girls of the same age" (*trissai halikes*). The image is commonplace enough to be parodied in the dedication of the three courtesans who offer Aphrodite shoes, cloak, and cup.[54]

Calame has shown that in myth the paradigm for the band of maidens

is Artemis with her nymphs, but in the poetic descriptions cited above an-
other term of comparison is given: Aphrodite with the Graces. In literature
the relationship of the goddess to the Graces and the Horae conforms to
the model of the band of maidens clustered around a star, however dubi-
ous a maiden Aphrodite may seem. The Graces dance with Aphrodite and,
together with the Horae, bathe and dress her; they weave for her, and they
gather around her at her birth.[55] This is the key to a better reading of the
pictures of the toilet of Aphrodite in a wool-working environment. The
subject is represented in both versions of the theme — collective and in-
dividual. On a lekanis lid described above (figs. 40–41), two figures are
being dressed — Aphrodite (Paphia) and Eukleia, who is brought a box by
Eunomia. A similar representation is on another lid where the two seated
figures are Aphrodite and Harmonia; their companions and attendants are
Eukleia, Eunomia, Pannychis, and Klymene.[56] Aphrodite alone in the pic-
ture on the New York pyxis (fig. 43) receives attention from Peitho, Eudai-
monia, Euklea, Paidia, Hygieia, and Eunomia.[57] In previous interpretations
of these scenes, it was assumed that the companions of the goddess are per-
sonifications, that is, figures that embody abstract notions and lack ground-
ing in the context of specific myths. Accordingly, much effort has gone into
explaining their relationship to Aphrodite in terms of conceptual or cultic
associations.[58]

To define certain figures as "personifications" is to draw a line between
mythological characters and embodiments of abstractions — a line that may
have been drawn differently or not at all in Archaic and Classical Greece. In
this view, Eros, for instance, falls on one side, although he is the embodi-
ment of love and the word for "love," his mythological associations being
stronger than for other personifications, while his brother Himeros falls on
the other.[59] Here, some of the attendants and companions of Aphrodite
make plausible "personifications." These are Euklea (Good Repute), Euno-
mia (Good Governance), Peitho (Persuasion), and Eudaimonia (Happi-
ness). Others are puzzling in this respect: Pannychis (All-Nighter), Paidia
(Joy), and Klymene, who is not a personification at all. But if these figures
are personifications in the same sense as Eros, their presence in these scenes
is to be expected: they are the Charites, or Graces.[60] The Charites could be
thought of as a band, comparable to the Nymphs. In the *Iliad*, the youngest
of the Graces is promised to Hypnos by Hera, and her name is Pasithea.[61]
Of the names that appear in the pictures under consideration, Peitho was
numbered among the Charites by Hermesianax and associated with both
Charites and Horae by Hesiod in the description of the adornment of Pan-
dora, on whom Aphrodite showered all her gifts. Hesiod also makes Euno-

mia one of the Horae.[62] The identification of Aphrodite's companions as Charites, or Charites and Horae, explains the fact that some seem to have "speaking" names that refer to virtues, while others have pretty names suitable for the likes of Nereids and Nymphs.

The paragons of Artemis and Aphrodite are another way of framing the paradox of the spinner, who is sexually charged but innocent of sex. What holds together the *thiasos helikon* is precisely the fact that its members are of a very special age: *parthenoi*, marriageable girls, who, like Nausicaa, will not remain *parthenoi* for long.[63] It is possible to draw up a list of their typical activities and circumscribe their habitat: with Europa, they prepare together for the dance, bathe at springs, and gather flowers. With Helen of Sparta, they spin and weave and play the lyre. They sing and dance at the wedding when one of the group marries.[64] These maidens, the rank and file and the beauties among them,[65] are our wool-workers.

KHARIENTA LOUTRA

Signs of wool-working belong principally to pictures illustrating the formal adornment of the *parthenoi*, an elaborate affair that begins with the bath and continues with the donning of clothes and jewels, marked throughout by lavish use of scents. Reference to the bath is provided by the frequent association of the mirror with a scent container, the plemochoe, and most frequently, the alabastron.[66] This is a significant combination, as can be seen by the way the two objects are evoked in Callimachus's *Bath of Pallas*. The goddess's attendants are told to bring neither perfumes and alabastra nor a mirror, because Athena prefers a more Spartan fare.[67] The painted vases show the rule to which the bath of Pallas is an exception. On a black-figure alabastron,[68] the wool basket is declared not to be in use by having it hang sideways on the wall (figs. 90–92). A young woman sits in an imposing chair, provided with a footstool, holding a mirror. She receives an alabastron from an attendant. Two more standing girls complete the picture, one bringing an alabastron and plemochoe, while the other has either taken off her mantle and deposited it in a bundle on a stool or she is dressing and about to put the mantle back on. In either case, the bundle of clothes, whether on the stool or on the wall or held, is a standard feature of the ablutions.[69] The picture in the tondo of a Louvre cup helps secure the connection of the image of the attendant with the mirror to the bath (fig. 93).[70] The girl, who displays the alabastron in her right hand and the mirror in her left, stands between a tall washbasin of standard form and a cushioned chair on which sits the wool basket. It is worth noting that here,

as in the preceding picture, the basket is lifted from the floor, where it is normally placed when it is in use, making it clear that in the given circumstances work has been briefly suspended.

Although the wool basket is rarely shown, the alabastron and the mirror reappear as the de rigueur accessories in the representations of young women washing at the basin on a stand (fig. 94). They are joined by a very special article of clothing: boots, prominently held up by an attendant or laid to the side of the basin. The boots, in turn, bring us back to the girls working wool. In a representation that includes wool baskets together with chests, a goose, and Eros, and is set in a hall with columns, one figure holds up the tall, apparently soft boots.[71] It is difficult at present to guess what the boots signify—whether status, some personal characteristic of the woman who will wear them, or the occasion for which they are appropriate, perhaps the dance.[72] But it is clear that they are part of the equipment of the maiden with many suitors: on the exterior of an Early Classical cup (figs. 63, 64), she stands wrapped in her mantle framed by two columns, outside of which are two young men. Other men accost her companions, who carry her distaff and her boots.

Where does the bath take place? The picture on the Boeotian pyxis in the Louvre (figs. 80–82) suggests that the washbasin may be part of the habitat of the wool-working maidens, that is, the *prothura*. There are a door and two columns; a basin on a stand emerges on the far side of one column; an attendant and Eros direct themselves toward a young woman seated on a throne. The fact that the setting includes a small altar seems to confirm that the room opens onto a court.[73] On another pyxis, this one Attic, the door is partly open so that a bed is visible.[74] Young women, some sitting, some standing, are engaged in a variety of tasks: spinning, bringing a chest and an alabastron, making a garland, looking into a chest, bringing a basket together with a portable frame, and just sitting holding a mirror. One ties the girdle of her chiton; the mantle sits rolled in a bundle on a stool, behind her. This figure, without the stool, appears again in a picture on the Durham kalathos (fig. 89). The bath is directly followed by the toilet. The fact that a few figures have their hair in a loose curly mass down the shoulders might indicate that it has just been washed and is still wet.[75]

The toilet scenes find correspondences in the verbal imagery describing one of the principal occupations of the group of maidens that was defined above, the *thiasos helikon*—dressing up, perhaps in preparation for the dance, for the festivities on the occasion of a marriage, or for its own sake. The proceedings begin with the bath. Europa customarily bathes together with her companions, *hetairai*, at springs. In a similar way, Nausicaa bathes

in the sea with her handmaidens, and the river Eurotas is the bathing place, *loetra*, for Helen of Sparta and her companions, *pasai sunomalikes*.[76] The paradigm of the band of nymphs on which the band of *parthenoi* is modeled is at work here as well. Nymphs are imagined to live by springs, and a few are reputed to bathe in them, for example, the Charites of Orchomenus.[77] They are also the normal following of certain goddesses. The nymphs who hunt with Artemis accompany her in "lovely baths," *kharienta loutra*, which she takes at the spring of Gargaphia, also called Parthenius. It is there that Actaeon sees her naked and is destroyed in consequence.[78] In like manner, Athena bathes together with nymphs and destroys Tiresias's sight because he has seen her.[79]

That the bath is of some symbolic importance is shown by the fact that three of the four goddesses who are represented bathing in myth—Artemis, Athena and Hera—also receive cult that involves the ritual bathing of an ancient statue. These are Artemis Daitis at Ephesus, Athena in the festivals of the Callynteria-Plynteria, and Hera at Samos and in the Argolid at the Canathus spring near Nauplia.[80] These practices have long presented a puzzle as to their purpose and meaning. Ginouvès noted how remarkable it is that, while most statues of the gods received periodic care, including cleaning, only female divinities should be carried to a stream or the sea to be cleansed. For Hera, the bath may be a prenuptial rite, but this explanation is not appropriate for either Athena or Artemis, who remain always *parthenoi*.[81] To judge from the use made of its representation in myth and in ritual, the bath is one of the most characteristic activities of *parthenoi*—legendary maidens like Helen (after whom a spring is named in the Corinthia, opposite Cenchreae), Europa and her companions, Nausicaa and her handmaidens, who have already been mentioned, and Atalanta, represented at her bath on Classical vases.[82] Nymphs are, of course, *parthenoi*, as are Athena and Artemis, virgin goddesses. In view of this, the cases that seem to be exceptional, Hera, in particular, and Aphrodite, merit closer attention.

The bath of Hera is mentioned only in the foundation legends of her cult at Argos and at Samos. On the occasion of the Samian festival of the Tonaia, the image of the goddess was taken to the sea shore and "purified" (*aphagnizesthai*).[83] The ceremony was a commemoration of the prodigy the statue performed when Tyrrhenian pirates had attempted to carry it away from Samos and back to Argos. After they had successfully loaded it on their ship, the pirates found themselves unable to leave. Frightened, they abandoned the statue on the shore, where the Carians found it and Admete purified it (*hagnisai*) before taking it back to its temple. Here the ritual of washing the statue is not explicitly linked to the *hieros gamos*, the ritual

reenactment of the marriage of Hera and Zeus, which is mentioned, however, in a late source as taking place on Samos.[84] A story concerning Hera, a bride's bath, and a marriage of Zeus enters, however, into the foundation legend of the Boeotian festival of the Daedala, related at length by Pausanias (*Description of Greece* 9.3). One time Hera had retreated in anger to Euboea. Zeus, following the advice of Cithaeron of Plataea, staged a mock marriage to Plataea, daughter of Asopus, by placing a wooden puppet, suitably wrapped, in the marriage wagon. Hera's discovery of the ploy and the consequent reconciliation were celebrated and reenacted in the Lesser and Greater Daedala. Both involved taking the wooden false bride to the river Asopus, where it was adorned (*kosmesantes*); it was then placed in a wagon and taken to the summit of Mount Cithaeron to be burned, together with the oxen and cows sacrificed to Zeus and to Hera, respectively.[85]

In being bathed, the wooden image was apparently subjected to the same ritual as a bride. From Plutarch, we learn that the nymphs Tritonides brought the water for its bath (*loutra*).[86] This function was performed for Hera by priestesses of her cult at Argos, the Eresides.[87] This bath is taken as a strong indication that the Argive ritual included a *hieros gamos*. The inference becomes stronger in view of the mysteries of Hera at the spring at Canathus in Nauplia. Every year, Pausanias was told, Hera became *parthenos*, virgin, by washing in that spring (*Description of Greece* 2.38.2–3). This prodigy is initially puzzling but becomes perfectly understandable if the bath was part of a *hieros gamos*. In the marriage ceremony, invariably bath, dressing, and adornment precede the voyage of the bride to her new residence.[88] In the phases preceding the procession of the marriage wagon the bride can be nothing but an unmarried girl, and this is how Hera, in effigy, was represented when she was bathed and dressed for her wedding by priestesses impersonating her attendant nymphs. Hera at her bath is Zeus's bride-to-be and not yet his consort; she is, in other words, a *parthenos*. Note that the meaning of *parthenos* is not so firmly anchored to the notion of a physical condition as the word "virgin," with which it is normally translated: it can indicate simply a woman's state of being unmarried.[89] The bath of Hera, then, is one more instance of a *parthenos* washing.

The case of Aphrodite is the reverse of that of Hera: no accounts of ritual bathing of statues survive, but she is represented washing in myth. An instance without apparent reference to virginity is the bath she takes at her temple in Paphos on Cyprus after she was caught by Hephaestus in bed with Ares, and finally released. The Charites bathe, anoint, and dress her.[90] The representation of her birth employs the imagery of the bath followed by the toilet: Aphrodite emerging from the waves is attended by the Horae,

who proceed to dress her and deck her with jewels.[91] The gods are quick to realize that she is the image of the perfect bride; each of them wishes he could take her home as his lawful wife. Overtones of virginal beauty are much clearer in the case of the bath and adornment that precede her seduction of Anchises (*Homeric Hymns* 5.53–201). Again, the Charites bathe her and anoint her with fragrant oils; then she dresses and puts on her jewels. Pretending to be a mortal, she stands before Anchises "looking like an unwed maiden (*parthenos admete*) in stature and beauty" (82–83). This description is more than a figure of speech, since Aphrodite here impersonates a *parthenos*. The story she tells is that she is the daughter of Otreus —as a well-bred maiden should, she omits her own name—and that she was snatched by Hermes while she together with other nymphs and unmarried girls, *numphai kai parthenoi* (119), performed a dance for Artemis.[92] In her own words, she is unwed and innocent of love, *admete . . . kai apeirete philotetos* (133). At least in this instance, for Aphrodite, as for Hera, Artemis, and Athena, the notion of bathing and dressing up is germane to the notion of nubility. This link is confirmed by the use of the adjective *parthenios*, virginal, to name places where these baths occur: the spring where Artemis bathes, for example, or the river bank called Parthenia in connection with the courtship of Hippodamia. The ancient name of Samos was Parthenia, perhaps after the river Parthenius, so called because Hera bathed in it when she was a *parthenos*.[93]

One of the connotations conveyed by the bath is that of beauty. The connection can be grasped in the words of Penelope to Eurynome, who has told her that she should bathe before appearing before of the Suitors (Homer *Odyssey* 18.178–81): "Do not persuade me to wash and anoint myself, because the gods who inhabit Olympus have destroyed my beauty since the day he [Odysseus] embarked on the hollow ships." The link is more explicit in the function that the bath has in the toilet of Aphrodite and in enhancing the beauty of Hera, Athena, and Aphrodite before they submit to the judgment of Paris. Helen blames her fate on "baths and springs," *loutra kai krenai*, which gave splendor to the goddesses' form.[94] There is also a narrative tie between bath and beautiful appearance in that washing is the first step in the formal adornment, *kosmos*, of the *parthenos*. But the primary connotation of the bath is *parthenia*, maidenhood. The bathing at streams or at the sea of the images of goddesses who are *parthenoi* is neither, strictly speaking, a marriage ritual nor a ritual to insure fertility, as has been hypothesized.[95] Rather, the ritual rendered these goddesses what was due to them as unmarried females, albeit divine ones, by reenacting procedures, *loutra* and *kosmos*, that corresponded to the common understanding of the

way a *parthenos,* at least a legendary one, looked and behaved. It is the terrain of this conceptual imagery that poetry, rituals, and the pictures share.

Kosmos phaeinos

The footed chest is never far from the maiden. It sits on the ground, by her side, together with the wool basket or is brought in by an attendant.[96] She herself may hold it in her lap, look inside and pause, uncertain of what to choose (fig. 95).[97] The chest holds jewels, as is made clear by pictures such as the London pyxis with the Argive heroines, where Danae lifts a necklace from the one she carries (fig. 2). As much as spindles and scents, jewelry is a fixture of the representation of the spinner: diadems — some of a peculiar shape, with spiked, leaflike projections (fig. 95);[98] snake-bracelets, earrings, and of course, necklaces, which are dangled by her attendants, as Eudaimonia does in the representation of the toilet of Aphrodite (fig. 43). The chest and the jewels pertain to the *kosmos,* the adornment of the *parthenos,* which is the last leg of her road to beauty. In the literary images of legendary maidens ornaments of gold figure prominently. The Nereids had a windfall when Hephaestus was rescued by Thetis and Eurynome and, in gratitude, spent nine years in their palace making jewelry for them; the thought of gold makes a girl's heart flutter.[99] The paradigm of the maiden's *kosmos,* once more, is the dressing of Aphrodite. The most detailed account is found in the Homeric hymn singing of the birth of the goddess as that of the ideal *parthenos:*

> They [the Horae] welcomed her joyously. They clothed her with heavenly garments: on her head they put a fine, well wrought crown of gold, and in her pierced ears they hung ornaments of orichalc and precious gold, and adorned her with golden necklaces over her soft neck and snow-white breasts, jewels which the gold-filleted Hours wear themselves whenever they go to their father's house to join the lovely dances of the gods. And when they had fully decked her, they brought her to the gods, who welcomed her when they saw her, giving her their hands. Each one of them prayed that he might lead her home to be his wedded wife, so greatly were they amazed at the beauty of violet-crowned Cytherea. (*Homeric Hymns* 6.5–18 [trans. Evelyn-White 1936])

Aphrodite's virginal beauty is cast in the same terms in the account of the seduction of Anchises (*Homeric Hymns* 5.84–90). From this and other texts

one extracts a number of essential elements that also occur in the toilet of nymphs and other mythological girls: clothes woven with gold that shine like the moon, snake-bracelets, earrings, pins, and necklaces. A splendid diadem figures in Hesiod's description of the making of Pandora, one of Hephaestus's wonderful creations:

> On it [the diadem] was much curious work, wonderful to see; for of the
> many creatures which the land and sea rear up, he put most upon it,
> wonderful things, like living beings with voices: and great beauty shone
> out from it. (Hesiod *Theogony* 581–84 [trans. Evelyn-White 1936])[100]

The vocabulary of the *kosmos* makes ample use of words for splendor and light: *lampein, phaeinos, aglaos, sigaloeis*. The point is glamour in the form of radiance, light emanating from shimmering cloth and gleaming metals. When the maiden herself is called golden, *khrusea*,[101] the maxim Gold is beauty is most striking and explicit. This figure pervades Alcman's *Partheneion*, where a girl's face and hair are cast in silver and gold. The list of ornaments that the chorus of maidens recites poem expresses the same conceit of fairness as splendor:

> Nor is any quantity of purple enough to help, nor chased dragon-
> armband of solid gold, nor the Lydian crown, ornament of maidens
> with limpid eyes, nor Nanno's tresses, nor godlike Areta, nor Thylacis
> and Clesithera. Nor would you, having reached Anesimbrota's place,
> say, "Let Astaphis stand by me and Philylla look my way and Damareta
> and lovely Hianthemis, but Hagesichora effaces me." (Alcman 1.3.64–
> 77)[102]

This sentiment is analogous to that voiced by the chorus of companions in Theocritus's *Wedding Song for Helen* 26–28, when they say that Helen shone among them like the dawn against the fading night.[103] In the same vein, the chorus members who sing Alcman's song can vie with one another in beauty on an equal footing, but they are helpless against Hagesichora, the gleam of their ornaments growing dim against her luminous beauty.[104] On the vases, jewels and jewel chests evoke this imagery of gilded maidens. The references to the *kosmos* have the purpose of bringing into the foreground one of the main defining characteristics of the *parthenos*—her beauty—and of introducing in the representation of the wool-worker connotations of charm and sexual allure.[105]

PARTHENOS AIDOIE

One element of the imagery has been noted as conspicuous and possibly significant in itself: the way in which some of the girls, whether seated or standing, are entirely enveloped by their mantle. Being wrapped in one's cloak from neck to toe is the right way to appear in public: the girl may stand between two young men (figs. 61, 62) or sit on her porch as men approach (fig. 6). The mantled figure is common in scenes of courtship, in which the cloak normally covers the person who is wooed, girl or boy (fig. 96) and, occasionally, the suitor as well.[106] In its extreme form, leaving only eyes and forehead exposed, the enveloping mantle belongs to women.[107] This costume appears to shelter the person from the gaze of strangers and to make a display of decency. It gives evidence of a heightened sense of modesty and, at the same time, commands respect. The word for this sentiment is *aidos*, variously translated depending on its context as shame, modesty, honor, or veneration. It is a virtue allied to the particular wisdom of *sophrosune*, with which it makes an apparently stern combination.[108] For this reason it is startling to find that *aidos* has erotic associations. In a poem of Lycophron listing the several objects of male desire—boys, maidens, and buxom women—*aidos* is said to engender beauty. At the wedding of Apollo and Cyrene, Aphrodite "cast lovely *aidos*" upon their marriage bed.[109]

Aidos is visible. This gift is the foundation of Pandora's allure, whom Hephaestus fashioned in the guise of a "modest virgin," *parthenos aidoie*. Aphrodite is *aidoie* as well, when she is born from the foam.[110] Athena, when she prepared Odysseus for his appearance before the Phaeacians, made him impressive and *aidoios* to behold by bestowing superhuman grace, *kharis*, on his head and by making him taller and sturdier in build.[111] What traits conferred *aidos*? According to Aristotle, it was a proverbial notion that *aidos* resides in the eyes. One finds an example of this in the Homeric hymn to Demeter: Metaneira addresses Demeter as a lady of rank, because *aidos* and grace are apparent in her eyes, as they are in the eyes of kings when they render judgment.[112] One way in which eyes express modesty can be deduced from the account of Heracles at the crossroads of Virtue and Vice.[113] The two materialize in the form of imposing women who are, predictably, exact opposite of each other. Virtue is fair and noble in bearing, her figure adorned with simplicity, her eyes showing *aidos*, her manner informed by *sophrosune*; she wears white. Vice—or Happiness, as the latter prefers to be called—shows the results of intemperance in her plump forms and is tricked out to look taller and fairer than she actually is. Her eyes are wide open, *anapeptamena*, and her dress lets as much as possible of her body

show through. She keeps looking around to see if anyone has noticed her. Although Virtue's gaze is not described in terms so explicit, the pointed contrast of corresponding features implies that hers is the opposite of Vice's impudent wide-eyed stare. It should then be steady and without guile, with eyelids modestly lowered. And if Virtue's white dress is the opposite of Vice's revealing costume, it will be one that covers as much of the body as possible.

Images of enclosing and uncovering are intimately connected to the concept of *aidos*, a fact easily explained when it has the sense of shame, as in *aidoia*. Odysseus, for instance, threatens to strip Thersites of the mantle and tunic that cover his private parts, *ta t' aido amphikaluptei*.[114] But this imagery extends to instances in which *aidos* is better understood as discretion or delicacy of feelings. Thus Odysseus brings his cloak over his head to hide his face so that the Phaeacians will not see that the song of Demodocus has made him cry, *aideto gar Phaiekas*; Phaedo covers himself to hide his tears when he realizes that Socrates has drunk the poison.[115] For women, *aidos* is a garment that can be shed, like a dress.[116] More significant, Aidos is a goddess, and there are indications that the enveloping mantle was a standard feature of the way in which she was represented. Hesiod describes her and Nemesis both covered in white cloaks, *leukoisin pharessi kalupsameno* (*Works and Days* 197–201). The episode of the submission of Penelope in Pausanias's *Description of Greece* is just as revealing.[117] Pausanias traces the origin of a statue of Aidos that stood on the road from Sparta to Arcadia to the wedding of Odysseus and Penelope, when Odysseus was taking his bride back to Ithaca. Her father, Icarius, followed the chariot imploring them to remain in Sparta, until Odysseus asked Penelope either to come willingly or remain with her father. Her only reply was to wrap herself up (*enkalupsamenes de*). This was apparently enough to tell her father that she would go with Odysseus. Icarius then dedicated a statue of Aidos in the place on the road where Penelope had covered herself. The *aidos*, which her action made explicit and the statue of personified *aidos* reproduced, is not easily understood as plain modesty. From its effect on Icarius, it may be deduced that the gesture acknowledged the fact that Penelope had passed from the guardianship of her father to that of her husband and that she must be transferred to her husband's home. From the start and in all ways, Penelope knows her place.

Aidos, then, is made visible by the chastely downcast glance and by the act of covering oneself.[118] The first can be recognized in the gentle inclination of the head given to some of our figures: seated with companions who make garlands there is one enveloped in her mantle who looks ahead and down (figs. 57, 58). Here both features have been combined, but much

more frequently the voluminous mantle, from which only head and feet emerge, is enough to convey the meaning that the figure is the embodiment of *aidos* (fig. 52). The connotations of the enveloping mantle have a place in the imagery of courtship but extend widely beyond it. The quality of *aidos* is one of the virtues of the *parthenos* but also of the wife and of all good men. The analysis of this concept, which plays a key role in the construction of gender, is carried further in chapter 3.

PHILERGOS

Visual indications that the wool basket carries connotations that have no immediate reference to the making of textiles are striking. In many pictures, the basket has an explicitly symbolic function, either because it occurs in contexts in which it does not belong or because its presence is abnormally stressed. Emphatic display, in its extreme form, characterizes these "parade" wool baskets. The basket may be unusually large, about twice its normal size, and it may be set upon a base or plinth of sorts (fig. 18). This image is paralleled by an Athenian grave monument consisting of a wool basket placed upon a chest (fig. 97), compounding beauty and labor — the jewels and the pensum — with admirable economy.[119] The basket may be brought to a girl, who is completely enveloped in her mantle, by an attendant who holds it up in a ceremonious, self-important gesture (figs. 47– 49).

The wool basket is displayed in a comparable manner in scenes in which the predominant theme is courtship. It is held up in a gesture of display by women who are pointedly *not* working wool, such as the girl seated all wrapped up on her porch, against the background of a scene of courtship (fig. 98), or the one standing, likewise wrapped, between two young men (fig. 61). On a lebes gamikos in Providence (fig. 84), the basket is ostensibly delivered to the seated young woman in the center who holds out her hands to receive it. But the attendant holds it high, out of her reach and toward another who stands behind the chair and raises her right hand in an emphatic gesture.[120] It is difficult to say what this pantomime means, but one can see it repeated — minus the central figure — on a pelike in Laon (fig. 99), where the attendant, at the side of a chair spread with a patterned rug, shows the basket to a young man decently covered by his mantle from head to ankles. Whether it is in use or merely displayed, the wool basket is the attribute of women being wooed. This is strikingly confirmed by representations of mythical rape. Europa holds up her basket as she is transported across the sea by Zeus in the guise of a bull; Aethra leaves hers on the ground or holds it high when she is chased by Poseidon (fig. 100).[121]

The wool basket has a place in representations of the toilet as well, where it is often paired with the alabastron. The clearest statement of an equivalence and affinity of the two objects, at least on a symbolic level, is given by the picture on a lebes gamikos. The main subject, a young woman examining the contents of the jewelry chest on her lap, is framed by two winged females in flight, one bringing alabastron and sash, the other, wool basket and sash (fig. 44). The equivalence of spinning and fragrance is stated again in grand toilet scenes. On the Chapel Hill lekythos (figs. 11, 12), where many girls are shown dressing, the basket appears in the hands of an attendant; on a hydria in Brussels the young woman, seated and holding a mirror, is surrounded by six attendants, three of whom bring an object apiece, plemochoe, alabastron, and wool basket (fig. 42).

It is apparent that the scenes of wool-working concern neither domestic husbandry nor, strictly speaking, the persona of the dutiful wife in the context of the family. These pictures show that spinning is the mark of females who are maidenly, beautified by scents, rich clothes, and ornaments and attract suitors who come bringing tasteful gifts. They are blushing maidens, *parthenoi aidoiai*, who live together in nymphlike community, sharing simple tasks and pleasures, such as working wool, gathering flowers and making garlands, playing ball, and dancing. Marriage puts an end to this state of affairs: in the depiction of beauty and courtly love there are few, if any, references to homes and husbands. One concludes that, while in real life making clothes may have been the most important task of the good wife, in the imaginary world depicted on the vases, signs of wool-working are predominantly attached to pretty girls. That is not to say that married women may not be represented as wool-workers, since this activity, as I try to show below, is the quintessential marker of femininity. But it is a fact that in the literary representations of women wool-work is predominantly an emblem of maidens. Of the few apparent exceptions, the two most striking confirm rather than contradict the interpretation of wool-work as an activity related to notions of love and beauty. The first is Penelope, who is both Odysseus's *gune aidoie*, chaste wife, and the most famous weaver of antiquity, weaving by day and unraveling the day's work by night. In her case, wool-work would seem to characterize the epitome of wifely virtues. But the extraordinary circumstances of her husband's return have placed Penelope in the same position as a *parthenos*. She is a marriageable woman with a court full of suitors, one of whom she must marry as soon as her weaving is completed. The second notorious case is Helen—a superb spinner and weaver not only in her maidenhood but also as the wife of both Paris and Menelaus. The essential feature of Helen's persona, however, is that in spite

of her marriage she continues to attract suitors because of her beauty and her virtue. Like Aphrodite and Pandora, Helen is the paradigm of the temptress, not the wife.[122]

The conceit that wool-working is the mark of the maiden informs the imagery on the well-known pair of miniature lekythoi by the Amasis Painter (figs. 101–6).[123] In the manner of wedding songs, the four vignettes, which decorate the shoulder and the body of each vase, propose a contrast between the bride and the band of maidens from which she is now detached. On the body of one lekythos is the wedding procession that takes the bride from her natal house to her husband's (figs. 101, 102).[124] On the body of the other lekythos is a vignette that includes several stages of wool-working, from weighing the wool to the finished cloth, dominated by a great upright loom (figs. 104, 105).[125] The shoulder of the wedding lekythos carries the picture of the girls engaged in dance to the music of lyre and *auloi* (fig. 103).[126] The shoulder of the weaving lekythos shows another image of the wedding: the bride sits, displaying her newly acquired matronly mantle, while her former companions dance (fig. 106).[127] The pointed juxtaposition of the condition of the *parthenos* and that of the wife thus informs the imagery of each vase and is carried over, in chiasmic fashion, from one vase to the other.

The literary imagery in which wool-working has a place overwhelmingly supports the conclusions reached in the preceding sections of this chapter. Spinning and weaving characterize goddesses, mythical creatures, and heroines who are paradigms of the condition of *parthenos*. It is not Hera who spins, but Artemis of the gold distaff, *khruselakate* (Homer *Odyssey* 4.122), and Athena, the patroness of spinners, herself, *philergos* and *philerithos*, a weaver who tolerates no competition. A fragment of Archaic lyric represents her spinning "with a fine thread of flax on the spindle." She must have been pictured with her wool basket, like Europa and Aethra, in one version of the story of Hephaestus's attempt to rape her: Athena resists and, when his semen falls on her leg, she wipes it off with a piece of wool.[128]

The mythical *thiasos*, the band of companion girls all of the same age, also consists of wool-workers. The Charites weave Aphrodite's dress; the Nymphs weave purple cloth on looms of stone; the Nereids have gold distaffs.[129] Dangerous and beautiful Calypso, the nymph whom neither men nor gods can have, sings as she weaves in her cave, and so does Circe in her palace.[130] Among mortal, legendary maidens, Helen most of all embodies the spinner's charm, but she is only one of many. Ariadne, too, must have had her wool basket at hand, if she was in a position to give Theseus the all-important clew. The most virtuous may be the daughters of Orion,

whom Aphrodite had blessed with beauty and Athena with the art of weaving. At their loom they received the news that a plague would break out unless two maidens sacrificed themselves. They promptly cut their own throats with the weaving shuttles, obtaining as a result long-lasting cult as *Coroneae* or Shuttle-Maidens.[131] The shuttle as the weapon of choice for working girls appears again in the story of Maeonian Arachne, the maiden who dared compete in weaving with Athena herself.[132] Because Arachne could not be defeated—her skill, admired even by the Nymphs, was impeccable—Athena bludgeoned her with the shuttle before transforming her into a spider. The same sort of excessive pride in their own industry led the daughters of Minyas to ignore the wishes of Dionysus and to continue to weave in their father's house while the other women took part in the mysteries of the god. Many anonymous, undistinguished weavers confirm that in words as well as in pictures the image of the wool-working girl has an almost proverbial cast. It has connotations of industry, as in the dedicatory epigrams collected in the *Greek Anthology,* or of youth, as for the unnamed children who work the loom, *histoponoi meirakes,* all that remains of a lost lyric.[133] Sometimes there is an explicit connection made, as in the vase pictures, between wool-working and love. In a fragment of Sappho the girl confesses: "Sweet mother, I cannot weave, overcome as I am with desire for a boy, because of tender Aphrodite."[134] The graffito on the underside of a large Archaic Attic black-figure kylix offers a different sort of testimony. The cup itself speaks, as it were, and says: "I am Melosa's prize. She won the girls' wool-carding event."[135] A sympotic vessel makes an improbable trophy for a girl, even granting that there was such a thing as wool-carding contests. In all likelihood, this is yet another dirty joke that exploits the juxtaposition of opposite kinds of working girls.[136] What matters here is the association of the maiden with wool-working.

These various strands of visual and verbal imagery bring together notions not so easily reconciled in the mind of the modern interpreter: physical beauty, described in terms of splendor (bath and *kosmos*), chastity and wisdom made visible by the enveloping mantle and modest gaze, and constant toil. A passage of Aristotle lays bare the nature of the nexus:

> The blessing of good children and numerous children needs little explanation. For the commonwealth it consists in a large number of good young men, good in bodily excellences, such as stature, beauty, strength, fitness for athletic contests; the moral excellences of a young man are self-control (*sophrosune*) and courage (*andreia*). For the individual it consists in a number of good children of his own, both male and

female, and such as we have described. Female bodily excellences are beauty and stature, their moral excellences self-control (*sophrosune*) and industrious habits, free from servility (*philergia aneu aneleuthereias*). (Aristotle *Rhetoric* 1361A1–7 [trans. Freese 1926]) [137]

The two sets of qualities, one for young males, the other for young females, are mentioned as something widely known (*ouk adela*)—something everybody knows. Each consists of three gifts, of which the first two are the same for girls as for boys: in body, both should be tall and handsome (the boys also strong); in character, both should have *sophrosune*, the quality akin to *aidos*, understood as wisdom, self-control, or modesty. The third quality is different for girls than for boys. Where the latter have *andreia*, manhood, the girls have *philergia aneu aneleutherias*, industriousness without connotations of baseness or servile status

It is easy to see that the ingredients that produce the ideal girl are the same ones that come together in the images of wool-working *parthenoi*. Their constant bathing marks them as *parthenoi*, unmarried; the *kosmos* conveys their physical beauty; the enveloping mantle expresses the particular brand of *sophrosune* appropriate to females, marked by permanent *aidos*. Wool basket, distaff, and spindle stand for the maiden's *philergia*. To make this point clear, the painter of a Late Archaic lekythos attached to his figure of a demure spinner the label *philergos* (fig. 107).[138] The epithet *philergos*, moreover, is applied to diligent maidens, such as the *philoergos* Telesilla, the child of the good Diocles, who dedicates to Athena, "the Maiden who has the wool-workers in her power," weaving-comb and spindle, wool basket and balls of wool.[139]

The juxtaposition of glamour and labor that the vase paintings display thus fits into the general prescription of the conditions of ideal femininity, as it is also articulated in myths and in philosophical thought. As the beautiful object of desire, the maiden is placed under certain constraints. *Aidos* confines her movements and, as will be seen, her ability to see and speak; dutiful zeal binds her, at best, to the level of production at which the craftsman operates and denies access to action and higher forms of intelligence, which are the concern of men.[140]

Figures of Speech

What was novel becomes commonplace, its past is forgotten, and metaphor fades to mere truth.

Nelson Goodman, *Languages of Art*

The preceding chapters traced the image of the wool-working female in Attic vase paintings and linked it with comparable images in different media, some also visual, such as ritual performances, others verbal, such as poetry and mythological narratives. The various representations brought together in this way belong to a discourse on gender. They present a definition of ideal femininity in terms of certain requirements, some of which seem natural enough—youth, chastity, beauty; others, like *aidos* and *philergia,* less so. The visual characteristics of the spinner—namely, the company she keeps, the shell of her cloak, her preoccupation with bathing, dressing up and jewelry, and the wool-working itself—each embodies one of those qualities. These features fit a model of maidenhood that is as much a construction of disparate parts unnaturally joined as Frankenstein's creature. No doubt, real women tried to live up to her model, but the spinner is not drawn from nature: the similarities and analogies that were pointed out all concern *representations.* Whether visual or verbal, the images open a window not onto the actual condition of women Athens of the fifth century B.C. but onto the way in which femininity there and at that time was defined and described.

The correspondences observed between visual and literary representations place the two forms of expression on the same interpretive plane, and

allow each the same status as projections of thought rather than reproductions of reality. The existence of such correspondences is easily accommodated within the model of structural linguistics that is adopted here on the grounds that both verbal and visual signs communicate ideas pertinent to the same discourses, circulating in the same social contexts. Accordingly, correspondences between the visual and the verbal systems do not, of necessity, imply contamination between the two. But to inquire into the nature of the correspondence and the way the image is constructed—how images operate in language and how they convey meaning independently of language—renders the very notion of two utterly discrete and independent systems of representation problematic. It raises the question of whether the connections that can be observed at the level of discourse do not inform the meaning that signs have as units of systems and whether one can speak of "system" as something apart from, and prior to, discourse. In other words, is the correspondence to be understood as one between blank words and dumb images, which become, respectively, image-laden and articulate when they are put to use? Or are their use in specific discourses and their connection to other means of expression the conditions for the very existence of an image and a word? It is proposed here that there is at least one form of direct connection between visual and verbal signs that bonds one to the other and grounds them both into specific discursive contexts: the analogy established by metaphor between the realm of the sensible and the realm of the intelligible.

Metaphor is implicit in the interpretations given in the two preceding chapters. The pictures of wool-working offer a definition of femininity by fleshing out certain properties concerning age-status and moral and physical excellence. We see a female taking jewelry from a chest and we understand that she is golden, like Aphrodite. The identification of these qualities involved the shift—normally and effortlessly performed when interpreting symbols—from what is the "concrete" and visual to what is the "conceptual" and verbal: from bath to maidenhood, from gold to beauty, from wool basket to zeal. We go from figure to figure of speech. This seeing as "seeing through," the "shift from literal to figurative sense" is the metaphor by which metaphor as a verbal trope is defined.[1] The question that presents itself now is this: is the play of metaphor confined to language, or is it at work in the making of the images?

At the outset, a brief digression is necessary to clarify what definition of metaphor is adopted here. Discussions of metaphor traditionally take their start from Aristotle. His key remarks on the subject appear in his *Poetics*:

> Metaphor is the application of an alien name by transference, the trans-
> ference being either from genus to species, or from species to genus, or
> from species to species, or on grounds of analogy, that is, proportion.
> (*Poetics* 1457B 6–9 [trans. Butcher 1902])

Aristotle fleshes out his treatment of metaphor in the third book of the
Rhetoric. There he defines metaphor a naming of the thing that is different
from "ordinary," *kurion*, usage. Although *kurion* can and has normally been
taken to mean "proper" or "literal" meaning, "ordinary usage" does not
necessarily mean proper meaning in the sense that the "name belongs
properly, that is to say essentially, to an idea," as Ricoeur observes.[2] Most
important for present purposes, Aristotle states that metaphor presents an
abstraction in concrete terms: it "sets the matter before the eyes"; it is vivid,
vividness or "urbane speech" being obtained by "using the proportional
type of metaphor and by language that sets things described before the
eyes."[3] In ancient rhetoric as well as in modern studies of metaphor, the vi-
sionary quality of metaphor is stressed, as well as its power to illustrate and
persuade through analogy—the proportional metaphor.

Ricoeur has explained how the progressive impoverishment and atro-
phy of the discipline of rhetoric was responsible for a reductive definition
of metaphor as a merely formal trope that consisted of the substitution of
one term with another. Metaphor was thus reduced to a device for am-
plification and ornament, which has affective impact but no cognitive im-
port.[4] This classical or "substitution" view of the proportional metaphor
has been largely replaced, in the course of the past fifty years, by the "inter-
action" theory, developed primarily by philosophers and linguists. The im-
portance of the latter formulation for theories of language and cognition
and for the interpretation of symbols lies in the proposal that metaphor is
not merely an aesthetic device but a mechanism that shapes our under-
standing of the world.

While debate continues in philosophy and critical theory on many
aspects of the definition of metaphor, there is agreement on certain funda-
mental points, all of which were part of the radical proposal that I. A. Rich-
ards first put forward in the Mary Flexner Lectures of 1936. First, the meta-
phoric shift is no longer seen as an *exchange* of terms—"a sort of happy
extra trick with words"—but as a *relationship*, the interconnection of the
metaphoric term and the sentence into which it is translated:

> In the simplest formulation, when we use a metaphor we have two
> thoughts of different things active together and supported by a single
> word, or phrase, whose meaning is a resultant of their interaction.[5]

Richards proposed neutral terms for the two "thoughts" active in this pro-
cess: "tenor" for the terms in the phrase that conform to ordinary usage —
or the import of the sentence, the thought one intends to convey — and "ve-
hicle" for the figure, reserving the word "metaphor" for the relationship
itself. The relationship of vehicle to tenor is clearer in Max Black's projec-
tion metaphor:

> Suppose I look at the night sky through a piece of heavily smoked glass
> on which certain lines will have been left clear. Then I shall see only the
> stars that can be made to lie on the lines previously prepared upon the
> screen, and the stars I do see will be seen as organised by the screen's
> structure. We can think of a metaphor as such a screen, and the system
> of "associated commonplaces" of the focal word as the network of lines
> upon the screen. We can say that the principal subject is "seen through
> the metaphorical expression — or, if we prefer, that the principal subject
> is 'projected upon' the field of the subsidiary subject." [6]

The import of Black's development of the interaction theory is that meta-
phor is not simply speaking of or seeing one thing in terms of another but
drawing connections between the two in such a way that the one (the image-
laden one, the vehicle) structures our understanding of the other.

The second cardinal point in Richards's proposal is that metaphor oper-
ates not at the level of the word but at the level of discourse. It is "a bor-
rowing between and intercourse of thoughts, a transaction between con-
texts," and the figurative term, the vehicle, remains tied to the context from
which it was abstracted. Black, again, has a helpful example of how one
may think about such "bound" images:

> Consider . . . "man is a wolf." . . . [It] will not convey its intended mean-
> ing to a reader sufficiently ignorant about wolves. What is needed is not
> so much that the reader shall know the standard dictionary meaning of
> "wolf" — or be able to use that word in the literal sense — as that he
> shall know what I will call the *system of associated commonplaces*. From
> the expert's standpoint, the system of commonplaces may include half-
> truths or downright mistakes (as when a whale is classified as a fish);
> but the important thing for the metaphor's effectiveness is not that the
> commonplaces shall be true, but that they should be readily and fully
> evoked. [7]

The third important challenge brought by Richards targeted another com-
monplace of the "substitution" view of metaphor: that a structural dis-

tinction can be made between "live" and "dead" metaphors. The difference resides in that the first are new and powerfully evoke an image, while the second, having become predictable through constant use, have become simple, imageless words and are no longer metaphors:

> What about that "strong" light? The light is a vehicle and is described —
> without anyone experiencing the least difficulty — by a secondary meta-
> phor, a figurative word. But you may say, "No! *Strong* is no longer a fig-
> urative word as applied to light as it is of a man or a horse. It carries not
> two ideas but one only. It has become 'adequated,' or is dead, and is no
> longer a metaphor." But however stone dead such metaphors seem, we
> can easily wake them up . . . This favourite old distinction between
> dead and living metaphors (itself a two-fold metaphor) is, indeed, a
> device which is very often a hindrance to the play of sagacity and dis-
> cernment throughout the subject. For serious purposes it needs a dras-
> tic re-examination.[8]

This question has crucial importance for the study of visual representations and will be discussed in the concluding section of this chapter. It is broached here, where it may be easier to see that the notion that metaphors "die" is not compatible with the interaction view of metaphor.

The classical definition presented vividness as the mark of metaphor in terms of the affective impact and surprise produced by the image, followed by pleasure as the sense of the exchange becomes clear. Loss of vividness, therefore, allegedly causes the death of the metaphor and entails the loss of the image. The interaction view instead defines metaphor as the mecha-nism that introduces an "impertinent" term into an alien domain. This defi-nition does not do away with vividness — the emotional impact of the "ten-sion," or suspension of belief that is resolved once the metaphor is properly sorted out by bringing to the fore the correspondences of the focal image to the thought.[9] But "vividness" is redefined: first, it is not *the* mark of met-aphor, but one of its properties; second, it is not a matter of presence or absence but a matter of degrees. The expression "many-fountained Ida, mother of wild beasts" may serve as an example of a "live," albeit not stun-ning, metaphor.[10] The images it evokes — mountain peaks, the female body — are not at peace with one another. One must pause to sort out the ways in which the mountain is like a mother (she nourishes and shelters) and the ways in which she is not (inert and glacial). The association of moun-tain and motherhood is not made so often as to be obvious. The metaphor "the dynamo generates electricity," on the other hand, might appear "dead."

Although it is at root more daring, it is much less vivid, being subliminally understood without conscious appeal to images of procreation. Nevertheless, that imagery is readily evoked once attention is focused on the expression. A distinction should be drawn, therefore, between the "impertinence" or the "logical opposition" of vehicle to tenor that produces the metaphorical twist and the "intensity" with which that tension is perceived by the hearer. The first determines that a meaning, which cannot be paraphrased, must be worked out by the resolution of an apparent contradiction; the second measures intellectual and emotional expenditure, that is, the effort required to understand that metaphor. It is important to realize that impertinence and vividness are not the same thing, although they are related, because the first is essential to metaphor while the second is not. So long as the interconnection of vehicle and tenor holds, that is, provided it is understood, is the fact that it no longer elicits surprise and requires effort enough to say that the phrase is not a metaphor and that the image is lost? In an expression such as "I am torn between hope and fear," the incongruity is in no way reduced by the fact that the figure of physical dismemberment it evokes is quickly seen through. If and how a metaphor dies are crucial issues as regards the image and, as Richards said, are issues in need of a drastic reexamination.

Armed with the basic propositions of the interaction view of metaphor, I now return to the *parthenoi* and their wool baskets. If incongruity, the tension that the vehicle introduces in the tenor, is one of the telling traits of metaphor, wool-working can be seen to operate in a predominantly metaphorical fashion in the pictures analyzed in the preceding chapter. As was shown, the scenes in which spinning and the wool basket figure are not about making cloth or even house-tending but about love and beauty. The clash between two contexts that are not obviously germane is remarkable in representations in which the wool basket is brought to girls engaged in an elaborate toilet and in scenes where it is ceremoniously presented to a girl who shows no inclination to take it and begin work. Comparison with literary sources, which deal with who works wool and under what circumstances, suggested that the image expresses the girls' industriousness. Precisely how the metaphor works—how wool-work structures this particularly womanly virtue—remains unclear. A look at the frequent baths of maidens, however, is more rewarding.

In the imagery of poetry and in myth there is a special connection of *parthenoi* with water. Ann Carson brought out the many ways in which the female nature is represented as wet and unbound, in contrast to the dry and sober male.[11] It is a complex imagery, though, where heat and parching

may stand more specifically for the devastation produced by lust and, I suggest, water for the absence of lust. The contrast is cast this way in Archilochus's portrait of a false maiden: "She held out water in one hand, the trickster, and in the other, fire." [12] I will start by listing the above-mentioned affinities of maidenhood and water. Maidens have names that evoke waters and watery places; springs have names that refer to nymphs; bathing is one of the standard activities of mortal and divine maidens as described in the literary sources; the ritual bathing of statues seems confined to goddesses who are, or must again be, virgins. To that let us add the tale that virgins could dive in deep water, where nonvirgins would drown. [13]

The metaphor "chastity is water" stands on the ground of a specific set of correspondences, mapping certain properties of water onto the abstract notion of chastity. What puts an end to maidenhood is, of course, intercourse. If not in real life, ideally the act resulted in pregnancy, a hopeful view that is unfailingly realized in myths, where hardly has the maiden's belt been untied that she finds herself pregnant. [14] If the language of defloration emphasizes the "through" (*diakoreuein*), that of insemination relies on images of sowing, cultivation, and mingling: *mignumi* (to mix) is the verb for copulate. The discourse on coupling itself relies on a metaphor that is the base of the "water is chastity" proposition, that of the uterus as container, an upside-down jug, in which the male and female seed are mixed as water with wine after the seal on the wine jug has been removed. [15] Hanson observes:

> The analogy between the opening of a wine jug and the subsequent
> mixing of liquids, on the one hand, and the defloration of the young
> girl and her impregnation through the mixing of her liquid seed with
> that of her man, on the other, is too vulgar for imagistic development
> in epic, and it is never exploited. [16]

Nevertheless, her analysis reveals that the image is at work in the popular imagination and can be recovered, if not in poetic texts, in medical treatises. If intercourse is unsealing and mixing of liquids, virginity may be thought of as an *unmixed* substance. The metaphor materializes in Andromache's lament in Euripides' *Trojan Women*: "Unmixed (*akeraton*) you took me from my father's house and first joined the virginal (*partheneion*), bed" (675–76) The same image occurs in Plato's *Laws*, in the proposal put forward by the Athenian that the citizen of the ideal state should not be sexually active until they reach the right age and marry. He points to the example of animals:

> Our citizens should not be worse than birds and other beasts that are
> generated in large flocks and live celibate and unmixed by intercourse
> (*akeratoi gamon*) and pure (*hagnoi*) until they reach the age for breeding.
> (Plato *Laws* 840D3–7)

In accordance with this imagery of mixing liquids, impregnation can be
said to have the unlikely effect of eliminating the liquid on contact, pro-
ducing a feeling of dryness.[17] The metaphor is extended to intercourse be-
tween males, as in the expression "the unmixed (*akerasion*), bloom of the
thighs," and to celibacy in general, as when Clytemnestra is charged with
failing to keep her bed *akeraton*.[18] The grounds upon which the virgin is like
water are not that she is wet, transparent, or clean, but that she is unmixed,
simple, water being a primary substance. Like the maiden, water is "un-
mixed," *akeraton* and pure, *hagnon hudor*, a spring is a virgin.[19] On these
grounds, water and virginity may be thought of as kindred elements, and
virginity as residing in water. Hera recovers her maidenhood yearly by a
plunge in the Canathus spring; the Proetids revert to virginal thoughts
when they are bathed in a spring at Lousoi; maidens deposit their virginity
into the Scamander.[20] In turn, the image of virginity as a simple substance
contained in the womb depends on a long-lived, widespread, basic meta-
phor, that of woman as container and more specifically as vase.[21]

The metaphor "maidenhood is water" occurs in a wide range of media.
Our starting point, of which we must not lose sight, were the allusions to
bathing on Attic vases. The metaphor "chastity is water" and the one on
which it is predicated, "intercourse is mixing liquids," run through verbal
texts, ritual acts, and medical practices. This shows that the mechanism of
metaphor extends to extralinguistic modes of expression. In other words,
the image of water structures verbal metaphors, and it does so *qua* image,
that is, visualized representation. The methodological implications of this
conclusion vis-à-vis the definition of metaphor as interaction must now be
confronted. It is acknowledged that the most striking feature of the meta-
phoric twist is that it introduces a "concrete" element through which an
idea is grasped. This "sensory" projection onto the verbal is what produces
liveliness and gives the concept its structure. The vehicle is most often char-
acterized as carrying an image — one speaks thus of "focal image," of "figu-
rative language," of "metaphorical seeing" as being "image-exciting."[22] But
this visionary quality is precisely the trouble with metaphor because, from
Richards onward, most studies of metaphor have denied that there is any-
thing visual to the metaphorical image:

> For example, just because I form an image of a wolf when I hear the re-
> mark "Man is a wolf," it is not clear that I must form such an image to
> understand the metaphor. At present, it is not even clear how one could
> demonstrate the necessity of images in metaphoric understanding.

Thus writes Johnson in his sober and enlightening survey of theories of
metaphor.[23] The terms of the problem may be examined best, again, in
Richards's formulation:

> We cannot too firmly recognize that how a figure of speech works has
> nothing necessarily to do with how any images, as copies or duplicates
> of sense perceptions, may, for reader or writer, be backing up his words.
> In special cases for certain readers they may come in — there is a long
> chapter of individual psychology which is relevant here. But the words
> can do almost anything without them, and we must put no assumption
> about their necessary presence into our general theory.[24]

The possibility that the image — or sound or feeling — called up by the ve-
hicle may be expressed in anything that is seen or heard or touched — other
than words — is thus rejected because any extralinguistic representation
would of necessity make sense-experience the basis for metaphor. This as-
sumption — that in order to be visualized the image in metaphor must lead
back to its referent through perception — makes of the image the proper
subject of sciences that deal with the physiology of cognition, such as psy-
chology. This point of view is shared by many who believe that metaphor
does extend outside language. In such a way, Ricoeur suggests an extension
of the inquiry on metaphor into psycholinguistics to account for its "quasi-
optic" as well as its "quasi-verbal" aspect;[25] a vigorous proposal for an ex-
planation in terms of experiential Gestalt was made by Lakoff, Johnson,
and Turner.[26]

So far, the debate on metaphor has been strictly observant of the dis-
tinction between the "linguistic" and the "extralinguistic" domains. While
the former allows discussion to remain within the boundaries of theories
of the symbol, the latter, being more heavily contaminated by reality, forces
the interpreter into a discussion on perception. Where extralinguistic ex-
pression is concerned, that is, the means by which meaning is conveyed
matter more than they do for language. Unlike language, pictures would be
a mixture of convention and reality, encapsulating a core, however small
and difficult to recover, of perceptual experience. It becomes permissible,

therefore, to speak of the notion of "mental images" as a red herring when one would think twice before calling the notion of concept a red herring.[27] It is this closely guarded boundary, guaranteeing the verbal expression the privilege of a greater distance from its referent, which must be probed.

What makes it impossible to detach images from the context of the "sensible" world and gives words the status of "purer" symbols is the overriding "dead" metaphor of metaphysics, which allows one to speak of reasoning in the first place. The axiom may be expressed by the following proportional analogy: images : perception = speech : intellect. Images speak the language of nature; intelligible speech, that of knowledge. Speech is comprehended by reason; images, by the senses, or "As sight is good in the body, so intelligence is good in the soul."[28] This proposition says that images are like words in certain respects, namely, in that they articulate "concrete" reality in the same way as speech articulates thought — the tension arising in the metaphor from the fact that the sensible world is, by definition, inarticulate. At one stroke, this metaphor creates the *logos* and its domain, the verbal, in the form of the opposite of sensation, whose domain is represented as pictures, sounds, and feelings. In the analogy, each of the terms retains the burden of its context: in order to function as the analogues of words, images must retain their materiality. In other words, the very ability to speak of ideas demands that images remain bound to the discourse of perception.[29]

In Greek thought, this metaphor is first sighted in the fragments of Heraclitus, where its implications for the representation of reality have often been analyzed. "Eyes and ears are poor witnesses for men if their souls do not understand the language."[30] Images and sounds provide for the observer who understands their language what words provide for the intelligence. Because "Nature loves to hide itself," sense perception is opaque and must be interpreted.[31] But:

> The interpretation, once found, must be seen as a "given" by and in the sense experience, not imposed from outside it; just as the meaning of a sentence lies in the words and is determined by them, not imposed on them from the outside.[32]

To interpret is to expose the "latent structure," which "is master of manifest structure"; the form of revelation obtained is other than speech: "The Lord whose oracle is in Delphi neither speaks nor conceals, but signifies."[33] What is both voiceless and evident is both invented, in the sense of "made" by the intelligence, and "invented," in the etymological sense of "found" in

Nature—that is the remarkable property of metaphor.[34] The intelligent vision of metaphor as reverse projection of thought onto perception may be recognized in the procedure described in Aristotle's essay *On Memory:*

> An account has already been given of imagination in the discussion of the soul, and it is not possible to think without an image. For the same effect occurs in thinking as in drawing a diagram. For in the latter case, though we do not make any use of the fact that the size of the triangle is determinate, we none the less draw it with a determinate size. And similarly someone who is thinking, even if he is not thinking of something with a size, places something with a size before his eyes, but thinks of it not as having a size. If its nature is that of things which have a size, but not a determinate one, he places before his eyes something with a determinate size, but thinks of it simply as having size.
> (Aristotle *On Memory* 449B30–450A6 [trans. Sorabji 1972])[35]

The procedure described here has a remarkable correspondence with the interaction generated in metaphor in that thinking *works through* the image selecting certain structuring features—shape in one case, size in the other—and disregarding those that are not relevant. One may note that the procedure is treated in the same terms as metaphor was described in *Rhetoric* as a "placing before the eyes," an expression paraphrased elsewhere as "making images" *eidolopoiein,* for mnemonic systems.[36] In fact, the passage cited implies a metaphor that may also be expressed thus: the relationship of three connected items is a triangle, although not, of course, in the sense that it has a certain dimension, color, texture, although the image of a triangle one must have before the eyes does. The crucial question, as regards the visual quality of the metaphoric image, is this: does the fact that the triangle is *visualized* as it is *spoken* of imply that the figure has a form other than words? To answer yes to this question, as I do, is to admit that the metaphoric image (the vehicle) is an extralinguistic representation and that it is made up by assembling in a concrete and coherent form selected features that will sustain the thought that is being entertained. Its sense, then, is not qualitatively different from the one tying a word to its referent.

In answer to Richards's statement quoted above that no images are needed in metaphor since the image implies a "confusion with the sense in which an image is a copy or revival of a sense-perception," one may say that the two issues should be separated. Yes, the image may be visual; and no, we need no more be forced into a discussion of perception by images than by words, or in the same measure.[37] One may, at this point, entertain the

possibility that one form of correspondence of visual to verbal imagery is direct: that images we see are the vehicles of metaphor. In this proposal, the imagery is not something that belongs to a system that is just as conventional as language but independent from it. Rather, extralinguistic representations are bonded to verbal representations at the level of discourse.[38] Derrida has shown how the "dead" metaphors embedded in abstract language may be revived to reveal the metaphorical tension the phrase once entertained.[39] If one's point of departure is not a verbal text but pictures, the process must be reversed, the path leading from the image to the word, to the point where they join. I will attempt to do this through an analysis of the image of the enveloping mantle.[40]

The figure, which I use to explain my hypothesis, is very common on Attic vases dating to the Late Archaic and Classical periods: the enveloping mantle, which encases the person like an impenetrable shell, leaving only head and feet exposed. It is most frequent in scenes painted on the "backs" of vases, normally column kraters, showing standing figures, generally three, of which at least one is often wrapped in the mantle. The traditional explanation, "conventional conversation scene," acknowledges that the picture is commonplace, as its frequency and repetitiveness indicate, but this is not to say, as the label implies, that the image is meaningless. On the contrary: by definition, what is commonplace is packed with meaning, so consistent and obvious to the viewer toward whom the image is directed as to be subliminal. To the modern viewer, on the other hand, the sense of these representations is all the more impenetrable for being given in stereotype, that is to say, reduced to a minimum of articulation, lacking emphasis.

Other scenes that include the enveloping mantle are richer and recognizably anchored to certain themes. In representations of courtship, it is the object of desire—boy, girl, or woman—who is represented wrapped, whether subjected to longing glances, offered gifts, or rarely, embraced.[41] There are indications—some subtle, some striking—that forestall "common sense" explanations of the dress as nothing more than fashion or protection from the elements. The way, for instance, in which a hand is awkwardly thrust out of the cocoon, emerging somewhere near the chin to reach for a gift, stresses that the mantle is a constraint and a cover not to be let down casually. The mantle-covered female is a staple of pictures traditionally called "women at the home"—many of them including woolworkers—and explained as "genre" scenes of everyday activities.[42] As in the courtship scenes, it is difficult to understand the use of the device as resulting simply from the artist observing things and objectively depicting them. It was observed above that the mantled girl may be surrounded by others

who are not;[43] when another girl holds a wool basket or a box out to her, she keeps her hands under wrap and makes no move to receive the object (fig. 108). Her head bowed, her gaze downcast, her body muffled, the mantled girl seems isolated from her surroundings (fig. 109), even though she is often the object of attention, the one to whom things are brought—not only wool baskets, but jars of scent, ribbons, and flowers.[44] There are, finally, representations in which the meaning of the mantle seems dictated by the circumstances. It is the costume of persons who grieve—Achilles, for instance, at the death of Patroclus—or of the members of a chorus in festival procession; "It is the garb of decency, mostly of schoolboys, sometimes of mourners."[45] This explanation is, I believe, basically correct. It remains to be seen why it is used where it is used, why it is more appropriate for some persons than for others, for some situations more than for others, and why it figures so prominently in representations of the object of love.

In the analysis of the pictures of girls working wool, the figure of the enveloping mantle was identified in verbal imagery concerning *aidos*.[46] Comparison of the visual with the literary imagery revealed a remarkable degree of correspondence, the two having in common not only the figure of the enveloping mantle but also the cast of characters, at least in part. As already noted, among the pictures of which the theme could be more or less identified, are scenes of "women at home" and of courtship. There the mantle is an attribute, respectively, of women and of objects of desire—women again, presumably unmarried, and boys and adolescent males. In the texts too, it is women of all ages, boys, and adolescent males for whom *aidos* is most appropriate. But to observe that a correspondence between word and image exists does not, as a matter of course, explain the nature of the relationship—how the meaning of the word is related to the meaning of the picture. The search for an explanation must begin with an examination of what the lexical item *aidos* signifies. The task is not simple because the semantic value of the word is unclear. The word is variously translated as shame, modesty, respect, fear, dishonor—the specific choice having to be made case by case, taking one's cue from the context in which it occurs. Such a variety of options warns that the grasp we have of this concept is partial or haphazard.[47] The word is untranslatable because the metaphoric connection to the figure that conveyed its meaning is not part of our cultural apparatus.

There exist now three studies of the word, which aim at establishing its semantic range through the historical analysis of the literary texts in which it occurs.[48] The wealth of observations they contain will be condensed here under the subheadings of the terms with which the *Etymologicum Mag-*

num defines *aidos: time,* honor; *phobos,* fear; *aiskhune,* shame; and *oneidos,* disgrace.

Aidos in a sense comparable to *time*—honor, respect, veneration—is both given and received, so that Schultz and Erffa speak of an "active" and a "passive" *aidos.* The two, however, do not "merge one into the other."[49] The exchange is not reciprocal, because the person who receives *aidos* owes *aidos* in turn, but to someone else. The party at the receiving end varies according to identity and circumstances. The young (*neoi*) honor their elders until they come of age. For this reason, Athena tells Telemachus that he no longer need feel *aidos* in addressing older men. Women, whatever their ages, owe respect to elders, husbands, and men in general: Medea has *aidos* for her parents, which she will lose when she is seduced by Jason; Penelope says that she is reluctant (*aidoumai*) to enter alone the company of men.[50] Servants honor their masters, so that Eumaeus refrains (*aideomai*) from even mentioning Odysseus's name, although the latter is away. All men must have *aidos* toward the gods. The guest, the wanderer, and the suppliants are *aidoioi,* who ask for compassion and asylum. Odysseus, cast ashore on the banks of a river, begs for protection: "[E]ven in the eyes of the immortal gods the man who comes as a wanderer is *aidoios* . . . pity me, lord, for I declare myself your suppliant."[51]

In general, *aidos* is due to men in authority by persons who are permanently or temporarily at disadvantage. In Plato's words:

> The better are superior to the worse, and the elder, generally speaking, to the young, and therefore parents are superior to offspring, men to women (*gunaikon*) and children (*paidon*), and rulers to the ruled. It would be fitting for everyone to feel awe (*aideisthai*) before all of those superiors. (Plato *Laws* 11.917A [trans. Pangle 1980])

In turn, the appropriate display of *aidos* imposes on those toward whom it is directed some form of restraint, resulting in immunity from insult, violence, or revenge for their subjects. *Phobos,* fear, is one of the feelings that produce *aidos* and is akin to it. The two are the constraints without which no army can be governed. Penelope, puzzled by the behavior of Odysseus, who has not yet revealed himself, asks Eumaeus: "[I]s he tremendously afraid of someone, or for some reason does he feel ashamed (*aideitai*) in the house?" Likewise, Electra is afraid (*aidoumai*) to mention the Furies who haunt her brother.[52]

Aiskhune, shame, is the notion most closely associated with *aidos* in the modern mind,[53] and it is one of the sentiments that bring forth *aidos* in

the sense of modesty, submission, cowering. For example, Phaedra asks her nurse to cover her head, because she is ashamed, *aidoumetha*, of what she has said, and Heracles covers his head, *peploisin*, ashamed to offer Theseus the spectacle of his guilt.[54] *Oneidos*, dishonor or disgrace, is the most surprising item in this checklist, one that seems, at first, in contradiction to the generally positive connotations of the term. The difficulty is resolved by the observation that there exist two different kinds of *aidos*, one desirable, the other shameful. What determines the difference is not a property objectively inherent in *aidos* itself, but whether the sentiment and the behavior it entails are assumed by persons to whom it is appropriate and under the appropriate circumstances. A key text for the distinction is Aristotle's *Nicomachean Ethics*, which defines *aidos* as an emotion and an inhibition:

> It is incorrect to speak of *aidos* (*peri de aidous*) as being a virtue or excellence, for it resembles an emotion more than a characteristic. At any rate, it is defined as a kind of fear of disrepute, and the effect it produces is very much like that produced by fear of danger: people blush when they feel ashamed and turn pale when they fear death. . . . This emotion does not befit every stage of life but only youth. For we think that young people ought to be bashful because, living by their emotions as they do, they often go wrong and then *aidos* inhibits them. We praise young people who have a sense of shame, but no one would praise an elderly man for being bashful, for we think he ought not to do anything that will bring him shame. (*Nichomachean Ethics* 1128B10– 21 [trans. Ostwald 1962, modified])

This brief survey shows equivocation in our understanding of the value of the term. On the one hand, it expresses something on which the very foundation of an orderly society rests, Zeus himself having arranged that citizens who "cannot partake of *aidos* and justice" should be put to death as dangerous to the community. On the other, Aristotle calls *aidos* an affliction from which good men ought not to suffer.[55] It is clear that, properly speaking, *aidos* is neither shame, nor honor, nor fear, nor disgrace but stands in some relationship to each. The periphrases and pseudosynonyms that the written sources offer describe a pattern of social interaction, in other words, what *aidos* does. For the common good, it constrains those who are incapable of behaving in a wise and responsible manner, thus preventing those who have power from using it in an arbitrary and destructive manner. But the texts do not reveal what holds together the disparate senses that *aidos* takes on in different contexts. For example, "modesty" and "disgrace" have

quite different spheres of meaning. *Aidos* enters upon one or the other depending on whether it is the good *aidos* on which the order of society rests or the bad kind, which is like fear. In this way, verbal discourses of *aidos* imply but do not show how these meanings are connected. It is precisely the configuration of this network of meanings, the implicit "semantic focal point," [56] that the image of the enveloping mantle, so explicit and concrete on the vases, allows us to retrace.

If the insight gained by comparing the literary imagery to the pictures is turned back onto the written texts, the mantle appears as the vehicle of metaphors, where it is the sign not of a person who has *aidos* but of *aidos* itself. Because the metaphor has evaded commentators, each of the following passages is an interpretive crux of long standing.

Pindar's ninth Pythian ode for Telesicrates of Cyrene opens with Apollo seizing the nymph Cyrene and marrying her. Aphrodite lends her help, speeding their chariot on its way; she then "cast lovely *aidos* on their sweet marriage bed" (12). The phrase refers to the consummation of the marriage, for which *aidos* serves "as a protection for both against external interference and a safeguard of privacy and intimacy within," as Woodbury noted.[57] But what does Aphrodite do? The phrase describes a gesture, which must be visualized. The image comes into focus if the metaphor "*aidos* is a mantle" is projected upon the text. The cloak is the bedcover. In epic poetry, the guest's bed is prepared by laying a cloak over it, and men sleep under cover of the *khlaina*. To lie with a man under the same mantle means to sleep with him, as Helen with Menelaus: "[T]he daughter of Zeus came to you under the same mantle." [58] What Aphrodite does—the literal meaning of the phrase—is to prepare the marital bed.[59] Such a scene appears on a black-figure tripod pyxis painted with the marriage of Heracles and Hebe.[60] The cortege approaches the newlyweds' *thalamos*, where two female figures place pillows at either end of the marital couch. The coverlet, which in Pindar's metaphor is the vehicle of *aidos*, hangs prominently down the side of the bed.

A second *aidos* metaphor in Pindar has been particularly impervious. It occurs in the fourth Pythian ode, where Jason urges Pelias, in the name of their common ancestry, to avoid armed conflict by reminding him that the Fates condemn strife among kin: Μοῖραι δ' ἀφίσταντ' εἴ τις ἔχθρα πέλει / ὁμογόνοις αἰδῶ καλύψαι (145–46). While it is acknowledged that the expression lacks a clear explanation, the interpretation according to which the *ekhthra* (enmities) cover the *aidos* is the one most widely adopted. This, by Segal, is its clearest formulation:

> The *Moirai* (Fates) stand apart if any enmity comes among kinsmen to
> cover up the respect that should exist between them.[61]

Burton explains:

> [The Fates] . . . stand apart from family quarrels, the effect of which is
> to hide from view the *aidos* or respect which should be visible to all in
> the behaviour of kinsmen toward one another . . . the infinitive *kalypsai*
> is explicative of *ei tis . . . homogonois*, not of *Moirai aphistantai*.[62]

This reading is based on the premise that *aidos* means respect (whereas, as
we have seen, it engenders respect) and that it is reciprocal, rather than uni-
lateral, between two parties. Why the Fates should stand back under these
circumstances remains unexplained. Another reading makes *kalupsai* de-
pendent upon *aphistantai*, "the Fates withdraw to hide their shame" or "the
Fates withdraw to cover Aidos."[63] The possibility does not seem to have
been entertained that *aphistantai* means something other than "withdraw,"
"depart," or "stand back." But "hinder" and "prevent" also are among the
meanings of the verb, and they are the appropriate ones here.

As in the previous example, Pindar's metaphor hinges on the figure of
aidos as mantle, but it is thick with references to other things, which require
a wealth of local knowledge to clarify. Any interpretation must take the mur-
der of kinsmen as its point of departure. Some of the background against
which the passage acquires meaning and resonance can be recovered from
what little is known of the beliefs and customs relating to family strife and
the resulting pollution and punishment. The most extensive source for these
matters is Aeschylus's *Eumenides*. In spite of the fact that he was purified at
Delphi for the murder of his mother, Orestes continues to be pursued by
the Furies of Clytemnestra. They follow him to Athens, where he appeals as
a suppliant to Athena for the pardon that will allow him to return home to
Argos. The Furies state that they carry out the mandates of the Fates:

> This the Fates who move the whole world through
> Charged customs to be our task for all time hence
> Watch to keep over all hands that drip red with kindred
> Blood, to wait till the Earth open . . . (*Eumenides* 335–39 [trans. Thom-
> son 1938])[64]

Their persecution will not cease, purification by Apollo notwithstanding,
because Orestes is guilty not simply of murder, but of the murder of blood

kin. When Orestes asks them why they did not so haunt Clytemnestra for the murder of Agamemnon, the Furies reply: "She was not bound by blood to him who she slew" (607–608). It is important to note that is the reason why they intend to see that he remain a suppliant unabsolved. What wins Athena's vote for Orestes is Apollo's argument that one's mother is not one's blood relative, a mother being no more than an incubator:

> A mother is not the parent of the child, Only the nurse of what she has conceived. (*Eumenides* 658–659)

The argument achieves the purpose of transforming the charge of murder of kin into a charge of simple murder. Apparently this is a necessary step before the issue of Orestes' pardon may be considered.

One learns then from the play what the Fates have to do with murder in the family and another essential fact: that someone guilty of shedding the blood of a relative was refused the means by which a man guilty of simple murder could shed his pollution, make reparation, and be restored to the community. In actual practice, this process, too, followed established rules. The rules operating in Archaic Athens are laid out in the seventh-century laws of Dracon, in which the procedure through which pardon might be granted is specified: the decision belonged to the male blood relatives of the victim, and the technical term for the pardon is *aidesasthai*.[65] What kind of *aidos* does the family of the victim exercise here? The question is crucial to an understanding of the law and of the passage in Pindar's fourth *Pythian* ode. In both cases, the central figure is the murderer as suppliant, who is filled with *aidos* and to whom compassion and asylum are due. It is the suppliant whom *aidos* covers, and it is to someone who has killed a relative that the suppliant's mantle is denied.[66] Pindar's dense metaphor, powerful as it is, is grounded in the commonplace metaphor through which the notion of *aidos* is grasped and expressed: "But if strife breaks out among kin, the Fates prevent *aidos* from covering," that is, withdraw the shelter that *aidos* affords a suppliant.[67]

No less troubling has been the interpretation of *aidos* in the lines where Aeschylus depicts the rape of Io. The passage begins after a lacuna: "[Io] yields to Zeus's harmless strength and passion" and "sheds a sorrowful *aidos* (*penthimon aido*) of tears."[68] Shame may not be out of place here, but to translate "let fall the sorrowing shame of tears"[69] is to make nonsense of the passage and to fail to realize that it contains a compound metaphor within the frame of the consummation of the rape. The image should be understood against the "system of associated commonplaces" that have to

do with rape:[70] the chase, the overpowering, the stripping. In fact, the shedding of clothes—the euphemism of the loosened girdle—stands for the sexual act and represents the letting down, under power of violence or persuasion, of the woman's last defense. Io has metaphorical clothes, her tears, the expected reaction of the ideal bride. In turn, the curtain of tears is the form of her *aidos*, and its falling signifies loss of shelter and violation.[71] A picture of Zephyrus and Hyacinthus illustrates better than words how problematic it is to maintain *aidos* while rape takes place (fig. 110).[72]

The last instance to be discussed here in which the metaphor "aidos is an enveloping mantle" helps solve an old puzzle is a sentence in Herodotus's *Histories* (1.8.3). Gyges resists Candaules's suggestion that he should see his wife naked: "Together with her dress, a woman also sheds her *aidos*" is the shocked reply. Some still take this as a cynical comment on the lability of woman's virtue, but it was seen long ago that *aidos* here means not "modesty" or "decency," but "the respect which a woman is owed."[73] Naked, a woman is not unvirtuous—*aidos*, as Aristotle says, is not a matter of virtue—but defenseless; there is a play, in the sentence, between the image of *aidos* as clothing and that of *aidos* as the boundary of decency.

The image of the lowered gaze as a sign of *aidos*, although not as pervasive as that of the enveloping cloak, also underlies a few expressions that have been misunderstood. In Xenophon's *Memorabilia*, for example, the impossibility of seeing clearly into the working of divine powers is illustrated with the parable of the man looking at the sun: "The sun does not allow man to see him closely (*akribos*) but if one attempts to gaze at him *anaidos* it takes his sight away" (4.3.14). *Anaidos* here means not "recklessly" but "with wide-open, unsheltered eyes." In Aeschylus's *Prometheus Bound*, the din that drove the Nereids out of their palatial cave struck their *themeropis aidos*, their "laid-down glance" (133–34). To translate "drove my gravemiened modesty away in fright" or "steady-eyed *aidos*" is to miss the image of lowered eyes suddenly becoming wide open with alarm.[74]

Just as the look of *aidos* sits well on a woman's face, as well as on the countenance of children, beggars, and suppliants, it is most inappropriate for a man, on whom it bears witness of bad *aidos*. Since Aristotle's discussion of proper and improper *aidos*, depending upon gender, age, station, and circumstances, was quoted above, one example may suffice here. In Euripides' *Hecuba* (970–75), the protagonist, speaking to Polymestor, confesses her shame to confront him in her present situation and her inability, due to *aidos*, to look at him "with insolent eyes," *orthais korais*. He should not, she adds, take this as a sign of ill will: it is against the rules for women to return a man's stare.

One can say at this point that the figure of the enveloping mantle and the related image of the lowered gaze carry the idea of *aidos*.[75] It is time to examine how the metaphor works. As the inconclusiveness of painstaking effort on the part of Schultz, Erffa, and Cairns shows, the semantic value of the term cannot be conveyed in abstract terms, nor can it be paraphrased. It is metaphor that makes the abstraction visible by casting it into its concrete analogue. In this manner a set of connections is established between the two, allowing the one (the "sensible" one, the vehicle) to organize our understanding of the other. The metaphor seizes certain properties of the "focal image," its capacity to hide things from view, to withdraw the body from the public domain and uses them as a template in order to map the network of relationships signified by *aidos*, the mechanism of social order.[76] *Aidos*, in other words, does for the social persona what the mantle does for the person who wears it: it conceals the shame within, that consciousness of being at fault that engenders respect and submission. In its outward presence, it shields the body by setting a boundary not to be transgressed. In doing so, the mantle of *aidos* traps the person "with shackles not of bronze," *akhalkeutois ezeuktai pedais*, like the robe in which Clytemnestra caught Agamemnon, the hunting net, *akhalkeutois pedais* (fig. 111).[77] While the mantle muffles the body and the lowered gaze dims perception, *aidos* finally takes possession of the tongue, making speech confused and obscure.[78] All possible avenues for perception, intelligence, and action are then effectively closed.

This last observation leads back to the vase paintings, specifically, to the courtship scenes and the question of what role the mantle plays in erotic discourse. As it signifies that the object of desire has *aidos*, it states that all claims to agency have been relinquished, it signals submission. I leave to Halperin the task of saying why that is as it should be:

> For women and boys will qualify as equally appropriate sexual targets
> for adult men only so long as they remain relatively stationary targets
> (so to speak), only so long as they are content to surrender the erotic
> initiative to men and to await the results of male deliberation.[79]

A suggestive analogy appears in Roszika Parker's study of the representations of women embroidering. Her caption to "In Love" (fig. 112) reads:

> Eyes lowered, head bent, the embroiderer's pose signifies subjugation,
> submission and modesty. [She] has become implicated in a stereotype

of femininity in which the self-containment of the woman sewing is represented as seductiveness.[80]

What are the consequences of the analysis presented above? *Aidos* the *concept* is not, it appears, sustained by the word *aidos* but by the metaphor "*aidos* is cover," as in "*aidos* is mantle" and "*aidos* is eyelid," where in the idea of *aidos* the visual image is bonded to the thought, as vehicle to tenor. If the awareness of that connection is absent — as it is for the modern interpreter of ancient texts — so is the fullness of the concept. As one could see, analyses of the verbal uses of *aidos* could not produce a meaning that would satisfy all occurrences. The paraphrases put forward by the scholars produced instead a number of other meanings — shame, respect, honor, dishonor — none of which is exhaustive by *aidos,* none of which reproduces its extension. The loss of the image, in other words, dissolved the metaphor, leaving no alternative but to fit the word into other metaphors in the several hopeless attempts to paraphrase it. What of the visual image of mantle, represented in pictures on the vases? By itself, in the absence of the word, the image conveys its meaning no better than the word does without the image. The wrapped girl fits modern notions of modesty, but one cannot recover the sense in which the mantle functions as a boundary and a defense as well as a constraint. As actually worn garment or as image, the enveloping mantle owes its existence to the concept. In typical metaphorical fashion, the figure leads away from the sensible toward the abstract, from seeing to understanding, and the key to understanding is the right metaphor. The metaphorical *connection* is thus as vital for the image as it is for the word.

The metaphor of *aidos* may be said to be dead in two different senses. It is historically dead in that the modern interpreter no longer registers the connection of image to thought as a live connection, although she may look at it as a fossil shape. This kind of death occurs when metaphors are transported into alien cultural domains, in time or space, as is the case for obsolete terms and loan words. Mark Turner points to the English word "pedigree" as an example of a truly dead metaphor, because the image of the crane's foot animating the genealogical diagram that the French maintains is lost in the borrowing.[81] Characteristically, this form of death entails the dissolution of the metaphor, a final parting of image and word, resulting in a modification of meaning for both. But "*aidos* is a mantle" was "dead" in ancient Greek culture as well, in the sense discussed above. It is a trite metaphor, a notion whose currency is so widespread and frequent that verbal texts may give no hint of image, and the images have the opacity of

stereotypes. This kind of death deserves special consideration because, as it is normally defined, it allows for the survival of words but not of images.

The venerable notion that metaphors die and become mere words has wide currency in philosophical writings and has been stated most forcefully by Ricoeur in a polemical answer to Derrida:

[handwritten margin note: metaphors become meaning]

> Dead metaphors are no longer metaphors, but instead are associated with literal meaning, extending its polysemy. The criterion of delimitation is clear: the metaphorical sense of a word presupposes contrast with a literal sense; as predicate, this contrasting sense transgresses semantic pertinence. Indeed, various traits that sustain the heuristic function of metaphor disappear with lexicalization: forgetting the customary meaning causes us to overlook the deviation in relation to the isotopy of the context. So it is only by knowing the etymology of the word that we can reconstruct the Latin *testa* ("little pot") in the French *tête* and the popular metaphor from which the French word is derived. In current usage the metaphor has been lexicalized to such an extent that it has become the proper word; by this we mean that the expression now brings its lexicalized value into discourse, with neither deviation nor reduction of deviation.[82]

The "criterion of delimitation," however, is far from clear. The loss of the sense of metaphoric transgression is a matter of "forgetting," of degrees measuring the extent to which the impact of the image is consciously registered. The rough-and-ready criterion seems to be the introduction of the metaphorical phrase as word in the dictionary,[83] but that holds true only if we all agree that, for instance, "Weight: Importance; power" is not a metaphor. French *tête*, of course, is a dead metaphor, being a loan word, severed from its language, Latin, and culture. Phrasing the question in terms of semantic pertinence and lexicalization is only possible by containing a theory of metaphor within the theory of language. But if the iconic function of metaphor is carried out by extralinguistic means, such as images, it is legitimate to ask: what happens to the images when the metaphors to which they belong die and the words take up domicile in the dictionary? Do they fade away, or are they too stored and classified somewhere? Or, does the enveloping mantle cease to be a symbol once the *aidos* metaphor is no longer new and become simply dress?

On the opposite front, Richards's view that "however stone dead such metaphors seem, we can easily wake them up" is now taken by two rather different approaches to the problem, that of George Lakoff, together with

Mark Johnson and Mark Turner, and that of Jacques Derrida.[84] The first have argued that the dead metaphor theory "fails to distinguish between conventional metaphors, which are part of our live conceptual system, and historical metaphors that have long since died out":

> The mistake derives from a basic confusion: it assumes that those
> things in our cognition that are most alive and most active are those
> that are conscious. On the contrary, those that are most alive and most
> deeply entrenched, efficient, and powerful are those that are so auto-
> matic as to be unconscious and effortless.[85]

The "power" of a highly conventional metaphor is not to startle and intro-duce a new understanding that "rich" or new metaphors have but to per-meate thought and action as invisible structure. This current of research is ultimately concerned with the relationship of the metaphorical with the nonmetaphorical—with the world as it is experienced and with cognitive processes. But on the issue of dead metaphors and their power, one may see a point of correspondence with Derrida's appraisal of metaphor in the realm of metaphysics.

As its subtitle, "Metaphor in the Text of Philosophy," states, Derrida's "White Mythology" is an essay concerned with metaphor's presence and role in theoretical language; it is an attempt to *"fill* the concept of meta-phor."[86] Far from being a marginal development, the "death" of metaphor is defined as essential to its function, or the condition of its effectiveness in the "translation" of the sensible in the realm of the intelligible. The essay opens with an analysis of Anatole France's *The Garden of Epicurus* and the seductive metaphor, offered by Polyphilos, of the wearing away of the image as the deliberate effacement of the sensible in philosophical dis-course.[87] The hypothesis of Polyphilos is that any abstraction conceals a fig-ure and that philosophical language is a development and a corruption of an original, primitive form of a sensory language. The erasure described here, as Derrida notes, is double—that of the original figure, and that of the original metaphorical appropriation: "Simultaneously the first mean-ing and the first displacement are then forgotten. The metaphor is no longer noticed, and it is taken for the proper meaning. A double effacement."[88] Derrida adopts the figure of consumption, both as a wearing out and "usure," as a way of making "sensible" the way in which metaphors must "die," but he uses it to mean not the double effacement (of figure and meta-phor) but only the effacement of metaphor itself:

> White mythology—metaphysics has erased within itself the fabulous
> scene that has produced it, the scene that nevertheless remains active
> and stirring, inscribed in white ink, an invisible design covered over in
> the palimpsest.[89]

It is the "inscription" or the "exergue"—what is outside the image and in-
scribes it—that is said to be effaced in the philosophical text, when the task
at hand is formulated later on: "The exergue effaced, how are we to deci-
pher figures of speech, and singularly metaphor, in the philosophic text?"[90]
This formulation has an implication, which I wish to adopt, that the figure
remains embedded in the text, while awareness of the inscription that al-
lowed the transplant in the first place—the interaction of vehicle and tenor
—has been erased.

Derrida does more than add the imagery of wearing away, grinding, and
"capitalizing" to that of dying and fading for metaphors that become mere
words or mere truths. He also points to what is lost, or lost from sight (or
buried, or effaced) when metaphor accomplishes its task by being erased.
What is affected is the juncture of image and thought, the transaction that
allows the raising of the sensible term, the vehicle, to the level of intelligent
discourse as a word. What becomes invisible, in other words, is neither the
image of metaphor with its context, the sensible, nor the import of the
statement with its context, the abstract, but the fact of "seeing through":
metaphor itself disappears in "the blind spot or central deafness," "the dis-
simulated focal point."

Although briefly, the possibility that the image may be other than words
is nevertheless broached:

> In signifying the metaphorical process, the paradigms of coins, of
> metal, silver and gold, have imposed themselves with remarkable in-
> sistence. Before metaphor—an effect of language could find its meta-
> phor in an economic effect, a more general analogy had to organize
> the exchanges between the two "regions." *The analogy within language*
> *finds itself represented by an analogy between language and something other*
> *than itself. But here, that which seems to "represent," to figure, is also that*
> *which opens the wider space of a discourse on figuration,* and can no longer
> be contained within a regional or determined science, linguistics or
> philology.[91]

From the point of view of someone concerned with visual representations,
this opening of the discourse of metaphor onto a discourse on figuration
seems to me a necessary premise for any consideration of metaphor and

one that has significant consequences. The first is a shift of emphasis. The concern with metaphysics has meant that all effort has concentrated in elucidating the function of metaphor in verbal discourse, in describing the movement from the sensible to the ideal. Should one admit that it is not just a matter of words, it would become apparent that metaphor is not a one-way street and that the movement from the verbal to the visual also requires elucidation. If one sticks to the interaction view of metaphor — and I do — it is indeed possible to think of metaphor as an "inscription" — of the vehicle within the tenor. This is a bridge between two domains, which affords extension in either direction — of the sensible into the abstract *as well as* of the abstract into the sensible. When it is first proposed, such interaction is subject to refusal, friction, and disruption. When, in discursive practice, the transaction between the two contexts is brought to a definitive and permanent halt, this activity ceases. The metaphor becomes unquestioned and fixed, locking image and thought in the interconnecting schema. Now erasure may begin, but it affects the image no less than the word. The effacement of the metaphor allows the verbal expression to be used as though it had no metaphorical import, in a purely abstract sense. But something also happens to the image that is thus comparably released into its own, nonverbal domain — the realm of things.

For the image, too, the erasure has consequences. The awareness is lost that it is, at least in some measure, an abstraction, its features the schema of a thought. If metaphysical language progressively erases the image while extending its structuring schema, visual representations go the other way — to extremes in the case of realistic representation. They flesh out the idea in forms that are seen as lifelike, natural. By such means the analogy, which had guaranteed the exchange in the first place, is reestablished and confirmed. The concepts articulated by speech correspond indeed to the things, given self-evident, albeit voiceless, representations. Death is the wrong metaphor for this process because nothing dies; rather, the transaction between the two contexts, that of the vehicle and that of the tenor — is brought to a standstill. One no longer understands "as if," one no longer "sees as": one simply knows and sees. One knows what decency is, and one sees that wretchedness must be clothed; one knows what chastity means, and also witnesses that virgins can swim while nonvirgins cannot; one sees that boys change gender and that females never grow up. The power that newly created metaphors possess to disrupt accepted ways of thinking and to affect the imagination turns into coerciveness as they atrophy, into the compelling power of immediate persuasion that the facts of life, marshaled into a reasonable order, exercise on both sense and understanding.

The task of the interpreter of images may then be seen as corresponding to the one that Derrida set for himself in "White Mythologies": "The exergue effaced, how are we to decipher modes of thought, and singularly metaphor, in the visual text?" If to perceive the metaphors hidden in abstract language is to locate figures of speech in the verbal text, to understand an image is to bring out its conceptual value, to expose the informing schema dissimulated under its sensible aspect. This remains an impossible task so long as images are considered part of the discourse of nature and, more properly than words, the object of perception. On the contrary, images are projections of thought. The language system corresponds to and is connected at the level of discourse to the system of conventions of visual representations, a vast storehouse ranging from clothes, to socially acceptable behavior, to ritual acts, to pictures.

And Heaven came, bringing on night and longing for love,
and he lay about Earth spreading himself full upon her.
Then the son from his ambush stretched forth his left hand
and in his right took the great long sickle with jagged teeth,
and swiftly lopped off his own father's members and cast
them away to fall behind him. . . . And so soon as he had
cut off the members with flint and cast them from the land
into the surging sea, they were swept away over the main a
long time: and a white foam spread around them from the
immortal flesh, and in there grew a maiden.

Hesiod, *Theogony* 176–192 (trans. Evelyn-White)

The images of the wool-working maidens examined in the first two chapters refer—it was argued—to their *philergia* as the quintessential mark of femininity, according to a commonplace notion that I traced to its most schematic formulation in Aristotle's *Rhetoric*:

The blessing of good children and numerous children needs little explanation. For the commonwealth it consists in a large number of good young men, good in bodily excellences, such as stature, beauty, strength, fitness for athletic contests; the moral excellences of a young man are self control (*sophrosune*) and courage (*andreia*). For the individual it consists in a number of good children of his own, both male and female, and such as we have described. Female bodily excellences are beauty and stature, their moral excellences self-control (*sophrosune*)

and industrious habits, free from servility (*philergia aneu aneleuthereias*). (Aristotle *Rhetoric* 1361A1–7)[1]

In this passage the *philergia* of the females of the species is the symmetrical opposite of the young males' *andreia*. The same correlation is otherwise often proposed in words and pictures that contrast the spinner with the warrior. A man's capacity for war is clearly expressed by his suit of armor. In the measure in which *andreia* corresponds to *philergia*, it is not wrong to say that her wool basket is a girl's shield. Indeed, such a conceit informs Moschus's ekphrasis of the work basket work-basket of Europa, modeled upon Homer's description (*Iliad* 18.483–606) of the shield of Achilles:

> But Europa herself bore a basket of gold, a marvel well worth gazing on, a choice work of Hephaestus. He gave it to Libya, for a bridal gift, when she approached the bed of the Shaker of the Earth, and Libya gave it to beautiful Telephassa, who was of her own blood; and to Europa, still an unwedded maid, her mother, Telephassa, gave the splendid gift. (Moschus *Europa* 37–42 [trans. Lang 1880])

Like the shield, Europa's *talaros*, her work basket, is one of the amazing objects produced by Hephaestus, which seem to have a life of their own.[2] Achille's shield goes on to have its own distinguished and tragic history; Europa's basket has a noble past. A few details bring basket and shield closer to each other: both are of made of metal (gold for the basket) with inlays of gold, silver, and bronze.[3] Both objects are illustrated with peopled, maplike landscapes:

> Many bright and cunning things were wrought in the basket: therein was Io, daughter of Inachus, fashioned in gold; still in the shape of a heifer she was, and had not her woman's shape, and wildly wandering she fared upon the salt sea-ways, like one in act to swim; and the sea was wrought in blue steel. And aloft upon the double brow of the shore, two men were standing together and watching the heifer's seafaring. There too was Zeus, son of Cronos, lightly touching with his divine hand the cow of the line of Inachus, and her, by Nile of the seven streams, he was changing again, from a horned heifer to a woman. Silver was the stream of Nile, and the heifer of bronze and Zeus himself was fashioned in gold. And all about the rim of the rounded basket, was the story of Hermes graven, and near him lay stretched out Argus, notable for his sleepless eyes. And from the red blood of Argus was

springing a bird that rejoiced in the flower-bright colour of his feathers,
and spreading abroad his tail, even as some swift ship on the sea doth
spread all canvas, was covering with his plumes the lips of the golden
vessel. Even thus was wrought the basket of the lovely Europa. (43–62)[4]

Appropriately, the basket illustrates the rape of Io, a preview of what is in
store for Europa herself, while Achille's shield holds a picture of the uni-
verse and the people who inhabit it. Nevertheless, the way in which the
ekphrasis is structured in Moschus's poem and its wording acknowledge
the Homeric description as a model. The basket is introduced as a great
wonder, *mega thauma* (38), a Homeric expression. *Daidala polla*, many cun-
ning things (43), recalls the opening of the description of the shield of
Achilles (*Iliad* 18.482), and so does the fact that in the *Europa* the first two
scenes are introduced by *en men* (44) and *en de* (50), as are the first two
scenes in the description of the shield (*Iliad* 18.483, 18.490). In *Europa*, the
reference to the epic shield is not so pointed as to result in parody, but it is
perceptible enough to suggest a parallel between the two beyond the allu-
sion to noble status and superhuman fate.

 The basic equivalence of wool-working tools and weapons as the re-
spective markers of womanly and manly identity is spun out in the parable
of Achilles and the daughters of King Lycomedes. In a vain attempt to save
her son from his fate, when the Greeks mounted the expedition against
Troy, Thetis hid Achilles in Scyros in the palace of King Lycomedes.[5] Dis-
guised as a girl, the hero was brought up together with the king's daughters.
He assumed feminine traits in semblance (the blush of maidenhood upon
his cheeks), in dress (his hair tucked into a snood), and "instead of arms he
learned to spin."[6] These habits, though, lay only a veneer of femininity over
his innate *andreia*, which led to his unmasking. Having heard that Achilles,
without whom Troy could not be taken, was hiding on Scyros, Odysseus
and Diomedes came to the island for him. Odysseus tricked him into be-
traying himself by the following ruse. While the princesses, and Achilles
with them, were picking flowers in the meadow, two sets of objects were
cast before them: wool baskets and other things with which girls entertain
themselves, and a suit of armor. The girls fell upon the feminine parapher-
nalia; Achilles, although protesting that he liked wool baskets and weaving-
combs best, reached for the armor and proceeded to strip off the female
garb he had on.[7]

 Philostratus the Younger, *Imagines* I, gives an ekphrasis of a painting de-
picting the discovery of Achilles. A cup in a private collection represents, I
believe, the fifth-century version of the story, set in the court of Lycomedes's

palace (figs. 113, 114).[8] Ionic columns on either side of the exterior suggest a unified setting. One side has three spinners, one seated between two standing, all in chiton and mantle, all wearing snoods. The other side shows a youth putting on armor. There are greaves on his legs and he fastens his corselet, while another beardless man dressed only in a mantle, stands ready to hand him helmet and shield. A second man, who has corselet and a spear but no greaves, helmet or shield, leads the way toward right. The three are not preparing for battle, since only the one in the center has a full panoply. This, and the allusion to a departure made by the stance of the third man, favor of the identification of the subject of the scene as Achilles donning his first set of armor before leaving for Troy with Diomedes, on the left, and Odysseus, on the right. It is the pointed contraposition of the arming to the spinning of the three girls that suggested this explanation in the first place. The women are where they belong, in the court of the palace of their father, doing what proper girls normally do, and they will remain there until they marry, if they marry. But for Achilles there is an end to the spinning; he must leave to take his place in the world of men.[9]

There are other features marking a correspondence of young women of an age to be taught the art of weaving and the young men who are taught the art of war. To begin with, they are represented as belonging to corresponding social structures. We have seen that in words and pictures the spinning girl is set within the group of her peers, *hetairai*, who share the pursuits appropriate to their common age and station and develop bonds of intimacy, *sunetheia*, and affection, *philia*. A standard feature of the band of girls, as it is represented by the mythological paradigms of Europa, Helen, Persephone, or Nausicaa, is that one of them is marked as the best of the lot, owing to extraordinary beauty and superior skill in weaving, making music, and dancing. This structure finds a parallel in the situation of the young hero, who towers above his contemporaries and comrades in arms, *hetairoi*, who are dear to him, *philoi*, by virtue of his superhuman beauty, strength, and courage. In myth, the best example of this situation, as well as the most complex, is Achilles.[10]

This casting of the adolescent men and adolescent women into groups by age and status is the model governing the organization of the young in the initiation rituals that span the transition from adolescence to adulthood. Here a correlation between adolescent males and females is frequently assumed. The social stage to which the *hetairoi* belong is that of young men who assume the responsibilities of adulthood—civic duties, military duties, and marriage. One postulates an analogous stage for the females, who are primed for their role as wives, ornaments to their husbands' estates, and

mothers. Beginning with the representation of the dance on the shield of
Achilles and the pictures of the vases of the Geometric and Orientalizing
periods, the two groups are brought together in the same chorus, holding
on to each other, hand on wrist.[11] As they come into view, confronting each
other on either side of the lyre player, they seem to be indeed the two halves
of the same whole and to flesh out Aristotle's eugenic prescription. This pic-
ture is not incorrect, but it is incomplete. A further characteristic that the
two categories share disrupts the pleasing symmetry that has been estab-
lished up to this point by introducing a third party. The two may appear op-
posite and complementary, but they are not meant for each other in the
view of the person who defines the social reality, that is, the man. In his
eyes, *parthenoi* and *eitheoi*, maidens and youths, are unlike each other and
unequal in all respects, except one: they are both sexual targets. Custom re-
quires that, for a short time, the young citizen male be available as a "loved
one," *eromenos*, to a man-lover, or *erastes*.[12]

The notion that boys and girls and men and women, are, at some point
in time or in some respect, equal to one another and that their lives follow
parallel paths is insistently proposed in ancient Greek sources. A basic par-
ity is also assumed in some modern scholarship, even as the profound so-
cial disparities between the sexes are acknowledged and described. It has
been argued, for instance, that boys and females — and males of inferior so-
cial condition — constitute a range of equivalent sexual choices available to
a man of citizen status.[13] There exists, it is true, a common verbal and vi-
sual vocabulary to describe the beauty of male and female objects of desire.
Like the girls, the boys who are the target of courtship in the vase scenes of-
ten wear their mantle in such a way that only head and feet emerge, and
sometimes a hand to say that the gift will be accepted. Like the gaze of girls,
the boys' gaze is the seat of *aidos* and bespeaks virginity, as in a line of Anac-
reon — *o pai parthenion blepon*, "boy with virginal eyes." Like girls, the boys
blush and, beginning with Achilles and Troilus, they too have pink cheeks.
Like boys, although rarely, loved ones who are girls may be called *paidika*,
darling.[14] What weight should one give, then, to ample evidence that in an-
cient Greek culture young men and females are entirely different kinds of
love objects? In ancient and modern sources one also commonly finds the
idea that young men and young women take their place in society in anal-
ogous ways, albeit each sex according to its capacity, whether natural or
prescribed. Scholars speak, accordingly, of female "initiations" as ordeals
comparable to the ones that admit the young males to citizenship, and of
marriage as an event that transforms a girl into a woman. This perspective
minimizes the import of much evidence to the contrary, including the fact

that allegedly comparable rituals have effects that are one the opposite of the other.

An uneasy coexistence of ostensible symmetry and effective disparity is apparent in Aristotle's definition of ideal masculinity and femininity. Two sets of three qualities each, marking the ideal male offspring, on the one hand, and the ideal female of the species, on the other, are set out in stark contraposition. To the youths' stature and beauty corresponds the girls' stature and beauty; in addition, the males should have athletic prowess. To the moral fiber of the ones corresponds literally the moral fiber of the others. But the third quality cannot be said to propose the same kind of equivalence or even logical correlation. One would expect the corresponding opposite of "manliness," *andreia*, to be a quality intrinsic to female sex. It is instead *philergia*, love of menial tasks, although not slavish in outlook. Nor has *philergia* been casually chosen as just any virtue to round up the enumeration of desirable traits with a difference. The importance of *all* these womanly properties is stressed in the sentence that follows in the passage cited in Aristotle's text:

> The object of both the individual and the community should be to secure the existence of each of these qualities in both men and women; for all those states in which the character of women is unsatisfactory, as in Lacedaemon, may be considered only half-happy. (*Rhetoric* 1361A7–11)

Because the girls' *philergia* and the boys' *andreia*, as well as the latter's athletic ability, are the only points of difference in this definition of ideal youth, it is apparent that industriousness of the right kind is more than desirable: it is a key element of proper femininity. Unlike *andreia*, however, *philergia* does not refer to sex, indeed, it has no connotations that make it specific to one sex. Presumably, males can be *philergoi* as well, although *philergia* is not a trait of the man. The correspondence of *andreia* to *philergia* that Aristotle proposes makes sense not in reference to sex, but in reference to gender. It implies a distinction between male and man, manliness being a desirable quality, therefore something that may or may not be present in a male, just as a female may or may not be *philergos*. But, while a male without *andreia* is not a man, a female who lacks *philergia* remains what she is. Thus Aristotle's definition of the qualities appropriate to each sex is both ostensibly balanced and intrinsically incoherent. In being so, it conforms to a distinctive pattern according to which the discourse on gender is carried out: on the one hand, analogies are drawn that outline parallel paths in the social development of males and females of the same class. On the

other hand, the correlation is only taken so far—to the point where natural fact gives way to social compact. Because the point of departure of all definitions is located in nature (the physical difference of the sexes), the fact that for males sex does not, in and of itself, determine gender is subsumed under the natural order of things. This line of thinking makes it necessary either to gloss over features that are not a fact of nature and thus belie the foundation from which the social construction of gender draws its ultimate justification or to recast those features in terms of natural laws.

This chapter and the two following explore the way in which fundamental asymmetries that determine gender are established at the point where sexual matters intersect with political concerns. The focus is on the crucial stage in the advancement of young males and females, the attainment of physical and social maturity. Female biology is found lacking at that stage and separated from the male by unbridgeable gaps. The differences consist in the inferiority of female beauty and the incapacity on the part of females to attain the age of reason. The disparity is cast as the distance between two separate and unequal erotic realms. The first, which is represented as primary, is inhabited only by men and is coterminous with the political domain. The second accommodates the sexuality of both men and nonmen, such as females, and may be thought of as the realm of natural instincts. The family is a gray, problematic area of overlap between the two, and that makes the husbanding and control of the females the central problem of polis culture.

Age and beauty are the central concerns in discussions on the nature of love and love within the polis, particularly in the debate on the respective merits of love toward women versus love toward boys and young men. Such a comparative approach informs the *Dialogue on Love* that goes under Plutarch's name. This is an especially informative source, although much later in date than most of the authors considered here. This treatise, with its affectation of broad-minded objectivity, brings to the fore some widespread and long-standing attitudes. The pretext for the dialogue is a situation that represents an inversion of the norm. A wedding will take place, but the bride has all the prerogatives that normally belong to the groom. Ismenodora is a rich widow of about thirty, good-looking, and with an unimpeachable reputation, who has set her sights on Bacchon, a younger man in his early twenties. In the end, she has him abducted and dressed for the ceremony, and marries him. The question is, is there anything wrong with this picture? The debate over what advice Bacchon should be given before it is too late takes the form of a discussion of the relative merits of *paiderastia*, love of young men,[15] and conjugal love. The proponents of *paiderastia*

hold that the only true eros is the love of young males, *paidikos*, and quoting Anacreon, compare it favorably with love of girls, *parthenios*, which is base, sizzling with desire and dripping perfumed oils (751A). To the suggestion that there is no difference, Pisias replies:

> Good lord, what coarseness, what insolence! To think that human beings who acknowledge that they are locked like dogs by their sexual parts to the female should care to transport the god from his home in the gymnasia and the parks with their wholesome fresh-air life in the sun and confine him in brothels with the vanity-cases and unguents and philtres of disorderly females! Decent women cannot, of course, either receive or bestow a passionate love. (Plutarch *Moralia* 752B–C [trans. Helmbold 1961])

Pisias ignores the distinction made between proper toilet practices—the *kosmetike tekhne*, which included bathing, dressing the hair, and the use of unguents and scents—and meretricious embellishment (*kommotike tekhne*) by means of rouge and white lead.[16] His aim is to bring out the contrast between the true beauty of the male and counterfeit beauty of the female. The notion that a woman's allure is largely prosthetic, consisting of an arsenal of gold trinkets, scents, and ornate clothes is, in fact, an old cliché. It underlies seduction scenes covering a broad range of time, from the description of Hera's enticement of Zeus in the *Iliad*, to Aphrodite's raid on Anchises, to the grizzled and painted whores of Old Comedy.[17] In the representations of the spinners that were analyzed in chapter 1, the scenes of the toilet, which convey the fact that the girls are beautiful, do so by emphasizing the trappings of beauty. These are precisely the ones mentioned by Pisias, the jewelry chests, the bottles of perfumed unguents, to which are added the woven hairbands, and the ubiquitous mirror. On the vases, these scenes of female toilets correspond to many scenes of young males at their toilet: at the washbasin, in the gymnasium, they are shown anointing their body with oil from aryballoi and wiping themselves with strigils, often under the gaze of older men.[18] Because the contrast of true and counterfeit beauty serves as a metaphor for virtue and vice, as in the passage of Xenophon cited above,[19] it is of no small consequence that in Plutarch's dialogue the former should be male and the latter, female.

In this dialogue, the qualitative difference in the respective physical beauty of youths and females, corresponds, in the eyes of the champions of *paiderastia*, to a substantial difference in the quality of the eros that either can inspire. The gallant effort to show that *neoi* and females share the same

origin and symptoms of eros *are* the same does little to undermine the notion that the eros that issues from males is far superior (766 D–E). The defense of the worth of women implies that, although a case can be made for beauty and excellence residing in maidens and women, the young males are the models to which women may or may not measure up. Youth, bloom, and virtue are paradigmatically male; that they belong to females as well is an arguable point. The sort of love accorded to the right sort of women, lawful wives, is basically a chore: pleasure is admittedly short; nevertheless, the advice is given that one should follow the good old Solonian prescription to have sex with one's wife three times a month (769A–B). It seems as though those physical traits that are invoked in praise of both girls and boys and that in the modern mind are primarily linked to femininity —the smooth cheeks, the blush, the modest gaze—are here understood as properties of the young male (767B). Against this background the remark attributed to the hetaira Glycera that for men "[B]oys are only beautiful for as long as they look like women," recovers the sense of a taunt and an insult.[20]

Age is a determinant factor in any discussion of proper and improper eros. In Plutarch's dialogue, the respective ages of Bacchon and Ismenodora are particularly at issue, but an awareness of rules that depend on age is implicit in all aspects of the discussion on eros. Age is measured differently for males than for females. When it comes to comparing the genders, the alternatives are not boy or girl, but young male (*pais*, *neos*) versus female, whether girl or woman.[21] A disparity is also apparent in the definition of the age at which a male and a female may be properly seduced. Either one must be "in bloom," or in its *hora*, the right season. That a female enters her *hora* is certain: Helen was abducted by Theseus when she was not yet in her *hora* and he was an old man; Atalanta refuses to marry, although she is in her *hora*.[22] It is not clear, however, that a female is ever past her *hora* for the duration of her childbearing years.[23] By contrast, the male *hora* is painstakingly defined in aspect and duration as a brief season. It comes at the peak of adolescence, "the form and hue and aspect of young men radiant in the prime of their beauty" (765B). The absence of coarse body hair is the single most significant mark of "the lovely flower of boyhood." "My *pais*, so long as thy cheek be smooth I will never cease to pay my court" sings Theognis.[24] Its demise is marked by the growth of a man's beard, which Bion the sophist used to call "Harmodius and Aristogeton [the tyrant slayers] because, as the hair grows, it frees their lovers from a beautiful tyranny" (770B–C).[25] It was considered indecent, although apparently not against the law, to continue to play the role of the passive partner after a certain age. The contempt

affected by popular morality toward pathic behavior took the form of comic slurs and moralizing quips in which beards and body hair figure prominently, fleshing out the figure of the superannuated *eromenos* who holds on to his ephebic looks by shaving. His features become feminized, quite opposite to those that had characterized him in his *hora:* like a woman, he reeks of perfumes and wears clothes to match. Under these conditions, the union of male to male is represented as an assault on decency, meretricious, and a vice, against nature, in fact.[26] For Bacchon, too, it is time for a change. His admirers complain that he is too young to marry when he is "just out of his chlamis." But that means that he is over twenty, and another speaker suggests that he is trying to "slip out of the clutches of his *erastai* . . . to the hands of a rich and beautiful woman" (755C–D).

Love between males becomes something entirely different after the *eromenos* grows a man's beard, biological sex remaining the same: it is viewed as an unnatural act, and it has the effect of assimilating the *pais* to a woman. By contrast, a girl's gender identity and sexual role do not change as she becomes older and marries, or "becomes a woman," as we say. Three, rather than two, sexual identities exist in ancient Greek culture, marking persons of the same social position: man, young man, and female. The three genders are distinguished according to biological sex, quality of physical and spiritual beauty, age, and sexual roles. The two kinds of love objects are further set apart by the nature of the eros appropriate to each. The notion that there exist two distinct erotic domains emerges most clearly in Plato's *Symposium*. The stage is a gathering of men at the home of Agathon, the tragic poet, on the occasion of his first victory at the Lenaea; Agathon's guests are prominent citizens like Phaedrus and Pausanias, Eryximachus the physician, Aristophanes the playwright, and Socrates. They are joined at the end by Alcibiades, former beauty and political leader, arriving drunk and with a flute girl in tow. The topic of the evening's conversation is love. Socrates introduces a female persona, the Mantinean prophetess Diotima, who, he says, initiated him to the mysteries of the true eros. Commentators on the *Symposium* have been at pains to discover what is new and originally Platonic in the thoughts expressed by the various speakers. I am concerned, instead, with the common ground of figures and beliefs from which the Platonic construction of true love takes off. The following analysis of the dialogue has the purpose of uncovering such implicit knowledge and its attendant myths.

Like the other speakers, Diotima is concerned not with Eros in general but with *paiderastia*. Her account differs in that it proposes that the true aim of *paiderastia* is not to possess the object of desire but to generate

knowledge. She describes the progress of the man toward the knowledge of beauty as a step-by-step process that eventually does away with carnal knowledge:

> A lover who goes about this matter correctly must begin in his youth to devote himself to beautiful bodies. First, if the leader leads aright, he should love one body and beget beautiful ideas there; then he should realize that the beauty of any one body is brother to the beauty of any other and that if he is to pursue beauty of form he'd be very foolish not to think that the beauty of all bodies is one and the same. . . . This is what it is to go aright, or be led by another, into the mystery of Love: one goes always upward for the sake of this Beauty, starting out from beautiful things and using them like rising stairs: from one body to two and from two to all beautiful bodies, then from beautiful bodies to beautiful customs, and from customs to learning beautiful things, and from these lessons he arrives in the end at this lesson, which is learning of this very Beauty, so that in the end he comes to know just what it is to be beautiful. (Plato *Symposium* 210A5–B5; 211 B9–D1)[27]

Diotima's revelation of the right kind of eros is not a condemnation of *paiderastia* altogether. Rather, sex with one particular beautiful *pais* becomes the first rung of a ladder to wisdom that leads from giving birth to "images of virtue" to giving birth to "true virtue" (212A). At the end of the dialogue, Socrates is represented having learned Diotima's lesson well. He tells the story of how he once turned down the opportunity to make love to one particular beautiful body, that of the young Alcibiades, because he held beauty itself:

> You [Alcibiades] seem to me to want more than your proper share: you offer me the merest appearance of beauty, and, in return you want the thing itself, "gold in exchange for bronze." (218E4–219A1)

Diotima's proposal unfolds against a background of certain assumed notions to which the other speakers also make reference, although each from their own vantage point. For instance, Diotima states that Eros in and of itself is neither praiseworthy nor shameful: the child of mortal Need and divine Resource is a means, a demiurge who may turn his skill to good as well as to bad ends (203D). The same point, also made in Pausanias's piece (180E), is spun out in Aristophanes' fable of the three genders (189D8–190A4). As the fable narrates in the beginning there were

three kinds of human beings, that's my first point—not two as there are now, male and female. In addition to these, there was a third, a combination of those two; its name survives, though the kind itself has vanished. At that time, you see, the word "androgynous" really meant something: a form made up of male and female elements, though now there's nothing but the word, and that's used as an insult. My second point is that the shape of each human being was completely round, with back and sides in a circle; they had four hands each, as many legs as hands, and two faces, exactly alike, on a rounded neck. There were two sets of sexual organs, and everything else was the way you'd imagine it from what I've told you.

The redundant primitive humans were strong and unruly. When they attacked the Olympians, Zeus had them sliced in two, their skin stretched to cover the wound and sewn at the navel, and their heads turned around to contemplate the scar. The creatures were miserable in their new state and kept attempting to recover their original shape, each seeking out and embracing its lost half. At long last, Zeus relented and allowed them some means of uniting by shifting the genitals of each half to the flat side and inventing intercourse:

> Each of us, then, is a "matching half" of a human whole, because each was sliced like a flatfish, two out of one, and each of us is always seeking the half that matches him. (191D5–7)

In that it is the drive toward one's lost half, desire is the same for all three genders and, in itself, neither a good nor a bad thing. Its value is determined by its object and by the kind of progeny it engenders. There are different issues to the different kinds of desire:

> That's why a man who is split from the double sort (which used to be called "androgynous") runs after women. Many lecherous men have come from this class, and so do the lecherous women who run after men. Women who are split from a woman, however, pay no attention at all to men; they are oriented more towards women, and lesbians come from this class. People who are split from a male are male-oriented. While they are boys, because they are chips off the male block, they love men and enjoy lying with men and being embraced by men; those are the best of boys and young men, because they are the most manly in their nature. Of course, some say such boys are shame-

less, but they're lying. It's not because they have no shame that such
boys do this, you see, but because they are bold and brave and mascu-
line, and they tend to cherish what is like themselves. Look, these are
the only kind of boys who show themselves to be men, when they en-
ter public life. When they're grown men, they are lovers of young men,
and they naturally pay no attention to marriage or to making babies,
except insofar as they are required by local custom. (191D8–192B3)

Although the erotic drive is produced by the same cause in all three cases,
the three kinds of eros do not simply represent the available choices of sex-
ual roles, because they are neither alike nor equivalent.[28] The female-to-
female eros hardly matters: it is neither praised nor blamed, perhaps be-
cause it has no issue. The other two kinds of love receive consideration, and
they correspond to the two discussed by Diotima — one directed mainly to-
ward women for the gratification of carnal desire and physical procreation;
the other capable of satisfying spiritual urges and of engendering intellec-
tually. The latter is directed exclusively toward young males. Aristophanes'
account differs from Diotima's in condemning the love of men for women
and of women for men as base and disruptive. But, as in Diotima's view,
male eros is altogether a good thing and is defined differently from the
other kinds of sexual inclinations in two important respects. First, sexual
role depends not on sex alone, but on sex and age: men love young men
and young men grow into *erastai*. Second, *paiderastia* is not only a source of
personal pleasure but also the practice that alone produces men for the
state. The point recalls Diotima's statement that the most beautiful children
generated in *paiderastia* are the wisdom and justice presiding over the or-
dering of the state and households.

Aristophanes too, then, makes a distinction between the kind of eros
that drives men to women and the kind that drives them to young males.
And he too relegates the first to the realm of the senses, which is inferior to
the one that breeds civic virtue. The distinction between the two realms is
made as well in the speeches of Eryximachus and Pausanias but cast in
terms of the spheres of competence of two different divinities. Pausanias's
piece is most eloquent. Like Diotima, Phaedrus (178E–179A), Eryximachus
(188D), and Aristophanes, Pausanias makes the point that male eros re-
sults in *arete*, virtue, for the young and in benefits for the polis:

[G]iving in to your lover for virtue's sake is honorable, whatever the
outcome. And this, of course, is the Heavenly Love of the heavenly god-
dess. Love's value to the city is immeasurable, for he compels the lover
and his loved one alike to make virtue their central concern. (185B6–10)

Pausanias further justifies the superior value of *paiderastia* over all other forms of intercourse on the grounds that its nature is different—as different as the Aphrodites of mixed parentage is from the Aphrodite who is purely male:

> I don't expect you'll disagree with me about the two goddesses, will
> you? One is an older deity, the motherless daughter of Uranus, the god
> of heaven: she is known as Urania, or Heavenly Aphrodite. The other
> goddess is younger, the daughter of Zeus and Dione: her name is Pan-
> demos, or Common Aphrodite. It follows, therefore, that there is a
> Common as well as a Heavenly Love, depending on which goddess is
> Love's partner. . . . Now the Common Aphrodite's Love is himself truly
> common. As such, he strikes whenever he gets a chance. This, of course,
> is the love felt by the vulgar, who are attached to women no less than to
> boys, to the body more than to the soul, and to the least intelligent
> partners, since all they are about is completing the sexual act. Whether
> they do it honorably or not is of no concern. . . . For the Love who
> moves them belongs to a much younger goddess, who, through her
> parentage, partakes of the nature both of the female and the male. Con-
> trast this with the Love of the Heavenly Aphrodite. This goddess, whose
> descent is purely male (hence this love for boys), is considerably older
> and therefore free of the lewdness of youth. That's why those who are
> inspired by her Love are attracted to the male: they find pleasure in
> what is by nature stronger and more intelligent. (180D6–181C9)

This passage proposes a correlation between youth, mindlessness, promis-cuity, and female nature on the one hand, and greater age, intelligence, dis-crimination in sexual activities, and manliness on the other. Why is Aph-rodite Urania "older," or why does it matter that she is older? This detail is not a vagary on the part of Plato, because the same preoccupation with age is shown by the inscription on the herm-like statue of Aphrodite Urania in the Athenian sanctuary *en kepois,* in the gardens, where it was said that she is the oldest of the so-called Fates.[29] For the kind of Eros that goes with Ura-nia, age matters as well, maturity, if not hoariness, being the feature that separates it from the "other" kind. Eros's great age is mentioned by Phae-drus (178C) and denied by Agathon (195 A–C), who makes him youngest of the gods and forever young. But the distinction is made again clearly in another, much later, disquisition on the two kinds of Eros, the Heavenly and the other:

Reflect in spite of all that Love is a twofold god . . . but the one love, be-
cause, I imagine, his mentality is completely childish, and no reason
can guide his thoughts, musters with great force in the souls of the fool-
ish and concerns himself mainly with yearnings for women. . . . But the
other Love is the ancestor of the Ogygian age, a sight venerable to be-
hold and hedged around with sanctity. (Lucian *Loves* 37)

In Diotima's account, Eros's age is not defined—presumably he is neither
young nor old, just as he is neither beautiful nor ugly—but age is men-
tioned twice with regard to the pregnant *erastes*, to whom Eros attaches: he
must have come of age, that is, he must be a man. It is possible that the
characterization of Aphrodite Urania as *presbutera* indicates that she has
that distinctive prerogative of males to grow into adulthood and to acquire
wisdom at the same time as a beard.

If the first four speeches of the *Symposium* express, in different ways, the
conception of Eros that Plato could attribute to Socrates' peers and con-
temporaries, it is one that stands in direct contradiction not to Diotima's
account but to Agathon's (Plato *Symposium* 194E–199C). For Agathon ac-
knowledges but one Eros, dispensing with the primal Eros of Hesiod and
Parmenides and with his role in the tale of the castration of Uranus that
produced the heavenly goddess. For him, Eros is not only young and beau-
tiful but also always good and gentle. Agathon's Eros also contributes to the
polity, but in ways that are a perversion of the ones emphasized by the pre-
vious speakers: Eros does not inspire bravery but disarms it; what he teaches
are not virtue and wisdom, but skills—poetry, weaving, and bronze-casting
all being placed on the same plane. Most significant, neither Aphrodite
Urania nor *paiderastia* are mentioned, male love being put on a par with all
the other kinds. The dialogue turns on Agathon's piece, which serves as a
foil to Socrates' disquisition. Socrates' effusive reaction has the effect of la-
beling the speech as a piece of sophistic rhetoric—nothing but hot air. Af-
ter Agathon has been put in his place, Diotima comes on stage to hand
down revelations concerning eros that build upon, rather than contradict,
the account of the ancient cosmogony and that are in substantial agree-
ment with current morality on the essential value of *paiderastia*.

Diotima begins by stating the purpose of eros: it is not to possess the ob-
ject of desire but "to give birth in beauty" (206B9–10). Moreover, Eros is
not, as the other speakers had stated or implied, beautiful or to be identi-
fied with the object of desire. Rather, Eros belongs to the *erastes* and, in it-
self, is neither beautiful nor ugly, neither divine nor human, but something

in between (203B–204D). The point is stressed that love's procreation in beauty is not simple, but twofold:

> Now, some people are pregnant in body, and for this reason turn more
> to women and pursue love in that way, providing themselves through
> childbirth with immortality and remembrance and happiness, as they
> think, for all time to come; while others are pregnant in soul — because
> there surely *are* those who are even more pregnant in their souls than in
> their bodies, and these are pregnant with what is fitting for a soul to
> bear and bring to birth. And what is fitting? Wisdom and the rest of vir-
> tue, which all poets beget, as well as all the craftsmen who are said to
> be creative. But by far the greatest and most beautiful part of wisdom
> deals with the proper ordering of cities and households, and that is
> called moderation and justice. (208E3–209B1)

A dichotomy is thus established between carnal and spiritual urges or be-tween the Eros who presides over the reproduction of the body and governs intercourse mainly — although not exclusively — with women, and the Eros whose concern is the immortality of the soul, which is achieved, as the paragraphs following make clear, through intercourse with young males.[30] Further, the realm of nature, to which the body with its drive toward phys-ical pleasure and reproduction belongs, is distinguished from the realm of culture, the "creative" arts, and the arts pertaining to public life — "the proper ordering of cities and households" — which are the outcome of the practice of *paiderastia*.

It seems at first glance that the image of the pregnant *erastes* is Plato's alone and entirely original. Diotima had introduced this metaphor of preg-nancy and birth earlier in the dialogue:

> That's why, whenever pregnant animals or persons draw near to beauty,
> they become gentle and joyfully disposed and give birth and reproduce;
> but near ugliness they are foul-faced and draw back in pain; they turn
> away and shrink back and do not reproduce, and because they hold on
> to what they carry inside them, the labor is painful. This is the source of
> the great excitement over beauty that comes to anyone who is pregnant
> and already turgid (*spargon*): beauty releases them from their labor.
> (206D3–E2)

The metaphor cannot be understood in light of the facts of nature as we know them, because it is the male who is pregnant. In reference to the fig-

ure of a birthing female, the image of the lover in labor is grotesque, because neither in the realm of experience nor in that of representation are the females of the species relieved of their burden by the sight of beauty. It is clear, moreover, that the figure invoked here is orgasm, not birthing.[31]

The conceit that the male orgasm is, in a sense, giving birth depends upon an understanding of the generative power of the semen that is expressed elsewhere in Plato and attested in other sources. One example, found in *Timaeus*, goes a long way toward explaining the imagery of the *Symposium*:

> At last the Eros of the male and the desire of the female bring the pair together, pluck as it were the fruit from the tree and sow the plough-land of the womb with living creatures still unformed and too small to be seen, and again differentiating their parts nourish them until they grow large within and thereafter bringing them to the light of day accomplish the birth of the living creature. (Plato *Timaeus* 91C7–D5)[32]

Intercourse can be construed as giving birth if in the process the man delivers himself of the tiny beings, but alive and complete, which are his burden. As the pangs of childbirth are likened to the lover's urge, there emerges a commonplace and long-lived metaphor well known from medical writers: that of the scrotum, where seed is held, as the male womb. Far from being particular to Plato, this notion that semen generates the new life as a potentially complete being, needing only a haven in which to gestate and nourishment in order to grow, is widespread and long-lived in ancient Greek thought.[33] According to Aristotle, the sperm contains the principle that animates living creatures:

> In all cases the semen contains within itself that which causes it to be fertile—what is known as "hot" substance, which is not fire nor any similar substance, but the *pneuma* which is enclosed within the semen and the foam, and the natural substance which is in the *pneuma*; and this substance is analogous to the element which belongs to the stars. (*On the Generation of Animals* 736B33–737A1 [trans. Peck 1943])

The principle of life is lacking in females, the female being a "sterile male," in this respect comparable to boys and old men:

> The female always provides the material, the male provides that which fashions the material into shape . . . Thus the physical part of the body

comes from the female, and the Soul from the male, since the Soul is
the essence of a particular body. (738B20–28)[34]

Sharing with Plato the belief that the mother will add nothing but matter,
Aristotle describes the male semen as the seed of a plant not yet sown, and
called *kuema*, "fetation" (736B8–13).

Conception and delivery, then, are collapsed into one in the *Symposium*
on the ground of notions about natural procreation that are left unspoken
because they are generally accepted. In Diotima's speech, the metaphor
which likens a man's ejaculation to childbirth, becomes then the ground
for a richer metaphor that concerns not any kind of sex but *paiderastia:*

> When someone has been pregnant with these [moderation and justice]
> in his soul from his youth (*ek neou*), being divine (*theios*), and, having
> arrived at the proper age, desires to beget and give birth, he too will cer-
> tainly go about seeking the beauty in which he would beget; . . . When
> he makes contact with someone beautiful and keeps company with
> him, he conceives and gives birth to what he has been carrying inside
> him for ages. (209B1–C4)

The passage proposes an analogy between procreation in nature and pro-
creation in *paiderastia:* as intercourse with a female results in childbearing,
intercourse with the *eromenos*'s beautiful body produces in him a pregnancy
of some kind. In light of the notions about conception that were just ana-
lyzed, this may well be a pregnancy of semen. The point in time is specified
at which the *erastes* was himself impregnated: when he was *neos* (*ek neou*).
He is further is characterized as *theios*, divine, in a way that suggests that
"divinity" has something to do with his pregnancy and coming of age.
Whether or not this construct is exclusively Plato's, it may be summarized
as follows: the young males become heavy with manhood and somehow
divine when they are at an age to be called *neoi*, and will deliver themselves
of their burden once they are of an age to become *erastai*. Physical inter-
course in *paiderastia* becomes, in turn, the vehicle of the metaphor casting
the *eromenos*'s pregnancy as a pregnancy of mind.[35]

There are several points of correspondence in Aristotle's scientific ac-
count of human procreation with the notions in evidence in the *Symposium*.
Most remarkably, a line is drawn separating procreation in nature—the nu-
tritive (*threptike*) and perceiving (*aisthetike*) souls activated in the female
womb—from the reproduction of the reasoning (*noetike*) soul. This latter
does not partake of any physical substance and is exclusively male. In hu-

mankind, the life principle consists of these three faculties of unequal value, all of which are present in the sperm as potentialities but actualized at different stages and in different ways. The nutritive soul is activated the moment the semen is planted in the mother's womb; later, the perceiving Soul also develops in the matter provided by the female. No less than the other two faculties, the principle of reason (*nous*) resides in the semen.[36]

Reason has a different relationship to the body that grows out of the mother's womb than does the other two faculties, because it partakes of matter not at all:

> It remains, then, that Reason alone enters in, as an additional factor, from outside, and that alone is divine (*theion*), because physical activity has nothing whatever to do with the activity of Reason. (*On the Generation of Animals* 736B27–29)

Being divine and nonphysical, the *nous* comes to an individual in some other way. The hypothesis is laid out that it may "come to be formed within the male from some outside force." When does this occur and by what means? It must be admitted that Aristotle's text gives no hint of the moment and the manner.[37] But we do know that his contemporaries placed the acquisition of a thinking mind at the age of majority, when youths "have begun to form minds of their own." An epitaph by Hyperides simply equates the acquisition of majority with that of a brain:

> Then, when they were boys (*paides*), they were mindless (*aphrones*);
> now they have become men of virtue (*andres agathoi*).[38]

There is no way to be sure that Aristotle's view conformed to the one current in fifth- and fourth-century B.C. Athens and expressed by the participants in the *Symposium*, that in ripe adolescence males should acquire a lover, consent to an affair being the price for wisdom. His remarks on the *pneuma* and the nature of *nous*, however, shed light on an obscure wording in the *Symposium*, which commentators have found troublesome. In the *Generation of Animals* the noetic faculty itself is called "the only divine one"; in Plato, the *erastes* is "divine," *theios*, and more filled with divinity, *entheos*, than the *eromenos*.[39] The "divinity" of the *erastes* can be seen as that of the power of reason that he acquired in his youth as a worthy man's *eromenos* and that resides in the man's sperm in its uncontaminated state of *pneuma*. The connections, variously described in the texts just examined between age, intelligence, and sex — the age of the *erastes*, his pregnancy, and his state of

"divinity"; the greater age of Aphrodite Urania, her wisdom, and *paiderastia*; *paiderastia*, the dawning of intelligence, and the production of *politikoi andres*, men for the city—outline a conception of mankind according to which the power of reason, which "alone is divine," is transmitted from man to man as *pneuma* from the sperm of the *erastes* to that of the *eromenos*, once the latter's physical growth is complete.[40] Let us note that in this scenario, female children, who, like the males, are born without power of reason, have no means of ever acquiring it.

The image of the pregnant male scrotum called up by Diotima's metaphors of physical and spiritual pregnancies pervades the conversation in the *Symposium* under another guise: Aphrodite Urania, the motherless daughter of Uranus. Her birth was told in the ancient cosmogonies, which described the universe taking shape as a series of procreations of different kinds. The exclusively female generative power of earth creates her mate Uranus, the Sky. Together they produce a large progeny. The exclusively male generative power of Uranus is released, as it were, when his son Cronus castrates him. Although the myth was also told by Parmenides and Orpheus, the only complete surviving version of the birth of Aphrodite Urania is Hesiod's:

> And Heaven came, bringing on night and longing for love, and he lay
> about Earth spreading himself full upon her. Then the son from his am-
> bush stretched forth his left hand and in his right took the great long
> sickle with jagged teeth, and swiftly lopped off his own father's mem-
> bers and cast them away to fall behind him. . . . And so soon as he had
> cut off the members with flint and cast them from the land into the
> surging sea, they were swept away over the main a long time: and a
> white foam spread around them from the immortal flesh, and in there
> grew a maiden. (Hesiod *Theogony* 176–192 [trans. Evelyn-White 1936])

The production of Aphrodite Urania relies on the notion, noted above, that the female is a receptacle and provides nourishing substance. Her place is taken by the sea, where deliverance takes place, and nourishment is provided by the froth of the sperm itself, which encloses Aphrodite's perfect form. Diotima does not mention the Heavenly Aphrodite by name, but Uranus's ejaculation into the sea, giving birth to the very form of beauty, is the metaphoric image on which she relies to describe the achievement of the true goal of Eros:

> [So that the lover of truth] turned to the vast sea of beauty and gazing
> upon it, may generate many and beautiful and glorious ideas and

thoughts in the boundless realm of philosophy, until, having grown in
size and strength there, he may look upon that one knowledge which is
the knowledge of this Beauty. (Plato *Symposium* 210D3–8)[41]

This passage contains two intertwined metaphors. The first is the familiar
metaphor of voyaging and seeing as the progressive acquisition of knowl-
edge. The lover fixes his gaze and contemplates, and he finally sees, that is,
knows. But this is not just any kind of seeing. The mention of the sea, where
eventually the form of beauty comes into view, evokes Aphrodite Urania
emerging from the foam. As Cronus had cast Uranus's member into the
"vast sea," *pelagos polu,* the lover of truth casts his conception into the "un-
bound realm of philosophy." In both cases, there follows a period of gesta-
tion, to allow for growth and strength, before beauty can emerge. The two
metaphors, which share the same shape of a progression — one from see-
ing to knowing, the other from conception to birth — come together at the
point where the emergence of knowledge is cast as a bringing into sight.
Uranus's travail articulates a third kind of generative power, exclusively
male, which joins the previous two. To the side of the matter-bound is-
sue of earth and the mixed reproduction obtained by the "sowing" of male
seed in the female, the castration opens the male womb, or the possibility
of a purely male identity with reproductive capability.[42] As has been ob-
served for other cultures, myths of male parthenogenesis have the purpose
of grounding the social practice of gendering males differently from fe-
males in the unquestioned origin of creation. Like females, males are born
of women; unlike women, men are engendered by men who endow them
with manhood through sexual intercourse, which may take many different
forms.[43] In ancient Greece, this impregnation with spiritual powers that
grant access to wisdom and citizen rights takes place under the patronage
of Aphrodite Urania.

This analysis and conclusion go against the long-lived scholarly con-
sensus on both the *Symposium* and Aphrodite in Greek myth and cult that
the distinction and contraposition of the Urania and the Pandemos is a Pla-
tonic invention.[44] How sound is this hypothesis? One may grant that the
Platonic model informs the philosophical discourse on eros for centuries
to follow, beginning with Xenophon's *Symposium*, where Socrates revisits
the matter of the two Aphrodites:

Now, whether there is one Aphrodite or two, Heavenly and Vulgar, I
do not know; for even Zeus, though considered one and the same, yet
has many by-names. I do know, however, that in the case of Aphrodite

there are separate altars and temples for the two, and also rituals, those
of the Vulgar Aphrodite excelling in looseness, those of the Heavenly in
chastity. One might conjecture, also, that different types of love come
from the different sources, carnal love from the Vulgar Aphrodite, and
from the Heavenly spiritual love, love of friendship and of noble deeds.
(Xenophon *Symposium* 8.9–10 [trans. Todd 1922])

Xenophon's Socrates provides a key piece of information: the distinction
between two Aphrodites was actually made in Athenian cults and it was
made before the time of Socrates. (No one, I trust, is prepared to argue that
Socrates here supports his argument by bringing up nonexistent temples,
altars, and rituals.) What little we know about Aphrodite Pandemos in-
cludes the notice that her first temple was built with the profits of the state
brothels that Solon instituted.[45] This seems to correspond to Socrates' char-
acterization of her as one concerned with the pleasures of the flesh. In other
ways, both literary and antiquarian sources all resist the theory that makes
Plato the originator of the notion that there are two distinct erotic spheres,
each under the patronage of a different Aphrodite. The two different ge-
nealogies are both archaic. While Hesiod gives us the genesis of Urania,
Homer introduces Dione, the mother to whom the wounded Aphrodite,
who is the patron of Paris and Helen, runs in *Iliad* 5.370.[46] Other sources
intimate that the cultic distinction is ancient. According to Pausanias, for
instance, the cult of Aphrodite Urania in Athens was established by The-
seus's father, Aegeus; and that of Aphrodite Pandemos, by Theseus him-
self.[47] In Thebes he saw three ancient statues, dedicated by Harmonia,
which were called Urania, Pandemos, and Apostrophia.[48] Both he and He-
rodotus locate the foundation of the most ancient cult of the Urania, on Cy-
thera, in mythical times and attribute it to Phoenician colonizers.[49] More
recent, but still well before the time of Socrates, was her temple in Elis,
which housed the gold and ivory statue made by Phidias and was next to
the sanctuary of the Pandemos.[50]

If not the two cults of Aphrodite, is the primal Eros mentioned by Phae-
drus and Pausanias in the *Symposium* a Platonic construct? The Eros who
had his altar at the gates of the Academy, which housed a gymnasium, has
been understood as the "male Eros." The altar was erected by a man called
Charmus, who had been the *eromenos* of either Pisistratus or his son Hip-
pias.[51] The fire on this altar lit the torches of the ephebes competing in the
torch race in the main festival of the city, the Panathenaea,[52] a fact that
demonstrates both the prominence of the cult and its particular relevance
to the youngest class of men. In this respect, the ritual may be compared

with the sacrifice to Eros performed by the Cretans and the Spartans before battle (Athenaeus *Sophists at Dinner* 13.56E–F).[53] This was presumably the Eros whom the Boeotians, who valued *paiderastia* at least as much as the Spartans did, worshipped at Thespiae and in the sanctuary on Helicon. There took place the quinquennial festival of the Erotideia, which is the occasion of Plutarch's *Dialogue on Love*.[54]

The *persona* of the Heavenly Aphrodite has remarkable characteristics that are hers alone. Her single most striking trait is manliness. Like other goddesses who partake of manly character—such as Athena and Artemis—the Urania may be represented as a warrior and the leader of the army.[55] She may be referred to in the masculine, and called by masculine epithets —*Aineias*, for instance, or *Enkheios*.[56] But most of all her maleness has to do with sex. Hesiod called her *philommedes*, "member-proud" (*Theogony* 200), and the foam from which she was born was freely equated with sperm in explanations of her name. Aristotle gives the earliest and most authoritative statement of the name's popular etymology:

> That the natural substance of semen is foam-like was, so it seems, not
> unknown even in early days; at any rate, the goddess who is supreme
> in matters of sexual intercourse was called after this substance. (*On the
> Generation of Animals* 736A18–21 [trans. Peck 1943, modified])

In this treatise an uncanny analogy can be seen between the nature of the Urania and the agent contained in male semen that alone has the power to generate life—the *pneuma* described above. Enveloped, like the Heavenly Aphrodite, in the foamlike substance of the sperm, the *pneuma* is similarly the agent of desire.[57] If the Heavenly Aphrodite is also known as Asteria, or star-like, the *pneuma* consists of a substance like the one of which the stars are made, a fifth element that is not of this earth.[58]

From the classical period onward, in visual representations Urania appears under the guise of a lovely maiden, as she does in Hesiod's account of her birth.[59] But in Archaic art and on the margins of the Greek world, the notion of the god of manly desire and male powers of reproduction occasionally took the form of a hybrid. On Cyprus, Aphrodite was worshiped as a creature with female body and dress, but also a beard and male genitals;[60] in Pamphilia there existed a cult of a bearded Aphrodite;[61] Rome knew a bald Venus with genitals of both sexes, a beard, and a comb in her hand.[62] None of these images survives, but the same conceit is fleshed out by early representations of the god, which were made in Greece itself and which have, so far, been given little weight. The most explicit is a Corinthian

terracotta of the sixth century B.C. representing Aphrodite Urania emerging from the scrotum sac (fig. 115).[63] The figure has female form and wears a dress; its incipient beard, however, makes it clear that it is male, a man, in fact. Jenkins, who recognized in the Corinthian piece Aphrodite Urania, called attention to two Laconian terracotta plaques where the "bisexual" nature of the god is analogously expressed: a female with long hair but also the *ioulos* of a youth in *hora* and male genitals.[64] The representations of the Heavenly Aphrodite as a bisexual creature, monstrous as they might seem, are in fact more transparent in their meaning than more "natural" images might be. They translate in the language of nature something that exists only as a cultural construct: the agent through which civilization—"the ordering of cities and households"—perpetuates itself. It may be thought of as a third sex, which is male but, unlike other males, is born of men without the aid of a female womb. Because it represents the sexuality of men, the figure has male genitals; to represent the kind of masculinity that has the capacity of coming of age, it has the makings of a beard. Its femalelike power to arouse desire accounts for breasts, female genitals, and female garments.

A second distinguishing mark of Urania, which may have something to do with the hoariness of her origin, is the fact that she represents an ancestral connection of the Near Eastern religion to the Greek. The ancient writers were aware of the fact that she is not uniquely Greek but the same god who is worshiped in the East, the Assyrian Ishtar and the Phoenician Astarte.[65] Although she is admittedly an import, it would be imprudent to think that she was considered an exotic, foreign intruder in the Greek pantheon. Her cults were state cults, which were represented as having been introduced in Greece in very ancient times, beyond which little memory remained. At Thebes, Pausanias saw images of Aphrodite, including the Heavenly Aphrodite, dedicated by Harmonia; in Athens he was told that her cult had been established by Aegeus, Theseus's father.[66] Images of the "naked goddess"—some closer to the oriental Astarte-type with hands to the breasts, others simply characterized by the bold display of the nude body—have been commonly recognized as representations of the "Oriental Aphrodite" in modern sources.[67] These figures appear, at first glance, to conform to the natural order and to be free of the metaphorical play in which the hybrid images engage the viewer. But in ancient Greek culture, a display of female nakedness is no less freakish than the manly female presented by the Archaic terracottas just examined. As everyone acquainted with Greek art knows, nudity as display is a feature of the representation of men.[68] The most conspicuous of these exceptions consists precisely of the representations of the "naked goddess," the Astarte-type. To say that the

type is "derived" from the East does not, as a matter of course, explain why the image was acceptable to Greek men nor what it meant to them. The fact that in the Greek world nudity is a prerogative of men suggests that it may have been understood as a manly feature, therefore equivalent to other specifically masculine properties, such as beards and male genitals. It may be, in other words, that the "naked goddess" is naked because she is the Heavenly goddess. The key to understanding how the nudity of the Astarte-type shows the manliness of the patron of male parthenogenesis will be sought, in the next chapter, in the representations of the rites of passage that make men out of boys.

Perikalles Agalma

. .] men comrades . . . very beautiful statue
Fragmentary dedication inscribed on the base
of the statue of a kouros from the Ptoion [1]

The particular beautiful statue, the *perikalles agalma* mentioned in the dedication to Apollo in his Theban sanctuary, is lost, but many of its kind have survived. The kouroi present us with an ideal of masculinity that is, in many respects, the symmetrical opposite of the ideal femininity represented by the spinners, the subject of chapters 1 and 2.

No less than the properties of correct femininity, the signs of manliness are the stuff of metaphors. The ancient writers refer to the acquisition of manhood by a figure of transformation, the verb itself, *androo*, meaning "to change [someone] into a man" in its active voice, and "to become a man" in the middle. The change is represented as material, such that it can be seen to have taken place: one is judged to be a man, *aner*; then, and only then, can he be enlisted in the ranks of men.[2] For the citizens' females, intercourse, followed by pregnancy and childbirth, puts an end to the state of maidenhood during which a girl may be called a *parthenos* or *kore*. But this is an event that may or may not take place. For males of the same social class, however, the realization of latent *andreia* is an intrinsic and inevitable development. Marriage is individual, not tied to a specific age. Such public ceremonies as may be attached to the proceedings involve the families of the parties concerned and not the state at large.[3] By contrast, the acquisition of manhood is a state institution, celebrated by state rituals; it is collective; and it is the prerogative of a specific age class.[4] These formalities

have consequences as specific as they are important: the acquisition of cit-
izen rights, that is, the ability to control one's patrimony, to join the Men's
House and the men's table—be it the Cretan *andreion*,[5] the Spartan *sussi-
tion*, or the Athenian symposium—to become part of the standing army,
and to speak and vote in the citizens' assembly. The facts that the change of
the boy into a man takes place when, as a member of his age class, he is
admitted to the next grade in the society and that it has the purpose of con-
ferring agency upon him in private and public conduct, mark a crucial junc-
ture. It is here that, in the fabrication of gender, the seam joining the bio-
logical fact of sex to the social reality of empowerment comes exposed. The
binding tissue is a property that males who belong to the dominant group
have, but females and disfranchised males have not: legal age.

For the boys coming of age means much more than a kind of physical
maturity and the ability to marry. *Andreia* carries within also the attainment
of virtue, and even more, the acquisition of the ability to think.[6] Admission
to the order of men is justified on various grounds, some logical, some not.
On the one hand, as a set of regulations that admit some to power and
leave others out, the notion of majority operates in the constitutional realm,
one that is clearly understood as an artificial order made and modified by
agreement among members of the society. It is described in those terms, for
instance, in Aristotle's *Constitution of the Athenians* (26.4, 42.1). On the other
hand—in myths, in the symbols of literary and visual imagery, and also in
rituals performed at festivals—the norm that establishes a different path
for men is represented as embedded in the natural order of things. The ac-
quisition of adult status is a prodigy that is hard to explain but not hard to
believe, since it is made apparent.

This chapter and the next are concerned with the visual symbols of
andreia and their social context. Here I explore the peculiarly Greek "ide-
alized" or "heroic" nude through an analysis of the kouroi, the figure of
the naked male—the peculiarly Greek "idealized" or "heroic" nude. I argue
that the kouros is the vehicle of a metaphor that casts the onset of *andreia*
in terms of a sexual metamorphosis that brought into being at once the
ideal citizen and the ideal object of desire. Taking, again, the kouros as a
point of departure, in chapter 6 I attempt to define the stage he has just en-
tered: *hebe*, youth, which is an institution as much as a phase and a quality.
The body of the new citizen, exemplified by Harmodius, the tyrant slayer,
is the place where the discourse on love and sexuality and that on politics
intersect. In this inquiry on the imagery of manhood and the political func-
tion of eros I make reference to the structure of the Greek polis as *Män-
nerbund*. I use the term in its current specialized sense to mean the type of

social organization so named in Schurtz's fundamental study of 1902, that is, a polity where all the power rests with the "league of men."[7] Schurtz's classification of the Greek city-state as a *Männerbund* was readily accepted by social historians of the classical world and informed authoritative works, such as those of Weber and Marrou, for the next generation.[8] Since then the idea has hardly been mentioned in studies of Greek society, although its impact is acknowledged by the often repeated quip that "the Greek city was for most purposes a men's club."[9] While I do not disagree with this characterization, I wish to bring out all it implies, particularly the way in which the mechanisms by which the group established and maintained its supremacy are connected. Many of the features of Greek society, which are often analyzed nowadays on the basis of internal evidence or in a rather free-ranging comparatist perspective, are precisely the constitutive elements of the *Männerbund*. These include dogmatic and institutional misogyny, the organization of the men by age classes, the Men's House, the identification of the citizen body with the army, the chronic state of warfare,[10] the cult of heroic death, and normative homoerotic behavior. There is merit, I believe, in considering these features in relation to one another and with respect to their political function.

The debate over the meaning of the male nude in Greece is now nearly two centuries old.[11] The issue does not concern instances where nakedness seems reasonable, under the circumstances: scenes of bathing and dressing, for example, or the stripped corpse of the dead in battle. What calls for explanation is the display of nakedness where it is pointedly out of place and aggrandizing, where it offers the spectacle "not of a huddled and defenseless body, but of a balanced, prosperous, and confident body: the body re-formed."[12] Pictures of heroes, fighting armed but naked, convey most loudly a note of grandeur, but the notion that seems most appropriate here—courage—will not explain why nudity is also appropriate in the context of the symposium or for portraiture.[13] Nor can athletic nudity be dismissed as unproblematic. On the contrary, the Greeks themselves felt a need to account for it by means of a foundation legend. The practice originated in the fifteenth Olympiad, when, according to one story, a Megarian runner lost his loincloth and found he could then run faster, or, in another version, when a Spartan ran naked.[14] The warrior and the athlete are the two most frequent types of nude figures, justifying, respectively, the modern labels, "heroic" and "ideal," with which the phenomenon is called.

As is well known, such incongruous nakedness belongs to men. With few exceptions, several occurring in the eight century B.C., females are rep-

resented clothed, even when there is manifest a desire to show the body through transparent or clinging drapery.[15] It has also been frequently observed that the phenomenon is culture-bound: the Greeks themselves, at least from the classical period onward, were aware that it set them apart from other peoples.[16] This representation of man is not a trait of the cultures of Egypt and the Near East, from which Greece drew much of its visual vocabulary in the Early Iron Age, most perceptibly in the seventh century B.C.[17] It is just as telling that the nude remains substantially foreign to cultures that are broadly Hellenizing in their visual arts, the Etruscan and the Roman. In Etruria "ideal" male nudity is rare;[18] in Rome, it is selectively adopted for public portraits of men in power, mostly emperors, where it is to be seen as a conscious recall of Hellenistic ruler portraits.[19] Written sources make it clear that, as a custom, nudity in public places was viewed as alien and distasteful.[20]

Ideal male nudity has been understood as the symbol of aesthetic principles—a representation of beauty—or of moral qualities such as courage and virtue, or of religious values. The terms in which the problem has been cast in modern scholarship and the range of possible interpretations can be examined closely in one of its most dramatic instances, the Archaic statues of young men that go under the modern label of "kouroi."[21] They stand in a striding pose, with arms at their side and clenched fists; most have long hair, elaborately detailed and falling on the shoulders in plaits which may be gathered at the ends (fig. 116). Youth and physical beauty of a certain kind are the most obvious features of the type, often endowed with emphatically projecting buttocks and massive thighs. There are, however, other features that are visually less striking or noticeable but no less telling as to the meaning of the statues—carved details and details that were rendered in fugitive color. These features add connotations that are, at first glance, contradictory: some add connotations of femininity, others denote budding manliness.

The kouroi are nude, but they are not entirely undressed.[22] Ribbons bind their hair and some wear a kind of skullcap; others wear a belt, or boots, or sandals.[23] They may also wear jewelry—a necklace and earrings: although in recent descriptions of the Sounion kouros the large roundel at the lobe is understood as a stylized rendering of the anatomy (fig. 117), Deonna saw that it has the same shape as earrings that women are represented wearing.[24] A confirmation of this possibility may be seen in the leaping kouroi in ivory from Samos, part of the decoration of a lyre of the seventh century B.C., where at the earlobe a hole marks the attachment for an earring,

perhaps of amber.[25] Here one may also note a curious notice in Servius's commentary to *Aeneid* 1.30 that at Cape Sigaeum there existed a statue of Achilles wearing an earring, like a woman.

It would be rash to discount these elements — few and poorly preserved as they are in the nearly total loss of color from the statues — as the product of artistic license. One should ask if they did not carry certain connotations of femininity for the ancient viewer as they do for the modern scholar. Deonna noted that the hairstyles of the kouroi have an uncanny resemblance to those of their female counterparts, the korai: locks or plaits falling on the shoulders, sometimes caught by the ribbon behind the ears or coiled into one thick tress at the back.[26] At some point in antiquity, hair down to the shoulders was indeed perceived as girlish. When Theseus first reached Athens, he was jeered for looking like a girl by the roofers at work on the Delphinium as he walked by because he wore a dress that reached his feet and had long tresses.[27] Moreover, jewelry, as was said before, is a mark of feminine beauty. But the youthful face framed by curls and tresses was graced, at least sometimes, by a fledgling beard, whiskers, or sideburns that were added in paint, as was the figure's pubic hair.[28] Since the color, which was integral part of the statue, in most cases has entirely disappeared, it is impossible to say whether all or just a few of the kouroi had an incipient beard painted on their face. Analyses of the traces of ancient polychromy on kouroi, however, reveal that several did.[29] Thanks to the nature of the stone, a moustache and "imperial" are well preserved on a kouros statuette in alabaster from Naucratis. Fifty years ago, Schrader could still see traces of light-brown painted "sideburns" on the cheeks of the Blond Boy from the Acropolis.[30]

In many regards, the kouroi are like the korai in apparent age and stance, but the maidens are elaborately dressed (fig. 118). Korai served either as tomb monuments or as dedications in sanctuaries, mainly in sanctuaries of goddesses — the Acropolis of Athens, the Artemision at Ephesus, the temple of Artemis at Delos, the Heraion of Samos. But a few come from sanctuaries of Apollo, the Ptoion in Boeotia and Didyma.[31] It is unknown whether the statues had an identity and, if they did, if they portrayed the goddess, a mythological character, or a person.[32] They did not represent the dedicants, because the inscriptions show that those were men more often than women. It is also unclear *what* the korai represent, if it is a concept that they are meant to convey, and whether an explanation is to be sought in formal terms — the aesthetic pleasure they offered the divinity and the viewer — or in social values: the display of aristocratic ideals of beauty, youth, and wealth.[33] The series of korai ends with the archaic period as well, without issue — unlike the kouros-type, which is succeeded by the athletic nude.[34]

The case of the kouroi is analogous but on a grander scale. They, too, may be funerary or votive;[35] they come mainly, but not exclusively, from sanctuaries of Apollo; many, in fact, were found in the sanctuary of Hera on Samos.[36] The link of the kouroi to Apollo, however, is clear and strong. Not only do they come in great numbers from his sanctuaries—the Ptoion in Boeotia, Delos, Delphi, Didyma, and Actium—and several bear an inscribed dedication to him, but the features themselves of the statues evoke the way in which the god is represented: the beautiful youth with flowing hair.[37] For this reason, the kouroi were identified as "Apollos" when they were first discovered, and it is probable that at least some of them indeed are representations of the god. Nudity is certainly one of his characteristic traits: Apollonius Rhodius describes him naked, *gumnos*, in his epiphany, and Pausanias mentions three naked statues of Apollo.[38] The absence, in most cases, of suitable attributes that would ensure identification and, most of all, the use of the type to mark the grave of individual men, prompted the interpretation of the figure as an object without identity, embodying a particular conception of physical beauty or ethical and religious values, often no more precisely definable than as some kind of *arete*.[39] The question is still open. A case for an identification of the kouros type with Apollo was made most recently by Ridgway. The argument that the figure has no specific identity but signifies a concept (the aristocratic ideal of *kalokagathia*, physical and moral excellence) was restated by Stewart.[40] The two views each tackle a different aspect of the puzzle. The connection to Apollo is tangible and must be explained, but it does not, in itself, explain why either the kouroi or Apollo look the way they do.[41] On the other hand, that the figures signify a notion or a quality does not really explain why they are naked. Whatever and whomever the kouros represents, it represents by means of its features, of which nudity is the most consistent and conspicuous. In this light, it is impossible to separate the question of the meaning of the kouros from the more general issue of the meaning of the symbolic nude as defined above: nonfunctional, public, and male.

Several contexts in which the idealized nude appears have been defined, namely, the athletic, the heroic, and the sympotic. There is, however, another discourse to which nudity belongs, that of the initiations of the young males, an event represented in myths, in pageants, and in commemorative monuments. A connection of both the kouros and kore statues to rites of passage was first proposed by Brelich. More recently, Bonfante has placed the origin of the kouros figure precisely in the context of male initiations, where nudity would be a special "costume" having a sacred quality and endowed with religious significance. From the religious sphere, nudity would

have then "developed a special social and civic meaning . . . [marking] men's status as citizens of the polis and as Greeks."[42] There remain unanswered, in this insightful proposal, two important questions: what is the meaning of ritual nudity, and is it legitimate to draw a distinction between its "religious" function and its "social" function? What is the role of nudity in initiatory rites? That is the issue that will be examined here, by analyzing the procedures by means of which the passage from adolescence to manhood was negotiated. There exist some remarkable features common to a number of Greek states, which emerge piecemeal, through layers of reforms and rationalizations imposed on customs in the course of time, to outline a certain conception of what coming of age means and how it happens. For a long time, indeed from antiquity, there has been agreement that the Cretan cities and Sparta have much in common as regards practices of male initiations and that, owing to the conservative nature of their institutions, they might have kept more ancient or "primitive" forms of the rites for longer. The Cretan rites will be taken up first.

The Cretan cities, like Sparta, offer an instance of tight bonds established among the males of the ruling class, *hetairoi*, who correspond to the Spartan *homoioi*. The two also share the custom of common meals for men, called *andreia* in Crete, *sissuthia* in Sparta. In Crete also, the men continue to live with their comrades in the men's house, *andreion*, for a time after they marry. At seventeen or eighteen they were recruited into *agelai* or herds.[43] Their training included the following event:[44] a man, that is, an adult male citizen, and the companions of a chosen *pais* staged a mock rape, the outcome of which was that the man carried the youth to a place outside the inhabited area and kept him there for some time, but no longer than two months. He must then release him, piling gifts on him: an ox to be sacrificed to Zeus Hetaireios, a suit of armor, a special dress, and a cup. The abductor and lover, the *erastes*, is called *philetor*; his beloved, the *eromenos*, *kleinos* or illustrious. The *kleinos* continued to wear the dress he had received from his *philetor* into his adult years, as a mark of honor.

We also know of rituals held on the occasion of a festival, which varied among the Cretan cities, marking the coming of age of the young males. For only one have we the foundation legend of the festival, preserved by Nicander of Colophon, and are able to establish a connection, albeit hypothetical, between myth and ritual practice. The legend goes as follows: a Cretan man called Lampros, husband of Galatea, threatened to kill their child at birth if it turned out to be female. For that reason, when she delivered a girl, Galatea kept her sex a secret and gave her a boy's name, *Leukippos*. When the girl grew and became very beautiful, Galatea feared that the deception would

be discovered. She sought refuge in the sanctuary of Leto Phythia and prayed that the goddess would turn her daughter into a boy. Leto granted her wish, and Leucippus became a young man. At the end, Nicander connects the myth to the appellative of the goddess and the name of the festival with unhappy brevity:

> The Phaestians commemorate this transformation and sacrifice to Leto
> *Phuthia*, because she made male genitals grow (*ephusen*) on the girl, and
> they call the festival *Ekdusia* because the girl took off (*exedu*) her peplos.
> It is customary at weddings to lay down first at the statue of Leucippus.
> (Antoninus Liberalis *Metamorphoses* 17.6)[45]

But the story does not account for the undressing, because Leucippus, a girl disguised as a boy, should not wear a girl's clothes. Rather, the name should be taken as descriptive of the form in which the transformation of Leucippus was re-enacted at the festival: men stepped out of women's clothes.[46]

More evidence of disrobing in connection with coming of age may be found at the level of myth on the one hand, and practice, on the other. The image of the beautiful girl who stands revealed as a boy when he takes off her clothes appears for a moment in the tale of Achilles at Scyros, between the picture of the boy in skirts and that of the hero in armor.[47] Undressing and dressing have long been connected to terms such as *ekduesthai, egduesthai,* and *esduesthai,* which appear in Cretan inscriptions from different cities recording the oath taken by the youths in the *agela* as they joined the citizen body. Of particular importance here is one from Dreros, in which the men describe themselves as *panazostoi,* naked—literally, "ungirdled"— one and all, and further on as "those who have just taken off their clothes," *tous toka egduomenous,* and "those who have come out naked," *tois epiginomenois azostois.* It is clear that stripping was a feature of the proceedings worth insisting upon.[48]

In the reconstruction of the Cretan initiations as they have been pieced together from disparate sources, there are evident features that are common to rites performed in the initiation of males in other states. The youth's full admittance into the society of men involves sexual commerce with one of the members. The liminal moment is marked by transsexualism at the level of myth—here, Leucippus's change from male to female; at the level of ritual there is transvestism, followed by the display of the body.[49]

Sparta offers the clearest evidence for the existence of a rigid system of age classes. The Spartan males were organized in *agelai* at the age of seven and went through several distinct grades extending well beyond adoles-

cence. In Spartan practices, nudity is prominent and it belongs in the context of the preparation of the young men, but its precise relationship to specific rites of passage is hard to pin down. To begin with, Athenaeus reports a testimony of Agatharchides, according to which the young men were examined nude by the ephors every ten days to see that there was nothing "unmanly," *anandroteion* about their figure, and that they did not become fat.[50] Ritual nudity is a feature of the Gymnopaidia, which included choral performances by age classes, one of which was that of the ephebes. It is not known to which god the festival belonged; perhaps it took place in the agora, where, according to Pausanias, stood statues of Apollo Pythaeus, Leto, and Artemis. We are told that the ephebes danced in honor of Apollo.[51] The name itself, *gumnopaidike*, means "naked dance."[52] There is no reason to doubt that the word here has its primary sense. Confirmation of this sense comes from a comparison of the definition of the Gymnopaidia given by Hesychius, on the one hand, and a remarkable piece of Lycurgan legislation concerning obstinate bachelors, on the other. Hesychius writes:

> *Gumnopaidia:* some say, a Spartan festival in which the ephebes ran in a circle around the altar of the Amyklaeum, hitting each other on the buttocks. But this is false. They perform in the agora.

The circular configuration of the dance and the location, the agora, connect this notice to the punishment of men who did not marry when they should. Sanctions included two that involved nudity. The confirmed bachelors were banned from the spectators of the Gymnopaidia, and they were themselves made to parade in a circle in the agora, in winter, without clothes, *gumnoi.* They were also required to sing a song about how they deserved their penalty for disobeying the laws.[53] The point of this procedure is understandable only in light of Hesychius's description: it is to subject the men to a perversion of the ritual through which they had attained manhood and which, like the Danaids in Hades, they are condemned to repeat, to no avail.

We are not told of transvestism in Spartan initiations, but this feature makes an appearance in a tale that Pausanias introduces in the narrative of the Messenian wars.[54] The fact that the events described take place in the sanctuary of Artemis Limnatis and on the occasion of a festival suggests that here, too, we may be dealing with a foundation legend, but the connection of myth to ritual is lost. According to the Spartans, Pausanias reports, a quarrel broke out when Messenian men violated Spartan girls, who

had come to the sanctuary of Artemis Limnatis to celebrate the festival, and killed the Spartan king, Teleclus, who had come to their defense. But the Messenians told a different story: Teleclus had planned an attack. He had selected "among the Spartiates some who had not yet grown a full beard, whom he disguised as maidens in dresses and jewels, and introduced them among the Messenians, who were resting, armed with daggers." The central deed of the Messenian version evokes an image, which is by now familiar, that of the young man stepping out of woman's clothes.

In Athens, the features that were pointed out in the Cretan customs — transsexualism, transvestism, and exhibition — are present in legends and practices concerning precisely adolescents around eighteen years of age. What survives is not a coherent structure connecting these elements, but fragments of such a scheme, surviving in myths and poorly documented and poorly understood practices. As in other states, the transition from childhood to manhood encompassed several stages, two of which are attested in ancient sources. At sixteen, the boys were introduced into their father's brotherhood, or phratry, on the third day of the festival of the Apaturia.[55] The presentation to the phratry at one end and the inscription into a deme at the other bracket a two-year period, that is, an age class. At eighteen, the young male entered a second two-year stage, his *hebe* or "youth," which began with his inscription into a township, or deme, and constituted the first leg — appropriately called *ephebia* — of a military service that would last forty-two years. In the wording of laws attributed to Solon and cited in fourth-century courtroom speeches, the technical term for membership in this class was ἐπὶ διετὲς ἡβᾶν — "to be in youth for two years."[56] We learn from sources concerning the *ephebia* of the fourth century B.C. that this stage was marked by certain restrictions and particular rituals. The *ephebos* served on the frontiers of Attica, his social activities in the city were limited, and he received his shield and spear after one year. Vidal-Naquet has shown that these regulations have the effect of placing the fledgling man in a position of marginality with respect to the rest of the adult citizenry and indicate that this was a distinct age grade through which each class passed.[57] There is little doubt, however, that citizen status was substantially achieved upon entering the *ephebia*, not at its completion. At the age of eighteen, the youths were enrolled into a deme; they were emancipated from tutelage and could represent themselves in court; they swore the oath of loyalty to the state in the shrine of Aglauros and they became soldiers.[58] As Pélékidis notes, the language in which it is described makes it clear that this transition takes the young males across the line that separates adolescence from manhood. To be enlisted in a deme is to be "inscribed among the men," *eis*

andras, and "to be judged to be a man," *andra einai dokimasthenai — aner* meaning, as was pointed out above, not male, but man, citizen.[59]

The formalities for admission to the deme involved nudity. The *dokimasia*, the examination, had the purpose of ascertaining that the youths were of the right age and in possession of the right credentials for citizenship, namely, an Athenian father. Those whose qualifications were questioned were referred to a court of law and examined again, naked. This last detail would be lost, except for the appearance in Aristophanes *Wasps* of what must have been a stale joke: Philokleon, on jury duty, looks forward to get a good look at the boys' genitals (578). Young men of ephebic age were at the center of the festival of the Oschophoria, which, like the Apaturia, took place in the month of Pyanepsion.[60] A scholium to Nicander's *Alexipharmaca*, 109, informs us that the festival took its name from the fact that boys carried sacred branches with grapes (*oschoi*); they "competed by tribe; they ran with vine branches from the temple of Dionysus to the temple of Athena Skiras." Another late source, Proclus's *Chrestomathia*, adds that *neaniai*, youths, give a choral performance, while ephebes competed in a running race by tribe (27).

The return of Theseus from the Cretan adventure together with the seven boys and seven girls saved from the Minotaur was the foundation legend for the festival. The return was reenacted by a procession from a sanctuary of Dionysus to that of Athena Skiras at Phaleron. This was led by two *neaniskoi*, youths, in woman's dress who carried vines with grapes, the *oschoi*.[61] The reason given for this is that Theseus had substituted two boys in disguise for two of the girls he led to Crete. There have been attempts to explain what was perceived as an aberration — youths dressed as girls — by the hypothesis that they wore Ionic costume, of which the chiton at some point was mistakenly understood to be female dress. But the account of this custom by Plutarch, who depends on an earlier source, the Atthidographer Demon, makes it clear that clothes are only part of the disguise. Theseus chose two young men who were delicate and feminine in appearance, although manly at heart. By means of hot baths, by keeping them in the shade, with ointments for the body and for the hair he transforms their appearance, and he teaches them to talk and walk like girls. Nudity may also be part of the Oschophoria. When and how, one may ask, is the female dress shed? It may be pertinent, here, that oschophoric dances were classified together with the Gymnopaidia.[62]

As in the tale of Leucippus of Phaestus — the girl in boy's clothes who sheds her peplos when she is turned into a man — there is a certain awk-

wardness in the way the myth is used here to justify the custom of dressing the leaders of the cortege as women. The incongruity is all the more apparent because the myth in question belongs not to the context of the return but to that of the departure for Crete.[63] It is precisely in legends concerning the Cretan ordeal that one finds traces of the two other elements characteristic of the initiation theme, namely, *paiderastia* and sexual inversion. One of the events of the departure of Theseus with the seven boys and seven girls was an ominous change of sex, in the sacrifice to Aphrodite Epitragia, reported in Plutarch:

> They say that the oracle at Delphi had ordered that he [Theseus] should take Aphrodite as his leader, invite her to accompany him on his journey, and that as he sacrificed to her by the seashore the usual offering of a she-goat, the goat became a billy-goat, spontaneously. For this reason the goddess is called *Epitragia*.[64]

Certain consistencies among the features that have been isolated here out of disparate and fragmentary accounts of myths and practices outline the way in which the passage into manhood is conceived. The change of the *pais* into an *aner* involves a transformation of gender, expressed in ritual by transvestism and display of the body; in myth, by stories of sexual inversion. Each of these elements has been recognized and well analyzed. Many studies of Greek initiations point to a vast body of comparative ethnographic material concerning ritual pederasty and transvestism, by which the young males are represented as the opposite of what they must become.[65] What should be stressed in this context is that the ritual representations play upon notions that are deeply rooted and are tied to a conception of gender that extends well beyond the ritual situation. To label the transvestism at the Oschophoria "ritual inversion"[66] is to restrict its implications to the occasion, that is, to deny or minimize that the casting of the boy as different in gender from men is a mental template at work in the day-to-day functioning of the society.

The performances have the purpose of justifying the granting of citizen rights only to a certain group of males. The ritual conveys its message through the analogy of transsexualism. The point is not that the boys are women, or that they are associated with the womanly realm of the *oikos*,[67] but that *like* women they are matter-bound, mindless, and subject to men. The transformation they undergo, being social rather than biological, does not change their sex, but *like* their sex it affects their gender; its magnitude

and consequences are *as great as* those that would be brought about by a switch in sex—from female to male. In this fashion, the metaphor of trans-sexual change that transvestism and nakedness articulate provides a concrete analog through which one may gauge the significance of the transition and appreciate its quality. At the same time, the juridical process is proposed as a law of nature, which, as other natural phenomena, simply *is* and evades logical or scientific scrutiny. The metamorphosis cannot be explained, but it is witnessed—as in the paradigmatic exempla of the lives of the heroes. It is illustrated dramatically in the pageantry of the festivals, where *andreia* is set before the eyes in the form of the emergence of a man from a female cocoon. As for the concept of *aidos*, the icon that makes *andreia* visible, the nude body, gives the abstract construct it embodies life-like form, inserts into the realm of the material world, places its truth beyond question.[68] As it fleshed out, so to speak, the quality of *andreia* and offered it for scrutiny to the community of men, nudity was one icon, which every member of the culture knew and understood well.

I believe the kouros represents the moment of coming of age. He is the young citizen at the moment of truth, displaying the beauty that rightfully belongs to free adult males. The kore-like details of his appearance that were mentioned above—coiffures, jewelry, and perhaps, sandals—refer to the feminine skin that he has just shed. The paradigm of the kouros is the Delian Apollo, whose image is frozen at the threshold to manhood: forever *horaios*, never growing a man's beard, always the archer and never the hoplite.[69] Like their appearance, the kouroi's allegiance to Apollo belongs in the context of the youths' initiations. Apollo is not simply the prototype of the kouros, he is also the divinity in whose realm the rites of passage are situated: together with the nymphs, he is the divinity who makes men out of boys.[70] It is worth noting also that the Athenian youths celebrating the Oschophoria are placed in the domain of Dionysus by the vine branches they carry: they are ready to take their place among men at the symposium. But they had set out on their initiatory ordeal by offering the *eiresione*, the olive branch wrapped in white wool, to Apollo Delphinios.[71]

To understand the meaning of the "heroic" or "ideal" male nude, beyond the kouros-figure, it is helpful to examine what *andreia* means. A sort of comprehensive definition of the term, occurring in the context of a discourse on gender, may be drawn from Aristophanes's speech in Plato's *Symposium*, where the boy of manly quality is said to demonstrate his manliness in his conduct of public affairs "as a citizen," *eis ta politika*. Although it includes virtue and courage, *andreia* cannot be reduced to either. It stands for the sum of qualities that warrant empowerment, in civic life as well as

in war; it operates in the agora and in the stadium no less than in combat.[72] Once acquired, this quality is never lost. For this reason, nudity belongs not only to the young but to men at any age, and it may be employed as the symbol of manliness whenever and wherever manliness must be stated or stressed. It is there ready to display itself in times when manly deeds must be done, and it may take the form of its first emergence, as when, at the wedding of Pelops and Hippodamia, the centaurs attack and "the hero caught by surprise" raises to the challenge, letting his mantle fall (fig. 119).

Two more observations should be made here in support of the conclusions presented above. The first concerns an inscription in meter on stone from the Ptoan sanctuary of Apollo, dedicating a splendid image, *perikalles agalma*, on behalf of "men companions," *andres hetairoi*.[73] I understand *hetairoi* to mean the members of a certain age class, one that has successfully made the transition to the grade of *aner* and offers a kouros to Apollo in thankful commemoration of the event.[74] The second point concerns the name by which the kouros type might have been called: *andrias*. Although from the fifth century B.C. onward, this word is used to mean "statue"— seated as well as standing, female as well as male—there are indications that it carried special connotations involving manliness and Apollo.[75] Like the kouroi, *andriantes* could be figures of men, but they have a special link to Apollo. The colossal Apollo dedicated by the Naxians on Delos is called *andrias* in the inscription on its base (the earliest occurrence of the word), and there are several mentions of such statues in sanctuaries of the god by ancient writers, along with mentions of *andriantes* representing Apollo.[76] That the term indicated particular features is suggested by its appearance in an inscription of the early fifth century B.C. from the sanctuary of Apollo at Didyma, in which a certain Ermeas dedicates "this Apollo *andrias*," *tonde ton and[rianta Apo]llona*, on behalf of his son.[77] The most revealing mention of the word is occurs in Demosthenes's oration *On the Crown* (129.5). The orator attacks Aeschynes's morals by describing his mother as a prostitute who raised him as an assistant in her trade: "a fine figure of a man," *ton kalon andrianta*. Manhood in the context of growing up is what this sardonic expression implies. It may or may not call up the image of a statue. In connection with this passage, an ancient gloss notes that the expression was a term of endearment used by mothers for their sons, and goes on to elaborate on the meaning of the word:

> The statue (*to agalma*) is also called *andrias* and this may be of bronze
> and wood and gold and whatever material is capable of being shaped
> and retaining the form (*eidos*). Each of these is also conventionally

called after its material—bronze *andrias*, wood *andrias*, and so on. *Andrias*, however, is also used improperly (*katakhrestikos*) to refer to the other figures (*zoa*).[78]

Distinctions are made here between the use of the term to refer to sons and to refer to a statue, and further, between proper usage, to refer to a particular kind of statue, and improper usage, to mean other figures or images of other beings. This passage suggests that the word *andrias* may have been applied initially to the kouros type and later, by extension of its positive connotations, to certain kinds of public honorary statues. Its stem is obviously the same as *andria*, *andreia*; its meaning should be "figure of manhood."

CHAPTER 6

The Body Politic

Thus speaks the fair-faced whelp of Atalanta,
his mother, huntress in the wilderness;
he is a man with the beauty of a boy,
the down just visible on his cheeks, the soft beginnings
of what will be a shaggy mane as his youth flourishes.
There he stands, with brilliant eye but savage mind un-
 suited to his name, Parthenopaios, "maiden-faced." [1]
 Aeschylus, *Seven against Thebes*
 532–536 (trans. Hecht and Bacon)

The kouros represents at once the essence of manhood and an erotic ideal. Oversize thighs, prominent buttocks, genitals, and cheeks graced by the first down of hair are the ingredients of the ancient Greek ideal of male beauty. Indeed, the erotic connotations of the kouros have not escaped the notice of modern interpreters.[2] The figure proposes boldly that connection of coming of age to *paiderastia* that is a consistent element of the rites of passage. In the Cretan ritual described by Ephorus, the abduction of the young man by the *erastes*, the lover, takes place just before the youth is released into society. At that time he receives the tokens that will admit him into the army, the assembly, and the symposium—that is, the suit of armor, the mantle, the ox, and the cup.[3] In Sparta, at some point, each young Spartiate became the *eromenos* of an adult male. The sources tell us that the relationship did not take the form of sexual acts, that physical contact between the two was forbidden. Nevertheless, the shape of the institution corresponds to the Cretan pairing of *philetor* and *kleinos*.[4] As regards

Athens, there remains no more than a hint of *paiderastia* in the sources: in one version of the myth, Theseus is cast as the *eromenos*, the beloved, of Minos. The account in Athenaeus is elliptical and unclear.[5] It is precisely the superfluity and incongruity of the tale of Minos's love that makes one suspect that it is not a late elaboration of the Cretan adventure but a necessary component in the narrative of Theseus's coming of age. Moreover, the legend conforms to a pattern common to myths concerning the youth of heroes, a phase characterized by *paiderastia*.[6] As in the myth of Pelops and Poseidon, the hero is the object of love before being released and given help in securing the right bride.[7]

The nexus between homoerotic practices and the rites of passage of young males has been the topic of discussion since Bethe's landmark study of "Dorian pederasty."[8] Although Bethe's idea that *paiderastia* was introduced by Dorian invaders and later spread to the other Greek states has been largely left behind, the two other main hypotheses put forward in his essay continue to have currency. The first is the conclusion that *paiderastia* was located in the rites of initiation of the young males into the *Männerbund*. The second is the idea that homosexuality, as a pedagogical practice in Archaic and Classical Greece, has its origin in the belief that semen has the magical property of imbuing the boy with the spiritual quality of the man. No small part of Bethe's argument relied on analogies with the "primitive" cultures of Africa and the southwest Pacific. The same comparatist approach informs much of the present debate now that a much greater body of ethnographic data is available. Herdt's study of the people he calls the "Sambia" has been most influential in proposing a model of institutionalized homosexuality by offering a clear instance of the belief that regular ingestion of semen over a period of years is needed to promote the growth of manliness in the child.[9] Patzer restated that *paiderastia* has the purpose of informing the boy with manliness through a process of assimilation and bonding.[10] Sergent, in his study of the homosexual loves of gods and heroes, stressed that these myths offer a paradigm of the initiatic transformation of the boy from "other than man" to "man." Remarkably, a dissenting opinion has been voiced by the author of the most authoritative study of Greek homosexuality after Bethe's, K. J. Dover.[11] Dover questions the way in which ethnographic parallels are brought to bear on the issue (if not the validity itself of the comparatist method) and the truth of the initiation hypothesis as a whole. He argues that whatever form it may have taken in the prehistory of Greece and in the Early Iron Age, "*overt* homosexuality" is best attested and vigorously espoused in the polis from the end of the seventh century onward.[12] Accordingly, any explanation of its purpose and func-

tioning should proceed from the assumption that the practice was a vital part of the life of the historical polis rather than the vestigial trace of half-forgotten customs. Therefore, any explanation of this phenomenon should be historically and contextually grounded. Dover also stresses the erotic valence of the relationship between *erastes* and *eromenos*, which he takes to be not the byproduct of its pedagogical aim, but the raison d'être of that relationship.

All discussions of *paiderastia* as a fundamental feature in Greek society share the assumption that the time at which a young male entered into a sexual relationship with a man fell within his adolescence, before he crossed the threshold into adulthood.[13] For this reason, Patzer questioned the use of the term "homosexuality" to describe such an affair and proposed that *Knabenliebe* or "pederasty" is its proper name.[14] This position was taken to its extreme consequences in Halperin's reconstruction of sexual roles in Athenian society. Halperin's argument that "homosexuality" in the modern sense was unknown in classical Athens depends upon the premise that the difference between the majority of the *erastes* and the minority of the *eromenos* amounts to a difference in gender. Age and class determine the sexual role one must play. Since role determines gender, there can be only two: that of the "sexual agent," the "insertive partner," the man; and that of the "receptive partner . . . whose submission to phallic penetration expresses sexual 'passivity.'"[15] The effect of classifying sexual partners into two categories only—"active" and "passive"—is to equate the several diverse targets of a man's attention: females, boys who will become fellow citizens, foreigners, slaves. Here we face a reductio ad absurdum.[16] If we know anything about notions of sexual relations in ancient Greek society, it is that the youth with a citizen's pedigree is a radically different object of love and desire from all others. This should become clear in the pages to follow.

The foregoing interpretation of the kouros type is not easily accommodated in this understanding, since it proposes that the figure embodies both the property of *andreia*, quintessential manhood, which only belongs to men, and all the erotic quality of the *eromenos*, who is subject to the men's desire. The same ambivalence pervades the figure of the most famous *eromenos* of all, Harmodius. In 514 B.C., a conspiracy to kill the tyrant Hippias, led by Harmodius and his lover Aristogiton, resulted in the murder of Hipparchus, the tyrant's brother. The conspiracy had been provoked in the first place by Hipparchus's attempt to seduce Harmodius. Since the assassination of the tyrant's brother did not bring down the tyranny (Hippias was forced into exile in 510 by the invading Spartan army),[17] to the modern historian the incident seems, on the whole, a private and inconsequential

matter. But the lovers lived on in Athenian lore for centuries as the Tyran-
nicides. In philosophical dialogues and courtroom speeches, their love was
brought up with a sense of religious awe, and with the assurance that it
would strike the right chord in the audience's heart. They were the para-
digm of the chaste and manly eros that is good for the state.[18] Following the
expulsion of Hippias, life-size bronze statues of them were set up in the
public square, which were looted by the Persians in 480. One of the first ac-
tions of the returning democracy was to replace the group with one by Crit-
ius and Nesiotes, which was thereafter quoted on the shield of Athena on
Panathenaic prize amphoras and joined other state symbols on Athenian
coins.[19] While fifth-century historians offered a sobering account of how
small a role the lovers had played in the overthrow of tyranny, it is clear that
they had a long-lived and major role in the Athenian discourse on love be-
tween men and the state.

The group by Critius and Nesiotes, which survives in Roman copies,
shows them lunging at the tyrant (fig. 134). Harmodius, ready to strike in
the pose of a Heracles or a Theseus, may be called a kouros in action. The
absence of a man's beard qualifies him as the junior partner of the couple,
but "minor" and "passive" are not words one would use to describe him.
Aeschylus's description of Parthenopaeus in the fragment of *Seven against
Thebes*, the epigraph of this chapter, is an apt characterization of the figure:
"fair-faced" with a "savage mind." As a matter of fact, Harmodius was not a
minor at the time of the deed, nor was he when Hipparchus first tried to se-
duce him, since Thucydides describes him as "radiant in the bloom of early
manhood" (*History of the Peleponnesian War* 6.54.2). In that he is the quin-
tessential embodiment of both the *eromenos* and the hero, Harmodius is
not the exception but the rule. Paradigms of manly *eromenoi* are given by
the heroes, Achilles, for example, who offered such an apt model for the rit-
uals of transvestism and disrobing of the young males. The fact that he was
of an age to join the Achaeans at the siege of Troy did not prevent Phaedrus,
in Plato's *Symposium* (180A4–7), from arguing that Achilles was Patroclus's
eromenos. Xenophon reverses their respective roles and adds other couples
composed of age mates to the list:

> Moreover, Niceratus, by Homer Achilles is represented taking splendid
> vengeance not for the Patroclus who was his love-boy, but for the Patro-
> clus who was his comrade. And Orestes and Pilades and Theseus and
> Pirithous and the many other demi-gods who excel are celebrated not
> because they slept together, but because by their enchantment toward

one another they accomplished together the greatest and most beautiful
deeds. (*Symposium* 8.31)

Xenophon neither denies that the heroes had sex with one another nor
minimizes the importance of their attachment. Rather, he offers their ex-
amples as paragons of the heroic conduct that *paiderastia* engenders.[20] Can
you have one without the other?

The Elean and Boeotian armies both included a unit where each *erastes*
was paired with his *eromenos*, who must then be man enough to fight. The
history of Sparta also knows of instances where an *eromenos* found himself
on the battlefield with his *erastes*.[21] While there are abundant indications
that the couple consisted of a man and a young man, the hypothesis that,
as a rule, the affair began when the latter was an adolescent between sixteen
and eighteen years of age lacks unequivocal documentation.[22] The abduc-
tion of the Cretan youth took place after he had entered the *agela* at seven-
teen or eighteen.[23] In Sparta, there is no question that the role of the *ero-
menos* was appropriate for a young warrior under the age of thirty.[24] Had
he acquired an *erastes* in his adolescence, as it is currently believed? From
several, disparate sources—mainly Xenophon, Plutarch, and Aelian—we
know that the experience was part of a Spartiate's education, the *agoge*, which
was seven classes long and extended past the age of majority.[25] In his account
of the Lycurgan legislation, Plutarch tells us that as their age advanced the
boys' physical training intensified, their hair was closely cropped, they went
barefoot and exercised nude, in an escalation of the hardships that had
marked their education since their twelfth birthday. As soon as they reached
"such an age," reputable youths became attached to *erastai*. What age? Ob-
viously Plutarch has a specific class in mind, and he writes for a reader in
the know. By itself, the passage allows no conclusions except that this hap-
pened somewhere between a boy's thirteenth and twentieth year.[26]

The shorn hair remained the mark of the young males through a stage,
which Xenophon consistently calls *hebe*: men who were past their *hebe* (ὑπὲϱ
τὴν ἡβητικὴν ἡλικίαν) wore their hair long.[27] Here as elsewhere there is a
technical ring to the words *hebetike helikia* (age of youth), *hebe* (youth), and
hebon (young man), which translate the idiosyncratic Spartan nomencla-
ture into terms familiar to an Athenian audience.[28] By drawing compari-
sons between Sparta and other Greek states, presumably including his own,
as regards the management of youths, Xenophon suggests that the *hebe* stage
corresponds to the Athenian biennial *ephebia* and that, like the *ephebia*, it
represented the first stage of adulthood.[29] But it is difficult to determine in

each case when Xenophon uses the term *paides* whether he uses it in a specific sense to refer to an age grade or in a more general, inclusive sense. The phrase ἐκ παίδων εἰς ἥβην (*Memorabilia* 2.1.21) designates the transition to adult status, the point at which, in Athens, the young become autonomous. In Sparta, the grade of the *hebontes* was preceded, in Xenophon's terminology, by that of the *paidiskoi*,[30] which set the *meirakioi* apart from the *paides*. Xenophon draws another parallel between Athens and Sparta, when he speaks of the transition from the category of the "boys" to that of the "young men":[31] at the age at which an Athenian would be cut loose from his *paidagogos* and schoolteachers and acquire a certain autonomy, the young Spartiate faced even stricter discipline. It is hard to say if the Spartan *paidiskoi* are a subset of the broad category of *paides*, which comprised several age grades, or one between the *paides* and adulthood.[32] But our sources leave us in no doubt that *philerastia* was associated with the youth's "bloom," his *hora*. For instance, Agesilaus had just "blossomed" and was in *hora* when Lysander fell in love with him;[33] Agesilaus's son was in love with Cleonymus, who was in the age class "just past the boys" (ἄρτι ἐκ παίδων) and the most beautiful and reputable among his classmates" (Xenophon *Hellenica* 5.4.25); Aelian, in his apology of Spartan *paiderastia*, employs the words *meirakion*, youth, *horaios*, in bloom, and *kalos*, beautiful, to mean *eromenos*.[34]

ANDROPAIS

Part of the difficulty in reckoning with the way *paiderastia* worked in Greek society is the result of thinking that the moment at which the young males came of age was a watershed, beyond which they were fully integrated into the ranks of the men. In one step, albeit one to which they had been led by elaborate preparation, the boys would go from being nonmen to being men. But there is much that suggests a more complex state of affairs, namely, the possibility of an intermediate stage. Vidal-Naquet revealed in the Athenian *ephebia* such a transitional state in the making of the citizen-warrior, a time when he is, in significant respects, cast as the antithesis of the hoplite he will be and is relegated to the margins of the polis.[35] What should not be overlooked, however, is that the ephebe is neither physically adolescent nor legally a minor. He is *aner*, however, in a qualified sense, and the slippage calls for a specialized vocabulary: *hebon, neanias, neaniskos, neos, meirakion, horaios*. But nobody calls him *pais*, except to say that he is someone's actual or potential *eromenos*.

That the *eromenos* may have achieved the state of *andreia* does not exclude the possibility that *paiderastia* has a place in the ritual process that

makes men out of boys. It does suggest, however, that the process conforms more closely to the classical model of the *rites de passage* in its series of transitions.[36] I have argued that in the passage from boyhood to manhood the moment of nudity represents the liminal stage. Both the metaphoric mode in which the passage is conveyed and the dramatic enactment of the metaphor are well-recognized features of this moment and may be compared to the staging of the passage as a birth in other cultures.[37] According to Van Gennep's definition of the structure of rites of passage, this moment is preceded by a phase of separation from the old condition and followed by one of incorporation in the new. Either stage may be reduced in the extreme or receive elaborate attention, but both are essential to the process.[38] That there should be a postliminal phase, a set time and prescribed conduct aimed at the acculturation of the novice, should come as no surprise. In other words, the youth at the kouros stage is not yet home free. Beyond the threshold on which he is poised lies a trial period, to see, among other things, that he acquire the right kind of sexual orientation. The ambiguity and glamour of this stage are conveyed by the concept of *hebe*. Loraux has caught its fundamental character of *seuil entre l'enfance et la virilité*, an in-between place where manly virtue is clad in the splendor of youth.[39] Such ambivalence marks the youth's sexual roles as well as social roles. *Hebe* is an experimental phase during which the newly minted *aner* has his first taste of autonomy and becomes sexually active. It is marked by physical prowess and extraordinary beauty, expressed by the kouroi's powerfully muscular body and idealized features. Most of all, *hebe* is fleeting, encompassing the brief span of time between the first appearance of down on the boy's face and the growth of a proper beard.

In Athenian legal terminology dating back to the time of Solon, his new condition is called *epi dietes heban*, "to be in *hebe* over a period of two years," and its inception *epi dietes hebesai*, to enter *hebe* for a period of two years.[40] The expression is used to say that the young male has reached the age of majority. It is equivalent to other phrases that refer to his entrance in the register of men, such as δοκιμάζεσθαι εἰς ἄνδρας, "to be admitted after scrutiny into the ranks of the men," and ἐγγράφεσθαι εἰς τοὺς δημότας, "to be enlisted among the townsmen."[41] In epic language, the expression "measure of youth," *metron hebes*, has social implications and visual connotations that correspond to the new status of the youth and to its visual features. The expression is often translated as "full measure of youth" or "terminus" of youth and understood to designate the achievement of manly strength. That is true, but the *metron hebes* is a phase rather than a point in time. It is a measure of time, as West says, "the ration allotted to us; some are reaching

it, some have it, others are past it."[42] Upon reaching his "glorious measure of *hebe*," the Homeric hero may marry, as Iphidamas did, and he is ready to join the men in war.[43] In any case, he can leave the house where he has been raised, indeed, in Eumaeus's case (Homer *Odyssey* 15.366–370), he must do so. In Archaic lyric and later poetry and prose, the same notions of bloom and agency are conveyed by the term *hora*, "season," generally, the moment of perfection at which a flower, a fruit, or a maiden are ready for plucking. In reference to young men, the word is used in a specialized sense, which captures the imagery of "blooming" that is associated with *hebe*, both in the sense of a particular season in life and in the sense of the first blush of hair on a man's face.

The male *hora* differs from the *hora* of other living things. Like the Homeric *metron hebes*, the moment is marked by a measure of agency. In his harangue against Timarchus, for instance, Aeschines declines to deal with indiscretions the accused had committed earlier when he was a *pais*, therefore mindless and having no choice in the matter. The charge is that Timarchus prostituted himself when he was "in bloom," ὡραῖος ὤν, that is, when he had reached the age of reason (φρονῶν καὶ μειράκιον ὤν) and was a strapping young man (εὔσαρκον ὄντα καὶ νέον).[44] The clearest indication that Timarchus was then beyond the *dokimasia* and had entered the stage of the *ephebia* is that he could dispose of the patrimony of his late father, which he squandered. Just as tellingly, in Plato's *Symposium* (217A5–6), Alcibiades describes how he pursued Socrates with all the arrogance of the prospective *eromenos* who knows he is irresistible because he is *horaios* (ἐπὶ τῇ ὥρᾳ θαυμάσιον ὅσον). The fact that at that time he could invite Socrates to dinner shows that the *hora* entails a kind of social agency that is unthinkable for a *pais*, a mere boy. Xenophon (*Anabasis* 2.6.28) reports, as an exceptional case, that Menon obtained the command of a contingent of mercenaries when he was *meirakion* and still *horaios*; he also associates the beauty of the *hora* with wisdom (*Memorabilia* 1.6.13). In short, a youth in his *hora* has come of age: he is an apprentice-man, but a man nevertheless.

The dawning of intelligence that is inherent to the *hora* also signals the moment when the youth may become sexually active and become attached to an *erastes*. That a young man who is *horaios* has substantial citizen rights, however, is never the point of the story. The discursive context to which the male *hora* belongs is that of courtship and sex, and its connotations are overwhelmingly erotic. The word occurs often in texts concerning male love, such as Theognis's erotic poems, Aeschines's prosecution of Timarchus, and several dialogues of Plato. Sex appeal is endemic to the *hora*: so long as they are in their *hora*, Socrates chides Glaucon, even homely boys

will be found beautiful in some way (*Republic* 474D–E). The onset of the beard in the form of downy sideburns or fuzz on the upper lip or chin is the overriding sign of *hebe*. Otus and Ephialtes, for instance, might have overthrown the Olympians had they reached their *hebes metron*, but Apollo killed them "before down (*ioulous*) blossomed beneath their temples and covered the cheeks with a full growth of beard" (Homer *Odyssey* 11.319–320). This first growth of beard has connotations of beauty, as in the Homeric phrase describing Hermes in the likeness of a "young man growing his first moustache (*hupenetes*), in whom the charm of youth is fairest."[45] In *Protagoras*, Socrates plays upon the erotic overtones that the first whiskers have when he defends his passion for Alcibiades, whose hairiness may be past the optimal stage for an *eromenos*. Ignoring the insinuation that it is fast growing out of control, he likens Alcibiades's moustache to the *hupene* of a youth at the moment when his grace is sweetest (309A–B).

The powerful erotic appeal produced by the combination of youth and the awakening of intelligence is signaled by the first down on the cheeks. In words and pictures, the Greek discourse on love and polity is dominated by images of facial hair that are consistent and painstakingly specific. Pausanias in Plato's *Symposium* (181C–182D) states that men who are moved by the manly love of the Heavenly Aphrodite "do not fall in love with little boys. They prefer older ones whose cheeks are showing the first traces of a beard—a sign that they have begun to form minds of their own" (181D1–3). In Xenophon's *Symposium* (4.23), the passion of Critobulus for Clinias is traced back to their schooldays together, and a description of the state of their respective fledgling beards is then offered as though it were an adequate explanation of the way such things go. Critobulus had just developed the first down (*ioulos*) under the ears, while Clinias's was already spreading upward from his chin. A little further down (4.28), after being chided for making advances toward Critobulus, Socrates asks him to stay away until Critobulus has developed a beard (*geneion*) as thick as the hair on his head, implying that the young man will be then incapable to arouse his desire. At the moment Critobulus is *ageneios*, which means not beardless but, as Pollux records,

> smooth-chinned, a youth with the down descending from under the ears or spreading upward around the mouth, one that is just getting a beard, in the early stage of the *hora*, at his peak, in bloom. (Pollux *Onomasticon* 2.10)[46]

The richly specialized Greek vocabulary for the onset of the beard, which has no equivalent in other languages, corresponds to particular renderings

in the visual arts. On the kouroi the softness of the youthful down is con-
veyed by the use of paint, rather than carving, to render the *hupene*, which
is still visible on the Naucratis statuettes, and the *ioulos* on the face of the
Acropolis Blond Boy.[47] In Early Archaic art, the very special juncture of
manhood and youth is inconsistently marked. East Greek representations
of the man in *hebe* often show him *hupenetes*, with a thin moustache and
no beard. This is the case with a good number of the aryballoi in the shape
of a warrior's head, which were produced in East Greece in the first half of the
sixth century B.C.[48] The ambiguous character of the young hero is evident in
a plastic vase that is akin to the aryballoi but is shaped as a bust (fig. 120).
The face is smooth except for a small moustache; the figure is helmeted but
lacks body armor. He wears instead a transparent tunic through which one
sees his nipples, with the areolae rendered as a circle of dots, as on the great
Samos kouros. To the modern eye, the long hair that falls in a mass on the
back and a tress on either shoulder produce the impression of femininity.[49]
The suggestion of a sexual hybrid is even clearer in the series of aryballoi in
the shape of male busts (fig. 121) also dressed in a diaphanous tunic, who
sport both a moustache and earrings — like some kouroi.[50]

Early Archaic sculpture offers an extraordinary representation of a young
man in his *hora*, with the *ioulos* spreading upwards from the jaw line onto
the cheeks and chin: the Rampin Rider (fig. 122).[51] Early Attic black figure
vase paintings often only acknowledge the distinction between boy and
man and, accordingly, represents gods and heroes who are in *hebe*, such as
Apollo and Triptolemos, with a proper beard.[52] But in the 530s B.C. full-
grown males are regularly shown "beardless" — for instance, Achilles on an
amphora by the Amasis Painter (fig. 123) and the *eromenoi* in the earliest
courtship scenes.[53] In red-figure vase paintings, the *hebe* is defined as an in-
termediate stage between manhood and adolescence by drawing the *ioulos*
not with black glaze, as full beards are, but in soft shades of dilute glaze on
the upper cheek. Like the painted facial hair on the kouroi, the whiskers in
dilute glaze have faded in most cases and are often not visible in photo-
graphs. The adoption of this convention produced a phenomenon that has
been widely recognized as the "youthening" of figures of myth and epic.
Euphronios, for instance, paints the dead Sarpedon once with a full beard
and once as *ageneios*.[54] The *ioulos* belongs to the young hero. On the name
piece of the Penthesilea Painter (fig. 124), Achilles is not "bearded" but has
a row of short black curls along the jaw line. Down on the upper cheek is
the mark of the star athlete (fig. 125), the symposiast (fig. 126), the target
of men's attention (fig. 127).

The age to be *eromenos* is short.[55] Plato's *Protagoras* opens with a hint to

Socrates that he should stop chasing after Alcibiades now that the young man's *hora* is at the end: "When I saw him yesterday he seemed a beautiful man still, but a man Socrates, between you and me, with a full beard." It is not true, then, that such relationships come to end with the first appearance of the *eromenos*'s beard. Rather, the first *ioulos* at one end and the adult's full beard, *geneion*, at the other bracket the span of time during which the male is at the peak of his sexual attractiveness and becomes available to a worthy lover, who will lead him into a man's full estate. This peculiar fixation on pubescent hair is tied not to the first appearance of the hairs on the face of each boy—an event that presumably was subject to a broad range of variations then as it is now—but to a social event, the point at which the boy reached of the age of majority. Although in the context of *paiderastia* relationship he may be called *pais*, or *paidika*, in all other respects he is *neos, meirakion,* and even *aner*. The word that best describes him is the untranslatable *andropais*, both "man and child," which Aeschylus applies to Parthenopaeus.[56]

The opening of Plato's *Charmides* (153D–154C) is enlightening on matters of beauty, age, and the male object of desire. Socrates and Critias approach the entrance to a wrestling school; Socrates, who has been away for a while, asks about the "young" (περί τε τῶν νέων; 153D4), if there are any that distinguish themselves for intelligence or beauty, or both. He will soon have his answer, Critias replies. Fighting their way into the palaestra are young men (νεανίσκους), the first wave followed by another, who are the would-be lovers of the one who is thought to be the most beautiful one (154A1–6). Socrates cannot guess his name: "Who is he? whose son?" The following exchange between the two is worth careful attention. Critias answers: "You do know him, but he had not yet come of age (οὔπω ἐν ἡλικίᾳ) when you left. He is Charmides, the son of Glaucon . . . " "Indeed I know him—replies Socrates—he was not bad even then, when he was a *pais*, and now I expect he is quite a *meirakion*" (154A7–B5). Socrates confesses that he finds beauty in all those "of age" (ἐν τῇ ἡλικίᾳ), but is as spellbound as the others when Charmides appears, followed by another pack of admirers. Boys and men, all stare at the young man "as though he were a statue." "Do you think he has a beautiful face?" asks Chairephon. "If he goes on to strip, you will think he has no face, such is the perfection of his figure" (154D4–5) This passage does more than draw attention to the difference between a *pais* on the one hand and a *meirakion* or *neaniskos* on the other. It establishes the social fact of coming of age, or being ἐν ἡλικίᾳ, as the moment of transubstantial change by which the young male acquires superhuman beauty and stature and becomes the ultimate object of desire. Beauty, maturity, and love are similarly linked in a text that belongs to a very different genre,

Thucydides' description (*History of the Peloponnesian War* 6.54.2) of the Ty-
rannicides' affair. Hipparchus had tried to seduce Harmodius away from
his *erastes* Aristogiton "when Harmodius had grown radiant in the bloom
of early manhood," γενομένου δὲ Ἁρμοδίου ὥρᾳ ἡλικίας λαμπροῦ.

Within the brief span of the *hora*, the youth goes from being the object
of desire to turning to his own desire onto others. In between, he can be
both: the *eromenos* of an older youth or a man and the *erastes* of a younger
youth. In Xenophon's *Symposium* (8.2–3), Socrates observes that Charmi-
des, who is pursued by many lovers, is himself in love and Critobulus, while
still an *eromenos*, has his heart set on others, namely, as we saw, Clinias.
Plato describes the suitors of Charmides as themselves *neaniskoi* (*Charmides*
154A); in the *Euthydemus*, Clinias is called *meirakion* (271B) and one of his
erastai, Ctesippus, is called *neaniskos* (273A7), as is Hippothales, the pro-
spective *erastes* of the *pais* Lysis (*Lysis* 203A). Athenian Late Archaic vase
painting offers several images of amorous encounters involving youths at
different stages of hairiness (fig. 128).[57] The pairs of youthful lovers at ban-
quet that decorate the Tomb of the Diver at Paestum (fig. 129) show that
the subject was appropriate for other media and contexts. Achilles and Pa-
troclus were represented as close to one another in age. Aeschylus, appar-
ently, made Achilles the *erastes*, while Phaedrus argues in Plato's *Symposium*
(180A4–7), that he should be the *eromenos* because he was "more beauti-
ful not only than Patroclus but than all the heroes, and was *ageneios* still,
therefore much younger than Patroclus, as Homer says." The painter of the
Sosias cup (fig. 130) agreed with him, it seems, and gave Achilles smooth
cheeks with an incipient *ioulos*, while he painted Patroclus *hupenetes* with a
rather fuller *ioulos*, which verges on the *geneion*.[58]

Dikaios Eros

We are now able to move forward from the foregoing analyses of the per-
sona of the kouros and of the erotic sphere encompassed by the words *hebe*
and *hora*. There is little doubt that *paiderastia* was a socially constructed
form of sexuality and not the social management of a naturally occurring
attraction of men to boys. It is an institution attributed to the great law-
makers, a prescribed and overregulated practice.[59] The first step in our anal-
ysis must be to map out the features of normative homosexuality, that is,
socially approved and state-sanctioned, and to distinguish it, more firmly
than has been done so far, from other forms of eroticism involving persons
of the same sex. It is clear that in actuality men fell in love with, seduced,
and made sexual use of boys of various ages and classes. But the sources

align such conduct with other kinds of behavior operating within a margin of tolerance beyond which they became actionable: men who played the *paidika* well past their *hora*, lechers who womanized their *paidika*, and adulterers, who were mad about women.[60] For men who seduced underage boys, the suspicion of *hubris* was never far away. Such practices existed alongside and on the edges of an area that ancient writers clearly mark off as holy. What are the rules of that *paiderastia* that is called "rightful love," *dikaios eros?*[61]

Our best sources are Athenian and Classical in date. From them we learn that the conventions differed over a wide spectrum, from the frank approval of sex between the partners in Elis and Boeotia to the prohibition of physical contact in Ionia. In Athens and Sparta, the norm, *nomos*, governing *paiderastia* is equally "complicated," we are told, although not the same.[62] The establishment of *paiderastia* as the kind of love that only happens between men is not where the customs of different states disagree. They diverge in the manners in which they deal with the resulting need to guard the boundary between the erotic desire directed at the young men and that which one may turn onto females and onto other kinds of male bodies. This was attempted by the regulation of sex between citizens in two areas, namely: age, the age at which a youth may become sexually active and the age after which a man should relinquish the role of *erastes;* and sexuality, by the allowance or prohibition of certain forms of intercourse.

Aeschines' prosecution of Timarchus again sheds light on the boundaries between proper and indecent conduct in these matters. Timarchus's misconduct had to do, among other things, with the fact that Misgolas, with whom he chose to live, was neither a friend of his father nor someone close to his own age but a stranger, older, and a lecher. On the one hand, the *erastes* may be a contemporary of the youth or older, but not much older; in any case, he should be a respected man of whom his parents approve, at least as interested in his *eromenos*'s intellectual development as in his body. On the other hand, the *eromenos* should be past boyhood. One may be reminded here of Pausanias's statement in Plato's *Symposium* that men who operate in the realm of Aphrodite Urania "do not fall in love with little boys." For those who do, and act upon their impulse, there are laws, as we learn from Aeschines's speech:

> But since the boy is not responsible and not yet able to distinguish between the man of genuine good will and the contrary, he [the legislator] chastens the man who is in love and postpones talk of *philia* to the age at which the boy has a more mature intelligence; that an *erastes*

should follow a boy and keep an eye on him he regarded as the greatest
guard and protection of chastity. (Aeschines *Against Timarchus* 139)

Dover asks: "How old is that, and who decides in each case when the boy
is old enough?"[63] One may attempt to answer the question. The boy is old
enough when he passes the *dokimasia* and is capable of informed consent.
In Athens at the time of the prosecution of Timarchus, that is, when he is
eighteen. Aeschines's tirade brings the all-important issue of consent into
the foreground. Since a minor is incapable of consent by definition, the
possibility should be seriously considered that seducing a boy constituted
statutory rape and was prosecutable under the law of *hubris*.[64] An *eromenos*
of Timarchus's age could accept or reject a potential *erastes* and do so with
full awareness of the social and legal consequences of his action. The sec-
ond set of norms concerns sexual roles. A youth in his *hora* could take on
the role of *erastes* toward one his own age or younger but not one older than
himself. Xenophon reports among the instances of reprehensible behavior
by Aristippus taking on a barbarian lover while he was in his *hora*, and that
he had an *eromenos* who had already developed a beard, while he himself
was still beardless (*Anabasis* 2.6.28).

There is a gap, as many have pointed out, between the ideal of rightful
paiderastia and its practice. The most determined proponent of its beneficial
effects for all concerned and the polis in Plato's *Symposium*, Pausanias, re-
veals some anxiety about the fact that it bordered upon, and was prone to
turn into, pedophilia. The briefness of the *hora* called for intense attention
to its onset, and we are left in no doubt that men fell in love with boys and
declared their passion openly and without incurring blame. Boys, particu-
larly young athletes, loom large in Athenian male fantasies, and they are
nowhere more in evidence than on the Late Archaic and Classical Athenian
vases.[65] In the first wave of representations of courtship, in the late sixth
century B.C., the *eromenos* is normally a young man: he has no beard and his
hair may fall on his shoulders in a long plait, but he is as tall as his *erastai*,
large, and muscular (fig. 131). From the turn of the century onward, how-
ever, alongside representations of a man and a youth there appear images
where the *eromenos* is a boy—significantly smaller that the *erastes* and some-
times modestly swathed in his mantle, like a girl.[66] As with the image of the
sexy spinners analyzed in the first two chapters, and that of the female sym-
posiast, which is taken up in the following chapter, it is imprudent, to say
the least, to take the scenes of courtship on the vases at face value. What im-
ages of men accosting boys (fig. 132) and sometimes kissing them demon-
strate is an obsession with, and a degree of tolerance for, the fantasy of sex

with a minor. There are, however, limits to what Athenian society would allow to be shown when it comes to the body of the future citizen, because the threshold to actual penetration is never crossed in the pictures — although it surely was in real life.[67] To say that these pictures attest to norms of conduct and moral standards is about as sound as to say that the filming and distribution of *Lolita* means that, by the 1960s, the laws of statutory rape had gone by the boards in the United States. The passage just cited from Aeschines's prosecution of Timarchus makes it clear that following the boy was an accepted, even praiseworthy custom, but sexual advances of any kind were prosecutable.

Suitors who went about this the right way secured access to the boy through the father. Xenophon's *Symposium* takes place against the background of the genteel courtship of Autolycus by Callias, who is his *erastes* in the sense that he is in love with him (1.2). Nothing, however, indicates that they are lovers. Autolycus is not emancipated, one gathers from the facts that he sits by his father, unlike the men who recline at the banquet, and that he is bashful. But he gives sure signs of *hora*. In the words of Socrates, who praises Callias for displaying the kind of love inspired by Aphrodite Urania, Autolycus has "strength, courage, manliness (*andreia*), and wisdom" (Xenophon *Symposium* 8.8). But the comic poets would cast on this charming scene a sinister light, as Eupolys did in the *Autolycus*, which scourged both the boy and his parents for immoral sexual behavior.[68] In a similar vein, one might contrast Plato's sympathetic portrayal of the lovesick Hippothales at the wrestling school (*Lysis* 207B) as he watches from afar the boy Lysis, with Aristophanes' characterization of such men, who "hang around in the palaestra trying to seduce boys."[69] Such behavior skirted the edge of socially acceptable conduct. A boy who allowed his *erastai* to approach too closely opened himself to suspicion of prostitution, a charge that might lead to his debarment from political life once he grew up. And a father who did not shield his son from the lust of an unscrupulous suitor risked the charge of pimping. Not unreasonably, fathers forbade their sons from talking to their *erastai* and hired *paidagogoi* to protect them on the way to the school and the palaestra, as we learn from Pausanias's complaints in Plato's *Symposium* (183C4–D3).

The dinner party Xenophon describes is in honor of Autolycus's victory at the Panathenaea in the *pankration*. This detail has considerable implications for the way in which the beautiful boy, who leans against his father in embarrassment at being praised, may be visualized. The *pankration* was a brutal event combining boxing and wrestling, which was limited to the men's category in the Olympian games until 200 B.C., although in Athens

it was opened to youths and, eventually, to boys and youths. It required a powerfully muscular physique, aptitude to violence, and it left scars.[70] Like all events that required long training and specialized instruction, the *pankration* was practiced by the sons of wealthy fathers. A late epigram conveys the appeal of this combination of violence and glamour:

> When Menecharmus, son of Anticles, won the boxing prize, I crowned
> him with ten soft fillets and thrice I kissed him, all dabbled with blood
> as he was. But the blood was sweeter to me than myrrh.[71]

Autolycus is on his way to acquiring the prizefighter's swollen ears that marked the Athenian "Laconizers," men who admired Sparta and affected Spartan ways.[72] There is the head of a late kouros or, more probably, a nude athlete with a boxer's swollen ears that sums up the prized qualities of the youth in his *hora*, namely, the toughness that Socrates so admired and muscular good looks (fig. 133).[73]

Athenian writers of the late fifth and fourth centuries are the mainstay of our knowledge of the way in which the Greeks conceived of sex acts between *erastes* and *eromenos*. Some general conclusions are possible even from this skewed and limited view on the matter. Both Xenophon and Plato characterize the rules of *paiderastia* in Athens and Sparta as complex and different from those of states where sexual use of the *eromenos* was considered normal, on the one hand, and from those of states where physical contact was prohibited, on the other. Complications arose, one imagines, because the same ethos that prescribed the erotic pursuit of young men by older men and left the initiative with the latter also demanded that the former should in no way be cast as the passive partner to avoid being seen as a woman. Accordingly, a sharp distinction is drawn between the sexual desire that drives men to intercourse with females for the purposes of procreation and pleasure and the one that drives them to young men, which must transcend the flesh and become love of the mind and soul. Limitations were placed accordingly on the use that could be made of the *eromenos*'s body and on the role that *aphrodisia*, carnal pleasures, should play in the relationship.

How states that are described as less sophisticated in these matters dealt with the problem is unknown. The Spartan ideal legislated by Lycurgus forbade intercourse and held it as abhorrent as incest.[74] Negotiating the conflict between that model and the lack of restraint that made "Laconize" synonymous with anal copulation in Athens calls for a great deal of finesse, but some justification was surely found. As to Athens, many and disparate

sources attest to the judgment that anal copulation with a man is an act contrary to nature. Aeschines offers his view:

> Such, then, was the judgment of your fathers concerning things shame-
> ful and things honorable. And shall their sons let Timarchus go free, a
> man chargeable with the most shameful practices, a creature with the
> body of a man defiled with the sins of a woman? (*Against Timarchus*
> 185 [trans. Adams 1919])

Aeschines neither states nor implies that homosexuality in the sense of sexual desire for young males is unnatural; it would be strange indeed if he had. He says that *copulation* with a man is against nature.[75] It is wrong for a man to submit to penetration because in so doing he does what is natural for a female but profoundly abnormal for a man. The Athenian speaker in Plato's *Laws* makes the same point:

> If we were to follow in nature's steps and enact that law which held
> good before the days of Laius, declaring that it is right to refrain from
> indulging in the same kind of intercourse with men and boys as with
> women, and adducing as evidence thereof the nature of wild beasts,
> and pointing out how male does not touch male for this purpose, since
> it is unnatural,—in all this we would probably be using an argument
> neither convincing nor in any way consonant with your states. (Plato
> *Laws* 836C [trans. Bury 1926])

Like Aeschines, Plato makes reference to ancestral custom and defines it as the way things were before Laius. The allusion is to the rape of Chrysippus, the source of the claim that Laius invented *paiderastia*.[76] Although each of the three great Athenian tragedians of the fifth century developed it into a play, the myth is known only in skeletal form. The deed took place in the Peloponnese, where Laius had found refuge with Pelops, after his expulsion from Thebes. One day, when he was teaching Pelops's young son the art of chariot racing, Laius was overcome with desire, seized Chrysippus, and took him away to Thebes.

At first glance, the seduction of Chrysippus fits the genre of homosexual loves of the heroes in their youth; it is included among them by Sergent, who takes it to be perfectly analogous to Poseidon's abduction of Pelops.[77] But the story is a sinister version of that theme. Unlike Pelops, the young man is not released by his lover and does not go on to marry. Chrysippus

kills himself from shame because Laius has violated him. And why should Laius be cursed and his race perish if all he did was to invent a kind of love for which gods and men alike showed considerable enthusiasm, both before and after the fact? What Laius inaugurates is not *paiderastia* but an eros that is called contrary to norm, *paranomos*, and unlawful, *athemitos:* anal intercourse. As a perversion of conjugal sex, his impious act incurs the wrath of Hera, who inflicts on the Thebans the scourge of the Sphinx when they fail to punish him.[78] Because he has sown his seed where he should not, where it would not grow, Laius himself is afflicted by a curse that denies him the benefits of lawful copulation: children who will continue his line. He is condemned to either abstain from sex altogether or father a progeny polluted by patricide and incest, which will self-destruct in the third generation.[79] Like his father, albeit unwittingly, Oedipus perverts intercourse by "sowing his seed in a forbidden field, his mother's, where he had been nurtured" (Aeschylus *Seven against Thebes* 753–54). The obvious analogy with Laius's transgression proposes the same correlation of male copulation to incest that is suggested by Plato (*Laws* 838B) and by Lycurgus, according to Xenophon.

The ancient taboo, which Plato wishes to reinstate, is an important element in the definition of *paiderastia* as an autonomous erotic sphere that diverges from the love of women in both purpose and method. Xenophon's Socrates explains in a helpfully prosaic mode how the difference between the eros inspired by the Vulgar Aphrodite and that inspired by the Celestial Aphrodite is registered even by the gods. It amounts to the difference between body and soul:

> Zeus, in fact, those mortals he loved on account of their beautiful appearance let remain mortal women (*autas*), after laying with them. But the ones he admired because of their worthy soul, those men (*toutous*) he made immortal. (Xenophon *Symposium* 8.29)

Like Aeschines, Aristotle qualifies penetration of the *eromenos* as abuse, *hubris:*

> Moreover, [sc. the disposition?] of sexual intercourse for males; for they come about [i.e., the pleasure in such actions comes about] for some by nature and for others through habituation, as, for example, for those who were first outraged (*hubrizomenois*) when they were boys. No one could describe as "lacking in self-control" those for whom nature is the cause, any more than (*sc.* we so describe) women (*lit.*) because they do

not mount sexually but are mounted. (Aristotle *Nicomachean Ethics*
1148B28–33 [trans. Dover 1989])

To mount a *paidika* the way one mounts a woman is wrong, and it may turn
him into a pathic for life. Significantly, in this passage the natural female
impulse to sexual passivity is equated with a lack of self-control and enjoy-
ment of the intercourse. The proper *eromenos*, on the contrary, displays the
self-possession, *enkrateia*, that keeps one from succumbing to pleasure. Xen-
ophon so describes his stance vis-à-vis an *erastes* who longs for his body
rather than his mind:

> Indeed, the *pais* does not share the man's pleasure in intercourse the
> way a woman does but, sober, beholds the spectacle of the other drunk
> with sexual desire. (Xenophon *Symposium* 8.21)

Paradoxically, the one who is acted upon is the *erastes*, who entreats like a
beggar (8.23–24) and is the slave of uncontrollable desire, his dignity in
shreds (Plato *Symposium* 183A–B). An honorable youth denies his lover
copulation and allows no more than the insertion of the penis between his
thighs, an operation that obliges the latter to squat and cling in order to
maintain his balance.[80]

The austere model, which I have assembled on the basis of literary, doc-
umentary, and visual sources, precludes an understanding of *paiderastia* as
"a sexual ethos of phallic penetration and domination."[81] The asymmetry
between the partners remains, and their roles are clearly differentiated in a
way that gives the older man greater agency. One pursues, the other is pur-
sued; sexual gratification belongs to one but not to the other. At the same
time, the youth's role is painstakingly distinguished from that of females
and noncitizen males by establishing norms concerning the sexual use that
may be made of his body and, most of all, by allowing him the right to
choose. In sexual matters, as in all other facets of his social life, the male
in *hebe* is on the margin, but well within the order of the men. If this con-
clusion is reasonably sound, that part of the Bethe hypothesis that located
the homosexual experience in the preliminal phase of initiations does not
hold. The analogy with initiatic customs in non-European cultures, where
the insemination of boys has the function of nourishing their manhood
also loses its edge, although it is not entirely invalidated. Unlike the inter-
course that "Sambian" children have with their elders, *paiderastia* is an af-
fair between two who are nearly the same.

That is not to say that a comparatist perspective has no place in an attempt

to understand what purpose this manly eros served in the polis. For we are dealing with a social construct, not with some natural urge that compels men toward young men or personal choices in sexual orientation. *Paiderastia* is mandated, protected, overregulated, the brainchild of the great lawgivers: Lycurgus of Sparta, Solon of Athens, the lawgivers of Thebes, and Minos and Rhadamanthys in Crete.[82] The analogy with institutionalized pederasty in other societies does not support an explanation of the Greek practices as either "ritual" (except in the broadest sense of the word) or magical. But it does bring to the fore the fact that erotic forces are deployed in the construction of social identity. A form of homosexuality parallel to the Greek is in fact present in societies that share the same structure. Homoerotic desire is endemic to the *Männerbund,* both in the form of pederasty proper and in the form of a contained and sublimated erotic feeling between men.[83] That this phenomenon is an integral element in what is called male bonding and that it stands in direct relationship to extreme and doctrinaire misogyny has been observed often, although no systematic cross-cultural study is at hand.[84] The exceptions in this regard are analyses of the youth organizations forming in Germany at the turn of the last century and of the ideology of the *Freikorps* in the years between the two wars.[85] Blüher's passionate advocacy of love between boys and men and between young men, in particular, made it impossible to ignore the strong homosexual component in the emergent *Männerbund.* His bold, often reckless combination of Schurtz's analysis of men's societies with Platonic notions of eros and *logos* and with Freudian psychology yields some brilliant insights into the kind of love that bonds men together. In an uncanny anticipation of the Foucaultian view of Greek homosexuality, Blüher disputed the dichotomy opposing "homosexual" and "heterosexual" identities — where men are concerned. Like the Greek *erastes* (and unlike females), he argued, the real man, the *Männerheld,* is equipped with both drives, one allowing him to eventually marry and have a family, the other sustaining his spiritual life.[86] But, like other writers on the subject, Blüher draws a line between this form of erotism and homosexuality.[87] The ideology of the *Männerbund* identifies in the "queer" its perversion and archenemy, so much more threatening in that it lives in its midst.

A structural understanding of this social phenomenon helps rather than excludes historical analysis. If it is true that ancient Greek homosexuality was not the relic of primitive initiation rituals but was a living organism in the historical polis, it is also true that it is a fact of culture, not nature, that "males tended to group themselves together."[88] The *Männerbund* is not the outcome of Darwinian evolution, as some claim,[89] but a configuration that

may or may not be chosen in a particular process of state formation taking place under specific circumstances. As regards ancient Greece, that configuration has been recognized in the polis, which comes into existence in the Early Iron Age and presents well-developed features in the Archaic and Classical periods. With regard to sexual matters, as in other respects, the polis defines itself by contrast to the Mycenaean society that had preceded it. A world in which women inspired ruinous passions is replaced by one in which the women are hobbled and despised and the erotic connection among the men becomes essential. Under the circumstances, let us ask: what cultural work does *paiderastia* do, in the polis?

EROTIC REGIMES

The distinction made in cult practices, as well as in political and philosophical discourse, between the realm of Aphrodite Urania and that of Aphrodite Pandemos is of crucial importance.[90] Eros among men is an autonomous sexual domain that is defined by what it is not, namely, sexuality in the domain of nature. *Phusis* is the imaginary realm in which living beings are prey to an amoral logic that drives them relentlessly to pursue sensual pleasure. Nature, of course, is not a free-for-all: there is a hierarchical structure to the deployment of passions in the sexual sphere. While the compulsion to mate affects both sexes, it takes a different form in males than in females: females find pleasure in being mounted, while males are compelled to mount. Moreover, the same desire that drives males toward females also drives them towards other younger males in indiscriminate pursuit of penetration. In either case the relationship of the partners is hierarchical, casting one in the dominant role of penetrator and the other in the passive role, according to the configuration described in detail by Halperin and others, but in reference to *paiderastia*. In both cases pleasure derives from the possession of the object of desire and the momentary appropriation of his body. Both experiences have issue, which is where they diverge.

Copulation with females produces harmless gratification at worst and at best children, as nature intended. But on the subject of intercourse with males, the Athenian discourse on the nature of sex becomes garbled and contaminated with concerns that are anything but natural. The complexity arises from the fact that male and female instincts have been defined as different at the core, *kata phusin,* and determinant of normative behavior in the social sphere. In this scenario, what becomes of the male victim of male aggression reveals a slippage between the alleged natural character of

sexual inclinations and their nature of social constructs. For, even if it an-
swers the call of nature, intercourse with males, who are or would be citi-
zens, has social consequences. If he shares in the aggressor's pleasure, the
male displays a woman's inclination towards subjection, whether innate or
acquired, and stands revealed as *kinaidos*. If the boy does not enjoy being
mounted but submits willingly for pay, he is a *pornos*; his conduct causes
him to lose his civil rights as a man. And if he does not submit willingly but
is taken by force, the rape brings shame to the victim and the law of *hubris*
down on the aggressor. For all these reasons, intercourse with males by
penetration is "against nature," in that it either violates the natural inclina-
tion of the love object or implies a deviant inclination on his part. Uncen-
sored copulation with males is confined to the brothels and the slave and
metic population.

While in the domain of Aphrodite Pandemos a man's eros may be freely
directed at females as well as at males, in the realm of Aphrodite Urania
there is only one source of desire: the male youth in *hora*. Passion is not
absent from that realm, but there it is mastered in the light of moral intel-
ligence, *phronesis*. Because sex under the sign of Aphrodite Urania is not a
function of nature, it is irrelevant to ask whether it is according to nature.
Instead, *paiderastia* is a civic institution and as such it answers the call of
custom, *nomos*, and law, *thesmos*. As a violation of the code of ethics, the vi-
olation of the body of a citizen (or the ward of a citizen), therefore, consti-
tutes *hubris*, assault, and it is not "against nature" but *paranomos*, "against
custom," and *athemitos*, "lawless." These last two adjectives describe the of-
fence Laius committed when he betrayed a father's trust and perverted the
pedagogical thrust of his dealings with Chrysippus. That he was acting on
natural impulse did not save him from the justice of Zeus.[91] The distinction
between right and wrong conduct is accordingly phrased in legal terms that
oppose the *dikaios eros* to the *athemitos*. In all respects, this rightful eros is
represented as the opposite of the natural impulse of the senses, carefully
eschewing assimilation of the youth to a man's partner in nature. Not only
is penetration of the *eromenos* condemned in Classical Athenian thought,
but the analogy with marriage for the lovers is never made. Instead there
are hints that the love an *erastes* has for his *eromenos* is likened to the love
of parents for their children or siblings for one another. The thought is im-
plied in the comparison of the sexual penetration of the youth to incest that
underlies Oedipus's tragic destiny, the prohibition of sex with the young,
which Xenophon attributes to Lycurgus, as well as Plato's radical proposal
to reinstate the ancient taboo broken by Laius. In addition, Plato has Soc-

rates state in the *Republic* (403B5) that the *erastes* should love, keep company, touch the loved one in the way a father would, and no more.

The apparently curious metaphor of the *eromenos* as son makes sense if one considers the most important respect in which love with a young man is different from love with women. The section of Plato's *Laws* that contains the condemnation of copulation with males and the reference to Laius, cited above, is concerned with the management of sexual desire in the ideal city. In the process of laying out a rigorously moral program from which sex for sensual pleasure is excluded, the Athenian speaker gives an enlightening analysis of the kinds of love that are available. Having laid out the rules for the education of the young, the speaker realizes what a disastrous situation he has created by allowing females access to athletic training and competition together with the males, by granting them, in essence, access to the polis:

> When in my discourse I came to the matter of education, I saw young
> men and young women affectionately consorting with one another.
> There a feeling of fear came upon me, naturally, as I wondered how one
> is to deal with such a state, in which young men and young women are
> both well-nourished and free from the strenuous and menial labors,
> which best restrain wantonness, and where the main concern for every-
> one through life consists of sacrifices, feasts, and dances. In a state such
> as this, how will the young abstain from those desires which frequently
> plunge many into ruin, all those desires from which reason, in its en-
> deavor to be law, enjoins abstinence? . . . But the sexual desire of the
> young, both male and female, and of men for women and women for
> men, which has been the cause of countless disasters to individuals and
> entire states—how is one to guard against this, and what medicine can
> one concoct so as to find refuge in each case from a danger such as this?
> This is not at all easy, Clinias. While in other matters, not a few, Crete
> generally and Lacedaemon furnish us (and rightly) with no little assis-
> tance in the framing of laws which differ from those in common use, in
> regard to sexual passion, since we stand alone, they are entirely our op-
> posite. For if one, following nature, were to enact that law which held
> good before the days of Laius—declaring that as regards sexual inter-
> course it is right not to consort with males and young men in the same
> manner as with females, introducing as witness the nature of wild ani-
> mals and pointing out how male does not touch male for this purpose,
> since it is not according to nature—he would probably be using an

argument neither convincing nor in any way consonant with your
states. (Plato *Laws* 835D4–836C9 ([trans. Bury 1926; modified])

The elliptical logic of this passage is worth a closer look. In crafting the
perfect constitution, the Athenian says, one must reckon with the fact that
sexual passion leads to the ruin of the state and, hence, one must guard
against it. The eros in question, of course, is the one that drives males to fe-
males and women to men. It is enough to raise the specter of Helen and
Paris, that paragon of bad judgment in matters of eros, by the mention of
desires that could destroy states. That a remedy must be found is beyond
doubt, but a model acceptable to both himself and his interlocutors—the
Cretan Megillus and the Spartan Clinias—is not at hand, because their cit-
ies leave men free to copulate with the *eromenos*, while Athens does not. As
it moves from the dangers of a world where men love women to the devi-
ant nature of anal intercourse, the argument skates over the assumption—
too obvious to Plato's audience to be spelled out—that the threat posed by
the female object of desire is neutralized by the creation of a superior ob-
ject of desire, namely, the youth in *hora*.[92] Because the polis is to know no
Helens and no Clytemnestras, men shall love men best. The question is not
what to do, but how to go about it:

It is necessary to discern the real nature of love (*philias*) and desire and
passion (*eroton*), so called, if we are to determine them rightly. For what
causes the utmost confusion and obscurity is the fact that this single
term embraces these two things, and also a third compounded of them
both. . . . Love (*philon*) is the name we give to the attraction *of like for
like* (*homoion homoioi*) in virtue and of *equal for equal* (*ison isoi*) and also
to that of the needy for the rich, which is of the opposite kind; and
when either of these feelings is intense we call it passion (*erota*). . . .
Love between opposites is terrible and wild and seldom mutual among
us, while that based on similarity is tame and reciprocal through life.
The kind that arises from a blend of these presents difficulties, first to
discover what the man affected by this third kind of love really desires
to obtain and, next, because the man himself is at a loss, being dragged
in opposite directions by the two tendencies—one of which bids him
to *seize the bloom* of his beloved, while the other forbids him. For he
that is in love with the body and *hungering after its bloom as if it were a
ripening peach, urges himself to take his fill of it*, paying no respect to the
shape of the soul of the beloved. Whereas he who counts bodily desires
as secondary, and puts longing looks in place of love, with soul lusting

really for soul, regards the bodily satisfaction of the body as assault
(*hubris*) and, reverently worshipping temperance, courage, nobility, and
wisdom, will desire to live always chastely with the chaste object of his
love. (Plato *Laws* 836E7–837D1 [trans. Bury 1926; modified])

It is important to realize that this discourse on the meaning of *philia* as
an equivocal term that encompasses sexless attachments at one end and in-
tense erotic feelings at the other only concerns love in the polis. Reckless-
ness and wildness are conventional attributes of men who are described as
sex-crazed, unscrupulous chasers of young males.[93] The familiar Platonic
contraposition of sensual to spiritual love occurs here in a discourse that is
specifically about the political function of eros. The existing and possible
paradigms for love in the state are accordingly discussed in terms of good
and bad governance. *Paiderastia*, the reasoning goes, is the means by which
the threat posed to the state by the reciprocal attraction of the sexes is
averted, but is not without its dangers, since it unleashes men's sexual de-
sire onto the bodies of the young citizens. The three forms that desire can
take are then briefly described, the first two being the opposites of each
other and the third, a mixture of the first two. The first kind of *philia*, in
which sensuality gives way to longing for the spiritual well-being of the
loved one, belongs to the relationship in which the partners are not only
"alike in virtue" but also have "equal rights." This love is "domesticated," re-
ciprocal, lifelong. Its opposite, defined by the domination of one partner
over the other, is "wild," marked by fear and lack of reciprocity. These two
regimes — embodied, respectively, by the righteous suitor, who finds his
pleasure in the contemplation of the manly virtues of the *eromenos*, and the
suitor *hubristes* who devours the young — are the warring components of
the third kind of *philia*, that is, *paiderastia*, and rightly so, since the *eromenos*
both is and is not "the same" as the *erastes* and his "equal." If the youth is
to be integrated in the order of the men, the Athenian argues, the present
custom allowing suitors to ask sexual favors of him should be abolished.
The *eromenos* should not be submitted to acts that reduce him to a woman;
sexual commerce among members of the polis should be taboo, just as it is
among members of the same family (Plato *Laws* 838A–B). Embedded in
the Athenian speaker's definition of the first two erotic regimes is an anal-
ogy with two equally conflicting forms of government. For the expression
used to describe the partners of first sort of *philia*, "like to like in virtue and
equal to equal" is a catchphrase in political discourse. It occurs, for in-
stance, in Aristotle's *Politics* (1295B25–26; cf. 1279A8–10), to characterize
the most desirable composition for the state, that which consists "of men

who are equal and alike" *ex ison kai homoion*. These properties are again paired in reference to the Spartiate elite in Isocrates' defense of his democratic sentiment:

> Most of the speeches I have delivered will reveal that I condemn oligarchies and seizures (*pleonexiais*), while I praise equal rights and democratic governments. . . . For I know . . . that for this reason the Lacedaemonians are the best governed of all people, because they are governed according to the most democratic principles. For in their selection of magistrates, in their daily life, and in their habits in general, we would see that among them the greatest equality and the greatest uniformity (*tas isotetas kai tas homoiotetas*) prevail more than among others. (*Aeropagiticus* 60–61)

It is important to understand what "equality" means in reference to polity and, metaphorically, to the good kind of *philia*. *Isos*, like *isotes* and *isonomia*, equality of rights, refers to a quality that is part of the dynamics of rightful government, but it does not mean that all citizens have an equal participation in the rule at the same time. In spite of some earnest efforts to explain this feature as the hallmark of democracy, it is clear that *isonomia* is not the property of one particular form of government, since it informs as well aristocratic rule and constitutional monarchy, such as the Spartan.[94] Nor is it accurate to say that *isonomia* is the opposite of tyranny, since the two are not comparable entities. The correlation to be drawn is between *isonomia* and *hubris*, the former prevailing in constitutional regimes, the latter in their perversions, of which tyranny is the worst. *Isonomia*, that is, is not a function of any particular form of government. It is the prerogative of that which is governed, that is, the citizen body, in which it may be either honored or violated by those who govern. Much of Aristotle's *Politics*, which defines the polis as the "partnership of the free," who participate in the conduct of the state and agree "to rule and be ruled well" in turn, is about balancing this inherent right to equality against the inevitable exercise of authority in the conduct of the state.[95]

The question of what *isonomia* really means may be better answered by considering how the citizen body is constituted. The polis comes into being through the regimentation of the males who are (or will be) *andres* into age groups that regulate, more or less strictly, their admission to public life and the political role they may take. The classification of the citizenry by age is a fundamental structure of the *Männerbund* as social organization, where it is claimed to foster solidarity among the men. Bernardi, in particu-

lar, has emphasized the egalitarian character of age-class societies and the way in which the artificial commonality of age functions to erase social differences.[96] There is, to be sure, a social hierarchy, since the superimposed age grades are endowed with different capacities. What matters, though, is that all the men should have a turn at the exercise of power as each class moves from an age grade to the next. This is, in fact, Aristotle's answer to the problem of how all citizens may fairly exercise their equal right to rule:

> It is clear that for many reasons it is necessary for all to share alike in ruling and being ruled in turn. This is what equality means to those who are alike. . . . On the other hand that the rulers should be superior to their subjects cannot be disputed . . . Nature made the distinction by making the group that is in itself one kind in part younger and in part older, of which one is fit to be governed and the other to govern. No one resents being governed on the basis of age, nor thinks himself better than his rulers, particularly since he will recover what he has contributed once he reaches the proper age. In a sense, therefore, we should say that the rulers and the ruled are the same, and in a sense different. (*Politics* 1332B25–42)

In Plato's political metaphor in the passage from the *Laws* discussed above, the rightful *philia* of peers is civilized and lifelong because it respects the inviolability of the citizen's body and allows no sexual acts. Rightful *paiderastia*, on the other hand, may be construed as the lawful exercise of authority of more advanced age classes over the youngest one, provided the *eromenos* consents to be subjected to the *erastes*'s desire. It is not Plato's intention to abolish the possibility of such a relationship, nor to alter the lovers' respective roles, only to purge the practice of the taint of satisfying a physical urge.

If respect for the citizens' equality is the mark of the best government, self-serving abuse characterizes the worst of regimes, tyranny, in the second kind of *philia* described in the *Laws*. Love between unequals is a lawless state where *hubris* is the preferred mode of action. Despotic excess is the mark of the domineering lover: he has amassed wealth, he consumes the beauty of the *eromenos* like a ripe fruit. Voracity that is only extinguished by glut is a standard feature of rulers who abuse their power, such as Jason of Pherae, who said that he felt hungry whenever he was not tyrant (Aristotle *Politics* 1277A24). It is grabbing more that one should or needs, the *pleonexia*, which Isocrates associates with oligarchy, the tyrannical *koros*—glut, surfeit— of Archaic lyric poetry. Of particular interest in this context is the web of

associations linking *koros* to *hubris* and excess in the political sphere, at one end, and *hubris* to tyranny, at the other.[97]

Does Plato use the figures of the good and bad governments for the right and wrong love in a purely metaphorical sense? Compare these figures to the often-quoted metaphor of Alcmaeon of Croton that health is the *isonomia* of the substances of the body.[98] In the latter the vehicle (*isonomia*) and the tenor (health) belong to different domains (the political and the physical, respectively), but the terms of the Platonic metaphor are not so easily disentangled. The sense of the metaphor implicit in the description of the first kind of *philia* is that each of the partners has equal rights with respect to the other, just as in the polis each man has equal rights. But the lovers' *isonomia* and the citizens' in reality coexist: since only citizens are equal to one another, *isonomia* in the political sphere is the necessary condition of the *isonomia* that characterizes the "tame" love. The same is true of the relationship of the "wild" *philia* to tyranny. Metaphorically it makes a subject of the *eromenos*. And, literally, this love tainted by violence is the only kind available to a tyrant, as Simonides learns in his interview with Hiero. Hiero claims that the love of *paidika* is unknown to tyrants and, when Simonides asks him what he would call his eros for Dailochus, the most beautiful, he explains:

> I desire to get from him not what I may have apparently for the asking, but that which a despot should be the last to take. The fact is, I desire of Dailochus just that which human nature, maybe, drives us to ask of the fair. But what I long to get, I very strongly desire to obtain by his goodwill, and with his consent; but I think I could sooner desire to do myself an injury than to take it from him by force. For to take from an enemy against his will is, I think, the greatest of all pleasures, but favours from a loved one are very pleasant, I fancy, only when he consents. . . . The fact is, a private citizen has instant proof that any act of compliance on the part of his beloved is prompted by affection, since he knows that the service rendered is due to no compulsion; but the despot can never feel sure that he is loved. For we know that acts of service prompted by fear copy as closely as possible the ministrations of affection. (Xenophon *Hiero* 1.32–38 [trans. Bowersock 1968])

Hiero is plainly in the grip of the mixed kind of *philia* described in the *Laws*, driven by the natural compulsion to possess the beautiful body and, at the same time, eager not to do so against the youth's will. But since fear un-

avoidably enters in all his dealings with his subjects, the tyrant can never be
sure that the loved one truly consents.

This interdependence of erotic and political regimes is bluntly put in the
often quoted speech by Pausanias in Plato's *Symposium* (180C1–185C3). In
the dialogue, Pausanias has the task of expounding the traditional Athe-
nian approach to *paiderastia*, a golden mean equally distant from the li-
cense of the Eleans and the Boeotians and the repressiveness of the Ionian
cities. There is repeated reference to a *nomos*—either law or binding con-
ventions, or a mixture of the two—which sets down the conditions under
which it is right for an *erastes* to gain sexual gratification and for an *eromenos*
to grant it. A cardinal rule is consent, evinced through persuasion in the
course of a courtship that begins when the young man is still a boy (183C–
D). Pausanias alludes to the form that legitimate gratification may take,
one that involves considerations of "timeliness"—probably as regards the
age of the *eromenos*—and means. Those who would like to see sexual con-
tact of any kind banned from such attachments, he says, have in mind the
"untimeliness," *akairian*, and "injustice," *adikian*, which characterize the con-
duct of bad *erastai*. But the practice itself is noble, provided one goes about
it the right way (182A, 183D). In fact, strong homoerotic bonds among
men are essential to the well-being of the citizen body and the source of re-
sistance against the despot:

> This is considered shameful by barbarians, together with the pursuit
> of philosophy and athletics, because of their tyrannical governments;
> since, I think, it is not in the interest of the rulers that their subjects de-
> velop high-minded ideals, or strong loves (*philias*) and partnerships,
> that and all the rest which *eros* is likely to engender. It is a lesson that
> our tyrants learned by experience. For the *eros* of Aristogiton and the
> *philia* of Harmodius were so steadfast that it destroyed their rule. Thus
> where it was established that it is shameful to gratify one's lover, the
> rule is due to the faults of those who made it, the avidity (*pleonexia*) of
> the rulers, on the one hand, and the unmanliness (*anandreia*) of the
> ruled. (182B7–D2)

It is probably true that Pausanias's speech is a tissue of clichés, including a
predictable appeal to the memory of the Tyrannicides. And we would be bet-
ter able to dismiss it out of hand if it were as obvious to us as it was to his
audience what it is that makes homoerotic bonds among the men the very
foundation of legitimate government. The Tyrannicides are a spectacular

demonstration of the fact that the two are inextricably bound in the Athenian mind.

In this story the good and the bad *erastes* battle one another like the conflicting desires in a lover's heart. On one side is Aristogiton, the righteous *erastes*; on the other, a son of the previous tyrant Pisistratus and brother of the present tyrant, Hippias. Thucydides and Aristotle are our principal sources on the facts of the matter but they are not dispassionate informants, since both are sympathetic to the cause of the Pisistratids.[99] Whereas Pausanias, the speaker in Plato's *Symposium*, had emphasized the political import of the couple's homoerotic attachment, Thucydides denounces the deed as an emotional and reckless act of private revenge. The historian argues that the belief that they killed the tyrant is a legend born of misinformation, one of those old tales that do not stand up under scrutiny, for "it was Hippias who was the eldest and the chief of the sons of Pisistratus, and Hipparchus and Thessalus were his brothers" (Thucydides *History of the Peloponnesian War* 1.20.2). His version of the facts goes as follows:[100] Hipparchus made a first unsuccessful attempt to seduce Harmodius away from Aristogiton, who "being in love as he was, was incensed and was afraid that Hipparchus with all his power, might take him [Harmodius] against his will (βίᾳ)" (6.54.3). This was the beginning of the conspiracy to overthrow the tyranny. After a second luckless try, Hipparchus took his revenge on the youth by insulting his sister. This only strengthened the plot to assassinate Hippias on the occasion of the Panathenaea of 514 B.C. But things did not go according to plan. As they approached Hippias in the Ceramicus with daggers drawn, the lovers saw him conferring with one of the conspirators and feared they had been betrayed. In their retreat, they came upon Hipparchus and kill him, either "to perform some daring exploit before they were arrested" (1.20.2), or "to have their revenge" (6.57.3). Harmodius was immediately killed by Hipparchus's bodyguards; his lover died later under torture. Hippias survived and remained in power. He was finally ousted by the Spartans three years later.[101]

It is actually far from certain that Hipparchus had no hand in the tyranny.[102] The Aristotelian *Constitution of the Athenians* (18) says that Hippias and Hipparchus ruled jointly and gives a different version of the events. It was a younger brother, Thessalus, "arrogant and violent in his behavior," who was the cause of all their troubles. He desired Harmodius and, failing to obtain his love, far from restraining his anger, first he complained bitterly to others, then, when Harmodius's sister was to carry the basket at the Panathenaea, he prevented her from doing so, reviling Harmodius for being effeminate (*malakos*)" (18.2). The rest of the story roughly matches

Thucydides' account, except that Hippias is placed on the Acropolis and the murder of Hipparchus lacks any overtones of personal revenge.

These narratives agree on two crucial points. The first is that the *eromenos* was threatened with sexual *hubris*, not just presented with a choice between two lovers. Intimations of rape are raised by Aristotle's characterization of Thessalus as "arrogant and violent" (*hubristes*), and they are not absent from Thucidides' narrative, which mentions the fear that Hipparchus might take Harmodius "by force"—βίᾳ is the term for rape in Attic law. *Hubris* specifically is mentioned in the *Politics*, 1312 b 29–33, as the cause of the fall of the Pisistratids. In addition, Aristotle gives indications that the youth was, or might be, cast in the role of the pathic: he reports the epithet *malakos* ("soft" or effeminate) with which Thessalus insults him and hints at Hipparchus's mild debauchery. Aristotle characterizes the latter as "frivolous, amorous, and a lover of music, who sent for Anacreon and Simonides and their associates and the other poets," while he praises Hippias, whom he calls "a natural statesman and a wise man." Although singly the adjectives applied to Hipparchus are capable of positive connotations, altogether in this context they draw an unflattering profile for a man in his late fifties. The contrast of his frivolity with his brother's wisdom and the joining of *erotikos* with *philomousos*, amorous and a lover of music, are revealing. An unfortunate reputation for effeminacy attached itself to lyre players and singers and made them a target for men like Misgolas, who expected shameful favors from their *eromenoi*.[103]

A second important point on which Aristotle's and Thucydides' stories converge is that Hippias's brother's attempt upon Harmodius's virtue provoked a conspiracy to kill not the perpetrator but Hippias, in which many men took part who had no personal stake in the matter. Hipparchus was assassinated *faute de mieux*, once it looked as though Hippias had been warned and the arrest of the conspirators was imminent. This twist is hard to reconcile with Thucydides' thesis that the murder was a private affair and only much later became in the popular mind an attack against the tyranny itself.[104] His script is belied, moreover, by considerable traces of state-sanctioned heroization of the couple immediately after the event. The bronze group by Antenor was erected in the public square in 509, after a period of just five years, at a time when the plot against Hippias was hardly an old fable.[105] It would have been difficult, one imagines, to find an Athenian who had not witnessed the expulsion of the tyrant and the Spartan invasion. The symbolic importance of the Tyrannicides for the city is further demonstrated by the fact that the commission for a new monument to replace the statues by Antenor was one of the first actions taken by the Athenians when

they returned to their destroyed city (fig. 134).[106] We do not know the date
of the institution of the cult of the Tyrannicides. That they had the status of
heroes in the popular imagination before 490 is suggested by the exhor-
tation to Callimachus, the hero of Marathon, which Herodotus (*Histories*
6.109.3) could plausibly attribute to Miltiades: "[L]eave for yourself a
memory such as neither Harmodius nor Aristogiton left." In addition, the
songs, which hailed them as saviors and were a standard feature at drink-
ing parties by the late fifth century probably date to the last years of Hip-
pias's rule. It has been argued that the opening lines of two of the preserved
four songs make better sense if understood as a rallying cry in the face of
the tyranny, not after its demise:

> I will carry my sword in a myrtle branch
> Like Harmodius and Aristogiton
> When they killed the tyrant
> And made Athens a place of equality. (Athenaeus *Sophists at Dinner*
> 15.695A–B)[107]

That the conspiracy had origin in the erotic sphere would not come as a rev-
elation to the men who commissioned the new monument. Far from being
swept aside as an incidental aspect of the deed, the love of Aristogiton and
Harmodius is integral part of their claim to glory. The group by Critius and
Nesiotes, in pairing the vigorous bearded man with the athletic *ageneios*
youth, represents them as both lovers and comrades, the contemporary
equivalent of heroic couples such as Achilles and Patroclus. The same years
saw the production of Aeschylus's *Mirmidons*, which put on stage Achilles'
passion for Patroclus. On Late Archaic and Early Classical vases, heroes like
Telamon, Heracles, and Theseus strike the pose of Harmodius or Aristogi-
ton.[108] As we have seen, in fourth-century courtroom speeches and philo-
sophical tracts, the Tyrannicides are predictably invoked as the quintessen-
tial model of virtuous *paiderastia*. Harmodius and Aristogiton, it seems,
became the founding heroes of Athenian democracy precisely because the
deed originated in their love affair not in spite of that fact.[109]

If the Tyrannicides are the most spectacular example of this overlap of
the erotic and the political spheres, their case is not unique. Rather, it is
an instance of a phenomenon that Aristotle (*Politics* 1311A–B) classified
among the causes of revolutions under the heading of "uprisings aimed at
the person of the ruler" and "provoked by *hubris*" (1311A31–33). In this
category he lists the attack on the Pisistratids, together with a series of other
notorious cases in which the sexual abuse or feminization of a youth had

given rise to a plot to murder the ruler. Among these is the death of the tyrant of Ambracia, Periander, who fell because he asked his *paidika* if he was pregnant with his child: a deadly insult, because it implied that he had submitted to sexual penetration. The outrage brought about a statewide uprising in which the *demos* joined forces with the young man and his supporters. The events surrounding the murder of Philip II of Macedon are suggestively analogous to the plot to assassinate Hippias. The protagonist is Pausanias (Philip's bodyguard and former *eromenos*) who had driven a rival to suicide with taunts of effeminacy. In revenge, Attalus, a friend of the latter and the uncle of Philip's new wife, made Pausanias drunk until he was unconscious, then had his muleteers rape him. Pausanias took his own revenge not on Attalus but on the king, because he had let the crime go unpunished.

As in these stories, in the saga of the Tyrannicides the integrity of the *eromenos*'s body and the integrity of the citizen body are so closely identified with one another as to be interchangeable. The "tyrannical" attempt upon Harmodius triggers a revolt against the tyranny itself; and the murder of Hipparchus effects not vindication of a personal affront but restoration of *isonomia* to the polis. In all these cases—as in Plato's definition of the two kinds of *philia* in the *Laws*—the connection of proper *paiderastia* to the constitutional order is not metaphorical but indexical. Since equality among the men is the necessary condition for its very existence, rightful eros bears witness to the egalitarian fabric of the polis. Unlawful encroachment upon that eros, therefore, reveals in the Pisistratid regime the kind of insatiable tyranny that devours the citizen body rather than the enlightened constitutional rule described by Thucydides. On these grounds the tyranny itself becomes the real enemy, against which the lovers fight to the death, defending at once their *philia* and the *isonomia* of their fellow men.

One might say that *paiderastia* is the deployment of sexual desire in the political sphere according to certain well-defined procedures.[110] The cult of the Tyrannicides in Athens is a large-scale demonstration that the political import of *paiderastia* lies in its function as wellspring of egalitarianism, which is essential to the constitution of the group of men who are the dominant caste and, ultimately, the state itself. The first step in the establishment of the polis is the exclusion of persons of different gender, first of all the females, and *paiderastia* is instrumental in this endeavor. Femininity is more than a foil against which manhood is defined. It is an ever imminent and serious threat, because allegedly women are the source of overpowering desire. The homoerotic experience, which makes of the Greek youth both an *eromenos* and an *erastes* in short turn, is then the means by which his emotional allegiance is removed from the murky ambiance of the *oikos*,

where the sexes have commerce with one another, and given over to the polis, which is constituted by only one sex. For all the insistence on the need to control its sensual aspects and direct it toward an attachment that seeks satisfaction of the soul, the appetite for the body, as strong as any natural impulse, is an essential element of the *dikaios eros*, and not even Plato ever suggests that it should be done away with.[111] This erotic charge effects the transference of a young man's allegiance from the family to the society of men not by the cool light of reason but through the undisputed force of passion. Manly eros effectively voids heterosexual eros of any personal worth and social merit, by relegating this dangerous urge to the sphere of bodily needs, which is by definition a distinct and inferior sexual domain. Stripping women of civil rights is an important and strictly enforced measure to see that these two domains do not merge; it was not, as has been said, a naturally arising state of things that favors the formation of special bonds among the men.

Why, then, is passion constrained, policed, hemmed in by age regulations, and finally told to transform itself into collegial friendship and comradeship? It is a paradox that *paiderastia* forbids what it has itself prescribed in the first instance. On the one hand, it requires that desire be directed toward the young men. On the other, it frustrates the fulfillment of that desire by strict protocols concerning the use of the body of the *eromenos* and by age regulations that eventually prohibit bodily consummation and lasting attachment of a sensual nature altogether.[112] The contradiction is large enough, and obvious enough, to make one wonder if the prohibition of sexual use of men is not the point of the exercise. One might look for an explanation to the need to control aggression or, more properly, the management of fear. The domain of carnal pleasure, the eros inspired by Aphrodite Pandemos, is the one where violence is the mode of action, rightly and inevitably so in intercourse with females, who are disposed to enjoy domination and constitutionally incapable of consent. In the domain of Aphrodite Urania the hierarchy that marks sexuality in the realm of nature is very nearly erased. The difference between the *erastes*'s agency and that of the *eromenos* is a matter of degrees and as fugitive as the youth's *hora*. But in a culture that conceives of sex acts as assault, intimations of power and conquest cannot entirely be absent from the transaction. The difference with women is that the *eromenos* agrees to "submit," *hupourgein*, just as under constitutional governments each man agrees to be ruled and rule in turn, according to his age. The possibility may be considered that the homoerotic sexual experience, just as the new class enters the ranks of the men, has the purpose of defusing potential antagonism and generational conflict. The

Thebans, apparently, conceived of *paiderastia*, which among them took the form of copulation with the youth, as a taming mechanism:

> On the whole, however, in Thebes it was not Laius's sin that gave rise
> to this intimacy with the *erastai*, as the poets say. Rather, the law-givers,
> with the intention to diffuse and soften their natural high-spiritedness
> and violence as soon as they came of age, inserted intense practice of
> the *aulos* in both their work and their play, giving it precedence and
> honor, and fostered the glory of *eros* in the life of the palaestra, thus
> tempering the disposition of the young men. (Plutarch *Life of Pelopidas*
> 19.1)[113]

Precisely because it fundamentally constitutes an act of aggression, however genteel, physical contact between lovers must cease as soon as the *eromenos* is past the ambiguous stage of his *hebe*. For, as it is often said, the body of the citizen is inviolable. In this light, the sex-starved *philia* of man for man is essentially a pact of nonaggression and mutual support against all those enemies the polis has, within its territory and without.

Fugitive Nudes

In the representation of manhood, the body takes center stage, naked be-cause it is perfect and no longer needs the shelter of *aidos*. It is a body in control of itself and of its desire, which it is now permitted to turn toward the junior classes of males, and toward females. For women this step is sheer folly, as the cautionary tale of the daughters of King Proetus illustrates.

From their condition of proper girls of marriageable age with many wooers from all Greek lands, the Proetids became outcasts because of their arrogance. The details of the transgression differ from one version of the myth to another. Either they offended Hera by boasting that their estate as maidens in their father's house was greater than hers, Zeus's wife; or that their beauty was greater, or by desecrating her image; or they refused the rites of Dionysus.[1] In any case, their sin was hubris, indecent presumption, which the punishment they received translated into terms of a correspond-ing perversion of nature: "[B]ecause of their wanton lust, they lost their bloom." Driven by desire, the girls bare their bodies, but the result is the op-posite than that obtained by the boys' undressing. It is not a blameless and invincible form that emerges from the clothes but a repulsive spectacle: "[L]eprosy covered all their flesh, their hair dropped from their heads, their fair scalps were made bare."[2] Crazed, the maidens run naked through the countryside thinking they are cows, bellowing like cows.[3] This last details adds to the picture of an inversion of the natural order, for alone among the species the female of the genus has a voice deeper than the male.[4]

The claim of the princesses to be richer or fairer than the goddess is as absurd as their claim to sexual desire. Lust, *makhlosune,* has no place in the soul of a *parthenos* or of any proper female. The word expresses a quality of whores, *pornai,* who are *makhladas* and *makhlontes.*[5] Note the connection

established in the myth of the Proetids between female lust and ugliness and the fact that *makhlosune* belongs to the discourse of prostitution. The same notions are expressed in images, precisely in scenes of sex between men and a certain type of women—what one may aptly call the pornography of Greece.[6] Because the proud exhibition that characterizes the male nude signifies empowerment, the female body may not be willfully displayed. Nevertheless, it is looked at all the time—glimpsed under filmy clothing and in images that catch women, respectable and not, as they bathe, dress, make love. While the male nude confronts the viewer as its judge and witness, the naked woman, like the naked boy, is represented as though unaware of the viewer, in contexts where nudity is a product of circumstances. Innocence and defenselessness are key pieces in the construction of the object of sexual desire as prey, a victim to whom one can relate only by prevarication, ranging from gentle persuasion to rape. The European world, heir to this vision, reacted with shock and disgust to Manet's *Olympia*, whose subject disrupts the game and spoils any pleasure to be had by gazing at her white naked body by turning a level, sensible gaze onto the viewer.[7] The most common fantasy featuring naked women, in myth as in pictures, is that of the *parthenos* surprised at her bath. The pleasure of the forbidden sight may be sharpened by attendant dangers—of being turned into a deer and devoured by one's own dogs, like Actaeon; of being blinded, like Tiresias when he saw Athena.[8] Attic vases of the late sixth and the fifth century offer several pictures of bathing beauties: swimming in a river or nude at the washbasin.[9] In this sense, the first and the most famous of the statues representing Aphrodite entirely unclothed, Praxiteles' Cnidia, is nothing new, although in no other case is the casting of the viewer as *voyeur* as explicit.[10]

The interpretation of the ancient representation of male and female genders drawn up in the past two chapters brings into the foreground deep asymmetries. It has been stressed that, although they are both objects of desire—boys on the one hand, girls and women on the other—the similarities and analogies in their representation are contradicted by fundamental distinctions. It was pointed out that boys undergo a radical change of gender, while girls do not, and that the change results in the acquisition of agency in the personal, civic, and military spheres, something that girls never gain. What is to be made at this point of the persistent suggestion that, although their social status is unequal to that of men, the development of women is analogous in its structure to that of men. Or that, to quote again a much-quoted phrase of Vernant, "Le mariage est à la fille ce que la guerre est au garçon: pour tous deux, ils marquent l'accomplissement

[handwritten margin notes: "annah!" and "not choice ↓ women have no choice in their mating"]

de leur nature respective, au sortir d'un état où chacun participe encore de l'autre"?[11] Repeated out of context, this striking sentence has lost many of its hedgers (it was said in reference to an "agrarian," pre-polis phase of Greek society) and is employed to propose a stark equivalence of woman-hood to manhood, as though both implied maturation and change. This notion rests on a conception of marriage as an event that alters the nature of the woman rather than simply her location, although it does not change that of the man. It relies, moreover, on the assumption that there were fe-male initiations, understood as procedures that brought about woman-hood in the same way in which male initiations caused the emergence of manhood.[12] But a comparative analysis of the two prescribed courses as re-gards their respective structures and the effects they obtain — organization by age classes, advancement to superior grade, personal and social effect of the procedures — uncovers severe distortions beneath apparent similarities and reveals the analogy to be false.

An analogy between the development of girls and boys is most osten-sibly proposed in accounts of Spartiate society. Through the Athenian and philo-Athenian lenses of literary texts that have survived, Sparta appears a quaint, upside-down world in many respect, not the least of which is its treatment of women, who apparently enjoyed a measure of authority and freedom that made them the object of scorn, admiration, and ridicule.[13] The upbringing of Spartan girls is depicted as parallel to that of the boys. They were encouraged to cultivate their bodies in the same way as males should, not by the use of cosmetics and adornments, but by keeping strong through exercise. The institution of athletics for girls, we are told, had the purpose of making them fit for the production of healthy children, able to sustain the pains of childbirth, and, if it need be, to fight. Like the young males, the girls were allowed, we are told, to parade naked in processions at festivals.[14] The most striking correspondence with male initiatory practices is brought up by the mention of *paiderastia*, of two kinds: like the young men, the girls acquired an adult lover of the same sex; like the boys, before their marriage the girls were sexually used "in the manner of boys," *hos paidikois*.[15]

The model of male *paiderastia* as a means of effecting the transition to adult status is in evidence in the Spartan marriage ceremony, which is only understandable as a mirror image of the rites by which the young Spartiate achieved manhood. The proceedings included transvestism. They are de-scribed in a notorious passage of Plutarch's *Life of Lycurgus* (15.3–4). The bride is transformed into the male initiate, with shorn hair and male dress; like the boys, she lies on a bed of rushes, from which she is then transported to a couch, *kline* — a passage that recalls the same transition for male, from

anal penetration?

the *stibades* to the dining couch at the *sussution*. Vidal-Naquet observed that
the procedure parallels male initiations, and thereby casts the young Spar-
tiate woman as "un 'garçon' manqué.'" [16] The ways in which she fails to be
a boy are not unimportant and will be examined now.

Nudity without shame, which for the males has ritual significance, may
be also, as was seen, a feature of the representation of the Spartan girl. There
is, however, an important difference: while for men nudity remains a char-
acteristic feature of the representation of manhood, for females it is con-
fined to the brief period in which they are likened to boys. Female nudity
is a fugitive, temporary feature, a privilege to which girls, not women, are
entitled. Among the correspondences of the female "initiation" model to
the male, the most striking are *paiderastia* for girls and transvestism at the
marriage ceremony. The mention of the bonding of an adult female to a
young one finds confirmation, as a more widespread phenomenon, in the
existence of "thiasoi" or schools of girls that have been reconstructed on the
basis of literary texts, particularly the poetry of Sappho. [17] Here one finds ex-
pressions of homoerotic sentiments that have their counterpart in male ho-
moerotic poetry, from Theognis to Anacreon. But the female model is lack-
ing in several important respects. To begin with, the relationship between
a girl and her lover comes to an end with the girl's marriage. That is, it does
not issue in the homosocial bonds that continue to link the *eromenos* to his
former *erastes* in all aspects of his life. One may refer to the continued com-
munal life of the young Spartiate and to the pairing in the combat of couples
of *erastai* and *eromenoi* in the Spartan and Theban armies. [18] Further, note a
complete lack of mythical hypostases for female *paiderastia*. To the wealth
of stories about heroes who are the *paidika* of other heroes or gods and then
grow up and marry, there are none about heroines. Even what would seem
to constitute a parallel, Artemis's relationship to her nymphs, is a false one,
because the relationship of the goddess to her followers is sexless, and she
neither releases them into marriage nor condones lapses and accidents.
There are neither stories nor pictures of goddesses abducting girls to match
the myths of gods pursuing boys and females. [19]

The transparent analogy to male initiation offered by the Spartan wed-
ding also bears closer scrutiny. While it is true that the bride is cast as an un-
derage male and her upgrading from *parthenos* to *gune* is effected through
sex, the agent of the change is not a person of the same sex but a man. In
the same way, the analogy with the male model is both stated and falsified
by the alleged practice mentioned above, that prescribed intercourse with
girls, before their wedding, "in the manner of intercourse with boy-loves."
While in the case of males it is men who make manhood happen, in the

case of girls, it is not women who bring womanhood forward, but, again, men.[20] The Spartan wedding depicts the bride as a boy, but as in a distorting mirror. Finally, although Pindar speaks of a "herd of maidens," *parthenon agela*, an expression that echoes the boys' initiatic "herds," there is no evidence to suggest that, like the boys, the Spartan girls were ever removed from their families and their training taken over by the state. Nor is there anything to suggest that they were organized in age classes — they are called *parthenoi* throughout.[21] An argument from silence such as this would normally carry little weight were it not for the fact that an elaborate nomenclature is reported for the age classes of males and for the emphasis that the ancient writers place on the similarity of the upbringing of males and females in Spartan society.

The conceit of female age classes is found twice again in ancient Greek sources, in the organization of the participants in the footrace in the festival of Hera at Olympia into three groups[22] and in Athens, in a context where it cannot be taken seriously — that is, in Old Comedy. In the *Lysistrata* of Aristophanes, the chorus of old women is pitched against the chorus of old men. Like the men, the women begin to strip for the fight.[23] They then state their claim to a voice in the state on the grounds of credentials qualifying them as "citizens" after a fashion. Their qualifications are recited as a series of mock grades:

> When I was seven I promptly served as *arrephoros*
> then at ten I was corn grinder for the leader;
> then pouring down the saffron mantle (*krokoton*) I was bear (*arktos*) at
> the Brauronia,
> and when I was a fair maiden I was basket carrier
> wearing a necklace of dried figs. (Aristophanes *Lysistrata* 641–647)[24]

The comic effect that was surely intended might have been produced by irreverent juxtaposition of roles of very different nature, or of real and imaginary functions, or by the fact that each evoked a corresponding step for males, the comparison resulting in ridicule. We know too little to guess why this is funny but we do know that it is meant to be. What the women describe is not a course prescribed for all Athenian girls, because at the time when Aristophanes was writing *arrephoroi*, carriers of secret things, *aletrides* (corn grinders), and *kanephoroi* (basket carriers) were few in number and selected from among the highborn (*eugeneis*). Moreover, these functions do not identify age classes: the age of the *arrephoros* being seven to eleven is

largely the same as that of the bear, five to ten, and one must fit the *aletris* between them.[25]

The rites involving the performance of the bear, *arktos*, for Artemis Brauronia, however, do seem to have the earmarks of an initiation. They are collective and public and acknowledge a step that may be considered a true age grade, with its attendant requirement. All Athenian girls, we are told by the scholia to the passage of Aristophanes quoted above, must play the bear at an established age, no older than ten and no younger than five, and none may be married before she does.[26] The other functions mentioned by the chorus of the *Lysistrata* give a girl a special role in a performance of cult activities directed at a divinity on behalf of the city. But the Arkteia directly affects the girls of the Athenians, marking them able for marital service.

At first glance, visual sources concerning the Brauron rites add to the picture of a correspondence with male initiation. These are the so-called krateriskoi, vases of a particular shape, normally painted in black-figure and dated, for the most part, to the first half of the fifth century B.C.[27] They were found in great numbers in the sanctuary of Artemis at Brauron and, with one exception, at other sanctuaries of that goddess in Athens and Attica.[28] To judge by what has been published, the figural scenes painted on them conform to a small and repetitive repertoire. This consistent association of subject matter and specific ceramic shape and the fact that the great majority of these vases come from Attic sanctuaries of Artemis justify the current assumption that the krateriskoi are ritual vases that belong to ceremonies in honor of Artemis.[29] The other assumption underlying current interpretations of the painted scenes, that they show actions performed at the time at which the vases were produced should instead be reexamined.[30]

The typology of the scenes, as was said, is small, consisting of few elements that flow together without apparent contradictions. We are shown a sanctuary, indicated by altar and palm tree and boundary wall on which hang fillets.[31] Leaping stags introduce some particular connotation, although it is uncertain whether they signify a sanctuary set in the wild or an ambiance sacred to Artemis. In this setting, one sees girls engaged either in a race or in a choral performance, dance or "procession."[32] A stag may tag along in the race. These quickly painted, shorthand notations were all that an ancient viewer needed to evoke a world of festival celebration. One, rare, amplified picture includes either grown women or mature girls with baskets and laurel branches in their hands.[33] The way in which the children are depicted is exceptional as regards the conventions of the female image in Attic vase paintings. An effort is made to define an age category standing

between childhood and maturity by means of bodies that are of standard height, but "unripe" in features, with small breasts. The girls may be clothed in short dresses as well as naked, and it is the older adolescent ones who are shown nude most often.[34] Both the representation of several stages of growth in the young women and their nudity call up the representation of the young males, whose development is charted according to several age classes and finally attested by the display of the body.

The pictures of nude girls of various ages represented on the krateriskoi have become the mainstay of a reconstruction of the ritual that goes as follows. The *Lysistrata* passage with its attendant scholia testifies to the fact that the *krokoton* was the dress of the *arktoi*. The nudity of the *arktoi* represented on the krateriskoi signifies that the ritual culminated in the shedding of the *krokoton*. This garment, therefore, was the costume the girls from the beginning of a period of service or of segregation at Brauron.[35] This reconstruction is founded on a series of dubious inferences. As Brelich admitted, sources that have a direct bearing on the Arkteia indicate nothing more than a festival.[36] There is no credible evidence to support the hypothesis that the girls underwent a period of segregation. A rich and subtle argument for a ritual shedding of the *krokoton*, however, was mounted by Sourvinou-Inwood on the basis of a textual crux in the *Lysistrata* passage quoted above. This too, however, does not bear close scrutiny.

Sourvinou-Inwood proposed that the reading of the Ravenna manuscript of *Lysistrata* at line 645, καταχέουσα τὸν κροκωτόν—taken to mean "shedding the *krokoton*"—should be preferred over the reading κατέχουσα of the other manuscripts, as well as over the widely accepted emendation κᾆτ' ἔχουσα, both of which yield "wearing the *krokoton*."[37] The argument consists of three main points. To begin with, καταχέουσα is the *lectio difficilior* and, therefore, preferable in principle. Second, the expression recalls the passage in Aeschylus's *Agamemnon* (239), where Iphigenia faces her own sacrifice, κρόκου βαφὰς δ' ἐς πέδον χέουσα, understood to mean that Iphigenia casts off her *dress* and is left naked. Finally, the fact that the krateriskoi show girls performing naked means that the ritual of the Arkteia involved removing one's clothes.

Of these arguments only the first will hold.[38] But, as does the phrase εἰς πέδον χέουσα in *Agamemnon*, καταχέουσα may mean "pouring down" in the sense of letting the *krokoton* down to one's feet, enveloping the body entirely.[39] Moreover, even if it were to fall, it is unlikely that the children at the Brauronia would be left naked. All we know about the *krokoton* is that it was a mantle.[40] We are left with the fact that wearing the *krokoton* was a feature

of the Arkteia, while there is nothing to suggest that it was taken off in the course of the ritual—except for the images on the krateriskoi themselves. Thus Sourvinou-Inwood's hypothesis ultimately rests on the premise that, because the imagery belongs to a discourse about the Arkteia, its referent is the Arkteia as it was performed at the time the vases were painted. This is a false assumption.

Any hypothesis claiming that these images attest to the practice of having young women run nude at a festival in the fifth century B.C. must reckon with the fact that men writing one or two generation earlier or later considered such a practice an aberration. Ibycus called the Spartan women *phainome-rides*, thigh flashers,[41] and Plato represents as the *communis opinio* that the very sight of females exercising naked, like the males, would be laughable:

> "If, then, we are to use the women for the same things as the men, we must also teach them the same things." "Yes." "Now music together with gymnastic was the training we gave the men." "Yes." "Then we must assign these two arts to the women also and the offices of war and employ them in the same way." "It would seem likely from what you say," he replied. "Perhaps then," said I, "the contrast with present custom would make much in our proposals look ridiculous if our words are to be realized in fact." "Yes, indeed," he said. "What then," said I, "is the funniest thing you note in them? Is it not obviously the women exercising unclad in the palestra together with the men, not only the young, but even the older, like old men in gymnasiums, when, though wrinkled and unpleasant to look at, they still persist in exercising?" "Yes, on my word," he replied, "it would seem ridiculous under present conditions."
> (Plato *Republic* 5.451E6–452B5 [trans. Shorey 1930])[42] *Now is not the time*

One should take careful notice of this passage, because it also indicates where it is that this naked woman may be contemplated with a straight face: a utopian city of the future. That is where females may be allowed a role comparable to that of men and where the women Guardians should be trained like the men Guardians in all the arts of the body and the mind. In the model city described in the *Laws*, female nudity is again envisioned in the context of separate but equal status with the men, but it is more suitably confined to a somewhat ungendered stage, to females under thirteen—older girls should be decently clad.[43] One concludes that female nudity for an Athenian is something that may be admitted only somewhere else, a place removed in space and culture, such as Sparta, or in time, such

very apt point!

as the future. That is to say, in Vidal-Naquet's happy turn of phrase, "female power is an issue only in comedy and in utopian thinking."[44]

But there is also the past. The ideal city of the future that Plato describes in the *Republic* and the *Laws* has a paradigm, explicitly recalled in *Timaeus* and *Critias:* primitive Athens.[45] In the last, unfinished dialogue, the early city is described as an ideal place. Before the cataclysms that produced its present aspect, Attica was greater, greener, a bountiful country, and Athens's institutions were just and wise, characterized by simplicity and moderation. The dominant class, the warriors, demanded no more than was needed, and all goods were held in common. Here one confronts again women who are equal to men and are trained like men:

> In fact, the pose and the image of the Goddess, who was represented
> as armed according to the custom of a time when the practices of war
> were common for men and women, is evidence that all living things,
> both female and male, who mate with one another, are by nature able
> to pursue, completely in common, the excellence proper to each kind.
> (*Critias* 110B5–C2)

It is difficult to say where Plato's representation of early Athens differs from that of his contemporaries, but the image of a different, Arcadian state is conjured up also by Herodotus's narration of the trouble with the Pelasgians. In the primitive past, neither the Athenians nor any other of the Greeks had servants, and the sons and daughters of the Athenians went to the fountain of nine spouts to fetch water; there they were raped by the Pelasgians.[46] The Arkteia also figures in the narrative of this early period: after repairing to Lemnos, the Pelasgians returned to kidnap "the maidens who were performing the Bear for the Goddess at the Brauronia."[47] The krateriskoi, I believe, represent this legendary state—not the "here and now" of Athenian fifth-century life but the Athens of a faraway past.

Let us examine at this point the evidence provided by three exceptional vases held in a private collection and lacking any indication of provenience.[48] These are not ritual vases, being larger than the black-figure krateriskoi dedicated at the Attic sanctuaries of Artemis and painted in red-figure technique. They correspond, nevertheless, to the krateriskoi in shape and in the subject matter of the scenes. As much as their modest black-figure counterparts, therefore, they belong to a discourse about the Arkteia. All three survive in fragments. On two are representations of the girls' races at a festival in a sanctuary indicated by the altar and palm tree. The first

shows tall maidens in dress and mantle—one holding a basket; another, leafy branches; a third is addressing a little girl, dressed in a loose, short tunic. A footrace of little girls similarly dressed follows.[49] The second red-figure krateriskos (fig. 135) shows the footrace of nude maidens carrying garlands.[50] Like the ones on the ritual krateriskoi, this picture has been understood to represent the performance of the *arktos,* indeed, to give the picture of the moment when the girls have shed the *krokoton* and perform nude races and dances. But here are difficulties. First, the painter has been at pains to make it clear that not one but two different age categories take part in the race by including among the adolescent runners one who is younger—that is, shorter and flat-chested. Second, the fauna is richer, with a small lower register showing dogs pursuing a hare and, in the picture itself of the race of maidens, a fleecy bear before the palm tree.

This figure anchors the picture to a specific frame of reference, for the bear belongs to the foundation legends for the ceremony which the Athenian girls performed at Brauron and at Munichia. The versions of the *aition* for the performance of the Arkteia at Brauron, preserved in the scholia to *Lysistrata* and in the *Suda,* are remarkably similar and consistent. In the words of the scholium to line 645 in the Ravenna manuscript of *Lysistrata:*

> A she-bear was given over to the sanctuary of Artemis and became
> tame. One day a girl teased her and was blinded by the bear.[51] In
> his grief, the girl's brother killed the bear. Artemis then, enraged, de-
> manded that every girl imitate (*mimesasthai*) the bear before she marry,
> and circle (*periepein*) the sanctuary wearing a saffron-colored mantle
> (*krokoton himation*), and this was called playing the bear (*arkteuesthai*).
> Others add that [Artemis] inflicted a plague upon the Athenians. And
> the goddess said that there would be an end to their woes, if as penal-
> ties for the slain bear they compelled their maidens to perform the bear
> (*arkteuein*). When the oracle was revealed, the Athenians decreed that a
> maiden could not marry, unless she had performed the bear for the
> goddess.[52]

The definition of *arkteuesthai* in the Ravenna scholium is repeated in the Leyden scholium to the *Lysistrata* passage, with some additional information:

> Imitating (*mimoumenai*) the bear, they executed the secret rite (*muste-
> rion*). The girls who played the bear for the goddess wore the *kroko-
> ton* and performed the sacrifice to Artemis Brauronia and Artemis
> Munichia.

The *Suda* (s.v. "Arktos e Brauroniois") adds that the "women" (*gunaikes*), who played the bear, held a "festival" (*heorten*) for Artemis.

Wearing a special mantle, performing sacrifice, and circling the sanctuary are actions that point prima facie to a procession to the altar in festival garb followed by a circular dance. How they add up to "imitating the bear" remains to be seen. What is clear, however, is that the bear *qua* beast figures only in the myth. Its appearance at the race of nude maidens has the effect of locating that representation in the mythical discourse of the foundation of the cult. There were probably other representations of the *aition*. A statue from the Acropolis, possibly from the shrine of Artemis Brauronia, may have been part of a group depicting the blinding of the little girl: it is a bear sitting on its haunches, front paws lifted.[53] The girl herself was recognized in a statue from Brauron of which only the head survives—the head of a pretty, blind child wearing a fancy diadem.[54]

With the third red-figure krateriskos (fig. 136) we unambiguously are confronted with a myth:[55] the story of Callisto, who was turned into a bear. In the several variants of the legend, scholars distinguish an Archaic from a Hellenistic tradition. Sources, which ultimately depend upon Eratosthenes' *Catasterisms*, attribute the former to Hesiod.[56] Callisto, daughter of Lycaon, was a virgin huntress and a companion of Artemis. She was raped and impregnated by Zeus and eventually gave birth to a son, Arcas. Artemis punished her for this by transforming her into a bear. In this version, the metamorphosis precedes Arcas's birth. The nexus between this part of the story and the next, which culminates in Callisto's catasterism, is garbled and probably contaminated.[57] Callisto the bear enters the sanctuary of Zeus Lycaeus, where men are forbidden to enter. Her son, now a young man, pursues her there, and he is about to kill her for the transgression, when Zeus intervenes, and transforms them both into constellations: the Great Bear, or Ursa Major, and Boötes, or Arctophylax.

Like its companions, the action on the third red-figure krateriskos unfolds over both sides of the vases, with leaping stags placed over the handles providing continuity (fig. 136). Artemis, flanked by Apollo and a standing female all wrapped in her mantle, aims her arrow at Callisto and Arcas. On the other side, mother and son are in the process of becoming beasts, with human bodies but the heads of bears.[58] The picture contains elements that may point to a tradition of the myth that is thought to be a Hellenistic development and is the basis for Ovid's treatment of the theme.[59] In that version, the divine agent of Callisto's transformation into a bear, after the birth of Arcas, is not Artemis but Zeus's jealous wife, Hera. And it is Hera who persuades Artemis to shoot down Callisto. The fact that in the picture

mother and son are side by side indicates that, indeed, the metamorphosis takes place after the latter's birth. The mantled figure may be Hera, as well as Leto,[60] and Artemis does point her arrow at the unhappy creatures.

None of our sources for the foundation legend of the Brauronian *arktos* mentions Callisto. Nevertheless, by virtue of its shape and by analogy with the scenes on its companion pieces, the third krateriskos squarely places the myth of Callisto in the discursive context of the Brauronian ritual and invites us to draw a connection between the two. In fact, structural correspondences between the Callisto myth and the foundation legend of the Brauronian and Munichian rites were noticed long before this vase came to light.[61] The most striking of these may be the fact that in both, the bear finds asylum in a sanctuary and there is killed (or nearly killed). Mapping the connection between Callisto and the tame bear slain by the Athenians is entirely a matter of conjecture. But in Callisto one finds the key to the puzzle of how a ring dance in fancy dress might be construed as "imitating" the bear. For Callisto is, in that order, a maiden, a bear, and a constellation. And, in the ancient Greek imaginary, constellations such as the Great Bear are dancing choruses of maidens.

The idea that the heavenly *kosmos* consists of the harmony-filled dances of planets and stars is well attested in Greek thought.[62] The catasterism of Callisto is one of many performed by Zeus, including those of the Pleiades and the Hyades. The former tried in vain to escape the endless chase of Orion, until Zeus turned both pursuer and pursued into constellations.[63] Zeus likewise took pity on the Hyades, whom Hesiod compared with the Graces, when they sorrowed away over the death of their brother.[64] Both bands of maidens joined the dance of the stars in the night sky. In *Electra*, the chorus describes them as they appear on Achilles' shield:

> The sun's blazing circle,
> Drawn up by winged horses,
> And the ethereal choral dances of stars
> The Pleiades and the Hyades,
> Terrifying in the eyes of Hector. (Euripides *Electra* 65–69 [trans.
> Miller 1986])

While in the constellations of the Pleiades and the Hyades each star represents a maiden, her catasterism has the effect of placing Callisto in the midst of a chorus of stars. A scholiast's explanation of an expression in Nicander's *Alexipharmaca*, Ἄρκτον ὑπ' ὀμφαλόεσσαν, thus evokes the image of the dance. Nicander calls the Bear *omphaloessan*, "omphalos-like"—the

scholium explains—either because it revolves around the Arctic Pole, or in reference to the Great Bear itself, "on account of the chorus of stars that surrounds it."[65]

If the movements of constellations may be cast as the choral dance of maidens, do choral dances of maidens ever mimic the dance of the stars? Debate over this issue has centered upon a scholium to Euripides' *Hecuba* 647, which contains a digression about the movements that accompanied the strophe-antistrophe-epode sequence. These correspond to the movements of heavenly bodies:

> As they say, the strophe portrayed the movement of the heavens from east to west, the antistrophe the movement of the planets from west to east, and the epode, which the chorus sing standing still, the fixed position of the earth.[66]

Given its context, this statement may be understood exclusively in reference to the tragic chorus. The *Etymologicum Magnum*, however, offers a similar statement with regard to lyric song, namely, the *hyporchema*:

> When they ran around the altar, they moved first from left to right, in imitation of the circle of the zodiac, which moves in a direction opposite to that of the heavens, from west to east. Then they moved from right to left, imitating the motion of the heavens, and finally they ran around the whole altar.[67]

These passages document the notion that the heavenly *kosmos* was the model for at least certain kinds of choral dances.[68] To go from here to postulating that choral dances might be cast as the dance of stars is a long step, but not an impossible one. There is some evidence that choral singers, as well as the choruses of drama, impersonated imaginary or mythological characters. After all, in its every performance the chorus that sang Theocritus's *Wedding Song for Helen* assumed the persona of the band of Helen's companions. And one finds in Athenaeus the description of an elaborate wedding featuring a chorus of one hundred men singing a wedding hymn, followed by dancers, some dressed as Nereids, others as Nymphs.[69] The possibility of a different understanding of the Arkteia presents itself at this point, conjectural, no doubt, but in agreement with the evidence—such as it is. The *aition* of the slain bear was understood in reference to the myth of Callisto, including her catasterism. The price, which Artemis exacted from the Athenians, was that their daughters honor Callisto. They would do so by

mimicking the movements of the Great Bear—the constellation, that is, not the beast. In other words, the *arktoi* perform a choral dance that imitates the movement of the stars, "circling" or "revolving around" the sanctuary.

In the imagery of monuments pertinent to a cult, the representation of the foundation legend is appropriate, indeed essential, having the task of grounding ritual practices in the unquestionable authority of ancestral custom, of overlaying them with the gilt of venerable antiquity. In such a way, the war of the Gods and the Giants that is the *aition* of the Panathenaic festival is the appropriate subject for the decoration of the tapestry that is dedicated to Athena on that occasion. For that reason, Athena's pyrrhic dance, performed on the occasion of the victory, is the image, basically unchanged for centuries, painted on the amphorae given as prizes at the festival.[70] In the same manner, the foundation legend of the Arkteia is a suitable subject for vases related, in a fashion yet to be determined, to rituals that took place in Attic sanctuaries of Artemis. If this hypothesis is correct, what we are being shown on the krateriskoi is not an image directly drawn from the performance of these rituals but something as removed from real life as proto-Athens. The primitive city is a place where the children of citizens—boys as well as girls—are sent to fetch water, where the countryside is well watered and well stocked, with stags and bears roaming near the city, when girls were brought up the way boys were. The pictures, then, do not represent the fifth-century Arkteia but a landscape with figures of the sanctuary of Artemis at the time at which the incident that determined the institution of the Arkteia took place. In no way do the images allow the conclusion that in fifth century Athens girls underwent initiations that included nudity, only that the daughters of ancestors *may be represented* doing so.

An ancient Arkteia instead may be involved in the picture on a Classical krater from Brauron, of which only a fragment survives (fig. 137). What remains is the lower end of a scene featuring a large altar. To its left is a male figure in himation seated on a chair; behind and to the right of the altar an indistinct mass that may be a heap of clothes. In front of the altar, on its platform, is an black-figure krateriskos, painted with the footrace of nude girls, lying on its side.[71] In Athenian iconography, the fallen object signals the surprise and disarray of the victim of a sudden violent attack. In such a way, for example, the hydria that Polyxena had been carrying lies on the ground beneath the horses in scenes that represent her and Troilus in flight from Achilles' ambush.[72] In a similar way, in the Pan Painter's depiction of the attack on Heracles by Busiris's men, the hero's club has fallen right in front of the altar on which they intend to sacrifice him.[73] The closest parallel to the scene on the Brauron fragment is the rape of the Leucippidae on

a hydria by Meidias (fig. 138).[74] In the upper part of the field, the Dioscuri are in the process of loading the maidens onto awaiting chariots. Below, Aphrodite sits by the altar, in front of which is a fallen sprig. The subject of the Brauron krater should be a mythical rape of a maiden caught as she was carrying her krateriskos to the altar. Boreas's rape of Oreithyia come to mind —although no surviving account of the myth locates the action at a sanctuary of Artemis—and the Pelasgian assault upon the Athenian women at Brauron.[75]

The foregoing analysis proposes a tamer and more prosaic interpretation of the Arkteia than the one that is widely accepted now. The festival was the occasion on which girls donned for the first time the mantle, the *krokoton himation* that would be the outward mark of their *aidos* from that point onward. No doubt, the ritual marked a rite of passage, although not one that was tied to a momentous event in the girls' life, since they were well below the age of menarche and far away from marriage ad childbirth. Beyond this step, there awaited them a life of spinning and a dependency on cosmetics and jewelry. With respect to the democratic polis, however—as it comes into being in the last decade of the sixth century B.C., which is the date of the earliest krateriskoi—the social import of the ritual is evident. Participation in the Arkteia was restricted to the daughters of Athenian citizens. Therefore, the roster of the devotees of Artemis Brauronia, inscribed on stelae displayed at Brauron and the Brauronion on the Athenian Acropolis, defined as well the pool of "Athenians," *astai*.[76] By the middle of the fifth century, Pericles' law of citizenship established that they alone were capable producing citizens.

The analogy with male initiations, which representations of Spartan customs advertise and which emerges as a more muted suggestion in the Athenian Arkteia and in other cities of Greece, is far from a full correspondence. It is characterized on the one hand by poverty—lack of mythical paradigms, lack of corresponding institutions, modest and private rituals—and on the other, by incoherence. The transvestism of the Spartan bride, for instance, suggests transsexual change but does not result, as it does for the boys, in a transformation of gender. The elusiveness, incoherence, and randomness of rites of female "initiation" in ancient Greece do not simply constitute "negative evidence" but conform to a pattern that is ethnographically well documented in age-class societies. The definition of a female age class in terms of structural age occurs, if at all, in connection to the onset of menarche; thereafter, the women are spoken of as belonging to classes defined in terms of social condition—unmarried, married, widowed—rather than by age.[77] It is also common to find that ceremonies marking the pas-

sage from one class to another are patterned on the rituals of the male initiations, that they are, as it is said, "reflections" of the latter.[78]

That a correspondence should exist at all is remarkable in itself. If female rites of passage do not have the same purpose and results as those for males, why are they represented as corresponding to them, and what is the sense of this representation? Their purpose, I believe, is to articulate the same notion that scholars express with the oxymoron "women of citizen status": to indicate the only way in which women share in the estate of men, as daughters, wives, and mothers of citizens. It is not womanhood that these ceremonies bring to fulfillment; the issue is not gender and empowerment but social status. While it is given as a fact that the women of citizens are incapable of self-governance and unfit for citizenship, it is also a fact that they are to be distinguished from other creatures that are more inept even than they are, such as slaves. The notion of these three degrees of humanity is pervasive and clearly stated, for instance, by Aristotle:

> There are by nature various classes of rulers and ruled. For the free rules the slave, the male the female, and the man the child in a different way. And all possess the various parts of the soul, but possess them in different ways; for the slave has not got the deliberative part at all, and the female has it, but without full authority, while the child has it, but in an undeveloped form. (Aristotle *Politics* 1260A7–14 [trans. Rackham 1959])

The boy has the potential for change; girls do not change when they become women, because they remain female—development is just not in the cards for them.[79] Better than words, the visual representation of women conveys the fact that women grow old, but they do not grow up. In the conventional language of the painted vases, the age of males is expressed by a combination of features, the most important of which are size and facial hair.[80] Several stages are conveniently illustrated in the assortment of males on a hydria by Phintias (fig. 139): a young adolescent, perceptibly smaller than other figures in the same scene, and perfectly hairless; a youth in his *hebe*, who is full grown but does not yet have a real beard.[81] This is a phase marked by the wispy sideburns that are the visual equivalent of what Plato calls "the first down on the cheeks," the *hora* of incipient manhood. The men in the picture have full beards and moustaches. Old men, like old women, are wrinkled, gray, sometimes bent and fat.[82] The characterization of females is parallel, but a step is missing. It is possible to tell adolescent girls, as was said above, by the fact that they are smaller in size; they may, in addition, have small breasts, although this feature is rare. No distinction

no distinction made

is made, however, between <u>maiden and matron: both are tall and buxom</u>, <u>their features and clothing indistinguishable</u>. Examples may be drawn from representations of goddesses as well as of mortals.[83] In scenes of Apollo between his mother and his sister, Artemis and Leto have the same features and the same costume; in a picture of the attempted rape of Leto by Tityos, Leto is no older-looking than her daughter (fig. 140).[84] In a scene of Argive heroines *en famille* (fig. 2), Helen and Clytemnestra are just as girlish as the latter's daughter Iphigenia;[85] in representations of the murder of Aegisthus, it is their different roles that allow one to distinguish between Electra and her mother.[86]

The only women who reach <u>middle age in Greek vase painting are prostitutes</u>. "Lovemaking" is a common subject on Attic vases of the sixth and fifth centuries, one on which much scholarship has focused in recent years. These representations, as Dover noted, reveal a substantial difference in the conception of women and boys as object of love in that, unlike the boy, the woman "is always in a 'subordinate' position."[87] This attitude is taken to extremes in a small number of Late Archaic paintings in which women are represented as abject creatures on whom every brutality may be visited. Prone on the ground or bent over stools, these persons are penetrated in every orifice, sometimes simultaneously, slapped around, singed with lamps.[88] These women are the exception to the ageless beauty of the female image that the vase painters offer us as a rule. They are past their prime, with rolls of lard at the waist and double chins, and they are homely, with large noses and low, bumpy brows (fig. 141).[89] There are elements to identify them as prostitutes: occasionally, short hair marks them as women of servile condition, and they are subjected to intercourse on the floor or on benches.[90] The notations of age are thus joined to those of ugliness in the figure of the *porne*. <u>She is the source of lust, rather than longing</u>. As in the case of the Proetids, with whom this chapter opened, her *makhlosune* takes the form of monstrously inappropriate masculine characteristics—in their case, adult age.

Between Men

> If I must also say something about womanly virtue, those
> who now shall be widows, I shall point to it in a brief ex-
> hortation. Great repute attaches to being not inferior to what
> you are by nature, and to her whose renown among the
> men is least, whether in praise or in blame.
>
> Thucydides, *History of the Peloponnesian War*, 2.45.2

The idea that marriage is an initiation, although not for men, has been
in the air for some time. Long before Vernant's quotable phrase that
"marriage is to a girl what war is to a boy," [1] the analogy between the com-
ing of age of the young men and the marriage of the girls occurs insistently
in ancient sources. In the Demosthenic speech against Neaera, to give just
one example, the speaker equates the admission of one's sons into the
phratries and their inscription in the demes, on the one hand, and the giv-
ing of one's daughters in marriage, on the other, as events by which both
girls and boys take their place in society. [2] This is, of course, a false symme-
try. Scholars from Van Gennep to Brelich and beyond have confronted the
slippage by pointing to the fact that "the social activity of a woman is much
simpler than that of a man," [3] which is to say that marriage is as much of an
initiation as a woman can sustain. Support for this idea has been found, be-
sides, in the conceit, widespread in Greek culture, that the death of an un-
wed maiden is a wedding in Hades or to Hades himself. The resemblance
of certain features of the ancient Greek wedding to features of funerals have
been stressed: the body is washed and dressed, it changes residence accom-
panied by song and by torchlight, and both ceremonies involve feasts. These

this is now reversed!

similarities have been taken to show that weddings and funerals are struc-
turally alike and that the wedding produces in the woman an irreversible
change and seals her incorporation in a new community.

Whatever change marriage produced in a woman, however, its impact
remained imperceptible to the eye. The latent character of female adult-
hood in the pictures examined in chapter 7 is in line with other kinds of ev-
idence that stress the impermanence of the marital union, the fact that the
married woman is denied full integration into the group to which she is
now attached, the reversibility of her condition. What effect did marriage
have on a girl, and what kind of rite is the Greek wedding?

A fundamental change informs the practice of marriage in the polis from
that described in the epic poems. In the world of the epic poems, the bride
is a prize for which men compete and for which they pay compensation,
the *hedna*, to her father or guardian, her *kurios*. The payment may take the
form of goods—cattle, ideally—or services, the performance of extraor-
dinary feats.[4] Things are different in the Archaic and Classical polis. For
one thing, men do not compete for the hand of a maiden. In this respect,
the procedure followed by Cleisthenes, tyrant of Sicyon to select a husband
for his daughter Agariste is the exception, a deliberately archaizing, self-
aggrandizing display that evoked the epic model but substantially observed
current customs.[5] It has been observed that that model is the courtship of
Helen, which brought to Sparta the kings of Greece bearing gifts and offers
of large *hedna*.[6] Tension and the possibility of strife among the suitors were
in this case particularly high, but even under the best of circumstances, the
relationship between the contenders for a bride's hand and her father and
fellow suitors may be described as adversarial. For Agariste's noble and
handsome suitors likewise came from all corners of Hellas, and Cleisthenes
kept them for a year, personally testing their manliness, their athletic skills,
their table manners, their worth as musicians and dancers. One may rec-
ognize in this procedure a version of the ordeals to which mythical suitors
were subjected, although one in which one risked only rejection. These suit-
ors brought no gifts and promised no *hedna*. Instead, they were lavishly en-
tertained by the tyrant, and all who were not chosen received a talent of sil-
ver as compensation. Agariste was given to the Athenian Megacles by *engue*,
according to the Athenian custom, that is, with a dowry.

In the imaginary world Homer describes, the practice of *hedna* coexists
uneasily with instances in which the bride is given away endowed.[7] On the
other hand, the *hedna* is unknown in the historical world of the polis, al-
though the word survives as an alternative name for the gifts given to the
bride by the groom in the course of the wedding.[8] In the polis, the custom

of providing the bride with a dowry is an essential element of legitimate marriage. I move forward from Gernet's premise, developed by Vernant, that this was not "a spontaneous or gradual development but the substitution of one social praxis with another,"[9] a radical change that was tied to the establishment of the polis. This shift in the rules governing the exchange of women between men reflects a new conception of the relationship of the family and the state, and a changed definition of the condition of wife. What follows is an attempt to bring to the fore ideas about marriage and womanhood, largely on the basis of Athens, the city-state about which we are best informed.

SECURING A BRIDE

The fundamental facts about marriage in Archaic and Classical Athens are generally agreed upon.[10] One distinguishes two important moments: the *engue*, usually translated as "betrothal," and the *ekdosis*, or transferal of the bride to the groom, accompanied by ceremonies that could be collectively called *gamos*. As an ancient law cited by Demosthenes makes clear, a man could keep in his house two kinds of women: his wife, and concubines, *pallakai*, with whom he would have freeborn children.[11] What distinguished the legitimate wife, *damar* or *gune gamete*, from the *pallake* was her capacity to produce children who would be not just free but future citizens, *gnesioi*. The act that established that capacity was a procedure called *engue*, as we learn from another law cited by Demosthenes and attributed to Solon by some:

> She whom her father or her homopatric brother or her grandfather on her father's side gives by *engue* to be a lawful wife, from her the children shall be legitimate.[12]

[handwritten note:] ⟶ all about rites and agreements; laws

The *engue* is not without its mythical paradigms, which make it clear that it was an event distinct from the *ekdosis*. In Euripides' *Iphigeneia in Aulis*, Agamemnon points to the fact that Achilles' mother, Thetis, was betrothed by Zeus, then given by her *kurios*, her father Nereus (703). In Euripides' *Phoenician Women*, Eteocles, who had betrothed Antigone to Haimon, charges Creon, who would become her *kurios*, with the task of giving her away (757–760). The earliest recorded instance of a historical *engue* is that of the marriage of Megacles to Agariste.[13] Cleisthenes says solemnly, *enguo*, which may be provisionally translated as "I pledge." Megacles' reply in the middle voice may mean "I accept the pledge" or "I pledge myself." Cleisthenes then

proceeds to execute the marriage. The formula occurs again in very similar form in comedy. The formal surrender of the bride to the groom, the *ekdosis*, might follow immediately or at a distance of time.[14] The *ekdosis* is the occasion for elaborate rituals, which include sacrifice and the bathing of the bride and groom. On the Anakalypteria there would be a banquet for the two families and friends, normally at the bride's house. The bride would be "uncovered" or "unveiled" and honored with gifts. The transport of the bride from the house of her *kurios* to that of her husband took place in the evening by the light of torches. In her new residence, more ritual secured the incorporation of the bride in the husband's *oikos:* the eating of a special food, a quince or pomegranate, and the showering of the pair with a basketful of dried fruits and nuts. With the consummation of the marriage began cohabitation.

There has been considerable debate in the past one hundred years as to which of these actions meets a juridical definition of marriage.[15] At no point in the procedure was there a moment at which the bride consented to the marriage. The only step that had legal consequences was the *engue*, for which not even her presence was required and which insured the status of children who might be born, should the parties involved actually ever enter into cohabitation.[16] But a woman thus promised might never be given away. For example, Orestes, who had pledged Electra by *engue* to Pilades, thus honoring their companionship, later advises him against marrying her (Euripides *Orestes* 1078–1079). As a historical example of an *engue* that had no effect, one often cites the notorious case of Demostenes' father, who near death pledged by *engue* his wife to Aphobos and his five-year-old daughter to Demophon.[17] In the event, neither marriage took place. In another fourth-century court case we find the *engue* deployed as a stratagem, in order to allow an illegitimate son to inherit.[18] When his legitimate son opposed his plan to introduce his son by a concubine into his phratry, Euctemon contracted with Democrates of Aphidna the *engue* of the latter's sister. Threatened with the prospect of the birth of more legitimate heirs with whom he would have to share his father's patrimony, Philoctemon withdrew his opposition, and the *gamos* of Euctemon and Democrates' sister never took place. The nonbinding quality of the *engue*, coupled with the fact that no other part of the procedure was in and by itself constitutive of marriage, leads one to conclude with MacDowell that "the legal difference between *engye* and *gamos* was, roughly, that *engye* was making a contract and *gamos* was carrying it out."[19] need both for legit. heirs

I now turn from the fact of the matter to the poetic qualities of legal formulas to consider first the *ekdosis*, then the *engue*, and finally the bride of

Hades metaphor. It is my thesis that the marriage procedures are governed
by a basic metaphor of commercial transaction out of which spins a series of
interrelated metaphors that are employed in rituals and in literary imagery.

What we call giving away the bride is expressed in the epic with the
simple *didomi*, "I give." In Classical Athens, *didomi* may again be used, as it
is, for instance in Menander's use of the formula, in which the bride is given
for the plowing: [20] "I give you this woman for the sowing of legitimate chil-
dren." But the technical terms for the conveyance of the bride are *ekdosis*
and the verb *ekdidonai*, "to give out," as it is used, for instance, by Isaeus.
The speaker's mother's legitimacy is demonstrated by the fact that she had
been "given out" by her father as well as "betrothed":

> For distant events I furnished hearsay vouched for by witnesses; among
> those who are still alive, I produced those who are familiar with the
> facts, who knew well that my mother was brought up in his house, that
> she was regarded as his daughter, that she was twice given out in mar-
> riage (*ekdotheisan*), twice pledged (*enguetheisan*).[21]

Wolff demonstrated that *ekdosis* is the term used in contracts for "a transfer
which . . . conferred title upon a transferee, but at the same time reserved a
right for the transferor."[22] In this sense it is employed for slaves handed
over for questioning by torture in lawsuits. In papyri it refers to the hand-
ing over of the baby to the wet nurse, and of an apprentice to a master. In
Xenophon's tract on horsemanship, for instance, *ekdidonai* is used both for
giving one's son out as an apprentice and for entrusting a colt to a trainer.[23]
The *ekdosis*, that is, is not a permanent surrender of the bride to the groom
but a conditional lease for the expressed purpose of producing legitimate *Lease!*
children. The metaphor is apt. Her natal family never relinquished its con-
trol over the married woman and the dowry that went with her, both of
which might revert to it for a variety of reasons.[24] We are best informed
about cases in which a married woman came into an inheritance, becom-
ing *epikleros*, and was claimed by her nearest male relative on her father's
side.[25] But marriages could be terminated for no particular reason, and
there is general agreement that divorce was easily obtained, although there
is debate on how frequently it actually occurred.[26] To this add that the mar-
ried woman did not become part of her husband *ankhistheia*, the group of
kin with rights of inheritance.[27] *no inheritance from husband*

No less than *ekdosis*, *engue* is used for a range of commercial transactions
that require a guarantee or the establishment of securities.[28] One pledges
himself as surety in the middle voice, and the thing which is pledged is the

engue, a sum of money in the case envisaged in Demosthenes' speech against Apaturius, who, had Demosthenes truly become guarantor, *enguemenos,* for Parmeno, would surely have demanded the sum guaranteed, *enguen,* at once.[29] The word is also used for posting bail, as in the case of the law introduced by Timocrates, cited by Demosthenes: sureties were established for the payment of bail money.[30] One understands the relationship between the two meanings of the word intuitively to mean that the future bride is pledged. But the words *engue* and *enguan* contain a schema, a metaphor, an image, upon which rests our understanding of the formalities of the *engue* and of its import. Since antiquity that figure has been reconstructed on the basis of a hypothetical etymological derivation of *engue* from *guion,* in the sense of hand, the hollow or palm of the hand.[31] This has led to seeing the *engue* as a "handing over," which has taken two distinct forms. Wolff understood *enguan* to mean "to hand over" and *enguasthai,* "to receive into one's hands." He explained the use of the same term for both guarantee and betrothal on the model of the Germanic contract of suretyship: "[G]uarantee was contracted by handing over the debtor to the guarantor who was to exercise control for the purpose of keeping the debtor at the creditor's disposal."[32] Accordingly, the bride would be placed in the groom's hands but kept at her father's disposal. This metaphor is inept in several obvious respects, the most important of which is that it is not at this stage that the bride is given to the groom. Gernet's explanation has won favor that the term originally meant a solemn promise made on behalf of the family group rather than the transferal of an object or person. In his view, what is put in the hand is a pledge, signified by a handshake.[33] This rationalizes the metaphor implicit in *engue* but does not bring its image into focus. What is the thing that is placed in the hand? The fact of the matter is that in the *engue* nothing changes hands, except, sometimes, the dowry.

According to Chantraine, *gue, guia,* and *gualon* constitute a group of terms that go back to the notion of "hollow," "vault." "The concrete sense of the group," he writes, "appears in the substantive . . . *gualon,* which designates various kinds of 'hollows.' "[34] This, I believe, is the image we are after. Hesychius defines *guala* as treasuries, vaults, hollows, but *guala* may also be said of cups and the canopy of heaven.[35] What holds together these various meanings is the image of a hollow space as a container. A dominant image is that of the stony hollow and the cavern. In Callimachus's *Hecale,* the great stone under which Aegeus places the sword and the boots for Theseus to find once he grows strong enough to lift it is a *gualon lithon.*[36] *Guala* may be valleys, such as the valleys of Pieria, which hold the tomb of Euripides, in an epigram by Ion.[37] In Pindar's tenth Nemean ode, the Dios-

curi, who share one life by spending each alternatively one day on earth
and the other in Hades, are said to be in the caves of Therapne, deep under
the earth.[38] In Euripides' *Andromache*, the underground caverns at Delphi
are both caverns and treasury, they are caverns filled with gold:

Ὁρᾶτε τοῦτον, ὃς διαστείχει θεοῦ
χρυσοῦ γέμοντα γύαλα, θησαυροὺς βροτῶν,
τὸ δεύτερον παρόντ' ἐφ' οἷσι καὶ πάρος
δεῦρ' ἦλθε, Φοίβου ναὸν ἐκπέρσαι θέλων;

[See that man who moves along the god's caverns filled with gold, trea-
sure houses of mortals, who comes again with the same aims as he did
when he came before, to sack the temple of Phoebus?] (*Andromache*
1092–1095)

Here, as elsewhere, the sense of *gualon* is akin to that of the English
"vault." The sense of depositing something of value in the vault underlies
the metaphoric use of *engue* in Aeschylus's *Eumenides*. The final dialogue
between Athena and the Furies is shot through with metaphors of com-
mercial exchange:

Χο. καὶ δὴ δέδεγμαι· τίς δέ μοι τιμὴ μένει;
Αθ. ὡς μή τιν' οἶκον εὐθενεῖν ἄνευ σέθεν.
Χο. σὺ τοῦτο πράξεις, ὥστε με σθένειν τόσον;
Αθ. τῷ γὰρ σέβοντι συμφορὰς ὀρθώσομεν.
Χο. καί μοι πρόπαντος ἐγγύην θήσῃ χρόνου;

[Ch. Now suppose I have accepted. What reward is in store for me?
Ath. That no household shall flourish without you.
Ch. Will you bring this about, that such power be mine?
Ath. We shall raise the fortunes of the one who reveres you.
Ch. And will you lay in store for me the fund of all time to come?]
 (*Eumenides* 894–898)

To Athena's offer of hospitality the chorus replies by asking what their com-
pensation will be—*time*, honor, but also reward and price. Athena prom-
ises to augment the fortunes of those who hold them in awe. When the
chorus ask if this will be forever, they use the expression *enguen tese*, will
you set, lay down, or deposit, as in a bank, an *engue* of all the time to come?
 The image of laying valuables in store in a vault, an underground vault,

structures the sense of *engue* as "deposit," one that suits its use both as guar-
antee and betrothal. For an understanding of the way in which *engue* and
ekdosis follow one another as stages of one and the same process, I rely on
Benveniste's explanation of the peculiar semantic development connecting
the expressions for hiding, burying, on the one hand, and giving out and
lending, on the other, in Gothic. While *filhan* means to hide, to withdraw
from sight—corresponding to Greek *krupto* and *thapto*—*ana-filhan*, equiv-
alent to Greek *ekdidosthai*, means "to give out," "to lease."[39] The German
practice of burying resources and valuables, Benveniste reasoned, underlies
the idea that goods that may be leased are buried treasure, which is un-
earthed at the moment of conveyance. What comes into play—not sur-
prisingly—is the image of the bride as treasure.[40] The fact that the female
is "spoken for" is cast in the figure of capital withdrawn from circulation
and placed in the vault, from which she will taken out when the moment
comes to hand her over to the groom.

ANAKALYPTERIA

The poetic force of the metaphor of the bride as buried treasure informs the
marriage ritual. An important phase of the *gamos* was the Anakalypteria,
first attested in a fragment of the cosmogony of Pherecydes of Syros, which
will be considered below. Most of our information, however, comes from
late sources, which explain that on that occasion the bride was "uncov-
ered."[41] The idea took shape long ago that the play of concealment and rev-
elation that the word implies was acted out through a formal unveiling of
the bride. There is now general agreement that the term was "used for
both the ceremonial unveiling of the bride before the bridegroom and also
for the gifts given by the groom to the bride immediately following this un-
veiling."[42] One should note, however, that Anakalypteria does not mean an
act of unveiling.[43] The term was used for the day on which the bride was
"uncovered" or "unveiled" for the groom to see and also for the gifts she re-
ceived on that day from the groom, relatives, and friends.[44] The lexicogra-
phers give *theoretra* and *opteria* as synonyms, both signifying seeing, as well
as *prosphthenkteria*, which emphasizes the fact that the bridegroom ad-
dressed the bride.[45] The singular *anakalupterion* signified the moment when
the bride was brought out, on the third day, as well as a gift given on that
occasion.[46] Debate continues over the place occupied by the unveiling in
the sequence of events that constituted the wedding ceremony.[47] A few
points seem secure. One source specifies that the brides "are uncovered,"
anakaluptontai, at the wedding feast for the husbands and guests to see.[48]

Since that was the moment at which she first became visible, the bride's un-
covering must have taken place before the couple's voyage to the husband's
house, on foot or by wagon.[49]

Reasonable as it seems, the hypothesis that there was a ceremonial un-
veiling runs into difficulties, in part because it is difficult to decide what form
the veiling took, in part because not every unveiling is an *anakalupterion*.
We have literary and visual evidence to the effect that the bride was well cov-
ered during and after the banquet. A caricature of the procession on a Clas-
sical Athenian vase shows her entirely wrapped, for example.[50] Lucian in his
Symposium writes of the strictly veiled bride at her own wedding feast (8).
And a metaphor in Aeschylus's *Agamemnon*, which is sometimes brought
forward in support of the unveiling,[51] seems to say precisely the opposite.
In that passage, Cassandra says: "[N]o longer will my prophecy peek out
from under veils, like a newly wedded bride (*neogamou numphes diken*)"
(1178–79). The *neogamos numphe* is the bride, but the bride just married,
not the bride-to-be. In addition, the newly wedded bride's mantle, or veil,
figures prominently in representations of the marriage procession, whether
by chariot or on foot, in Archaic and Classical art. On Athenian black-figure
vases it is a richly woven affair that she wears drawn over her head and
holds out to shield her left cheek, in a distinctive flourish that is in part a
display of decorum and in part sheer display. In kind, the "bridal gesture,"
as it is called, is an exaggeration of the act of veiling oneself, which is per-
formed by all persons possessed of *aidos*.[52] On the Francois vase, Thetis is
shown through the half-open door seated in her chamber, holding out the
mantle in this fashion, as the gods arrive to the wedding feast (fig. 83).[53] She
holds this pose standing in the chariot, surrounded by the gods (fig. 142),[54]
but even the protagonist of the Amasis Painter's modest wedding by mule
cart parades her oversize mantle with ostentation (fig. 101).[55] The bridal
gesture is rare on Late Archaic and Classical Athenian vases, but the mantle
is no less in evidence. When the procession is on foot, attention is drawn
to it by the fussy gesture of an attendant, the *numpheutria*, who follows the
bride as the pair approach the marriage chamber, adjusting the way the
mantle falls on her head or on her neck and shoulders (fig. 143).[56] On a
black-figure tripod pyxis of the early fifth century, for instance, is the pic-
ture of the cortege arriving at the newlyweds' *thalamos*. This is the wedding
of Heracles and Hebe, and behind Hebe the woman arranging the bride's
mantle may be Aphrodite.[57] On a skyphos by Makron, it is indeed Aphro-
dite who arranges Helen's mantle, as the latter, as though a bride, is led
away by Paris (fig. 144).[58]

Evidence of the importance of the bride's mantle is not limited to vase

painting or to Athens. From the sanctuary of Persephone at Locri come series of votive terracotta plaques decorated with subjects related to the marriage of Persephone and Hades. These include one series depicting a cortege bringing the mantle, which lays folded upon a tray, and a deep cup (fig. 145).[59] In the representations of the married pair on Classical reliefs depicting the hero at his banquet, the wife performs the bridal gesture.[60] The mantle is at center stage on the metope from the temple of Hera at Selinus that represents a marriage of divinities, probably Zeus and Hera (fig. 146).[61] The god, seated, grasps the bride's wrist in the traditional gesture of marriage. She stands before him, framed by the great mantle. The display of the mantle characterizes Hera among the gods on the east frieze of the Parthenon, advertising the fact that she is the *kouridie alokhos* of Zeus (fig. 147). Does this gesture signify the ritual unveiling at the Anakalypteria? Twice in literary imagery the figure indeed marks the moment at which the bride is transferred to the groom. In a fragment of Euphorion, the city of Thebes is said to be the *anakalupterion* of Zeus to Persephone, "when she was about to see her husband for the first time, turning aside the cover of her nuptial mantle."[62] Centuries later, Philostratus describes a painting of Pelops and his bride Hippodamia in the chariot, "she arrayed in nuptial attire, uncovering her cheek, now that she has won the right to a husband."[63]

There remains to be considered what is arguably the most important testimony for the ceremony: its foundation legend. The *aition* survives in part in a fragment of the sixth-century cosmogony of Pherecydes of Syros. The Anakalypteria, Pherecydes says, has its origin in the marriage of Zas to Khthonie. This is preceded by the creation of his grand *oikos*, composed of houses and possessions. On the third day, Zas weaves the whole world into a great mantle, *pharos*. There follows a lacuna, after which we find Zas offering this mantle to Khthonie and asking her to unite with him. Accepting the mantle, she makes her reply, but at this point the text breaks off:

> For him they make the houses many and great. And when they had
> finished providing all this, and also furnishings and menservants and
> maidservants and all else required, when all is ready, they carry out the
> wedding. On the third day of the wedding, Zas makes a robe, large and
> fair, and in it he weaves Earth and Ogenos and his dwelling . . . "For
> wishing your marriage to take place, I honor you with this. Therefore
> receive my greeting and be my wife." This they say was the first Anaka-
> lypteria, and hence arose the custom among gods and men. And she
> answers him, receiving the robe from him . . . [64]

It is apparent that the information we have about the Anakalypteria breaks down into categories according to the genres of our sources. In the anti-quarian and anecdotal material furnished by the lexicographers, one finds no mention of the mantle in connection with an unveiling, and the bride does not uncover herself but is uncovered. The visual and literary imagery, on the other hand, focuses suggestively on the figure of the mantle and on the gesture by which the bride uncovers herself. And at the heart of the foundation legend is a very special mantle, which the bride does not take off but receives, at a point at which she obviously is in the presence her groom. These are not necessarily contradictory accounts. Rather, one may think of them as representing different points of view of the same events. Understanding the nature of the ceremony involves, therefore, a kind of tri-angulation, mapping the relationship of the archetype of all Anakalypteria to come—its *aition*—to ritual actions and to perceptions and folk explana-tions of those actions. The symbolic import of the mantle can hardly be overplayed, and that shall be our starting point. The robe appears indirectly in another fragment of Pherecydes, where we learn that

> Zas and Khronos existed always, and Khthonie; but Khthonie acquired the name Ge [Earth], since Zas gives the earth to her as a gift of honour (*geras*).[65]

Schibli notes:

> The *geras* is the embroidered earthrobe, the gift of honour and wedding present for the bride of Zas. . . . The bestowal of the robe upon Chtho-nie signifies not only a bridal gift but also an official act of investiture by which she becomes Ge.[66]

In the symbolic function of the mantle in the wedding of Zas and Khtho-nie, we have an explanation of the role of the nuptial mantle in visual rep-resentations of the wedding and the wife. This is the first of a series of cor-respondences between the foundation legend of the Anakalypteria and its earthly performance. Zas's bride is Khthonie, "she who is beneath the earth." Like the word *engue*, her name evokes the image of the bride in sub-terranean confinement, from which she emerges on the day she meets her husband. Khthonie undergoes a transformation. The turning point is her acceptance of the mantle, when the groom addresses her for the first time.[67] With the great *pharos*, she receives the earth as her domain and becomes

[handwritten: Woman becoming Earthly and fertile]

Earth herself. The mortal bride's transformation into fertile ground is stated in the classic marriage formula, which casts her in the shape of arable land: "I give you this woman for the sowing of legitimate children." In other ways, as Detienne has shown, allusions to the cultivation of grain figure prominently in the rituals of the banquet and the procession.[68] The *aition* of the Anakalupteria thus contains the blueprint of the symbolic structure of the wedding, and this should guide our interpretation of the disparate fragments of evidence for the ritual. The "uncovering" that gives the day its name refers primarily, I suggest, to the emergence of the bride into sight from figurative seclusion in *engue*. This is in line with the testimony of Hesychius, who defines *anakalupterion* as the bringing forth of the bride.[69] We are not told how the mortal bride acquired her nuptial mantle nor at which point in the proceedings she donned it.[70] It is possible that it came to be understood simply as nuptial attire,[71] but the votive reliefs from Locri, mentioned above, may indicate that this garment was the focus of ritual acts that have left little trace in the literature. It is likely that the bride wore the nuptial mantle as she emerged from her chamber, at once revealed and veiled, and that, poised in the bridal gesture, she exposed her face to the groom, shielding it, at the same time, from the other men present. Whether or not this act was ritually significant remains to be seen. It certainly came to be perceived as such, as the passages of Euphorion and Philostratus cited above demonstrate.

DEATH AND MARRIAGE

[handwritten in margin: Phrasikleia]

The conceit that the death of a maiden ready for marriage is a marriage in Hades, or to Hades, is commonplace in funerary epigrams and frequently exploited on the Athenian tragic stage. Significantly and poignantly, the moment of death often coincides with the day of the Anakalypteria and the wedding procession. For example, Erinna's epitaph for Baucis tells us that she died as the cortege had reached the groom's house: her father-in-law lights the funeral pyre with the torches that had lit her wedding procession; the *humenaia* turn into dirges. A number of studies produced over the past twenty years have analyzed these and many other examples, in which the death of a maiden or a bride is represented as a marriage in Hades or to Hades himself.[72] These analyses have stressed points of resemblance between the rites of *ekdosis* and funerals. It is now a widely accepted proposition that the correspondences between wedding and funeral are made possible by the fact that the two rituals are structurally alike. Seaford gave an influential formulation of this idea:

That is to say, a transition effected by nature (death) is enclosed by the imagination within a similar transition effected by culture (marriage). It is important to observe that this enclosure is facilitated by the presence in the wedding of elements associated with death, to some extent perhaps actual lamentation, but more importantly "equivocal" elements common to the two rites of passage; in both wedding and funeral the girl is washed, anointed, and given special πέπλοι and a special στέ- φανος in order to be conveyed on an irreversible torchlit journey (on a cart) accompanied by song, and to be abandoned by her kin to an unknown dwelling, an alien bed, and the physical control (χεὶϱ ἐπὶ ϰαϱπῷ) of an unknown male.[73]

similarities

On this basis one speaks of an "interpenetration" or a "conflation of marriages and funerals" in a way that implies that marriage is as much a death as death is a marriage. Against this interpretation of the "bride of death" topos in tragedy, funerary epigrams, and visual imagery stands the fact that, while the bride's death may be cast as a marriage, a marriage is never cast as a death. The bride of Hades, in other words, is a metaphor that projects a very special type of death through the vehicle of the wedding. As any metaphor, it demands that we distinguish between vehicle and tenor and that we know which parts of the metaphoric image to focus on and which ones to ignore. In this case, we know that the bride's journey to her new home is not irreversible and that, far from abandoning her, her kin retains control over her. The metaphor relies suggestively upon the imagery of the Anakalypteria, particularly the procession—the torches, the songs, the wedding chamber. The funeral procession and the marriage cortege, however, are not analogous: one is the reversal of the other. They move, as it were, in opposite directions: the first follows the uncovering, the "bringing out" of the woman; the latter takes her to her burial. The focal image of this metaphor is that of the bride in *engue* as treasure buried or entrusted to a vault. This is the ground upon which her death before or at the moment of the *ekdosis* may be cast as the inversion of her wedding.

Fundamentally, the conceit of the marriage in Hades relies on a commonplace root metaphor, that of the grave as *thalamos*, the place where one goes to sleep. This image is employed in the case of the maiden ready for marriage with a sinister twist. The particular *thalamos* to which she is consigned is projected as the one in which the marriage would be consummated: the room with the nuptial bed, the *numpheion*. The difference between the bland figure of the grave as the final resting place and the grave

of the bride is the difference between a death that is perceived as part of the natural order of things and a death that comes unfairly at the wrong time. The dead *numphe* is *aore*, the untimely dead, whose grave is charged with potency and makes an excellent conduit to the infernal powers.[74] The death of the woman precisely at the point at which she should generate life is a violation of both the natural and the social order. It opens up the vision of the world turned upside down, where "the things of this world can be truly perceived only by looking at them backwards."[75] Because they are polar opposites, marriage and death constitute alternatives, as is the case with Phrasikleia. Her epitaph has her say: "I shall be called kore forever, since the gods destined me to this name in place of marriage."[76] Wedding songs and dirges, wedding torches and funeral torches, the wedding banquet and the meal that follows the funeral are not analogous to one another, but one is the inverse of the other. When they change places, the effect is to invert the ritual. That is, when a maiden ready to marry dies, and particularly when she is murdered, the normal order of things is reversed and the *ekdosis* is replaced by the *engue*, with horrible results.

In Sophocles' *Antigone* this conceit is deployed in a sustained manner, making use of the image of the cavern, the stony hollow. Thebes is a city where cultural norms have been turned upside down, where the dead lays unburied, where it is left to a woman to stand up for what is right. Antigone openly defies Creon's edict, which prohibits the burial of her brother's corpse. The king of Thebes is as well her present *kurios* and future father-in-law, since she is betrothed to his son Haimon. Creon should deliver Antigone to the groom, but he does the opposite. Instead of "giving her out," Creon buries her in "a rocky cavern" (774), to which she is led as though to a bridal chamber—"the hollowed rock, death's stone bridal chamber" (1204–1205).[77] The exclamation of Antigone as she enters the cavern is deservedly the most famous expression of the metaphor of the grave as *numpheion*:

> Tomb, bridal chamber, prison forever dug in rock, it is to you I am go-
> ing to join my people, that great number that have died, whom in their
> death Persephone received. (891–894)[78]

Note that Antigone is not the bride of Hades: let her marry someone *in* Hades, Creon says (654); Hades leads her alive to the shore of Acheron, but to marry Acheron (808–810); and, in the end, she marries Haimon, in Hades.[79]

Antigone's infernal wedding is emblematic of the world upside down

over which Creon rules. Tiresias reveals to him the monstrosity of his
policies:

> You have thrust one that belongs above below the earth, and bitterly
> dishonored a living soul by lodging her in her grave; while one that
> belonged indeed to the underworld gods you have kept on this earth
> without due share of rites of burial, of due funeral offerings, a corpse
> unhallowed. (1068–1071)

This passage unambiguously proposes the death of the bride as a prime in-
stance of normative inversion and the polar opposite of the wedding. For
marriage to Hades, or in Hades, is no marriage at all: no *humenaia*, no
hymns accompany Antigone to the shore of Acheron (806–816); [80] she will
have no bridal bed, no bridal song, no joy of marriage, no portion in the
nurture of children: [81]

> And now he takes me by the hand and leads me away, unbedded, with-
> out bridal, without share in marriage and in the nurturing of children;
> as lonely as you see me; without friends; with fate against me I go to
> the vault of death. (916–920)

Most importantly for present purposes, death is a state from which a
woman never will emerge, and that is not true of marriage. The dead is per-
manently separated from the living and incorporated into the community
of the shadows; the boy is initiated into the polis. Neither can ever go back
to what he was before. But a woman can cross the threshold of marriage
many times over, unaccompanied by ritual on the reverse journey, becom-
ing each time a bride again, to be pledged and given out, to be revealed
again for the first time and carried off with torches raised high and the
singing of *humenaia* and hymns, under escort. *Dis ekdotheisa, dis enguetheisa*,
says the speaker of one of Isaeus's speeches of his mother with under-
standable pride, "twice given out, twice pledged" (Isaeus 8.29). The process
that makes a maiden into a wife and mother entails, the first time, the loss
of *parthenia*, but does not produce any change in her as a social being. One
might say of marriage what Bruce Lincoln has said of female initiations in
general: "Status is the concern of the male, and women are excluded from
direct participation in the social hierarchy. The only status that is indepen-
dently theirs, if status it be, is that of woman." [82]

The wedding is surely a rite of passage, but not one that left indelible
marks on the object of the ritual. Rather than with initiations, it has affinities

with what Van Gennep called "rites of appropriation," "whose purpose it is to remove a person from the common domain in order to incorporate him into a special domain: rites of sacred appropriation of new lands, the transfer of relics, or of statues of gods (fig. 149). "The act of carrying," Van Gennep writes, "is in this context the performance of a transition rite."[83]

BETWEEN MEN

A major difference between the marriage by *hedna* represented in the epic and the marriage by *engue* as we find it practiced in Archaic and Classical Greece is that the women are not given to their husbands with the understanding that the arrangement is permanent. In the formula of the lease, they are afforded conditionally by one man to another as the means of social reproduction. From a legal standpoint, as Sealey observes, "marriage did not create a new community of husband and wife; it was a means to provide heirs to the bridegroom's estate by continuing his line."[84] Indeed, permanence and stability were not features of the marriage itself, since the shape of the institution made divorce easy, and remarriage, normal.[85] The in-between status of the married woman—neither detached from her father's *ankhisteia* nor integrated into that of her husband—hardly seems designed to foster a harmonious, permanent relationship. What the system achieved, as Roger Just says most clearly, was to establish bilateral lines of descent for the children of the marriage, who therefore stood to inherit from their matriline as well as the patriline.[86] Should one conclude, therefore, that the primary and paramount function of marriage is to ensure the continuation of a man's *oikos?* There exists now general consensus that marriage existed in order to perpetuate the *oikos* and that it is as well its basic constitutive element.[87] This assumption ultimately relies on the notion that the "biological family"—the natural partnership of man and woman in procreation—is at once also a social structure, the "elementary family," and the basic building block of all human societies.[88] The model employed in discussions of the ancient Greek family seems to be roughly the following: the *oikos* comes into being with marriage and is constituted by the married couple and their children. In other words: "the 'normal' Greek household . . . contained a nuclear family and the residence pattern was neolocal; that is, upon marriage the newly-weds would set up a separate and autonomous household."[89] Let us ask, is there a single attested instance of this pattern? Or was it the case that the *oikos*, into which the wife would be introduced, pre-existed the marriage, that it was normally polygynous, and, if a man could afford it, included concubines and their children?

no word!

There is in Greek no word that corresponds to the English "family," meaning a kinship group sharing one residence. To translate the term *oikos* as "household," as is usually done, simply masks the slippage. The descent group of blood kin sharing ancestral cults is the *ankhisteia*, whose members are spread across several *oikoi*.[90] *Oikos* has the extensive meaning of "estate," a man's patrimony. It includes his house or houses and other real estate, and their inhabitants, ranging from animals, to slaves, to all women and minors under the guardianship of the *kurios*.[91] The word may be used in a restricted sense either of the house itself or metaphorically of the "family" in the sense of descent group.[92] I know of no case in which it signifies the wedded couple or the couple and their children, in marked opposition to its other meanings.[93] When a man marries, the wife becomes part of his *oikos*, but the *oikos* neither comes into existence with the marriage nor ceases to exist when the wife leaves. A propertied man who does not marry is nevertheless the head of his *oikos*, and an *oikos* without a man at its head is "void," *eremos*, although it may house his pregnant widow.[94] What made an *oikos* was the union of man and property, not that of man and wife. Nor was marriage the only source of sons who would care for their father in his old age and inherit his estate. In spite of efforts to deny its existence in ancient Greek society, it is apparent that concubinage, *pallakia*, was widely practiced and legally acknowledged.[95] The ancient law on justifiable homicide, cited by Demosthenes in the fourth century, reads as follows:

> If a man unintentionally kills another in an athletic contest, or unwittingly brings him down on the road or in war, or on account of his spouse, or mother, or sister, or concubine, whom he keeps for [generating] free children, he shall not be exiled for having killed on these accounts.[96]

In the eyes of the law, the concubine in charge of procreation, *pallake*,[97] is unequivocally a member of the *oikos*. Most of our information about concubinage unfortunately concerns Athens in the Classical period and it comes from courtroom speeches and comedy. There is enough, nevertheless, to reconstruct the bare bones of the institution. The picture that emerges is coherent with what we know of concubinage in other societies.[98] A *pallake* normally resided in the man's *oikos*, although not always under the same roof as his wife, if he was married.[99] Her status was inferior to that of the wife, and she might be a slave or a metic,[100] but she might come as well from an Athenian *oikos*.[101] Her children, too, were inferior to children born of a marriage, but to say that they were excluded from their father's

ankhisteia and barred from citizenship is a vast overstatement, which is founded upon their particular status in Athens from the fourth century onward. We learn from Aristotle (*Politics* 1278A28–30, 1319B7–10) that many states admitted to citizenship bastards, *nothoi*.[102] It follows a fortiori that these children were able to inherit their father's property and so to perpetuate his *oikos*. In the Archaic period this was the case in Athens as well. Literary sources allow us to trace back to the early sixth century a series of measures aimed at the exclusion of the *nothoi* from the descendants' group and possibly from citizenship. A law of Solon limited a *nothos*'s membership in his father's *ankhistheia* to cases where there were no legitimate children, and exempted him from the obligation to support his father.[103] Solon further attacked the prerogatives of blood kin by abolishing the rule that a man's estate should go to a member of his *genos* upon his death:

> By allowing a man to bestow [his estate] on whomever he wished, if
> he had no children, [Solon] placed greater value upon personal attach-
> ment (*philia*) than blood ties (*sungeneia*) and upon beauty (*kharis*) than
> necessity (*ananke*), and he gave control of their patrimonies to those
> who owned them. (Plutarch *Life of Solon* 21.2)

A joke at the expense of the patron hero of all *nothoi*, Heracles, in Aristophanes *Birds* (1649–1670) may indicate that in the late fifth century a *nothos* had no right to inherit, so long as there were surviving legitimate heirs.[104] But the exclusion of *nothoi* from the *ankhisteia* under any circumstances is not established until the passage of a law to that effect in 403/402 B.C.[105] From such fragments of legislation spanning two centuries and testifying to the progressive erosion of their civil rights, it is possible to reconstruct in outline what the condition of the *nothoi* was in the Archaic period in Athens. The children of concubines were members of the man's *ankhisteia* and so of his *genos*, as well as part of his *oikos*. As such, they had the duty to care for their father in his old age and were entitled to inherit a share of the patrimony, albeit inferior to that of his legitimate children—if any existed. Scant as they are, these are clear indications that marriage was not the only kind of family an *oikos* housed, nor its only means of preservation. Is there any reason to believe that it was its foundation?

Modern discussions of the ancient Greek marriage focus on its importance for the *oikos*. The ancient discourse about marriage revolves instead around the state and citizenship and is at pains to distinguish the kind of partnership that ensures the permanence of the polis from that which ensures the continuity of the *oikos*. The opening chapters of Aristotle's *Politics*

are an important source in this regard. The investigation into the nature of
the state begins by tracing its development from a point of origin through
several stages. The polis is the point of arrival of a teleological process,
which, therefore, presupposes its existence. There is first mating (*sunduaze-
sthai*) under the natural compulsion to reproduce, the way animals and
plants do as well, under the sign of *ananke*, necessity (1252A26–30). The
most elementary form of human society, *koinonia*, binds a man, who is by
nature the master, to his natural subjects, the woman and the slave, in the
institution of the *oikos:*

> ἐκ μὲν οὖν τούτων τῶν δύο κοινωνιῶν οἰκία πρώτη, καὶ ὀρθῶς Ἡσίοδος
> εἶπε ποιήσας
> οἶκον μὲν πρώτιστα γυναῖκά τε βοῦν τ' ἀροτῆρα,
> ὁ γὰρ βοῦς ἀντ' οἰκέτου τοῖς πένησίν ἐστιν. ἡ μὲν οὖν εἰς πᾶσαν ἡμέ-
> ραν συνεστηκυῖα κοινωνία κατὰ φύσιν οἶκός ἐστιν, οὓς Χαρώνδας μὲν
> καλεῖ ὁμοσιπύους, Ἐπιμενίδης δὲ ὁ Κρὴς ὁμοκάπους.

> [These two associations then (constitute) the first house (*oikia*), and
> Hesiod spoke correctly, when he wrote, "First of all a house and a
> woman and an ox for the plough," for the ox serves instead of a ser-
> vant for the poor. Therefore, the association that comes into existence
> for the everyday in accordance with nature is the household (*oikos*),
> people whom Charondas calls "bread-chest mates" and Epimenides
> of Crete calls "through mates."] (*Politics* 1252B9–15)

The expression "for the everyday" (εἰς πᾶσαν ἡμέραν) has the specialized
meaning of "level of subsistence," which emerges by contrast to the defini-
tion of the next higher social formation.[106] The village, which is the associ-
ation of several *oikoi*, serves "purposes other than daily needs" χρήσεως
ἕνεκεν μὴ ἐφημέρου (1252B16–17). Finally, the association of several vil-
lages results in the polis, "which comes into being for the sake of living, but
which exists for the purpose of living well" (1252B29–30: γινομένη μὲν
τοῦ ζῆν ἕνεκεν, οὖσα δὲ τοῦ εὖ ζῆν).

Together with Aristotle's statement that the polis is composed of *oikoi*,[107]
scholars invoke this passage in the *Politics* as proof that the nuclear family,
composed of a man, wife, and children, was the quintessential component
of Greek society. It is crucial, therefore, to realize that marriage enters not
at all in Aristotle's definition of the *oikos*. In fact, the passage of Hesiod,
which he quotes, continues thus:

Οἶκον μὲν πρώτιστα γυναῖκά τε βοῦν τ' ἀροτῆρα,
κτητήν, οὐ γαμετήν, ἥτις καὶ βουσὶν ἕποιτο

[First and foremost a house and a woman and an ox for the plough,
A woman you own, not a wife, to follow the plough.] (*Works and Days*
405–406)[108]

Moving forward from the premise that Aristotle by *gunaika* must mean "wife," scholars have attempted to dismiss Hesiod's definition of the *oikos* and the connotations it imparts to the passage in which it is embedded. West postulates an unattested original phrase in which *gune* simply meant "wife."[109] Most have argued that, by omitting line 406 of *Works and Days*, Aristotle intentionally distorts Hesiod's meaning and transforms the concubine into a wife.[110] Such reasoning relies on equivocation, made possible by the fact that *gune* may mean either and both. Indeed, Aristotle himself noted in passing (presumably in reference to marriage) that language had no specific terms for either the "union of man and woman" or for the "procreation of children" (*Politics* 1253B10–12). The fact that Greek lacks words for the fundamentals of the institutions of marriage, however, need not betray vagueness in the definition of the institution.[111] This remark may be understood best by applying to the semantic range of words like *gune, sunoikein,* and *gamos* the linguistic distinction between marked and unmarked lexical terms.[112] In its unmarked capacity, *gune* has the extensive meaning of "sexually mature female" under any one of her social aspects — slave and free, young and old, wife as well as concubine. The marked category "concubine" is a subset of the unmarked term as is that of "wife," and the two are mutually exclusive.[113] The marked meaning "wife" is either contextually determined or specified by the addition of a qualifier, as in *gune gamete* or *gune enguete.*[114] By the same means, the extensive semantic range of *paidopoiesthai,* "procreate," can be restricted to the particular case of *paidopoiesthai gnesios,* "to procreate legitimately." Determining the meaning of *gune* in the quotation of line 405 of *Works and Days* at *Politics* line 1252B11, therefore, is not a matter of choosing between "concubine" and "wife." The question is whether the word has its general, unmarked sense, which encompasses both concubine and wife, or a narrower meaning. Hesiod removes any ambiguity by specifying that she should be a concubine. If the omission of line 406 from the quote given in the *Politics* has any effect, it is to restore its extensive capacity to the word *gune:* a woman, any woman, for the bare necessities of food, shelter, and procreation. Where the *oikos* is concerned, that is, it does not matter whether she is a concubine, slave or free,

or a wedded wife. Most of Aristotle's ancient readers would have been able to complete the quote of Hesiod by heart, and they would have been aware that either one would do. But even readers who did not know their Hesiod would not miss the connotations of barbarism implicit in the citations from Charondas and Epimenides. To say that the member of the natural *oikos* are "bread-chest mates," *omosipuous*, and "through-mates," *homokapous*, is to evoke the picture of man, woman, and slave brutishly feeding together at the same trough.

The distinction between the wife and the concubine, however, becomes crucial at the political level in Classical Athens, when, in the noose of radical democracy, tightened requirements for citizenship forced attention to the mother's pedigree and the nature of the parents' union. The line is drawn thus in the notorious statement about love, marriage, and the state contained in the Demosthenic speech *Against Neaera*:

> Τὸ γὰρ συνοικεῖν τοῦτ' ἔστιν, ὃς ἂν παιδοποιῆται καὶ εἰσάγῃ εἴς τε τοὺς φράτερας καὶ δημότας τοὺς υἱεῖς, καὶ τὰς θυγατέρας ἐκδιδῷ ὡς αὐτοῦ οὔσας τοῖς ἀνδράσιν. Τὰς μὲν γὰρ ἑταίρας ἡδονῆς ἕνεκ' ἔχομεν, τὰς δὲ παλλακὰς τῆς καθ' ἡμέραν θεραπείας τοῦ σώματος, τὰς δὲ γυναῖκας τοῦ παιδοποιεῖσθαι γνησίως καὶ τῶν ἔνδον φύλακα πιστὴν ἔχειν.

> [For this is to be married, to have children and to introduce the sons into one's phratry and one's deme and to give out the daughters to the men as one's own. We have hetairai for pleasure, concubines for the day-to-day care of our body, and wives in order to procreate lawfully and to have a trusted guardian of the household.] ([Demosthenes] 59.122)

One recognizes the stages outlined in Aristotle's brief history of mankind (minus the village phase), recast here as the three different spheres of intercourse. Relationships with hetairai are comparable to the sexual encounters in the wild described in the *Politics* in that they are driven by desire and do not produce long-term attachments. The correspondence is clearest in the way in which the task of the *pallake* is defined: "the day-to-day care of our body." The meaning of this phrase, which puzzled Vernant,[115] comes into focus in light of the passage in the *Politics* that posited the *oikos* as the lowest form of social organization, one that aims at no more than securing what is needed for the "everyday." Such are the necessities addressed by the *pallake*, in charge of the day-to-day care of the body. The *oikos*

then is properly the habitat of the concubine and the site of the production of natural children, who are "spurious," *nothoi*, however, with respect to the state. In the Demosthenic speech, the meaning of *gune* is contextually determined by explicit contrast to *pallake* and by reference to "legitimate" offspring. As the instrument of political reproduction, she is the bridge between the *oikos* and the polis. Accordingly, *to sunoikein*, meaning the married state, is defined largely in terms that have nothing to do with the *oikos* and all to do with the polity: the phratry, the deme, the men. ⟶ *wife*

The quantum leap separating the wife from the concubine corresponds to the distance between what is necessary for the state to exist and the purpose for which the state exists. The polis, in Aristotle's words, comes into being for the sake of living, but it exists for the sake of living well (*Politics* 1252B30–31). In this statement he sums up a series of distinction he had drawn earlier between ephemeral and permanent, necessity and freedom, nature and culture, *oikos* and polis. In its extensive sense, the unmarked category polis includes both the totality of *oikoi and* the political superstructure that insures civilized life—and much else besides. In specific reference to that superstructure, however, polis has the marked meaning of "partnership of citizens in the state," κοινωνία πολιτῶν πολιτείας (1276B2), which excludes slaves, metics, minors, men over sixty (1275A3–5), and all women. For, as Aristotle says, "not all the persons, without whom the polis would not exist, are citizens" (1278A3–5). With regard to the state, the *oikos* is as necessary as women are, and as marginal.

While the association of a man with his woman and his slave is sufficient to create an *oikos*, marriage requires a partnership between men, one founded upon reciprocal feelings of affection, *philia*. The relevant passage in Aristotle's *Politics* deals once more with the definition of the state and with the question of whether persons, who share a territory and form temporary alliances for purposes of war or trade, constitute a polis. He answers this in the negative:

> While these are necessary conditions for the existence of the polis, even if they were all present, not these would make a polis, but the association for living well with both *oikoi* and clans, for the purpose of a perfected and self-sufficient life. And this will not come about unless they inhabit one and the same place and practice intermarriage; such practices have resulted in relations by marriage throughout the states, and brotherhoods and sacrificial rites and social recreations. And this is the result of *philia*, because *philia* is the motor of social life.[116]

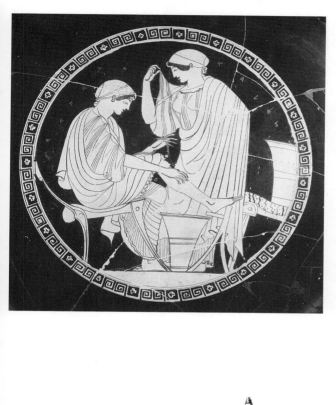

1. Attic red-figure kylix interior. Berlin, Antikensammlung, Staatliche Museen zu Berlin F 2289. Photo: Jutta Tietz-Glagow.

2. Attic red-figure pyxis. London, British Museum E 773. After Furtwängler and Reichhold 1904–32, pl. 57, 1.

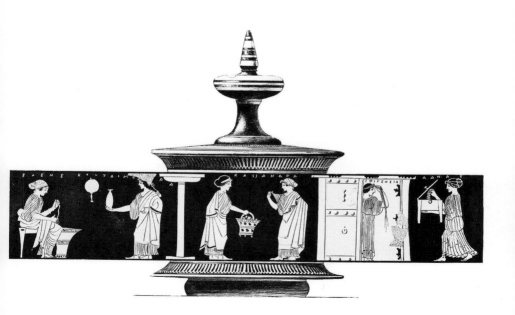

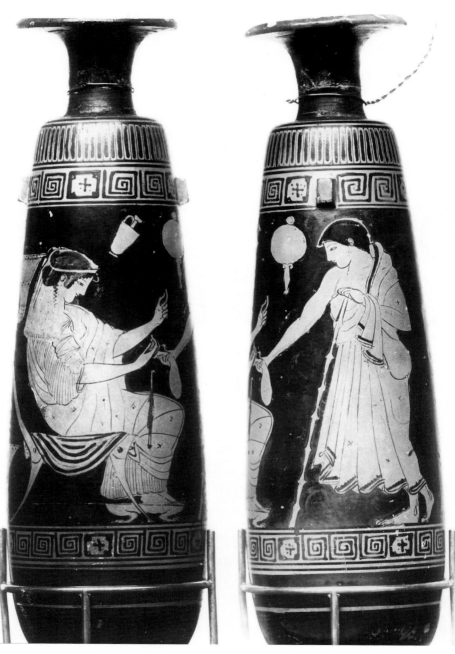

3-4. Attic red-figure alabastron. Berlin, Bildarchiv Preussischer Kulturbesitz, Antikensammlung, Staatliche Museen zu Berlin F 2254.

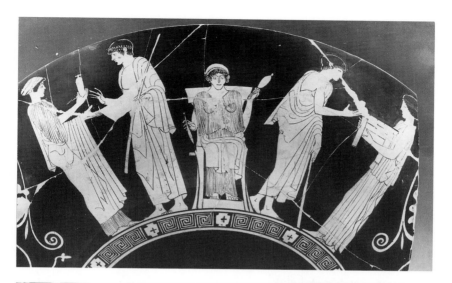

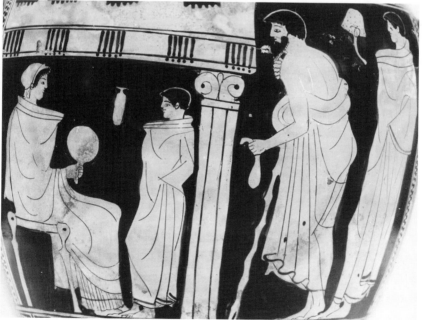

5. Attic red-figure kylix exterior. Berlin, Antikensammlung, Staatliche Museen zu Berlin V.I. 31426. Photo: Jutta Tietz-Glagow.

6. Attic red-figure hydria. Tampa, Florida, Tampa Museum of Art 86.70. Tampa Museum of Art, Joseph Veach Noble Collection, purchased in part with funds donated by Mr. and Mrs. James Ferman, Jr.

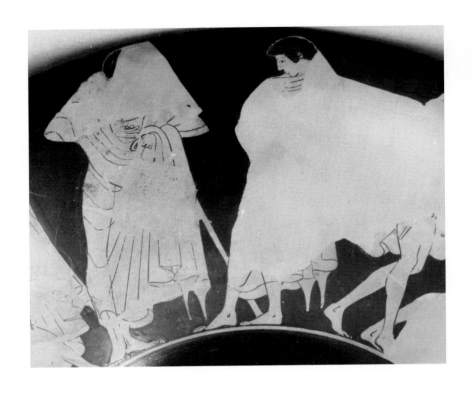

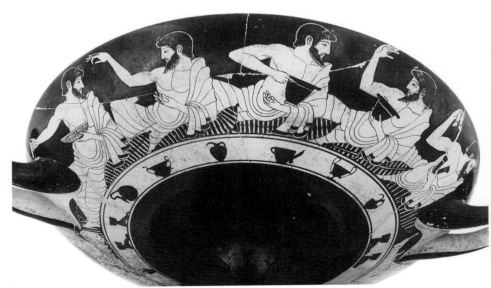

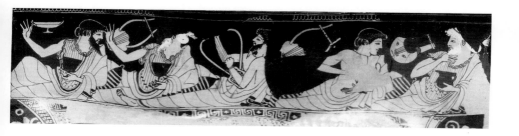

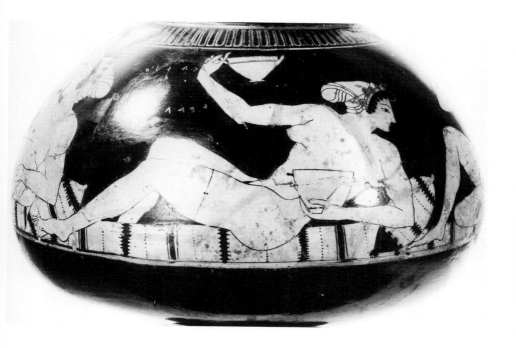

7. *(opposite above)* Attic red-figure kylix exterior. Bochum, Ruhr-Universität, Kunstsammlungen S 507. Photo: G. Fittschen-Badura.

8. *(opposite below)* Attic red-figure kylix exterior. Berlin, Antikensammlung, Staatliche Museen zu Berlin F 2298. Photo: Jutta Tietz-Glagow.

9. *(above)* Attic red-figure rhyton. Richmond, Virginia, Virginia Museum of Fine Arts 79.100, The Adolph D. and Wilkins C. Willams Fund.

10. *(above)* Attic red-figure psykter. St. Petersburg, Hermitage Museum 664.

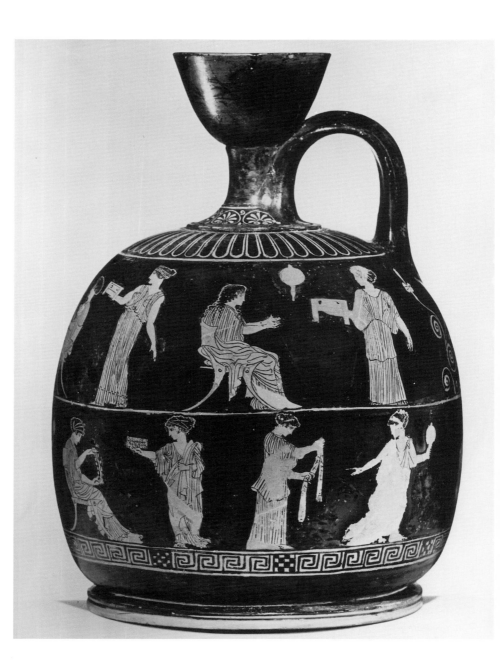

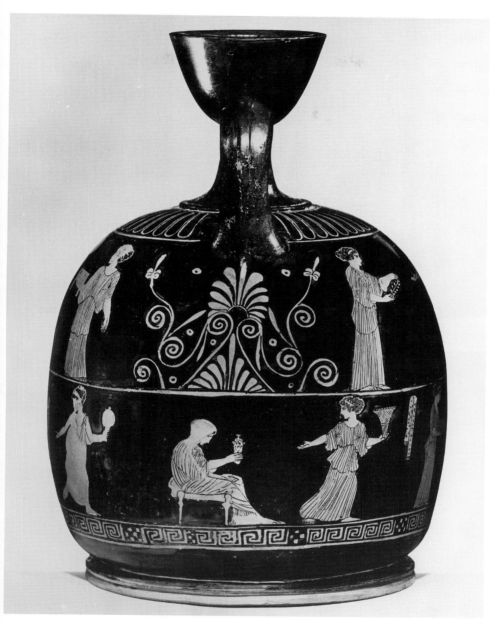

11–12. *(opposite & above)* Attic red-figure squat lekythos. Chapel Hill, North Carolina, The Ackland Art Museum 71.8.1, The University of North Carolina at Chapel Hill, The William A. Whitaker Art Fund.

13. Attic red-figure kylix interior. Sydney, Nicholson Museum, University of Sydney 46.40.

14. Attic white ground oinochoe. London, British Museum D 13. © Copyright The British Museum.

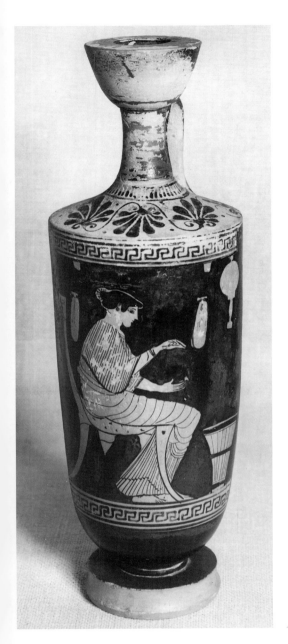
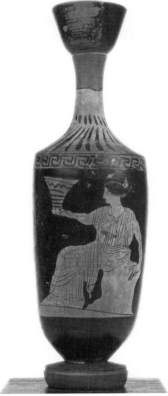

15. Attic red-figure lekythos. Geneva, Musée d'Art et d'Histoire 18.043.
16. Attic red-figure lekythos. Laon, Musée Municipal 37.967. Photo: Studio Alex.

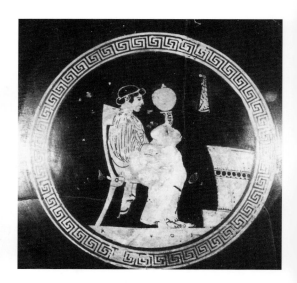

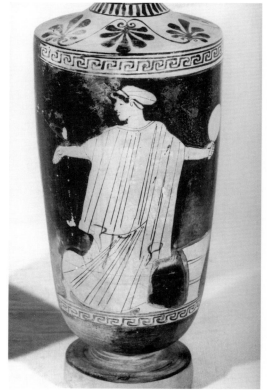

17. *(above)* Attic red-figure squat lekythos. Vibo Valentia, Museo Statale Vito Capialbi C 67. Graphic by B. Sady after *CVA* Vibo Valentia 1, Italy 67, pl. 30, 2.

18. *(above right)* Attic red-figure kylix interior. Rome, Museo di Villa Giulia 25006. Courtesy of Soprintendenza Archeologica per l'Etruria Meridionale.

19. *(right)* Attic red-figure lekythos. Laon, Musée Municipal 37.959. Photo: Chuzeville.

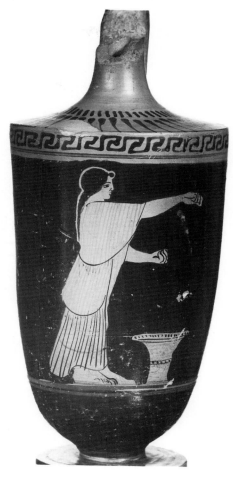

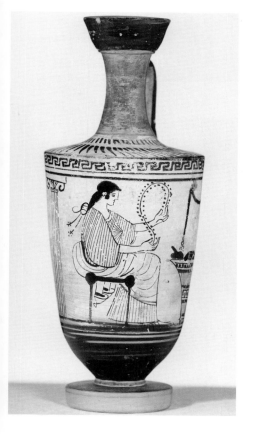

20. *(left)* Attic white ground lekythos, Bochum, Ruhr-Universität, Kunstsammlungen S 1004. Photo: G. Fittschen-Badura.

21. Lekythos. Brussels, Musées Royaux d'Art et d'Histoire A 2138. Photo: A. C. L.

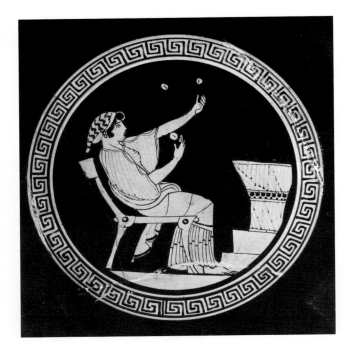

22. Attic red-figure kylix interior. Paris, Musée du Louvre G 331. Photo R. M. N.

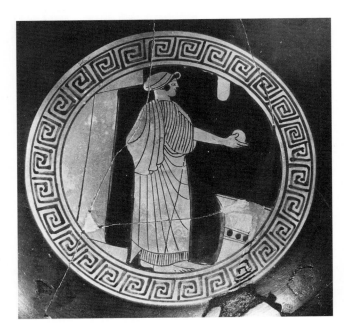

23. Attic red-figure kylix interior. Athens, National Archaeological Museum 18723.

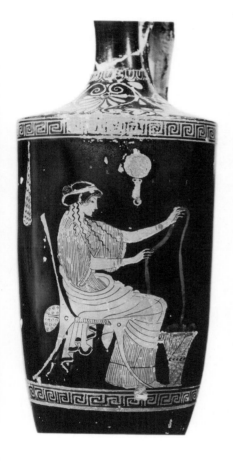

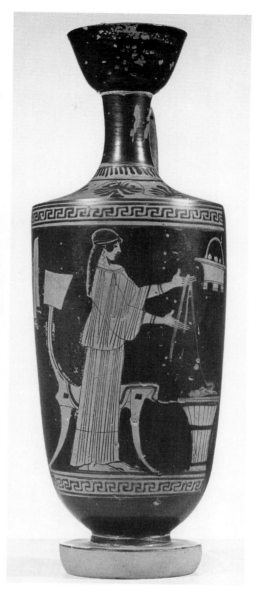

24. Attic red-figure lekythos. Boston, Museum of Fine Arts 13.189. Francis Bartlett Donation. Courtesy, Museum of Fine Arts, Boston. Reproduced with permission. © Museum of the Fine Arts, Boston. All Rights Reserved.

25. Attic red-figure lekythos. Chapel Hill, North Carolina, The Ackland Art Museum 78.15.1, The University of North Carolina at Chapel Hill, Gift of Nathan A. Perilman.

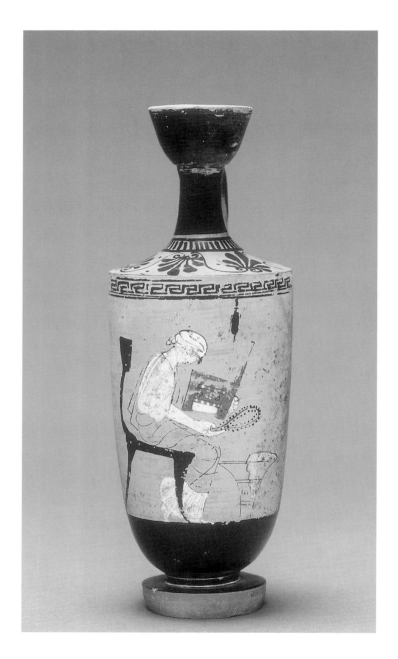

26. Attic white ground lekythos. Formerly part of the Hirschmann collection. Photograph provided courtesy of Sotheby's.

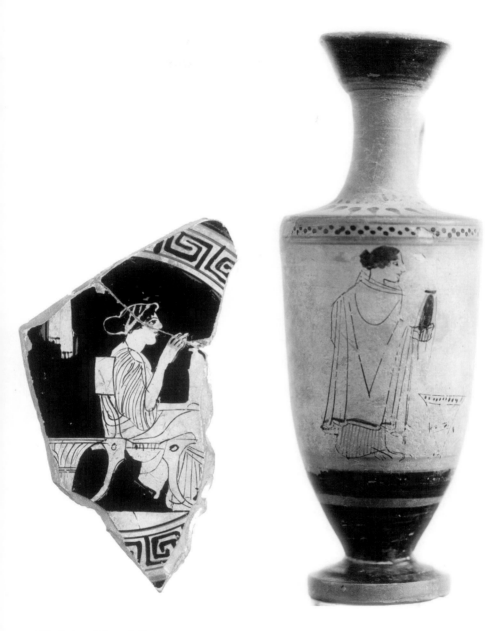

27. Attic red-figure kylix interior. Amsterdam, Allard Pierson Museum 1.11324.
Photo: Allard Pierson Museum, Amsterdam.

28. Attic white ground lekythos. Brussels, Musées Royaux d'Art et d'Histoire A 1687.

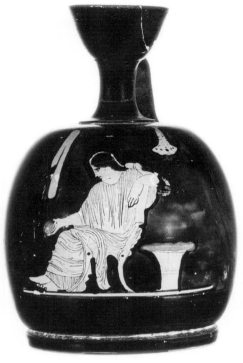

29. Attic red-figure squat lekythos. Oxford, Ashmolean Museum 1925.69. Photo: Ashmolean Museum, University of Oxford.

30. Attic red-figure squat lekythos. Tübingen, Institut für Klassische Archäologie, Universität Tübingen 7394.

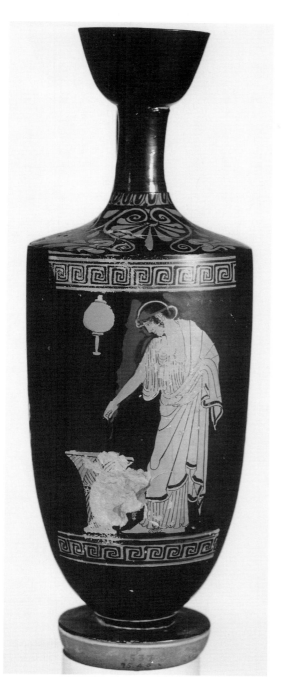

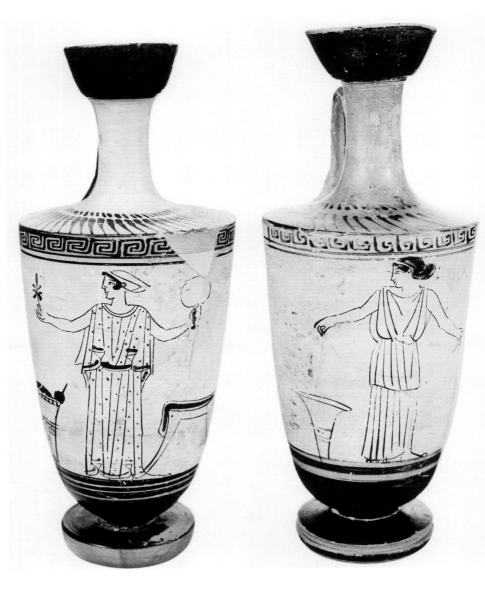

32. Attic white ground lekythos. Palermo, Banco di Sicilia, Mormino Collection 177. Courtesy of Banco di Sicilia.

33. Attic white ground lekythos. Palermo, Banco di Sicilia, Mormino Collection 327. Courtesy of Banco di Sicilia.

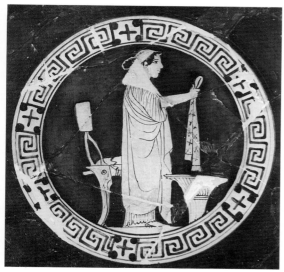

34. Attic red-figure kylix interior. Bologna, Museo Civico Archeologico 392.

35. Attic red-figure squat lekythos. Edinburgh, National Museums of Scotland 1956.472. © The Trustees of the National Museum of Scotland.

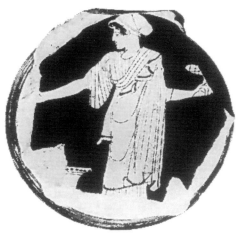

36. Attic red-figure stemless cup interior. Adria, Museo Archeologico B 329. Graphic by B. Sady after *CVA* Adria 1, Italy 28, pl. 37, 11.

37. Attic red-figure lekythos. Karlsruhe, Badisches Landesmuseum B 787.

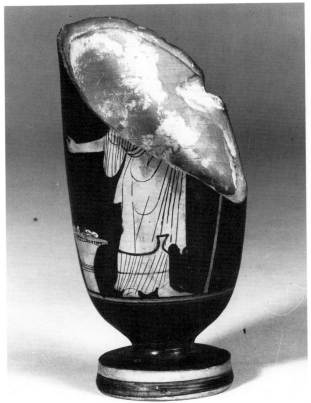

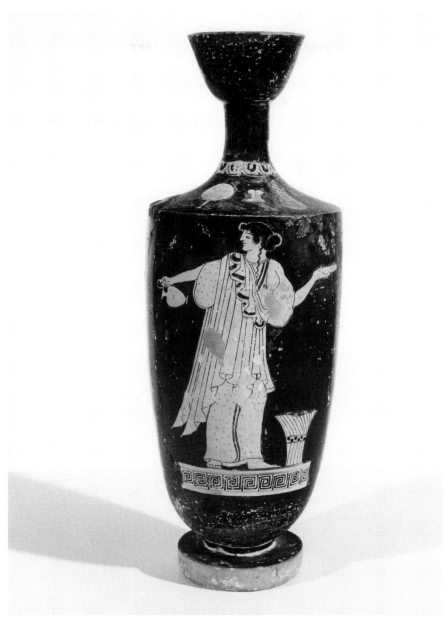

38. Attic red-figure lekythos. Tampa, Florida, Tampa Museum of Art 86.81. Tampa Museum of Art, Joseph Veach Noble Collection, purchased in part with funds donated by Mr. and Mrs. James Ferman, Jr.

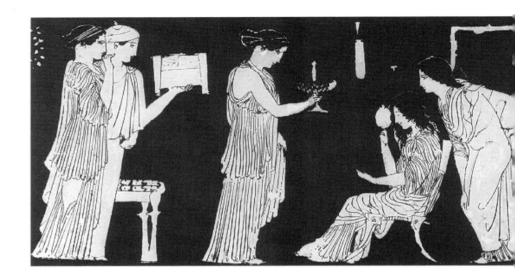

39. *(above)* Attic red-figure pyxis. Athens, Ephoria Athinon A 1877. Graphic by B. Sady after Lezzi-Hafter 1988, pls. 166–67.

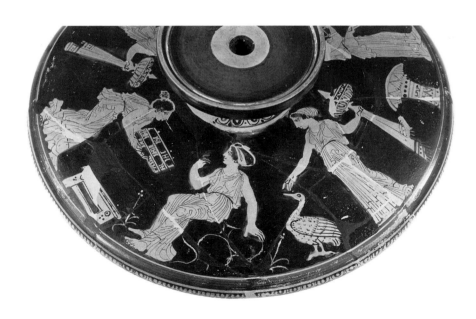

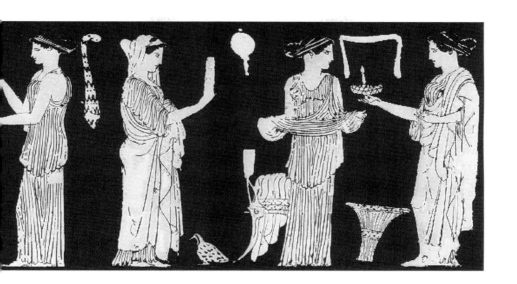

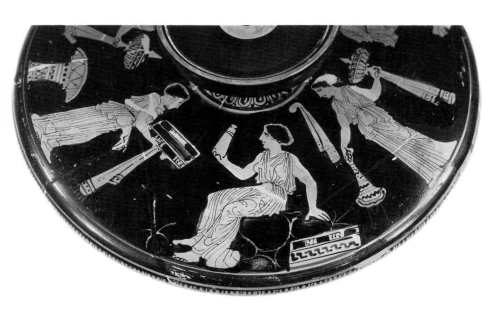

40–41. *(opposite & above)* Attic red-figure lekanis lid. Universität Mainz, Nr. (?) 118.

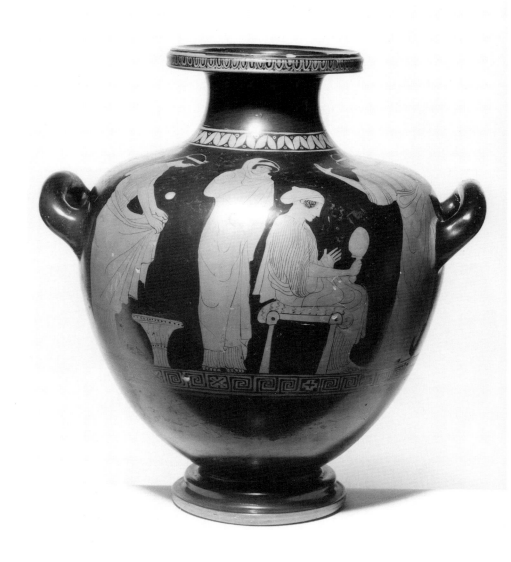

42. Attic red-figure hydria. Brussels, Musées Royaux d'Art et d'Histoire A 3098.

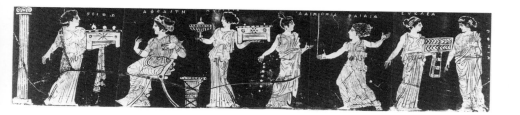

43. Attic red-figure pyxis. New York, Metropolitan Museum of Art 09.221.40. After Richter and Hall 1936, pl. 159 no. 161.

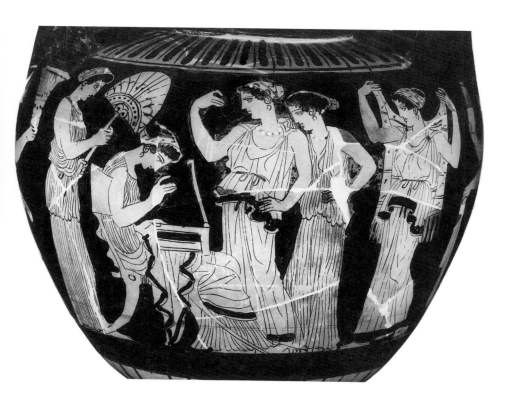

44. Attic red-figure lebes gamikos. Basel, Antikenmuseum Basel und Sammlung Ludwig BS 410.

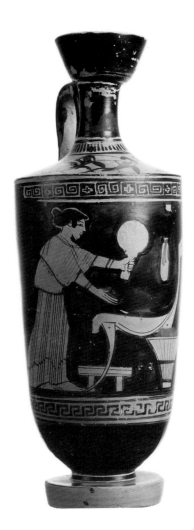

45. Attic red-figure lekythos. Brussels, Musées Royaux d'Art et d'Histoire A 3132.

46. Attic red-figure pyxis. New York, Metropolitan Museum of Art 06.1117. After Richter and Hall 1936, pl. 96 no. 96.

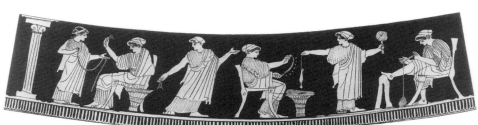

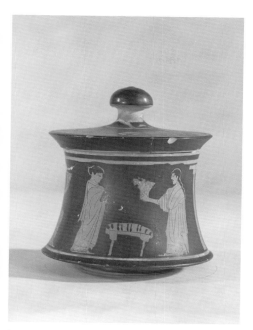

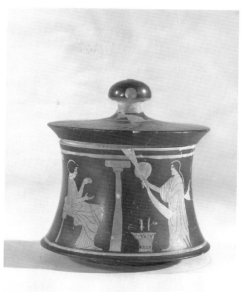

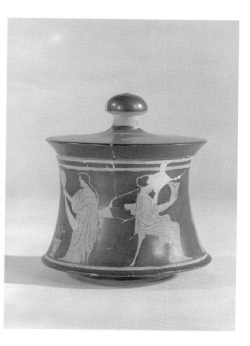

47–49. Attic red-figure pyxis. Cambridge, Mass., Arthur M. Sackler Museum 1925.30.39. Bequest of Joseph C. Hoppin. Courtesy of the Arthur M. Sackler Museum, Harvard University Art Museums. Photo: Rick Stafford.

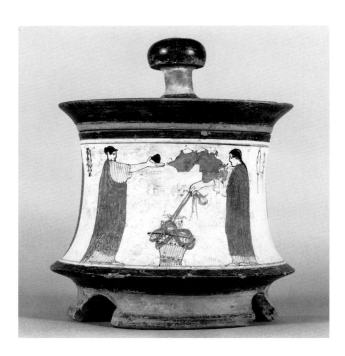

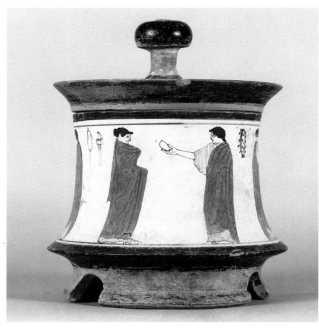

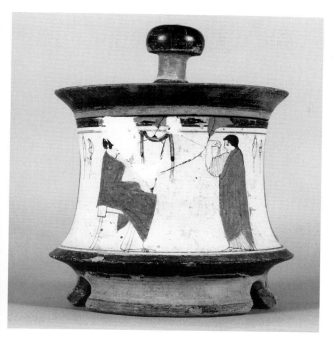

50–52. Attic white ground pyxis. Boston, Museum of Fine Arts 65.1166, Gift of Horace L. Mayer. Courtesy, Museum of Fine Arts, Boston. Reproduced with permission. © Museum of Fine Arts, Boston. All Rights Reserved.

53. *(below)* Attic red-figure hydria. Iris & B. Gerald Cantor Center for Visual Arts at Stanford University; Stanford Family Collections 17.412.

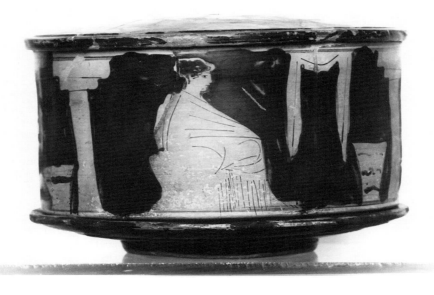

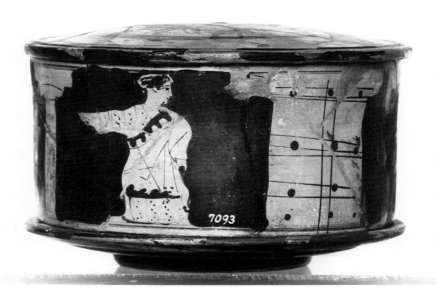

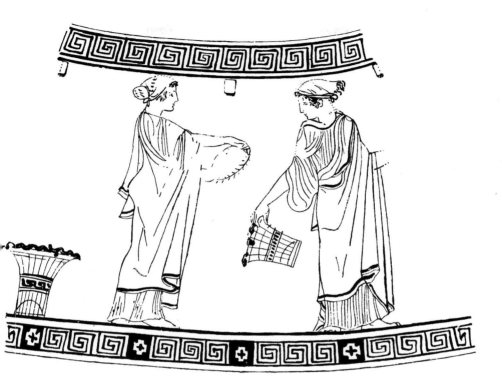

56. Attic white ground alabastron.
Delphi, Archaeological Museum 8713.
After Perdrizet 1908, 169, fig. 708 bis.

54–55. *(opposite above and below)*
Attic red-figure pyxis. Copenhagen,
National Museum, Department of Near
Eastern and Classical Antiquities 7093.

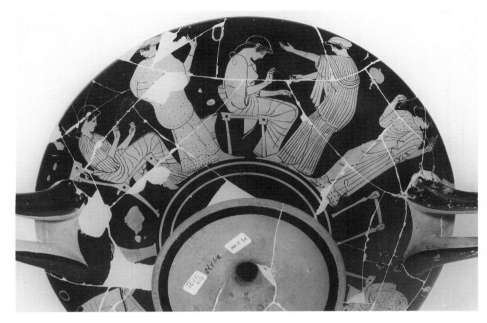

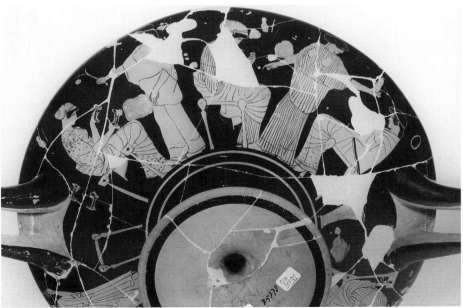

57–58. Attic red-figure kylix exterior. Florence, Museo Archeologico 75770.
Courtesy of Soprintendenza Archeologica per la Toscana, Firenze.

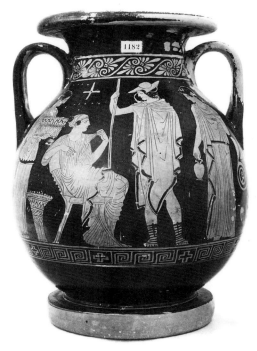

59. Attic red-figure pelike.
Athens, National Archaeological
Museum 1182.

60. Attic red-figure Nolan
amphora. Cambridge, Mass.,
Arthur M. Sackler Museum
1972.45. Bequest of Frederick M.
Watkins. Courtesy of the Arthur
M. Sackler Museum, Harvard
University Art Museums. Photo:
Rick Stafford.

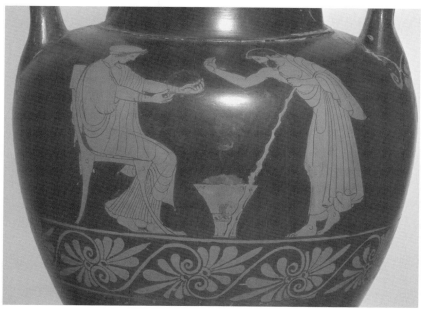

61–62. Attic red-figure kylix exterior. Florence, Museo Archeologico 81602. Courtesy of Soprintendenza Archeologica per la Toscana, Firenze.

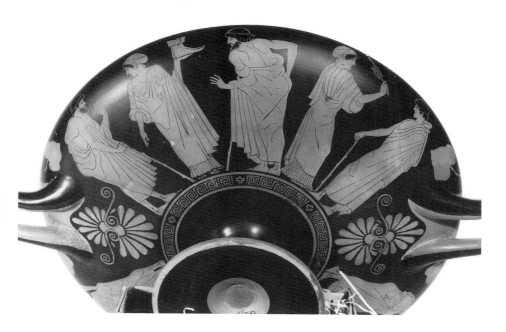

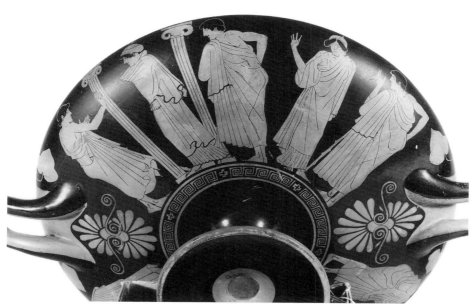

63–64. Attic red-figure kylix exterior. Oxford, Ashmolean Museum G 279.
Photo: Ashmolean Museum, Oxford.

65–67. Attic red-figure pyxis. South Hadley, Mass., Mount Holyoke College Art Museum 1932.5.B.SII.

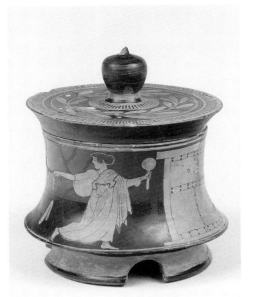

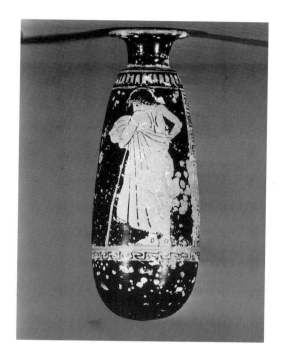

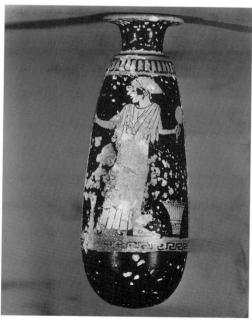

68–69. Attic red-figure alabastron. Eichenzell near Fulda, Hessische Hausstiftung, Museum Schloss Fasanerie 57.

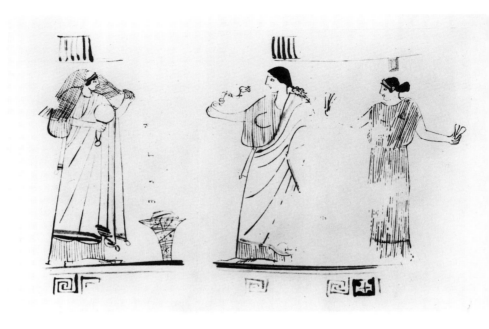

70. Attic white ground alabastron. Athens, National Archaeological Museum 16457. After *CVA* Athens 2, Greece 2, IIIJc pl. 19.

71. Attic red-figure hydria. St. Petersburg, Hermitage Museum 4525.

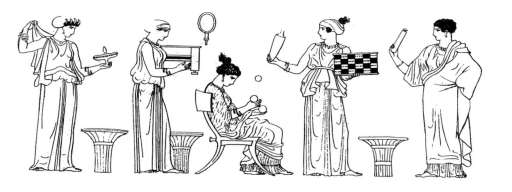

72. Attic vase. Drawing by Adam Buck, Dublin, Trinity College Library. After Jenkins 1989, 18.

73. Attic red-figure pyxis. Paris, Bibliothèque Nationale, Cabinet des Médailles 864. After Ridder 1902, 507, fig. 122.

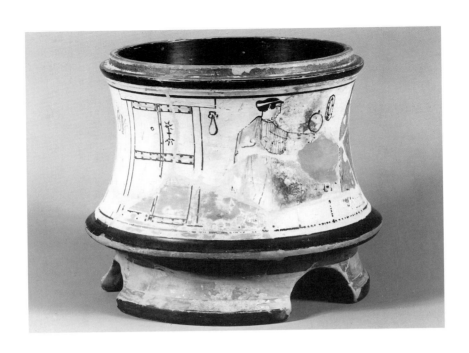

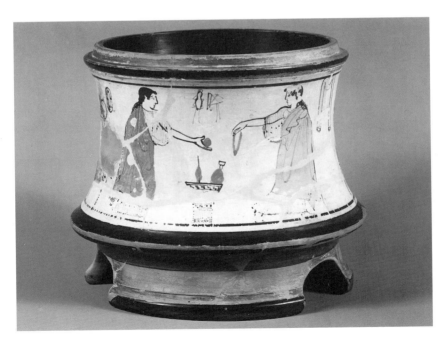

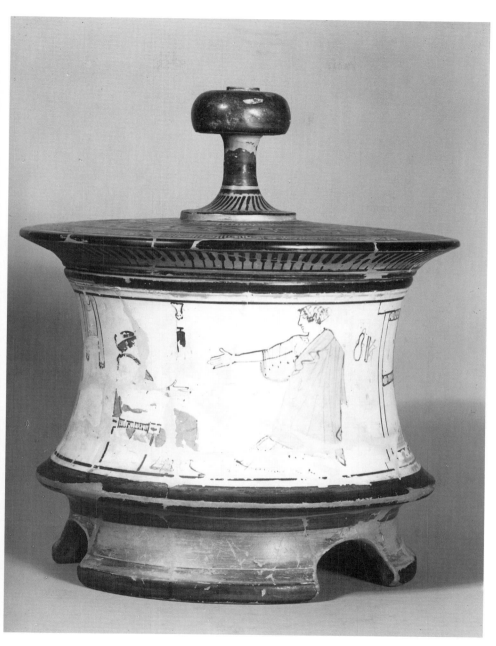

74–76. Attic white ground pyxis. Berlin, Antikensammlung,
Staatliche Museen zu Berlin F 2261. Photo: Jutta Tietz-Glagow.

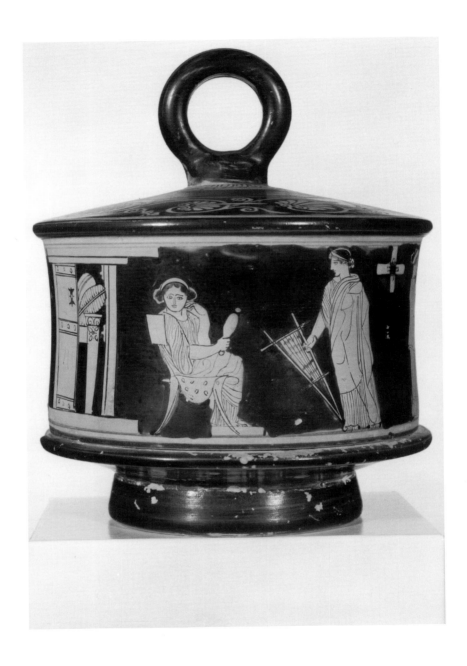

77. Attic red-figure pyxis. Paris, Musée du Louvre CA 587. Photo: R. M. N.

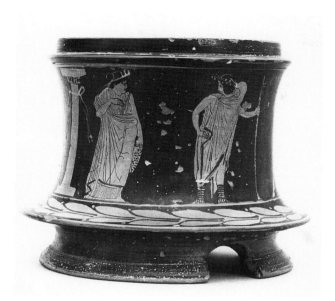

78–79. Attic red-figure pyxis. Athens, National Archaeological Museum 17191.

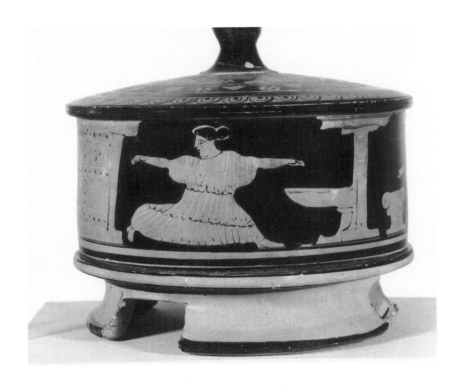

80–82. Boeotian red-figure pyxis. Paris, Musée du Louvre CA 1857. Photo: R. M. N.

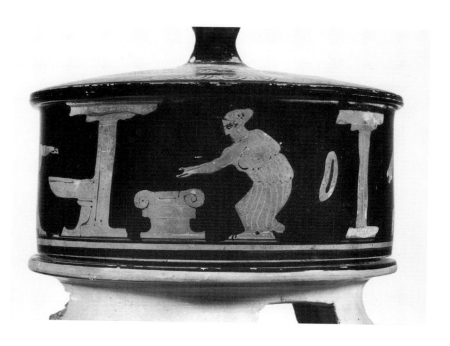

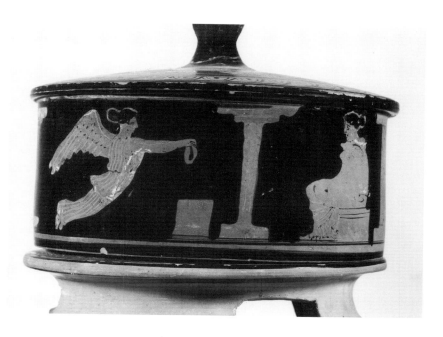

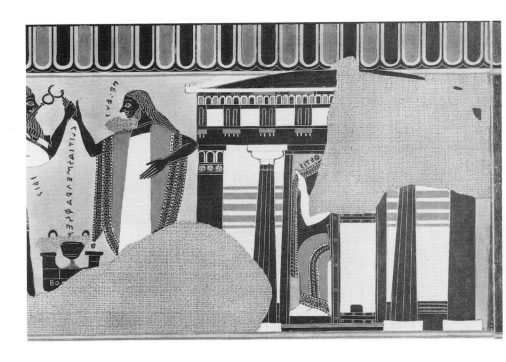

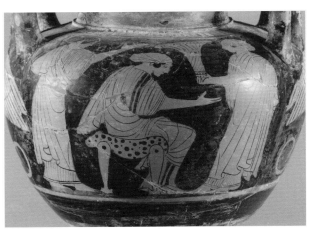

83. Attic black-figure volute krater, detail. Florence, Museo Archeologico 4209. After A. Furtwängler and K. Reichhold 1904–32. Griechische Vasenmalerei, pls. 1–2.

84. Attic red-figure lebes gamikos. Providence, R.I. Museum of Art 28.020, Rhode Island School of Design, Gift of Mrs. Gustav Radeke. Photography by Del Bogart.

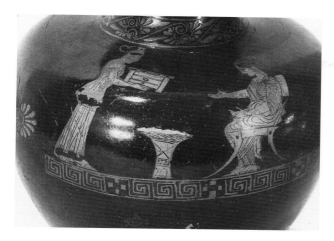

85. Attic red-figure hydria. St. Petersburg, Hermitage Museum B 267.

86. Attic white ground phiale. Boston, Mass., Museum of Fine Arts 65.908, Edwin E. Jack Fund. Courtesy, Museum of Fine Arts, Boston. Reproduced with permission. © Museum of Fine Arts, Boston. All Rights Reserved.

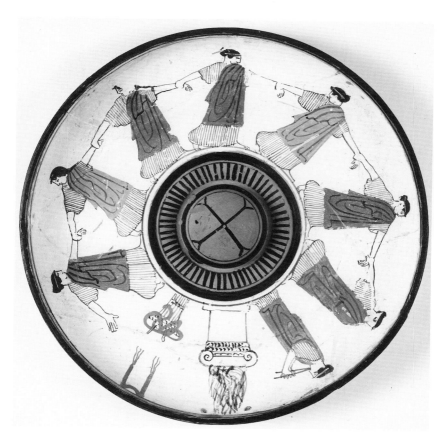

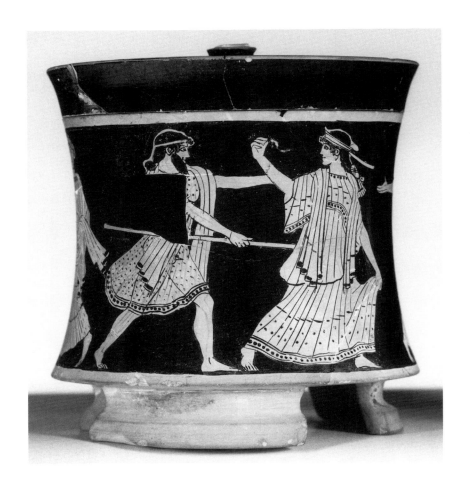

87–88. *(above and opposite top)* Attic red-figure pyxis. Cambridge, Fitzwilliam Museum, University of Cambridge GR 10.1934.

89. *(opposite right)*
Attic red-figure kalathos.
Durham, University.
After Williams 1961.

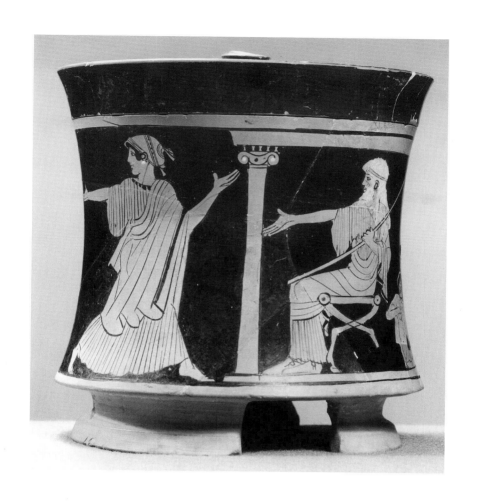

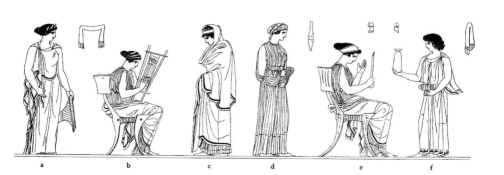

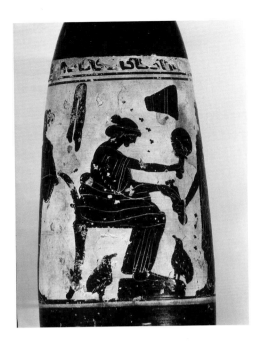

90–92. Attic black-figure alabastron. Eichenzell near Fulda. Hessische Hausstiftung, Museum Schloss Fasanerie 16.

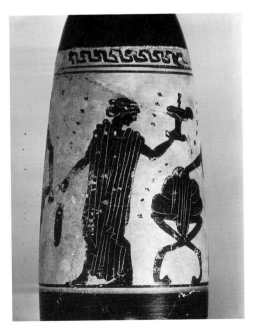

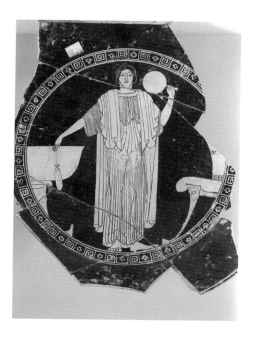

93. Attic red-figure kylix interior.
Paris, Musée du Louvre S 3916.
Photo: R. M. N.

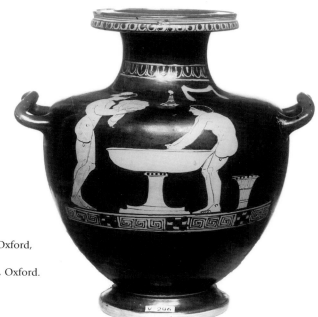

94. Attic red-figure hydria. Oxford,
Ashmolean Museum 296.
Photo: Ashmolean Museum, Oxford.

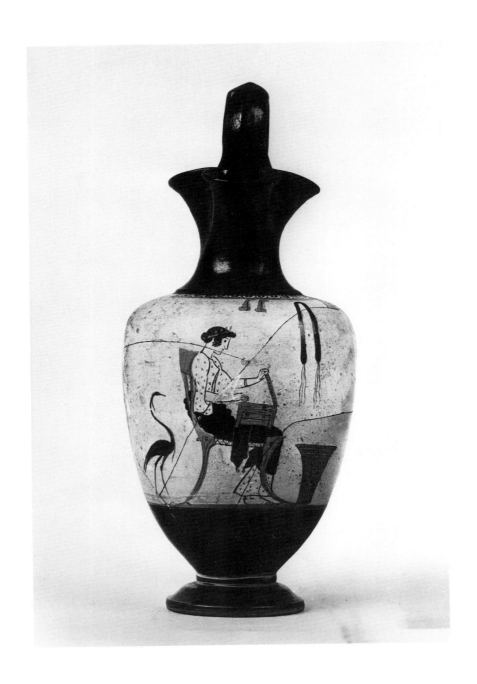

95. Attic white ground oinochoe. Athens, National Archaeological Museum 2186.

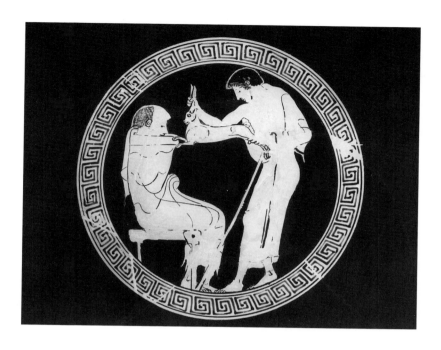

96. Attic red-figure kylix interior.
Würzburg, Martin von Wagner
Museum, Universität Würzburg 480.
Photo: K. Oehrlein.

97. Grave monument. Athens,
National Archaeological Museum
7908 a&b.

98. Attic red-figure kylix exterior detail. Warsaw, National Museum 142317 MNW. Photo: Z. Dolinski.

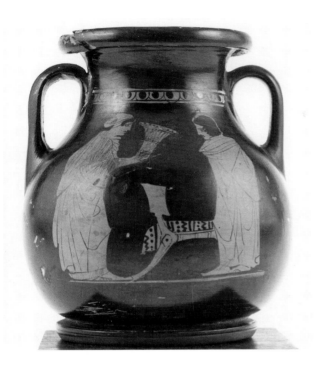

99. Attic red-figure pelike.
Laon, Musée Municipal 37.1030.
Photo: Studio Alex.

100. Attic red-figure hydria.
London, British Museum E 174.
© Copyright The British
Museum.

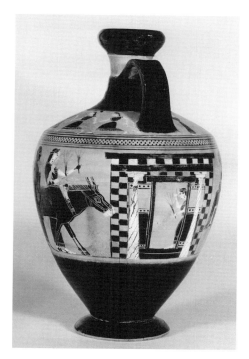

101–103. Attic black-figure lekythos. New York, The Metropolitan Museum of Art 56.11.1. Purchase 1956, Walter C. Baker Gift. All rights reserved, The Metropolitan Museum of Art.

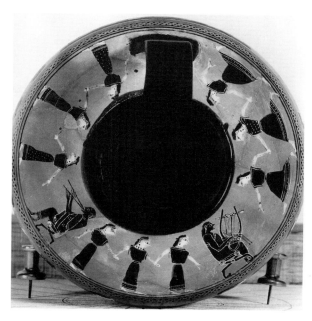

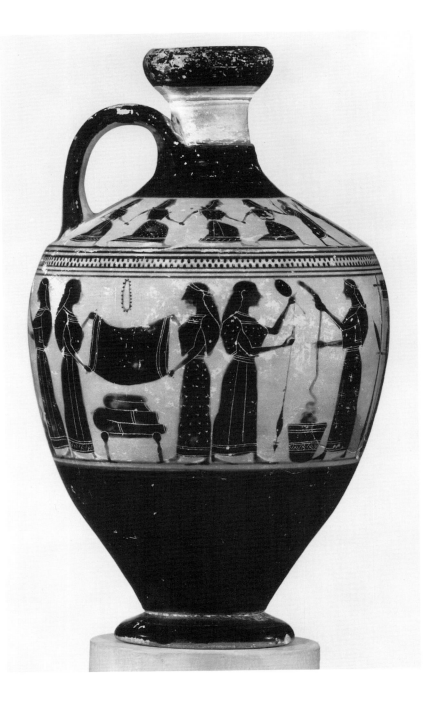

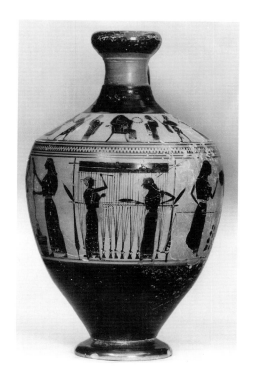

104–106. Attic black-figure lekythos. New York, The Metropolitan Museum of Art 31.11.10. Fletcher Fund, 1931.

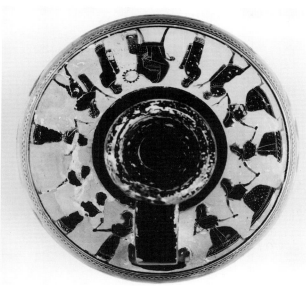

107. Attic red-figure lekythos. Paris, Bibliothèque Nationale, Cabinet des Médailles 1647.

108. Attic red-figure squat lekythos. Toledo, Ohio, Toledo Museum of Art 1917.131.

109. Attic red-figure alabastron. Würzburg, Martin von Wagner Museum, Universität Würzburg 546. Photo: K. Oehrlein.

110. Attic red-figure kylix fragment. Boston, Museum of Fine Arts 13.94. Gift of Edward Perry Warren. Courtesy, Museum of Fine Arts, Boston. Reproduced with permission.
© Museum of Fine Arts, Boston. All Rights Reserved.

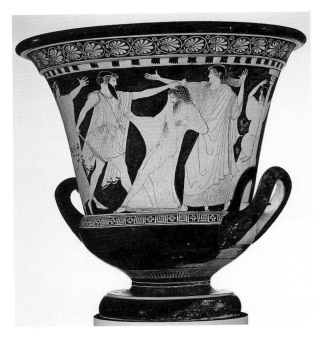

111. Attic red-figure calyx krater. Boston, Museum of Fine Arts 63.1246. William Francis Warden Fund. Courtesy, Museum of Fine Arts, Boston. Reproduced with permission. © Museum of Fine Arts, Boston. All Rights Reserved.

112. Illustration of "In Love" by Marcus Stone (1888) in Parker 1984, pl. 5.

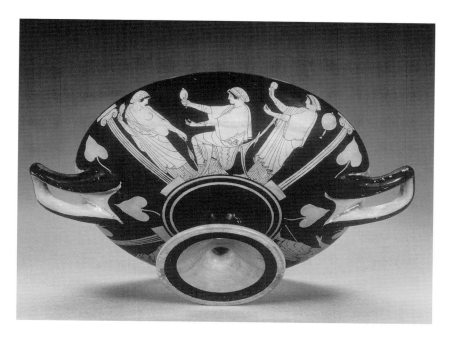

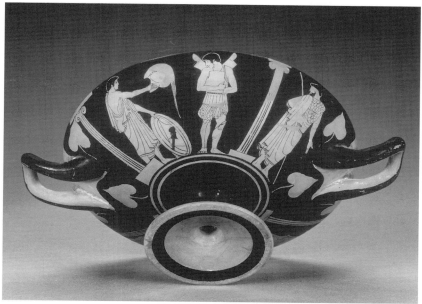

113–114. Attic red-figure kylix exterior. Courtesy of William I. Koch. Photo: Christie's.

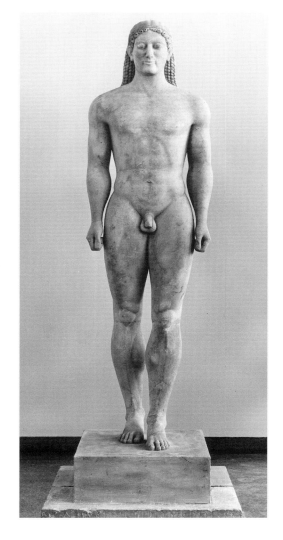

115. Terracotta plaque from Perachora. Athens, National Archaeological Museum 16980.

116. Kouros from Anavyssos. Athens, National Archaeological Museum. Photo: Hirmer Fotoarchiv.

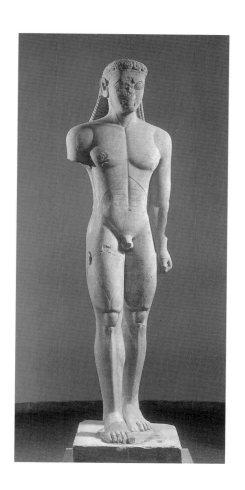

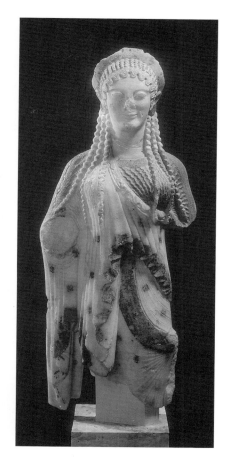

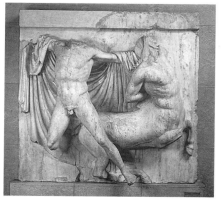

117. Kouros from Sounion. Athens, National Archaeological Museum 2720. Photo: Nimatallah/Art Resource, N.Y.

118. Kore. Athens, Acropolis Museum 675. Photo: Nimatallah/Art Resource, N.Y.

119. Athens. Parthenon, south metope XXVII. Centauromachy. Photo: Art Resource, N.Y.

120. East Greek aryballos. New York,
The Metropolitan Museum of Art 56.11.7.
Rogers Fund, 1956. All rights reserved,
The Metropolitan Museum of Art.

121. East Greek aryballos. London, British
Museum 1613. © Copyright The British
Museum.

122. Head of young man (Rampin Head).
Paris, Musée du Louvre MA 3104.
Photo: Erich Lessing/Art Resource.

123. Attic black-figure amphora. Boston, Museum of Fine Arts 01.8027. Henry Lillie Pierce Fund. Courtesy, Museum of Fine Arts, Boston. Reproduced with permission. © Museum of Fine Arts, Boston. All Rights Reserved.

124. Attic red-figure kylix interior. Munich, Staatliche Antikensammlungen 2688. Photo: Hirmer Fotoarchiv.

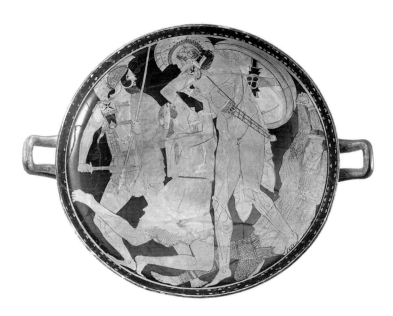

125. Attic red-figure amphora, Boston, Museum of Fine Arts 10.178. James Fund and by Special Contribution. Courtesy, Museum of Fine Arts, Boston. Reproduced with permission. © Museum of Fine Arts, Boston. All Rights Reserved.

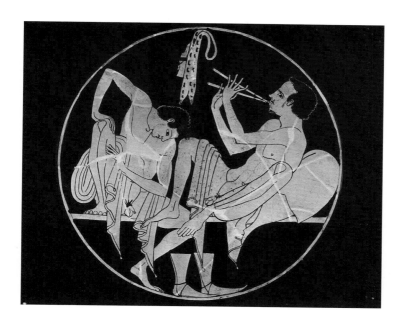

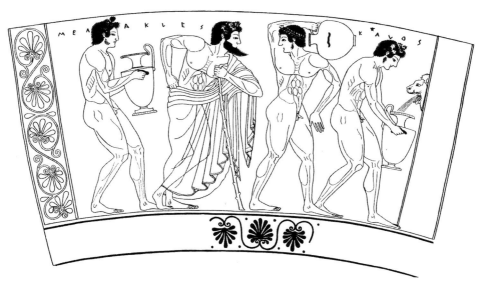

126. Attic red-figure kylix interior. Boston, Museum of Fine Arts 01.80.18. Henry Lillie Pierce Fund. Courtesy, Museum of Fine Arts, Boston. Reproduced with permission. © Museum of Fine Arts, Boston. All Rights Reserved.

127. Attic red-figure hydria. London, British Museum E 159. After Hoppin 1919, vol. 2, 361.

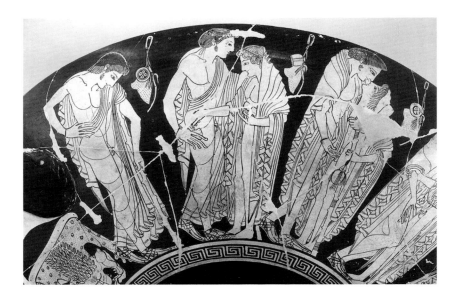

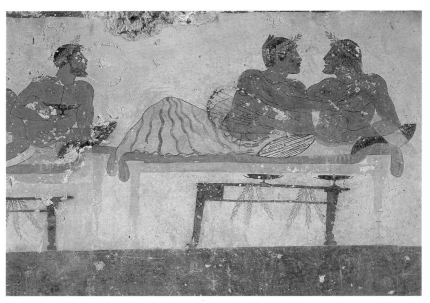

128. Attic red-figure kylix exterior. Berlin, Bildarchiv Preussischer Kulturbesitz, Antikensammlung, Staatliche Museen zu Berlin F 2279.

129. Tomb of the Diver. Detail of wall painting. Paestum, Museo Archeologico Nazionale. Photo: Scala/Art Resource, N.Y.

130. Attic red-figure kylix interior. Berlin, Bildarchiv Preussischer Kulturbesitz, Antikensammlung, Staatliche Museen zu Berlin F 2278.

131. Attic black-figure amphora. Munich, Staatliche Antikensammlungen und Glyptothek 1468. Photo: Moessner.

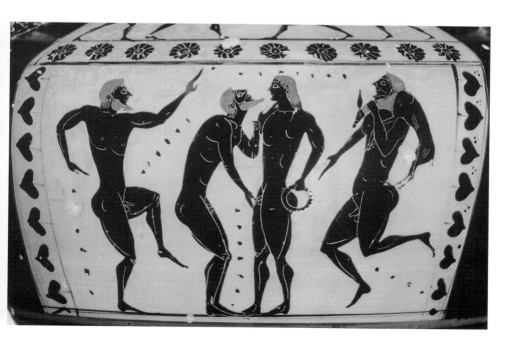

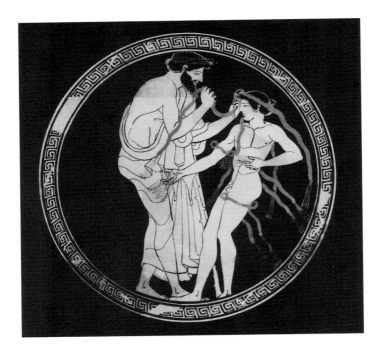

132. Attic red-figure kylix interior. New York, Metropolitan Museum of Art 1979.11.9; 1978.11.7a, d; 1980.304; 1988.11.5; 1989.43. The Metropolitan Museum of Art, Purchase, Mr. And Mrs. Martin Fried Gift, 1979; David L. Klein, Jr. Memorial Foundation, Inc. and Stuart Tray Gifts, 1978; Gift of Dietrich von Bothmer, 1980; Classical Purchase Fund, 1988; Gift of Elizabeth Hecht, 1989.

133. Head of a young man (Rayet Head). Copenhagen, Ny Carlsberg Glyptotek 418.

134. The Tyrannicides. Naples, Museo Nazionale. Photo: Hirmer Fotoarchiv.

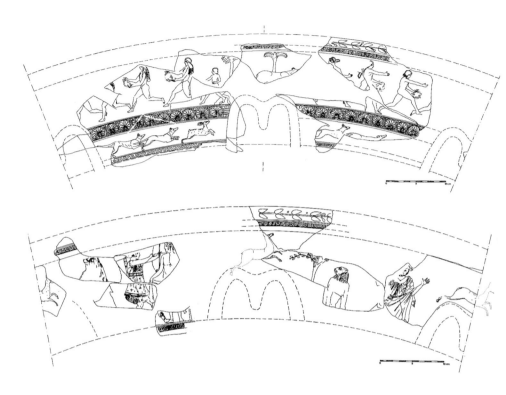

135. Attic red-figure krateriskos. Basel, Cahn Collection HC 502. After Kahil 1977.

136. Attic red-figure krateriskos. Basel, Cahn Collection HC 503. After Kahil 1977.

137. Fragment of Attic red-figure krater. Brauron, Archaeological Museum. Graphic by B. Sady after Kahil 1963, pl. 14.3

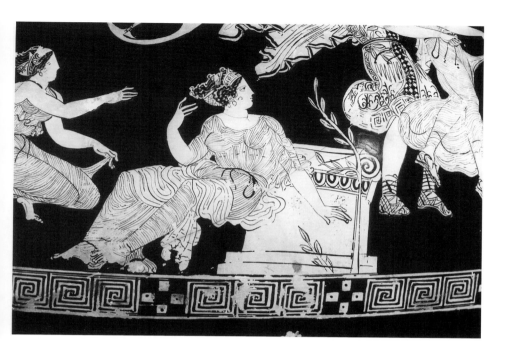

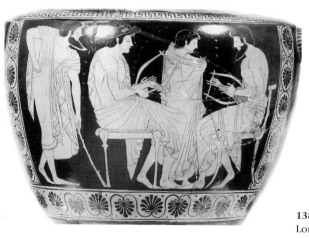

138. Attic red-figure hydria, detail. London, British Museum E 224. © Copyright The British Museum.

139. Attic red-figure hydria. Munich, Staatliche Antikensammlungen und Glyptothek 2421. Photo: Hirmer Fotoarchiv.

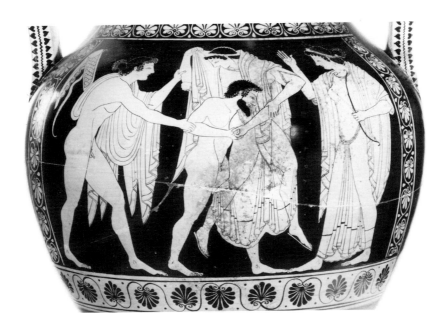

140. Attic red-figure amphora. Paris, Musée du Louvre G 42. Photo: Chuzeville.

141. Attic red-figure kylix exterior. Malibu, Calif, J. Paul Getty Museum 80.AE.31. Gift of Alan E. Salke.

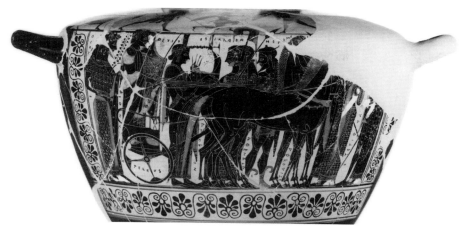

142. Attic black-figure hydria. Florence, Museo Archeologico 3790. Courtesy of Soprintendenza Archeologica per la Toscana, Firenze.

143. Attic red-figure loutrophoros. Boston, Museum of Fine Arts 03.802. Francis Bartlett Donation. Courtesy, Museum of Fine Arts, Boston. Reproduced with permission. © Museum of Fine Arts, Boston. All Rights Reserved.

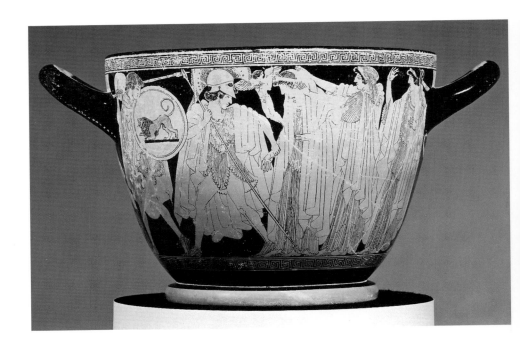

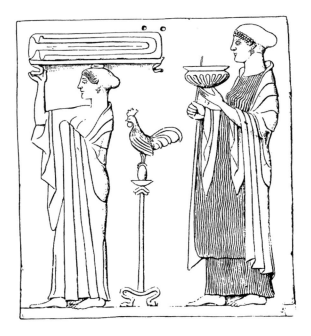

144. Attic red-figure skyphos.
Boston, Museum of Fine Arts
13.186. Francis Bartlett Donation.
Courtesy, Museum of Fine Arts,
Boston. Reproduced with permission.
© Museum of Fine Arts, Boston.
All Rights Reserved.

145. Pinax from Locri. Reggio
Calabria, Museo Archeologico.
After Prückner 1968, 44.

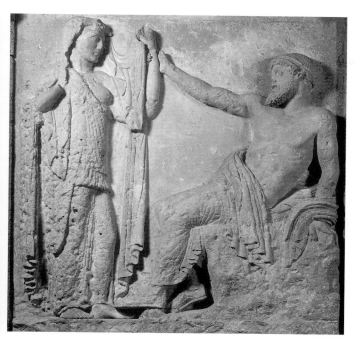

146. Metope from Temple
E at Selinus. Palermo,
Museo Archeologico.
Photo: Scala/Art Resource,
N.Y.

147. Athens. Parthenon
frieze, detail. London,
British Museum. Photo:
Foto Marburg/Art Resource,
N.Y.

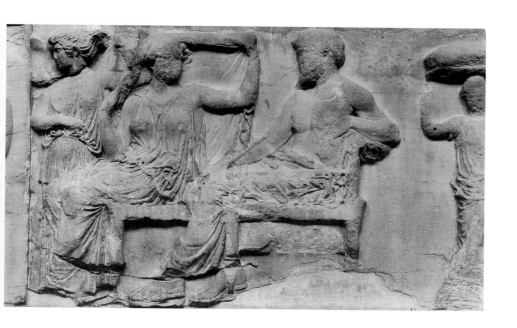

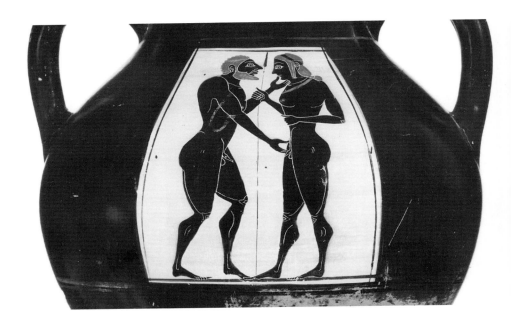

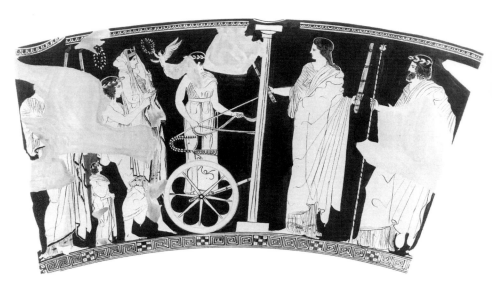

148. Attic black-figure amphora. Würzburg, Martin von Wagner Museum, Universität Würzburg L 241. Photo: K. Oehrlein.

149. Attic red-figure loutrophoros, now lost. Previously in Berlin, Staatliche Museen F 2372. After Furtwängler 1883, pl. 58.

Where in the spectrum of meanings that the word *philia* covers, from friendship to erotic passion, does the *philia* among fellow citizens fall?

The poem to Pindar's seventh Olympian ode offers some insights into the way in which the bond that marriage creates between men was conceived:

Φιάλαν ὡς εἴ τις ἀφνειᾶς ἀπὸ χειρὸς ἑλών
ἔνδον ἀμπέλου καχλάζοισαν δρόσῳ
δωρήσεται
νεανίᾳ γαμβρῷ προπίνων οἴκοθεν οἴκαδε, πάγχρυσον, κορυφὰν
 κτεάνων,
συμποσίου τε χάριν κᾶδός τε τιμάσαις ἑόν, ἐν δὲ φίλων
παρεόντων θῆκέ νιν ζαλωτὸν ὁμόφρονος εὐνᾶς.

καὶ ἐγὼ νέκταρ χυτόν, Μοισᾶν δόσιν, ἀεθλοφόροις
ἀνδράσιν πέμπων, γλυκὺν καρπὸν φρενός,
ἱλάσκομαι,
Ὀλυμπίᾳ Πυθοῖ τε νικώντεσσιν. ὁ δ' ὄλβιος, ὃν φᾶμαι κατέχοντ'
 ἀγαθαί·
ἄλλοτε δ' ἄλλον ἐποπτεύει Χάρις ζωθάλμιος ἀδυμελεῖ
θαμὰ μὲν φόρμιγγι παμφώνοισί τ' ἐν ἔντεσιν αὐλῶν.

[As if someone, taking a cup foaming inside with the dew of the vine, from wealthy hand should make a gift of it to his son-in-law, a youth in his prime, pledging it with a toast from house to house, solid gold, the pride of possessions, honoring the grace of the symposium and of his own kin in marriage, and thereby, with friends present, makes him enviable for the marriage-bed, to which they both consent,

So do I, by sending a draught of nectar, gift of the Muses, the sweet fruit of my mind, to prizewinning men, beseech them, the victors of Olympia and Pytho. For he is blessed, whom good reports surround; Grace, who brings life into bloom, visits now one, now another, often with the sweet-singing phorminx and the full-voiced equipment of the auloi.] (*Olympian* 7.1–12)[117]

The simile compares Pindar's song of praise with the toast from the man who gives the bride away to the bridegroom at the wedding banquet.[118] The figure of *philotesia*, "loving cup," informs each of its terms and, in turn, is compounded with another metaphor, a different one in each case. Within this symmetrical structure, as in an echo chamber, metaphor responds to

metaphor in such a way that the relationship of father to son-in-law illustrates that of poet to patron and vice versa.

Propinein was a sympotic ritual in which one man addressed another by name toasting him and, at the same time, making him a gift of the cup from which the latter also should drink.[119] *Philotesia* means the cup itself and, by extension, the entire procedure.[120] One does not know how old the custom was by the time of Pindar—perhaps as old as the symposium itself. It appears first in a fragment of Anacreon, where it conveys an erotic metaphor:

Ἀλλὰ πρόπινε
ῥαδινούς, ὦ φίλε, μηρούς.

[Toast to me,
my love, your slender thighs.][121]

In Pindar's seventh Olympian ode, the father of the bride follows the three-step procedure (1–6). He takes the *phiale* (ἑλών), pledges it to his son-in-law with a toast (προπίνων), and presents it to him (δωρήσεται). The gesture is the vehicle of a transparent metaphor of *ekdosis*, the handing over of the bride to the groom.[122] Like the *phiale*, she changes hands and passes indeed *oikothen oikade*, from house to house. The figure is sustained as well by the image of the woman in *engue* as hoarded treasure, solid gold in this case, the most precious of her father's possessions.

The metaphor of *philotesia* in the comparandum of the simile in turn relies on an internal metaphor of poetry as wine. Pindar sends his song as if it were a loving cup to the victor, filled not with wine but with the "poured nectar" of the Muses. This conceit is attested again in a fragmentary elegy by Dionysius Chalcus, written a generation later:

δέχου τήνδε προπινομένην
τὴν ἀπ' ἐμοῦ ποίησιν. ἐγὼ δ' ἐπιδέξια πέμπω
σοὶ πρώτῳ Χαρίτων ἐγκεράσας χάριτας.
καὶ σὺ λαβὼν τόδε δῶρον ἀοιδὰς ἀντιπρόπιθι,
συμπόσιον κοσμῶν καὶ τὸ σὸν εὖ θέμενος.

[Accept this (cup) that is pledged to you, one of
poetry from me. I send it to the right to you
first, after mixing (in it) the graces of the
Graces. And you, as you take this gift,

pledge songs in return, adorning the symposium and doing
honor to yourself.] [123]

Although Dionysius Chalcus apes Pindar elsewhere,[124] nothing here indi-
cates specific derivation from *Olympian 7*. There are, however, striking co-
incidences in wording, which may be explained best by reference to for-
mulas traditionally employed in *philotesia*. Dionysius Chalcus's symposiast
"sends" his cup of poetry to the man on his right (2: πέμπω); Pindar "sends"
the phiale containing the nectar of song to the victors (8: πέμπων). The re-
cipient of the cup is urged to respond in kind, thereby adorning the sym-
posium and doing honor to himself (συμπόσιον κοσμῶν καὶ τὸ σὸν εὖ
θέμενος, 5). The welfare of the symposium and one's own are similarly con-
joined in Pindar's description of the effect of the wedding toast — συμπο-
σίου τε χάριν κᾶδός τε τιμάσαις ἑόν. A fragment of the *Anacreontea*, which
reads like a rhapsody of sympotic clichés, again brings the erotic connota-
tions of *philotesia* to the fore:

> Come, my heart, which way are you mad, maddened as you are by the
> best madness of all? Come, shoot your arrow with a firm hand, so as to
> hit the target and depart. Give up the bow of Aphrodite, by which she
> overcame the gods. Do as Anacreon did, the glorious singer, pledge
> your *phiale* to boy-loves, the lovely *phiale* of words; taking comfort from
> a drought of nectar, let us flee the scorching star.[125]

Pindar evokes the image of the praise-singer as *erastes* at the opening of the
second Isthmian ode, where Woodbury recognized echoes of Alcaeus and
Anacreon. Pindar compares unfavorably the whorish Muse of his days with
the Muse of old and her songs of boy-loves:[126]

> The men of old, o Thrasyboulos, who mounted the chariot of the gold-
> crowned Muses confronting a noble lyre, would dart off swiftly honey-
> voiced hymns of boy-love, if one in beauty held well-throned Aphro-
> dite's sweetest late-summer season of wooing.

Pindar thus makes explicit reference to a hallowed tradition of poetry that
mapped the relationship between poet and patron according to that be-
tween *erastes* and *eromenos*. This model, I believe, is the one adopted in the
seventh Olympian ode, within the frame of reference that is appropriate
to it, that is, the ambiance of the symposium evoked by the metaphors of
philotesia.[127]

Expectations of eroticism are raised by the mention of the Grace, who fa-
vors now one man, now another. The *kharis* that makes "life bloom" (11–
12) is an allusion to the *hora*, the season of bloom that marks the time for
one to be *eromenos*.[128] *Kharis* is the quality of being *kalos* that inaugurates
the "season of wooing" mentioned in the second Isthmian ode (2.5); it vis-
its "now one man, now another" because it is as ephemeral as it is splendid.
It is the word *hilaskomai* (9), however, that establishes the erotic valence of
the poet's gift of "poured nectar." The verb is used normally in prayers to
the gods, and it means to appease, supplicate, or propitiate. Pindar uses the
language of prayer again in an unmistakably homoerotic sense in the eighth
Nemean ode. The ode opens in praise of eros and of the loves of Zeus and
Aegina, from which Aeacus was born. There follows a description of Aea-
cus as irresistible object of desire. The poet then offers Aeacus his song in
honor of Deinias of Aegina and his father in an intricate metaphor that in-
volves himself as suppliant, a fillet, the hero, and the city:

> Many times many prayed (*litaneuon*) they would behold him. For, un-
> bidden, the flower of the heroes who dwelled around wished to submit
> to his commands of their own accord, both those who marshaled the
> host in rocky Athens and the descendants of Pelops in Sparta. A suppli-
> ant (*hiketas*), I touch the hallowed knees of Aeacus, on behalf of the city
> dear to him and of these citizens bringing a Lydian fillet, to the high
> sound of the auloi, embroidered Nemean ornament for the double vic-
> tory in the foot-race of Deinias and his father Megas.[129]

The ode is metaphorically the fillet, which the athlete received upon his
victory, and its performance becomes the dedication of that fillet in the
sanctuary of the Aeginetan hero, in commemoration of that victory.[130] The
boundary separating the athlete from the hero is blurred. Like the athlete,
Aeacus is imagined at the peak of his prowess and his beauty, at the *ero-
menos* stage. Such a star is, for instance, Archestratus of Cyrene, "both beau-
tiful to behold and imbued with the bloom, which once, with Aphrodite,
warded from Ganymede a ruthless fate."[131] In the eagerness of the heroes
to obey Aeacus's every command one easily recognizes a commonplace in
stories of *paiderastia*: the readiness of the *erastes*, in the throes of love, to
submit to any of the *eromenos*'s demands in the hope that the latter will
grant him favors, *kharizesthai*.[132] Then the poet decks Aeacus with the vic-
tor's fillet.[133] The action has the effect of assimilating the hero with the ath-
lete and, at the same time, the poet with his *erastai* of old: just as those had

"prayed," *litaneuon*,[134] he entreats, like a suppliant, *hiketas*. The figure of en-treaty in the seventh Olympian ode, *hilaskomai*, has the same meaning.[135]

The figure of the *erastes* as beseecher of the godlike, aloof *eromenos* is a stereotype in the representation of male courtship.[136] In Plato's *Symposium*, for instance, Pausanias's speech offers a prose version of the behavior, to which Pindar alludes in the eighth Nemean ode:

> If a man intended to behave towards another the way *erastai* do to-wards their *paidika* with the intention of taking money from him, or gaining office, or some other power—entreating by means of supplica-tions and pleadings, swearing oaths, sleeping in doorways, willing to submit to slavery such as no slave would suffer—he would be pre-vented from doing so by both friends and enemies . . . but virtuous charm is ascribed to the lover who does all these things, and he is al-lowed to do them without reproach under our customs, as if he were accomplishing a most honorable deed.[137]

Far from Pindar's heights, at the level of popular culture and in a manner that approximates caricature, the painted vases illustrate this notion in the earliest scenes of male courtship. In what Beazley called "the up-and-down" gesture, the man reaches for the genitals of the *paidika* with his right and raises the left to touch his chin, in the standard gesture of supplication (fig. 148).[138]

The erotic ingredient in sympotic and encomiastic poetry does not ex-press, of course, the poet's personal impulses. Rather, homoerotic praise proposes the figure of the *eromenos* as the paragon of *arete* and the desire he thereby engenders among his fellow men as the highest cultural and civic ideal. These are important elements of the *philia*, which brings together the good men of the city, the *agathoi*, into one, harmonious community.[139] Cairns identified this model in Pindar's first Olympian ode, with its daring transformation of the myth of Tantalus's grizzly feast into a tale of *paidera-stia* and of the hero of Olympia into the *eromenos* of Poseidon.[140] When Pelops asks the god for help in winning his bride, he appeals to the grati-tude that was owed him for favors granted, "the beloved gifts of Cypris" (75). Poseidon honors him, *agallon* (86), with the gift of the gold chariot and winged horses, thus completing the cycle of reciprocal exchanges of services and favors.[141]

The sense of the simile that opens the seventh Olympian ode is plain enough: the song of praise generates fame, which extends a man's achieve-

ment into the future, just as a legitimate wife bears him children who continue his line in the polity. In this overarching metaphor, however, tenor and vehicle are not mapped directly one onto the other. Instead, both bride and song are each seen through the vehicle of *philotesia*, which establishes an equivalence of the bride as *phiale* to the song as *phiale*, and of the poet to the man who gives the bride away. In other words, the structure of the simile requires that, as we project the image of the bride onto that of the song, we also project the persona of the *erastes* onto that of the father of the bride. Pindar's posture toward the prizewinning athletes, *hilaskomai*, qualifies as well the sense in which the father-in-law honors, *timasais*, his newly acquired kin. Here, too, one recognizes key words of the language of male courtship. To translate νεανίᾳ γαμβρῷ as "to his young son-in-law" is to strip the expression of its glamour.[142] *Neanias* is a specialized term for one who is *horaios* and, in Homer's words, "one growing his first moustache, in whom the charm of youth is fairest" (*Odyssey* 10, 278–79). The fact that the gesture of *philotesia* is made in the presence of assembled *philoi*, φίλων παρεόντων (5–6), belongs to the discourse of *paiderastia* as well in that it expresses the *erastes*'s public acknowledgement of his devotion. Compare the scene with that evoked by Theognis 1341–44, where disclosure is forced upon the *erastes*:

> Alas, I love a boy with tender skin, who exposes me to all my *philoi*,
> though I am unwilling. I will endure, not hiding the many acts of violence I suffered against my will. At least I have been revealed as the conquest of a not unseemly boy.[143]

Finally, let us note that the expression *homophronos eunas* (Pindar *Olympian* 7.6) is deployed with intentional ambiguity, its sense sliding from a literal to a metaphorical meaning. The two who are to share the marriage bed are groom and bride, but the two consenting parties are father- and son-in-law, and the spotlight is on their unanimity.[144]

This vignette throws into relief the act constitutive of marriage, with respect to which ritual actions that focus on the bride and the relationship between bride and groom are but epiphenomena. On stage is a vivid illustration of Lévi-Strauss's classic definition of marriage as alliance:

> The total relationship of exchange which constitutes marriage is not established between a man and a woman, where each owes and receives something, but between two groups of men, and the woman figures only as one of the objects in the exchange, not as one of the partners

> between whom the exchange takes place. . . . the relationship of reci-
> procity which is the basis of marriage is not established between men
> and women, but between men by means of women, who are merely
> the occasion of this relationship.[145]

To this I would add that marriage is not a matter of "superimposing upon the natural links of kinship the henceforth artificial links . . . of alliance governed by rule,"[146] but of substituting a set of natural relationships with a set of social regulations. Far from masking the fundamentals of the exchange, the ideology of the polis poses marriage as the opposite of the elementary family, which comes about "according to nature," *kata phusin,* in the *oikos.* The link of kinship between a father and his "authentic" children, *gnesioi,* is not a matter of consanguinity, as it is in the case of *nothoi,* but of contractual agreement.

Lévi-Strauss took this model to apply in different forms in different societies, both primitive and complex. The case of the Greek polis represents a particular instance of this general principle, characterized, among other things, by the fact that the relationship of the bride-receiver to the bride-giver is friendly, indeed harmonious. The very fact that in the seventh Olympian ode and in myths marriage could be cast as the outcome of *paiderastia* reveals that in the polis marriage is subsumed under the homoerotic ethos that governs the society of men. More has changed from the world of the epic than the shift from the payment of the *hedna* to the endowment of the bride. In mythical and epic weddings the prospective father-in-law assumed an adversarial position toward his prospective son-in-law, requesting compensation in goods or services. In the world of the polis, one guarantees and freely extends to the other access to the means of social reproduction, in the cycle of reciprocity based upon *philia* that is the wellspring of political life. In this light, the ideological import of the *engue* becomes evident. The contract is the necessary and sufficient condition of the marriage because it establishes the consensual partnership of two citizens in the enterprise of producing an offspring of citizens.[147] This fact is highlighted symbolically by the absence of the bride's consent from the legal procedure. The poetics of reproduction in the polis firmly exclude the woman except as the necessary vessel for procreation.

I have argued that marriage is not an initiation and that it does not mark for a woman the passage to a new estate in society. The procedures that mark off a segment of the female population as a pool of legitimate wives, however, are not without effect. These are best documented for Athens in the Classical period. The rites of the Arkteia invest the daughters of Atheni-

where is love?!

ans with the capacity of marrying. The quality of being the daughter of a citizen and the potential mother of a citizen is signified by the oxymoron *politis*, "woman citizen," in reference to such women.[148] The *engue* establishes a permanent dual guardianship for such women, which substantially limits the authority of a husband over his wife. Her ability to initiate divorce, either by informal appeal to her *ankhisteia* or by formal proceedings, gave a woman a measure of indirect control over the dowry, which had entered her husband's *oikos* with her and would leave with her.[149] There comes into view a class of women privileged on the basis of ethnicity and wealth distinct from the majority of women who populate the Greek polis: the prostitutes, the courtesans, the poor—the metic and free women a man may take in concubinage.[150] No doubt, upper-class wives exercised a shadowy authority, and some point to this to show that the lot of women in ancient Greece was not as grim as others would make it. One should note, however, that such authority as a *politis* had depended upon her ability to make herself invisible. The wife's power rests precisely upon her submission, which is advertised and prominently displayed in social practices and personal behavior. The ideal that a woman should be confined to the house and her public appearances strictly controlled did not apply to all women, but specifically to her.[151] Nor should her presence otherwise materialize in public places, in the form of *kleos*, her name or any kind of renown.[152] The *locus classicus* on this point is in Thucydides' version of the funeral oration delivered by Pericles for the war dead in the first year of the Peloponnesian War. The eulogy takes the form of a panegyric for the polis, after which the orator turns to those the men had left behind—their fathers, their sons and brothers, and finally, their widows. He acknowledges the men's loss and points to the honor that accrues to them in the future on account of that loss. As to the widows, he has this to say:

> If I must also say something about womanly virtue, those who now
> shall be widows, I shall point to it in a brief exhortation. Great repute
> attaches to being not inferior to what you are by nature, and to her
> whose renown among the men is least, whether in praise or in blame.
> (2.45.2)

By these words Pericles did not mean to vilify these women but to honor them.[153] And, as he stepped down, they "clasped his hand and crowned him with garlands and fillets like a victorious athlete," if Plutarch is to be believed (*Life of Pericles* 28). The statement itself is paradoxical in the way a preterition is. At the same time as he identifies in self-effacement a woman's

supreme achievement, the orator makes that achievement visible by point-
ing to it in the most hallowed and public of situations. The paradox, of
course, is only apparent, for what matters, as in a *damnatio memoriae*, is the
fact of the erasure itself. The point is not that women should be ignored but
that their lack of agency be stated and recorded. To that effect, their absence
from public places is punctuated by controlled and carefully staged ap-
pearances,[154] and their names, prominently inscribed in stone in the rec-
ords of the Artemis Brauronian and upon their tombs,[155] are pointedly
withheld in public speeches.[156] Wrapped in *aidos*, their eyes downcast, the
wives wore their invisibility as a badge of honor. And, inasmuch as it guar-
anteed their safety and privilege, it was one they would not easily relin-
quish, as Plato notes. In the sixth book of the *Laws*, the Athenian deplores
that the Spartan and Cretan lawgivers have failed to provide a structure for
women's conduct, namely, the practice of public common meals as the
foundation of social life:

> How shall one attempt, without being laughed at, actually to compel
> women to take food and drink publicly and exposed to the view of all?
> The female sex would more readily endure anything rather than this:
> accustomed as they are to live a life subterranean and dark (*dedukos kai
> skoteinos*), women will use every means to resist being led out into the
> light and they will prove much too strong for the lawgiver. So that else-
> where, as I said, women would not so much as listen to the mention of
> the right rule without shrieks of indignation; but in our state perhaps
> they will. (Plato *Laws* 781 C2–D2 [trans. Bury 1926, modified])

ἐπὶ διετὲς ἡβᾶν

There are nine instances of this formula, eight of which concern the rights of inheritance of sons upon their coming of age. The verb occurs in the present in three cases, and the aorist in all others. Debate concerning the specific age encompassed by this biennial *hebe* began with ancient commentators. Harpocration (s.v. "ἐπιδιετὲς ἡβῆσαι") equated the time of the *hebe* with the *ephebia*, that is, the eighteen to twenty age span.[1] The author of *Anecdota Graeca* (Bekker 1814) 255, 15, s.v. "ἐπὶ διετὲς ἡβῆσαι," on the other hand, takes the phrase to mean that at eighteen one is "two years past the *hebe*." The latter interpretation is preferred by modern scholars and was defended by Pélékidis, who interpreted *hebe* as "puberty" or "adolescence."[2] In her view, the aorist form of the expression refers to a two-year age class, which precedes the age of eighteen and the attainment of majority: "ὁ ἡβήσας signifie celui qui ayant dépassé l'âge de l'hébé a atteint dix-huit ans, l'âge de la majorité, de l'éphébie." Because the present ἐπὶ διετὲς ἡβᾶν does not convey the sense that the time of *hebe* has come to an end at the age of eighteen, its use would be improper and is explained by the hypothesis that fourth-century authors no longer had an accurate perception of *hebe* as an age class.

Although present and aorist appear to be used interchangeably, they are are not equivalent. The present subjunctive ὅσοι ἐπὶ δίετες ἡβῶσι is used by Aeschines 3.122 to mean straightforwardly adult males, that is, those who found themselves in the category of "youth." In the same way, the present denotes the state of being in the legal *hebe* in the law cited by Demosthenes 46.24 and in the passage of Hyperides quoted by Harpocration: . . . ὁ νόμος . . . ὃς κελεύει κυρίους εἶναι τῆς ἐπικλήρου καὶ τῆς οὐσίας ἁπάσης τοὺς παῖδας, ἐπειδὰν ἐπιδιετὲς ἡβῶσιν. [. . . the law, . . . which establishes

that the sons shall have control of the heiress and of all the patrimony, once they are in their two-year *hebe*]. In the aorist the phrase is found in Isaeus 8.31, 10.12, frag. 25; Demosthenes 46.24, 20. In all these cases it should be understood, as an ingressive aorist, signifying not the end of *hebe* but, on the contrary, entrance upon the state of *hebe*. This is particularly clear in the law given by Demosthenes in the last passage cited: καὶ ἐὰν ἐξ ἐπικλήρου τις γένηται, καὶ ἅμα ἡβήσῃ ἐπὶ διετὲς, κρατεῖν τῶν χρημάτων . . . [And if one is the son of a heiress, as soon as he becomes a youth for a period of two years, he shall control the patrimony].

Equally incorrect is the interpretation of the term *hebe* as phase of adolescence preceding the age of majority in the phrase μέχρι ἥβης. This occurs in passages referring to the state maintenance of the war orphans "until their *hebe*," as in Aeschines 3.154:

μέχρι μὲν ἥβης ὁ δῆμος ἔτρεφε, νυνὶ δὲ καθοπλίσας τῇδε τῇ πανοπλίᾳ, ἀφίησιν ἀγαθῇ τύχῃ τρέπεσθαι ἐπὶ τὰ ἑαυτῶν . . .

[these young men . . . the state nourished until their *hebe*, and now armed in this full suit of armor sends forth with prayers of good fortune to go each his own way . . .]

Pélékidis supports her interpretation of the expression as "until the end of the *hebe*," that is, up to and no further than the age of eighteen, with a passage referring to the bestowing of the panoply on the orphans in Plato:

. . . καὶ ἐπειδὰν εἰς ἀνδρὸς τέλος ἴωσιν, ἀποπέμπει ἐπὶ τὰ σφέτερ' αὐτῶν πανοπλίᾳ κοσμήσασα . . .

[. . . and when they arrive at a man's estate, (the city) sends them back to their own place, after bestowing upon them full military equipment . . .] (*Menexenus* 249A)[3]

By understanding the expression "when they arrive at a man's estate" to refer to the moment at which a young man is inscribed in the registry of his deme at eighteen, it is possible to argue that the bestowal of the panoply marked both the end of the state support for the youth and the end of his *hebe*.

I would argue, however, that the phrase "a man's estate" is not used here in the technical sense of ἐπὶ διετὲς ἡβῆσαι, and reflects, instead, that conception of *hebe* as a still transitional, albeit postliminal, stage in the prog-

ress of the youths toward manhood, which is explored in detail later in chapter 6, above. It is, in any case, unlikely that at any time war orphans were equipped with the hoplitic armor before they had received any formal military training. From the Aristotelian *Constitution of the Athenians* (42, 4), we learn that the *epheboi* received the panoply in their second year, after performing a tattoo in the theater of Dionysus for the assembled citizenry. The interpretation of *hebe* as an age class that follows, rather than precedes, the acquisition of substantial citizen rights at eighteen is in agreement with the frequent use of the participle ἡβῶν to mean "adult,"[4] and with the formation of the word ἔφηβος itself to mean ὁ ἐφ' ἥβης, that is, one who is in the time of *hebe*.

The Vases

The following checklist contains the vases upon which the analyses of the imagery of females working wool in chapters 1 and 2 are based. The corpus is subdivided accordingly into two main sections: images that consist of a single figure (the "meaningful figures" or formulas); and the main themes in which they are deployed: toilet, leisure, and courtship, followed by scenes of pursuits and weddings. A final section lists scenes too elliptical or poorly preserved to be identified. I have included all representations that contain notations of wool-working known to me, including a few in which no "formula" appears, such as, for example, the white alabastron in the Kannellopoulos Museum with two girls seated on either side of a wool basket on which perch birds. The list does not claim to be exhaustive; in fact, it could easily be doubled by a thorough canvassing of museum storerooms. At over six hundred vases, however, the sample is significant enough for an accurate sketch of the semantic range of the figure of the spinner. It reveals as well the repetitive, combinatory quality of the scenes in which she appears.

The format of each entry is modeled on the conventions used in *ABV* and *ARV*². Unless it is otherwise specified, the vase is Attic red-figure. The identifications of painters follow Beazley's; attributions by other scholars are noted selectively in parentheses. Whenever possible, the presence of inscriptions is acknowledged. Capital letters at the end of each entry identify the recognizable "formulas" that appear in the scene.

FORMULAS

A. Seated Spinner

ATHENS, National Museum 12428, lekythos.
ATHENS, National Museum, Acropolis Collection 363a, fragment of kylix floor. Graef and Langlotz 1909–33, II, 33, pl. 27.

SYDNEY, University of Sydney, Nicholson Museum of Antiquities 46.40, kylix. Eucharides Painter. *ARV*² 231, 87.

PHILADELPHIA, University of Pennsylvania, University Museum of Anthropology and Archaeology 73-25-1, white lekythos.

ZURICH, Universität Zurich, Archäologische Sammlung 2507, lekythos. *CVA* Zurich 1, Switzerland 2, 1973, pl. 24,9–10.

Variant

Seated figure weaves on portable frame

LONDON, British Museum 1905.11.2.3, lekythos in Six technique. Clark 1983, pl. 15, 4.

B. Standing Spinner

BASEL MARKET, Münzen und Medaillen, white lekythos. Carlsruhe Painter. *ARV*² 734, 92; *Paralipomena* 412.

LONDON, British Museum D 13, white-ground oinochoe. Foundry Painter. *ARV*² 403, 38, 405; *Beazley Addenda* 231. *he pais kale.*

NAPLES, Museo Nazionale 86388 (Raccolta Cumana), white lekythos. *CVA* Naples 5, Italy 69, pl. 71.

NEW HAVEN, Yale University 118, white lekythos. Two-Row Painter. *ARV*² 727, 24.

ORVIETO, Museo Civico, Collection Faina 105, kylix tondo. Clinic Painter. *ARV*² 810, 21.

PALERMO, Museo Nazionale V 693, lekythos. Recalls the Triptolemos Painter. *ARV*² 367.

PALERMO, Museo Nazionale V 694 (ex Astuto), lekythos. Astuto Group. *ARV*² 311, 1.

PARIS, Bibliothèque Nationale, Cabinet des Médailles 1647 (Froehner IX 245), lekythos. Villa Giulia Painter. *ARV*² 624, 81. *philergos.*

TARANTO, Museo Archeologico Nazionale 8241, lekythos. Berlin Painter. *ARV*² 211, 207; *Beazley Addenda* 196.

Possibly also the following:

AGRIGENTO, Museo Archeologico Regionale, lekythos. Hermonax. *ARV*² 490, 118.

C. Sitting Figure at Wool Basket Holds Wool

GENEVA, Musée d'Art et d'Histoire 18043, lekythos. Bowdoin Painter. *ARV*² Figure 682, 104 bis; *Paralipomena* 406. *Pasithea.*

Probably also the following:

BRUSSELS, Musées Royaux d'Art et d'Histoire A 3131, lekythos. Bowdoin Painter. *ARV²* 682, 107; *Beazley Addenda* 279.
OXFORD, Ashmolean Museum of Art and Archaeology 326, squat lekythos. *CVA* Oxford 1, Great Britain 3, 1927, pl. 40.17.

D. Sitting Figure Holds Wool Basket

BASEL MARKET, A.G., lekythos. Münzen und Medaillen 1971, 34–35 no. 41.
LAON, Musée Archéologique Municipal 37.967, fragmentary lekythos. *Paralipomena* 462; *CVA* Laon 1, France 20, n.d., pl. 41,6.
MAINZ, Johannes Gutenberg Universität 130, alabastron. Painter of Copenhagen 3830. *ARV²* 724, 6.

E. Standing Figure Holds Wool Basket

BRAURON, Archaeological Museum, white lekythos.
SOFIA, National Museum 7550, lekythos. Selinus Painter. *ARV²* 1686 (1201, 5); *Paralipomena* 462; Reho 1990, 105 no. 20, pl. 17.
SOLOTHURN, Langendorf, lekythos. Oionokles Painter. *ARV²* 649, 41, 1706 *Paralipomena* 402.
VIBO VALENTIA, Museo Statale Vito Capialbi C 67, squat lekythos. Seireniske Painter (De Cesare). *CVA* Vibo Valentia 1, Italy 67, pl. 30, 2.

F. Seated Figure at Wool Basket Holds Mirror

Once AGRIGENTO, Giuliana, lekythos. Bowdoin Painter. *ARV²* 682, 105.
ATHENS, National Museum 1194 (CC 1375), lekythos. Bowdoin Painter. *ARV²* 682, 106.
ATHENS, National Museum 1214 (CC 1507), squat lekythos. Group of Copenhagen 6442. *ARV²* 706, 1.
ATHENS, National Museum 1624 (CC 1198), lekythos. Sabouroff Painter. *ARV²* 844, 157.
BASEL MARKET, white lekythos. Münzen und Medaillen 1971, 38–39, no. 50.
BASEL MARKET, lekythos. Jean-David Cahn AG 1996, no. 21.
BUCAREST, National Museum 0467, lekythos. *CVA* Bucarest 1, Romania 1, 1965, pls. 33, 7; 34, 1.
ESSEN, Museum Folkwang RE 49, lekythos. Froning 1982, 184–86 no. 75.
Once LONDON, Rogers 314, lekythos. Providence Painter. *ARV²* 643, 122, 1581.15. *Glaukon kalos.*
PALERMO, Banco di Sicilia, Collezione Mormino 798, lekythos. *CVA* Palermo, Mormino 1, Italy 50, 1971, III, I, pl. 4, 1.

ROME, Museo Nazionale Etrusco di Villa Giulia 25006, kylix tondo. Telephos Painter. *ARV*² 819, 39; *Beazley Addenda* 293.

G. Standing Figure at Wool Basket Holds Mirror

ATHENS, National Museum 1278 (CC 1381), lekythos. Aischines Painter. *ARV*² 711, 61. *kale.*

ATHENS, National Museum 1574 (CC 1212), kylix. Painter of the Yale Kylix. *ARV*² 396, 20.

BASEL MARKET, lekythos. Jean-David Cahn AG 2000, 25 no. 61.

BOSTON, Museum of Fine Arts 98.928, white-ground head kantharos. Syriskos Painter. *ARV*² 265, 78; *Beazley Addenda* 205.

BRUSSELS, Bibliothèque Royale Albert 1er. 10, lekythos. Pan Painter. *ARV*² 556, 110.

BRUSSELS, Musées Royaux d'Art et d'Histoire A 3132, lekythos. Bowdoin Painter. *ARV*² 681, 91; *Beazley Addenda* 279.

CAMBRIDGE, Robertson, squat lekythos. Painter of London E 673. *ARV*² 705, 5. Winged.

LAON, Musée Archéologique Municipal 37.959 bis, lekythos. Painter of Prague 774. *ARV*² 695, 2.

NANTES, Musée Dobrée 903-644, lekythos. Aischines Painter (Frère). *CVA* Nantes, France 36, pl. 25, 1–3.

SOFIA, National Museum 7554, squat lekythos. Bowdoin Painter. *ARV*² 1666 (688, 233 bis); *Paralipomena* 406; Reho 1990, 105 no. 201, pl. 18.

VIBO VALENTIA, Museo Statale Vito Capialbi C 66, squat lekythos. Aischines Painter (De Cesare). *CVA* Vibo Valentia 1, Italy 67, pl. 29, 1.

VIENNA, Universität Wien, Universitätmuseum 53 c 2, kylix fragment. Follower of Makron. *ARV*² 810, 32.

WARSAW, National Museum 198554, white lekythos. Sappho Painter. *ARV*² 302, 19; *Paralipomena* 357; *Beazley Addenda* 212.

Probably also the following:

LAON, Musée Archéologique Municipal, lekythos. *CVA* France Laon 1, France 20, n.d., pl. 43,4.

Variants

Standing Figure Holds Mirror and Wool Basket

SYRACUSE, Museo Archeologico Nazionale 21162, lekythos. Painter of the Yale lekythos. *ARV*² 658, 32.

Standing Figure Holds Mirror and Naked Distaff

KARLSRUHE, Badisches Landesmuseum 56/81, lekythos. Carlsruhe Painter (Garscha). *CVA* Karlsruhe 3, Germany 60, 1990, pl. 41, 8–9; 42, 2.

LIPARI, Museo Archeologico Eoliano T 233, lekythos. Related to the Icarus
Painter. *ARV*² 1702 (696); Bernabò-Brea and Cavalier 1977, 200, fig. 95.

Standing Figure at Wool Basket Holds Mirror and Alabastron

PARIS, Musée du Louvre G 282 (S 1350), kylix tondo. Douris. *ARV*² 432, 60;
436, 106; 437, 117; 1706; *Beazley Addenda* 237, 238, 239.

Standing Figure at Wool Basket Holds Mirror and Flower

ANN ARBOR, University of Michigan, Kelsey Museum 2603, lekythos. *CVA* University of Michigan 1, USA 3, 1933, pl. 16,2. S/T.
ATHENS, National Museum 2207, lekythos.
COPENHAGEN, National Museum 137 (Inv. Chr. VIII 949), small lekythos. Icarus Painter. *ARV*² 698.32; *Beazley Addenda* 281.
PALERMO, Museo Nazionale (147), white lekythos. Manner of Carlsruhe
Painter.

Standing Figure at Wool Basket Holds Mirror and Sash

OXFORD, Ashmolean Museum of Art and Archaeology 1925.73, kylix. Brygos
Painter. *ARV*² 378, 140.
PARIS, Musée Auguste Rodin TC 531, white lekythos. *CVA* Rodin 1, France 16,
1945, pl. 27,1.

H. Seated Figure at Wool Basket Makes Garland or Circlet

BERLIN, F 2252, white lekythos. Syriskos Painter. *ARV*² 263, 54, 1641; *Paralipomena* 351; *Beazley Addenda* 205. *ho pais kalos, kalos, Olunpikhos kalos.*
BERLIN, Antikensammlung V.I. 3140,286, squat lekythos. *CVA* Berlin 8, Germany 62, 1991, pl. 45, 2, 8–9.
BOCHUM, Ruhr Universität, Kunstsammlungen S 1004, white lekythos. Icarus
Painter (Kunisch). Kunisch 1980, 27 no. 173.
CASTELVETRANO, Museum, white lekythos. Providence Painter. *ARV*² 643,
123; 1581; Papoutsakis-Sermpetis 1983, 184 no. 132. *Glaukon kalos.*
ELEUSIS, Archaeological Museum TB 8 no. 201, lekythos. Manner of the Providence Painter (Cook). *ARV*² 645.3 bis.
HILLSBOROUGH, Hearst 18 (once SAN SIMEON, Hearst Hist. St. Mon.
12305), lekythos. Manner of Aischines Painter. *ARV*² 720, 21; *Beazley Addenda* 282.
HOUSTON, Museum of Fine Arts 34.131, white lekythos. Bowdoin Painter. *Paralipomena* 407 (*ARV*² 687, 210 bis); *Beazley Addenda* 280.
LONDON, British Museum D 20, white lekythos. Near the Villa Giulia Painter.
*ARV*² 626, 3; *Beazley Addenda* 271. *kale.*
OXFORD, Ashmolean Museum of Art and Archaeology 1966.441, small plate.
Painter of Acropolis 24. *ARV*² 22, 2; *Paralipomena* 323; *Beazley Addenda* 154.

PHILADELPHIA, University of Pennsylvania, University Museum of Anthropology and Archaeology M 4082, white lekythos.

TÜBINGEN, Eberhard-Karls-Universität, Antikensammlungen des Archäologischen Instituts S/10 1387 (E 58), white lekythos. Aischines Painter. *ARV*² 716, 209; *Beazley Addenda* 282. *kale.*

I. STANDING FIGURE AT WOOL BASKET MAKES WREATH

BRUSSELS, Musées Royaux d'Art et d'Histoire A 2138, lekythos. Carlsruhe Painter. *ARV*² 733, 67.

BRUSSELS, Musées Royaux d'Art et d'Histoire A 2990, white lekythos. *CVA* Brussels 3, Belgium 3, n.d., III Jb, pl. 5,2.

COPENHAGEN, National Museum 7610, lekythos. *CVA* Copenhagen 4, Denmark 4, n.d., pl. 165,8.

PHILADELPHIA, University Museum 5670, kylix tondo. Sabouroff Painter. *ARV*² 839, 37.

J. SITTING FIGURE AT WOOL BASKET TOSSES BALLS

ATHENS, National Museum 1414, lekythos.

ATHENS, National Museum 1513 (CC 1435), lekythos. Icarus Painter. *ARV*² 698, 45.

ATHENS, National Museum 1788, lekythos. Papaspyridi Karouzou 1945, pl. VI, 2.

ATHENS, National Museum 12553, squat lekythos.

LEIPZIG, Karl-Marx Universität, Antikenmuseum T 429, white lekythos. Manner of the Icarus Painter. *ARV*² 701, 10; *Beazley Addenda* 281.

LIPARI, Museo Archeologico Eoliano T 1279, lekythos. Bernabò-Brea and Cavalier 1977, 200, fig. 94.

NEW YORK, Metropolitan Museum of Art 41.162.145, lekythos. Carlsruhe Painter. *ARV*² 733, 66.

PARIS, Musée du Louvre G 331, kylix. Telephos Painter. *ARV*² 819, 42; *Paralipomena* 421; *Beazley Addenda* 293.

Variant

Standing Figure at Wool Basket Tosses Balls

BERLIN, Antikensammlung F 2478, squat lekythos. Bowdoin Painter. *ARV*² 688, 231; *CVA* Berlin 8, Germany 62, 1991, pl. 38, 4–5, 8–9.

NEW YORK, Metropolitan Museum of Art 41.162.147, lekythos. Carlsruhe Painter. *ARV*² 733, 62; *Beazley Addenda* 283.

OXFORD, Ashmolean Museum of Art and Archaeology 1914.9, lekythos. Carlsruhe Painter. *ARV*² 733, 64.

ROME, Accademia dei Lincei 2756, lekythos. Carlsruhe Painter. *ARV*² 733, 63.

K. Standing Figure at Wool Basket Holds Ball

ATHENS, National Museum 1648 (CC 1391), lekythos. Bowdoin Painter. ARV^2
681, 83.
ATHENS, National Museum 18723, kylix tondo. Painter of the Yale Kylix. ARV^2
395, 4; *Beazley Addenda* 229.
BASEL MARKET, lekythos. Jean–David Cahn AG 1996, no. 24.
BUCAREST, National Museum Gr. 5, squat lekythos. *CVA* Bucarest 1, Romania
1, 1965, pl. 34, 7.
CAMBRIDGE, Mass., Harvard University, Arthur M. Sackler Museum 1991.28,
white lekythos. Reeder 1995, 211–12 no. 46.

Variant

Standing at Wool Basket Unravels Ball of Wool

BASEL MARKET, Münzen und Medaillen A.G., lekythos. Providence Painter
(Beazley). Papoutsakis-Sermpetis 1983, 127 no. 104.
MUNICH, Staatliche Antikensammlungen 7821, lekythos. Carlsruhe Painter.
ARV^2 732.50, 1668.

L. Seated Figure Lifts Yarn from Wool Basket

ATHENS, National Museum 17350, lekythos. L.
BOSTON, Museum of Fine Arts 13.189, lekythos. Brygos Painter. ARV^2 384,
214; *Beazley Addenda* 228.
ELEUSIS, Archaeological Museum, white lekythos. Bowdoin Painter. ARV^2
687, 211.
METAPONTO, lekythos. Metaponto 1978, fig. 19.
RHODES, Archaeological Museum 11902, white lekythos. Bowdoin Painter.
ARV^2 687, 210.
ROME, Museo Nazionale Etrusco di Villa Giulia 43986, kylix tondo. *CVA* Villa
Giulia 2, Italy 2, n.d., pl. 37,3.

Probably also the following:

BERLIN, Antikenmuseum, inv. 1981.31, white lekythos. Beldam Workshop
(Wehgartner). *CVA* Berlin 8, Germany 62, 1991, pls. 7, 5–6; 9,1. Pseudo
inscription.
VIENNA, Universität Wien, Universitätmuseum 740, squat lekythos. Group of
Carlsruhe 280. ARV^2 1363, 7.

M. Standing Figure Lifts Yarn from Wool Basket

ATHENS, National Museum 1343 (CC 1417), lekythos. Bowdoin Painter. ARV^2
681, 81.

BASEL MARKET, lekythos. Münzen und Medaillen 1971, 27–28 no. 29. Possibly the same vase as the lekythos in the Manner of the Providence Painter, *Paralipomena* 402; Papoutsakis-Sermpetis 1983, 229 no. T4.

CHAPEL HILL, University of North Carolina, Ackland Art Museum 78.15.1, lekythos. Bowdoin Painter. *ARV*² 681, 82; *Beazley Addenda* 279.

NEW YORK MARKET, lekythos. Christie, Manson, & Woods International Inc. 2000, 110 no. 108.

OXFORD, Ashmolean Museum of Art and Archaeology 1914.8, lekythos. Bowdoin Painter. *ARV*² 681, 79.

Probably also the following:

PALERMO, Banco di Sicilia, Collezione Mormino 167, white lekythos. Bowdoin Painter (de la Genière). *CVA* Palermo, Mormino 1, Italy 50, III, Y, pl. 5, 3.

Variants

COPENHAGEN, National Museum 6441, squat lekythos. *CVA* Copenhagen 4, Denmark 4, n.d., pl. 167.9. Eros

TÜBINGEN, Eberhard-Karls-Universität, Antikensammlungen des Archäologischen Instituts 7358 (O.Z. 158), lekythos. Carlsruhe Painter. *ARV*² 734, 83, 1668; *Beazley Addenda* 283. Satyr.

N. Seated Figure at Wool Basket Holds Chest

ATHENS, National Museum 2186 (CC 1846), white-ground oinochoe. Akin to Naples 2439. *ARV*² 1562; *Beazley Addenda* 388.

WÜRZBURG, Bayerische-Julius-Maximilians-Universität, Martin von Wagner Museum 575, squat lekythos. Comacchio Painter. *ARV*² 958, 71.

Once ZURICH, Hirschmann G 25, white lekythos. Bloesch 1982, 82–83 no. 40; Sotheby & Co. 1993, 115 no. 51

O. Seated Figure at Wool Basket Holds Alabastron

AMSTERDAM, Allard Pierson Museum 1.11324 (formerly Bonn 1623), fragment of kylix tondo. Calliope Painter. *ARV*² 1261, 55.

Variants

P. Standing Figure at Wool Basket Holds Alabastron

ATHENS, Kannellopoulos Museum, white alabastron.

ATHENS, Kerameikos Museum, lekythos from grave S 12.

BRUSSELS, Musées Royaux d'Art et d'Histoire A 1687, white lekythos. *CVA* Brussels 3, Belgium 3, n.d., III J b, pl. 5,4.

Variants

GELA, Museo Civico (cim. spor. 1948–49), white lekythos. Manner of the Bowdoin Painter. *ARV²* 691, 29.

OXFORD, Ashmolean Museum of Art and Archaeology 325, squat lekythos. *CVA* Great Britain 3, pl. 40.19

Q. SEATED FIGURE AT WOOL BASKET HOLDS BALL

OXFORD, Ashmolean Museum of Art and Archaeology 1925.69, squat lekythos. Washing Painter. *ARV²* 1132, 189.

R. FIGURE STANDING OR IN MOTION AT WOOL BASKET

AMSTERDAM, Allard Pierson Museum 8887, lekythos. Seireniske Painter. Hemelrijk 1976, 105, fig. 10.

ATHENS, Agora Museum P 25838, squat lekythos fragment. Moore 1997, 264 no. 910, pl. 90.

ATHENS, National Museum 1213 (CC 1510), squat lekythos.

ATHENS, National Museum 1575, kylix type C. Interior.

ATHENS, National Museum 1576, kylix type C. Interior.

BASEL MARKET, lekythos. Christie, Manson, & Woods International Inc. 1997, 50.

BASEL Market, lekythos. Bowdoin Painter. Münzen und Medaillen 1971, 24–25 no. 23. Perhaps the same vase as the lekythos by the Bowdoin Painter, *Paralipomena* 406 (*ARV²* 681.88ter). "Woman standing at wool basket."

CENTRE ISLAND, private collection, lekythos. Carlsruhe Painter. *ARV²* 732, 40.

COLOGNE, private, white lekythos. Painter of Taranto 2606. *Paralipomena* 411 (*ARV²* 725.1 bis).

COPENHAGEN, Ny Carlsberg Glyptothek 2781, white lekythos. Manner of the Providence Painter. *ARV²* 645, 10. *kalos.*

MONTPELLIER, Musée Fabre 175 (S.A. 191), lekythos. Following of the Seireniske Painter. *ARV²* 707, 4; *Beazley Addenda* 281. Winged.

OSTWESTFALEN, D.J. collection, lekythos. Stähler 1983, 51 no. 29, pl. 40a.

PALERMO, Banco di Sicilia, Collezione Mormino 207, lekythos. *CVA* Palermo, Mormino 1, Italy 50, 1971, III, I, pl. 4, 4.

SANTORINI, Fira, Archaeological Museum, kylix interior.

TÜBINGEN, Eberhard-Karls-Universität, Antikensammlungen des Archäologischen Instituts 7394 (O.Z. 194), squat lekythos. Group of Copenhagen 6442. *ARV²* 706, 6; *Beazley Addenda* 281.

VIBO VALENTIA, Museo Statale Vito Capialbi C 69, squat lekythos. Seireniske Painter (De Cesare). *CVA* Vibo Valentia 1, Italy 67, pl. 29, 4.

VATICAN, Museo Gregoriano Etrusco G 72, kylix. Comacchio Painter. *ARV²* 955.1.

WÜRZBURG, Bayerische-Julius-Maximilians-Universität, Martin von Wagner Museum 490, kylix tondo. Painter of Louvre G 456. *ARV*² 825, 12.

Probably also the following:

ADRIA, Museo Archeologico B 250, kylix interior. Painter of Munich 2676. *ARV*² 393.31.
ENSÉRUNE, Musée d'Ensérune, kylix. Painter of the Naples Hydriskai. *ARV*² 1267.20; Lezzi-Hafter 1988, pl. 10.
LIPARI, Museo Archeologico Eoliano T 987, white lekythos. Bernabò-Brea and Cavalier 1977, 200, fig. 92.

Possibly also the following:

Once AGRIGENTO, Giudice 1748, lekythos. Icarus Painter. *ARV*² 698, 30.

Variants

PALERMO, Banco di Sicilia, Collezione Mormino 204, lekythos. Group of Palermo 16. *ARV*² 1687 (1204.9) (inv. no. given as 35).

S. STANDING FIGURE AT WOOL BASKET HOLDS BLOOM

ATHENS, National Museum, Acropolis Collection 843, lekythos. Aischines Painter. *ARV*² 711, 69. *kale.*
BOSTON, Museum of Fine Arts 95.40, lekythos. Telephos Painter. *ARV*² 820, 53; *Paralipomena* 421; *Beazley Addenda* 293. *Likhas kalos.*
LONDON, British Museum E 51, kylix. Manner of Douris. *ARV*² 449, 4, 1653; *Paralipomena* 376. *he pais, kalos.*
NAPLES, Museo Nazionale 86384 (Raccolta Cumana), white lekythos. *CVA* Naples 5, Italy 69, pl. 70.

Probably also the following:

CORINTH, Archaeological Museum MP 107, lekythos. Bowdoin Painter. *ARV*² 681, 85.
OXFORD, Ashmolean Museum of Art and Archaeology 1929.464, kylix. Brygos Painter. *ARV*² 379, 158.

T. STANDING FIGURE AT WOOL BASKET HOLDS DISTAFF

ATHENS, Agora Museum P 6503, squat lekythos. Moore 1997, 264 no. 912, pl. 91.
ATHENS, National Museum 1346 (CC 1472), lekythos. Icarus Painter. *ARV*² 698, 33.
CAMBRIDGE (Mass.), Harvard University, Arthur M. Sackler Museum 1925.30.36, lekythos. Aischines Painter. *ARV*² 711, 60.

CHALKIS, Archaeological Museum 564, lekythos. Carlsruhe Painter. *ARV*² 733, 56.
GENEVA, Wuarin, lekythos. Dörig 1975, no. 218.
LONDON MARKET, lekythos. S.M.M. Group. *Paralipomena* 411.
OMAHA, Joslyn Art Museum 1952.258, lekythos. Carlsruhe Painter. *ARV*² 732, 31; *Beazley Addenda* 283.
OXFORD, Ashmolean Museum of Art and Archaeology 1927.4461, lekythos. Carlsruhe Painter. *ARV*² 732, 51.
PALERMO, Banco di Sicilia, Collezione Mormino 177, white lekythos. Icarus Painter. *ARV*² 1667 (699, 61 bis); *Beazley Addenda* 281.
PALERMO, Banco di Sicilia, Collezione Mormino 301, lekythos. Aischines Painter. *CVA* Palermo, Mormino 1, Italy 50, 1971, III, I, pl. 4, 10.
ST. PETERSBURG, State Hermitage Museum b 1530 (B662), kylix. Carlsruhe Painter. *ARV*² 738, 147; *Paralipomena* 515.
ST. PETERSBURG, State Hermitage Museum b 2639 (B 871), lekythos. Carlsruhe Painter. *Paralipomena* 515.
TÜBINGEN, Eberhard-Karls-Universität, Antikensammlungen des Archäologischen Instituts 1588 (E 76), lekythos. Aischines Painter (Watzinger). *CVA* TÜBINGEN 5, Germany 54, 1986, pl. 38,5-6.

Probably also the following:

ATHENS, National Museum 1503, lekythos. Carlsruhe Painter. *ARV*² 733, 53.
GELA, Museo Archeologico Nazionale, lekythos. Aischines Painter. *ARV*² 711, 58.
MANNHEIM, Reiss-Museum 190, lekythos. Carlsruhe Painter. *ARV*² 733, 61.

U. STANDING FIGURE AT WOOL BASKET HOLDS SASH

ATHENS, Goulandris Museum 262, lekythos.
ATHENS, National Museum 1751 (CC 1442), lekythos. Carlsruhe Painter. *ARV*² 732, 38.
PALERMO, Banco di Sicilia, Collezione Mormino 327, white lekythos. *CVA* Palermo, Mormino 1, Italy 50, 1971, III, Y, pl. 4, 4.
SYRACUSE, Museo Archeologico Nazionale 19900, white-ground lekythos. Pan Painter. *ARV*² 557, 122; *Beazley Addenda* 259.

V. STANDING FIGURE AT WOOL BASKET HOLDS SCARF

BOLOGNA, Museo Civico Archeologico 392, kylix. Calliope Painter. *ARV*² 1259, 12; *Paralipomena* 470.
COPENHAGEN, National Museum 8236, squat lekythos. *CVA* Copenhagen 4, Denmark 4, n.d., pl. 167,2.

Variant

Seated Figure at Wool Basket Holds Scarf or Hair Net

ALERIA, Musée Archéologique 65/51, kylix. Jehasse and Jehasse 1973, 245 no. 646, pl. 47.
BASEL MARKET, lekythos. Jean-David Cahn AG 2000, 23–24 no. 59.

W. STANDING FIGURE AT WOOL BASKET HOLDS BOX

ATHENS, National Museum 1210, squat lekythos.
BONN, Universität, Akademisches Kunstmuseum 86, squat lekythos. *CVA* Bonn 1, Germany 1, 1938, pl. 25,8.
EDINBURGH, Royal Museum of Scotland 1956.472, squat lekythos. *CVA* Edinburgh 1, Great Britain 16, 1989, pl. 28,8.

Variant

Standing Figure at Wool Basket Holds Chest

ATHENS, National Museum 1743, squat lekythos.

X. STANDING FIGURE AT WOOL BASKET HOLDS PLEMOCHOE

ADRIA, Museo Civico B 329, stemless kylix fragment. Carlsruhe Painter. *ARV*² 737.132.
ATHENS, National Museum 1344 (CC 1416), lekythos. Painter of Athens 1344. *ARV*² 739.1.

Y. STANDING FIGURE AT WOOL BASKET HOLDS STAFF OR SPEAR

KARLSRUHE, Badisches Landmuseum (B 787), lekythos. Carlsruhe Painter. *ARV*² 732, 46.

Z. STANDING FIGURE AT WOOL BASKET HOLDS OINOCHOE AND PHIALE

TAMPA, Museum of Art, lekythos. Painter of the Paris Gigantomachy. *ARV*² 423, 130, 1652; *Beazley Addenda* 235; Murray 1985, checklist number 73 p. 46.

Variant, with phiale only:

ATHENS, National Museum 1275 (CC 1431), lekythos. Carlsruhe Painter. *ARV*² 732, 48.
ATHENS, National Museum 1627 (CC 1458), lekythos. Painter of the Paris Gigantomachy. *ARV*² 424, 131. Z.

THEMES

TOILET

ADOLPHSECK, Schloss Fasanerie 16, black-figure alabastron. Diosphos Painter. *ABV* 703 (510, 24 bis). F, P, FX/P.

ATHENS, Agora Museum P 10459, fragment of pyxis type A. Moore 1997, 272– 73 no. 994, pl. 97.

ATHENS, Ephoria Athinon A 1877, pyxis. Calliope Painter. *ARV*² 1707 (1263, 84 bis); *Paralipomena* 471; Lezzi-Hafter 1988, 347 no. 256, pls. 166–67. X, F (or distaff?), R, P. Nereids. *Galene, Alexo, Psamathe, Thetis, Eukl[umene], [Gl]auke, Kumododoe (?), Theo, Aura, Khruseis.*

ATHENS, Kannellopoulos Museum, lebes gamikos fragment. N, W.

ATHENS, Kannellopoulos Museum 825, skyphos. W.

ATHENS, Kerameikos Museum, lebes gamikos from grave H 56. Side A: W (winged), U.

ATHENS, National Museum 1454 (CC 1228), lebes gamikos type 1. Painter of Athens 1454. *ARV*² 1178, 1, 1685; *Paralipomena* 460; *Beazley Addenda* 340. G, W, P, R.

ATHENS, National Museum 1595, pelike. R, X.

ATHENS, National Museum 1987, white lekythos. R, X.

ATHENS, National Museum 12845, lebes gamikos bowl fragment. W, P, E.

ATHENS, National Museum 13676a, pyxis type A. Painter of Athens 1585. *ARV*² 1360, 3; *Beazley Addenda* 370. E, W/V, I(winged).

ATHENS, National Museum 14790, lebes gamikos. Bowl, side A: W (winged, in flight), W, P/V (winged, in flight). Stand: U, P, E.

ATHENS, National Museum 14791, lebes gamikos. Bowl, sided A: U (winged, in flight), W, P/V (winged, in flight). Stand: E.

ATHENS, National Museum, alabastron. G.

ATHENS, National Museum 1481, hydria. I, R, P/W.

BASEL, Antikenmuseum BS 410, lebes gamikos. Painter of London 1923. *ARV*² 1103, 6; *Paralipomena* 451, *Beazley Addenda* 329. Body: N, E/U, U, W, P/V. Stand: E, U.

BASEL MARKET, lekythos. Christie, Manson, & Woods International Inc. 1999, 18 no. 20. P, E.

BERLIN, Antikensammlung F 2385, hydria. Phiale Painter. *ARV*² 1020, 96; Oakley 1990, pl. 75 b. O, G.

BERLIN, Antikensammlung F 2404, lebes gamikos type 1. Sabouroff Painter. *ARV*² 841, 70; *Beazley Addenda* 296; Heilmeyer et al. 1988, 146–47 no. 2. Body: P, S (winged), F, H. Stand: T, P.

BERLIN, Antikensammlung F 2405, lebes gamikos type 1. Sabouroff Painter. *ARV*² 841, 71; Heilmeyer et al. 1988, 146–47, no. 1. Body: U. Stand: R, P, G. *kale.*

BERLIN, Antikensammlung F 2406, lebes gamikos type A. Painter of Berlin 2406 (Furtwängler). *ARV*² 1225, 1; *Beazley Addenda* 350. Body: F, P. Stand: P, K.

BERLIN, Antikensammlung F 2523, kylix exterior: Bordeaux Painter. *ARV*² 835, 1. F, I, Y, V.

BERLIN, Antikensammlung F 2720, pyxis type C. Painter of Athens 1585. *ARV*² 1360, 4; *Beazley Addenda* 370; *CVA* Berlin 8, DDR 3, 1990, pl. 47,1. N, G, R, I.

BOLOGNA, Museo Civico Archeologico 392, kylix. Calliope Painter. *ARV*² 1259, 12; *Paralipomena* 470. Interior: V. Exterior: U, P.

BRAUNSCHWEIG, Herzog Anton-Ulrich-Museum AT 220, hydria. Near the Hector Painter. *ARV*² 1037, 3. T, P, H, A, U.

BRUSSELS, Musées Royaux d'Art et d'Histoire A 1380, lebes gamikos. Sabouroff Painter. *ARV*² 841, 74. H, P/S, R.

BRUSSELS, Musées Royaux d'Art et d'Histoire A 3098, hydria. Near Hermonax. *ARV*² 493, 2; *Paralipomena* 380; *Beazley Addenda* 249. F, E, X, P.

CAMBRIDGE, Fitzwilliam Museum 13/23, loutrophoros. Painter of the Naples Centauromachy (Beazley). *CVA* Cambridge 1, Great Britain 6, 1930, pl. 36,3. G, P.

CAMBRIDGE, Fitzwilliam Museum GR 1.1922, pyxis type A. Near the Deepdene Painter. *ARV*² 501; *Beazley Addenda* 251. H, P, F, R.

Once CAMBRIDGE, Hope, hydria. Tillyard 1923, 63–64 no. 114, pl. 15. V. *Euklea, Peitho.*

CHAPEL HILL, University of North Carolina, Ackland Art Museum 71.8.1, squat lekythos. Shapiro 1981, 128–31 no. 50; Lezzi-Hafter 1988, pl. 158a–d. I, W, R, F, O, E, W, Q, G, H, W, V, G.

COPENHAGEN, National Museum, no no., pyxis lid fragment. *CVA* Copenhagen 8, Denmark 8, 1963, pl. 354,6. T.

DURHAM, University 3, kalathos. Williams 1961, pls. 13–14. E, A (variant), P/X.

FERRARA, Museo Archeologico 2534, oinochoe. Aurigemma 1965, 121–22, pl. 151,3. G/W/X, V.

GENEVA, Musée d'Art et d'Histoire 20851, white alabastron. Painter of Copenhagen 3830. *ARV*² 723, 3; *Beazley Addenda* 282.

GENEVA, Musée d'Art et d'Histoire H 239, lebes gamikos type 2. Painter of London E 489. *ARV*² 548, 44; *Paralipomena* 386. O, E, P, R(winged).

LEIDEN, Rijksmuseum van Oudheden I.1950/6.4, pyxis type B. Group of the Athena-head Pyxides. *ARV*² 1224, 3; *Paralipomena* 466; *CVA* Leiden 4, The Netherlands 7, 1991, pl. 200, 1–3.

LEIDEN, Rijksmuseum van Oudheden I.1957/10.1, lebes gamikos type 2. L.C. Group. *CVA* Leiden 4, The Netherlands 7, 1991, pl. 193. E (winged), P(winged), N.

LEIDEN, Rijksmuseum van Oudheden KvB 157, pyxis typeA. Class of Munich 2720. *ARV*² 1223, bottom; *Beazley Addenda* 350; *CVA* Leiden 4, The Netherlands 7, 1991, pl. 198. R (Erotes).

LEIDEN, Rijksmuseum van Oudheden RO II 94, pyxis type A. *CVA* Leiden 4, The Netherlands 7, 1991, pl. 199. P/U(Eros), D, V, X/U.

LONDON, British Museum 1919.6–20.14, kantharos. Class of Czartoryski Kantharos. *ARV²* 982.3. A, P.

LONDON, British Museum E 188, hydria. Christie Painter. *ARV²* 1048, 42; *Beazley Addenda* 321. H, S.

LONDON, British Museum E 210, small hydria. Hasselmann Painter. *ARV²* 1137, 33. U, P?

MAINZ, Johannes Gutenberg Universität 118 (ex Preyss), lekanis. Manner of the Meidias Painter. *ARV²* 1327, 87; *Beazley Addenda* 364. X/V, W/V, O, X/V, W. *Paphia, Eunomia, Eukleia.*

MANNHEIM, Reiss-Museum 182, kylix. Sabouroff Painter. *ARV²* 838, 18. Interior: O (variant). Exterior: V, F (might be a distaff), S, P, T.

MELBOURNE, University 1927.3. Cohen 2000, fig. 9.6.

MUNICH, Staatliche Antikensammlungen 2433 (J 289), hydria. Washing Painter. *ARV²* 1131, 165, 1684.

MUNICH, Staatliche Antikensammlungen 2723, pyxis type C. Painter of London E 777. *ARV²* 944, 85. V, W/V, R.

MYKONOS, Archaeological Museum, lebes gamikos stand fragment. "Voisin du Dinos Painter" (Beazley). Dugas 1952, 45 no. 95, pl. 39. E/W/P.

MYKONOS, Archaeological Museum, lebes gamikos. Mykonos Painter. *ARV²* 514, 1. U, P, W, G, H, R.

MYKONOS, Archaeological Museum, lebes gamikos. Naples Painter. *ARV²* 1098, 38. Body: H, E, V.

NAPLES, Museo Nazionale, Santangelo 316, lekanis. Manner of the Meidias Painter. *ARV²* 1327, 85; *Beazley Addenda* 364. I, V/X, P. *Pa[ph]ile.*

NAPLES, Museo Nazionale, Santangelo 2296, lekanis. Manner of the Meidias Painter. *ARV²* 1327, 86; *Beazley Addenda* 364. I, P/U/V, P/U, U/V/W. *Pa-[phi]e, Klumene, Nesaie, Halie.*

NEW YORK, Metropolitan Museum of Art 06.1021.185, hydria. Chrysis Painter. *ARV²* 1158, 5. G, S. *Khrusis, Phile, Io.*

NEW YORK, Metropolitan Museum of Art 08.258.27, alabastron. Persephone Painter. *ARV²* 1013.18; *Paralipomena* 440. G, X.

NEW YORK, Metropolitan Museum of Art 09.221.40, pyxis type D. Manner of the Meidias painter. *ARV²* 1328, 99; *Paralipomena* 479; *Beazley Addenda* 364. V, X, W/V, R. *Aphrodite, Peitho, Hugieia, Daimonia, Paidia, Euklea, Eunomia.*

NEW YORK, Metropolitan Museum of Art 41.162.89, hydria. Schuvalov Painter. *ARV²* 1210, 63; *Beazley Addenda* 346.

OXFORD, Ashmolean Museum 296, hydria. Washing Painter. *ARV²* 1131, 156; *Paralipomena* 454.

OXFORD, Ashmolean Museum G.303 (V. 537), amphoriskos. Eretria Painter. *ARV²* 1248, 10; *Paralipomena* 469; *Beazley Addenda* 353. *Theano.*

PROVIDENCE, Rhode Island School of Design 22.114, hydria. Christie Painter. *ARV*² 1049, 47. S, R, F.

SAN FRANCISCO, Palace of Legion of Honor 1873, alabastron. Aischines Painter. *ARV*² 717, 226. P. *kale.*

ST. PETERSBURG, State Hermitage Museum b 267 (B761), hydria. Manner of the Schuvalov Painter. *Paralipomena* 518; *Beazley Addenda* 346.

SANTORINI, Fira, Archaeological Museum, hydria. N, W.

TAMPA, Museum of Art, pyxis. Sub-Meidian Kylix-Group. *ARV*² 1397, 12; *Paralipomena* 487; *Beazley Addenda* 373; Murray 1985, checklist no. 90 p. 48. F, B, V, X.

TORONTO, Royal Ontario Museum 919.5.31 (370), pyxis. Manner of the Meidias Painter. *ARV*² 1328, 96; *Beazley Addenda* 364; Burn 1987, pl. 51b.

VIENNA, Kunsthistorisches Museum 3719, pyxis type A. *CVA* Austria 1, pl. 49.1–3. A, P, H, F.

WÜRZBURG, Bayerische-Julius-Maximilians-Universität, Martin von Wagner Museum H 4455 (541), pyxis type A. Washing Painter. *ARV*² 1133, 196, 1684; *Beazley Addenda* 333. R, J.

WORK AND PLAY

ATHENS, Agora Museum P 16916, fragment of pyxis Type A. Veii Painter (Moore). Moore 1997, 272 no. 988, pl. 96. R.

ATHENS, Kannellopoulos Museum, white alabastron.

ATHENS, Kerameikos Museum, pyxis of type A from Offering Channel HS 8. R, M.

ATHENS, National Museum 1240 (CC 1542), alabastron. Painter of London E 342. *ARV*² 669, 47; *Paralipomena* 404. H.

ATHENS, National Museum 1289 (CC 1569), pyxis type B. Long-Chin Group. *ARV*² 1222, 4. M.

ATHENS, National Museum 1584 (CC 1550), pyxis. Brückner 1907, 11–13, pl. 2. A.

ATHENS, National Museum 1587 (CC 1556), pyxis type A. Phiale Painter. *ARV*² 1023, 143; *Beazley Addenda* 316; Oakley 1990, pls. 114–15. L, R, A.

ATHENS, National Museum 1591 (CC 1557), pyxis type A. Group of Athens 1591. *ARV*² 955, 1; *Beazley Addenda* 307. R.

ATHENS, National Museum 1593 (CC 1548), pyxis.

ATHENS, National Museum 1661 (CC 1563), pyxis type A. Long-Chin Group. *ARV*² 1221, 1; *Beazley Addenda* 349. R.

ATHENS, National Museum 1741 (CC 1564), pyxis type A. Veii Painter. *ARV*² 906, 111; *Beazley Addenda* 303. S, R, D, M.

ATHENS, National Museum 1844, white lekythos. H, X.

ATHENS, National Museum 1991, pyxis type A. L?, R.

ATHENS, National Museum 2179 (CC 1589), epinetron. *AE* 1892, pl. 13. Side B. V, P.

ATHENS, National Museum 2181 (CC 1591), epinetron. Painter of Munich 2335. *ARV*² 1167, 117. E, G.

ATHENS, National Museum 2188 (CC 1845), white-ground pyxis type A. Painter of London D 12. *ARV*² 963, 94; *Beazley Addenda* 308. K, R.

ATHENS, National Museum 2383 (CC 1590 gives 3383), epinetron. Clio Painter. *ARV*² 1082, 21. Side A: A.

ATHENS, National Museum 2387 (CC 1570), pyxis lid. E.

ATHENS, National Museum 12465, powder pyxis. Lid: R, B.

ATHENS, National Museum 12467, fragmentary lebes gamikos. Side B: I, T, R (winged).

ATHENS, National Museum, 15264, pyxis lid. W/V, W, R, T.

ATHENS, National Museum 16263, lebes gamikos bowl fragment. F, T.

ATHENS, National Museum 16457, white alabastron. *CVA* Athens 2, Greece 2, III J c, pl. 19.1–4. T, S.

ATHENS, National Museum, Acropolis Collection 560, pyxis type A. Makron. *ARV*² 479, 336 and 458; *Beazley Addenda* 247. T, G. *Nausistra[t]e, -]elita ka[le], -]odamas kale.*

ATHENS, National Museum, Acropolis Collection. Loutrophoros fragment. Hermonax. *ARV*² 489.90.

ATHENS, National Museum, white alabastron decorated on two registers on each side. Side A: H, *kale;* side B: B, U, *ka[le].*

BALTIMORE, Walters Art Gallery 48.233, bf alabastron, white-ground. Manner of the Emporion Painter. *ABV* 585, 1.; *Beazley Addenda* 139. T. *kale, kale.*

BASEL MARKET, white-ground alabastron. Painter of Munich 2676. *ARV*² 394, 51; *Beazley Addenda* 229. T.

BERLIN, Antikensammlung F 2261, white-ground pyxis type A. Veii Painter. *ARV*² 906, 116; *Beazley Addenda* 303. R, G, K.

BERLIN, Antikensammlung F 2289, kylix Interior: Douris. *ARV*² 435, 95, 426, 1653, 1701; *Paralipomena* 375; *Beazley Addenda* 238.

BERLIN, Antikensammlung F 2376, hydria. Zimmer 1987, 9, fig. 4. L, M, R.

BERLIN, Antikensammlung F 2394, hydria. Washing Painter. *ARV*² 1131, 172; *Paralipomena* 454; *Beazley Addenda* 333.

BOCHUM, Ruhr Universität, Kunstsammlungen S 148, pyxis type B. Painter of London D 12. *ARV*² 963, 98; *Beazley Addenda* 308. R, J, M.

BONN, University, Akademisches Kunstmuseum 84a, alabastron. Painter of Munich 2676. *ARV*² 393, 47. M, R.

BOSTON, Museum of Fine Arts 65.908, white-ground phiale. Truitt 1969, 89, fig. 20.

BOSTON, Museum of Fine Arts 65.1166, pyxis type A. Painter of London D 12. Truitt 1969, 72–83, figs. 1–5. K, M.

BOSTON, Museum of Fine Arts 76.238, kylix tondo. Painter of London D 12. *ARV*² 962, 75; *Beazley Addenda* 308. E.

BRAURON, Archaeological Museum (once Athens, National Museum), fragmentary kylix Exterior: Stieglitz Painter. *ARV*² 827, 1; *Paralipomena* 422; *Beazley Addenda* 294.

BRAURON, Archaeological Museum, fragment of kylix tondo. R.

BRUSSELS, Bibliothèque Royale 9, pyxis type A. Pistoxenos Painter. *ARV*² 863, 31; *Beazley Addenda* 299. F, H, J.

BRUSSELS, Musées Royaux d'Art et d'Histoire A 1922, alabastron. Villa Giulia Painter. *ARV*² 625, 89. I, Q. *kale, kale.*

CAMBRIDGE (Mass.), Harvard University, Arthur M. Sackler Museum 60.340, hydria. Painter of the Yale Oinochoe. *ARV*² 503, 22.

CAMBRIDGE (Mass.), Harvard University, Arthur M. Sackler Museum 1925.30.39, pyxis type A. Painter of London D 12. *ARV*² 963, 92. C, G, D, E.

COPENHAGEN, National Museum 5, hydria. Painter of the Yale Oinochoe. *ARV*² 503, 24; *Beazley Addenda* 251. B.

COPENHAGEN, National Museum 3830, white alabastron. Painter of Copenhagen 3830. *ARV*² 723, 1; *Beazley Addenda* 282.

COPENHAGEN, National Museum 7093, pyxis type B. Long Chin Group. *ARV*² 1222, 5. R.

COPENHAGEN, National Museum 7359, hydria. *CVA* Copenhagen 4, Denmark 4, n.d., pl. 156,1. E, U.

DELPHI, Archaeological Museum 8713, white alabastron. Perdrizet 1908, 168, figs. 708, 708 bis. E, I.

DRESDEN, Staatliche Kunstsammlungen, Albertinum 312, neck-amphora. Dresden Painter. *ARV*² 655, 10. L.

EDINBURGH, Royal Museum of Scotland 1956.460, alabastron. Painter of the Yale lekythos. *ARV*² 661, 80; *CVA* Edinburgh 1, Great Britain 16, 1989, pl. 27, 9–11. E, H.

FLORENCE, Museo Archeologico 3918, kylix tondo. Stieglitz Painter. *ARV*² 827, 7. G.

FLORENCE, Museo Archeologico 3927, stemless kylix. Manner of Meidias Painter. *ARV*² 1329, 119; Burn 1987, fig. 15d (seated with Eros in her lap).

FLORENCE, Museo Archeologico 4217, pyxis type B. Painter of Florence 4217. *ARV*² 1222, 2. G, V, E.

FLORENCE, Museo Archeologico 75770, kylix exterior: Pistoxenos Painter. *ARV*² 861, 15; *Beazley Addenda* 298. H, P, B, R, I.

GELA, Museo Archeologico Nazionale N 30, black-figure lekythos. Sappho Painter. *Paralipomena* 246 (*ABV* 507, 39); *Beazley Addenda* 126.

GENEVA, Musée d'Art et d'Histoire MF 200, small hydria. *CVA* Geneva 1, Switzerland 1, 1962, pl. 18,3. G, M.

GIESSEN, Justus-Liebig Universität, Antikensammlung K III-41, white alabastron. Villa Giulia Painter. *ARV*² 625, 93. G, B.

HEIDELBERG, Ruprecht-Karls-Universität, Archäologisches Institut, white alabastron. Two-Row Painter. *ARV*² 727, 17. U, T, B.

HOUSTON, Museum of Fine Arts 80.95, hydria. Shapiro 1981, 132–33, no. 51. P, R.

KARLSRUHE, Badisches Landesmuseum 69/20, lekythos. Carlsruhe Painter (Thimme). *CVA* Karlsruhe 3, Germany 60, 1990, pl. 41, 5–7; 42, 1. I, R. he pais kale.

KARLSRUHE, Badisches Landesmuseum 206 (B 10), small pelike. Carlsruhe Painter. *ARV*² 735, 111, 1668; *Beazley Addenda* 283. T, R.

LAON, Musée Archéologique Municipal 37.1009, black-figure pyxis type A (without cover). *CVA* Laon 1, France 20, n.d., pl. 11.1, 1–3. F, S, B, M, E, L, R.

LEIDEN, Rijksmuseum van Oudhen GNV 56, hydria. *CVA* Leiden 3, Netherlands 5, 1983, pl. 142,1–5. L (mirror or distaff in left), R.

LONDON, British Museum 1907.5–19.1, pyxis lid. Brümmer 1985, 35, fig. 5d. J, V, R.

LONDON, British Museum D 12, pyxis type A. Painter of London D 12. *ARV*² 963, 96; *Beazley Addenda* 308. L, Q, M, K.

LONDON, British Museum E 187, hydria. Kensington Painter. *ARV*² 1071, 2. C, U (Eros).

LONDON, British Museum E 194, hydria. Class of London E 195. *ARV*² 1077, 2. E.

LONDON, British Museum E 195, hydria. Class of London E 195. *ARV*² 1077, 1. L, D, G, U.

LONDON, British Museum E 223, hydria. *CVA*, British Museum 6, Great Britain 8, 1931, pl. 90, 6; Smith 1896, 173. G, U. *Autopsia.*

LONDON, British Museum E 773, pyxis type A. Followers of Douris, Undetermined. *ARV*² 805, 89, 1670; *Paralipomena* 420; *Beazley Addenda* 291. L, P. *Iphigeneia, Danae, Helene, Klytaime[st]ra, Kassandra.*

LONDON, British Museum E 777, pyxis type A. Painter of London E 777. *ARV*² 944, 79; *Beazley Addenda* 307. P, R, M.

Once LONDON market? Lost vase. Drawing by Adam Buck in Dublin, Trinity College Library ms. 2031. Jenkins 1989, 18 no. 66:75.

LONDON MARKET, hydria. Advertisement for Minerva 1989. V, S, A.

Once LONDON MARKET, pyxis type A. Painter of Bologna 417. Roberts 1978, 65 no. 11, 184, pls. 43, 1; 102. R (one winged).

MAINZ, Universitätssammlung 130, alabastron. Painter of Copenhagen 3830. *ARV*² 724, 6. E.

MUNICH, Staatliche Antikensammlungen 2721, pyxis type A. Painter of Bologna 417. *ARV*² 917, 199; *Beazley Addenda* 304. R.

MUNICH, Staatliche Antikensammlungen 7578, lebes gamikos stand. Washing Painter. *ARV*² 1126,, 3; *Beazley Addenda* 332. E, V.

MUNICH, Staatliche Antikensammlungen 6452, hydria. Kleophon Painter. *ARV*² 1147, 62; *Paralipomena* 456. X.

MYKONOS, Archaeological Museum, hydria. Manner of the Florence Painter. *ARV*² 545, 9. D, W.

MYKONOS, Archaeological Museum, 1008, hydria. Near the Phiale Painter, ii. *ARV*² 1025.1. P, E.

MYKONOS, Archaeological Museum, hydria. Christie Painter. *ARV*² 1049, 50. R.

MYKONOS, Archaeological Museum, hydria. Group of Athens 1480. *ARV*² 1149, 20. R.

MYKONOS, Archaeological Museum, hydria. Group of Athens 1480. *ARV*² 1149, 21.

MYKONOS, Archaeological Museum, hydria. Group of Athens 1480. *ARV*² 1149, 22. T, H.

NAPLES, Museo Archeologico Nazionale Stg. 243, small hydria. Painter of the Naples Hydriskai. *ARV*² 1267, 11; *Paralipomena* 471; Lezzi-Hafter 1988, pl. 126 no. 199. U

NEW YORK, Metropolitan Museum of Art 06.1021.90, lekythos. Bowdoin Painter. *ARV*² 682, 102. L, U (Eros).

NEW YORK, Metropolitan Museum of Art 06.1117, pyxis type A. Painter of Philadelphia 2449. *ARV*² 815, 3; *Beazley Addenda* 292. U, S, H, B.

NEW YORK, Metropolitan Museum of Art 24.97.35, squat lekythos. Lezzi-Hafter 1988, 344 no. 244, pl. 159c–d. (Eros)

NEW YORK, Metropolitan Museum of Art 41.162.71, alabastron. Painter of Copenhagen 3830. *ARV*² 724, 5. B, E.

NEW YORK, Metropolitan Museum of Art 07.286.35, lebes gamikos stand. Washing Painter. *ARV*² 1126, 1; *Paralipomena* 453; *Beazley Addenda* 332. E, V.

NEWTON, Walston, hydria. Akin to Clio Painter. *ARV*² 1083, 1. L, T. *kale*.

OXFORD, Ashmolean Museum 294, hydria. Group of Brussels A 3096. *ARV*² 1033, 5. L, E, U.

OXFORD, Ashmolean Museum 531, hydria. Syracuse Painter. *ARV*² 520, 36. E (also distaff and spindle), H (but thread, no basket), Z (phiale and garland).

PADUA, University, Inst. Arch. i.g. 1702 (K 10), small hydria. Lezzi-Hafter 1976, cat. no. F1, pl. 174a. R.

PARIS, Bibliothèque Nationale, Cabinet des Médailles 446 (4895), hydria. Washing Painter. *ARV*² 1131, 169; Ridder 1902, 341, pl. XVIII. J, W.

PARIS, Bibliothèque Nationale, Cabinet des Médailles 864 (4968), pyxis type A. Painter of London D 12. *ARV*² 963, 89; *Beazley Addenda* 308; Truitt 1969, 79 fig. 8. E, M

PARIS, Musée du Louvre CA 587, pyxis type B. Painter of the Louvre Centauromachy. *ARV*² 1094, 104, 1682; *Paralipomena* 449; *Beazley Addenda* 328. P.

PARIS, Musée du Louvre F 224, small neck-amphora. Three-line Group. *ABV* 320, 5; 672, 694; *ARV*² 1605; *Paralipomena* 140, 317; *Beazley Addenda* 86. L, T, E, L, T. *Pedieus kalos*.

PARIS, Musée Auguste Rodin TC 922, pyxis lid. *CVA* Rodin 1, France 16, 1945, pl. 26,4–5. I, E/K, S (Eros with wreath).

Once PARIS, Pourtalès-Gorgier, hydria. Panofka 1834, pl. 34. A (variant), W.

PROVIDENCE, Rhode Island School of Design 28.020, lebes gamikos. Pan Painter. *ARV*² 552, 27. Body (side B). E, R.

ROME, Museo Nazionale Etrusco di Villa Giulia 15708, kylix tondo. Sabouroff Painter. *ARV*² 839, 35; *Paralipomena* 423. F. *kale nai, he pais kale.*

ST. PETERSBURG, State Hermitage Museum b 198 (B 735), pelike. Painter of London E 395. *ARV*² 1140, 16; *Paralipomena* 517. U.

ST. PETERSBURG, State Hermitage Museum b 1154 (B 745), pelike. Painter of London E 395. *Paralipomena* 517.

ST. PETERSBURG, State Hermitage Museum b 1642 (B 750), hydria. Aischines Painter. *ARV*² 717.231; *Paralipomena* 515. U, G.

ST. PETERSBURG, State Hermitage Museum b 4525, hydria. Painter of the Louvre Centauromachy. *ARV*² 1094, 99; *Paralipomena* 517. P, E, S.

SAN ANTONIO, Texas, San Antonio Museum of Art 86.134.74, alabastron. Stieglitz Painter (Guy). Shapiro and Picón 1995, 156–57 no. 79. E, E.

SANTORINI, Fira, Archaeological Museum, hydria. R.

SANTORINI, Fira, Archaeological Museum, hydria. G, E, W.

STANFORD, Stanford University 17.410, pelike. Earlier Mannerist, viii. *Paralipomena* 393 (*ARV*² 586); *Beazley Addenda* 263. A, B.

STANFORD, Stanford University 17.412, hydria. Earlier Mannerist, viii (Webster). *Paralipomena* 393 (*ARV*² 587, 56 bis). A (variant), R, C, A.

TOLEDO, Museum of Art 63.29, white-ground pyxis type A. Painter of London D 12. *ARV*² 1675 (963, 94 bis); *Paralipomena* 434; *Beazley Addenda* 308. K. G, J.

TÜBINGEN, Eberhard-Karls-Universität, Antikensammlung des Archäologisches Instituts 676 (E 53), Nolan neck-amphora. Dresden Painter. *ARV*² 655, 2, 1588; *Beazley Addenda* 276. U, R. *Kallikles kalos.*

VIENNA, Kunsthistorisches Museum 889, pelike. Group of Vienna 888. *ARV*² 1358.2. T, U.

VIENNA, Kunsthistorisches Museum 1082, pelike. Near the Group of Vienna 888. *ARV*² 1358, 3. H, G.

VIENNA, Kunsthistorisches Museum 1863, pyxis type A. *CVA* Austria 1, pl. 49.4–6. R.

VIENNA, Kunsthistorisches Museum 3720, pyxis type A. Painter of London D 12. *ARV*² 963, 88. R.

WARSAW, National Museum 142456, white alabastron. Painter of Taranto 2602. *ARV*² 725, 6. G, R.

WARSAW, National Museum 142471, white lekythos. Compared to the Group of Athens 2025. *ARV*² 723, 1. I, P.

WARSAW, National Museum 198055, hydria. Class of Cambridge 1.02. *Paralipomena* 465, 3. H, W/K.

RECEPTION SCENES

ADOLPHSECK, Schloss Fasanerie 41, pelike. Manner of the Pig Painter. *ARV*[2] 566, 6; *Beazley Addenda* 261. S.

ADOLPHSECK, Schloss Fasanerie 57, alabastron. Aischines Painter. *ARV*[2] 717, 227. T.

ALERIA, Musée Archéologique 68/25 (2262a), kylix Exterior: Workshop of the Penthesilea Painter, perhaps by the Penthesilea Painter. Jehasse and Jehasse 1973, 507–8 no. 2095, pl. 51. H, B.

ALERIA, Musée Archéologique 67/459 (2164a), kylix Exterior: Penthesilea Painter. *Paralipomena* 428 (*ARV*[2] 882, 36 bis); *Beazley Addenda* 301. E. *ho pais kalos.*

ALEXANDRIA, Greco-Roman Museum 23446, hydria fragment. Earlier Mannerist. *ARV*[2] 587, 56; Sutton 1981, 403 no. G 72. E, Q, G.

ATHENS, Kannellopoulos 688, alabastron. Wehgartner 1983, 123 no. 1. H.

ATHENS, Kerameikos Museum, siphon. Unattributed. Ghali-Kahil 1955, 66 no. 22, pl. 68, 1–3. F. Paris and Helen.

ATHENS, Kerameikos Museum 2713, alabastron. *Paralipomena* 331 (*ARV*[2] 101) and 523; *Beazley Addenda* 172. A. *he pais kale; [ka]los eimi.*

ATHENS, Kerameikos Museum HS 107, white alabastron. Wehgartner 1983, 119, no. 2, pl. 41.1–3. *kalos.*

ATHENS, National Museum 1162 (CC 1438), squat lekythos. Manner of the Meidias Painter. *ARV*[2] 1325, 48. Paris and Helen?

ATHENS, National Museum 1169 (CC 1255 gives 1189), hydria. Phiale Painter. *ARV*[2] 1020, 91; Oakley 1990, pl. 71. A, R.

ATHENS, National Museum 1182 (CC 1262), pelike. Group of Polygnotos. *ARV*[2] 1059, 133. W, Z.

ATHENS, National Museum 1239 (CC 1204), alabastron. Group of the Paidikos Alabastra. *ARV*[2] 101, 3; *Paralipomena* 331; *Beazley Addenda* 172. R, B.

ATHENS, National Museum 1250 (CC 1231), lebes gamikos type 1. Ariana Painter. *ARV*[2] 1102, 5; Kauffmann-Samaras 1988, 287, fig. 2. E/V, W.

ATHENS, National Museum 1271 (CC 1377), lekythos. Group of Harvard 2685. *ARV*[2] 1369, 1. E (variant), Nike.

ATHENS, National Museum 1441 (CC 1277), pelike. Polygnotos. *ARV*[2] 1032, 56; *Beazley Addenda* 318. Side A: X.

ATHENS, National Museum 1588 (CC 1552), pyxis type A. Phiale Painter. *ARV*[2] 1023, 144; *Beazley Addenda* 316; Oakley 1990, pls. 116–17. H, E, B.

ATHENS, National Museum 1592 (CC 1554), pyxis type A. Curtius Painter. *ARV*[2] 935, 76. A, R.

ATHENS, National Museum 1597 (CC 1549), pyxis lid. Roberts 1978, 146 no. 2, pl. 103, 2. U, I, E, R.

ATHENS, National Museum 1620 (CC 1568), pyxis lid. F, P, R.

ATHENS, National Museum 1707 (CC 1559), pyxis type A. Painter of London D 12. *ARV*[2] 963, 90; *Beazley Addenda* 308. R, U, M.

ATHENS, National Museum 2179 (CC 1589), epinetron. *AE* 1892, pl. 13. Side A.

ATHENS, National Museum 2383 (CC 1590 gives 3383), epinetron. Clio Painter. *ARV*² 1082, 21. Side B: E, W.

ATHENS, National Museum 12465, powder pyxis. Box: T.

ATHENS, National Museum 12778 (N 1073), lekythos. Painter of Athens 12778. *ARV*² 663, 3; *Beazley Addenda* 277. A. *[k]ale; kalos.*

ATHENS, National Museum 17207, Columbus alabastron. Pan Painter. *ARV*² 557, 124. X (also holds bloom).

ATHENS, National Museum 19351, pelike. T.

ATHENS, National Museum TE 1623, pyxis type A. Leningrad Painter. *Paralipomena* 391 (*ARV*² 572.88 bis). A, E, R.

ATHENS, private, pyxis type A. Veii Painter. *ARV*² 906, 115; *Beazley Addenda* 303.

ATHENS, Vlasto, alabastron. Carlsruhe Painter. *ARV*² 735, 108. T.

BASEL, Antikensammlung BS 442, kylix exterior. Briseis Painter. *Paralipomena* 372 (*ARV*² 408, 32 bis); *Beazley Addenda* 232. G, R, I.

BERLIN, Antikensammlung F 2254, alabastron. Pan Painter. *ARV*² 557, 123; *Paralipomena* 387; *Beazley Addenda* 259. A, T?

BERLIN, Antikensammlung F 2395, hydria. Unattributed. Heilmeyer et al 1988, 142–43 no. 6; LIMC 1, s.v. "Amphiaraos," no. 27. Eryphile, Alcmaeon, and Amphiaraus; Demonassa spins. *Eruphile, Alkmeon, Amphiar[eos], Demo[nassa].*

BERLIN, Antikensammlung F 3240, kylix exterior. Manner of the Foundry Painter. *ARV*² 405; *Beazley Addenda* 232. A

BERLIN, Antikensammlung F 31426, kylix. Euaion Painter. *ARV*² 795, 100, 1702; *Beazley Addenda* 290. A, P, Z, R, K?

BLOOMINGTON, IN, Indiana University Art Museum 69.89.3, bell krater. B.

BOCHUM, Ruhr Universität, Kunstsammlungen S 509, skyphos. Kunisch 1972, 112–13, no. 94.

BOSTON, Museum of Fine Arts 10.205, fragment of kylix exterior. Manner of Onesimos. *ARV*² 331, 11. A. *kal[e].*

BOSTON, Museum of Fine Arts 13.84, kylix tondo. Penthesilea Painter. *ARV*² 883, 61. J?

BOSTON, Museum of Fine Arts 93.108, pyxis type A. Roberts 1978, 48–49 no. 12, pl. 27; Padgett 1988, 48–49 no. 22. H? R.

BRAURON, Archaeological Museum 528, pyxis fragment, type A. A, J.

BRAURON, Archaeological Museum, pyxis fragment. R, M.

BRUSSELS, Musées Royaux d'Art et d'Histoire A 73, hydria type 1. Cassel Painter. *ARV*² 1085, 25. A, R.

CAMBRIDGE (Mass.), Harvard University, Arthur M. Sackler Museum 1960.342, hydria. *CVA* Robinson 2, USA 6, pl. 43.

CAMBRIDGE (Mass.), Harvard University, Arthur M. Sackler Museum 1972.45

THE VASES

237

(ex Watkins), Nolan amphora. Providence Painter. *ARV*² 638, 43; *Beazley Addenda* 273. H. *kale.*

CAMBRIDGE, Fitzwilliam Museum 37.24, small doubleen neck-amphora. Triptolemos Painter. *ARV*² 362, 15. B.

CENTRE ISLAND, private collection, kylix exterior. Penthesilea Painter (Bothmer). Jenkins and Williams 1985, 417 no. 6, pl. 44, 2–3. A (variant), O.

CHICAGO, Art Institute 16.140, stamnos. Copenhagen Painter. *ARV*² 258, 18, 1640. G, B, S (variant), R.

CHICAGO, Art Institute 1889.27, kylix exterior. Penthesilea Painter. *ARV*² 884, 77; *Beazley Addenda* 302. R.

CHICAGO, University of Chicago, David and Alfred Smart Museum 1911.456, hydria. Leningrad Painter. *ARV*² 572, 88; *Beazley Addenda* 261.

CRACOW, Czartoryski Museum 1473, hydria. Hephaistos Painter. *ARV*² 1116, 44.

ENSÉRUNE, Musée National d'Ensérune, kylix. Painter of the Naples Hydriskai. *ARV*² 1267, 20; Lezzi-Hafter 1988, pl. 10. Interior: R? Exterior: U? E, R.

FLORENCE, Museo Archeologico Etrusco 4018, Nolan neck-amphora. Dresden Painter. *ARV*² 655, 11. U. *kalos* and other inscriptions.

FLORENCE, Museo Archeologico 81602, kylix. Close to the Clinic Painter. *ARV*² 810, 24; 808. B, E.

FLORENCE, Museo Archeologico PD 422, kylix. Carlsruhe Painter. *ARV*² 738, 148. T.

GREIFSWALD, Ernst-Moritz-Arndt-Universität 322, fragment of kylix. Near Makron. *ARV*² 481, 5. B.

HAVANA, Lagunillas, kylix Exterior: Penthesilea Painter. *ARV*² 884.78; *Paralipomena* 428; Olmos 1990, 127–31 no. 36. R, H, S. *ho pais kalos*, three times.

HEIDELBERG, Ruprecht-Karls-Universität, Archäologisches Institut 64/5, hydria. Later Mannerists. *ARV*² 1121, 14; *Paralipomena* 453; Zwierlein-Diehl 1971, 51–52, no. 81, pl. 57. A, U.

KARLSRUHE, Badisches Landesmuseum B 3078, i, hydria. Naples Painter. *ARV*² 1100, 60. E, R (winged).

LAON, Musée Archéologique Municipal 37.920, lekythos. Emporion Painter. *ABV* 708 (585, 20); *Paralipomena* 291. T?

LAON, Musée Archéologique Municipal 37.1030, pelike. Washing Painter. *ARV*² 1129, 123. E.

LEIDEN, Rijksmuseum van Oudheden I.1957/1.1, alabastron. Group of Leiden 1957. *ARV*² 724, 2; *CVA* Leiden 4, The Netherlands 7, 1991, pl. 194, 2–7. G.

LONDON, British Museum E 193, hydria. Cassel Painter. *ARV*² 1085.30; *Beazley Addenda* 327. A holds distaff and spindle).

LONDON, British Museum E 215, hydria. Painter of London E 215. *ARV*² 1082, 1; *Beazley Addenda* 327. A.

LONDON, British Museum E 719, alabastron. *ARV*² 1560. *Alexomenos kalos, kale; he pais kale.*

LONDON, British Museum E 781, pyxis type A. Roberts 1978, 65 no. 9, pl. 44.

LOS ANGELES, County Museum of Art 50.8.9, hydria. Io Painter. *ARV*² 1122.3; *Beazley Addenda* 332. R.

MANCHESTER, University III I 2, pyxis type A. Near the Painter of Brussels R 330. *ARV*² 931, 2; *Beazley Addenda* 306.

MUNICH, Staatliche Antikensammlungen 2438 (J 292), hydria. Dwarf Painter. *ARV*² 1011, 18, 1678.

MUNICH, Staatliche Antikensammlungen 2687 (WAF), kylix Exterior: Wehgartner 1983, pls. 28, 29.

MUNICH, Staatliche Antikensammlungen SL 476, hydria. Akin to the Clio Painter. *ARV*² 1083, 2; *Beazley Addenda* 327. A.

MUNICH, private collection, kylix Exterior: Münzen und Medaillen 1975, 60–61, no. 148, pl. 33; Immerwahr 1984. H, B. *Rhodon, Antiphane, Aphrodisia, -Jobole.*

MYKONOS, Archaeological Museum, hydria. Group of Polygnotos. *ARV*² 1061, 149; *Beazley Addenda* 323. E.

MYKONOS, Archaeological Museum, lebes gamikos type A. Akin to the Washing Painter. *ARV*² 1135, 1. W/V, P, E.

NAPLES, Museo Nazionale, Santangelo 272, kylix exterior. Telephos Painter. *ARV*² 819, 40; *Beazley Addenda* 293. G (wool basket under handle).

NEW YORK, Metropolitan Museum of Art 17.230.15, hydria. Orpheus Painter. *ARV*² 1104, 16; *Beazley Addenda* 329. X, A, E.

NEW YORK, Metropolitan Museum of Art 96.18.29 (GR 580), pelike. Argos Painter. *ARV*² 289, 14. T.

OXFORD, Ashmolean Museum 327, alabastron. Aischines Painter. *ARV*² 717, 225, 1667. B. *kale.*

OXFORD, Ashmolean Museum 1966.483 (ex Beazley), fragment of kylix tondo. Brygos Painter. *ARV*² 376, 85; *Paralipomena* 366.

OXFORD, Ashmolean Museum G.279 (V.517), kylix exterior. Euaichme Painter. *ARV*² 785, 8; *Paralipomena* 418, *Beazley Addenda* 289. T.

PAESTUM, Museum, 49808, pelike. G.

PALERMO, Museo Archeologico, hydria. Adriani 1971, pl. 72a. H, W.

PALERMO, Banco di Sicilia, Collezione Mormino 788 or 818, skyphos. Oakley 1990, 92 no. 154ter, pl. 132 c–d.

PARIS, Bibliothèque Nationale, Cabinet des Médailles 312, black-figure alabastron. Ridder 1902, 204–5, fig. 35.

PARIS, Bibliothèque Nationale, Cabinet des Médailles 508, alabastron. *ARV*² 1610; Sutton 1992, 20, fig. 1.6. H. *he numphe kale; Timodemos kalos.*

PARIS, Bibliothèque Nationale, Cabinet des Médailles 817, kylix exterior. Euaion Painter. *ARV*² 795, 103. A, Z.

PARIS, Musée du Louvre C 1005 (G 151), kylix exterior (one side). Briseis Painter. *ARV*² 406, 8 and 398, 8; *Paralipomena* 371; *Beazley Addenda* 232. A, R. Paris arrives at Troy.

PARIS, Musée du Louvre G 331, kylix. Telephos Painter. *ARV*[2] 819, 42; *Paralipomena* 421; *Beazley Addenda* 293. Interior: J. Exterior: J, E.

PARIS, Musée du Louvre G 444, lekythos (shoulder). Achilles Painter. *ARV*[2] 993, 91; *Beazley Addenda* 312.

PARIS, Musée du Louvre G 453, kylix. Splanchnopt Painter. *ARV*[2] 892, 9. J (variant), P.

PARIS, Musée du Louvre G 551, pelike. Washing Painter. *ARV*[2] 1130, 141. Eros with chest.

PARIS, Musée Auguste Rodin TC 213, lekythos. Aischines Painter. *ARV*[2] 714, 172. Remains of inscription. R, I.

PHILADELPHIA, University Museum 5670, kylix exterior. Sabouroff Painter. *ARV*[2] 839, 37. G, P.

PROVIDENCE, Rhode Island School of Design 25.087, alabastron. Triptolemos Painter. *ARV*[2] 363, 29 bis; *Beazley Addenda* 222. U.

PROVIDENCE, Rhode Island School of Design 25.088, alabastron. Villa Giulia Painter. *ARV*[2] 624, 88; *Beazley Addenda* 271. G.

RHODES, Archaeological Museum 13261, hydria. Leningrad Painter. *ARV*[2] 571, 82; *Beazley Addenda* 261. L? K.

RICHMOND, Virginia Museum of Fine Arts 62.1.13, pelike. Eucharides Painter. *ARV*[2] 1637 (227, 10 bis); *Paralipomena* 347; *Beazley Addenda* 199.

ROME, Museo Nazionale Etrusco di Villa Giulia 869, small pelike. Lezzi-Hafter 1976, 113, pl. 90c–d. (young man at wool basket)

ROME, Museo Nazionale Etrusco di Villa Giulia 1054, column krater. Harrow Painter. *ARV*[2] 275, 50; *Beazley Addenda* 207. S. Erotes.

ROME, Museo Nazionale Etrusco di Villa Giulia 15708, kylix exterior. Sabouroff Painter. *ARV*[2] 839, 35; *Paralipomena* 423. H, G, I, F. *kale nai, he pais kale.*

ROME, Museo Nazionale Etrusco di Villa Giulia 25006, kylix exterior. Telephos Painter. *ARV*[2] 819, 39; *Beazley Addenda* 293. H, B?

SOUTH HADLEY, Mt. Holyoke College 1932 5.B.SII (ex Seltman), pyxis type A. Veii Painter. *ARV*[2] 906, 109; *Beazley Addenda* 303. Q, T.

ST. PETERSBURG, State Hermitage Museum b 263 (B 747), pelike. Washing Painter. *Paralipomena* 517.

ST. PETERSBURG, State Hermitage Museum b 264 (B 746), pelike. Washing Painter. *Paralipomena* 517.

ST. PETERSBURG, State Hermitage Museum b 1621 (B 740), pelike. Manner of the Washing Painter. *ARV*[2] 1134, 11; *Paralipomena* 517; *Beazley Addenda* 333.

ST. PETERSBURG, State Hermitage Museum b 3384 (ex Stieglitz Mus. 489), kylix tondo. Stieglitz Painter. *ARV*[2] 827, 3; *Paralipomena* 515.

ST. PETERSBURG, State Hermitage Museum b 4316, pelike. Hasselmann Painter. *Paralipomena* 517.

SYDNEY, Univeristy, Nicholson Museum of Antiquities 54.03 (ex Campanari), hydria. Chrysis Painter. *ARV*[2] 1159, 6. G. Possibly Polynices and Eryphile.

TARANTO, Museo Archeologico Nazionale 4536 (8284), white alabastron. Villa Giulia Painter. *ARV*² 625, 92; *Beazley Addenda* 271. G.

Once TORONTO, Borowski, kylix exterior. Oedipus Painter. *ARV*² 451, 3; *Beazley Addenda* 242. A, B. Achilles and the daughters of King Lycomedes.

TORONTO, Royal Ontario Museum 919.5.27, hydria. Phiale Painter. *ARV*² 1020, 94; *Beazley Addenda* 316. N.

TRONDHJEM, Art Gallery 807, skyphos type B. Aischines Painter. *ARV*² 718, 238, 1667; *Paralipomena* 409. F. *kale, kalos.*

VATICAN, Museo Gregoriano Etrusco, kylix exterior. Makron. *ARV*² 469, 154.

VATICAN, Museo Gregoriano Etrusco, kylix exterior. Telephos Painter. *ARV*² 819, 41; *Beazley Addenda* 293. F. *kalos.*

VIENNA, Kunsthistorisches Museum 462, pelike. Washing Painter. *ARV*² 1129, 111. U.

VIENNA, Kunsthistorisches Museum 846, Nolan neck-amphora. Oionokles Painter. *ARV*² 648, 27. *kalos, kalos.*

WARSAW, National Museum 142317, kylix exterior. Boot Painter. *ARV*² 821, 6. D.

WARSAW, National Museum 147219, pelike. Calliope Painter. *ARV*² 1688 (1262, 75 bis); *Paralipomena* 471.

WÜRZBURG, Bayerische-Julius-Maximilians-Universität, Martin von Wagner Museum 506, loutrophoros. Painter of Würzburg 537. *ARV*² 1224, 2. O, W/U, W, U, E (also holds torch).

WÜRZBURG, Bayerische-Julius-Maximilians-Universität, Martin von Wagner Museum 546; alabastron. Langlotz 1932, 112 no. 546, pl. 204.

Pursuit

ATHENS, National Museum 17640, lekythos. Painter of the Yale Lekythos. *ARV*² 660, 59; *Beazley Addenda* 277. Danae and the Golden Rain.

ATHENS, National Museum, Acropolis Collection 2451, black-figure plate. *LIMC* 4, s.v. "Europe," no. 36. Europa on the bull holding wool basket.

BASEL MARKET, Münzen und Medaillen (ex Giudice), calyx-krater. Kleophrades Painter. *ARV*² 186, 48; *Beazley Addenda* 188; Frank 1990, 114 no. 34. E. Poseidon pursues Aethra who holds wool basket.

GREAT NECK, Pomerance, stamnos. Hephaisteion Painter. *ARV*² 298, 3; 1643; *Paralipomena* 356; *LIMC* 1, s.v. "Aithra," no. 4. Side A: Poseidon pursues. Side B: Aethra, who holds wool basket.

LAON, Musée Archéologique Municipal 37.1053, pyxis type B. Painter of Brussels R 330. *ARV*² 930, 106. Hermes pursues maiden.

LONDON, British Museum E 174, hydria. Eucharides Painter. *ARV*² 229, 39; *Beazley Addenda* 199. Poseidon pursues Aethra; between them, wool basket.

LOS ANGELES, Dechter, hydria. Hamma 1989, 45. E. Poseidon pursues Aithra.

NEW YORK MARKET, Early Classical column-krater. Christie, Manson, &
 Woods International Inc. 2000, 94–95 no. 88.
ST. PETERSBURG, State Hermitage Museum b 1564 (B 601), amphora type C.
 Painter of the Munich Amphora. *ARV*² 245, 3; *Paralipomena* 511. Side A: Eu-
 ropa on the bull holding wool basket; Side B: Zeus.
VATICAN, Museo Gregoriano Etrusco16554, hydria. Syleus Painter. *ARV*² 252,
 47; *Beazley Addenda* 203. E. Poseidon Pursues Aethra.

WEDDING

MUNICH, Staatliche Antikensammlungen 7578, lebes gamikos. Washing
 Painter. *ARV*² 1126, 3, *Beazley Addenda* 332. Under each handle, Nike fly-
 ing (with scarf and alabastron and scarf, respectively).
MUNICH, Staatliche Antikensammlungen NI 9493, loutrophoros. Reeder 1995,
 322–34 no. 102. E, P, V.

UNDETERMINED

ABERDEEN, Paton, neck-amphora. Providence Painter. *Paralipomena* 400 (*ARV*²
 638.46 bis). Side A: F or G.
ADRIA, Museo Civico B 327, kylix. Near the Painter of Munich 2676. *ARV*² 394,
 3. I: B.
ATHENS, Agora Museum P 256, fragment of lebes gamikos bowl. Moore 1997,
 155 no. 147.
ATHENS, Agora Museum P 1940, fragment of pyxis type C. Moore 1997, 278
 no. 1048, pl. 100.
ATHENS, Agora Museum P 3889, pyxis type A. Veii Painter. *ARV*² 906, 114;
 Beazley Addenda 303; Roberts 1978, pl. 36, 1. R.
ATHENS, Agora Museum P 3892, lekythos fragment. Moore 1997, 261 no. 877,
 pl. 88.
ATHENS, Agora Museum P 4307, fragment of bell krater or calyx krater. Moore
 1997, 221 no. 579, pl. 59.
ATHENS, Agora Museum P 5233, white alabastron fragment. Villa Giulia
 Painter. *ARV*² 625, 94. Moore 1997, 271 no. 985, pl. 95. K.
ATHENS, Agora Museum P 9470, lekythos. Bowdoin Painter. *ARV*² 681, 88;
 Moore 1997, 257 no. 832, pl. 86.
ATHENS, Agora Museum P 10571, fragment of lebes gamikos stand. Moore
 1997, 153 no. 133, pl. 23.
ATHENS, Agora Museum P 13363, fragment of kylix tondo. Moore 1997, 344
 no. 1582, pl. 149.
ATHENS, Agora Museum P 15207, fragment of lebes gamikos stand. Naples
 Painter (Moore). Moore 1997, 153 no. 130, pl. 22.

ATHENS, Agora Museum P 18512, lid fragment of pyxis Type C. Moore 1997, 277 no. 1041, pl. 100.

ATHENS, Agora Museum P 24253, fragment of pyxis type A . Veii Painter. ARV^2 906, 113; Beazley Addenda 303; Moore 1997, 272 no. 989, pl. 96.

ATHENS, Agora Museum P 24769, loutrophoros fragments. Moore 1997, 148 no. 103, pl. 17.

ATHENS, Kerameikos Museum 5014, pyxis type A. Wehgartner 1983, 137–38, no. 3, pl. 49.1–2.

ATHENS, National Museum 1614 (CC 1240), lebes gamikos type A, stand fragment. Washing Painter. ARV^2 1127, 7.

ATHENS, National Museum 1615 (CC 1594), epinetron fragment. E.

ATHENS, National Museum 1619 (CC 1239), fragment of lebes gamikos. Brückner 1907, 93.

ATHENS, National Museum 1750, lekythos. Eros holding jewelry chest flies over wool basket.

ATHENS, National Museum 12770 (N 980), white lekythos. Timokrates Painter. ARV^2 743, 7. U, V.

ATHENS, National Museum, Acropolis Collection. Loutrophoros fragment. Naples Painter. ARV^2 1098, 40.

ATHENS, National Museum, Acropolis Collection. Loutrophoros fragment. Aison. ARV^2 1176, 22.

ATHENS, National Museum 2183, epinetron. Side A: L, E; side B: K.

BRAURON, Archaeological Museum, black-figure epinetron fragment. B, L.

BRAURON, Archaeological Museum, epinetron fragment.

BRAURON, Archaeological Museum, alabastron fragment. S.

BRAURON, Archaeological Museum, fragment of type A pyxis.

BRAURON, Archaeological Museum 85, fragment of type A pyxis. K.

BRAURON, Archaeological Museum 67, fragment of type A pyxis. B, R.

COPENHAGEN, National Museum 153 (VIII 5207), small hydria. Washing Painter. ARV^2 1131, 161, 1684; Beazley Addenda 333. B (nude).

DELOS, Archaeological Museum, pyxis type A fragment. Veii Painter. ARV^2 906, 112.

LONDON, British Museum E 219, hydria. Painter of Munich 2528. ARV^2 1258, 3; Beazley Addenda 355.

LOS ANGELES, Dechter, pelike. Hamma 1989, 46.

LOS ANGELES, Dechter, skyphos. Hamma 1989, 47. Satyr leaping at wool basket and dancing girl.

MYKONOS, Archaeological Museum, hydria fragment. Dugas 1952, pl. 30, no. 87.

MISSISSIPPI, University Art Museum 77.3.196, pelike. Shapiro 1981, 26–27, no. 6. Eros and naked girl at wool basket.

NEW YORK, Metropolitan Museum of Art 26.199.103, black-figure kylix fragment. CVA Metropolitan Museum of Art 2, USA 11, 1953, pl. 33 no. 52.

PARIS, Bibliothèque Nationale, Cabinet des Médailles 400, pelike. Washing Painter. *ARV*² 1128, 99; Ridder 1902, 294–95, fig. 64, pl. 15.

PARIS, Musée du Louvre G 249, fragment of head kantharos, white ground. Wehgartner 1983, 166–67, no. 4.

PARIS, Musée du Louvre MNC 627, white alabastron. Villa Giulia Painter. *ARV*² 625, 91; *Beazley Addenda* 271.

TÜBINGEN, Eberhard-Karls-Universität, Antikensammlung des Archäologischen Instituts S/10 1575 (E 154), fragment of pyxis. Follower of Douris. *ARV*² 806, 91; *Beazley Addenda* 291.

VIENNA, Kunsthistorisches Museum 730, hydria. Disney Painter. *ARV*² 1265, 12; *Beazley Addenda* 356; Lezzi-Hafter 1988, 336 no. 194, pl. 122.

VIENNA, Kunsthistorisches Museum 3746, white lekythos. *ARV*² 998.164; *Beazley Addenda* 313; Oakley 1997.

ABBREVIATIONS

AA	*Archäologischer Anzeiger*
AbhMainz	*Abhandlungen der Geistes- und Sozialwissenschaftlichen Klasse, Akademie der Wissenschaften und der Literatur in Mainz*
ABV	J. D. Beazley, *Attic Black-figure Vase-painters* (Oxford: Clarendon, 1956)
AE	*Archailogike Ephemeris*
AJA	*American Journal of Archaeology*
AJP	*American Journal of Philology*
AM	*Mitteilungen des Deutschen Archäologischen Instituts, Athenische Abteilung*
AncW	*The Ancient World*
AntK	*Antike Kunst*
ArchCl	*Archeologia classica*
ARV²	J. D. Beazley, *Attic Red-figure Vase-painters*, 2d ed. (Oxford: Clarendon, 1963)
BABesch	*Bulletin antieke beschaving*
Beazley Addenda	T. H. Carpenter, *Beazley Addenda: Additional References to ABV, ARV² and Paralipomena* (Oxford: Oxford University Press, 1989)
BCH	*Bulletin de correspondence hellénique*
BICS	*Bulletin of the Institute of Classical Studies of the University of London*
BMFA	*Bulletin of the Museum of Fine Arts, Boston*
BSA	*Annual of the British School at Athens*
ClAnt	*Classical Antiquity*
CP	*Classical Philology*
CQ	*Classical Quarterly*
CR	*Classical Review*
CSCA	*University of California Studies in Classical Antiquity*

CVA	*Corpus Vasorum Antiquorum*
EAA	*Enciclopedia dell'arte antica, classica e orientale* (Rome, 1958–)
FrGrHist	F. Jacoby, ed., *Die Fragmente der griechischen Historiker* (1923–)
GaR	*Greece and Rome*
GRBS	*Greek, Roman and Byzantine Studies*
HSCP	*Harvard Studies in Classical Philology*
ICr	*Inscriptiones creticae*
IG	*Inscriptiones graecae*
JdI	*Jahrbuch des Deutschen Archäologischen Instituts*
JHS	*Journal of Hellenic Studies*
LIMC	*Lexicon iconographicum mythologiae classicae* (Zurich: Artemis, 1981–97)
LSJ	H. G. Liddell, R. Scott, and H. S, Jones, *A Greek-English Lexicon*
Meded	*Mededelingen van het Nederlands Historisch Instituut te Rome*
MemLinc	*Memorie. Atti dell'Accademia Nazionale dei Lincei, Classe di scienze morali, storiche e filologiche*
MMAJ	*Metropolitan Museum of Art Journal*
MusHelv	*Museum Helveticum*
Paralipomena	J. D. Beazley, *Paralipomena* (Oxford: Clarendon, 1971)
ProcBritAc	*Proceedings of the British Academy*
RA	*Revue archéologique*
RE	Pauly-Wissowa, *Real-Encyclopädie der classischen Altertumswissenschaft* (1893–)
RÉA	*Revue des études anciennes*
REG	*Revue des études grecques*
RhM	*Rheinisches Museum für Philologie*
RM	*Mitteilungen des Deutschen Archäologischen Instituts, Römische Abteilung*
RPhil	*Revue de philologie, de littérature et d'histoire anciennes*
Roscher	W. H. Roscher, Ausführliches Lexikon der griechischen und römischen Mythologie (Leipzig: Teubner, 1884–1937)
Suda	
TAPA	*Transactions of the American Philological Association*
ZPE	*Zeitschrift für Papyrologie und Epigraphik*

Introduction

1. Quotation attributed to Arnaldo Momigliano in P. Green's review of his Sather Lectures (Momigliano 1990), *Times Literary Supplement*, 19 July 1991.

2. Boardman 1974, 239–41; Boardman 1975, 239–41; Boardman 1989, 239–41.

3. Cook (1997, chapter 15) gives a detailed history of the scholarship on Greek vases; for a critical analysis of this tradition, see Lissarrague and Schnapp 1981, 275–82. Frontisi-Ducroux and Lissarrague (1990a) provide a review of scholarly trends for the period 1970–90.

4. Lissarrague and Schnapp 1981, 277: "The two halves of the sundered body of the 'Science of Antiquity' were thus permanently apportioned. To the historian of literature, the images of myth; to the archaeologists, daily life, the *realia.*"

5. On Beazley's adoption of Morellian methodology, see Kurtz 1985. A sense of Beazley's role in shaping the direction of scholarship in this field may be gained from the lectures delivered on the occasion of the centenary of his birth, published in Kurtz 1985, and from Robertson 1991.

6. See Hoffmann 1979, 61–70; Beard 1991, 15–19; Vickers and Gill 1994, 190–200; Settis 1998; Boardman 2001, chapter 2.

7. Ginzburg 1983, 87. In an essay on style, Ginzburg (1998, 46–47) thus compares the two approaches to the work of art, one individual and absolute, the other relational and historical: "The two approaches are both necessary and mutually incompatible, they cannot be experienced simultaneously. But we can address the absolute qualities of the object through the language of history, not the other way around."

8. Hoffmann 1972; Sourvinou-Inwood 1979.

9. Bérard 1989a. For the colloquium on that project at a distance of twelve years, see *AJA* 1996. On the term "imaginary," see Kurke 1999, 4 n. 2.

10. The intellectual and institutional situation of classical archaeology as a discipline is reviewed in Snodgrass 1985; Snodgrass 1987, 1–66. In the latter, Snodgrass voiced a justified concern that "classical archaeology suffers from a 'separation from a common tradition of archaeological research,' that it has 'painted itself into a corner'" (12–13):

Perhaps we have reached a point where it may be conceded, at least for the purposes of the argument, that classical archaeology today stands in danger of a certain stultification. If so, the explanation may partly lie in its traditional incorporation in classical studies, and in its resulting tendency to accept aims originally laid down for it by the sister subjects of classics and ancient history. I would argue that classical archaeology has an existence as a branch of knowledge independent of even these allied disciplines; . . . If it is to achieve the intellectual vitalization that I believe lies within its grasp, then it can only do so by capitalizing on its own strengths. These derive from factors and achievements that on the one hand are really quite independent of its traditional subordination to classical studies and on the other exempt it from the need merely to ape the practices of other branches of archaeology.

For an analysis of tradition of the discipline as history of art, see Bianchi Bandinelli 1976. For recent assessments of the history of the field, mainly in regard to the Anglo-American tradition, see Morris 1994; Shanks 1996.

11. The fixed focus imposed on archaeological research by the historical texts is the subject of chapter 3 in Snodgrass 1987.

12. Momigliano 1950. Momigliano returned on the subject of the antiquarian in his third Sather Lecture, "The Rise of Antiquarian Research" (Momigliano 1990).

13. Momigliano 1950, 286.

14. Momigliano 1950, 286.

15. Varro in Augustine *Concerning the City of God Against the Pagans* 6.3 (quotation in Momigliano 1950, 288–89).

16. Morris 2000, 3. Foucault 1972, 7, seems pertinent here:

There was a time when archaeology, as a discipline devoted to silent monuments, inert traces, objects without context, and things left by the past, aspired to the condition of history, and attained meaning only through the restitution of a historical discourse; it might be said, to play on words a little, that in our time history aspires to the condition of archaeology, to the intrinsic description of the monument.

17. Foucault 1972, 126–40, 162–65; see also Kurke 1999, 4.

18. Vernant 1990, 25; for a demonstration of this approach, see Vernant's essay on the kouros, "Figuration de l'invisible et catégorie psychologique du double: Le colossos," in Vernant 1996, 325–51.

19. Himmelmann 1998, 67–102; Snodgrass 1987, chapter 5.

20. Robert 1881, 1–11.

21. Lazarus and Steinthal 1860. Robert acknowledged no source for the concepts of *Volksbewusstein* and *Volksvorstellung*, but from Kern's parallel lives of Hermann Diels and Carl Robert one learns that Diels took courses in linguistics in Berlin with Steinthal and that Robert, too, spent 1872–73 in Berlin, his last as a student (Kern 1927, 33, 41–43). It is remarkable that another founding figure of structuralism, Saussure, spent eighteen months of his four years in Germany as a student of Indo-European linguistics in Berlin; see Culler 1976, 13–14, 123. On the connection between Saussure and Steinthal, see Belke 1971, cx. Durkheim (1926, 9–20, 415–47) acknowledges his debt to the founders

NOTES TO PAGES 5-10



of the *Völkerspsychologie*. The dependence of his notion of "representation" on psychologi-
cal theory is apparent in Durkheim 1898 (see 301 in particular). For an analysis of Durk-
heim's concepts of *conscience collective* and *représentations collectives*, as well as of their post-
Durkheimian developments, see Bohannan 1960, 77–96.

22. On the "modes of arrangement" of linguistic signs, see Jakobson 1977, 239–59.
The basic principles of structural linguistics go back to Saussure 1916; the most lucid anal-
ysis of the concept of sign within the Saussuran definition is by Barthes (1967). Derrida
(1976, chapter 2) attacked Saussure's notion of the signified. His critique does not invali-
date, however, the Saussuran definition of syntagmatic and paradigmatic associations.

23. Jakobson 1981, 21–27.

24. A fuller treatment of this issue will appear in Ferrari forthcoming.

25. Berlin, Antikensammlung F 2289: *ARV*² 435.95; *Paralipomena* 375; *Beazley Ad-
denda* 238: "I, women preparing wool."

26. For a discussion of the notion of the "natural sign" in the visual arts (in the form
of a critique of Gombrich's work), see Mitchell 1986, chapter 3. The physical body as a
system of symbols is analyzed by Douglas 1973, 93–112. Pictures such as the one under
consideration are the sources for reconstructing ancient wool-working procedures, e.g., in
Barber 1991, 77–78 (on making roves with and without knee guards).

27. On the representation of age and whether it is possible to distinguish the depic-
tion of "girl" from that of "woman," see below, chapter 6; on sex and gender, see chapter 4.

28. Lissarrague and Schnapp 1981, 286–97.

29. Lissarrague 1995, 97.

30. I use the term "content" in an attempt to avoid what Eco (1979, 58–62) calls "the
referential fallacy," the assumption that the content of the sign (image, in our case) corre-
sponds to an object or to an objectively possible activity or state of things. But, in view of
the fact that images refer to nonexistent beings and things—such as sphinxes, phallus-
birds, and centaurs—it is preferable to speak not of the "referent" of an image but of its
"content," in the sense of a cultural unit, whose "existence is linked to a cultural order,
which is the way in which a society thinks, speaks and, while speaking, explains the 'pur-
port' of its thought through other thoughts." (Eco 1979, 61)

31. See chapters 1 and 7.

32. A particularly incisive treatment of this concept is Rubin 1975, passim, particu-
larly 178 and 159: "A "sex/gender system" is the set of arrangements by which a society
transforms biological sexuality into products of human activity."

33. Cohen 1991, chapters 3 and 4, passim; an important critique of this notion in
Sourvinou-Inwood 1995a.

34. On the difference, see Murray 1983.

35. As Riley (1988) and Butler (1999, 3–11) have pointed out, the very notion of
"woman" as a universal category is in need of some rethinking.

36. Like Bron and Lissarrague 1991, 21, some think that it is not necessary to postu-
late a connection among the scenes on the same vase. A connection can be shown, how-
ever, in the few cases when we know what the vase is about: for instance, the Panathenaic
amphorae (see Ferrari 1988a); the Brauron krateriskoi (chapter 6 below). For an attempt
to relate imagery to shape, see Scheibler 1987.

37. Momigliano 1950, 311.

Chapter 1

1. Keuls (1983, 209–10) notes the prominence of weaving and textiles in myths of female rebellion. Penelope managed to keep the Suitors at bay by claiming that she could not marry before she finished weaving the shroud for Laertes (Homer *Odyssey* 2.85–110). The tale of the Minyads is told at length in Ovid *Metamorphoses* 4; their transgression is described in the following terms (32–35, trans. Miller 1925): "The daughters of Minyas alone stay within, marring the festival, and out of due time ply their household tasks, spinning wool, thumbing the turning threads, or keep close to the loom, and press their maidens with work.".

2. Ovid *Metamorphoses* 6.424–674.

3. Aeschylus *Agamemnon* 1381–83. The saga of Deianira is the subject of Sophocles' *The Women of Trachis* (the death of Heracles by clothing [749–812]); the death of Glauce after she puts on the finery Medea has sent her is described in Euripides *Medea* 1136–1203.

4. On Greek myths about women and textiles, see Barber 1994, 232–44. For the wider valence of the metaphor of weaving in Greek and Roman cultural poetics, see the important study by Scheid and Svenbro (1996, 181 n. 75 on weaving by men).

5. The erotic connotations of the image are picked up by Sutton (1981, 355–56) and fully explored by Frontisi-Ducroux (1997), chapter 3. Keuls (1983a, 32) sees here the telling signs of what she calls the "Lucretia syndrome": "After for the profit of the male establishment, women have been divided into chaste spinsters . . . and desirable but contemptible whores, men, somewhat perversely tend to derive sexual excitement from the very virtues of chastity and industry which they themselves have articulated with a utility other than sexual in mind." For Eros with the wool-workers, see pp. 258–59 below.

6. Alabastron by the Pan Painter, Berlin, Antikensammlung F 2254: *ARV²* 557, 123; *Paralipomena* 387; *Beazley Addenda* 259. For scenes of male courtship, see Dover 1989, 91–103; Sutton 1992, 14–19. The courtship of females has attracted considerably less scholarly attention, except insofar as it can be interpreted as depicting hetairai. The most comprehensive treatment of the theme for Late Archaic and Classical vases remains Sutton 1981. On age connotations, see chapter 6 below.

7. Rodenwaldt 1932, 7–21; Beazley 1931a, 121; 1931, 24 no. 59. Schnapp (1986, 147–59) traces the history of the extraordinary notion of the "spinning hetaira" going back to Robert (1919, 125–29) with wit and elegance. I thank Keith De Vries for sending me a copy of this article. The latest contributions to the debate are Meyer 1988, 87–125; Sutton 1992, 19–20; and Reeder 1995, 181–87, nos. 36–38. On historical evidence for such high-price courtesans, see Davidson 1997, 104–7.

8. On the divide between the hetaira and the prostitute, *porne*, see Harvey 1988, 249; Kurke 1999, chapter 5; and below, chapter 7.

9. Cup, Berlin, Antikensammlung V.I. 31426: *ARV²* 795, 100; *Beazley Addenda* 290. See, e.g., Davidson 1997, 89.

10. Williams 1993, 97; hydria in Tampa, Florida, Museum of Art 86.70: *ARV²* 276, 70; *Beazley Addenda* 207.

11. Keuls 1983, 229. Meyer (1988, 88–103) skirts the issue of the sense of the wrapped

figure on the Tampa vase. As Neils (2000, 213) notes: "The Athenian manner of depicting hetairai can be quite subtle and needs proper decoding by the modern viewer."

12. Jenkins and Williams 1985, 416. Davidson 1997, 88: "The brothel, especially a cheap brothel, would have to double as a textile factory." To show that spinning and sex are "interchangeable," Davidson (1997, 87–88) cites Hellenistic epigrams that juxtapose wool-work and whoring, such as "To Athena she [the weaver Bitto] said, 'I shall apply myself to Aphrodite's work and vote, like Paris, against you'" (Greek Anthology 6.48). What these jokes show, however, is that, like two sides of the same coin, the two are opposites; on this point, see Crome 1966. Much has been made lately of the names of the girls on the exterior of a cup by the Ambrosios Painter in a private collection (Munich, Zanker collection; Immerwahr 1984). This is a scene of courtship, featuring a standing spinner and two girls with a basket full of loaded spindles and two others, one of whom plays the aulos. Their names are Rhodon, Antiphane, Aphrodisia, and Obole (the aulos player). The last name has been read as a pun on the word "obol" and fast evidence that the figure is a two-bit prostitute; see Münzen und Medaillen 1975, 60–61; Williams 1993, 96–97; Davidson 1997, 88. As Immerwahr (1984, 11) observes, however, the first three are all attested as perfectly respectable names. As to "Obole": "[T]he name looks like the end of a name like Aristoboule. . . . As a pun, it seems an impossible formation." As in the case of the New York pyxis (chapter 2, n. 66), the puzzle may be resolved by scientific examination, since Immerwahr (1984, 10) reports that the vase was re-fired and that its surface is uneven and coated with a plastic film.

13. Knigge 1981; 1983, 212; 1991, 93; Reinsberg 1989, 140–42; Davidson 1997, 85–90. Lind (1988) attempts to identify Bau Z with the establishment that Euctemon owned in the Kerameikos (Isaeus 6).

14. According to Neils (2000, 206–9), e.g., one is a subset of the other.

15. On prices, see Halperin 1990, 107–12.

16. Davidson 1997, 73–77, chapter 4, particularly 109–12; Kurke 1999, chapter 5.

17. The same contrast is reflected in the opposite connotations of dice and knucklebones; see Kurke 1999, 283–95: "Where kuboi were identified with the disembedded economics of pornai in the elite tradition, knucklebones seem to have been aligned with the mystified status of hetairai."

18. On this passage, see Davidson 1997, 120–30; Kurke 1999, 180.

19. Xenophon Memorabilia 3.11.4: ἐάν τις—ἔφη—φίλος μοι γενόμενος εὖ ποιεῖν ἐθέλῃ, οὗτός μοι βίος ἐστί [(I)f someone becomes my friend and wishes to benefit me, that is my livelihood.]

20. Davidson 1997, 112.

21. Ferrari 1986, 218; 1988, 147–49; Schnapp 1986. Neither receives acknowledgement in current scholarship on the subject, which assumes that the identification of the bag with a money pouch is a fact rather than a hypothesis. See, e.g., Reden 1995, 195–211, on the shifting symbolism of the money pouch.

22. Hampe 1951.

23. Touchefeu-Meynier 1972; Hampe 1976, 192–202 (for a range of sizes and materials for astragaloi, 197–99, fig. 6). Sutton (1981, 291–97, 328–29) attempts to distinguish bags of astragaloi—that are pointed and plain, are pointed and have a side flap opening,

have a rounded shape but are large, or have nets, or are small and decorated—from the so-called purses, which are smallish, plain, and rounded. Two points emerge clearly from his analysis: bags of *astragaloi* are a standard feature of courtship, and there are several different kinds of bags to hold them, depending on the size and quality of the knucklebones the painter had in mind. The various types are clearly interchangeable.

24. It is wishful thinking to identify coins, rather than knucklebones, with the roundish objects represented on the cup fragment Louvre G 143: *ARV*² 469,148; *Beazley Addenda* 245 (a flower in one hand and two coins in the other?) and on the skyphos, St. Petersburg, Hermitage 4224: *ARV*² 889, 166; *Paralipomena* 516; Peredol'skaia 1967, pl. 106, 1; Sutton 1992, 17–18.

25. Athens, National Museum 12778: *ARV*² 663.3; *Beazley Addenda* 277.

26. On these scenes, see chapter 7 below; the so-called purse appears, to my knowledge, on two representation of sex, a cup by the Antiphon Painter (*ARV*² 339, 55; *Beazley Addenda* 218; Boardman 1975, fig. 241) and an Early Classical cup in a private collection (*ARV*² 923.29; *Beazley Addenda* 305; Keuls 1985, fig. 162). The pictures taken to represent buying and selling are reviewed by Meyer 1988, 112–19.

27. Pointed satchel with side opening, hanging on the wall: cup in Berlin, Antikensammlung 3359: side A, *ARV*² 407, 19; *CVA* Berlin 2 (Germany 21, 1962) pl. 74,1; skyphos in Schwerin, Staatliches Museum 708: *ARV*² 862, 30; *Paralipomena* 425; *Beazley Addenda* 298; Simon 1976, fig. 181 (Iphicles' music lesson). Plain, large bag offered as a prize: the cup in Oxford, Ashmolean Museum 1916.13: side B, *ARV*² 1259, 6; *CVA* Oxford 1 (Great Britain 3, 1927) pl. XI,4. Plain, small, and rounded bag on the wall together with writing tablets, shoes, small lyre: cup in Melbourne, National Gallery Felton 1644/4: *ARV*² 892, 7; *Beazley Addenda* 303; Beck 1975, pl. 19 no. 101. The scene continues on side B of this cup, where, in the same position, a small pointed satchel with a side opening is depicted; Beck, pl. 52 no. 273.

28. See, e.g., the plain, small, round-bottomed bag, indistinguishable from the ones that appear in the depictions of courtship, on the "conversation scene" on the exterior of a cup in Florence (side B), Museo Archeologico 76363: *ARV*² 894, 40 bis; *Paralipomena* 429; *CVA* Florence 4 (Italy 38, 1964) pl. 135,2–3: man and boy, writing tablets on the wall; youth offering tablets to another boy; the bag hangs on the wall between the two couples. On the interior of this cup is another "conversation scene" and, on the wall in this scene, an identical satchel. A comparable representation appears also in the tondo of a stemless cup in Hamburg, Museum für Kunst und Gewerbe 1893.101: *ARV*² 898, 137; *Beazley Addenda* 303; Beck 1975, pl. 17 no. 95.

29. See, for instance, the little bag on the cup fragment in Braunschweig, Herzog Anton-Ulrich Museum 543: *ARV*² 867, 9; *CVA* Braunschweig (Germany 4, 1940) pl. 17,10, again of the same shape and dimensions as the ones carried by *erastai*.

30. On the pyxis in Berlin, Antikensammlung F 2261: *ARV*² 906, 116; *Beazley Addenda* 303; *CVA* Berlin 3 (Germany 22, 1962) pl. 136, the small, plain, rounded bag keeps company on the wall of the portico with sandals, sash, and alabastron. The females represented in these settings are the kind that play with knucklebones; see the representations listed by Oakley (1990, 41) to which should be added the pyxis in Vienna, Kunsthistorisches Museum 1863: *CVA* Vienna 1 (Austria 1, 1951) pl. 49,4–6.

31. Reden 1995, 201: "Gifts of money in courtship scenes do not seem to play any role that is distinct from that of other gifts."

32. Paris, Cabinet des Médailles 508: *ARV*² 1610. According to Sutton (1992, 20), this scene represents an adaptation of the iconography of prostitution to the representation of married life.

33. Koch-Harnack (1983) draws a distinction between gifts that have "material" value, such as pets and venison, knucklebones and balls, from gifts that have no material value, that is, flowers, garlands, and fruit. It is unclear, however, what constitutes an appropriate love gift under what circumstances. Penelope, for instance, feels entitled to, and demands, valuable presents from the Suitors (see below).

34. Aristophanes *Wealth* 149–56; on this passage, see Schnapp 1986, 150–51.

35. Page 1962, 199, no. 53.

36. Plutarch *Life of Lysander* 8.5. Plutarch's *Lives* are cited from the Loeb Classical Library Series edition (trans. Perrin; 1914–26). On the game itself, see Schädler 1996. Kurke (1999, 290–95) stresses the game's connotations of innocent childhood as well as its erotic associations.

37. Cup by Makron, Bochum, Ruhr-Universität S 507: *ARV*² 1654, 206 bis; *Beazley Addenda* 246. Kunisch (1997, 184, no. 227, 121–22, n. 553) describes the objects the man holds as coins. Skyphos fragment in Athens, Acropolis 512a: *ARV*² 806, 2; Graef and Langlotz, pl. 40. Bucharest stele: Beschi 1978, 7, fig. 3.

38. Munich, Antikensammlungen 2427: *ARV*² 189, 72; *Paralipomena* 341; *Beazley Addenda* 188; *CVA* Munich 5 (Germany 20, 1961) pl. 228.

39. See Lissarrague (1999, 52–57) for a recent statement that the spinners in these scenes are not courtesans but ideals of domestic femininity.

40. Beard (1991, 21–30), who takes the little bag to be a money pouch and the spinning as the mark of the housewife, suggests that the image plays upon these alternative identities.

41. Beazley 1931a, 121.

42. On this passage, see chapter 8.

43. On this passage, see pp. 199–200. In general, courtroom speeches demonstrate remarkably little affection toward wives; see Vial 1985, 56–57. On the distinction between work and play—wives, on the one hand, and on the other, courtesans and virgins—see Carson 1990, 135–69.

44. That everyday life is represented on the vases currently is held as a self-evident truth; the classification of such scenes is codified in Boardman's handbooks of Attic vase paintings. For instance, in Boardman (1989, 217–21), the "scenes of reality" are defined, and their realism is qualified (218): "scenes with figures which are not identifiably mythical or divine. The 'real' scenes no less than the 'mythical' are subject to formulae and conventions, and their message may be no less subtle for the apparent ordinariness of their settings." The subjects are subdivided accordingly into "everyday life," "fighting," "work and play, public and private," and "religion." The problematic aspects of the distinction and the realism of the representations are discussed by Zinserling (1977) and Dummer (1977). On proposals for an outright dismissal of the division of the images into myth and genre, see Bazant 1981; Harvey 1988; Ferrari forthcoming.

45. Berlin, Antikensammlung F 2298: *ARV*² 364, 52; *Paralipomena* 364; *Beazley Addenda* 223; *CVA* Berlin 2 (Germany 21, 1962) pl. 64,1–2; Guy 1981, 10: "a mortal symposium."

46. Richmond, Virginia Museum of Fine Arts 79.100. Guy (1981, 9) observes that the

kantharoi in the picture are "unmistakable symbols of special status." But on the Berlin cup, too, unusual drinking vessels are used: phialai, which are the sort of cups out of which gods drink (e.g., on the cup by the Codrus Painter in the British Museum, E 82: *ARV*[2] 1269, 3; *Beazley Addenda* 356).

47. Syracuse, Museo Nazionale 30747: *ARV*[2] 1153, 17; *Beazley Addenda* 336; Kron 1976, 264 (P 8), pl. 13,2; Beazley 1935, 487. It is still described as a "departure scene" in Reeder 1995, 158–60, no. 20.

48. The second vase is the lekanis by the Meidias Painter in Naples, Museo Nazionale, Santangelo 311: *ARV*[2] 1314, 17; *Paralipomena* 477; *Beazley Addenda* 362; Kron 1976, 264 (P 9), pl. 14.

49. Lissarrague and Schnapp 1981, 286–97.

50. Ferrara, Museo Archeologico Nazionale T 293A, 6631: *ARV*[2] 1259, 2; Lezzi-Hafter 1988, 324, no. 97, pls. 76–77.

51. Ferrara, Museo Archeologico Nazionale T 617, 278: *ARV*[2] 1259, 1; *Beazley Addenda* 355; Lezzi-Hafter 1988, 324, no. 98, pl. 78–79: "3 Jünglinge, 3 Musen." Sutton (1981, 342) proposes that the Calliope Painter "does not draw a sharp line between divinities and mortals in these scenes which are pervaded by Apollonian serenity."

52. London, British Museum E 773: *ARV*[2] 805–806, 89: "[T]he artist has given the women names of Argive heroines"; *Paralipomena* 420; *Beazley Addenda* 291. Roberts (1978, 186) notes: "If there were no inscriptions it [the scene] would be entitled women in the home or in German text 'Frauengemach.'"

53. Burn 1987, 83. Toilet of Aphrodite in Mainz, Johannes Gutenberg Universität 118: *ARV*[2] 1327, 87; *Beazley Addenda* 364; on this vase, see further below, p. 46. "Generic" toilet: the pyxis in Oxford, Ashmolean Museum 551: *ARV*[2] 1328, 98; *Paralipomena* 479; *Beazley Addenda* 364; Burn 1987, pls. 21c–21d; 49–50.

54. Burn 1987, 84.

55. This principle is explicitly stated by Dummer (1977, 60): "Die Realitätsbezogenheit zeigt sich selbstverständlich auch bei den mythologischen Darstellungen. . . . Wenn Athena ein Pferd wie ein menschlicher Künstler modelliert, so gibt der Zeichner damit eine für ihn reale Vorstellung wieder. Dass sie wie ein Mensch verfährt, hat freilich mit dem Realitätsgehalt nichts zu tun." But were we unable to identify the figure as Athena, we would say that there were, in Athens, women sculptors.

56. St. Petersburg, Hermitage 644: *ARV*[2] 16, 15; *Paralipomena* 509; *Beazley Addenda* 153; Peredol'skaia 1967, pls. 14–15, 166, 2–7; Pasquier and Denoyelle 1990, 164–67. On the inscriptions, see Kretschmer 1894, 87; Csapo and Miller 1991, 373, 377–78. The other women are Palaisto, Sekline, and Agape. The same subject, but with inscriptions in Attic dialect, occurs on the hydria by Phintias in Munich, Antikensammlungen 2421: *ARV*[2] 23–24, 7; *Paralipomena* 323; *Beazley Addenda* 155. The argument presented here was first proposed at the colloquium that revisited the *Cité des images* project (*AJA* 1996, 361) and is developed further in Ferrari forthcoming 2. On the imagery of the banquet of "hetairai," see Peschel 1987; Kurke 1999, 205–7.

57. On the representations of the game, see Lissarrague 1990, 80–86; Csapo and Miller 1991, 379–81; Jacquet-Rimassa 1995, 129–70.

58. The hypothesis was put forward by Kretschmer 1894, 87.

59. Reinsberg 1989, 112–14.

60. Reinsberg 1989, 114, 156.

61. Harvey 1888.

62. Csapo and Miller (1991, 380) and Kurke (1999, 205–206), who express doubts about the existence of symposia of hetairai and point to the possibility that these images are a male fantasy, nevertheless continue to identify the women as prostitutes and hetairai, respectively.

63. Peschel 1987, 73–74; Reinsberg 1989, 112–14.

64. On the iconography of the symposium, see Lissarrague 1990, in particular chapter 4 ("Drinking Games").

65. Peschel (1987, 73–74) points out that the women depicted as symposiasts are shown as taking over male roles. On the representation of Amazons, see DuBois 1982; Tyrrell 1984. For the Greek view of Etruscan women, see Bonfante 1986, 232–41.

66. See chapter 7 below.

67. Although Immerwahr (1990, 74 n. 51) states that "[t]he dialect is Sicilian" as though it were a fact, this is a hypothesis put forward by Kretschmer (1894, 87), prompted by the fact that the game the women are playing was thought to be of Sicilian origin. The dialect of the inscription cannot be more closely identified than as Doric; the form *tin* for *soi* is attested in Laconia, according to Bechtel 1923, 347.

68. Syracuse, Museo Nazionale 2408: ARV^2 537, 6; *Beazley Addenda* 255; Touchefeu-Meynier 1968, 230 no. 418, pl. 32,3.

69. Meyer 1988, 105: "Wenn mehrere Einzelpaare, eine Frau zwischen zwei oder drei Männer mit Geschenken oder einmal ein Mann mit Geldbeutel zwischen zwei Frauen dargestellt sind, kann es sich nur um Liebeswerbungen und bei den Frauen um Hetären handeln."

70. Petersen 1892, 181–82; *LIMC* 6, s.v. "Mnesteres," no. 1. The gifts Penelope receives are more substantial than the trinkets featured in the courtship scenes, but it is perfectly proper that she should accept them. When Penelope complains that she is not being wooed as custom prescribes with gifts of food and other goods, Antinoos replies (Homer *Odyssey* 18.285–287, trans. Lattimore 1967): "Daughter of Ikarios, circumspect Penelope, / whatever gifts any Achaian wishes to bring here, / take it; it is not honorable to refuse the giving." The gifts are then described:

> Each man sent his herald off to bring back the presents.
> Antinoos' herald brought in a great robe, beautiful
> and elaborate, and in it were twelve double pins, golden
> all through, and fitted with bars that opened and closed easily.
> Eurymachos' man came back with an elaborate necklace
> of gold, strung with bits of amber, and bright as sunshine.
> Eurydamas' servants came back bringing a pair of earrings
> with triple drops in mulberry clusters, and there was radiant
> charm in them. From the house of the lord Peisandros, Polyktor's
> son, his servant brought a necklace, a wonderful offering.
> Each of the Achaians brought a different beautiful
> present. (*Odyssey* 18.291–301 [trans. Lattimore 1967])

71. Bérard, in Bérard 1989a, 110.

72. See Lissarrague 1991, 161: "Il convient de préciser — on nous pardonnera ce rap-

pel—que l'image n'est pas une évidence photographique, qu'elle ne va pas de soi mais qu'elle est le produit d'une élaboration qui a sa logique, autant dans ses fonctions que dans sa construction. Les peintres procèdent à des choix dans le réel qui les entoure—certains sujets sont représentés, d'autres pas. Ils choissent aussi dans ce qui est montré, retenant tel élément plutôt que tel autre, manipulant l'espace et le temps en image afin de rendre visible le réel."

73. Goodman 1976, 38; an eloquent quote, reported as occurring in an essay on Virginia Woolf: "Art is not a copy of the real world. One of the damn things is enough" (3).

74. This point is forcefully made by Christiane Sourvinou-Inwood in a number of writings, for instance, Sourvinou-Inwood 1987, 41–43.

75. The semiotic current in modern studies of the vase paintings is represented especially well by Bérard (1983, 5–37).

76. These principles were formulated by Saussure (1915); an influential elaboration was given by Jakobson (1977; 1981).

77. On the construction of such "series," see Lissarrague 1990, 9–12.

78. For an attempt to identify sign-components of pictures by tracing the way in which one may be substituted for another, see Ferrari forthcoming 2.

79. Morgan 1985, 5–19.

80. Morgan 1985,10: "The meaning is more than the sum of its parts yet encompasses characteristics of the component units. It cannot do otherwise if the components have a meaning of their own."

81. This is, in fact, Morgan's assumption, and one that is employed in her detailed analysis of the miniature fresco from Thera, where the representations are traced to the landscapes, animals, and peoples that the painter would have seen. Even in the depiction of things that do not exist, natural elements are recognized, as in the image of the griffin, a beast with the head and wings of an eagle and the body of a lion (Morgan 1985, 10; 1988).

82. Bérard 1983, 7–12. This approach to the analysis is further developed in Bron et al. 1991; Viret Bernal et al. 1992. The point that "a sign has no fixed meaning" or only acquires meaning in a given context is made also, although in a different manner, by Sourvinou-Inwood 1987, 42–43.

83. Benveniste 1971, 105.

84. Benveniste 1971, 110.

85. Benveniste 1971, 110.

86. I adopt here the model of the communication event outlined by Jakobson 1981, 22:

<div align="center">

context

message

addresser---addressee

contact

code
</div>

87. Foucault 1972, 215–37.

88. Hedreen (1992) has reconstructed a Naxian cycle of myth to which the satyrs of Dionysus are attached.

89. The pictures were gathered from publications, taking Beazley's lists in *ABV* and *ARV²* as the point of departure. No systematic effort was made to collect unpublished material except in cases of special interest. The size of the corpus of images insures that it is representative, but no claim is made that it is complete.

90. For a discussion of the textile hand-frames, see Clark 1983; Jenkins and Williams 1985, 411–18; Barber 1991, 122–24. Jenkins and Williams include a list of representations of the hand-frames, which is augmented by Oakley 1990, 144 n. 311; add the hydria in Stanford University 17.412, Webster 1965, 64, fig. 6. For the representations of upright looms, see Crowfoot 1936–37, 36–47. I know of four complete representations of the loom on Attic vases: the black-figure lekythos New York, Metropolitan Museum of Art 31.11.10: *ABV* 154.57; *Paralipomena* 64; *Beazley Addenda* 45; Bothmer 1985, 185–87 no. 48; the skyphos in Chiusi, Museo Archeologico Nazionale 1831: *ARV²* 1300, 2; *Paralipomena* 475; *Beazley Addenda* 360; *CVA* Chiusi 2 (Italy 60, 1982) pl. 35–36; the hydria once in the Robinson Collection, Baltimore, *CVA* Robinson 1: (USA 6, 1937) pl. 43; the epinetron in Athens, National Museum 2179: *AE* 1892, pl. 13,1. Barber 1991, 92 n. 7, adds five fragmentary examples, including two plaques, not all of which may be Attic.

91. On Europa, see *LIMC* 4, s.v. "Europe," nos. 36, 38; Christie, Manson, and Woods International Inc. 2000, 94–96 no. 88. Aethra: *LIMC* 1, s.v. "Aithra," nos. 1–4; add the kalpis by the Geras Painter in a private collection, Hamma 1989, 45. Scholars have found Aethra and her wool basket difficult to explain: see, e.g., U. Kron's commentary at *LIMC* 3, s.v. "Danae," no. 4. On the remarkable semantic range of the *kalathos*, wool basket, see Lissarrague 1995, 95–96.

92. Early Classical pyxis in Brussels, Bibliothèque Royale 9; *ARV²* 863, 31.

93. Sourvinou-Inwood (1987, 42; 1988, 18–20) makes what I think is a similar distinction between "iconographic" analysis and "semantic" analysis. The procedure I outline is analogous to the construction of a "series" in Lissarrague 1990a, 10–12, although my point of departure differs.

94. University of North Carolina at Chapel Hill, Ackland Museum of Art 71.8.1. Shapiro 1981, 128–31 no. 50: "[s]eventeen women, each holding an attribute which figures in the daily life of Athenian matrons and their maid-servants" (128).

95. Athens, Ephoria Athinon A 1877: *ARV²* 1707 (1263, 84 bis); Lezzi-Hafter 1988, 347, no. 256, pls. 166–67, takes the picture as related to the wedding, as does Barringer 1995, 125.

96. Mainz, Johannes Gutenberg Universität 118: *ARV²* 1327, 87; *Beazley Addenda* 364; Hampe 1955, 107–23, pls. 42–45. Hampe's identification of Paphia as Aphrodite on this vase and on the lekanis in Naples, Museo Nazionale 2296 (*ARV²* 1327, 86; *Beazley Addenda* 364; Metzler 1980, 77, fig. 2) is repeated by Burn 1987, 28.

97. Brussels, Musées Royaux d'Art et d'Histoire A 3098: *ARV²* 493, 2; *Paralipomena* 380; *Beazley Addenda* 249; *CVA* Brussels 3 (Belgium 3, 1949) pls. 15,1; 16,2.

98. New York, Metropolitan Museum of Art 09.221.40: *ARV²* 1328, 99; *Paralipomena* 479; *Beazley Addenda* 364; Richter and Hall 1936, 202–3, no. 161.

99. Basel, Antikenmuseum BS 410: *ARV²* 1103, 6; *Paralipomena* 451; *Beazley Addenda* 329; *CVA* Basel 2 (Switzerland 6, 1984) pls. 55,1–4; 56,1–6.

100. Berlin, Antikensammlung F 2385: *ARV²* 1020, 96; Oakley 1990, 81–82 no. 96, pl. 75 B.

101. Lekythos in Brussels, Musées Royaux d'Art et d'Histoire A 3132: *ARV*[2] 681, 91; *Beazley Addenda* 279; Kurtz 1975, pl. 15,1.

102. Metropolitan Museum of Art 06.1117: *ARV*[2] 815, 3; Richter and Hall 1936, 124–25 no. 96.

103. Brussels, Bibliothèque Royale 9: *ARV*[2] 863, 31; *Beazley Addenda* 299; Callipolitis-Feytmans 1948, 49–54, pls. 21–22.

104. Cambridge, Mass., Harvard University, Arthur M. Sackler Art Museum 1925.30.39: *ARV*[2] 963, 92; *CVA* Gallatin and Hoppin Collections (USA 8, 1942) pl. 13,7–10.

105. Boston, Museum of Fine Arts 65.1166: Truitt 1969, 72–74, figs. 1–3.

106. Pyxis once auctioned on the London market at Christie's, Roberts 1978, 65–66, no. 11, 184, pls. 43,1; 102

107. Stanford University hydria 17.412 (n. 90 above).

108. Pyxis in Copenhagen, National Museum 7093: *ARV*[2] 1222, 5; *CVA* Copenhagen 4 (Denmark 4, 1931) pl. 162,5.

109. New York, Metropolitan Museum of Art 41.162.71: *ARV*[2] 724, 5; *CVA* Gallatin and Hoppin Collections (USA 8, 1942) pl. 58,1. Delphi, Museum 8713, Perdrizet 1908, 169, fig. 708 bis.

110. On the game, see Papaspyridi Karouzou 1945, 42.

111. Florence, Museo Archeologico 75770: *ARV*[2] 861, 15; *Beazley Addenda* 298; *CVA* Florence 3 (Italy 30, 1959) pl. 105.

112. Cup, Louvre C 1005 (G 151): *ARV*[2] 406, 8; *Paralipomena* 371; *Beazley Addenda* 232. The interpretation of the scene as the homecoming of Paris was proposed by Hampe 1937, 142–47, pl. 51,2–3.

113. Pelike in Athens, National Museum 1182 (CC 1262): *ARV*[2] 1059, 133; Kahil 1955, 64, no. 18.

114. Cambridge, Mass., Harvard University, Arthur M. Sackler Art Museum 1972.45: *ARV*[2] 638, 43; *Beazley Addenda* 273; Fogg Art Museum 1973, 64–65 no. 25.

115. Berlin, Antikensammlung 3240: *ARV*[2] 405; *Beazley Addenda* 232; *CVA* Berlin 2 (Germany 21, 1962) pl. 71,1.

116. Florence, Museo Archeologico 81602: *ARV*[2] 810, 24; *CVA* Florence 3 (Italy 30, 1959) pl. 103.

117. Oxford, Ashmolean Museum 517: *ARV*[2] 785, 8; *Paralipomena* 418; *Beazley Addenda* 289; *CVA* Oxford 1 (Great Britain 3, 1927) pl. 8, 1–2.

118. South Hadley, Mount Holyoke College 1932. 5.B.SII: *ARV*[2] 906, 109; *Beazley Addenda* 302; Roberts 1978, pl. 30,1; 34,1.

119. St. Petersburg, Hermitage 750: *ARV*[2] 717, 231; *Paralipomena* 515; Peredol'skaia 1967, pl. 111,2.

120. Adolphseck, Schloss Fasanerie 57: *ARV*[2] 717, 227; *CVA* Schloss Fasanerie 1 (Germany 11, 1956) pl. 40,7–9.

121. Winged females—whether divinities or personifications—abound; see, for one example, the lebes gamikos in Basel (n. 74 above). Eros in attendance: lekythos Metropolitan Museum of Art 06.1021.90: *ARV*[2] 682, 102; Richter and Hall 1936, pl. 33; hydria,

British Museum E 187: *ARV²* 1071, 2; *CVA* British Museum 5 (Great Britain 7, 1930) pl. 82,2; squat lekythos, Copenhagen, National Museum 6441: *CVA* Copenhagen 4 (Denmark 4, 1931) 167,9. Satyr handling wool: the lekythos in Tübingen, Eberhard-Karls-Universität, Antikensammlung des archäologisches Instituts 7358: *ARV²* 734, 83; *Beazley Addenda* 283; *CVA* Tübingen 5 (Germany 54, 1986) pl. 39,4–6. See also pp. 273–74 below.

122. Athens, National Museum 16457: *CVA* Athens 2 (Greece 2, 1954), pl. 19.

123. Hermitage 4525: *ARV²* 1094, 99; *Paralipomena* 517; Peredol'skaia 1967, pl. 133,1.

124. Mykonos, Museum 1008: *ARV²* 1025, 1; Oakley 1990, 93, no. 51, pl. 141; see also the hydria in Brussels (n. 97 above).

125. British Museum E 188: *ARV²* 1048, 42; *Beazley Addenda* 321; *CVA* British Museum 6 (Great Britain 8, 1931) pl. 85,2. See also the hydria in Providence, Museum of Rhode Island School of Design 22.114, *CVA* Providence 1 (USA 2, 1933) pl. 22,1.

126. Clytemnestra is represented in the tondo of a cup by the Brygos Painter that was once in Berlin (F 2301: *ARV²* 378, 129; *Beazley Addenda* 226) and is now lost according to Prag (1985, 19, 140 [C 17]). For a Thracian woman from the death of Orpheus, see another cup by the Brygos Painter, New York, Metropolitan Museum 96.9.37: *ARV²* 379, 156; *Beazley Addenda* 227; Zimmermann 1980, 168–69, fig. 2. On the notion of the "excerpt," see Raab 1972, 92–102.

127. Drawing by Adam Buck in Dublin, Trinity College Library, ms. 2031; Jenkins 1989, 18 no. 66:75.

128. Pyxis in Vienna, Kunsthistorisches Museum 3719: Oakley 1990, 90, no. 144 bis, pls. 118–19. The figure is rare in the "domestic" scenes, but there are a few examples, such as the hydria in Leiden, Rijksmuseum van Oudheden GVN 56: *CVA* Leiden 3 (Netherlands 5, 1983) pl. 142; the Stanford hydria (n. 90 above). See also the hydria in Braunschweig, Herzog Anton Ulrich-Museum 220: *ARV²* 1037, 3, *CVA* Braunschweig (Germany 4, 1940) pls. 24,4–6; 25; 26,5; 27,3.

129. Frontisi-Ducroux 1997, 92–96.

130. Barringer (1995, chapter 7) collects and analyzes "domestic" scenes of the Nereids.

Chapter 2

1. On these "paradise gardens," see Burn 1987, 19–21.

2. Pyxis, British Museum E 773: *ARV²* 805, 89 (fig. 2); *Paralipomena* 420; *Beazley Addenda* 291; pyxis, Copenhagen, National Museum 7093: *ARV²* 1222, 5; pyxis, Vienna, Kunsthistorisches Museum KM 3720: *CVA* Vienna 1 (Austria 1, 1951), pl. 49; pyxis, Paris, Bibliothèque Nationale 864: *ARV²* 963, 89; *Beazley Addenda* 308; Ridder 1902, 507, fig. 122.

3. Pyxis, Berlin Antikensammlung F 2261: *ARV²* 906, 116; *Beazley Addenda* 303. See also the pyxides Vienna 3719 and South Hadley, Mount Holyoke College 1932 5.B.SII (figs. 65–67).

4. See also the pyxis in a private collection in Athens, Roberts 1978, 78–79, pl. 32,1, and the hydria from the Noble collection in the Tampa Museum of Art (fig. 6).

5. Pyxis, British Museum D 12: *ARV²* 963, 96; *Beazley Addenda* 308 (fig. 65).

6. This hypothesis is treated as a fact in all comprehensive studies of these scenes: Zevi

1937, 291–350; Götte 1957; Sutton 1981, 48–51; Lissarrague 1995, 97. Note, however, Lezzi-Hafter's (1988, 249) remark that on London E 774 the closed door is viewed from the outside. Nevett (1999, 11–12, 19–20) recognizes in the vase paintings potentially important sources of information but acknowledges as well crucial difficulties in their interpretation. On the definition of these scenes, see Brümmer (1985, 144–45), who questions the validity of the distinction between pictures of "women at their toilet" and representations of wedding preparations. Roberts (1978, 177–87) avoids dealing with this issue and focuses her analysis on scenes of weddings and mythological subjects. On the problem of "genre," see above, chapter 1.

7. Pyxis, Louvre CA 587: *ARV*[2] 1094, 104; *Paralipomena* 449; *Beazley Addenda* 328. Moving from the premise that the spinners are prostitutes, Jenkins and Williams (1985, 416) suggest that the door opens to reveal not a *thalamos* but a couch in the men's dining room, the *andron*.

8. Athens, National Museum 17191: *CVA* Athens 2 (Greece 2, 1954) pl. 29.

9. Pyxis, Louvre CA 1857. For the altar of Zeus in the palace court, see Homer *Iliad* 9.771–75, 24.306; *Odyssey* 22.333–37; 378–80. Athenaeus *Sophists at Dinner* 5.189E: "Homer always uses *aule*, where stood the altar of Zeus Herkeios, in the singular." Knox (1973, 10) suggests that this altar may have been a "regular feature" of the Homeric palace. Ginouvès (1962, 302) takes the Boeotian pyxis to show a sanctuary.

10. Gould (1980, 38–59, particularly pp. 40, 46–51) reviews the literary sources and the scholarly debate on this point. On the seclusion of women, see below, chapter 8.

11. Pindar *Olympian* 13.4–5; Oppian *Halieutica* 5.288–90.

12. Homer *Odyssey* 10.220–23; Plato *Symposium* 175A. See also Plato *Protagoras* 314C and Thucydides *History of the Peloponnesian War* 6.27, for *prothura* as part of buildings in use in the fifth century.

13. Pindar *Olympian* 6.1–3:

Χρυσέας ὑποστάσαντες εὐτειχεῖ προθύρῳ θαλάμου / κίονας, ὡς ὅτε θαητὸν μέγαρον / πάξομεν.

14. *ABV* 76, 1; *Paralipomena* 29; *Beazley Addenda* 21.

15. New York, Metropolitan Museum of Art 56.11.1: *Paralipomena* 66; *Beazley Addenda* 45; Bothmer 1985, 64, 182–83 no. 47.

16. Herodotus *Histories* 6.35.

17. Knox 1973, 10–11.

18. Plutarch *Life of Solon* 32.1–2. For the use of *toikhos* to mean the wall of the court, see the reconstruction of the plan of the palace of Odysseus by Gray 1955, 7–9.

19. Homer *Odyssey* 7.4; 4.20–22.

20. For example, Homer *Iliad* 24.323; *Odyssey* 3.493.

21. Gray 1955, 8–9, takes *en prothuroisin* to mean "inside the aule" and points out that at least once the expression *prothuroio kai aithouses epidromou* means that the chariot is within the court. At *Iliad* 24.265–323, Priam's chariot is harnessed within the palace. For animals driven through the *prothura* and into the *aule* see *Homeric Hymns* 4.270–72 (the cattle of Apollo, stolen by the infant Hermes) and *Odyssey* 20.176 (goats to feed the Suitors); on this point in general, Knox 1973, 9.

22. Homer *Odyssey* 17.266–68.

23. Lorimer 1950.

24. Homer *Odyssey* 7.7–13. This is also the position of Euryclea (*Odyssey* 20.124–28): Telemachus wakes up and dresses, then he goes to the threshold to speak to Euryclea, who, therefore, must have been waiting just outside the door.

25. A porticoed area in front of the door, that is, on the side facing the road, is implied, for instance, at Herodotus *Histories* 6.35.

26. *Aithousa aules:* Lorimer 1950, 415.

27. This last is also called *prodomos,* Lorimer 1950, 416–17; see also *Odyssey* 20.1– 9. The location of the last two, *aithousa aules* and *prodomos prosthen thalamoio thuraon* is specified in the story of Phoenix's escape, *Iliad* 9.471–77. Wace (1951, 203–11) makes an analogous case for a general and several specific meanings of words such as *thalamos* and *mukhos.*

28. Homer *Odyssey* 7.95–131, 18.5–10; *Iliad* 11.767–79.

29. Lorimer 1950, 416.

30. Homer *Odyssey* 1.103–43: here the Suitors are in front of the doors, *proparoithe thuraon;* the same expression is used at *Odyssey* 18.32, where it refers to the doors of the *megaron.*

31. Homer *Odyssey* 17.530–31, 15.466–67.

32. Above, n. 4.

33. Lorimer 1950, 416–17; Bassett 1919, 295–96; Knox 1973, 8–9.

34. The Suitors are said to dance at *Odyssey* 1.421–22 (and elsewhere) and to exercise at *Odyssey* 4.625–27.

35. Lorimer 1950, 416–17; Knox 1973, plans of *megara,* 2 (fig. 1), 8.

36. My position on this issue is akin to that of Knox (1973, 1): "It is quite possible that descriptions in the *Iliad* and the *Odyssey* may contain purely imaginary elements. One has only to reflect on the beautiful golden palaces inhabited by princesses in European fairy-tales. And if a poet is working in a long tradition, he may pass his fantasies as well as his facts down to the next generation of poets, who will mingle both indiscriminately, treating the fantasies as part of the factual material of the tradition."

37. Knox (1973, 12–13) makes the point that doors are mentioned frequently in connection with the word *thalamos:* "If a thalamos was to be described, the poet automatically thought of doors." When Helen joins Menelaus and Telemachus at *Odyssey* 4.120– 23, she comes out of her *thalamos.*

38. Barber (1994, 207–14) discusses this passage in connection with spindles in precious metals from Early Bronze Age archaeological contexts in Anatolia.

39. On Penelope, see Homer *Odyssey* 20.387–89.

40. The wool basket itself seems the point of some scenes, in which it is held up and out in a gesture of display directed at a young man rather than at the seated girl: hydria in Karlsruhe, Badisches Landesmuseum B 3078: *ARV*[2] 1100, 60; *CVA* Karlsruhe 1 (Germany 7, 1951) pl. 22,1; the pelike in Laon, Musée Archéologique Municipal 37.1030: *ARV*[2] 1129, 123; *CVA* Laon 1 (France 20, n.d.) pl. 33.5. A fragmentary pyxis from the Athenian Kerameikos (Wehgartner 1983, pl. 49) displays impressive distaffs and spindles. Monumental baskets are not uncommon: see the lekythos in Bochum, Ruhr-Universität S 1004: Kunisch 1980, 27 no. 173 (fig. 20) or the cup (fig. 36), Louvre G 331: *ARV*[2] 819, 42; *Para-*

lipomena 421; *Beazley Addenda* 293; Schettino Nobile 1969, pl.16-17; the scene on the exterior of a cup (fig. 98) in Warsaw, National Museum 142317: *ARV²* 821, 6; *CVA* Goluchow (Poland 1, 1931) pl. 37,1; the scene on the exterior of a cup in Rome, Villa Giulia 25006: *ARV²* 819, 39; *Beazley Addenda* 293; Schettino Nobile 1969, pl. 43.

41. Phiale in Boston, Museum of Fine Arts 65.908: Truitt 1969, 89, fig. 19.

42. Pindar *Paean* 6.132-37; Kaempf-Dimitriadou 1979, 22-25, no. 213, pl. 12, 4-6.

43. *Greek Anthology* 6.1, 5.153, 5.164.

44. Moret 1991, 251. On the rarity of representations of looms, see p. 26 above.

45. Kaempf-Dimitriadou 1979, 26-30 (Amymone), 35-36 (Persephone). For Europa, see *LIMC* 4, s.v. "Europe." On the setting of the rape of maidens gathering flowers, Piccaluga 1966, 232-53. On the porch as the site of the transition from the private to the public sphere and the outer boundary of a respectable woman's world, see Woodbury 1978, 293-99.

46. See pp. 31-32 above.

47. Hermitage 750: *ARV²* 717, 231; *Paralipomena* 515; Peredol'skaia 1967, pl. 111,2.

48. Reilly (1989, 411-44) explained the scenes on the lekythoi as the dressing of the bride. It is noteworthy that, although they are very similar in iconography to the images featuring the spinners, these scenes show no hints of wool-work.

49. This phenomenon is studied by Calame 1997, 21-30; Dowden 1989.

50. Calame (1997, particularly 1: 30-43) stresses the ambivalence of the relationship of the most beautiful and sought after of the maidens, the leader of the chorus, to the other members of the group.

51. Moschus *Europa* 68-70 (trans. Gow 1953; Bühler 1960). On Europa's basket see below, chapter 4.

52. Theocritus *Idylls* 18.26-28 (trans. Gow 1953).

53. On the imagery of light and precious metals, Calame 1977, 2: 102.

54. *Greek Anthology* 6.174, 208; see also 6.206 on the dedication of sandals, hair net, and veil.

55. Homer *Odyssey* 8.364-66 (trans. Lattimore 1967): "[T]he Graces bathed her and anointed her with ambrosial / oil, such as abounds for the gods who are everlasting, / and put delightful clothing about her, a wonder to look on." Aphrodite's dance with the Charites is mentioned at *Odyssey* 18.192-94. That the Charites weave for the goddess is said in *Iliad* 5.338 and in a fragment of the *Cypria* preserved in Athenaeus *Sophists at Dinner* 15.682E-F. The Charites are present at the birth of Aphrodite, Quintus of Smyrna *The Fall of Troy* 5.72. For a synthetic treatment of the written sources concerning the Charites, see A. Furtwängler in Roscher I,1, s.v. "Charis, Chariten."

56. Naples, Museo Nazionale, Santangelo 316: *ARV²* 1327, 85; *Beazley Addenda* 364; *LIMC* 6, s.v. "Harmonia," no. 14.

57. The name of the Grace who stands behind Peitho was at first read as *Ponia*, Toil; this reading was emended by Richter (Richter and Hall 1936, 203 n. 5) to *[A]ponia*. A new examination of the inscription revealed that the correct reading is *Eunomia*, one of Aphrodite's constant companions; see Ferrari 1995. On the connection of Eunomia to Aphrodite, see Metzler 1980.

58. The cultic connections are stressed by Hampe 1955, 107-23. Burn (1987, 32-40)

explains the figures as follows: "One of the most obvious and important functions of the Meidian personifications is to look decorative. But if this were their sole purpose, there would be no need to distinguish them as personifications—beautiful anonymous women would have sufficed. It seems that a rather more significant function of the personifications is explanatory. They constitute an effective shorthand for conveying ideas which the painters would otherwise have found difficult, if not impossible, to express." For a comprehensive treatment of the subject, see Shapiro 1977.

59. Shapiro (1977, 1–32) discusses the problem and Eros, in particular (25–27).

60. Although the most authoritative tradition on the Charites fixes their number at three and gives their names as Aglaia, Thalia, and Euphrosyne, fluctuations in number and names are well attested; see Hesiod *Theogony* 909; Pindar *Olympian* 14.13–15; L. Annaeus Cornutus *On the Nature of the Gods* 15.

61. Homer *Iliad* 14.267–69.

62. Pausanias *Description of Greece* 9.35.1; Hesiod *Works and Days* 72, *Theogony* 901–902. I was unable to verify the statement by Furtwängler (above n. 55, 874) that in Themistius *Orations* X 16 (p. 406 of Petavius's edition), Eunomia is named as one of the Charites.

63. Homer *Odyssey* 6.31–36; *Greek Anthology* 6.276.

64. Moschus *Europa* 28–33; Theocritus *Idylls*, 18; Pindar *Pythian* 3.29–32, 9.18–20; Euripides *Iphigenia in Tauris* 1140–51; Callimachus *Aitia*, 42, *Hymns* 5.33–34. For an overview of the activities of the band of maidens, see Calame 1997, passim, and Wickert-Micknat 1982, 30.

65. I borrow the phrase from Page 1951, 64.

66. See above, chapter 1.

67. Callimachus *Hymns* 5.13–17. For the figures characteristic of the toilet, see above, chapter 1.

68. Adolphseck, Schloss Fasanerie 16: *CVA* Schloss Fasanerie 1 (Germany 11, 1956), pl. 15. On the artificiality of women's beauty, see chapter 4 below.

69. Ginouvès 1962, 164–65; Reilly 1989, 423.

70. Louvre G 282 (S 1350): *ARV²* 432–33, 60; *Beazley Addenda* 237; Ginouvès 1962, 96, pl. 17, no. 52; for representations of bathing on vases, see Ginouvès 1962, 113–23, 163–73.

71. Paris, Musée Auguste Rodin 922: *CVA* Rodin (France 16, 1945) pl. 26,4. The wool basket appears in the representation of actual ablutions on the hydria in Oxford, Ashmolean Museum 296: *ARV²* 1131, 156; *Paralipomena* 454; *CVA* Oxford 1 (Great Britain 3, 1927) pl. 32,7–8.

72. On the boots, Ginouvès 1962, 165, 224 n. 6.

73. Ginouvès (1962, 302) is inclined to take the picture as a representation of a sanctuary of Aphrodite. The altar in the court of a palace belongs to Zeus Herkeios, see above, pp. 36, 43. In the *Odyssey*, bathing facilities are represented on the ground floor (4.750–51, 17.48–49).

74. Vienna, Kunsthistorisches Museum 3719; see chapter 1, n. 128.

75. Thetis on the pyxis in Athens (fig. 22); the seated figure on the upper register of the Chapel Hill squat lekythos (fig. 11).

76. See above, n. 64, for Europa. On Helen, see Theocritus *Idylls* 18.23–24.

77. Servius's commentary to *Aeneid* 1.720. For the nymphs Ionides, see Pausanias *Description of Greece* 6.22.7; for healing and oracular nymphs, Ginouvès 1962, 364–65. The sources connecting nymphs to flowing waters and springs are collected by Ballentine 1904.

78. On the bath of Artemis, see Ginouvès 1962, 290–93, 422 n. 3, 366–67 (springs connected with Artemis); Lacy 1990. For the name *Parthenios* given to the spring, see also Apollonius Rhodius *Argonautica* 3.876; Hyginus *Fabulae* 181.

79. Callimachus *Hymns* 5.70–82.

80. On the baths of goddesses in myth and cult, Ginouvès 1962, 283–98. On Artemis Daitis, *Etymologicum Magnum*, s.v. "Daitis." On Plynteria, Xenophon *Hellenica* 1.4.12; Photius, s.v. "Kallynteria kai Plynteria."

81. Ginouvès 1962, 284, 292–94.

82. On *Helenes loutron*, see Pausanias *Description of Greece* 2.2.3. On Atalanta washing, see Ginouvès 1962, 117–18; *LIMC* 2, s.v. "Atalante," nos. 86–89; Metzger 1951, 344–45.

83. Athenaeus *Sophists at Dinner* 15.672A–D. On the baths of Hera, see Ginouvès 1962, 288–90.

84. Varro in Lactantius *The Divine Institutes* 1.17–18 (trans. McDonald 1964):

Varro writes that the island of Samos was before named Parthenia, because there Juno grew to maturity and even wedded Jove. So her noblest and most ancient temple is at Samos, and her statue is fashioned in the attire of a bride, and the sacred anniversaries of her nuptials are celebrated with rites.

On the *hieros gamos* of Zeus and Hera, see Cook 1914, 1025–65.

85. I prefer the reading *kosmesantes*, joining bath and adornment, given by the manuscripts of the text of Pausanias (*Description of Greece* 9.3.7), to the needless emendation *komisantes* adopted by most editors; on this point see Ginouvès 1962, 298 n. 5.

86. Plutarch in Eusebius *Preparation for the Gospel* 3.1–2; Sandbach 1967, 157.6.

87. *Etymologicum Magnum*, s.v. "Eresides"; Hesychius, s.v. "Eresides."

88. Glotz 1904, 74; Oakley and Sinos 1993, 15–21.

89. Calame 1997, 27.

90. Homer *Odyssey* 8.362–66; on the baths of Aphrodite, Ginouvès 1962, 284–88.

91. *Homeric Hymns* 6.

92. For "the widespread practice of referring to women not by name but by their relation to the men in the family," see Keuls 1985, 88–89; Schaps 1977, 323–30; Gould 1980, 45.

93. For Artemis, see above n. 78; on the spring at Olympia, see Pausanias *Description of Greece* 6.21,7. For the sources concerning Samos, see Cook 1914, 1027 n. 1. On shores and springs named Parthenios, see Glotz 1904, 72–79.

94. Euripides *Helen* 675–78; see also *Andromache* 283–89.

95. Ginouvès 1962, 295–98, 405–28.

96. Brümmer (1985, 138–51) gives an exhaustive analysis of representations of chests. Although the chest is very frequently shown in the paintings under consideration, I have not yet found the standing figure of the attendant holding it as the single figure on a vase.

97. Oinochoe in Athens, National Museum 2186: *ARV*[2] 1562; *Beazley Addenda* 388; Wehgartner 1983, 45–46, pl. 12,1.

98. On this type of diadem, which is sometimes identified as a bridal crown but does not belong exclusively to the bride, see Blech 1982, 75–81.

99. Homer *Iliad* 18.400–402; Euripides *Electra* 176–77, 191–93.

100. The golden crown of Aphrodite is mentioned in *Homeric Hymns* 6.7–8.

101. Hesiod *Works and Days* 65.

102. Alcman 1.3.64–77 (Calame 1983): οὔτε γάρ τι πορφύρας / τόσσος κόρος ὥστ' ἀμύναι, / οὔτε ποικίλος δράκων / παγχρύσιος, οὐδὲ μίτρα / Λυδία, νεανίδων / ἰανογ[λ]εφάρων ἄγαλμα / οὐδὲ ταὶ Ναννῶς κόμαι / ἀλλ' οὐδ' Ἀρέτα σιειδής / οὐδὲ Σύλακίς τε καὶ Κλεησισήρα / οὐδ' ἐς Αἰνησιμβρ[ό]τας ἐνθοῖσα φασεῖς· / Ἀσταφίς [τ]έ μοι γένοιτο / καὶ ποτιγλέποι Φίλυλλα / Δαμαρέτα τ' ἐρατά [τ]ε ϝιανθεμίς· / ἀλλ' Ἀγησιχόρα με τείρει. Page 1951 provides the most accessible English translation and commentary to this difficult poem; the most detailed discussion of these verses is by Calame 1977, 2: 87–88 n. 78, 98–100.

103. See Calame 1997, 42–43, on the metaphors casting superior beauty as stronger light.

104. Unless one has in mind the image (the visual image) of beauty as golden radiance, the sense of τείρει as "dims," "fades" (translated here with "effaces") is unrecoverable. This passage is one of the many classic cruxes of this poem; for a summary of previous interpretations, see Calame 1977, II, 89 n.82. Calame (101, n. 105) also takes gold as a metaphor for physical beauty.

105. Hesiod *Works and Days* 65–66. Beauty is the defining characteristic of the *parthenos*; see Calame 1997, 196–99.

106. Cup in Würzburg, M. von Wagner Museum 480: *ARV*² 478, 320; *Beazley Addenda* 247.

107. Galt (1931, 373–93) proposed that the custom of veiling women in ancient Greece was analogous to the modern practice in the Near East. Keuls (1985, 87) has perceptive comments on the matter of women "muffled into shapeless forms."

108. The most exhaustive treatments of the word are Schultz 1910; Erffa 1937; and Cairns 1993. See also Chantraine 1968–80, s.v. " aidomai." On the concept of *sophrosune*, see North 1977, 35–48, and insightful remarks in Carson 1990, 142: "Sophrosyne . . . is the activity of checking some natural impulse or closing the boundaries of *phrenes* . . . The resulting soundness of *phrenes* is closely associated in Greek thought with *aidos* ('shame'): both virtues concern self-containment."

109. Lycophron 1, in Athenaeus *Sophists at Dinner* 13.564A–B. The wedding of Apollo and Cyrene appears in Pindar *Pythian* 9.9–14.

110. On Pandora, see Hesiod *Works and Days* 70–71; *Theogony* 571–72. On Aphrodite, see ibid., 194–95; *Homeric Hymns* 6.1.

111. Homer *Odyssey* 8.18–23.

112. *Homeric Hymns* 2.213–215. On the connection of *aidos* and *kharis*, see Erffa 1937, 46–47; Aristotle (*Rhetoric* 2.6.18) states that the eyes are the seat of *aidos*.

113. Xenophon *Memorabilia* 2.1.21–22. On the notion that large size is an element of beauty, see Verdenius 1949, 294–98.

114. Homer *Iliad* 2.257–64. On the notion of *aidos* as covering, real or symbolic, see Erffa 1937, 180–81.

115. Homer *Odyssey* 8.83–92; Plato *Phaedo* 117C.

116. Herodotus *Histories*, 1.8, gives Gyges's shocked reaction to the suggestion that he should see Candaules's wife naked: "Together with her dress, a woman sheds her *aidos.*" On this passage I follow Harder 1953, 446–49.

117. Pausanias *Description of Greece* 3.20.10–11. On this passage and on the question of the cult of Aidos, see Schultz 1910, 98–100.

118. See Tiberios 1989, 26–26, n. 36; Touchette 1990, 86; Ferrari 1990, 186–91; Cairns 1996, 152–56. The averted glance and downcast eyes are part of Aphrodite's mimicry of a *parthenos admete* in the seduction of Anchises, *Homeric Hymns* 5.156: μεταστρε-φθεῖσα κατ' ὄμματα καλὰ βαλοῦσα. See also the description of Hera the bride in Statius *Thebaid* 10.62–64: "expers conubii et timide positura sororem / lumine demisso pueri Iovis oscula libat / simplex et nondum furtis offensa mariti." Iphigenia, led to her death as a bride to her wedding, has "the face of *aidos*" (τὸ τᾶς αἰδοῦς [. . .] πρόσωπον, Euripides *Iphigenia at Aulis*, 1089–91). Aeschylus *Agamemnon* 231–38, puts her on stage enveloped in her robes, *peploisi peripete;* on this image, see Ferrari 1997, 2–10. *Helikopis* qualifies the glance of the young, of Atalanta whom her father calls *helikopis koure*, the girl who averts her eyes in Hesiod's *Catalogue of Women* (Merkelbach and West 1967, no. 75, 15; see also no. 180, 13: [κούρην τ' α]ἰδοίην ἑλικώπιδα καλ[λιπάρηον]). Harder (1953, 448–49) notes that the gesture that symbolizes *aidos* is the covering; perceptively he compares it with "a protective mantle, which acts as a barrier against pollution; for that reason in Hesiod the mantle [of Aidos and Nemesis] is white."

119. Cup in Rome, Villa Giulia; above n. 40. The Athens grave monument, National Museum 1052, is reproduced by Brummer 1985, 155, fig. 38a.

120. Providence, R.I. School of Design 28.020: *ARV*² 552, 27.

121. Hydria, British Museum E 174; *ARV*² 229, 39; *Beazley Addenda* 199 (fig. 100).

122. The debate on Helen's virtue and on whether she was to blame for the Trojan War began in antiquity and is reviewed by Kahil (1955, 285–301).

123. New York, Metropolitan Museum of Art 56.11.1: *Paralipomena* 66; *Beazley Addenda,* 45. New York, Metropolitan Museum of Art 31.11.10: *ABV* 154, 57; *Paralipomena* 64, 66; *Beazley Addenda* 45. According to Bothmer (1985, 186), the two lekythoi were "reliably reported" to have been found together.

124. Bothmer 1985, 182–184, no. 47.

125. Bothmer 1985, 185–187, no. 48.

126. Lonsdale (1993, 215–17) compares the positions of the dancers to the courtship dances described in the ekphrasis of the shield of Achilles and suggests that the central figure of the group flanked by the musicians may be the bride-to-be.

127. On the "bridal gesture" and the mantle of the bride, see below, chapter 8.

128. Lobel and Page 1955, 295 frag. 17. Apollodorus *The Library* 3.14.6. Moret 1991, 237–38, 242, 251.

129. Homer *Iliad* 5.338; Bacchylides *Epinician* 8.1 (Charites); Homer *Odyssey* 13.106–108 (nymphs); Pindar *Nemean* 5.36 (Nereids).

130. Homer *Odyssey* 7.245–47, 5.61–64 (Calypso), 10.220–23 (Circe). On the representation of Circe at her loom, see Moret 1991.

131. Antoninus Liberalis *Metamorphoses* 25.

132. Ovid *Metamorphoses* 6.5–145.

133. Preserved in Hephaestion *On Meter* 9.1 (Consbruch 1906). See also *Greek Anthology* 6.174.

134. Sappho, frag. 102 (Lobel and Page 1955).

135. Metropolitan Museum of Art, 44.11.1. On the inscription, see Guarducci 1967, 288 no. 9: Μελόσας ἐμὶ νικατέριον· ξαίνοσα τὰς κόρας ἐνίκε; on whether Melousa was a nice girl or not, see Milne 1945.

136. On this kind of jokes, see Davidson 1997, 87–88.

137. On this passage, see Frontisi-Ducroux 1997, 104, and below, chapter 4.

138. Paris, Bibliothèque Nationale, Cabinet des Médailles 1647 (Froehner IX 245), *ARV*² 624, 81; Immerwahr 1990, 103 no. 714 (fig. 107).

139. *Greek Anthology* 6.160.

140. A key text for the statement of several degrees of knowledge and action is Aristotle *Nicomachean Ethics* 6.3–7 (trans. Ostwald 1962), in which a distinction is made between "production" and "action," "art" dealing with production and not with action. "Action" is the mark of "practical wisdom"; "theoretical wisdom" is granted not just to any maker, but "to the most precise and perfect masters of their skills: we attribute it to Pheidias as a sculptor in marble and to Polycletus as a sculptor in bronze."

Chapter 3

1. This is the current definition of metaphor as "interaction," best known in the formulation of Black 1962, chapter 3. There are several discussions of the history of the concept of metaphor; Ricoeur (1977) may be singled out as the most detailed and fullest; Johnson (1981) is an anthology of significant writings of the past half century, preceded by a clear introduction (3–47) and supplemented by a valuable annotated bibliography (329–52).

2. Ricoeur 1977, 19.

3. Aristotle *Rhetoric* 1405B13, 1411B21.

4. Ricoeur 1977, 44–64. He discusses the passages of Aristotle that deal with metaphor (9–43). On the Aristotelian definition, see also Derrida 1982, 230–57.

5. Richards 1936, 93.

6. Black 1962, 41.

7. Black 1962, 39; Richards 1936, 94–95, 130–31.

8. Richards 1936, 101–2. The traditional view is taken, among many, by Ricoeur (1977), who discusses the issue (290–95) and alludes to it throughout the book and by its French edition title, *La métaphore vive*.

9. Richards 1936, 124–27. A long discussion of the suspension of belief is given by Ricoeur (1977) in his seventh Study, "Metaphor and Reference" (216–56). The characteristic of tension, or "deviance," from the "literal meaning" is the feature by which metaphor may be recognized—but only by "native speakers" (Johnson 1981, 20). It is, it seems, impossible to define the conditions of metaphor in purely linguistic terms as a deviation in syntax or meaning. Loewenberg (1975, 315–38) shows how metaphors can only be caught as they occur in a given context and "only if some knowledge possessed by

speakers which is decidedly not knowledge of relationships among linguistic symbols can be taken into account" (331).

10. *Homeric Hymns* 5.68.

11. Carson 1990, 135–69, particularly 137–45, 153–58.

12. Archilochus frag. 184 (West 1989).

13. Pausanias *Description of Greece* 10.19.2.

14. The point is made by Sissa 1990a, 358.

15. Hanson 1990. The metaphor of unsealing and mixing is revealed by Eustathius, who connects intercourse with the description of serving wine (Homer *Odyssey* 3.390–94) in terms of "loosing the cover" of the wine jar and mixing the wine and water in the bowl. Sissa (1990a, 339–64) subjects the ancient concept of virginity to a thorough examination; this analysis reveals a dichotomy between the *parthenia* that comes to an end with defloration (342–43) and *parthenia* as unmarried state. She argues convincingly that the notion of the hymen as the condition of virginity enters in neither meaning. On intercourse as mixing, see also Carson 1990, 159 n. 47.

16. Hanson 1990, 325–26.

17. Aristotle *History of Animals* 636B39–637A1; Lonie 1981, 124; Hanson 1990, 315, 328.

18. *Greek Anthology* 12.93; Euripides *Orestes* 575.

19. Homer *Iliad* 24.303; Pindar *Isthmian* 6.74; Aeschylus *Persians* 613.

20. For the connection of maidens and nymphs to springs, see above, pp. 49–51. The immersion of maidens in the Scamander, in the Troad is mentioned by in [Aeschines], *Letters* 10.3. The words there attributed to the girls, "Scamander take"— or "receive," *labe*— "my virginity," are variously interpreted: Dowden (1989, 123) takes this as an invitation to seduction, for instance; Carson (1990, 152) understands the event as a shedding of virginal "wildness."

21. This metaphor and others for the female body are analyzed by DuBois 1988, 47–61, 132–36.

22. The "focal image" is Black's (1962); the other expressions occur throughout the discussion of metaphor as a trope, reviewed by Ricoeur (1977) in his first two Studies (9–64).

23. Johnson 1981, 30.

24. Richards 1936, 98.

25. Ricoeur 1978, 143–59.

26. To give a brief definition of this approach one may quote from Lakoff and Johnson 1980, 235:

> From the experientialist perspective, metaphor is a matter of *imaginative rationality.* It permits an understanding of one kind of experience in terms of another, creating coherences by virtue of imposing gestalts that are structured by natural dimensions of experience. New metaphors are capable of creating new understandings and, therefore, new realities. But metaphor is not merely a matter of language. It is a matter of conceptual structure. And conceptual structure is not merely a matter of the intellect—it involves all the natural dimensions of our experience, including aspects of our sense ex-

periences: color, shape, texture, sound, etc. These dimensions structure not
only mundane experience but aesthetic experience as well. Works of art pro-
vide new experiential gestalts and, therefore, new coherences.

This approach was extended to poetic metaphor in Lakoff and Turner 1989; Turner 1987.
Although not in terms of metaphor, an interpretive frame based on theories of perception
was proposed, long ago, by Gombrich 1956. On Gombrich and his most recent position
on the relationship of art to nature, see Mitchell 1986, 75–94.

27. Richards 1936, 98: "the vicious influence of this red herring." A defense of the no-
tion of the mental image, informed by Wittgenstein's investigations, is mounted by Mitch-
ell 1986, 14–19.

28. Aristotle *Nicomachean Ethics* 1096B28–29 (trans. Ostwald 1962).

29. Mitchell (1986, 43) describes this understanding of extralinguistic representations
as follows: "The relationship between words and images reflects, within the realm of rep-
resentation, signification, and communication, the relation we posit between symbols
and the world, signs and their meaning. We imagine the gulf between words and images
to be as wide as the one between words and things, between (in the largest sense) culture
and nature."

30. Diels 1951, B107; translation from Kahn 1979, 106. Kahn comments: "Heraclitus
thus develops the double aspect of *logos* indicated in the proem: spoken words, and a uni-
versal pattern of experience. The world order speaks to men as a kind of language they
must learn to comprehend."

31. Diels 1951, B123.

32. Hussey 1982, 33–59 (quotation on 36).

33. Diels 1951, B54, B93.

34. The pun is Ricoeur's (1977, 239): "It would seem that the enigma of metaphorical
discourse is that it 'invents' in both senses of the word: what it creates, it discovers; and
what it finds, it invents."

Nietzsche gave a less than kind view of this procedure:

> If somebody hides a thing behind a bush, seeks it again and finds it in the
> selfsame place, then there is nothing much to boast of, respecting this seek-
> ing and finding; thus, however, matters stand within the seeking and finding
> of "truth" within the realm of reason. If I make the definition of the mam-
> mal and then declare after inspecting a camel, "Behold a mammal," then no
> doubt a truth is brought to light, but it is of very limited value, I mean it is
> anthropomorphic through and through, and it does not contain one single
> point which is "true-in-itself," real and universally valid, apart from man.
> (Nietzsche [1873] 1911, 171–92)

On this essay, see Stern 1978, 64–82. Also helpful is Warnock 1978, 33–63. Nietzsche's
essay is quoted here because it places metaphor at the heart of the problem of knowledge
and truth. Richards (1936, 101–2) gives the same thought a tamer wording: "The pro-
cesses of metaphor in language, the exchanges between the meanings of the words which
we study in explicit verbal metaphors, are superimposed upon a perceived world which
is itself a product of an earlier or unwitting metaphor, and we shall not deal with them
justly if we forget that this is so."

35. In considering this passage, Sorabji (1982, 303) wonders: "The idea that defining

characteristics are within the image will be harder to understand for some examples. When I think of man, the form of man (rationality) can hardly be embodied in an image in the same way as the form of the triangle. Nonetheless, Aristotle clearly thinks that his account will apply to all cases." On this passage see also Nussbaum 1978, 266–67, in the context of a discussion of the concept of *phantasia* (221–69). Her proposal that *phantasia* for Aristotle is an operation involving interpretation in the Wittgensteinian sense of "seeing as" and that it need not be a visualized image seems reasonable, but the insistence that it can *never* be a visualized image seems excessive.

36. Aristotle *On the Soul* 427B19–21; *Rhetoric* 1410B33.

37. My position on this point has been strongly influenced by Goodman 1976; metaphor receives particular attention at pp. 45–95, but the issue surfaces throughout the book. The "conventionalist" hypothesis is laid out on page 226:

> Nonlinguistic systems differ from languages, depiction from description, the representational from the verbal, paintings from poems, primarily through lack of differentiation—indeed through density (and consequent total absence of articulation)—of the symbol system. Nothing is intrinsically a representation; status as representation is relative to symbol system. A picture in one system may be a description in another; and whether a denoting symbol is representational depends not upon whether it resembles what it denotes but upon its own relationships to other symbols in a given system.

38. This thesis is extensively developed in Ferrari 1997.

39. Derrida 1982.

40. Ferrari (1990) gives a preliminary version of the analysis presented here.

41. A representative sample of scenes of male courtship is in Dover 1989; see, for instance, fig. R637, Munich, Antikensammlungen 2655: *ARV*² 471, 196; *Beazley Addenda* 246 (courtship); fig. R59, Louvre G 45: *ARV*² 31, 4; *Paralipomena* 324; *Beazley Addenda* 157 (kissing). On this subject, see also Koch-Harnack 1983. Reinsberg 1989 (part 3, entitled "Das Hetärenwesen") has collected representations of the courtship of girls and women: see, in particular, fig. 71, p. 128 (Hermitage 605: *ARV*² 272, 12; *Paralipomena* 511).

42. For a sample of such scenes, see Roberts 1978, fig. 24 (Boston, Museum of Fine Arts 65.1166); fig. 23 (Athens, National Museum 2188: *ARV*² 963, 94; *Beazley Addenda* 308); fig. 18,3 (Oxford, Ashmolean Museum 1965.130: *ARV*² 864, 15; *Paralipomena* 426; *Beazley Addenda* 299), to give just a few examples.

43. As a rule, although all figures in a scene may wear a cloak, the enveloping mantle sets off one or two as special. See, e.g., the hydria in St. Petersburg, Hermitage 750 (*ARV*² 717, 231; *Paralipomena* 515; Peredol'skaia 1967, pl. 111, 2) and many of the pyxides illustrated in Roberts 1978.

44. See, for instance, the pyxis in Toledo, Ohio, Museum of Art 63.29: *ARV*² 1675 (963, 94 bis); *Paralipomena* 434; *Beazley Addenda* 308; Truitt 1969, 85; or the pelike in the Cabinet des Médailles, 399: *ARV*² 1221, 12, Ridder 1902, 38, where Eros brings the seated, wrapped girl a garland.

45. Knauer 1976, 214 n. 17.

46. See pp. 54–56 above.

47. Erffa 1937, 9: "eine eigene Kraft, für die uns das Wort fehlt." Cairns 1993, 433:

That such a central term of Greek moral and social discourse should carry such close associations with "face" and facial or ocular interaction (blushing, the lowering of one's eyes, etc.) and with terms of value which are fundamentally aesthetic in nature (*kalon, aiskhron, aeikes,* etc.) *provides* some indication that the conceptualization of experience entailed by *aidos* and related concepts is not our own.

48. Schultz 1910; Erffa 1937; Cairns 1993.

49. Erffa 1937, 12.

50. In the order of citation: Homer *Odyssey* 3.14; Pindar *Pythian* 4.218–19; Homer *Odyssey* 18.184.

51. Theognis 1179–80 (West 1989); Homer *Odyssey* 5.447–50.

52. Sophocles *Ajax* 1075–1076; Homer *Odyssey* 17.576–78; Euripides *Orestes* 37–38.

53. Erffa 1937 provides a close comparative study of the two terms.

54. Euripides *Hippolitus* 244–45; *Madness of Heracles* 1198–1200.

55. Plato *Protagoras* 322D1–5. Riedinger (1979, 62–79) distinguishes a "personal" kind of *aidos* from a "social" kind. The former affects persons who are permanently or temporarily at disadvantage (see *time,* above); the latter, what the male adult citizen may feel toward the group of his peers, seems akin to the disgraceful *aidos,* which a man ought not to feel. On the dual nature of *aidos,* see also Pseudo-Lucian *Loves* 37.

56. Derrida 1982, 213.

57. Woodbury 1982, 248.

58. Theocritus *Idyls* 18. 19–20. Marinatos 1967, 9; Arrigoni 1983, 12–18, 40–41; Buchholz 1987, 6, 53; Scheid and Svenbro 1996, 14, 63–73. In Plato *Symposium* 219B–C, Alcibiades wraps his cloak around Socrates, then slips under the philosopher's worn mantle and embraces him hoping for more than sleep; on this notorious passage, see Carson 1990, 22–23.

59. See Theocritus *Idyls* 17.133–34; Apollonius Rhodius *Argonautica* 4.1141–43. The image of the ritual, omen-laden preparation of the marriage bed occurs again at Ovid *Metamorphoses* 6.430–31, where Procne claims that hers was prepared by the Furies; on the tradition, see Bömer 1976, 125–26.

60. Warsaw, National Museum 142319; Oakley and Sinos 1993, figs. 100–4.

61. Pindar *Pythian* 4.145–46; Segal 1986, 19–20.

62. Burton 1962, 159.

63. Schultz 1910, 43.

64. Aeschylus *Eumenides* 335–39: Μοῖρ' ἐπέκλωσεν ἐμπέδως ἔχειν / θνατῶν τοῖσιν αὐτουργίαι / ξυμπέσωσιν μάταιοι / τοῖς ὁμαρτεῖν, ὄφρ' ἂν / γᾶν ὑπέλθῃ.

65. Gagarin 1981, 48–53. On the pollution created by murder within the family, see Parker 1983, 108–9, 122–23.

66. The same metaphor of cover as defense and token of decency is present in Plato *Laws* 9.873B: the corpse of the parricide is to be hurled naked beyond the boundaries of the land.

67. In Aeschylus *Suppliants* 190, it is the altar to which the Danaids flee that is cast as cover: fortress and shield; later in the same play (656) the Danaids as suppliants make

an allusion to the fact that their heads are veiled by speaking of their mouths as "overshadowed." Friis Johansen and Whittle (1980, 3: 25–27) discuss all possible meaning of *huposkios* in this context, from moustaches to suppliants' boughs.

68. Aeschylus *Suppliants* 576–79: βία δ' ἀπημάντῳ σθένει / καὶ θείαις ἐπιπνοίαις / παύεται, δακρύων δ' ἀποστάζει πένθιμον αἰδῶ. On this passage, see Cairns 1993, 187–88.

69. See, e.g., Johansen and Whittle 1980, 462–65.

70. For the definition of the "system of associated commonplaces" as the connective tissue that allows metaphors to convey meaning, see Black 1962, 72–79.

71. Io should here be imagined in human form, particularly since she is represented as a bull rather than as a cow on vases; Moret 1990, 3–26.

72. Boston, Museum of Fine Arts 13.94: *ARV*² 1570, 30; *Beazley Addenda* 389. Dover (1989) notes in the caption to this image at fig. R603 that "[t]he painter has represented the deity's penis as somehow penetrating the clothing of the youth." Shapiro (1992, 64–65) identifies the winged figure as Eros. The same visual paradox is given by the image of the girl tossing balls in the air while keeping her hands under her mantle on a Classical lekythos in Leipzig, Karl-Marx-Universität Antikenmuseum: *ARV*² 1204, 7; *Beazley Addenda* 344; Hauser 1886, 192, no. 38. Appropriately, *aidos* is invoked in the representation of the rape of Leto by Tityus on a Late Archaic red-figure amphora, Louvre G 42: *ARV*² 23, 1; *Paralipomena* 323; *Beazley Addenda* 154; *LIMC* 2, s.v. "Apollon," no. 1069 (fig. 140). The giant runs away from Apollo holding in his right arm Leto, who lifts her mantle to cover her face. Artemis stands at his other side. Painted inscriptions give the name of Apollo, that of Leto in the genitive (vertically at the right of the figure) and the word *aidos*, vertically at the right of Artemis. O. Weser in Roscher 5, 1043, s.v. "Tityos," caught both the sense of Leto's gesture and the meaning of the inscription, "Leto's honor," which he understood as a label for the scene. It is possible as well that *Letous aidos* belongs to a category of inscription that are not labels but introduce snatches of sound into the picture, such as the first words of a song, dialogue, or exclamations. On such inscriptions on vases, see Lissarrague 1990, chapter 7; Ferrari 1987; Ferrari 1994–95, 224–25. For a review of the many interpretations of this scene and its inscriptions, see Cairns 1996.

73. Harder 1953, 446–49. Schulz (1910, 52) converts the metaphor into simile: "pudicitia velut vestis castitatem tegit ac tuetur."

74. Smyth 1938, 229 (lines 132–34); Cairns 1993, 186. On *aidos* and the eyes, see Carson 1985, 21; Touchette 1990, 86.

75. On the use of this figure in the scene of the sacrifice of Iphigenia in Aeschylus's *Agamemnon*, see Ferrari 1997, 2–10.

76. On "mapping," Lakoff and Turner 1989, 3–4.

77. Euripides *Pirithous* frag. 16; Aeschylus *Libation Bearers* 493.

78. Aeschylus *Libation Bearers* 665–67. See also Theognis 85–86 (West 1989): "Base greed does not drive those on whose tongue and eyes *aidos* sits," and Sappho frag. 137 (Lobel and Page 1955); Aristotle *Rhetoric* 1367A.

79. Halperin 1990, 35.

80. Parker 1984, fig. 5.

81. Lakoff and Turner 1989, 129.

82. Ricoeur 1977, 290.

83. Ricoeur 1977, 97: "[T]he dictionary contains no metaphors."

84. Lakoff and Johnson 1980; Lakoff and Turner 1989; Derrida 1982.

85. Lakoff and Turner 1989, 129.

86. Derrida 1982, 229.

87. Derrida 1982, 210: "Metaphysicians, when they make a language for themselves, are like knife-grinders, who instead of knives and scissors, should put medals and coins to the grindstone to efface the exergue, the value and the head. When they have worked away till nothing is visible in their crown pieces, neither King Edward, the Emperor William, nor the Republic, they say: 'These pieces have nothing English, German or French about them; we have freed them from all limits of time and space; they are not worth five shillings any more; they are of an inestimable value, and their exchange value is extended indefinitely.' They are right in speaking thus. By this needy knife-grinder's activity words are changed from a physical to a metaphysical acceptation."

88. Derrida 1982, 211.

89. Derrida 1982, 213.

90. Derrida 1982, 219.

91. Derrida 1982, 216. Emphasis added.

Chapter 4

1. See pp. 59–60 above.

2. Brommer 1978, 138–156 gives a checklist of the things made by Hephaestus.

3. The way in which different metals are employed finds a precedent in the Homeric shield, as well as in Hesiod *Shield of Heracles* 141–43. Only exceptional work baskets, such as the one that belongs to Helen, come in precious metals; Homer *Odyssey* 4.121–26.

4. On the Homeric echoes in this passage, see Campbell 1991.

5. Apollodorus *Library* 3.13.8; on other sources for this myth, see Waldner 2000, 82–84.

6. Bion *Wedding Song for Achilles and Deidameia* 2.15–20: λάνθανε δ' ἐν κώραις Λυκομηδίσι μοῦνος Ἀχιλλεύς / εἴρια δ' ἀνθ' ὅπλων ἐδιδάσκετο, καὶ χερὶ λευκᾷ / παρθενικὸν κόπον εἶχεν, ἐφαίνετο δ' ἠΰτε κώρα· / καὶ γὰρ ἴσον τήναις θηλύνετο, καὶ τόσον ἄνθος / χιονέαις πόρφυρε παρηίσι, καὶ τὸ βάδισμα / παρθενικῆς ἐβάδιζε, κόμας δ' ἐπύκαζε καλύπτρῃ. See also Apollodorus *Library* 3.13.8; and Frazer 1921, 2: 73–74.

7. Jeanmaire 1939, 353, 581; Crawley 1893, 243–45; and Sergent 1986, 252–53, connect the myth to the initiation rituals considered in chapter 5 below.

8. Kylix by the Oedipus Painter once in the Borowski collection: *ARV*² 451, 3; *Beazley Addenda* 242; Leipen 1984, no. 13; Christie et al. 2000, 86–87 no. 83. The medallion in the interior of the cup shows a satyr holding a footed chest of the type that is often represented in the scenes of toilet. As for the painter's name piece, the Vatican cup with a scene from Aeschylus's *Sphinx* (*ARV*² 451.1; *Paralipomena* 376; *Beazley Addenda* 242; Simon 1982, 141–42), the subject may have been inspired by a satyr play now lost. Although no title has been preserved that exactly fits this representation, the theme of Achilles on Scyros was the subject of a play by Euripides (*The Scyrians*; Nauck 1964, 574–75; Austin 1968, 95–96 no. 19) and of one by Sophocles by the same title (Pearson 1917, 2: 191; Lloyd-Jones 1996, frag. 550–57). For satyr-plays of the early fifth century reconstructed

from pictures on vases, see Simon 1982. Pausanias *Description of Greece* 1.22.6 records the existence of a painting by Polygnotus of the hero among the daughters of Lycomedes.

9. Simon (1963, 57–59) identified a scene of the farewell of Achilles to Deidameia on a volute krater by the Niobid Painter in Boston (Museum of Fine Arts 33.56: *ARV²* 600.12; *Paralipomena* 395; *Beazley Addenda* 266; *LIMC* 1, s.v. "Achilleus," no. 176) that depicts on the other side the departure of Neoptolemus from Scyros, with the names of the characters inscribed.

10. Nagy 1999, 102–9. On the erotic connotations of the relationship between two heroes, issuing from a broader definition of "friendship," see Halperin 1990, 75–87.

11. Hydria from Analatos, Athens, National Museum 313. See *JdI* 2 (1887): pl. 3.

12. The fundamental study of male love in Greek society, or *paiderastia*, is Dover 1989. The phenomenon receives full consideration below in chapter 5.

13. Halperin 1990, 15–40.

14. Anacreon 15 (Gentili 1958), cited in Athenaeus *Sophists at Dinner* 13.564D. Later in the same text (603F–604A), a fragment of Phrynichus evokes the image of flushed pink cheeks: "The light of love shines on his [Troilus's] crimson cheeks." The line is spoken by Sophocles, who is represented courting a blushing wine-pourer "in bloom" (*horaios kai eruthros*) at a symposium. On the use of the term *paidika*, Dover 1989, 16.

15. On this term, see pp. 128–29.

16. Grillet 1975, 11–20, particularly 11–13.

17. On painted old women, see Grillet 1975, 101–2, and, for an example, Aristophanes *Assembly of Women* 1072–74. On the adornment of Aphrodite, see above, chapter 2. On Hera's toilet, see Homer *Iliad* 14.159–221.

18. Ginouvès 1962, 126–29, discusses the representations of males at the washbasin (females at the washbasin, 114–26). The commonplace erotic connotations of the boys' ablutions are exploited by Aristophanes in *Birds*, lines 139–42, a passage cited by Ginouvès. Grillet (1975, 62 n. 26, 88) observes that, although it appears to be a fact, the use of cosmetic substances by males is seldom discussed or represented.

19. See pp. 54–55.

20. Clearchus in Athenaeus *Sophists at Dinner* 13.605D.

21. Plutarch *Moralia* 751B, 751F, 766E, 769B (*paides/gunaikes*), 766E (*paides, neaniskoi/ parthenoi, gunaikes*).

22. On Helen, see Plutarch *Life of Theseus* 31.1. On Atalanta fleeing marriage *horaien per eousan*, see Theognis 1289.

23. Helen retains her maidenly charms a full twenty years after her elopement with Paris, "looking like Artemis of the golden distaff" (Homer *Odyssey* 4.121–22). Like Penelope, Ismenodora is a woman in her thirties who has no *kurios* and many suitors (Plutarch *Moralia* 749D–E, 752E–F). By mistake, Auge is given in marriage to her own son: Hyginus *Fables* 100. Representations of women on the vases as a rule make no distinction between girl and adult female; on this point see below, chapter 6.

24. Theognis 1327–28.

25. Theognis (1303–1304) warns a reluctant *eromenos*: "[T]he gift of violet-crowned Aphrodite will not be yours for long." The contrast of male and female *hora* receives

elaboration in Lucian *Loves* 25–26 (trans. MacLeod 1967): "Thus from maidenhood to middle age, before the time when the last wrinkles of old age finally spread over her face, a woman is a pleasant armful for a man to embrace . . . But the very man who should make attempts on a boy of twenty seems to me unnaturally lustful and pursuing an equivocal love. For then the limbs, being large and manly, are hard, the chins that once were soft are rough and covered with bristles, and the well-developed thighs are as it were sullied with hairs."

26. For instance, Diogenes is represented reviling a man with shaven chin: "It cannot be, can it, that you have any fault to find with nature because she made you a man instead of a woman?" Athenaeus *Sophists at Dinner* 13.565C, see also 564F–565A, 565E–F.

27. This and other passages from the dialogue hereafter are quoted in the translation by Nehamas and Woodruff 1989, with minor changes.

28. Halperin 1990, 18–21.

29. The monument is described by Pausanias *Description of Greece* 1.19.2.

30. *Symposium* 209B–C; on this passage see Bury 1909, 122.

31. Halperin (1990, 140) notes that the shrinking and recoiling and the tumescent excitement describe "an almost embarrassingly anatomical metaphor" of erotic arousal and release.

32. See Morrison 1964, 51–55; Pender 1992, 73–76.

33. For the earliest formulation of this view in scientific terms, see Aristotle *On the Generation of Animals* 716A19–B1, 739B1–20. The "one seed" explanation of human generation is opposed to the one endorsed in later writings that the female also emitted seed. References to much of the large bibliography on the subject are given by Halperin 1990, 139; Laqueur 1990, 35–44; Hanson 1993, 42–44.

34. See also Aristotle *On the Generation of Animals* (trans. Peck 1943) 737A27–30: "The female is as it were a deformed male; and the menstrual discharge is semen, though in an impure condition, i.e., it lacks one constituent and one only, the principle of Soul."

35. Compare Plato *Republic* 490B. On this image see Burnyeat 1977, 7–10; Halperin 1990, 137–42.

36. Aristotle *On the Generation of Animals* 737A8–13: "Consider now the physical part of the semen. This is which, when it is emitted by the male, is accompanied by the portion of the soul-principle and acts as its vehicle. Partly this soul-principle is separable from physical matter—this applies to those animals where some divine element is included, and what we call Reason (*nous*) is of that character—partly it is inseparable." It was apparently commonly believed in medical circles that the sperm was produced in the brain; see Hanson 1993, 46.

37. Peck 1943, 169, notes: "Aristotle does not, however, give any fuller solution than this to his own 'very difficult puzzle' how and when rational Soul, which is thus supplied in a *potential* state by the male, is *actualized* in the offspring."

38. Hyperides *Epitaph* 28–29, cited by Loraux 1975, 2 n. 7.

39. Plato *Symposium* 209B1. Bury (1909, 121) rejects the emendation of θεῖος to ἤθεος proposed by Burnet and adopted by several editors, e.g., by Nehamas and Woodruff 1989, 56: "while he is still a virgin." Bury connects the expression θεῖος to the word ἔνθεος with which the *erastes* is qualified at 179A7 and 180B4, and both to a passage in

Plato *Meno*, 99C11–D5, where θεῖος denotes a state of divine possession, or inspiration, involving seers and poets on the one hand, and citizens, on the other.

40. Bethe (1907, 459–74) argued that the metaphor of the transmission of divine *pneuma* or soul (evoked, in my view, by expressions such as *theios* and *entheos* in the *Symposium*) is the figure animating the Spartan term for the *erastes: eispnelas*, "breathing forth" or, literally "inspiring." Bethe concluded that sperm was understood to contain the soul (468). The word *eispnilos* is explained in glosses to Theocritus *Idylls* 12.13, and *eispnelais* occurs in Callimachus *Aitia* frag. 68. According to the *Etymologicum Magnum*, s.v. "Eispneles," *eispnein* is "to love," *eran*, in the Laconian dialect. For a complete list of sources see Bethe 1907; Bremmer 1980, 294 n. 29; Ogden 1996a, 144–47.

41. Plato *Symposium* 210D3–8: ἀλλ' ἐπὶ τὸ πολὺ πέλαγος τετραμμένος τοῦ καλοῦ καὶ θεωρῶν πολλοὺς καὶ καλοὺς λόγους καὶ μεγαλοπρεπεῖς τίκτῃ καὶ διανοήματα ἐν φιλοσοφίᾳ ἀφθόνῳ, ἕως ἂν ἐνταῦθα ῥωσθεὶς καὶ αὐξηθεὶς κατίδῃ τινὰ ἐπιστήμην μίαν τοιαύτην, ἥ ἐστι καλοῦ τοιοῦδε.

42. The hypothesis that castration (in the rites of Cybele) serves the same purpose as other forms of mutilation in initiation rites—namely, of providing males with an analog of the female sex and its procreative ability—goes back to Bettelheim 1955, in particular, 46–67, 154–64. In this context, I should note a recorded instance of couvade in the Cypriot cult of Aphrodite Ariadne (Plutarch *Life of Theseus* 20), which Farnell (1897, 633–34) connects to Aphrodite Urania, although he denies that "the practice of one of the youths 'lying-in' on one of the festival days and imitating the cries of women in travail" is an instance of couvade. For a review of this issue, see Pirenne-Delforge 1994, 349–51.

43. There is a vast bibliography on this subject, to which Brelich 1969, introduction; and Halperin 1990, 143–44, provide access. See also Herdt 1982, 44–98; 1994, chapters 7 and 8.

44. Recent, if summary, expressions of this view are in Simon (1983, 51) and Shapiro (1989, 118) who, however, goes on to identify the Eros worshiped in the Academy as the "male" Eros (123). For an opposing position, see Knigge 1982, 164–65.

45. According to Nicander of Colophon, quoted in Athenaeus *Sophists at Dinner* 13.569D.

46. See Settis (1966, 100) who in part 2 gives the most comprehensive treatment of the issue. Settis believes that, while the two different epithets were in existence before Plato, the contraposition of the two Aphrodites and attendant Loves originates with Plato and affects later representations and social practices. The same view is expressed by Pirenne-Delforge 1988; 1994, 276, 432.

47. Pausanias *Description of Greece* 1.14.7; 1.22.3. The sanctuary of Aphrodite Urania, which Pausanias described, may have bee recovered in the excavations of the Athenian Agora; see Camp 1986, 56–57. On the location of the sanctuary of the Pandemos, see Pirenne-Delforge 1994, 26–28.

48. Pausanias *Description of Greece* 9.16.3; full bibliography in Pirenne-Delforge 1994, 275–81. In the pronaos of the ruined temple of Aphrodite in Megalopolis, in Arcadia, Pausanias (8.32.2) again saw three statues, one named Urania, the second Pandemos, and the third nameless; Pirenne-Delforge 1994, 265–66.

49. Pausanias *Description of Greece* 1.14.7, 3.23.1; Herodotus *Histories* 1.105; Pirenne-Delforge 1994, chapter 8.

50. Pausanias *Description of Greece* 6.25.1.

51. On the altar in the Academy and the cult of the male Eros in Athens, see Shapiro 1989, 119–20, 123–24. On the cult of Eros in the gymnasia, see O. Waser in *RE* VI, 1909, s.v. "Eros," 491–92.

52. Plutarch *Life of Solon* 1.7; scholium to Plato *Phaedrus* 231E.

53. The cult of Aphrodite Urania at Sparta is attested by an inscription found in the vicinity of Amyclae, *IG* V:1, 559; Pirenne-Delforge 1994, 211. On the cult of the Urania at Aegeira in Achaea, see Pausanias *Description of Greece* 7.26.7; Pirenne-Delforge, 248–50.

54. Pausanias *Description of Greece* 9.27.1; 9.31.3; Athenaeus *Sophists at Dinner* 13.561E–F; scholium on Pindar *Olympic* 7.154. For the cult of Aphrodite Urania at Thebes, see Pausanias *Description of Greece* 9.16.3.

55. On the armed Aphrodite, see Flemberg 1991.

56. According to Pausanias (*Description of Greece* 3.23.1), Aphrodite Urania was represented armed in "the holiest and most ancient of her sanctuaries in Greece," the one on Cythera. See Farnell 1897, 653–55, 638–41, 737–38 no. 45c (*Aineias*). Hesychius, s.v. "Enkheios."

57. For the relationship of *pneuma* to desire, see Aristotle *On the Movement of Animals* 703A4–10. For commentary of this passage, see Nussbaum 1978, 156–57.

58. Johannes Lydus *Liber de mensibus* 2.11 (Wünsch 1967): "The Aphrodite who is the origin of all sensible objects, that is, the substance begotten by the father (*patrogene*), the oracles call also Asteria and Urania." A few sentences later, this text refers to Aphrodite as "having both male and female nature" and as *arrenothelus*, "male-female." On the problem of whether *pneuma* is *aither* itself or an *aither*-like substance, see Nussbaum 1978 158–64, with references to other studies. The *pneuma* is also likened to warm air by Aristotle; see *On the Generation of Animals* 736A1.

59. Settis 1966, 163.

60. Macrobius *Saturnalia* 3.8.2–3, drawing on classical sources, namely, Aristophanes and Philochorus; see also Servius's commentary on *Aeneid* 2.632. The ancient sources concerning the "bisexual" Aphrodite are collected by Farnell 1897, 755–56; Pirenne-Delforge 1994, 68–69, 348–51; Waldner 2000, 215–18. On the "male" Aphrodite in Sparta, see White 1979, 51–62.

61. Johannes Lydus *Liber de mensibus* 4.64 (Wünsch 1967).

62. Scholium to Homer *Iliad* 2.820; *Suda*, s.v. "Aphrodite." On the Venus Calva and its role in initiations, see Torelli 1984, 151–56.

63. Athens, National Museum 16980; R. J. H. Jenkins in Payne 1940, 231–32 no. 183a, pl. 102: "The dotting on the chin is only explicable as a beard; it runs unequivocally down the cheeks, and cannot be a necklace . . . The everted rim of the bag or sac makes it clear that the figure is emerging from it, not descending into it." The Corinthian figure is identified as Aphrodite also by Will 1955, 229–31; Burkert 1985, 155; Ammermann 1991, 225; Pirenne-Delforge 1994, 123. An attempt to disassociate it from the Uranus story was made by Sale 1961, 508–21. Conflicting interpretations of the Classical image of the goddess riding a she-goat across the night sky are given by Knigge 1982, 153–70 (Pandemos) and Edwards 1984, 59–72 (Urania).

64. Wace, Thompson, and Droop 1908–9, 120 fig. 3, 121 no. 34. Jenkins 1932–33,

71–72: "Remarkable figure of a bisexual deity from the Menelaion, which is bearded and has male genitals, but also female breasts held in the traditional fashion of the naked Oriental goddess, and a painted design obviously meant to represent female dress." Payne 1940, 232, compared the Menelaion figurine with a lead figurine from the sanctuary of Orthia, published in Dawkins 1929, pl. 193 no. 5. On the first facial hair as the marker of a young man's beauty and manliness, see below, chapter 6.

65. The Eastern origin of Aphrodite Urania is discussed by Farnell 1897, 626–57, and more recently, by Ammermann 1991, 203–30, passim, particularly 222–30. Ammermann notes (222–23 n. 95) that, from the fourth century B.C. onward, the identification of Aphrodite with Astarte is documented by funerary and votive inscriptions. Herodotus (*Histories* 1.105) takes the Phoenician temple at Ascalon to be the most ancient sanctuary of the Urania; Pausanias (*Description of Greece* 1.14.7) states that her cult was instituted by the Assyrians followed by the inhabitants of Paphos on Cyprus and by the Phoenicians, who introduced her worship on Cythera. Ammermann argues that the Greek appropriation of the cult of the Phoenician Astarte took place on Cyprus. Although the form of the "transmission" of the Eastern cult and the specific identity of the goddess are debated, there is little doubt that the Urania is likened to the Eastern divinity by Greek writers—what is uncertain, at times, is whether the latter was assimilated to Aphrodite only. "On the whole, she is certainly Hera, but she also has something of Athena, Aphrodite, Selene, Rhea, Artemis, Nemesis and the Fates. In one hand she holds a scepter, in the other a spindle. On her head she bears rays and a tower and she wears a girdle with which they adorn only celestial (*Ourania*) Aphrodite." Thus writes Lucian in his description of the statue of the goddess of Hierapolis, Atargatis, whom he calls Hera, (*The Syrian Goddess* 32 [trans. Attridge and Oden 1976]). On the possible assimilation of Astarte to other goddesses, see Ammermann 220–30.

66. Pausanias *Description of Greece* 9.16.3; 1.14.7.

67. The identification is maintained in sources on Cyprus. Ammermann 1991 traces the image to Syro-Phoenician sources. Bohm (1990) collects all Greek images of nude or naked females, although not all may be a naked goddess. The ivory in the Metropolitan Museum inv. 17.190.73, for instance, has been interpreted, not implausibly, as a representation of the Proetids (see below, chapter 7). Because representations of the naked females were deposited in sanctuaries of several divinities—Aphrodite, but also Leto, Athena, Artemis, Eileithyia—Bohm argues that nudity does not consistently identify Aphrodite (140). Adding to the confusion is the fact that the identification of the divinity in whose realm the naked figures occur is often far from secure. And it is, of course, no more than a guess that the naked figures were dedicated by women and even that they were dedicated to the "main" divinity of the site. On this complex knot of problems, see Ammermann 1991, 226–30.

68. See chapter 5.

Chapter 5

1. Ducat 1971, 386, no. 238: "-ἀν]δρες ἑταιροι δ[- - / - -]οι περικαλλες ἀγ[αλμα]."

2. E.g., Plutarch *Moralia* 761B; Plato *Symposium* 192A–B. On the meaning of *aner*, see Loraux 1975, 4–5, 20.

3. The point was made by Lincoln (1991, 117) as regards female initiations in general: "For, as has often been noted, women's rituals tend to be celebrated for individuals,

while those for men are usually corporate affairs. And whatever immediate causal explanation or justification might be offered by either the practitioner or the analyst of these rights, the long-term consequences are all too clear. For whereas group solidarity, which serves men exceedingly well in the political arena, is ritually constructed for them in the course of their collective initiation, the corresponding rituals for women most often atomize the initiands, and provide them with neither bonds of solidarity nor experience in group mobilization that could be useful in later political action."

4. On age classes in Athenian initiations, see Pélékidis 1962, 58–70. The pseudoinitiations of women are the subject of chapter 7.

5. Lavrencic 1988.

6. See Hyperides *Epitaph* 28–29. For a definition of the dual value of the initiation, see Bernardi 1985, 39: "All types of post-pubertal initiation imply social recognition of the youth's physiological maturation. The youth is marked as being socially autonomous and therefore capable of acting responsibly in his community's social activities. What is peculiar to the initiation model of age class systems is the structural outcome of youth initiation, which is not simply and not only the social recognition of the youth's physical maturation, but also its structural consequence — by which the same youth, on being recognized as an adult, is made a member of an age class, assigned the same social age as his mates in the same class, and assigned a social grade."

7. Schurtz 1902, 122–24, 313–15 (on ancient Greece). When that study appeared, sociologists and anthropologists were quick to realize its value, even those who despised its radically sexist and racist sentiment. The importance of the definition of the structure by age classes is acknowledged by Lowie 1920, chapters 10 and 11, although there follows a long critique of Schurtz's tripartite division of the men into boys, bachelors, and married men. Schurtz's evolutionary scheme and his notion that the supremacy of men is a fact of nature have, by and large, gone by the boards, leaving intact the fundamental validity of his definition of the men's group as social structure. For a reappraisal, see Stewart 1977, 8–10; Schweizer 1990; for a critical overview of the currency of the term in studies of Greek society, see Waldner 2000, 40–44.

8. Weber 1972, 223, 517–18, 684–85. Marrou (1948, 478–79) does not refer directly to Schurtz but cites Wikander 1938.

9. I could trace the expression no further back than Barker 1925, 218. On the Archaic Greek symposium as a feature of the *Männerbund*, see Murray 1983.

10. Connor (1988) reviews the generally accepted view that the Greek city-state was a war culture. Connor disputes the actual frequency of war but locates the importance of war at the heart of polis culture (8): "For the Greeks war was more than tactics, strategy, and gore; it was linked to almost every aspect of their social organization and to their rich imaginative life. The significance of war in early Greek civilization, it can be seen, is not to measured by its frequency but by its symbolic power."

11. For an overview of the scholarship on this subject, although mostly with reference to German sources, see Himmelmann 1990, 1–22. Reviews of the problem are offered by Bonfante 1989, 543–70; Stewart 1997, 24–42. An abbreviated version in this chapter was published in Ferrari 1993. The content of my lectures on the subject is cited in Ridgway 1993, 45, 102, 109.

12. Clark 1956, 3.

13. Only a few representative examples will be mentioned here; Himmelmann 1990, 29–85, offers a discussion of the full range of images. Portraits range from the heroic (the Tyrannicides, Stewart 1990, 1: 135, figs. 227–31) to the mundane (the infibulated Anacreon, Richter 1965, 76, no. 5, fig. 279). On nudity at symposia, Bonfante 1989, 554–55; for a sample of illustrations, see Lissarrague 1990.

14. Pausanias *Description of Greece* 1.44.1; Dionysius of Halicarnassus *Roman Antiquities* 7.72.2–3. On athletic nudity and the ideal nude, G. Becatti, *EAA* V 576–81, s.v. "Nudo"; Bonfante 1975, 19–21; 1989, 552–53; Stewart 1990: 1: 105–6; McDonnell 1991, 182–93.

15. The problem of the Geometric representations of nude females is examined by Himmelmann 1990, 29–34. On transparent drapery in sculpture, see Ridgway 1981, xviii, xix, 94. Diaphanous clothes are common in vase paintings of the fifth century B.C.; for a striking example, see the skyphos by Makron with the recovery of Helen in the Museum of Fine Arts, Boston, 13.186 (*ARV*[2] 458, 1; *Paralipomena* 377; *Beazley Addenda* 243) where Helen's pubic hair is visible through her clothes.

16. E.g., Herodotus *Histories* 1.10: "The Lydians and other barbarians think it shameful to be seen naked, even men."

17. This is the *communis opinio*, stated by Himmelmann 1990, 15.

18. On Etruscan dress and nudity, see Bonfante 1975, 28–29, 35–36, 54–55, 102; 1989, 563–66.

19. Himmelmann 1990, 79–82; see also Smith 1988, 33–34; and Stevenson 1998, with references to earlier studies. Smith takes nakedness to be "distancing," "flexible," and "neutral" for Hellenistic kings, but denoting "special status" for the Roman rulers.

20. Tacitus *Annals* 14.20; Pliny *Natural History* 34.10.18. For Roman attitudes to nakedness, see Bonfante 1989, 563.

21. The two basic studies of the typology of the kouros are Deonna 1909, and Richter 1960.

22. Deonna 1909, 49–53; Himmelmann 1990, 33–35; Stewart 1986, 56.

23. On some figures, the definition of the crown of the head as a series of broad horizontal striations suggests a skull cap, such as the one worn by Ganymede in the Olympia terracotta group, Lullies and Hirmer 1960, pl. 105. On detail, see Ridgway 1990, 591–612, passim. On the belt, see Ridgway 1993, 72–4; Boardman 1978, 22; both observe that the form of the belt of the early kouroi is the same as that worn by Daedalic statues of women. On boots, see Richter 1960, nos. 12 A and B, 22, 23, on sandals, no. 106.

24. Deonna 1909, 53; Ridgway 1993, 109. Compare the disk-shaped lobe of the Dipylon head (Richter 1960, no. 6, fig. 51) with the earrings of the korai, Acropolis 616 and 641 (Richter 1968, no. 129, fig. 422; no. 187, fig. 598: "disk earrings with central knob"), or the boss-shaped lobe of the kouros, Istanbul 1645(Richter 1960, no. 127, fig. 370) to the earring of the korai, Acropolis 660 and 674 (Richter 1968, no. 114, fig. 357; no. 127, fig. 412). For necklaces on kouroi, see Richter 1960, nos. 1, 6, 32, 106.

25. Simon 1978, 66–67.

26. Deonna 1909, 45 n. 5, 107, 114–17. Compare the hair of the Sounion kouros (Richter 1960, no. 2, figs. 38–39) with that of the Lady of Auxerre (Richter 1968, no. 18, figs. 76–77); that of the Lyons kore, with a ribbon binding the hair at ear level (Richter 1968, no. 89, fig. 281) with the hair of the Tenea kouros (Richter 1960, no. 73, fig. 250);

the tress of a head of kouros from the Ptoon (Richter 1960, no. 147, fig. 435) with that of the Berlin kore (Richter 1968, no. 42, fig. 139). For the "cap," compare the head, Acropolis 666 (Richter 1960, no. 139, fig. 403) with the kore head, Acropolis 616 (Richter 1968, no. 129, fig. 422).

27. Pausanias *Description of Greece* 1.19.1. On the hairstyle of the kouroi and its similarity to feminine coiffures, see Harrison 1988, 247–50.

28. Traces of color survive on the pubic area of the Anavyssos kouros; see Reuterswärd 1960, 45; Richter 1960, 118.

29. For Brinkmann's research on the polychromy of ancient Greek sculpture, see Brinkmann 1994. Brinkman spoke about his findings of mustaches and sideburns on kouroi at the Colloquium on the Getty Kouros held in Athens in May 1992; his remarks are cited in Ridgway 1993, 99.

30. Schrader 1939, 197. The Naucratis kouroi: Moscow, Museum of Fine Arts NI I.a.3000: Richter 1960, 88 no. 82; London, British Museum B440: Pryce 1928, 185; Boston, Museum of Fine Arts 88.730: Caskey 1925, 5 no. 2; Deonna 1909, figs. 175–76. Kyrieleis (1996, 24–25) suggests that the groove above the upper lip of the colossal Samian kouros defines the lower edge of a painted mustache.

31. There is no up-to-date systematic analysis of proveniences, but Ridgway (1993, 63–66) gives an overview.

32. For a summary of interpretations, see Ridgway 1982, 123–27. There and in Ridgway 1990, the author argues again the view that the korai are, at the origin, images of divinities, goddesses or nymphs. On korai that served as funerary monuments, see Sourvinou-Inwood (1995, 241–52), who argues that the type represents the nubile maiden (245).

33. Schneider 1975.

34. Ridgway 1993, 94.

35. On funerary kouroi, see Sourvinou-Inwood 1995, 252–270, with discussion of previous scholarship.

36. Freyer-Schauenburg 1974, 61–105.

37. Kouros-like figures in vase paintings identified as statues of Apollo: W. Lambrinudakis et al., *LIMC* 2, 189–90, s.v. "Apollo."

38. Apollonius Rhodius *Argonautica* 2.707. Pausanias, *Description of Greece* 7.20.3, 7.26.6. In Corinth, "There are three temples close together, one of Apollo, one of Artemis, and a third of Dionysus. Apollo has a naked wooden image of native workmanship, but Artemis is dressed, and so, too, is Dionysus, who is, moreover, represented with a beard" (2.30.1). Mooney (1964, 193) explains *gumnos* at *Argonautica* 707 as "beardless," but Vian (1974, 210) sees a kouros "nu et chevelu."

39. See, for example, Zinserling 1975, 19–33; Himmelmann 1990, 36.

40. Ridgway 1993, 66–75; Stewart 1986, 54—70; Stewart 1997, 63–70. Sourvinou-Inwood (1995, 254, 259) proposed that the kouros is emblematic of the young man as an athlete.

41. Brelich (1969, 435–36) points out that to observe the "convergence" of the kouros type with the iconography of Apollo does not illuminate the "origin" of the type nor the reason why it came into being.

42. Bonfante 1989; the quote comes from p. 569. See Brelich 1969: "[S]ospetto . . . che questi monumenti siano per qualche ragione particolarmente legati a culti che hanno assorbito in se elementi delle iniziazioni maschili e femminili" (448–49). That nudity was an element of initiation rituals has been pointed out repeatedly, see Jeanmaire 1939, 559, 566; Brelich 1969, 72 n. 60, 157–58, 200–1; Vidal-Naquet 1986, 117.

43. A comparative treatment of the Spartan and Cretan customs is given by Brelich 1969, 113–207. For Crete, see also Willetts 1962, 43–53.

44. Ephorus in Strabo Geography 10.480–84; FrGrHist 70 F 149.

45. Antoninus Liberalis Metamorphoses 17.6: ταύτης ἔτι μέμνηνται τῆς μεταβολῆς Φαίστιοι καὶ θύουσι Φυτίῃ Λητοῖ, ἥτις ἔφυσε μήδεα τῇ κόρῃ, καὶ τὴν ἑορτὴν Ἐκδύσια καλοῦσιν, ἐπεὶ τὸν πέπλον ἡ παῖς ἐξέδυ. νόμιμον δ' ἐστὶν ἐν τοῖς γάμοις πρότερον παρα-κλίνασθαι παρὰ τὸ ἄγαλμα τοῦ Λευκίππου. The implications of the myth for the defini-tion of masculinity and Cretan initiations are analyzed by Leitao 1995, 130–63.

46. This point was made by G. Weicker in RE VII (1910): 519, s.v. "Galateia"; Willetts 1962, 175–78; Waldner 2000, 225. See Jeanmaire (1939, 442, 345–46), on the incoher-ence of accounts explaining rituals through legends. The aition significantly connects the liminal moment of the initiation to the wedding, which on Crete followed it immedi-ately; see Brelich 1969, 199, 201–2.

47. See above, chapter 4. Crawley (1893) was the first to interpret the myth of Achilles on Scyros in light of initiatory rites; contra, Waldner 2000, 82–101.

48. ICr I, IX, 1: A, lines 11–12; C, lines 99–100; D, lines 139–41. The other inscrip-tions referring to the undressing are ICr I, XVIII 9b 8; I, XIX 1,18; IV, 16. While most, like the Dreros inscription, belong to the third and second centuries B.C., the last is Archaic. On these inscriptions, see Brelich 1969, 200–1; Vidal-Naquet 1986, 117. Bonfante (1989, 551) refers to the youths in the Cretan agelai "stripping off their clothes while the younger boys wore girlish clothes," possibly after Burkert 1985, 261.

49. Waldner (2000, 222–42, particularly 240) detaches the ritual disrobing at the fes-tival of Leto from the procedures that admitted the youth to the army and the assembly. She argues instead that the performance should be interpreted in reference to both the de-tachment of the young man from the female-controlled environment of the oikos and to future involvement with that environment for the purpose of physical reproduction.

50. Athenaeus Sophists at Dinner 12.550C.

51. Pausanias Description of Greece 3.11.9; Bekker 1814, 234, 4–6. For general com-ments on the occasion and location of the performance, see Bolte 1929, 124–30; Brelich 1969, 139–40, 188–90; Pettersson 1992, chapter 2.

52. Gumnos here has been understood to mean not unclothed, but unarmed—a met-aphorical meaning the word sometimes assumes in the context of combat. See, for in-stance, Wade-Gery 1949, 79, and on the various possible meanings of gumnos, see Bon-fante 1989, 547. Pettersson (1992, 43) has shown, however, that the sense of "nude" is certain in this case.

53. Plutarch Life of Lycurgus 15.1–2. Although Spartan legislation did not dictate that the youths marry immediately following their initiation, there was an age limit, probably thirty, after which to remain wifeless was anomalous, unseemly, and subject to penalties; see Brelich 1969, 125.

54. Pausanias Description of Greece 4.4.3: Τήλεκλον . . . ἐπιβουλεύοντα δὲ ἐπιλέξαι

Σπαρτιατῶν ὁπόσοι πω γένεια οὐκ εἶχον, τούτους δὲ ἐσθῆτι καὶ κόσμῳ τῷ λοιπῷ σκευά-
σαντα ὡς παρθένους ἀναπαυομένοις τοῖς Μεσσηνίοις ἐπεισαγαγεῖν, δόντα ἐγχειρίδια.
See Brelich 1969, 164.

55. On the festival, Vidal-Naquet 1986, 98–99, 108–12. Although secure evidence is
lacking, it is possible that on that occasion, the boys had their hair cut and their shorn
locks dedicated to Artemis, in a rite known as the *koureion*, as Labarbe 1953 proposed. On
the institutional function of the phratry as "the direct channel of mediation between fam-
ily and community," that is, not a relic but an integral part of the democratic constitution,
see Murray 1990, 14–16.

56. On this expression, see appendix 1.

57. On the term *neoi* designating a special class of *andres*, that is, the *epheboi*, see Lo-
raux 1975, 1–31. Vidal-Naquet (1986, 98) acknowledges the fact that the age class of six-
teen to eighteen year olds and that of the *epheboi*, eighteen to twenty year olds, are two
different grades. The essay on the Black Hunter (chapter 5), however, where the marginal-
izing features of the latter are cast into relief, collapses the one into the other. The founda-
tion legend of the Apaturia—the fight of Melanthus and Xanthus—and the situation of
liminality that that legend implies, are telescoped into the institution of the *ephebia*, with
which they have nothing to do. Vidal-Naquet 1989 revisits the issue; the author stresses
that the *ephebia* entails citizen status but argues that the fourth-century ephebe differs sub-
stantially from a postulated "archaic ephebe" (396–401). The Athenian system conforms
to a model that has been well-defined on the basis of ethnographic studies, in which the
structure of grades according to age classes extends beyond the passage out of adoles-
cence; see Bernardi 1985, 48–61.

58. Aristotle *Constitution of the Athenians* 42.1: μετέχουσιν μὲν τῆς πολιτείας οἱ ἐξ
ἀμφοτέρων γεγονότες ἀστῶν, ἐγγράφονται δ' εἰς τοὺς δημότας ὀκτωκαίδεκα ἔτη γε-
γονότες. On this, see Pélékidis 1962, chapter 4.

59. Pélékidis (1962, 51–52, 74, 87) analyzes the way in which the transition is
worded.

60. Hesychius, s.v. ὠσχοφόρια· παῖδες εὐγενεῖς ἡβῶντες καταλέγονται οἱ φέροντες
τὰς ὤσχας εἰς τὸ τῆς Σκιράδος Ἀθηνᾶς ἱερόν. On the festival, see Deubner 1932, 142–47;
Jeanmaire 1939, 338–63; Pélékidis 1962, 226–28; Walker 1995, 98–104; Waldner 2000,
102–34.

61. Plutarch *Life of Theseus* 22–23; Proclus *Chrestomathia* 27 also mentions the fact
that the procession was led by two youths (*neaniai*) dressed as women.

62. Athenaeus *Sophists at Dinner* 14.631B. The fact that oschophoric dances and the
Gymnopaidia are grouped together does not necessarily mean that the former were also
performed by nude dancers—it may mean that they are both initiatory dances; on this
point, see Jeanmaire 1939, 442–43. On the restriction of certain dances to specific age
classes and their role in "choreographic" initiations, Bernardi 1985, 41 and chapter 10.
On nudity at the Oschophoria, see Waldner 2000, 115, 168–71, 174–75.

63. Waldner 2000, 106.

64. Plutarch *Life of Theseus* 18.2. Jeanmaire (1939, 320–22) interpreted Theseus's sac-
rifice to Aphrodite Epitragia as a paradigm for the change of sex implied in initiations.

65. Sergent 1986, 49–54; Jeanmaire 1939, 321–22; Brelich 1969, 72 n. 60. In her
analysis of these myths of transsexual change and of rituals involving transvestism, Wald-

ner (2000, passim, especially 43–50, 99–101, 144–45, 176, 248) puts forward the dia-
metrically opposite view: there being no unequivocal evidence for initiatory practices,
only for a drawn-out "process of socialization" (246), the donning and shedding of fe-
male garb is not symbolic of the boy's transformation into a man but refers heterosexual
relationships and to the young man's past and future involvement with the *oikos*

66. See, for example, Vidal-Naquet 1986, 116: "[I]t is not the *kind* of disguise that is
important, rather the *contrast* that it underscores."

67. Waldner 2000, 86, 100, 144, 150.

68. See pp. 83–85 above.

69. There are a few representations of Apollo with a beard in the Archaic period,
(*LIMC* 2, s.v. "Apollo," nos. 314, 316, 625, 818, 820, 876, 1010, 1022, 1067). On these
see below, p. 136.

70. Farnell 1907, 148. Hesiod *Theogony* 346–347: the nymphs *andras kourizousi*, bring
youths into manhood, together with the lord Apollo; on the meaning of the expression,
see Brelich 1969, 435 n. 284. In the *Odyssey*, the disguised Odysseus refers to his son's
coming of age "thanks to Apollo," Ἀπόλλωνός γε ἕκητι (*Odyssey* 19.86).

71. Plutarch *Life of Theseus*, 18.1; Jeanmaire 1939, 299, 312–13, 262, 359–60.

72. The connection of *politeia* and *andreia*, of legal rights and gender, is illuminated by
the connection of Apollo as god of male initiations and the *apellai*, assemblies, that was
demonstrated by Burkert 1975, 1–21. Steuernagel (1991, 35–48) identifies in the kouros
type the ideal hoplite.

73. Epigraph that begins this chapter. Ducat 1971, 386 no. 238: "que viennent faire
ici ces ἄνδρες ἑταῖροι?"

74. For the use of the term *hetairoi* to designate an age class, see Herodotus *Histories*
5.71; Jeanmaire 1939, 100. On *hetairiai*, Roussel 1976, 123–32.

75. On the uses of the term, Philipp 1968, 106–7.

76. The Naxian dedication: Jeffery 1961, 292 no. 10; Stewart 1986, 57 n. 14. On
andriantes at temples of Apollo, see for example, Herodotus *Histories* 8.27.22, 8.121.8
(Delphi); Demosthenes, 12.21.3 (Delos). On *andriantes* of Apollo, see Diodorus Siculus
Historical Library 13.108.4.1; Herodotus *Histories* 6.118.12.

77. Jeffery 1961, 360 no. 9. Lazzarini (1976, 286 no. 767) corrects *Apollona* to *Apolloni*.

78. Bekker 1814, 394–95.

Chapter 6

1. Aeschylus *Seven against Thebes* 532–536 (trans. Hecht and Bacon 1973; the last two
lines are there transposed to follow line 544): τόδ' αὐδᾷ μητρὸς ἐξ ὀρεσκόου / βλάστημα
καλλίπρωρον, ἀνδρόπαις ἀνήρ· / στείχει δ' ἴουλος ἄρτι διὰ παρηίδων / ὥρας φυούσης,
ταρφὺς ἀντέλλουσα θρίξ. / ὁ δ' ὠμόν, οὔτι παρθένων ἐπώνυμον, / φρόνημα γοργόν τ' ὄμμ'
ἔχων, προσίσταται (Hutchinson 1987).

2. Percy 1996, 115–16; Steiner 2001, 212–18. Osborne (1998a) expresses the oppo-
site view that the kouros is essentially asexual and his nudity is simply a mark of gender.
The male nude would become sexually charged in the Classical period: "[O]nce sexually
explicit scenes, and figures and scenes with rich reference to the circumstances of daily

life, developed, nakedness could no longer be a symbol simply of gender." See also Osborne 1998.

3. On the symbolism of the armor and the cup, see Link 1994, 25–27.

4. Brelich 1969, 197–201; Patzer 1982, 70–74.

5. Athenaeus *Sophists at Dinner* 13.601F: "Minos put down his hatred of Athenians, in spite of the fact that it had been provoked by the death of his son, because he fell in love with Theseus, to whom he gave in marriage his own daughter, Phaedra." See Sergent 1984, 198–99, 63–64.

6. I use the ancient word *paiderastia* to avoid confusion of this custom with modern notions of homosexuality as well as with other kinds of homoerotic behavior. On this point, see Calame 1997, 248–49.

7. Sergent 1986, 198–99; on the *erastes* as bride-giver, see chapter 8.

8. Bethe 1907, 438–75.

9. Herdt 1994; 1982, 44–98; 1982a, preface. Recent discussions in Calame (1999, 94–98) and Ogden (1996a, 139–44), who draws a point-by-point parallel between "Sambian" and Spartan practices. Elliston (1995) questions both the validity and the cross-cultural applicability of the category of "ritualized homosexuality."

10. Patzer 1982, discussed by Halperin 1990, 54–61.

11. Dover 1989, 185–203, 205–6; 1989a, 127–46.

12. There is evidence, admittedly fragmentary and debatable, that *paiderastia* is far older than the late seventh century B.C.; see Stewart 1997, 240. The point that the practice is central to the Archaic and Classical polis remains valid, nevertheless. Furtwängler (1995, 441–45) interprets the emblem on an electrum coin from the Clazomenae hoard as the depiction of an *eromenos* receiving his cup.

13. Ogden (1996a, 107–11, passim) exposes the inadequacy of the "pederasty model" vis-à-vis massive evidence that sex between men was an institutionalized practice in many city-states.

14. Patzer 1982, 43–67, particularly 51.

15. Halperin 1990, 15–40 (quotation on 30).

16. See the critiques by Thorp 1992, 54–61; Richlin 1993, 523–32; 1997; Davidson 1997, 168–82; Sissa 1999.

17. Thucydides *History of the Peloponnesian War* 1.20.2; 6.54–59; Aristotle *Constitution of Athens* 18. I analyze the saga of the Tyrannicides in detail later in this chapter.

18. Plato *Symposium* 182C5–7; Aeschines *Against Timarchus* 140. On the cult of the Tyrannicides, see Taylor 1991, chapter 1.

19. On the statues of the Tyrannicides and the *fortuna* of their image, see Brunnsåker 1971.

20. On whether the *Iliad* contains intimation of a love affair between Achilles and Patroclus, see Ogden 1996a, 123–25.

21. Xenophon *Symposium* 8.32–35, *Hellenica* 4.8.39; Plutarch *Pelopidas* 18; see Dover 1989, 191–92. Ogden (1996a) gives an exhaustive survey of the evidence and argues cogently that "homosexual" relationships were of key importance in the constitution of the Theban, Elean, Spartan, and Macedonian armies.

22. Buffière (1980, 605–17) notes that many source give eighteen as the ideal age for an *eromenos* and attest to the existence of many *eromenoi* over twenty.

23. Hesychius, s.v. ἀπάγελος· ὁ μηδέπω συναγελαζόμενος παῖς. ὁ μέχρι ἐτῶν ἑπτακαί-δεκα· Κρῆτες. *Mekhri* can mean either "through" the boy's seventeenth year or "until" the beginning of his seventeenth year. Link (1994, 126) observes that Cretan *paiderastia* is a relationship between adults.

24. Plutarch *Life of Lycurgus* 25.1: "Those younger than thirty never went to the marketplace but performed all necessary transactions through their relatives and *erastai*." See Cartledge 2001, 98.

25. On the *agoge*: Xenophon *Constitution of the Lacedaemonians* 2.12–14; Plutarch *Life of Lycurgus* 16–21; Brelich 113–157. On *paiderastia*, see Cartledge 2001, 91–105.

26. Plutarch *Life of Lycurgus* 16.6–17.1: διὸ καὶ τῆς ἡλικίας προερχομένης ἐπέτεινον αὐτῶν τὴν ἄσκησιν [. . .] γενόμενοι δὲ δωδεκαετεῖς ἄνευ χιτῶνος ἤδη διετέλουν [. . .] ἤδη δὲ τοῖς τηλικούτοις ἐρασταὶ τῶν εὐδοκίμων νέων συνανεστρέφοντο. ἤδη τοῖς τηλικού-τοις now is taken to refer to the rather distant δωδεκαετεῖς, and translated "as soon as they reached that age," that is, as soon as they were twelve years old. τηλικοῦτος, however, means one of "such an age" (*LSJ*, s.v. "τηλικοῦτος"). The expression, therefore, may refer to the age of twelve mentioned in the preceding paragraph but is better understood as "old enough," meaning the appropriate age at which a youth might acquire a lover. This sense is reinforced by the use of *neos* in the genitive τῶν εὐδοκίμων νέων, which I refer to τοῖς τηλικούτοις, following Cartledge 2001, 96: "*erastai* associated with (or lived together with) those of the reputable youths who had reached such an age."

27. Xenophon *Constitution of the Lacedaemonians* 11.3; Plutarch *Lycurgus* 22.1: διὸ κο-μῶντες εὐθὺς ἐκ τῆς τῶν ἐφήβων ἡλικίας.

28. The Spartan terms for the age classes are given by a scholium to Herodotus *Histories* 9.85 and a gloss in the margins of a manuscript of Strabo, published by Diller (1941, 499–501). The most convincing attempt to determine the actual age limits for each class remains Tazelaar 1967. Kennel (1995, chapter 1) rightly casts doubt upon our ability to reconstruct the shape of the *agoge* in Archaic and Classical Sparta with any degree of certainty. His contention that, except for Xenophon, all sources refer to the institution in the Hellenistic and Roman periods, however, takes an argument from silence to extremes; see Ducat 1999, 63 n. 3; Cartledge 1997; 2001, 85.

29. In *Constitution of the Lacedaemonians* 4.7, Xenophon implies a comparison between the *hebetike helikia* of the Spartans and the Athenian *ephebia*, beyond which no formal training was required: "The other Greek states relieve those who are past the age of *hebe* (τὴν ἡβητικὴν ἡλικίαν), who also fill the highest offices, from continuing to train to ensure their fitness, although at the same time they require them to serve in the army. But Lycurgus established that for those at that age hunting was the best pursuit" Like his Athenian counterpart, the Spartan *hebon* is not technically a minor, since he may be called *aner* (ibidem, 4.3). Tazelaar (1967, 145–46) equates the Athenian *ephebia* with the last two years of the Spartan training.

30. Xenophon *Constitution of the Lacedaemonians* 3.5; *Hellenica* 5.4.32.

31. Xenophon *Constitution of the Lacedaemonians* 3.1: ἐκ παίδων εἰς τὸ μειρακιοῦσθαι. Compare the very similar wording at Plato *Laches* 179A6 (ἐπειδὴ μειράκια γέγονεν).

32. Kukofka (1993) attempts to reconcile the list of age grades found in later sources

(above n. 28) with the testimony of Xenophon, placing the *paidiskoi*'s age at nineteen to twenty and that of the *hebontes*, at twenty-one to thirty.

33. Plutarch *Life of Agesilaus* 2.1–2. On the age connotations of *hora*, see below.

34. Aelian *Varia Historia* 3.10–12.

35. Vidal-Naquet 1986, chapter 5.

36. Leitao 1995, 140.

37. Brelich 1969, 33.

38. Van Gennep 1960, 15–25.

39. Loraux 1975, 1–31 (quotation on 6).

40. See appendix 1.

41. On these expressions, see Pélékidis 1962, 52–70; Rhodes 1981, 503.

42. West 1978, 185.

43. On Iphidamas, see Homer *Iliad* 11.225–227; on Orsilochus and Crethon, see *Iliad* 5.550–53.

44. Aeschines 1.39–42. Earlier (21–22), Aeschines makes it clear that the case would be made against the father, had Timarchus been a minor (*pais*) at the time of the Misgolas episode; instead, Timarchus himself is charged, because he was then legally of age.

45. Homer *Iliad* 24.346–48; *Odyssey* 10.278–79: νεηνίη ἀνδρὶ ἐοικώς / πρῶτον ὑπηνήτῃ, τοῦ περ χαριεστάτη ἥβη. On the meaning of *hupene* and its connotations of youth, see Fink 1952, 112–13; Buffière 1980, 605–17.

46. Pollux *Onomasticon* 2.10: ἀγένειος, λειογένειος, ἰούλῳ νέον ὑπανθῶν, παρὰ τὰ ὦτα καθέρποντι ἢ περὶ τὴν ὑπήνην ἀνέρποντι, ὑπηνήτης, ἐν ἧρι τῆς ὥρας, ἐν ἀκμῇ, ἐν ἄνθει. In athletic events, the *ageneioi* are a category of age that falls between the *paides* and the *andres*; see Pindar *Olympian* 9.88–90.

47. See above, p. 116.

48. These have been studied by Lederman 1998; see 102–5 on chronology and on the appearance and meaning of the moustaches.

49. Metropolitan Museum 56.11.7. Ducat (1966, 47–48) notes the presence of several feminine traits in this representation.

50. Ducat 1966, 37–38.

51. The head is in the Louvre, MA 3104 and the body, in Athens, Acropolis Museum 590. The figure has been identified as a winner in the Nemean or Isthmian games (Stewart 1990, 1: 120) or one of the Dioscuri (Ridgway 1993, 200–1). A comparable rendering of the *ioulos* is found on a kouros in the Museum of Fine Arts in Boston, 17.598: Caskey 1925, 6 no. 3.

52. The point is well made by Fink 1952, 113–14.

53. Museum of Fine Arts, Boston 01.8027: *ABV* 152, 27; *Paralipomena* 63; *Beazley Addenda* 44. On an amphora by the Affecter (British Museum 1836.2–24.46: *ABV* 243, 45; *Beazley Addenda* 62), both lovers are bearded. Kilmer (1997, 43, pl. 9) observes, however, that the beard of the beloved, identified as such by the wreath he holds and the long locks, is shorter and thinner than that of the *erastes*. This may be an attempt to render in black-figure technique the special quality of the *ioulos*.

54. The point is made by Robertson 1992, 29. Similarly, the Archaic statue of Hya-

cinthus, which Pausanias saw at Amyclae, represented Apollo's *eromenos* sporting a beard, while the painting by Nicias showed him *horaios*, and so, presumably, *ageneios;* Pausanias *Description of Greece*, 3.19.4–5. The expression "to youthen" was coined by Beazley 1950, 321. Most recently on the topic, Stewart 1997, 80–85, who emphasizes the erotic valence of the "beardless" youth in fifth-century representations.

55. This is a leitmotif of Hellenistic erotic poetry; see Tarán 1985.

56. Aeschylus *Seven against Thebes* 533; see epigraph to this chapter. In a fragment of Sophocles (619 Radt 1977), the term refers to Troilus. Hesychius, s.v. ἀνδρόπαις· ἀνδρούμενος ἤδη παῖς. ἢ ἀνδρὸς φρόνησιν ἔχοντα. See also Kassel and Austin 1984, 380–81.

57. Several pairs of near-coevals were identified on Attic black-figure vases by Hupperts 1988, 255–68.

58. Berlin, Antikensammlung F 2278: *ARV*² 21, 1; *Paralipomena* 323; *Beazley Addenda* 154. In Ferrari Pinney 1983, 134–36, I mistakenly took Patroclus's peculiar beard as a mark of "Scythianness," by comparison to the beards of Scythian archers.

59. On the official character and political import of Spartan *paiderastia*, see Cartledge 2001, 105.

60. This is the distinction drawn at length by Aeschines *Against Timarchus* 135–159. Past attempts to recover the form of normative *paiderastia* such as Patzer (1982) and Percy (1996, 1–11) are marked by an interest in its pedagogical, rather than its political, value.

61. Aeschines *Against Timarchus* 136. On the expression, see Dover (1989, 45–47) who argues that "legitimate eros" does not correspond to any "illegitimate eros" in Greek thought, all eros being good. The contrast would rather be between eros and prostitution. Aeschines's prosecution of Timarchus, however, makes it clear that the code of correct *paiderastia* was concerned with many matters beyond the major violation of taking money for sex, age among them.

62. Xenophon *Constitution of the Lacedaemonians* 2.12–13; *Symposium* 8.34; Plato *Symposium* 182A–C.

63. Dover 1989, 49 (Aeschines passage quoted on 49).

64. Cohen 1991, 176–80.

65. On eros and the gymnasium, see Calame 1999, 101–9; Steiner 2001, 222–34.

66. See above, chapter 3.

67. Dover 1989, 106–7; Sutton 1992, 12–14. In the two exceptional cases in which the penetration of a male is the subject, the norms of *paiderastia* are inverted: the "penetrator" is the youth, and the mood is violent. These are the Eurymedon oinochoe (Hamburg, Museum für Kunst und Gewerbe 1981.173: Ferrari 1984, 181–83; Smith 1999) and the Tyrrhenian amphora in Orvieto, Faina 41: *ABV* 102, 100; *Paralipomena* 38; *Beazley Addenda* 27. On the latter, see Kilmer (1997, 44–48), who is inclined to see the picture as an indication of actual *mores*.

68. Dover 1989, 146–47.

69. Aristophanes *Wasps* 1025; *Peace* 762–63.

70. Kyle 1987, 184.

71. *Greek Anthology* 12.123; cited by Percy 1996, 98.

72. Plato *Gorgias* 515E; *Protagoras* 342B; Dover 1989, 187.

73. Rayet head in Copenhagen, Ny Carlsberg Glyptotek 418, from Athens; for the body of the kouros, see Schmidt 1969. The swollen ears were identified as the ears of a boxer by Ridgway 1982, 118–27; see also Ridgway 1993, 108.

74. Xenophon *Constitution of the Lacedaemonians* 2.13: "But if it became apparent that one yearned for the body of the *pais*, he held that relationship as profoundly shameful and established that in Sparta *erastai* abstain from their *paidika* no less than parents abstain from intercourse with their children and brothers and sisters with one another."

75. Calame 1999, 138–41.

76. Athenaeus *Sophists at Dinner* 13.602F–603A.

77. Sergent 1984, part 2, chapter 1.

78. Scholium to Euripides *Phoenician Women* 1760: ἱστορεῖ Πείσανδρος ὅτι κατὰ χόλον τῆς Ἥρας ἐπέμφθη ἡ Σφὶγξ τοῖς Θηβαίοις ἀπὸ τῶν ἐσχάτων μερῶν τῆς Αἰθιοπίας, ὅτι τὸν Λάιον ἀσεβήσαντα εἰς τὸν παράνομον ἔρωτα τοῦ Χρυσίππου, ὃν ἥρπασεν ἀπὸ τῆς Πίσης, οὐκ ἐτιμωρήσαντο. . . . πρῶτος δὲ ὁ Λάιος τὸν ἀθέμιτον ἔρωτα τοῦτον ἔσχεν. ὁ δὲ Χρύσιππος ὑπὸ αἰσχύνης ἑαυτὸν διεχρήσατο τῷ ξίφει. [Pisander narrates that the Sphinx was sent to the Thebans from the depths of Ethiopia by the wrath of Hera, because they did not exact vengeance from Laius for his unlawful love of Chrysippus, whom he kidnapped from Pisa. . . . Laius was the first to indulge in this kind of aberrant love. Chrysippus, in his shame, killed himself with his sword.] Chrysippus's suicide is evoked by Aelian *On Animals* 6.15. The story is also reported by Athenaeus *Sophists at Dinner* 13.602–603.

79. Laius learns of the curse when he interrogates the oracle at Delphi about his childlessness. The oracular response is reported as such in the *hypothesis* to Sophocles' *Oedipus Tyrannus* and paraphrased in Euripides *Phoenician Women* 1–62. On the myth in tragedy, see Lloyd-Jones 1983, 119–23.

80. Dover 1989, 106–7. On the characterization of the *eromenos* as neither passive nor truly subordinate, see Golden 1984, 308–24. Sutton (2000, 184–91) argues that the few sixth-century vase paintings with scenes of anal penetration of males also express a negative view of such acts.

81. Halperin 1990, 35.

82. For Lycurgus, see Plutarch *Life of Lycurgus* 17.1; for Thebes, see Plutarch *Life of Pelopidas*19.1. On Solon, see Diodorus Siculus *Historical Library* 9.1.3; on Crete, Ephorus in Strabo *Geography* 10.4.19 (*FrGrHist* 70F149); Aristotle *Politics* 1272A23–26.

83. Blüher (1919, 243–44) observed that Schurtz (1902)—the seminal study of the *Männerbund* as a type of social organization—ignored the vast evidence that homosexual practices involving the young are as constant a feature as the Men's House. The same reticence informs Lowie 1920, Stewart 1977, and Bernardi 1985. See, however, Marrou 1948, 57: "L'homosexualité grecque est de type militaire; elle est très différente de cette inversion initiatique et sacerdotale que l'ethnologie étudie de nos jours chez toute une série de peuples 'primitifs' . . . A l'amour grec il ne serait pas difficile non plus de trouver des parallèles, moins éloignés de nous dans l'espace ou le temps: je pense au procès des Templiers, aux scandales qui éclatèrent en 1934 dans la Hitlerjugend . . . L'amitié entre hommes me parait une constante des sociétés guerrières, où un milieu d'hommes tend à se renfermer sur lui-même."

84. For an introduction to the topic (although in each the focus is on a particular culture), see Harris 1993, 77–114; Bohle 1990. On ancient Greece, see Winterling 1990.

85. Blüher 1919; Theweleit 1987–89. On Blüher and homosexuality in the youth movement, see Laqueur 1984, 50–52, 62–65. Laqueur aptly characterizes Blüher's work as an embarrassment, too brilliant to be dismissed and too eccentric to be taken seriously. Part of the embarrassment that his contemporaries felt toward his work derived, perhaps, from the fact that in his fervor Blüher reveals the madness that lay beneath the surface of the ideal of male supremacy. On the relationship of the image of the Tyrannicides to that of the *Männerpaaren* in Fascist art, see Fehr 1984, 63–68.

86. Blüher 1919, passim, particularly part 1, chapter 1.

87. Effeminate men belong to a separate category and are examples of androgyny and bisexuality; men who love exclusively men and never marry are a perversion of manly love (Blüher 1919, 123, 148–50). Theweleit (1987–89, 1: 54–57) struggles with the reductive application of the term "homosexuality" to a variety of behaviors; a sustained examination of the question leads him to conclude that "the forms associated with the white terror appear in no sense 'truly' homosexual. . . . Nor is the white terror the strict opposite of homosexuality—'here' versus 'there'" (2: 306–40). A number of the characteristics evoked in Blüher's descriptions of the *Wandervögel* youth movement, and even the S.A., as man-loving "free men and heroes" are clearly in some way connected to "homosexual desire." In the preface to the second edition of *Men in Groups* (Tiger 1984) and in Tiger 1990, 67–68, Tiger reports as an unforeseeable accident that his description of affective ties among men had been taken as an endorsement of gay lifestyles. Unsure of how to spell out the distinction between "homosexuality" in the sense of intense "camaraderie and *ésprit*" and homosexuality as queer behavior—although very sure that there is a distinction—Tiger denies throughout the book (e.g., xv, 79, 134) that there is anything "erotic" to the "sexual" bonding of the males. He concludes, however, that "there may be analytic and practical profit in seeing male homosexuality as a specific feature of the more general phenomenon of male bonding" (216–17). The line is thus drawn by Herdt (1994, 3–4): "It is crucial that we distinguish from the start between homosexual *identity* and *behavior*. All Sambia males undergo the experience of ritually introduced, secret, socially sanctioned behaviors of only one sort. . . . At either end of the behavioral distribution of individuals, however, there are a very small number of deviants: a few who are known to have had a low interest in homosexual activities and who are extremely heterosexual; and a few who have a high interest in homosexual fellatio, persisting in its practice past the appropriate transitional period. . . . These relationships thus do not make Sambia into homosexuals . . . in our meaning of that term: Sambia do not think of themselves as attracted only to males during the stage of homosexual activity; they are also excited by women's bodies; and in most cases, men leave behind homosexual behavior following marriage."

88. The reference is to Dover's call for a contextual analysis of Greek homosexuality, see p. 128–29 and n. 11 of this chapter; the quote is from Dover 1989, 202.

89. Tiger (1984, chapter 3) offers a quasi-scientific formulation of this widespread functionalist explanation according to which the band of men arises naturally in the dawn of prehistory, when the crippling deficiencies of the female race becoming apparent bring about their confinement. Dover (1989, 201–2) also naturalizes this phenome-

non as the inevitable outgrowth of a condition endemic either to Greek society or to humanity as a whole.

90. See chapter 4 above.

91. Euripides frag. 840 (Nauck 1964): λέληθεν οὐδὲν τῶνδέ μ' ὧν σὺ νουθετεῖς, / γνώμην δ' ἔχοντά μ' ἡ φύσις βιάζεται.

92. The same point is implied by Aristotle (Politics 1269B12–27, 1272A23–26), drawing a direct correlation between denying women freedom and love between men.

93. Dover 1989, 34–39.

94. A critical analysis of the debate on the meaning of isonomia is given by Fornara 1970, 155–80. For a review of recent studies, see Hornblower 1991, 455–57.

95. Aristotle Politics 1279A21, 1277A25–29.

96. Bernardi 1985, 30: "Indeed, the very same concept of age commonality that makes the members of a class an essentially egalitarian body is itself a fiction, a fictio iuris. It constitutes a true manipulative device whereby people of physiologically diverse ages come to be jointly characterized by the same structural age and placed at the same social level . . . "; see also 53–55,146–47,156–58, 169–71. On the "homogeneity" of age sets, see also Stewart 1977, 115–17.

97. Solon, 6.3–4 (West 1989): "[K]oros breeds violence (hubris) when great wealth comes to persons not of sound mind." Pindar (Olympian 13.10) calls hubris "mother of koros"; and in Sophocles Oedipus Tyrannus (873), the Chorus state that "hubris breeds the tyrant." On the concept of koros in epic and archaic lyric, see Anhalt 1993, 78–96. The juxtaposition of riches and tyranny is common, and implied in Archilochus 19 (West 1989): "I do not wish for the lot of Gyges, rich in gold, . . . and I have no love for the grandeur of tyranny"

98. Diels 1951, 24, no. 4.

99. Thucydides' hostility to the Tyrannicides and admiration for the tyrants is such that ancient scholars thought he must be a descendant of the Pisistratids; Hermippus cited in Marcellinus Life of Thucydides 18.

100. The full story is told in an unusually large excursus in book 6.54–59 of the History of the Peloponnesian War. This is itself interrupted by a long eulogy of the Pisistratids' rule, followed by an attempt to demonstrate that Hippias was indeed the eldest son and only tyrant.

101. Before Thucydides, Herodotus reacts against the idolization of the Tyrannicides by reminding the reader that the assassination of Hipparchus only made the tyranny harsher (Histories 5.55) and that the Alcmeonidae had a greater role than they in the liberation of Athens (6.123).

102. There is some ambiguity even in Thucydides' treatment of this question, see Gomme, Andrews, and Dover 1970, 318–23.

103. Examples in Dover 1989, 73–74. As to Anacreon, his name is tied to the image of the lyre singer and reveler in "Ionian" costume that begins to appear on Attic vases just about the time of the expulsion of Hippias. The pictures show figures with conflicting gender traits: they have great beards, but to Athenian eyes their chitons, turbans, parasol, and earring carried unmistakable feminine connotations. On the Anacreontic vases, see Board-

man and Kurtz 1986, 35–70; Frontisi-Ducroux and Lissarrague 1990. Price (1990) convincingly connected these figures with comedy and argued that the type caricatures the effete Ionian poet.

104. Gomme et al. (1970, 318) observe that Thucydides obscures the fact that the conspiracy's aim was not revenge but the removal of the tyrant.

105. Pliny *Natural History* 34.9.17. For a discussion of the date of the original group, see Brunnsåker, 33–43, 90–98; Taylor 1991, 13–15.

106. The group by Critius and Nesiotes was dedicated in 477/6, according to the *Marmor Parium* (*IG* XII, part 5, 444, 70–71). The Antenor group was taken to Susa and returned to Athens after Alexander's conquest of Persia. A discussion of the sources for the history of Antenor's group and the date of the one by Critius and Nesiotes is given by Brunnsåker, 33–45.

107. The point is made by Brunnsåker 1971, 23–24, and Fornara 1970, 158, 178. The four songs dedicated to the Tyrannicides are numbers 10–13 in a series of twenty-five Attic scholia preserved in Athenaeus *Sophists at Dinner* 15.694C–695E, in which Bowra recognized a collection of pieces spanning the years between the late sixth century and the post–Persian Wars period; Bowra 1961, 373–97.

108. Schefold 1944, 189–202; Taylor 1991, chapters 4, 5.

109. The notion that the personal motive for the murder was in conflict with the public-spirited plot to end the tyranny is deeply ingrained in scholarship about the Tyrannicides. See, e.g., Brunnsåker 1971, 30–31; Taylor 1991, 1–4; Steiner 2001, 219–20. Stewart (1997, 73), however, notes that the statue group in the Agora "placed the homoerotic bond at the core of Athenian political freedom." On the east frieze of the Parthenon, the ten couples each pairing a younger, "beardless" youth and a bearded man also may have had the purpose of displaying the political importance of the *erastes-eromenos* relationship; see De Vries 1992, 336.

110. On the relationship of homoerotic desire and political power, see Sedgwick 1985, 1–25. As Sedgwick notes, "for the Greeks the continuum between 'men loving men' and 'men promoting the interest of men' appears to have been quite seamless" (25).

111. Aeschines, in his harangue against Timarchus's sexual misconduct, gladly admits to being *erotikos*, amorous, himself and hounding the beautiful youth in the gymnasia. Xenophon (*Agesilaus* 5.4–7) praises the king's mastery, *enkrateia*, over so strong a desire for the young Megabates that it would have overcome a lesser man. As to Socrates, the passage in Plato *Charmides* (155C7–D4; trans. Dover 1989, 155) cited by Dover on this point may suffice. The beautiful Charmides, sick with a headache, has come to sit by him: "When Critias told him that I was the man who knew the cure, and he looked me in the eye—oh, what a look!—and made as if to ask me, and everyone in the wrestling school crowded close all round us, that was the moment when I saw inside his cloak, and I was on fire, absolutely beside myself . . . "

112. The apparent contradiction was noticed by Dover (1989, 191) with regard to Sparta; Theweleit's (1987–89, 339–340) "double double-bind" makes the same observation about homoeroticism in Fascist ideology: "the double-bind that simultaneously prohibited and commanded incest between men: thou shalt love men, but thou shalt not be homosexual."

113. As Dover (1989, 68–69) observes, physical strength and a capacity for violence

are as important qualities of the male in his *hebe* as his beauty. On the taming function of eros in *paiderastia* in the poetry of Theognis, see Lewis 1985, 219–22.

Chapter 7

1. Analyses of the sources of this myth are given by Massenzio 1970; Dowden 1989, chapter 4; Seaford 1988, 118–36.

2. Hesiod *Catalogue of Women* frag. 132–33 (Merkelbach and West 1967); West 1985, 78–79. Aelian (*Varia Historia* 3.42) writes that Aphrodite made the Proetids *makhlous* and that they ran maddened and naked, *gumnai*, across the Peloponnesus. In Apollodorus *Library* 2.2.2, they are described as running in total disarray, *met'akosmias hapases*. On the point that the wantonness of the girls is part of their punishment, not the cause of it, see Vian 1965, 26–27. A relief in ivory of the late seventh century B.C. in New York (Metropolitan Museum of Art 17.190.73) has been identified as a representation of the myth; Dörig 1962, 72–91, particularly 85–91. It shows two female figures taking off their dresses, one nearly naked.

3. Virgil *Eclogues* 6.48–51.

4. Aristotle *On the Generation of Animals* 786B17–23. In Bacchylides (*Epinician* 10.56) the sound that the Proetids emit is *smerdalean phonan*. While Burnett (1985, 100) takes the expression to mean "the semi-metamorphosis of the girls into something like beasts," Seaford (1988, 134–35) observes that *smerdaleos* is primarily associated with the male voice and in particular with the war cry. He compares the adjective with the cry of the Bacchae (Euripides *Bacchae* 1133), *elalazon*, which he understands as a "powerful expression of the maenadic assumption of male roles." The characterization of the Proetids as cows thus stands in sharp contrast to the stereotype, frequently encountered in lyric poetry, that casts the maiden as a filly or a lively mare; on this see Calame 1997, 214–16; 238–44.

5. See, for instance, *Suda*, s.v. "Makhladas: *pornas*", "Makhlontes: *porneuontes*"; further, see Licht 1932, 330–32.

6. See p. 178.

7. Clark (1999, chapter 2) gives a penetrating analysis of the reception of the *Olympia* at the 1865 Salon and of the way in which the painting played upon and subverted the representation of the female nude. What Clark says of the nude in pre-1860 France may be applied, in a general sense, to ancient Greece as well. Note that, as in the case of the Proetids, her awareness of sexuality determines a perception of *Olympia* as "masculinized" (130–32) and ugly—aged, cadaverous, apelike.

8. On the Acteon myth, see Apollodorus *Library* 3.4.4; Ovid *Metamorphoses* 3.131–252. For an overview of written and visual sources, see L. Guimond, *LIMC* 1, 454–69, s.v. "Aktaion." On Tiresias, see Apollodorus *Library* 3.6.7 (citing Pherecydes); Callimachus *Hymns* 5.58–136. Lacy (1990, 40, n. 83) lists other sightings of bathing deities.

9. Swimming is rare; see the amphora by the Andokides Painter, Louvre F 203: *ARV*[2] 4–5, 13; *Beazley Addenda* 150; Schefold 1978, fig. 136 (probably the Nereids). Representations of the bath are collected by Ginouvès 1962, 25–28, 112–23 (legendary baths), 164–74, 220–24. The *parthenos* bathing is depicted on the pyxis, New York 1972.118.148: Bothmer 1961, pl. 91 no. 243.

10. See Stewart 1997, 97–106.

11. Vernant 1974, 37–39 (quotation on 38).

12. Cole (1984, 243) gives a limpid statement of this view: "Like the koureion, the arkteia marked the end of childhood and the beginning of a transitional period culminating in adult status: citizenship for the male, and marriage for the female."

13. The strongest disapproval for the license accorded Spartan women is voiced by Aristotle *Politics* 1269B–1270A; they are lampooned in comedy (Aristophanes' *Lysistrata*) and in Archaic lyric (Ibycus frag. 58, Page 1962). But the fact that they are somewhat like men does not make the Spartans less desirable; on the contrary, they are the most beautiful of Greek women: Σπάρτην ἐς καλλιγύναικα (Homer *Odyssey* 13.412). In Athenaeus (*Sophists at Dinner* 13.566A), Sparta gives birth to the most beautiful women. On Helen and beauty, see Calame 1997, 196–99. Conflicting views on the ancient image of the Spartan woman and the truth of the matter are reviewed by Calame 1997, 233–38; Thommen 1999; Cartledge 2001, 106–26. On the ideological roots of the Athenian representation of the manly Spartans, see Millender 1999. For a visual satire of Spartan women on the psykter by Euphronios in St. Petersburg, see above, chapter 1.

14. Plutarch *Life of Lycurgus* 14.2–15.1; *Moralia* 227D–E. Athenaeus (*Sophists at Dinner* 13.566E) mentions the Spartan custom of displaying girls naked in front of strangers.

15. Plutarch (*Life of Lycurgus* 18.4) mentions *paiderastia* as part of the upbringing of girls. See also Hagnon of Tarsus in Athenaeus *Sophists at Dinner* 13.602E.

16. Vidal-Naquet 1986, 151. On the Spartan wedding as initiation, see Paradiso 1986, 137–53. In this connection the bearded brides of Argos are often mentioned, see Plutarch *Moralia* 245F. On the *stibades* on which the boys slept and their use on the occasion of the Hyakinthia, see Brelich 1969, 116, 145.

17. For a comprehensive treatment of such "circles," see Calame 1997, part 4, passim, particularly 210–14, 231–33, 244–53; 1999, 98–101. See also Burnett 1983, 209–28.

18. See chapter 6 above.

19. Calame (1997, 252–53) attempts to find mythical paradigms for female *paiderastia* in the predilection of Artemis for certain nymphs and in myths where, however, it is *men* disguised as women who seduce nymphs.

20. Calame 1997, 254, n. 169 (but compare with Calame 1977, 1: 434); Dover 1964, 36–37. I am inclined to follow the suggestion cautiously put forward by Brelich (1969, 158) that the practice is imaginary and that its invention has the purpose of adding a colorful touch to the depiction of the Spartan girl—a boy in all respects.

21. Pindar frag. 101 (Bowra 1935); contra, Calame 1997, 214–19. Se also Brelich 1969, 157–66; Paradiso 1986, 143.

22. Pausanias *Description of Greece* 5.16.2–3; discussed by Scanlon 1984, 77–90. Dillon (2000) reviews the evidence for women's roles at festivals and in athletic competitions.

23. Aristophanes *Lysistrata* 614–705. The old men's "Let's strip," ἐπαποδυώμεθ', in the second line of their half of the choral debate (615) corresponds to the women's "Dump your cloak," θώμεσθ' . . . ταδί (637). At one level, the point of the undressing is that the verbal sparring is being cast as an athletic event, probably a boxing match (in the preceding line, 636, the women threaten to disfigure the men to the point that their own mothers will not recognize them). But when both choruses go on to take off the rest of their clothes (658–65, 683–89) the old men speak proudly of how improper it is for a man to keep under wraps. As they undress, the women claim a right to the nudity that is re-

served for men, and, in doing so, they are shown as doubly grotesque—because they are women and because they are old; on this point, see the passage in Plato's *Republic* quoted below.

24. Aristophanes *Lysistrata* 641–647 (Henderson 1987): ἑπτὰ μὲν ἔτη γεγῶσ' εὐθὺς ἠρρηφόρουν / εἶτ' ἀλετρὶς ἦ δεκέτις οὖσα τ' ἀρχηγέτι / καὶ χέουσα τὸν κροκωτὸν ἄρκτος ἦ Βραυρωνίοις· / κα'κανηφόρουν ποτ' οὖσα παῖς καλὴ 'χουσ' / ἰσχάδων ὁρμαθόν.

25. Vidal-Naquet 1986, 145: "The chorus in *Lysistrata* is arguing *as if* the women of Athens were in fact the citizens. The stages referred to are those of a fictitious cycle." For the *arrephoroi*: Harpocration, s.v. "Arrephorein"; *Etymologicum Magnum* 149, 18; Brelich 1969, 232–38. For the *aletrides*, who may perform in the service of Demeter or Athena, see scholium to *Lysistrata* 643; Hesychius, s.v. "Aletrides"; Eustathius at Homer *Odyssey* 105; Brelich's 1969, 238–40. For the *kanephoroi*, who have a role in many of the city cults, see Philochorus, *FrGrHist* 328F8; Hesychius, s.v. "Kanephoroi"; scholium to Aristophanes *Acharnians* 242; Brelich 1969, 275–90. The most exhaustive, best documented, and clearest examination of the *Lysistrata* passage as evidence of an Athenian female *agoge* is given by Brelich 1969, chapter 2. Although he admits that the linear process described, from *arrephoros* to *pais kale*, corresponds to no historical reality (231), Brelich attempts to retrace the connection that each step might have had to a conjectured primitive institution and to reconstruct an ancestral system of grades. He explains the fact that service as *arrephoros*, *aletris*, and *kanephoros* was not collective, as a true initiatory rite would require, by postulating a historical development from a system in which all daughters of Athenians would have filled those function to one in which a few chosen ones acted as representative of their class (238, 311). As the rationale for the change, it is postulated that collective rites, involving all the girls, would have become unnecessary and difficult to stage. Note, however, that collective initiations for the males remained, somehow, both necessary and practicable. Brelich also attempts to eliminate the difficulty of the overlap in the prescribed ages for *arrephoroi* and *arktoi* by positing another historical development of the institution, in which the age requirement for the Arkteia was lowered (265–73).

26. The sources are collected and analyzed in Brelich 1969, 246–59; Sale 1975; Palaiokrassa 1991, 30–32, 38–41. On the Arkteia in the context of the cult of Artemis as regards women's rituals, see Cole 1998, passim. It does not seem possible to determine the age prescribed for the Arkteia, but the number ten occurs in all sources. The *Lysistrata* passage places the bear at an unspecified moment after service as corn-grinder, at ten; Sourvinou-Inwood (1988, 136–48) has argued that *deketis ousa* goes with the shedding of the *krokoton* at the end of the Arkteia. One of the scholia to *Lysistrata* 645, however, supported by the *Suda*, s.v. "Arktos he Brauroniois," gives as the correct age five to ten. Harpocration, s.v. "Dekateuein," gives a false etymology of the term as "to be ten years of age" and quotes Lysias to the effect that it was the same as *arkteusai*, to perform the bear. There have been many attempts to reconcile these testimonies among themselves and to bring the age of the Arkteia in line with a biological event, that is, the mean age of the onset of menarche; notably: Brelich 1969, 265–73; Perlman 1983, 115–30. Grebe (1999) argues for an age past ten, on the basis of *Lysistrata* 641–42. Sourvinou-Inwood (1988, 61) states that the Arkteia marks "the transition to a stage perceived as a period of maturation in which the girl is 'no longer a child, not yet marriageable.'" So far as we know, there was in Greece no lower age limit for marriage. For the present purposes, the issue of age as number of years is irrelevant; what matters is that an age *terminus* was specified for all

girls, independently of individual physical development—the condition defining structural age.

27. On the date of the earliest krateriskoi, see Kahil 1981, 259.

28. On the distribution of the krateriskoi, see Kahil 1981, 253–63; 1983, 235–37.

29. Only a sample of the krateriskoi from Brauron has been published. Palaiokrassa (1991) published the architectural remains and the finds from Munichia. The argument for a connection of the vases to rites for Artemis was made by Kahil and restated in Kahil 1977, 88–89.

30. Most studies of these vases in relationship to the ritual assume a direct and self-evident link between these representations and actual contemporary events—e.g., Dowden 1989, 31: "On the *krateriskoi* we catch a glimpse of Bears in action." Hamilton (1989, 449–72) disassociates the scenes from the performance of the Arkteia but keeps to the common view that they represent "real" activities located at Brauron and corresponding to those described or suggested in Alkman's "partheneia." Stewart (1997, 122–24), however, expresses sympathy with the thesis of this chapter, published in abstract form in Ferrari 1995a.

31. See, e.g., the krateriskos from Munichia, illustrated by Kahil 1965, pl. 9, 12–14.

32. See the classification of the imagery by Kahil (1965, 20–22), into "neutral" (patterns and figures whose relevance to the cult is not understood, such as the owl), A (races), and B (dances). For the race of nude adolescent girls, see Kahil 1963, 13 no. 25, pl. 6,1; a race of young girls in short dresses, Kahil 1965, 21, pl. 7, 2–6; a dance: Kahil 1965, 21–22, pl. 8,5 (clothed), pl. 8,7 (nude). The question of the stags has not received much consideration, except for Sourvinou-Inwood (1988, 63, 102 n. 298), who proposes "a metaphorical association between girls leaving childhood and female deer." On the symbolic value of the placement of sanctuaries of Artemis "on the edge of cultivation, on the coast or the wild margins of rivers," Osborne 1985, 152.

33. See below, n. 49

34. Sourvinou-Inwood (1988, 31–66) has attempted to define the representation of three distinct age groups on the krateriskoi in relationship to the ages for younger and older *arktoi* and *kanephoroi*. Her analysis takes into consideration the height of the figures, proportions—namely, the size of the head in relationship to that of the body—and the size of the breasts. The result is a clear differentiation of the image of the child, smaller, with a larger head and no breasts, from the pubescent type, with a smaller head and small breasts, and of both from the representation of the "ripe" girl, the marriageable *parthenos* or *kanephoros*. The distinction between "younger kanephoros" and "older bear," on the other hand, is not convincing, since, as the author herself observes, the two may merge (56–57).

35. Sourvinou-Inwood 1988, 21–22, 63–64, 127–134; followed by Lonsdale 1993, 177–78.

36. Brelich 1969, 258: "Il mito *postula*, dunque, la segregazione delle fanciulle addette all'*Arkteia* all'interno del luogo sacro: ma i dati letterari non dicono nulla in proposito."

37. Sourvinou-Inwood 1971, 339–42; 1988, 136–148.

38. Stinton's emendation καὶ χέουσα, which relies on Sourvinou-Inwood's reading, is adopted in Henderson's edition of the play (Henderson 1987; Stinton 1976). Sommer-

stein (1990), following Sourvinou-Inwood's interpretation, prints καταχέουσα. Grebe (1999) retains the emendation κἆτ' ἔχουσα.

39. Sourvinou-Inwood (1988, 132–33) adopted the interpretation by Lloyd-Jones (1952, 132–35) that the line in *Agamemnon* should be taken to say not "shedding the saffron robe" but "with her robe of saffron hanging toward the ground." She maintained, however, her reading *katakheousa* at *Lysistrata* 645, in the sense of "shedding." On the mantle of Iphigenia in *Agamemnon*, see Ferrari 1997, 6–10.

40. Leyden scholium to *Lysistrata* 645: πᾶσαν παρθένον . . . περιέπειν τὸ ἱερὸν κρο-κωτὸν ἱμάτιον φοροῦσαν; see Perlman 1983, 118 n. 19. Sourvinou-Inwood 1988, 125–26 n. 18, explains *himation* here as "cloth."

41. Ibycus frag. 58 (Page 1962).

42. Compare with *Republic* 5.457A.

43. Plato *Laws* 8.833C–D. See also Euripides *Andromache* 595–600. Taking Plato's utopian state as descriptive of Athenian reality, Perlman (1983, 123 n. 42) attempts to bring the images of the girls running naked on the krateriskoi—which she believes illustrate real events—in line with an age limit for nudity at thirteen, with the result that the taller girls with pronounced breasts are taken to be younger than smaller, flat-chested girls. On this point see Sourvinou-Inwood 1988, 15, 69 n. 10; Hamilton 1989, 459 n. 18.

44. Vidal-Naquet 1986, 150.

45. Plato *Timaeus* 23–24; *Critias* 110–11. Vidal-Naquet (1986, 264), in his treatment of the myth of Atlantis, points out that "[t]he city whose fundamental institutions were described in the *Republic* provides the paradigm for the constitution of proto-Athens" or "it is proto-Athens that is the paradigm." Broneer (1949, 47–59) attempted to reconcile the picture of the primitive city given by Plato in *Critias* with the archaeological finds.

46. On visual representations of this story, see Ferrari forthcoming.

47. Herodotus *Histories* 6.137–138; Philochorus, *FrGrHist* 328F100–1.

48. Kahil 1977, 86–98; Lonsdale 1993, 188–93; Reeder 1995, 322–28. Calame (1997, 99) states that the red-figure krateriskoi were "found at Athens," but Kahil (1977, 86) traces them back only so far as the Lifschitz collection, provenience unknown.

49. Cahn collection HC 501; Reeder 1995, 323, 325, no. 98.

50. Cahn collection HC 502; Sourvinou-Inwood 1988, 39–65, passim; Reeder 1995, 324–327, no. 99.

51. I translate ἔπαιξε with "teased" in light of the wording in the *Suda*, s.v. ἄρκτος ἢ Βραυρωνίοις (προσπαίζειν and ἀσελγαινούσης τῆς παιδίσκης), which indicates provocation.

52. See Sale 1975, 267.

53. Athens, Acropolis Museum 3737, to which Kahil (1977, 94, pl. 21, 6–7) called attention. Kahil explained the presence of the bear in the scene on the red-figure krateriskos as the appearance of *the* sacred animal for whom the ritual takes place; Sourvinou-Inwood (1988, 63) sees the bear as "ideally present." Hamilton 1989, 463: "Most likely, the bear is a symbol of the ritual and identifies the race as part of the Brauronia."

54. Papaspyridi-Karouzou 1957, 68–87, pll. 18–19.

55. Cahn collection HC 503; Reeder 1995, 327–28, no. 100.

56. Hesiod frag. 163 (Merkelbach and West 1967). On the mythographic tradition, see Sale 1962, 1965; Henrichs 1987, 254–67; Borgeaud 1988, 26–34.

57. For an understanding of the composite nature of the myth of Arcas, I rely on Sale 1962, 127–29. In Henrichs's view (1987, 260–62) the version of the legend that appeared in the Hesiodic corpus did not include the catasterism.

58. Kahil 1977, 92–93; Kahil (1983, 238) interpreted the scene as a representation of the ritual performance of the *musterion* and identified in the bear-headed figures a priestess and, tentatively, a priest, wearing masks. Simon (1983, 87–88) recognized in the picture the myth of Callisto.

59. Apollodorus *Library* 3.8.2; Callimachus frag. 632 (Pfeiffer 1949); Pausanias *Description of Greece* 8.3.6–7; Ovid *Metamorphoses* 2.401–530. See Henrichs 1987, 262–64.

60. I. McPhee, *LIMC* 5, s.v. "Kallisto," no. 18.

61. See Henrichs 1987, 265, with references to earlier literature: "Unattested in the ancient sources, the connection between the *Arkteia* and the Kallisto myth, though hypothetical, rests on close structural similarities." In light of Kahil's hypothesis that the vase represents the *musterion* of the Arkteia, Henrichs (ibid.) considers the possibility that the subject is Callisto, and that her transformation was reenacted in the ritual. On this issue, see also Sourvinou-Inwood 1990, 8–10.

62. See Miller 1986, particularly chapter 1.

63. Hyginus *Poetic Astronomy* 2.21.

64. Hyginus *Poetic Astronomy* 2.21; scholium to Homer *Iliad* 18.486. Hesiod frag. 291 (Merkelbach and West 1967).

65. Geymonat 1974, 31, 7a: ἢ αὐτὴν τὴν Ἄρκτον διὰ τὸν παρακείμενον αὐτῇ τῶν ἄστρων χορόν.

66. Scholium to Euripides *Hecuba* 647: Demetrius Triclinius, Περὶ μετρῶν Ἑκάβης, in Dindorf 1863.

67. *Etymologicum Magnum* 690.47, s.v. προσῴδιον.

68. See Lawler 1960; Miller 1986, 35–37.

69. Athenaeus *Sophists at Dinner* 4.129F–130A.

70. On the Gigantomachy as the foundation legend of the Panathenaea and on the pyrrhic dance of Athena, see Ferrari 1988a.

71. Kahil 1963, 25, pl. 14.3; 1965, 24–25 fig. 8.8. Kahil (1983, 237) suggested that the fallen krateriskos had been used for a libation, a hypothesis supported by Sourvinou-Inwood 1990, 12–13. Hamilton (1989, 64, 70) suspects that the scene is part of a story but takes the krateriskos to be a dedication.

72. *LIMC* 1, s.v. "Achilleus" VIIb.

73. Athens, National Museum 9683: *ARV*² 554, 82; *Paralipomena* 386; *Beazley Addenda* 258.

74. British Museum E 224: *ARV*² 1313, 5; *Paralipomena* 477; *Beazley Addenda* 36–62.

75. According to most sources (Plato *Phaedus* 229B–C; Apollodorus *Library* 1.19.5), Boreas carried away Oreithyia from the banks of the Ilissus. A scholium to Homer *Odyssey* 14.533 preserves a version in which she was seized in the course of a procession to the altar of Athena Polias on the Acropolis. For the Pelasgian raid on Brauron, see n. 47 above.

76. Remains of six stelae from the fourth century, *IG* II² 1514–31; Linders 1972; Cole 1998, 37–38, 41–42.

77. Chapter 11 of Bernardi (1985), "Women and Age Class Systems," defines this phenomenon in its general terms on the basis of analyses of African and American native societies. He concludes (141): "First, age class systems have a decisively masculine character. Second, the positions of women are diversified in relation both to the structure and functioning of these systems"; "this impels us to recognize the existence of a direct link between age class systems and the political control exercised by men rather than women."

78. Brelich (1969, 41–44) takes issue against the widely accepted view that female "initiations" are patterned on those of the males, arguing that the evidence for women's rites is more elusive, because of their secrecy. His call for a reexamination of the evidence rightly stresses the complexity of the problem. His arguments, however, seem unsound. In particular: female initiations *should* exist, because women are members of the community (41); in an hypothetical primitive form female initiations may have been collective and public, like those of the males (42) and should be restored as including rites of reincorporation (43); female initiations are different from the male's because women's lives are dominated by physiology in a way that men's lives are not.

79. Carson (1990) exposes the deeply seated and pervasive conception that age works differently for women than for men, in that "a woman's life has no prime" (144). Her insight that sexual activity, not calendar years, puts an end to a girl's bloom is, I think, true, but it should be understood in connection with the other distinction Carson makes between the discourse of love as pleasure, to which the virgin and the prostitute belong, and that of love as the work of procreation, which concerns the wife. In the former, sexual activity results in the loss of youth and beauty—"Sexual indulgence brings the woman not to her peak but past it" (146). In marriage, her erotic charge being under control, the woman apparently enters a state of suspended animation. If she is to be a "chaste" wife, her sexual operation must be kept to a functional minimum and void of pleasure (on this point, see Carson 1990, 150,156–57); then, like Helen of Sparta, who loved no one, she may keep her bloom for the duration of her child-bearing life.

80. The iconography of the males on Archaic and Early Classical vases has been thoroughly analyzed by Dover 1989, 68–100.

81. Munich, Antikensammlungen 2421: *ARV*² 23, 7.

82. See, e.g., the representation of Aethra in the Ilioupersis by the Kleophrades Painter, the hydria Naples, Museo Nazionale 2422: *ARV*² 189, 74; *Paralipomena* 341; *Beazley Addenda* 189 and that of Pelias on an Early Classical calyx krater (Tarquinia, Museo Archeologico 685: *ARV*² 864, 16; *Paralipomena* 426; *Beazley Addenda* 299).

83. Sourvinou-Inwood (1988, 16–17) observes that the representation of age in vase paintings is "structural" and that the same conventions apply to *parthenoi* and *gunaikes*. She limits her analysis to depictions of mortal figures, fearing that goddesses are idealized.

84. For representations of Apollo with Artemis and Leto: amphora by Psiax, Madrid, Museo Arqueológico Nacional 11008: *ARV*² 7, 2; *Paralipomena* 128, 321; *Beazley Addenda* 150; *CVA* Madrid 1 (Spain 1) pll. 23–24; amphora, British Museum E 256: *ARV*² 168; *Beazley Addenda* 183; *LIMC* 2, s.v. "Artemis," no. 1122; amphora, Würzburg, Martin von Wagner Museum L 220, *LIMC*, no. 1107. The rape of Leto is painted on the amphora by Phintias, Louvre G 42: *ARV*² 23, 1; *Paralipomena* 323; *Beazley Addenda* 154; here fig. 140.

85. Pyxis, British Museum E 773: *ARV*² 805, 89; *Paralipomena* 420; *Beazley Addenda* 291.

86. Several representations of the death of Aegisthus are illustrated in *LIMC* 1, s.v. "Aigisthos," nos. 10–13.

87. Dover, 100–6 (quotation on 101). Also: "Whereas men and youths are often depicted mauling and hauling women—not, of course, women of citizen status—the protection afforded to freeborn boys by the law on hybris is reflected in the rarity of homosexual assault in the visual arts" (93).

88. On these scenes, see Sutton 2000, 195–99. Among the vases with images notable for sadism are the cup by the Pedieus Painter, Louvre G 13: *ARV*² 86; *Beazley Addenda* 170; *CVA* Louvre 19 (France 28, 1977) pl. 68,2–69; the cup by the Brygos Painter, Florence 3921: *ARV*² 372, 31; *Beazley Addenda* 225; Boardman and La Rocca 1978, 97–99. According to Kurke (1999, 209–13), the women on the Pedieus Painter's cup are *hetairai*, momentarily revealed as *pornai*.

89. Fat old whores: Malibu, J. Paul Getty Museum 80.AE.31: *Beazley Addenda* 155 (24, 12 bis), Weiss 1989, 90. See also the kantharos in Boston, Museum of Fine Arts 95.61: *ARV*² 132; *Beazley Addenda* 177; Boardman and La Rocca 1978, 86.

90. For terms that characterize a prostitute as "lying on the ground," *khamaitupe*, and brothels as places where one lies on the ground, see Licht 1932, 332; Sutton 1992, 7–14. On the divide between the *porne* and the *hetaira*, see Licht, 1932, 339–63; Boardman, in Boardman and La Rocca 1978, 48–53; Reinsberg 1989, 86–162; Davidson 1997, 83–136; Kurke 1999, 178–219. Although both draw a sharp line between the two on the basis of literary texts, neither Reinsberg nor Kurke identifies the visual features that might help tell one from the other. The violent brothel scenes considered here are taken to be "orgies" at the end of a symposium—following Peschel 1987—and the women in them, hetairai.

Chapter 8

1. Vernant 1974, 38.

2. [Demosthenes] 59.122; on this passage, see pp. 199–200.

3. Van Gennep 1960, 67; Brelich 1969, 42–43.

4. Vernant 1974, 65

5. Herodotus *Histories* 6.126–130.

6. Hesiod *Catalogue of Women* frag. 196–204 (Merkelbach and West 1967).

7. Snodgrass 1974.

8. Pollux *Onomasticon* 3.36.

9. Gernet 1983, 147: "Il y a tout de même un changement radical qui s'explique non pas par une évolution spontanée ou lente, mais par la substitution du régime social à un autre." Gernet 1983, 204; Vernant 1974, 70–71.

10. Vérilhac and Vial (1998) give the latest exhaustive survey of sources for the ancient Greek marriage. On the wedding as initiation, see Arrigoni 1983, 12, 48–56.

11. Demosthenes 23.53; see p. 195.

12. Demosthenes 46.18: ἣν ἂν ἐγγυήσῃ ἐπὶ δικαίοις δάμαρτα εἶναι ἢ πατὴρ ἢ ἀδελφὸς ὁμοπάτωρ ἢ πάππος ὁ πρὸς πατρός, ἐκ ταύτης εἶναι παῖδας γνησίους. The procedure is not limited to Athens. Herodotus (*Histories* 6.57.4) refers to marriage by *engue* at Sparta,

and according to Diodorus Siculus (*Historical Library* 9.10.4), "by most of the Greeks the marriage contract is called *engue*." On the diffusion of this term, see Vatin 1970, 157–163.

13. Herodotus *Histories* 6.130: τῷ δὲ Ἀλκμέωνος Μεγακλέι ἐγγυῶ παῖδα τὴν ἐμὴν Ἀγαρίστην νόμοισι τοῖσι Ἀθηναίων. Φαμένου δὲ ἐγγυᾶσθαι Μεγακλέος, ἐκεκύρωτο ὁ γάμος Κλεισθένει.

14. Vérilhac and Vial (1998, 229–58) argue unconvincingly that *engue* and *ekdosis* are two words for one and the same act of "giving" the bride, which is, in turn, distinct from the *gamos*.

15. Wolff 1944 remains of fundamental importance. For a recent attempt to recover in Greek marriage practices the structure of a quasi-legal process that might resemble Roman marriage procedures, see Patterson 1991, and Patterson 1998, 107–14.

16. Wolff 1944, 51–53. Vérilhac and Vial (1998, 229–32) review of the history of scholarship on the *engue*.

17. Demosthenes 28.15–16; 29.43; Harrison 1968, 6–8.

18. Isaeus 6.22. Cox 1998, 23.

19. MacDowell 1978, 86.

20. Menander *Perikeiromene* 1013–1014: Ταύτην γνησίων παίδων ἐπ' ἀρότῳ σοι δίδωμι. Occurrences of this formula in ancient authors are collected by Vérilhac and Vial 1998, 232–233.

21. Isaeus 8.29: τῶν μὲν παλαιῶν ἀκοὴν μαρτυρούντων παρεχόμενος, τῶν δὲ ἔτι ζώντων τοὺς εἰδότας ἕκαστα τούτων, οἳ συνήδεσαν παρ' ἐκείνῳ τρεφομένην, θυγατέρα νομιζομένην, δὶς ἐκδοθεῖσαν, δὶς ἐγγυηθεῖσαν.

22. Wolff 1944, 48–51 (quotation on 48).

23. Xenophon *On Horsemanship* 2.2: χρὴ μέντοι ὥσπερ τὸν παῖδα ὅταν ἐπὶ τέχνην ἐκδῷ, συγγραψάμενον ἃ δεήσει ἐπιστάμενον ἀποδοῦναι οὕτως ἐκδιδόναι [τὸν πῶλον]. [As he would do if he gave out his son as an apprentice, he should give out (his colt) with a written statement of what it is to know, when it is returned.]

24. Wolff 1944, 47, 50, 53–65. Gernet 1983, 210: "Au total, la femme est un instrument; et même mariée au dehors, elle n'est jamais ni intégrée au groupe de son mari, ni détachée de son groupe original. Les significations de la dot sont en rapport avec l'institution matrimoniale: le mari ne devient jamais propriétaire de la dot, laquelle est transmise aux enfants s'il y a des enfants — et, s'il n'y en a pas doit toujours être rétrocedée au constituant. Elle est l'accompagnement symbolique de la femme qui, en un sens, n'est jamais que 'prêtée.'"

25. Just (1989, 95–104) gives a clear and concise exposition of the rules governing *epikleroi* in Athens. For a broader, if tendentious, overview, see Patterson 1998, 91–106.

26. Gernet 1983, 207; Cox 1998, 71–72; Thompson 1972; Roy 1999, 9–10. Cohn-Haft's thesis (1995) that divorce was infrequent has all the weaknesses of arguments from silence.

27. Just 1989, 85–89.

28. Wolff 1944, 51–53.

29. Demosthenes 33.24: ὥστε εἰ ἦν ἠγγυημένος ἐγὼ τὸν Παρμένοντα, οὐκ ἂν τρίτῳ ἔτει ὕστερον, ἀλλ' εὐθὺς τότε εἰσέπραττεν ἄν με τὴν ἐγγύην. [Therefore, had I been guar-

NOTES TO PAGES 184–86

antor for Parmeno, he (Apaturius) would not have waited until two years later, but would have exacted the sum guaranteed from me at once.]

30. Demosthenes 24.40: τῷ δὲ καταστήσαντι τοὺς ἐγγυητάς, ἐὰν ἀποδιδῷ τῇ πόλει τὸ ἀργύριον ἐφ' ᾧ κατέστησε τοὺς ἐγγυητάς, ἀφεῖσθαι τῶν δεσμῶν. [The debtor who has appointed guarantors on his own behalf shall be released from imprisonment upon payment to the state of the money for which he appointed such guarantors.]

31. Chantraine 1968–80, 240.

32. Wolff 1944, 52.

33. Gernet 1917, 249–93, 363–83, particularly 365–73; Harrison 1968, 3–6. Sutton (1989, 334–51) tentatively identified the *engue* in the representation of an old king shaking hands with a youthful traveler on the loutrophoros in Boston, Museum of Fine Arts 03.802. There may be here an allusion to the wedding to come, which is represented on the other side of the vase. In and of itself, however, the handshake need be no more that a gesture of greeting.

34. Chantraine 1968–80, 239.

35. Hesychius, s.v. γύαλα· θησαυροί, ταμεῖα, κοῖλα.

36. Callimachus *Hecale* frag. 9–10: ἐν γάρ μιν Τροιζῆνι κολουραίη ὑπὸ πέτρῃ / θῆκε σὺν ἁρπίδεσσιν . . . εὖτ' ἂν ὁ παῖς ἀπὸ μὲν γυαλὸν λίθου ἀγκάσσασθαι / ἄρκιος ἢ χείρεσσιν. [For in Troizen he put it (the sword) under a hollow stone together with the boots . . . whenever the child should be strong enough to lift with his hands the hollow stone.]

37. *Greek Anthology* 7.43: χαῖρε μελαμπετάλοις Εὐριπίδη ἐν γυάλοισι / Πιερίας τὸν ἀεὶ νυκτὸς ἔχων θάλαμον· / ἴσθι δ' ὑπὸ χθονὸς ὤν, ὅτι σοι κλέος ἄφθιτον ἔσται / ἴσον Ὁμηρείαις ἀενάοις χάρισιν. [Hail Euripides, who inhabits the chamber of eternal night in the dark-leafed valleys of Pieria! Know that, although you are under the earth, your glory shall be everlasting, equal to the perennial grace of Homer.]

38. Pindar *Nemean* 10.55–56: μεταμειβόμενοι δ' ἐναλλὰξ / ἁμέραν τὰν μὲν παρὰ πατρὶ φίλῳ / Δὶ νέμονται, τὰν δ' ὑπὸ κεύθεσι γαίας / ἐν γυάλοις Θεράπνας. [Changing in succession, they spend one day with their dear father Zeus, the other in the caves of Therapne deep under the earth.]

39. Benveniste 1969, 159–61.

40. Of particular interest here are Gernet's observations in his essay on the mythical concept of value connecting the idea of *thesauros* as a "vault . . . dug into rock and covered with a lid" and the *thalamos*, where a wife or daughter would be kept; see Gernet, 1968, 129–30.

41. Pollux *Onomasticon* 3.36; Harpocration, s.v. " Anakalypteria." See below, n. 44.

42. See, e.g., Oakley 1982, 113; Vérilhac and Vial 1998, 304.

43. The term *anakalupsis*, commonly used in modern scholarship on the Greek wedding, apparently occurs only once in extant literature, in Plutarch *Moralia* 518D1, to mean "disclosure" of some sickness. In formation, Anakalypteria is analogous to, e.g., Anthesteria, the festival of flowers, and means "the feast of *anakaluptein*"; see Chantraine 1933, 62–64. Whatever form it took, the uncovering was only one part of the Anakalypteria, since the festal day identified by that name included as well the banquet, the procession that accompanied the newlyweds to their destination, and the reception of the bride in her new *oikos*. The word itself might be used, therefore, for other moments of that day.

The historian Timaeus (*FrGrHist* 566F122), for instance, reports that Agathocles of Syracuse abducted his niece, who had been given to another man, "from the Anakalypteria." The theft is likely to have taken place during the procession, the classic moment for attempts on the bride, who traveled under escort precisely in order to guard against attacks of this kind; see Deubner 1900, 149; Toutain 1940, 345. On the escort guarding the bride and cases of attempted seduction and rape on route, see Oakley and Sinos 1993, 27.

44. Pollux *Onomasticon* 3.36: τὰ δὲ παρὰ τοῦ ἀνδρὸς διδόμενα δῶρα ἕδνα καὶ ὀπτήρια καὶ ἀνακαλυπτήρια· οὐ γὰρ μόνον ἡ ἡμέρα ἐν ᾗ ἐκκαλύπτει τὴν νύμφην οὕτω καλοῖτ' ἄν, ἀλλὰ καὶ τὰ ἐπ' αὐτῇ δῶρα. Τὰ δὲ ἀνακαλυπτήρια καὶ προσφθεγκτήρια ἐκάλουν. Harpocration, s.v. "Anakalypteria": ἀνακαλυπτήρια· δῶρα διδόμενα ταῖς νύμφαις παρά τε τοῦ ἀνδρὸς καὶ τῶν οἰκείων καὶ φίλων, ὅταν τὸ πρῶτον ἀνακαλύπτωνται ὥστε ὁραθῆναι τοῖς ἀνδράσι. Καλεῖται δὲ τὰ αὐτὰ καὶ ἐπαύλια. Ταῦτα δ' εἰσὶ τὰ παρ' ἡμῖν θεώρετρα. See also *Suda*, s.v. "Anakalypteria"; Deubner 1900, 148–51.

45. See above, n. 44, and Pollux *Onomasticon* 2.59: εἴρηται δὲ καὶ ὀπτήρια τὰ δῶρα τὰ παρὰ τοῦ πρῶτον ἰδόντος τὴν νύμφην νυμφίου. Hesychius, s.v. ὀπτήρια· τὰ ἐν τοῖς ἀνακαλυπτηρίοις διδόμενα δῶρα τῇ νύμφῃ.

46. Hesychius, s.v. ἀνακαλυπτήριον· ὅτε τὴν νύμφην πρῶτον ἐξάγουσιν [τοῦ θαλάμου] τῇ τρίτῃ ἡμέρᾳ [*Anakalupterion*: when for the first time they bring the bride [out of the chamber] on the third day.]

47. The view that the unveiling preceded the procession is represented by Deubner 1990, 149–50; Patterson 1991, 68 n. 40; Oakley 1982, 113–14. For the hypothesis that it took place at the groom's house, see Toutain 1940; Sissa 1990, 97–98; Rehm 1994, 141–42; Vérilhac and Vial 1998, 304–12. Harpocration (above n. 44) has been accused of confusing the Anakalupteria with the Epaulia, which was the day after; Deubner 1900, 148; Oakley 1982, 13 n. 5; Vérilhac and Vial 1998, 304 n. 68. On the Epaulia, according to the lexicographer Pausanias, quoted by Eustathius at Homer *Iliad* 24.29, a procession brought the gifts to the groom's house: καὶ ἐπαύλια τὰ μετὰ τὸν γάμον, ὡς δηλοῖ καὶ Παυσανίας, ἐν οἷς λέγει ἐπαυλίαν ἡμέραν, καθ' ἣν ἐν τῇ τοῦ νυμφίου οἰκίᾳ ἡ νύμφη πρῶτον ἐπηύλισται, καὶ ἐπαύλια τὰ μετὰ τὴν ἐχομένην ἡμέραν τοῦ γάμου δῶρα παρὰ τοῦ τῆς νύμφης πατρὸς φερόμενα τοῖς νυμφίοις ἐν σχήματι πομπῆς. παῖς γάρ, φησιν, ἡγεῖτο, χλανίδα λευκὴν ἔχων, καὶ λαμπάδα καιομένην, ἔπειτα παῖς ἑτέρα κανηφόρος, εἶτα λοιπαὶ φέρουσαι λεκανίδας, σμήγματα, φορεῖα, κτένας, κοίτας, ἀλαβάστρους, σανδάλια, θήκας, μύρα, νίτρα, ἐνίοτε, φησι, καὶ τὴν προῖκα. To this list the *Suda*, s.v. "Epaulia," adds *khrusia*, jewelry. Together with the mention of the dowry, this suggests that the Epaulia does not involve a second wave of wedding presents but was the formal delivery of the gifts that had been assembled in the bride's *oikos* on the Anakalypteria; see Zancani-Montuoro 1960, 48–49. Harpocration's statement, therefore, may be interpreted to say that *anakalupteria* is the name of the gifts given on the Anakalypteria, and that another name for the same gifts is *epaulia*, the occasion when they were ceremonially delivered to the groom's house.

48. Bekker 1814, 200.6–8 (=390.26): ἀνακαλυπτήρια· δῶρα διδόμενα ταῖς νύμφαις ὅταν πρῶτον ἀνακαλύπτωνται ἐν τῇ ἑστιάσει τῶν γάμων, τοῖς ἀνδράσι καὶ τοῖς ἑστιωμένοις ὁρώμεναι.

49. Deubner 1900, 149, 151; followed by Oakley 1982, 113–14; and Patterson 1991, 68 n. 40.

50. "Salt-cellar," Bonn, University 994. On this and other vase paintings of the bride with her face covered, see Oakley and Sinos 1993, 31–32, 137 n. 63, figs. 68–70.

51. Rehm 1994, 47.

52. Above, chapter 3.

53. Florence, Museo Archeologico 4209: *ABV* 76, 1; *Paralipomena* 29; *Beazley Addenda* 21; Roberts 1978, pl. 96, 2.

54. Attic black-figure hydria, Florence, Museo Archeologico 3790: *ABV* 260, 30; *Paralipomena* 114; *Beazley Addenda* 68.

55. New York, Metropolitan Museum of Art 56.11.1: *Paralipomena* 66; *Beazley Addenda* 45.

56. Oakley 1982, 116 n. 16. Many examples are illustrated in Oakley and Sinos 1993; see fig. 85 (loutrophoros in Athens, National Museum 1174); fig. 90 (pyxis Louvre L 55); fig. 94 (loutrophoros in Copenhagen, National Museum 9080); fig. 106 (loutrophoros in Boston, Museum of Fine Arts 03.802).

57. Oakley and Sinos 1993, 35, figs. 100–4. Much attention has focused on a fragmentary Classical loutrophoros in Boston, Museum of Fine Arts 10.223, which offers a representation of the bride and groom seated facing one another, in the presence of a young man, while a woman pours down on them a basketful of small objects. Behind the bride, an attendant lifts the veil or mantle from her forehead. Sutton (1989, 351–59) identified in this picture the *katakhusmata,* the showering of the newly married woman with dried fruit and nuts upon her arrival at the groom's house. Following Beazley (*ARV*² 1017, 44) and Sutton (1989, 358), I believe that this action should be understood as a veiling rather than as an unveiling. As in the examples just cited, it is a means of emphasizing the mantle or veil, not, as Oakley (1982, 114–18) has argued, its removal.

58. Boston, Museum of Fine Arts 13.186: *ARV*² 458, 1; *Paralipomena* 377; *Beazley Addenda* 243; Oakley and Sinos 1993, 32–33, fig. 86.

59. Zancani-Montuoro 1960, 40–50; Prückner 1968, 42–45.

60. Dentzer 1982, 484–89.

61. Marconi 1994, 142–44, 276–90.

62. Van Groningen 1977, no. 111: Ἀλλ' οὔπω Θήβῃ πεπρωμένα κεῖτο τάλαντα, / τήν ῥά ποτε Κρονίδης δῶρον πόρε Περσεφονείῃ, / ὃν γαμέτην ὅτε πρῶτον ὀπωπήσεσθαι ἔμελλε / νυμφιδίου σπείροιο παρακλίνασα καλύπτρην.

63. Philostratus *Imagines* 1.17.3: ἡ δ' ἔσταλται τὸν γαμικὸν τρόπον ἄρτι τὴν παρειὰν ἀνακαλύπτουσα, ὅτε ἐς ἀνδρὸς ἥκειν νενίκηκε.

64. Pherecydes of Syros frag. 68 (Schibli 1990): [αὐ]-/τῷ ποιεῦσιν τὰ ο[ἰ]κία / πολλά τε καὶ μεγάλα· / ἐπεὶ δὲ ταῦτα ἐξετέ-/λεσαν πάντα καὶ χρή-/ματα καὶ θεράποντας / καὶ θεραπαίνας καὶ / τἄλλα ὅσα δεῖ πάντα, / ἐπεὶ δὴ πάντα ἑτοῖ-/μα γίγνεται, τὸν γά-/μον ποιεῦσιν· κἄπει-/δὴ τρίτη ἡμέρη γί-/γνεται τῷ γάμῳ, τό-/τε Ζὰς ποιεῖ φᾶρος μέ-/γα τε καὶ καλόν, καὶ / ἐν αὐτῷ ποικ[ίλλει Γῆν] / καὶ Ὠγη[νὸν καὶ τὰ Ὠ[-/γηνοῦ [δώματα] [ὦ] [βουλόμενος] / γάρ σεο τοὺς γάμου[ς] / εἶναι, τούτῳ σε τιμ[έω.] / σὺ δέ μοι χαῖρε καὶ σύ[ν-/ι]σθι. ταῦτά φασιν ἀν[ακαλυπτήρια πρῶτον / γενέσθαι, ἐκ τούτου δ[ὲ] / ὁ νόμος ἐγένε[το] καὶ / θεοῖσι καὶ ἀνθρ[ώπ]οι-σιν. ἡ δέ μι[ν ἀμείβε-/ται δεξαμ]ένη εὖ τὸ / φᾶ[ρος [ὦ]. Translation Freeman 1948, modified.

65. Pherecydes of Syros frag. 14 (Schibli 1990): Ζὰς μὲν καὶ Χρόνος ἦσαν ἀεὶ καὶ Χθονίη· Χθονίη δὲ ὄνομα ἐγένετο Γῆ, ἐπειδὴ αὐτῇ Ζὰς γῆν γέρας διδοῖ. Translation Freeman 1948.

66. Schibli 1990, 51–52.

67. Schibli (1990, 63–64) maintains the traditional view that the unveiling was central to the Anakalypteria but notes: "The custom at Greek nuptials to which Pherekydes refers was not, however, the unveiling itself, but the giving of gifts by bridegroom (or friends and relatives) to bride; in Pherekydes' account this is reflected in the presentation of the robe by Zas to Chthonie" (64).

68. Detienne 1972, 215–17.

69. Hesychius, above n. 46.

70. Schibli (1990, 65–66) cites mythical parallels for Zas's gift of a robe to his bride: the peploi given to Harmonia by Cadmus, together with the notorious necklace (Apollodorus *Library* 3.4.2) upon their marriage and the beautiful peplos that Helen gave to Telemachus, destined for his bride (Homer *Odyssey* 15.123–128).

71. According to Pollux *Onomasticon* 3.37, the bride's mantle was called *heanos* and *kaluptra*.

72. The striking use of wedding imagery in laments was fully analyzed by Alexiou and Dronke 1971, 819–63. See, further, Jenkins 1983; Seaford 1987; Rehm 1994.

73. Seaford 1987, 106–7.

74. Faraone 1991, 22 n. 6; Johnston 1999, chapter 5.

75. Balthasar Gracian, *El Criticón,* cited by Babcock 1978, 13–36 (quotation on 13). On opposites in Greek thought and "polar expressions," see Lloyd 1971, part 1.

76. *IG* I³ 1261. On marriage and death as alternatives, see Alexiou and Dronke 1971, 833–37. On polar opposites as alternatives, Lloyd 1971, 93–94, 127–28, 134–37.

77. Sophocles *Antigone* 773–776: ἄγων ἐρῆμος ἔνθ' ἂν ᾖ βροτῶν στίβος / κρύψω πετρώδει ζῶσαν ἐν κατώρυχι, / φορβῆς τοσοῦτον ὡς ἄγος μόνον προθείς, / ὅπως μίασμα πᾶσ' ὑπεκφύγῃ πόλις. [I will bring her where the path is loneliest, and hide her alive in a rocky cavern there. I'll give just enough of food as shall suffice for a bare expiation, that the city may avoid pollution.] 1203–5: καὶ τύμβον ὀρθόκρανον οἰκείας χθονὸς / χώσαντες, αὖθις πρὸς λιθόστρωτον κόρης / νυμφεῖον Ἅιδου κοῖλον εἰσεβαίνομεν. [We raised a high mound of his native earth; then we set out again for the hollowed rock, death's stone bridal chamber for the girl.] The text cited here is Griffith 1999; translations Grene 1991.

78. Sophocles *Antigone* 891–94: ὦ τύμβος, ὦ νυμφεῖον, ὦ κατασκαφὴς / οἴκησις αἰείφρουρος, οἷ πορεύομαι / πρὸς τοὺς ἐμαυτῆς ὧν ἀριθμὸν ἐν νεκροῖς / πλεῖστον δέδεκται. Φερσέφασσ' ὀλωλότων.

79. Sophocles *Antigone* 1240–41: κεῖται δὲ νεκρὸς περὶ νεκρῷ, τὰ νυμφικὰ / τέλη λαχὼν δείλαιος ἔν γ' Ἅιδου δόμοις. [There they lie, the dead upon the dead. So he has won the pitiful fulfillment of his marriage within death's house.]

80. Sophocles *Antigone* 806–16: ὁρᾶτέ μ', ὦ γᾶς πατρίας πολῖται, / τὰν νεάταν ὁδὸν / στείχουσαν, νέατον δὲ φέγ-/γος λεύσσουσαν ἀελίου, / κοὔποτ' αὖθις· ἀλλά μ' ὁ παγ-/κοίτας Ἅιδας ζῶσαν ἄγει/τὰν Ἀχέροντος / ἀκτάν, οὔθ' ὑμεναίων / ἔγκληρον, οὔτ' ἐπὶ νυμ-/φείοις πώ μέ τις ὕμνος ὕ-/μνησεν, ἀλλ' Ἀχέροντι νυμφεύσω. [You see me, you people of my country, as I set out on my last road of all, looking for the last time on this light of this sun—never again. I am alive but Hades who gives sleep to everyone is leading me to the shores of Acheron, though I have known nothing of marriage songs nor the chant that brings the bride to bed. My husband is to be the Lord of Death.]

81. Sophocles *Antigone* 916–20: καὶ νῦν ἄγει με διὰ χερῶν οὕτω λαβὼν / ἄλεκτρον, ἀνυμέναιον, οὔτε του γάμου / μέρος λαχοῦσαν οὔτε παιδείου τροφῆς, / ἀλλ' ὧδ' ἐρῆμος πρὸς φίλων ἡ δύσμορος / ζῶσ' ἐς θανόντων ἔρχομαι κατασκαφάς.

82. Lincoln 1991, 102.

83. Van Gennep 1960, 186–87.

84. Sealey 1984, 121.

85. See above n. 26.

86. Just 1989, chapter 5, passim.

87. See, for instance, Patterson 1998, 125; Pomeroy 1997, 33: "Marriage was the foundation of the oikos"; Nevett 1999, 13; Roy 1999, 1. Cox (1998, 132–35) cites many more statements to this effect in her critique of the notion that the *oikos* was the basic family unit. She, too, maintains, however, that "at the basis of the oikos, as the law defined it, was marriage" (134).

88. The history of this concept in anthropology is traced by Schneider 1984, 97–112. For Classical studies, see Patterson, chapter 1. This paradigm was first denounced as a fallacy by Durkheim 1897, 306–19. See, further, Lévi-Strauss 1963, 50–51, and the devastating critique by Schneider 1984, particularly 165–201.

89. Gallant 1991, 23. Gallant questions the orthodox view only to conclude that "it is probably the case that the simple conjugal family" was the prevalent type of household (25).

90. Isaeus 11.1–3 (*On the Estate of Hagnias*); Harrison 1968, 143–49; Just 1989, 85–89.

91. See Cox 1998, 130–55, for a review of sources.

92. E.g., Isocrates 19.7 (*Aegineticus*); Demosthenes 43.48 (*Against Macartatus*); see MacDowell 1989, 15.

93. MacDowell (1989, 15–10) has shown that *oikos* is not a legal term for "family."

94. MacDowell 1989, 19–20.

95. Debate over the existence of lawful concubinage raged in the nineteenth century, after Bürmann (1877–78, 569–97, 619–43) proposed that *pallakia* was a quasi marriage and that, like marriage, it was contracted by *engue* and produced *gnesioi* children. Just as extreme was Hruza's response, who denied that concubinage was practiced at all; Hruza 1894, 62–93. Beauchet (1897, 82–107) gives a comprehensive summary of the controversy. As Davidson (1997, 131) observes, recent scholarship tends to ignore problematic categories of women such as the mistress and the concubine. Recently, Patterson has revived Hruza's argument; see Patterson 1991a, 281–87, and Patterson 1998, 128. Cox (1998, 170–189) lumps prostitutes with *pallakai* into one category, which she arbitrarily calls "hetairai," on the ground that both were "encroachments" upon the *oikos*. Ogden (1996, 100–6), as well, deliberately downplays the role of concubines by equating them with hetairai of comedy. My own view of Greek concubinage is informed by Wolff 1944, 65–75, 93, and Sealey 1984.

96. Demosthenes 23.53: ἐάν τις ἀποκτείνῃ ἐν ἄθλοις ἄκων, ἢ ἐν ὁδῷ καθελὼν ἢ ἐν πολέμῳ ἀγνοήσας, ἢ ἐπὶ δάμαρτι ἢ ἐπὶ μητρὶ ἢ ἐπ' ἀδελφῇ, ἢ ἐπὶ θυγατρί, ἢ ἐπὶ παλλακῇ ἣν ἂν ἐπ' ἐλευθέροις παισὶν ἔχῃ, τούτων ἕνεκα μὴ φεύγειν κτείναντα. Lysias 1.31 refers to the same law, which is attributed to Solon in Plutarch *Life of Solon* 23.1.

97. The word means "girl" in a broad sense and has the marked meaning of "concubine." Herodotus (*Histories* 1.135, 9.76), for instance, uses it to refer to the concubines of the Persians, in contrast to their wives; De Vries 1927, 2–8. Since Hruza (1894), scholars who hold that the Greeks did not practice concubinage have equated the *pallake* with the mistress, or hetaira. The Roman jurist Granius Flaccus, cited in Justinian *Digest* 50.144, is at pains to state the difference: Granius Flaccus in libro de iure Papiriano scribit: pellicem nunc vulgo vocari quae cum eo, cui uxor sit, corpus misceat, quosdam eam, quae uxoris loco, sine nuptiis in domo sit, quam παλλακὴν Graeci vocant." [Granius Flaccus writes in his book about the jus Papirianum that a *pellex* is now the usual name for someone who sleeps with someone who has a wife, but once upon a time someone who was in a household in place of a wife, but without being married, whom the Greeks call *pallake*.] Translation Watson 1985; on this text, see Wolff 1944, 73.

98. Cox 1998, 177.

99. Euctemon's *pallake* Alce, a former prostitute, for instance, resided in a tenement he owned, not in his house, as we learn from Isaeus 6.19–21. The cases of Alcibiades (Plutarch *Life of Alcibiades* 8.3–4) and Periander of Corinth demonstrate the explosive potential of the jealousy between wives and concubines. Diogenes Laertius (*Lives of the Philosophers* 1.94.9–11) provides the details of Periander's murder of his wife. Periander killed the pregnant Melissa, either by throwing a footstool at her or by a kick, in a fit of anger brought about by slanderous accusation of his *pallakai*, whom he later burnt alive.

100. The *pallake* of Philoneus was probably a slave; Antiphon 1; see Cox 1998, 173 n. 27. The most clamorous case of *pallakia* involving a foreign woman, of course, is that of Pericles and Aspasia (Plutarch *Life of Pericles* 24). In her attempt to deny the existence of concubinage, Patterson suggests that they were married; see Patterson 1991a, 284.

101. Discussion of *pallakia* involving women with an Athenian pedigree has centered on a passage of Isaeus 3.39. The speaker claims that his opponent's mother had not been married to his father with *engue*, because she had brought no dowry, and supports his claim with the following argument: ἐπεὶ καὶ οἱ ἐπὶ παλλακίᾳ διδόντες τὰς ἑαυτῶν πάντες πρότερον διομολογοῦνται περὶ τῶν δοθησομένων ταῖς παλλακαῖς. [Since even those who give their women in concubinage all of them first negotiate what should be given to those concubines.] As Sealey (1984, 116–17) points out, nothing in this passage suggests that, in turning to *pallakai*, the subject has shifted to the slave trade. See also Grzybek 1989, 206–12. Isaeus refers to the female relations of the poor, who risked remaining unmarried and a burden to the family unable to provide a dowry. The very fact that, in the absence of a dowry, it could be alleged that the woman who passed for a wife was in actuality a concubine, indicates that the practice was common. In the upper circles of Athenian society, that of Chrysilla, the wife of Isomachus, may be the case of a love affair that turned into de facto *pallakia*. In his attack on Callias, Andokides 1.124–27, reports that, after her husband died, Chrysilla went to live with Callias, who at the time was married to her daughter. The daughter attempted suicide, then fled the house; sometime afterwards, Callias sent Chrysilla back to her native *oikos*. He refused to acknowledge his paternity of the son to whom she gave birth. Later, however, he took her back and formally recognized the child as his own. Their son was ridiculed on the comic stage as "Callias's bastard" (Metagenes frag. 14 [Kassel and Austin 1984]).

102. On this passage, see MacDowell 1976, 90–91. On the status of *nothoi* as an integral part of the *oikos*, see Patterson (1990, 40–73, particularly 50), who attempts to limit

the meaning of the word *nothos* to the children a man sired out of wedlock and formally recognized as his own. For a broader definition, see Ogden 1996, 14–17, and 217–24 on the Spartan *nothoi* and *mothakes*, and their mothers.

103. Plutarch *Life of Solon* 22.4; the law is cited by Demosthenes 46.14, and Aristophanes *Birds* 1660–1661.

104. Ogden 1996, 34–37.

105. Isaeus 6.47; Demosthenes 43.51; Athenaeus *Sophists at Dinner* 13.577. In dealing with this law, Cox (1998, 172–73) confuses the *oikos* with the *ankhisteia*.

106. Newman 1887, 112.

107. Aristotle *Politics* 1253B3; *Nicomachean Ethics* 1162A17–19.

108. Hesiod *Works and Days* 405 is quoted as well in the Aristotelian *Oeconomicus* 1343A20. Κτητήν (406) means not "bought" but "acquired," in one's possession by any means; compare with Plato *Laws* 8.841E1: ὠνηταῖς εἴτε ἄλλῳ ὁτῳοῦν τρόπῳ κτηταῖς.

109. West 1978, 259: "[T]he meaning in the original saying must have been 'a wife,' essential to the *oikos* for its continuation."

110. Newman 1887, 112; Pomeroy 1997, 21–22: "Aristotle, however, understands *gyne* as 'wife,' and in so doing misrepresents Hesiod."

111. J.-P. Vernant, in "Le mariage" (Vernant 1974, 57–81), argued that the lack of specific terminology reflects the absence of an unequivocal definition of marriage and uncertainty in the distinction between wife and concubine. I follow Just 1989, 43–45, in the opinion that the line is clearly drawn by the procedure of the *engue*.

112. On markedness, see R. Jakobson, in Waugh and Halle 1984, 1–14; Jakobson 1990, 134–40.

113. For the understanding of marked and unmarked in terms of set and subset, I rely on Waugh 1982, 299–318, particularly 302–5. An English-language example of an unmarked category that includes terms that are in opposition is "day." In the expression "there are seven days in a week," it encompasses "night" as well as "day," which are mutually exclusive marked categories.

114. For an example of a term whose marked sense is largely determined by the discursive context, see the analysis of "bachelor" by Jakobson 1990 a, 317–18.

115. Vernant 1974, 60: "Courtisane et plaisir — on comprend assez bien ce que veut dire Démosthène. Épouse légitime et procréation d'enfants — il n'y a point non plus de difficulté. Mais la pallaké? Comment faut-il comprendre cette θεραπεία τοῦ σώματος à laquelle elle serait vouée?" Sealey (1984, 118) and Ogden (1996, 102) share Vernant's view that the qualification of the *pallake* is vague and ultimately meaningless. Mossé (1991, 273–79) suggests that she had the task of bathing her *kurios*.

116. Aristotle *Politics* 1280B31–39: ἀλλὰ ταῦτα μὲν ἀναγκαῖον ὑπάρχειν, εἴπερ ἔσται πόλις, οὐ μὴν οὐδ' ὑπαρχόντων τούτων ἁπάντων ἤδη πόλις, ἀλλ' ἡ τοῦ εὖ ζῆν κοινωνία καὶ ταῖς οἰκίαις καὶ τοῖς γένεσι ζωῆς τελείας χάριν καὶ αὐτάρκους. οὐκ ἔσται μέντοι τοῦτο μὴ τὸν αὐτὸν καὶ ἕνα κατοικούντων τόπον καὶ χρωμένων ἐπιγαμίαις· διὸ κηδεῖαί τ' ἐγένοντο κατὰ τὰς πόλεις καὶ φρατρίαι καὶ θυσίαι καὶ διαγωγαὶ τοῦ συζῆν. τὸ δὲ τοιοῦτον φιλίας ἔργον· ἡ γὰρ τοῦ συζῆν προαίρεσις φιλία.

117. My reading of the text relies heavily upon Braswell 1976, particularly in construing ἀφνειᾶς ἀπὸ χειρὸς with δωρήσεται rather than ἑλών (233–35).

118. Rehm 1994, 156 n. 6; Vérilhac and Vial 1998, 303–4. The idea that the occasion of the toast is the *engue* rather than the feast that accompanied the *ekdosis* was first formulated by Braswell (1976, 241–42) and has gained some currency. See Redfield 1982, 186, and Stoddart 1990, 57 (neither of whom acknowledges Braswell); Brown 1984, 38–41; Kurke, 119–20. This hypothesis is founded on two premises: first, that, if this were the wedding, the bride would be praised or, at least, mentioned; second, that no respectable woman would be present at any symposium. As to the first, the fact that the bride appears only through the screen of metaphor is precisely the point of the simile. The second is simply false: we know from descriptions of the event in comedy and in Lucian's *Symposium* that women, including the bride, attended the feast, although at tables separate from the men. Most sources are summarized in Oakley and Sinos 1993, 22–24. To those add Lucian *Toxaris* 24–26, an exemplum of *philia*. Menecrates finds himself stripped of his patrimony and unable to provide a dowry for his hopelessly ugly daughter, who, therefore, seems destined to remain unmarried. Under the pretense that he has found a husband for her, his friend Zenothemis invites them both to the wedding banquet. There he reveals himself as the groom (25):

ἐπεὶ δὲ ἐδεδείπνητο αὐτοῖς καὶ ἔσπεισαν τοῖς θεοῖς, ἐνταῦθα δὴ μεστὴν αὐτῷ τὴν φιάλαν προτείνας, "δέδεξο—εἶπεν—ὦ Μενέκρατες, παρὰ τοῦ γαμβροῦ φιλοτησίαν· ἄξομαι γὰρ ἐγὼ τήμερον τὴν σὴν θυγατέρα Κυδι-μάχην· τὴν προῖκα δὲ πάλαι εἴληφα, τάλαντα πέντε καὶ εἴκοσι." [After they had dined and had poured libations to the gods, then holding out the phiale full of wine, "Accept," he said, "the loving cup (*philotesian*) from your son-in-law: today I shall wed your daughter Cydimache; the dowry I received long ago, twenty-five talents."]

The bride is there. In spite of his friend's appeal not to saddle himself with the deformed creature, Zenothemis accomplishes the *gamos* by taking the girl into his room and deflowering her, before returning to the banquet.

119. Scholia to Demosthenes 3.110.2: ἀπὸ μεταφορᾶς τοῦ προπίνειν ἐν τοῖς συμποσίοις, ὅταν τις χάριν ὁμολογῶν τινι δεξιωσάμενος αὐτὸν τῷ πόματι μετὰ τοῦ ποτοῦ χαρίσηται αὐτῷ καὶ τὸ ποτήριον ἀργυροῦν ὂν ἢ χρυσοῦν. Scholia to Pindar *Olympian* 7.5: προπίνειν ἐστὶ κυρίως τὸ ἅμα τῷ κράματι τὸ ἀγγεῖον χαρίζεσθαι. Braswell 1976, 235–36 n. 10.

120. Harpocration: φιλοτησία· Δημοσθένης ἐν τῷ κατ' Αἰσχίνου· ἡ κύλιξ ἣν κατὰ φιλίαν τοῖς φίλοις προῦπινον φιλοτησία ἐκαλεῖτο, ὡς Ὑπερείδης φησὶ καὶ Ἄλεξις. *Suda* 427.6: καὶ φιλοτησίαν προπίνειν ἐστίν, ἡνίκα τις ἐν ἀρίστῳ ἀπὸ τῆς δοθείσης αὐτῷ φιάλης πιὼν μέρος, τὸ λοιπὸν παράσχῃ φίλῳ, καὶ τὴν φιάλην χαρισάμενος.

121. Gentili 1958, frag. 43; cited in the scholia to Pindar *Olympian* 7.5. This is enough to disprove Verdenius's contention that the use of *propinein* to mean both toast and gift is post-Classical; Verdenius 1987, 45.

122. Young 1968, 73–74; Brown 1984, 40–41; followed by Kurke 1991, 121–22.

123. Gentili and Prato 1985, frag. 1; see also frag. 3: ὕμνους οἰνοχοεῖν, "to pour the wine of hymns," ibidem.

124. Vetta 1983, xxxii.

125. West 1984, no. 60, 24–36: ἄγε, θυμέ, πῇ μέμηνας / μανίην μανεὶς ἀρίστην; / τὸ βέλος φέρε, κράτυνον, / σκοπὸν ὡς βαλὼν ἀπέλθῃς / τὸ δὲ τόξον Ἀφροδίτης / ἄφες ὡς

θεοὺς ἐνίκα. / τὸν Ἀνακρέοντα μιμοῦ, / τὸν ἀοίδιμον μελιστήν. / φιάλην πρόπινε παισίν, / φιάλην λόγων ἐραννήν· / ἀπὸ νέκταρος ποτοῖο / παραμύθιον λαβόντες / φλογερὸν φυγόντες ἄστρον.

126. Pindar *Isthmian* 2.1–5: οἱ μὲν πάλαι, ὦ Θρασύβουλε, φῶτες, οἳ χρυσαμπύκων / ἐς δίφρον Μοισᾶν ἔβαινον κλυτᾷ φόρμιγγι συναντόμενοι / ῥίμφα παιδείους ἐτόξευον μελιγάρυας ὕμνους, / ὅστις ἐὼν καλὸς εἶχεν Ἀφροδίτας / εὐθρόνου μνάστειραν ἁδίσταν ὀπώραν.

127. The sympotic opening may have the function of announcing the occasion for the performance of the ode, the great banquet celebrating the victory; on the so-called "convivial odes," see Vetta 1983, xxv–xxvi. On Pindar's use of sympotic and erotic motifs, see Lasserre 1974, 5–33; Crotty 1982, chapter 3, particularly 83–103.

128. On the concept of *hora* and its crucial role in *paiderastia*, see chapter 6 above; MacLachlan 1993, chapter 4.

129. Pindar *Nemean* 8.8–16: πολλά νιν πολλοὶ λιτάνευον ἰδεῖν· / ἀβοατὶ γὰρ ἡρώων ἄωτοι περιναιεταόντων / ἤθελον κείνου γε πείθεσθ' ἀναξίαις ἑκόντες, / οἵ τε κρανααῖς ἐν Ἀθάναισιν ἅρμοζον στρατόν, / οἵ τ' ἀνὰ Σπάρταν Πελοπηιάδαι. / ἱκέτας Αἰακοῦ σεμνῶν γονάτων πόλιός θ' ὑπὲρ φίλας / ἀστῶν θ' ὑπὲρ τῶνδ' ἅπτομαι φέρων / Λυδίαν μίτραν καναχηδὰ πεποικιλμέναν / Δείνιος δισσῶν σταδίων καὶ πατρὸς Μέγα Νεμεαῖον ἄγαλμα.

130. On dedications of prizes in sanctuaries, see Rouse 1902, 151–60.

131. Pindar *Olympian* 10.103–105: ἰδέᾳ τε καλὸν / ὥρᾳ τε κεκραμένον, ἅ ποτε / ἀναιδέα Γανυμήδει μόρον ἄλαλκε σὺν Κυπρογενεῖ.

132. Dover 1989, 44–45.

133. Steiner 1986, 90: "[T]he act of crowning unites the living athlete with the dead." A fillet, *mitra*, for the victor is mentioned also at Pindar *Isthmian* 5.62.

134. This verb is used of a lover's plead also at Pindar *Nemean* 5.32.

135. The use of *hilaskomai* here has troubled commentators; Brown (1984, 44 n. 30) gives a summary of interpretations.

136. Dover, 51–52, 82, 199. See also Davies 1986, 13–14.

137. Plato *Symposium* 183A–B: Εἰ γὰρ ἢ χρήματα βουλόμενος παρά του λαβεῖν ἢ ἀρχὴν ἄρξαι ἢ τιν' ἄλλην δύναμιν ἐθέλοι ποιεῖν οἷάπερ οἱ ἐρασταὶ πρὸς τὰ παιδικά, ἱκετείας τε καὶ ἀντιβολήσεις ἐν ταῖς δεήσεσι ποιούμενοι, καὶ ὅρκους ὀμνύντες, καὶ κοιμήσεις ἐπὶ θύραις, καὶ ἐθέλοντες δουλείας δουλεύειν οἵας οὐδ' ἂν δοῦλος οὐδείς, ἐμποδίζοιτο ἂν μὴ πράττειν οὕτω τὴν πρᾶξιν καὶ ὑπὸ φίλων καὶ ὑπὸ ἐχθρῶν [. . .] τῷ δ' ἐρῶντι πάντα ταῦτα ποιοῦντι χάρις ἔπεστι, καὶ δέδοται ὑπὸ τοῦ νόμου ἄνευ ὀνείδους πράττειν, ὡς πάγκαλόν τι πρᾶγμα διαπραττομένου.

138. Beazley 1947, 198.

139. On the concept of *philia* in Pindar, see Crotty 1982, 76–79. Lewis 1985, 219: "The process of eros . . . emerges in response to a social problem, the need to control erotic feelings, which, while necessary to form social bonds, are potentially disruptive to society." On the political role of *paiderastia*, see chapter 6 above.

140. Cairns 1977, 129–32.

141. Myth and epic sagas offer several other instances in which the *erastes* provides his *eromenos* with a bride when their relationship comes to an end, as it must. Thus Minos falls in love with Theseus, has him as his *paidika*, then gives him his daughter Phaedra in

marriage; Zenis of Chios in Athenaeus *Sophists at Dinner* 13.601F; Sergent 1986, 198–99. Orestes betroths his sister Electra to Pilades as a token of their comradeship (Euripides *Orestes* 1078–1079).

142. Brown 1984, 47–48.

143. Theognis 1341–44: αἰαῖ, παιδὸς ἐρῶ ἁπαλόχροος, ὅς με φίλοισιν / πᾶσι μάλ' ἐκφαίνει κοὐκ ἐθέλοντος ἐμοῦ. / τλήσομαι οὐ κρύψας ἀκεούσι⟨α⟩ πολλὰ βίαια / οὐ γὰρ ἐπ᾽ αἰκελίῳ παιδὶ δαμεὶς ἐφάνην. Translation Lewis 1985, 220.

144. Braswell 1976, 240–42: "[W]herever there is mention of likemindedness those who share in the unity are explicitly indicated." On deliberate ambiguity as "shading," see Easterling (1999, 95–107), who defines it as an "oscillation, or shading between literal and metaphorical meaning" (96).

145. Lévi-Strauss, 1969, 115–16. See also Just 1989, 46–47; and Rubin 1975, 174: "If it is women who are being transacted, then it is the men who give and take them who are linked, the woman being a conduit of a relationship rather than a partner to it."

146. Lévi-Strauss 1969, 480. Note that in the sentence following, Lévi-Strauss compares marriage with the "artificial and temporary 'conjugality' between young people of the same sex in some schools," citing Balzac to the effect that "it is never superimposed upon blood ties but replaces them." On the erotic bond between men as the basis of the marriage bond, see also 483–84.

147. It is perhaps another sign of its importance that a language so lacking in specific terms for the union of man and wife has a special word for this partnership: *gambros*. The word denotes the relationship between the married man and the men of his wife's family. Its meaning ranges accordingly from "son-in-law" to "brother-in-law" and, exceptionally, "father-in-law." Chantraine 1968–80, 208–9, writes: "Le charactère général et imprécis du terme s'explique par le fait qu'il désigne l'homme (mari, beau-frère, beau-père) par rapport à la femme, ce qui est un lien originellement peu important. Le mot signifie au fond 'allié'" (209). Idiomatically, a man is another man's *gambros* "on account of" or "in charge of" the woman, e.g., Ctesias, *FrGrHist* 688F 13,26: γαμβρὸς ἐπὶ τῇ θυγατρὶ Ἀμύτι τοῦ Ξέρξου.

148. Just 1989, 21; Gould 1980, 46, nn. 17, 56; Patterson 1986, 49–67, passim.

149. Foxhall 1989, 32–39.

150. On the "citizen women" as a privileged class, see Just 1989, 23–25.

151. The literature on the question of the seclusion of women in Greek society is extensive. Gould (1980) laid the foundations of the debate in recent years. For a recent statement to the effect that "women can be seen to have economic, social, and religious interests which regularly took them outside the confines of their houses," see Patterson 1998, 128, following Cohen 1991, 149–70. Just (1989, chapter 6) gives a useful review of the issue. He points out that it is absurd to define the ideal of female seclusion in terms of physical sequestration (113–14):

> What the women of the poor were forced to do need not contradict a dominant ideology in terms of which female seclusion was desirable. And such an ideology can remain dominant, although it was perhaps only the well-to-do who could translate it fully into practice. . . . In dealing with so complex a social phenomenon as sexual segregation and female seclusion, we are dealing with an ideology, with a set of moral ideas and values. These could

still operate although women went to the spring to draw water, or slipped
out of the house to visit neighbours . . . To determine whether or not Athe-
nian women were secluded and segregated by whether or not they appeared
outside their houses or talked to men is to adopt an extraordinarily sim-
plistic criterion which would be rejected by anyone who has actually spent
time in, for example, modern rural Greece. Interestingly, for the most part
it would be an inapplicable way of registering female seclusion and sex-
ual segregation even in those Islamic or "oriental" societies which have
been taken by classical scholars as the archetypal examples of female
confinement.

152. Schaps 1977, 323–30. On the custom of nicknaming public women, see Cox
1998, 173–74.

153. Both Cartledge (1993, 129) and Kallet-Marx (1993) point this out. Kallet-Marx's
contention (141) that the war widows are now wards of the state, for which Pericles
speaks, is unsubstantiated.

154. On the visibility of women in the public sphere, see Sourvinou-Inwood 1995a.

155. Osborne (1997) maps the striking increase of depictions of women on Athenian
Classical grave monuments and cogently argues that this phenomenon marks the greater
importance of women in the political climate that produced Pericles' law of citizenship
of 451.

156. Patterson (1986, 63) shows how this ethos of invisibility might have been inter-
nalized: "political life, the invention and the domain of men, required the economic and
social stability of the Athenian family, which in turn depended on women who were in-
visible, yet recognized as insiders and natives . . ."

Appendix 1

1. Keaney 1991, 103, E94; see also *Etymologicum Magnum*, s.v. "ἐπιδίετες"; scholium
to Aeschines 3.122; Pollux *Onomasticon* 8.105.

2. Pélékidis 1962, 51–70, particularly 58–61 (quotation on 55).

3. Pélékidis 1962, 15–17.

4. Pélékidis 1962, 55–56.

Adams, C. D. 1919. *The Speeches of Aeschines.* London: W. Heinemann; New York: G. P. Putnam's Sons.

Adriani, A. 1971. *Odeon.* Palermo: Banco di Sicilia.

AJA. 1996. "*A City of Images:* Some Views 12 Years Later." Vol. 100: 359–61.

Alexiou, M., and P. Dronke. 1971. "The Lament of Jephta's Daughter: Themes, Traditions, Originality." *Studi Medievali* (Centro Italiano di Studi sull'Alto Medioevo, Spoleto), 3d ser. vol. 12, no. 2: 819–63.

Ammermann, R. M. 1991. "The Naked Standing Goddess." *AJA* 95: 203–30.

Anhalt, E. K. 1993. *Solon the Singer.* Lanham, Md.: Rowman & Littlefield.

Arrigoni, G. 1983. "Amore sotto il manto e iniziazione nunziale." *Quaderni Urbinati di Cultura Classica,* vol. 44, no. 2: 7–56.

Attridge, H. W., and R. A. Oden. 1976. *Lucian of Samosata. The Syrian Goddess.* Missoula, Mo.: Scholars Press.

Aurigemma, S. 1965. *La necropoli di Spina in Valle Trebba.* Rome: L'Erma di Bretschneider.

Austin, C. 1968. *Nova Fragmenta Euripidea.* Berlin: de Gruyter.

Babcock, B. A., ed. 1978. *The Reversible World: Symbolic Inversion in Art and Society.* Ithaca: Cornell University Press.

Ballentine, F. G. 1904. "Some Phases of the Cult of the Nymphs." *HSCP* 15: 77–119.

Barber, E. J. W. 1991. *Prehistoric Textiles: The Development of Cloth in the Neolithic and Bronze Ages with Special Reference to the Aegean.* Princeton, N.J.: Princeton University Press.

———. 1994. *Women's Work: The First 20,000 Years.* New York and London: Norton.

Barker, E. 1925. *Greek Political Theory.* London: Methuen.

Barringer, J. M. 1995. *Divine Escorts.* Ann Arbor: University of Michigan Press.

Barthes, R. 1967. *Elements of Semiology.* Trans. A. Lavers and C. Smith. New York: Hill & Wang.

Bassett, S. E. 1919. "The Palace of Odysseus." *AJA* 23: 288–311.

Bažant, J., Jr. 1981. *Studies on the Use and Decoration of Athenian Vases.* Prague: Academia.

Beard, M. 1991. "Adopting an Approach. II." In *Looking at Greek Vases*, eds. T. Rasmussen and N. Spivey, 12–35. Cambridge: Cambridge University Press.

Beauchet, L. 1897. *Histoire du droit privé de la république athénienne.* Vols. 1–2, *Le droit de famille.* Paris: Chevalier-Marescq.

Beazley, J. D. 1931. *Der Pan-Maler.* Berlin: H. Keller.

———. 1931a. Review of *CVA* Athens 1 (Greece 1, 1930). *JHS* 51: 121.

———. 1935. "Some Inscriptions on Vases. III." *AJA* 39: 475–88.

———. 1947. "Some Attic Vases in the Cyprus Museum." *ProcBritAc* 33: 195–243.

———. 1950. "Some Inscriptions on Vases. V." *AJA* 54: 310–22.

Bechtel, F. 1923. *Die griechische Dialekte.* Vol. 2. Berlin: Weidmann.

Beck, F. A. G. 1975. *Album of Greek Education.* Sydney: Cheiron Press.

Bekker, I. 1814. *Anecdota Graeca.* Vol. 1. Berlin: Nauck.

Belke, I. 1971. *Moritz Lazarus und Heymann Steinthal.* Tübingen: J. C. B. Mohr.

Benveniste, E. 1969. *Le vocabulaire des institutions indo-européennes.* Vol. 1, *Économie, parenté, société.* Paris: Éditions de Minuit.

———. 1971. *Problems in General Linguistics.* Trans. M. E. Meek. Coral Gables, Fla.: University of Miami Press.

———. 1973. *Indo-European Language and Society.* Trans. E. Palmer. London: Faber.

Bérard, C. 1983. "Iconographie, iconologie, iconologique." *Études de Lettres* 4: 5–37.

———. 1989. "Festivals and Mysteries." In Bérard 1989a, 109–20.

———, ed. 1989a. *A City of Images: Iconography and Society in Ancient Greece.* Trans. D. Lyons. Princeton, N.J.: Princeton University Press.

Bernabò-Brea, L., and M. Cavalier. 1977. *Il Castello di Lipari e il Museo Archeologico Eoliano.* Palermo: S. F. Flaccovio.

Bernardi, B. 1985. *Age Class Systems.* Trans. D. I. Kertzer. New York: Cambridge University Press.

Beschi, L. 1978. "Gli 'astragalizontes' di un Policleto." *Prospettiva* 15 (Oct.): 4–12.

Bethe, E. 1907. "Die dorische Knabenliebe." *RhM* 62: 438–75.

Bettelheim, B. 1955. *Symbolic Wounds.* London: Thames & Hudson.

Bianchi Bandinelli, R. 1976. *Introduzione all'archeologia.* Bari: Laterza.

Black, M. 1962. *Models and Metaphors.* Ithaca: Cornell University Press.

Blech, M. 1982. *Studien zum Kranz bei den Griechen.* Berlin and New York: de Gruyter.

Bloesch, H., ed. 1982. *Greek Vases from the Hirschmann Collection.* Zurich: H. Rohr.

Blüher, H. 1919. *Die Rolle der Erotik in der männlichen Gesellschaft.* Jena: E. Diederichs.

Boardman, J. 1974. *Athenian Black Figure Vases.* London: Thames & Hudson.

———. 1975. *Athenian Red Figure Vases: The Archaic Period.* London: Thames & Hudson.

———. 1978. *Greek Sculpture: The Archaic Period.* London: Thames & Hudson.

———. 1989. *Athenian Red Figure Vases: The Classical Period.* London: Thames & Hudson.

———. 2001. *The History of Greek Vases.* London: Thames & Hudson.

Boardman, J., and D. C. Kurtz. 1986. "Booners." In *Greek Vases in the J. Paul Getty Museum, Volume 3.* Occasional Papers on Antiquities, no. 2, 35–70.

Boardman, J., and E. La Rocca. 1978. *Eros in Greece.* New York: J. Murray.

Bohannan, P. 1960. "Conscience Collective and Culture." In *Essays on Sociology and Philosophy,* ed. K. H. Wolff, 77–96. New York: Harper & Row.

Bohle, B. 1990. "Ritualisierte Homosexualität–Krieg–Misogynie. Beziehungen im und um den Männerbund: Beispiele aus Neuguinea." In Völger and Welck 1990, 2: 285–96.

Bohm, S. 1990. *Die 'Nackte Göttin.'* Mainz am Rhein: P. von Zabern.

Bolte, F. 1929. "Zu lakonischen Festen." *RhM* 78: 124–43.

Börner, F. 1976. *P. Ovidius Naso. Metamorphosen.* Vol. 3. Heidelberg: C. Winter.

Bonfante, L. 1975. *Etruscan Dress.* Baltimore: Johns Hopkins University Press.

———. 1989. "Nudity as Costume in Classical Art." *AJA* 93: 543–70.

———, ed. 1986. *Etruscan Life and Afterlife.* Detroit: Wayne State University Press.

Borgeaud, P. 1988. *The Cult of Pan in Ancient Greece.* Trans. K. Atlass and J. Redfield. Chicago: University of Chicago Press, 1988.

Bothmer, D. von. 1961. *Ancient Art in New York Private Collections.* New York: Metropolitan Museum of Art.

———. 1985. *The Amasis Painter and His World.* New York and London: Thames & Hudson.

Bowersock, G. W. 1968. *Xenophon. Scripta Minora.* London: W. Heinemann; Cambridge, Mass.: Harvard University Press.

Bowra, C. M. 1935. *Pindari Carmina.* Oxford: Clarendon Press.

———. 1961. *Greek Lyric Poetry from Alcman to Simonides.* Oxford: Clarendon Press.

Braswell, B. K. 1976. "Notes on the Prooemium to Pindar's Seventh Olympian Ode." *Mnemosyne,* 4th ser., 29: 233–42.

Brelich, A. 1969. *Paides e Parthenoi.* Incunabula Graeca, no. 36. Rome: Edizioni dell'Ateneo.

Bremmer, J. 1980. "An Enigmatic Indo-European Rite: Paederasty." *Arethusa* 13: 279–98.

Brinkmann, V. 1994. *Beobachtungen zum formalen Aufbau und zum Sinngehalt der Friese des Siphnierschatzhauses.* Ennepetal: Biering & Brinkmann.

Brommer, F. 1978. *Hephaistos.* Mainz am Rhein: P. von Zabern.

Bron, C., and F. Lissarrague. 1991. "Looking at the Vase." In Bérard 1989a, 11–21.

Bron, C., F. Viret Bernal, C. Bérard, A. Oberlin, A. Rogger, and D. de Werra. 1991. "Héraklès chez T.I.R.E.S.I.A.S.: Traitement informatique de reconnaissance des éléments sémiologiques pour l'identification analytique des scènes." *Hephaistos* 10: 21–33.

Broneer, O. 1949. "Plato's Description of Early Athens and the Origin of Metageitnia." *Hesperia* Suppl., no. 8: 47–59.

Brown, A. 1984. "The Bridegroom and the Athlete: The Proem to Pindar's Seventh Olympian." In *Greek Poetry and Philosophy. Studies in Honour of Leonard Woodbury,* ed. D. E. Gerber, 38–41. Chico, Calif.: Scholars Press.

Brückner, A. 1907. *Lebensregeln auf athenischen Hochzeitgeschenken.* Berlin: G. Reimer.

————. 1907a. "Athenische Hochzeitgeschenke." *AM* 32: 79–122.

Brümmer, E. 1985. "Griechische Truhenbehälter." *JdI* 100: 1–168.

Brunnsåker, S. 1971. *The Tyrant-Slayers of Kritios and Nesiotes*. 2d. ed. Skrifter utgivna av Svenska institutet i Athen, no. 17 in 4°, 33–120. Stockholm: [Svenska Institutet i Athen Edition].

Buchholz, H.-G. 1987. "Symbol des gemeinsamen Mantels." *JdI* 102: 1–55.

Buffière, F. 1980. *Eros adolescent*. Paris: Belles Lettres.

Bühler, W. 1960. *Die Europa des Moschos*. Hermes Einzelschriften, no. 13.

Bürmann, H. 1877–88. *Drei Studien auf dem Gebiet des attischen Rechts. Jahrbücher für classische Philologie* Suppl., no. 9.

Burkert, W. 1975. "Apellai und Apollo." *RhM* 118: 1–21.

————. 1985. *Greek Religion*. Trans. J. Raffan. Cambridge, Mass.: Harvard University Press.

Burn, L. 1987. *The Meidias Painter*. Oxford: Clarendon Press.

Burnett, A. P. 1983. *Three Archaic Poets*. Cambridge, Mass.: Harvard University Press.

————. 1985. *The Art of Bacchylides*. Cambridge, Mass.: Harvard Unversity Press.

Burnyeat, M. F. 1977. "Socratic Midwifery, Platonic Inspiration." *BICS* 24: 7–10.

Burton, R. W. B. 1962. *Pindar's Pythian Odes*. Oxford: Oxford University Press.

Bury, R. G. 1909. *The Symposium of Plato*. Cambridge: W. Heffer and Sons; London: Sipkin, Marshall and Co.

————. 1926. *Plato. The Laws*. London: W. Heinemann; New York: G. P. Putnam's Sons.

Butcher, S. H. 1902. *The Poetics of Aristotle*. London: Macmillan.

Butler, J. 1999. *Gender Trouble*. 2d ed. New York and London: Routledge.

Jean-David Cahn AG. 1996. *Kunst der Antike: Lekythoi, Oinochoai. Katalog 8*. Basel: Jean-David Cahn.

————. 2000. *Kunstwerke der Antike*. Basel: Jean-David Cahn.

Cairns, D. L. 1993. *Aidos: The Psychology and Ethics of Honour and Shame in Ancient Greek Literature*. Oxford: Oxford University Press.

————. 1996. "Veiling, αἰδώς, and a Red-figure Amphora by Phintias." *JHS* 116: 152–58.

Cairns, F. 1976. "Ἔρως in Pindar's First Olympian Ode." *Hermes* 105: 129–32.

Calame, C. 1977. *Les chœurs de jeunes filles en Grèce archaïque*. 2 vols. Rome: Edizioni dell' Ateneo e Bizzarri.

————. 1983. *Alcman*. Rome: Edizioni dell'Ateneo.

————. 1997. *Choruses of Young Women in Ancient Greece: Their Morphology, Religious Role, and Social Function*. Trans. D. Collins and J. Orion. Lanham, Md.: Rowman & Littlefield. Revised edition of Calame 1977.

————. 1999. *The Poetics of Eros in Ancient Greece*. Trans. J. Lloyd. Princeton, N.J.: Princeton University Press.

Callipolitis-Feytmans, D. 1948. *Les vases grecs de la Bibliothèque Royale de Belgique*. Brussels: Éditions de la Librairie Encyclopédique.

Camp, J. M. 1986. *The Athenian Agora*. London: Thames & Hudson.

Campbell, M. 1991. *Moschus, Europa.* Hildesheim, Zurich, and New York: Olms-Weidmann.

Carson, A. 1985. *Eros the Bittersweet.* Princeton, N.J.: Princeton University Press.

———. 1990. "Putting Her in Her Place." In Halperin, Winkler, and Zeitlin 1990, 135–69.

Carter, J. C. 1978. *University of Texas Excavations at Metaponto, 1978.* Austin: University of Texas at Austin.

Cartledge, P. 1993. "The Silent Women of Thucydides 2.45.2 Re-viewed." In Rosen and Farrell 1993, 125–32.

———. 1997. "Spartan Upbringing." *CR* 47: 98–100.

———. 2001. *Spartan Reflections.* London: Duckworth.

Caskey, L. D. 1925. *Museum of Fine Arts, Boston. Catalogue of Greek and Roman Sculpture.* Cambridge, Mass.: Harvard University Press.

Chantraine, P. 1933. *La formation des noms en grec ancien.* Paris: E. Champion.

———. 1968–80. *Dictionnaire étymologique de la langue grecque.* Paris: Klincksieck.

Christiansen, J., and T. Melander, eds. 1988. *Proceedings of the 3rd Symposium on Ancient Greek and Related Pottery.* Copenhagen: Ny Carlsberg Glyptotek.

Christie, Manson, & Woods International Inc. 1997. *Antiquities.* New York, N.Y.: Christie's.

———. 1999. *Antiquities.* New York, N.Y.: Christie's.

———. 2000. *Ancient Greek Vases Formerly in the Private Collection of Dr. Elie Borowski.* [New York, N.Y.]: Christie's, 2000.

Clark, K. 1956. *The Nude: A Study in Ideal Form.* London: J. Murray.

Clark, L. 1983. "Notes on Small Textile Frames Pictured on Greek Vases." *AJA* 87: 91–96.

Clark, T. J. 1999. *The Painting of Modern Life.* Rev. ed. Princeton, N.J.: Princeton University Press.

Cohen, B., ed. 2000. *Not the Classical Ideal: Athens and the Construction of the Other in Greek Art.* Leiden: E. J. Brill.

Cohen, D. 1991. *Law, Sexuality, and Society: The Enforcement of Morals in Classical Athens.* Cambridge: Cambridge University Press.

Cohn-Haft, L. 1995. "Divorce in Classical Athens." *JHS* 115: 1–14.

Cole, S. G. 1984. "The Social Function of Rituals of Maturation: The Koureion and the Arkteia." *ZPE* 55: 233–44.

———. 1998. "Domesticating Artemis." In *The Sacred and the Feminine in Ancient Greece,* eds. S. Blundell and M. Williamson, 27–43. London and New York: Routledge.

Cook, A. B. 1914. *Zeus. A Study in Ancient Religion.* Part 2, vol. 3. Cambridge: Cambridge University Press.

Cook, R. M. 1997. *Greek Painted Pottery.* 3d ed. New York: Routledge.

Connor, W. R. 1988. "Early Greek Land Warfare as Symbolic Expression." *Past and Present* 119: 4–29.

Consbruch, M., ed. 1906. *Enchiridion.* Leipzig: Teubner.

Cox, C. A. 1998. *Household Interests.* Princeton, N.J.: Princeton University Press.

Crawley, A. E. 1893. "Achilles at Skyros." *CR* 7: 243–45.

Crome, J. F. 1966. "Spinnende Hetairen?" *Gymnasium* 73: 245–47.

Crotty, K. 1982. *Song and Action.* Baltimore: Johns Hopkins University Press.

Crowfoot, G. M. 1936–37. "Of the Warp-weighted Loom." *BSA* 37: 36–47.

Csapo, E., and M. C. Miller. 1991. "The 'Kottabos Toast' and an Inscribed Red-figure Cup." *Hesperia* 60: 379–81.

Culler, J. 1976. *Saussure.* Hassock, Sussex: Harvester Press.

Davidson, J. N. 1997. *Courtesans and Fishcakes.* London: HarperCollins.

Davies, M. 1986. "Alcman and the Lover as Suppliant." *ZPE* 64: 13–14.

Dawkins, R. M., ed. 1929. *The Sanctuary of Artemis Orthia at Sparta. JHS* Suppl., no. 5.

Dentzer, J.-M. 1982. *Le motif du banquet couché dans le Proche-Orient et le monde grec du VIIe au IVe siècle avant J.-C.* Bibliothèque des Écoles françaises d'Athènes et de Rome, no. 246. [Rome]: École française de Rome.

Deonna, W. 1909. *Les "Apollons" archaïques.* Paris: Libr. Georg & Co.

Derrida, J. 1976. *Of Grammatology.* Trans. G. C. Spivak. Baltimore: Johns Hopkins University Press.

———. 1982. *Margins of Philosophy.* Trans. A. Bass. Chicago: University of Chicago Press.

Detienne, M. 1972. *Les jardins d'Adonis.* Paris: Gallimard.

Deubner, L. 1900. "ΕΠΑΥΛΙΑ." *JdI* 15: 148–51.

———. 1932. *Attische Feste.* Berlin: H. Keller.

De Vries, M. 1927. *Pallake.* Amsterdam: H. J. Paris.

Di Donato, R., ed. 1983. "Forme e strutture della parentela nella Grecia antica. Tre inediti di Louis Gernet." *AION. Sezione di archeologia e storia antica* 5: 109–210.

Diels, H. 1951. *Die Fragmente der Vorsokratiker.* Vol. 1. Berlin: Weidmann.

Diller, A. 1941. "A New Source on the Spartan Ephebia." *AJP* 62: 499–501.

Dillon, M. 2000. "Did Parthenoi Attend the Olympic Games? Girls and Women Competing, Spectating, and Carrying out Cult Roles at Greek Religious Festivals." *Hermes* 128: 457–80.

Dindorf, W., ed. 1863. *Scholia Graeca in Euripidis Tragoedias.* Oxford: Oxford University Press.

Dörig, J. 1962. "Lysippe und Iphianassa." *AM* 77: 72–91.

———. 1975. *Art antique. Collections privées de Suisse romande.* Geneva: Éditions archéologiques de l'Université de Genève.

Douglas, M. 1973. *Natural Symbols.* New York: Pantheon.

Dover, K. J. 1964. "Eros and Nomos." *BICS* 11: 31–42.

———. 1989. *Greek Homosexuality.* 2d ed. Cambridge, Mass.: Harvard University Press.

———. 1989a. *The Greeks and Their Legacy.* Oxford: Oxford University Press.

Dowden, K. 1989. *Death and the Maiden.* London and New York: Routledge.

DuBois, P. 1982. *Centaurs and Amazons: Women and the Prehistory of the Great Chain of Being.* Ann Arbor: University of Michigan Press.

————. 1988. *Sowing the Body: Psychoanalysis and Ancient Representations of Women*. Chicago: University of Chicago Press.

Ducat, J. 1966. *Les vases plastiques rhodiens archaïques en terre cuite*. Bibliothèque des Écoles françaises d'Athènes et de Rome, no. 209. Paris: E. de Boccard.

————. 1971. *Les kouroi du Ptoion*. Bibliothèque des Écoles françaises d'Athènes et de Rome, no. 219. Paris: E. de Boccard.

————. 1999. "Perspectives on Spartan Education in the Classical Period." In Hodkinson and Powell 1999, 43–66.

Dugas, C. 1952. *Les vases attiques à figures rouges*. Exploration archéologique de Délos, no. 21. Paris: E. de Boccard.

Dummer, J. 1977. "Realität des Lebens und Realitätsschwund in der Vasenmalerei." In Kunze 1977, 57–62.

Durkheim, E. 1897 [1898]. Review of J. Kohler, *Zur Urgeschichte der Ehe, Totemismus, Gruppenehe, Mutterrecht* (Stuttgart: Enke, 1897). *L'année sociologique* 1: 306–19.

————. 1898. "Représentations collectives." *Revue de métaphysique et de morale* 6: 273–302.

————. 1926. *The Elementary Forms of the Religious Life*. Trans. J. W. Swain. London: G. Allen & Unwin; New York: Macmillan.

Easterling, P. E. 1999. "Plain Words in Sophocles." In *Sophocles Revisited*, ed. J. Griffin, 95–107. Oxford: Oxford University Press.

Eco, U. 1979. *A Theory of Semiotics*. Bloomington: Indiana University Press.

Edwards, C. M. 1984. "Aphrodite on a Ladder." *Hesperia* 53: 59–72.

Elliston, D. A. 1995. "Erotic Anthropology: 'Ritualized Homosexuality' in Melanesia and Beyond." *American Ethnologist* 22: 848–67.

Erffa, A. E. 1937. Αἰδώς *und verwandte Begriffe in ihrer Entwicklung von Homer bis Demokrit*. *Philologus* Suppl., no. 30, part 2.

Evelyn-White, H. G. 1936. *Hesiod, the Homeric Hymns and Homerica*. London: W. Heinemann; Cambridge, Mass.: Harvard University Press.

Faraone, C. A. 1991. "The Agonistic Context of Early Greek Binding Spells." In *Magika Hiera: Ancient Greek Magic and Religion*, eds. C. A. Faraone and D. Obbink. New York: Oxford University Press.

Farnell, L. R. 1897. *The Cults of the Greek States*. Vol. 2. Oxford: Clarendon Press.

————. 1907. *The Cults of the Greek States*. Vol. 4. Oxford: Clarendon Press.

Fehr, B. 1984. *Die Tyrannentöter*. Frankfurt am Main: Fisher Taschenbuch Verlag.

Ferrari, G. 1984. "For the Heroes Are at Hand." *JHS* 104: 181–83.

————. 1986. "Money-bags?" *AJA* 90: 218.

————. 1987. "Menelas." *JHS* 107: 180–82.

————. 1988. *I vasi attici a figure rosse del periodo arcaico. Materiali del Museo Archeologico Nazionale di Tarquinia*. Rome: G. Bretschneider.

————. 1988a. "Pallas and Panathenaea." In Christiansen and Melander 1988, 465–77.

————. 1990. "Figures of Speech: The Picture of *Aidos*." *Métis* 5: 185–200.

————. 1993. "Coming of Age in Ancient Greece." In *Gender, Race, and Identity*, eds.

C. Barrow, K. Frank, J. Philips, and K. Sanderlin, 99–110. Chattanooga, Tenn.: Southern Humanities Press.

———. 1994–95. "Heracles, Pisistratus and the Panathenaea." *Métis* 9–10: 219–26.

———. 1995. "The End of Aponia." *MMAJ* 30: 17–18.

———. 1995a. "Fugitive Nudes: The Woman Athlete." *AJA* 99: 303–4.

———. 1997. "Figures in the Text: Metaphors and Riddles in the *Agamemnnon.*" *CP* 92: 1–45.

———. Forthcoming. "Myth and Genre on Athenian Vases." *ClAnt* 21.

———. Forthcoming 2. "Meaningful Figures." In *A City of Images: Some Views 12 Years Later*, ed. R. F. Sutton.

Ferrari Pinney, G. 1983. "Achilles, Lord of Scythia." In Moon 1983, 127–46.

Fink, J. 1952. "Zur Bärtigkeit der griechischen Götter und Helden in archaischer Zeit." *Hermes* 80: 110–14.

Flemberg, J. 1991. *Venus Armata: Studien zur bewaffneten Aphrodite in der griechisch-römischen Kunst.* Skrifter utgivna av Svenska institutet i Athen, no. 10 in 8°. Stockholm: Svenska institutet i Athen.

Fogg Art Museum, 1973. *The Frederick M. Watkins Collection.* Cambridge, Mass.: Harvard University Press.

Fornara, C. W. 1970. "The Cult of Harmodios and Aristogeiton." *Philologus* 114: 155–80.

Foxhall, L. 1989. "Household, Gender and Property in Classical Athens." *CQ* 39: 22–44.

Foucault, M. 1972. *The Archaeology of Knowledge.* Trans. A. M. Sheridan Smith. London: Tavistock.

Frank, S. 1990. *Attische Kelchkratere.* Frankfurt am Main: P. Lang.

Frazer, J. G. 1921. *Apollodorus. The Library.* Cambridge, Mass.: Harvard University Press.

Freeman, K. 1948. *Ancilla to the Pre-Socratic Philosophers.* Cambridge, Mass.: Harvard University Press.

Freese, J. H. 1926. *Aristotle. The Art of Rhetoric.* London: W. Heinemann; New York: G. P. Putnam's Sons.

Freyer-Schauenburg, B. 1974. *Bildwerke der archaischen Zeit und des strengen Stils.* Samos, no. 11. Bonn: Rudolf Habelt.

Friis Johansen, H., and W. Whittle, eds. 1980. *Aeschylus. The Suppliants.* 3 vols. Copenhagen: Gyldendalske.

Froning, H. 1982. *Katalog der griechischen und italischen Vasen.* Essen: Museum Folkwang.

Frontisi-Ducroux, F. 1997. *Dans l'oeil du miroir.* Paris: Odile Jacob.

Frontisi-Ducroux, F., and F. Lissarrague. 1990. "From Ambiguity to Ambivalence: A Dionysiac Excursion through the 'Anacreontic' Vases." In Halperin, Winkler, and Zeitlin 1990, 211–56.

———. 1990a. "Vingt ans de vases grecs." *Métis* 5: 205–24.

Furtwängler, A. 1883. *Die Sammlung Sabouroff.* Vol. 1. Berlin: A. Asher & Co.

Furtwängler, A., and K. Reichhold. 1904–32. *Griechische Vasenmalerei.* Munich: Bruckmann.

Furtwängler, A. E. 1995. "Poterion und Knabenliebe. Zum Schatzfund von Klazomenai 1989." *AA* (1995): 441–50.

Gagarin, M. 1981. *Drakon and Early Athenian Homicide Law*. New Haven, Conn.: Yale University Press.

———, ed. 1991. *Papers on Greek and Hellenistic Legal History*. Cologne: Böhlau.

Gallant, T. W. 1991. *Risk and Survival in Ancient Greece*. Stanford, Calif.: Stanford University Press.

Galt, C. M. 1931. "Veiled Ladies." *AJA* 35: 373–93.

Gentili, B. 1958. *Anacreon*. Rome: Edizioni dell'Ateneo.

Gentili, B., and C. Prato. 1985. *Poetarum elegiacorum testimonia et fragmenta*. Leipzig: Teubner.

Gernet, L. "Hypothèses sur le contract primitif en Grèce." *REG* 30: 249–93.

———. 1968. *Anthropologie de la Grèce antique*. Paris: Maspero.

———. 1983. "Observations sur le mariage en Grèce." In Di Donato 1983, 197–210.

Geymonat, M. 1974. *Scholia in Nicandri Alexipharmaca*. Varese-Milano: Cisalpino-Goliardica.

Ginouvès, R. 1962. *Balaneutikè; recherches sur le bain dans l'antiquité grecque*. Bibliothèque des Écoles françaises d'Athènes et de Rome, no. 200. Paris: E. de Boccard.

Ginzburg, C. 1983. "Morelli, Freud and Sherlock Holmes: Clues and Scientific Method." In *The Sign of Three*, eds. U. Eco and T. A. Sebeok, 81–118. Bloomington: Indiana University Press.

———. 1998. "Style as Inclusion, Style as Exclusion." In *Picturing Science, Producing Art*, eds. P. Galison and C. A. Jones, 27–54. New York and London: Routledge.

Glotz, G. 1904. *L'ordalie dans la Grèce primitive*. Paris: Fontemoing.

Golden, M. 1984. "Slavery and Homosexuality at Athens." *Phoenix* 38: 308–24.

Golden, M., and P. Toohey, eds. 1997. *Inventing Ancient Culture*. London and New York: Routledge.

Götte, E. 1957. *Frauengemachbilder in der Vasenmalerei des 5. Jahrhunderts*. Munich: Uni-Druck.

Gombrich, E. 1956. *Art and Illusion*. Princeton, N.J.: Princeton University Press.

Gomme, A. W., A. Andrews, and K. J. Dover. 1970. *A Historical Commentary on Thucydides*. Vol. 4. Oxford: Clarendon Press.

Goodman, N. 1976. *Languages of Art*. Indianapolis, Ind.: Bobbs-Merrill.

Gould, J. P. 1980. "Law, Custom and Myth: Aspects of the Social Position of Women in Classical Athens." *JHS* 100: 38–59.

Gow, A. S. F. 1953. *The Greek Bucolic Poets*. Cambridge: Cambridge University Press.

Graef, B., and E. Langlotz. 1909–33. *Die antiken Vasen von der Akropolis zu Athen*. Berlin: de Gruyter.

Gray, D. 1955. "Houses in the Odyssey." *CQ* 5: 1–12.

Grebe, S. 1999. "Jüngere oder ältere Mädchen? Aristophanes, *Lysistrate* 641–647." *MusHelv* 56: 194–203.

Grene, D. 1991. *Sophocles I. The Complete Greek Tragedies*, eds. D. Grene and R. Lattimore. Chicago: University of Chicago Press.

Griffith, M. 1999. *Sophocles. Antigone*. Cambridge: Cambridge University Press.

Grillet, E. 1975. *Les femmes et les fards dans l'antiquité grecque.* Lyon: Centre National de la Recherche Scientifique.

Groningen, B. A. van. 1977. *Euphorion.* Amsterdam: Hakkert.

Grzybek, E. 1989. "Die griechische Konkubine und ihre 'Mitgift.'" *ZPE* 76: 206–12.

Guarducci, M. 1935–50. *Inscriptiones Creticae.* Rome: Libreria dello Stato.

———. 1967. *Epigrafia greca.* Vol. 1. Rome: Istituto Poligrafico dello Stato.

Guy, J. R. 1981. "A Ram's Head Rhyton Signed by Charinos." *Arts in Virginia* 21, no. 2: 2–15.

Halperin, D. M. 1990. *One Hundred Years of Homosexuality.* New York and London: Routledge.

Halperin, D. M., J. J. Winkler, and F. I. Zeitlin, eds. 1990. *Before Sexuality: The Construction of Erotic Experience in the Ancient Greek World.* Princeton, N.J.: Princeton University Press.

Hamilton, R. 1989. "Alcman and the Athenian Arkteia." *Hesperia* 58: 449–72.

Hamma, K., ed. 1989. *The Dechter Collection of Greek Vases.* San Bernardino: California State University.

Hampe, R. 1937. "Rückkehr eines Jünglings." In *Corolla, Ludwig Curtius zum sechzigsten Geburtstag dargebracht,* 142–47. Stuttgart: Kohlhammer.

———. 1951. *Die Stele aus Pharsalos im Louvre.* Winckelmannsprogramm der Archäologischen Gesellschaft zu Berlin, no. 107. Berlin: W. de Gruyter.

———. 1955. "Eukleia und Eunomia." *RM* 62: 107–23.

———. 1976. "Tönerner Phormiskos aus Metapont." *AA:* 192–202.

Hanson, A. 1990. "The Medical Writers' Woman." In Halperin, Winkler, and Zeitlin 1990, 324–30.

———. 1993. "Conception, Gestation, and the Origin of Female Nature in the *Corpus Hippocraticum.*" *Helios* 19: 31–71.

Harder, R. 1953. "Herodot I, 8, 3." In Mylonas and Raymond 1953, 446–49.

Harris, J. 1993. "Love and Death in the *Männerbund:* An Essay with Special Reference to the *Bjarkamál* and *The Battle of Maldon.*" In *Heroic Poetry in the Anglo-Saxon Period. Studies in Honor of Jess B. Bessinger, Jr.,* eds. H. Damico and J. Leyerle. Studies in Medieval Culture, no. 22, 77–114. Kalamazoo, Mich.: Medieval Institute Publications.

Harrison, A. R. W. 1968. *The Law of Athens.* Vol. 1, *The Family and Property.* Oxford: Clarendon Press.

Harrison, E. B. 1988. "Greek Sculptured Coiffures and Ritual Haircuts." In *Early Greek Cult Practice,* eds. R. Hägg, N. Marinatos, and G. C. Nordquist, 247–54. Skrifter utgivna av Svenska institutet i Athen, no. 38 in 4°. Stockholm: Svenska Institutet i Athen.

Harvey, F. 1988. "Painted Ladies: Fact, Fiction and Fantasy." In Christiansen and Melander 1988, 242–54.

Hauser, F. 1886. "Eine Sammlung von Stilproben griechischer Keramik." *JdI* 11: 177–97.

Hecht, A., and H. H. Bacon. 1973. *Seven against Thebes.* New York: Oxford University Press.

Hedreen, G. M. 1992. *Silens in Attic Black-figure Vase-painting: Myth and Performance.* Ann Arbor: University of Michigan Press.

Heilmeyer, W.-D., E. Goemann, L. Giuliani, G. Platz, and G. Zimmer. 1988. *Antikenmuseum Berlin: Die ausgestellten Werke*. Berlin: Staatliche Museen Preussischer Kulturbesitz.

Helmbold, W. C. 1961. *Plutarch's Moralia*. Vol. 9. Cambridge, Mass.: Harvard University Press.

Hemelrijk, J. M. 1976. "Two lekythoi by the Icarus Painter in the Allard Pierson Museum." *BABesch* 51: 93–95.

Henderson, J. 1987. *Aristophanes. Lysistrata*. Oxford: Clarendon Press.

Henrichs, A. 1987. "Three Approaches to Greek Mythography." In *Interpretations of Greek Mythology*, ed. J. Bremmer, 242–77. London: Croom Helm.

Herdt, G. H. 1994. *Guardians of the Flutes: Idioms of Masculinity*. 2d ed. New York: McGraw-Hill.

Herdt, G. H., ed. 1982. *Rituals of Manhood*. Berkeley, Los Angeles and London: University of California Press.

———, ed. 1982a. *Ritualized Homosexuality in Melanesia*. Berkeley: University of California Press.

Himmelmann, N. 1990. *Ideale Nacktheit in der griechischen Kunst*. Berlin and New York: de Gruyter.

———. 1998. "Narrative and Figure in Archaic Art." In *Reading Greek Art. Essays by N. Himmelmann*, ed. W. Childs, trans. H. A. Shapiro. Princeton, N.J.: Princeton University Press. First published in *AbhMainz* as "Erzählung und Figur in der archaischen Kunst" (1967, no. 2): 73–97.

Hodkinson, S., and A. Powell, eds. 1999. *Sparta. New Perspectives*. London: Duckworth.

Hoffmann, H. 1977. *Sexual and Asexual Pursuit: A Structuralist Approach to Greek Vase Painting*. Occasional Papers, no. 34. London: Royal Anthropological Institute.

———. 1979. "In the Wake of Beazley." *Hephaistos* 1: 61–70.

Hoppin, J. C. 1919. *A Handbook of Attic Red-figured Vases by or Attributed to the Various Masters of the Sixth and Fifth Centuries B.C.* Cambridge, Mass.: Harvard University Press.

Hornblower, S. 1991. *A Commentary on Thucydides*. Vol. 1. Oxford: Clarendon Press.

Hruza, E. 1894. *Beiträge zur Geschichte des griechischen und römischen Familienrechtes*. Vol. 2. Erlangen and Leipzig: Deichert.

Hupperts, C. A. M. 1988. "Greek Love: Homosexuality or Paederasty?" In Christiansen and Melander 1988, 255–68.

Hussey, E. 1982. "Epistemology and Meaning in Heraclitus." In Schofield and Nussbaum 1982, 33–59.

Hutchinson, G. O., ed. 1987. *Aeschylus. Septem contra Thebas*. Rev. ed. Oxford: Clarendon Press.

Immerwahr, H. R. 1984. "An Inscribed Cup by the Ambrosios Painter." *AntK* 27: 10–13.

———. 1990. *Attic Script*. Oxford: Clarendon Press.

Jacquet-Rimassa, P. 1995. "ΚΟΤΤΑΒΟΣ. Recherches iconographiques. Ceramique italiote. 440–300 av. J.-C." *Pallas* 42: 129–70.

Jakobson, R. 1977–88. *Selected Writings*. 2d ed. The Hague, Paris, and New York: Mouton.

————. 1977. "Two Aspects of Language and Two Types of Aphasic Disturbances." In Jakobson 1977–88, 2: 240–59.

————. 1981. "Linguistics and Poetics." In Jakobson 1977–88, 3: 18–51.

————. 1990. "The Concept of Mark." In Waugh and Monville-Burston 1990, 134–40.

————. 1990a. "Some Questions of Meaning." In Waugh and Monville-Burston 1990, 315–23.

Jeanmaire, H. 1939. *Couroi et courètes. Essai sur l'éducation spartiate et sur les rites d'adolescence dans l'antiquité hellénique.* Lille and Paris: Bibliothèque Universitaire.

Jeffery, L. H. 1961. *The Local Scripts of Archaic Greece.* Oxford: Clarendon Press.

Jehasse, J., and L. Jehasse. 1973. *La nécropole préromaine d'Aléria (1960–1968). Gallia* Suppl., no. 25.

Jenkins, I. 1983. "Is There Life after Marriage: A Study of the Abduction Motif in Vase Paintings of the Athenian Wedding Ceremony." *BICS* 30: 137–45.

————. 1989. *Adam Buck's Greek Vases.* Occasional Papers, no. 75. London: British Museum.

Jenkins, I., and D. Williams. 1985. "Sprang Hair Nets: Their Manufacture and Use in Ancient Greece." *AJA* 89: 411–18.

Jenkins, J. H. 1932–33. "Laconian Terracottas of the Daedalic Style." *BSA* 33: 71–72.

Johnson, M. 1981. *Philosophical Perspectives on Metaphor.* Minneapolis: University of Minnesota Press.

Johnston, S. I. 1999. *Restless Dead.* Berkeley, Los Angeles, and London: University of California Press.

Just, R. 1989. *Women in Athenian Law and Life.* London and New York: Routledge.

Kaempf-Dimitriadou, S. 1979. *Die Liebe der Götter in der attischen Kunst des 5. Jahrhunderts v. Chr. AntK* Beiheft, no. 11.

Kahil, L. G.1955. *Les enlèvements et les retours d'Hélène dans les textes et les document 5 figurés.* Paris: E. de Boccard.

————. 1963. "Quelques vases du sanctuaire d'Artémis à Brauron." In *Neue Ausgrabungen in Griechenland,* 5–29. *AntK* Beiheft, no. 1.

————. 1965. "Autour de l'Artémis attique." *AntK* 8: 20–33.

————. 1977. "L'Artémis de Brauron: Rites et Mystère." *AntK* 20: 86–98.

————. 1981. "Le 'craterisque' d'Artémis et le Brauronion de l'Acropole." *Hesperia* 50: 253–63.

————. 1983. "Mythological Repertoire of Brauron." In Moon 1983, 231–44.

Kahn, C. H. 1979. *The Art and Thought of Heraclitus.* New York: Cambridge University Press.

Kallet-Marx, L. 1993. "Thucydides 2.45.2 and the Status of War Widows." In Rosen and Farrell 1993, 133–43.

Kassel, R., and C. Austin. 1984. *Poetae Comici Graeci.* Vol. 3, part 2, *Aristophanes: Testimonia et fragmenta.* Berlin: de Gruyter.

Kauffmann-Samaras, A. 1988. "Mère et enfant sur les lébetès nuptiaux à figures rouges attiques du Vème siècle av. J.-C." In Christiansen and Melander 1988, 286–99.

Keaney, J. J. 1991. *Harpocration. Lexeis of the Ten Orators.* Amsterdam: Hakkert.

Kennell, N. M. 1995. *The Gymnasium of Virtue*. Chapel Hill: University of North Carolina Press.

Kern, O. 1927. *Hermann Diels und Carl Robert: Ein biographischer Versuch. Jahresbericht über die Fortschritte der klassischen Altertumswissenschaft* Suppl., no. 215.

Keuls, E. C. 1983. "Attic Vase-painting and the Home Textile Industry." In Moon 1983, 209–30.

———. 1983a. "'The Hetaera and the Housewife': The Splitting of the Female Psyche in Greek Art." *Meded* 44–45, n.s. 9–10: 23–40.

———. 1985. *The Reign of the Phallus*. New York: Harper & Row.

Kilmer, M. 1997. "Painters and Pederasts: Ancient Art, Sexuality, and Social History." In Golden and Toohey 1997, 36–49.

Knauer, E. R. 1976. "Fragments of a Cup by the Triptolemos Painter." *GRBS* 17: 209–16.

Knigge, U. 1981. "Kerameikos. Tätigkeitsbericht 1979." *AA*: 385–93.

———. 1982. "Ὁ ἀστὴρ τῆς Ἀφροδίτης." *AM* 97: 153–70.

———. 1983. "Kerameikos. Tätigkeitsbericht 1981." *AA*: 209–21.

———. 1991. *The Athenian Kerameikos*. Trans. J. Binder. Athens: Krene.

Knox, M. O. 1973. "Megarons and Megara." *CQ* 67: 1–21.

Koch-Harnack, G. 1983. *Knabenliebe und Tiergeschenke*. Berlin: Mann.

Kretschmer, P. 1894. *Die griechischen Vaseninschriften*. Gütersloh: C. Bertelsmann.

Kron, U. 1976. *Die zehn attischen Phylenheroen*. Berlin: Mann.

Kukofka, D.-A. 1993. "Die ΠΑΙΔΙΣΚΟΙ im System der spartanischen Altersklassen." *Philologus* 137: 197–205.

Kunisch, N. 1980. *Antiken der Sammlung Julius C. und Margot Funcke*. Bochum: Ruhr-Universität Bochum.

———. 1997. *Makron*. Mainz am Rhein: P. von Zabern.

Kunze, M., ed. 1977. *Beiträge zum antiken Realismus*. Schriften der Winckelmann-Gesellschaft, no. 3. Berlin: Akademie-Verlag.

Kurke, L. 1991. *The Traffic in Praise*. Ithaca: Cornell University Press.

———. 1999. *Coins, Bodies, Games, and Gold: The Politics of Meaning in Archaic Greece*. Princeton, N.J.: Princeton University Press.

Kurtz, D. C. 1975. *Athenian White Lekythoi*. Oxford: Clarendon Press.

———. 1985. "Beazley and the Connoisseurship of Greek Vases." In *Greek Vases in the J. Paul Getty Museum. Volume 2*. Occasional Papers on Antiquities, no. 3, 237–50. Malibu, Calif: The Museum.

———, ed. 1985. *Beazley and Oxford*. Oxford: Oxford University Committee for Archaeology.

Kyle, D. G. 1987. *Athletics in Ancient Athens*. Mnemosyne Suppl., no. 95.

Kyrieleis, H. 1996. *Der grosse Kuros von Samos*. Samos, no. 10. Bonn: R. Habelt.

Labarbe, J. 1953. "L'âge correspondant au sacrifice du *koureion* et les données historiques du sixième discours d'Isée." *Académie Royale de Belgique. Classe de Lettres. Bulletin* 39: 358–93.

Lacey, W. K. 1968. *The Family in Classical Greece*. London: Thames & Hudson.

Lacy, L. R. 1990. "Aktaion and a Lost 'Bath of Artemis.'" *JHS* 110: 26–42.

Lakoff, G., and M. Johnson. 1980. *Metaphors We Live By.* Chicago: University of Chicago Press.

Lakoff, G., and M. Turner. 1989. *More than Cool Reason.* Chicago: University of Chicago Press.

Lang, A. 1880. *Theocritus, Bion, and Moschus.* London: Macmillan & Co.

Lang, M. 1908. *Die Bestimmung des Onos oder Epinetron.* Berlin: Weidmann.

Langlotz, E. 1932. *Griechische Vasen in Würzburg.* Munich: J. B. Obernetter.

Laqueur, T. W. 1990. *Making Sex: Body and Gender from the Greeks to Freud.* Cambridge, Mass.: Harvard University Press.

Laqueur, W. 1984. *Young Germany: A History of the German Youth Movement.* 2d. ed. New Brunswick, N.J.: Transaction Books.

Lasserre, F. 1974. "Ornements érotiques dans la poésie lyrique archaïque." In *Serta Turyniana,* eds. J. L. Heller and J. K. Newman, 5–33. Urbana: University of Illinois Press.

Lattimore, R. 1951. *The Iliad of Homer.* Chicago: University of Chicago Press.

———. 1967. *The Odyssey of Homer.* New York, Evanston, and London: Harper & Row.

Lavrencic, M. 1988. "Andreion." *Tyche* 3: 147–61.

Lawler, L. B. 1960. "Cosmic Dance and Dithyramb." In *Studies in Honor of Ullman,* eds. L. B. Lawler, D. M. Robathan, and W. C. Korfmacher, 12–16. Saint Louis, Mo.: Classical Bulletin, 1960.

Lazarus, M., and H. Steinthal. 1860. "Einleitende Gedanken über Völkerpsychologie als Einladung zu einer Zeitschrift für Völkerpsychologie und Sprachwissenschaft." *Zeitschrift für Völkerpsychologie und Sprachwissenschaft* 1: 1–73.

Lazzarini, M. L. 1976. "Le formule delle dediche votive nella Grecia arcaica." *MemLinc,* ser. 8, 19: 47–353.

Lederman, G. S. 1998. "Athletes, Warriors, and Heroes: The Helmeted-head Aryballos in Its Archaic Greek Context." Ph.D. diss., Bryn Mawr College.

Leipen, N., ed. 1984. *Glimpses of Excellence: A Selection of Greek Vases and Bronzes from the Elie Borowski Collection.*Toronto: Royal Ontario Museum.

Leitao, D. D. 1995. "The Perils of Leukippos: Initiatory Transvestism and Male Gender Ideology in the Ekdusia at Phaistos." *ClAnt* 14: 130–63.

Lévi-Strauss, C. 1963. *Structural Anthropology.* Trans. C. Jacobson and B. G. Schoepf. New York: Basic Books.

———. 1969. *The Elementary Structures of Kinship.* Rev. ed. Trans. J. H. Bell, J. R. von Sturmer, and R. Needham. London: Eyre & Spottiswoode.

Lewis, J. M. 1985. "Eros and the *Polis* in Theognis Book II." In *Theognis of Megara,* eds. T. J. Figueira and G. Nagy, 197–222. Baltimore: Johns Hopkins University Press.

Lezzi-Hafter, A. 1976. *Der Schuwalow-Maler.* Mainz am Rhein: P. von Zabern.

———. 1988. *Der Eretria-Maler.* Mainz am Rhein: P. von Zabern.

Licht, H. 1932. *Sexual Life in Ancient Greece.* Trans. J. H. Freese. London: Constable.

Lincoln, B. 1991. *Emerging from the Chrysalis.* 2d ed. New York: Oxford University Press.

Lind, H. 1988. "Ein Hetärenhaus am Heiligen Tor?" *MusHelv* 45: 158–69.

Linders, T. 1972. *Studies in the Treasure Records of Artemis Brauronia Found in Athens.* Stockholm: Svenska Institutet i Athen.

Link, S. 1994. *Das griechische Kreta*. Stuttgart: Steiner.

Lissarrague, F. 1990. *The Aesthetics of the Greek Banquet*. Trans. A. Szegedy-Maszak. Princeton, N.J.: Princeton University Press.

———. 1990a. *L'Autre guerrier*. Paris and Rome: La Découverte.

———. 1991. "Femmes au figuré." In *Histoire des femmes en Occident*, ed. P. Schmitt Pantel, 1: 159–251. Paris: Plon.

———. 1995. "Women, Boxes, Containers: Some Signs and Metaphors." In Reeder 1995, 91–101.

———. 1999. *Vases grecs: Les athéniens et leurs images*. Marano (Vicenza): Hazan.

Lissarrague, F., and A. Schnapp. 1981. "Imagerie des grecs ou Grèce des imagiers?" *Le temps de la réflexion* 2: 286–97.

Lloyd, G. E. R. 1971. *Polarity and Analogy*. Cambridge: Cambridge University Press.

Lloyd-Jones, H. 1952. "The Robes of Iphigenia." *CR* 2: 132–35.

———. 1983. *The Justice of Zeus*. Berkeley, Los Angeles, and London: University of California Press.

———. 1996. *Sophocles. Fragments*. Cambridge, Mass.: Harvard University Press.

Lobel, E., and D. L. Page. 1955. *Poetarum Lesbiorum Fragmenta*. Oxford: Clarendon Press.

Loewenberg, I. 1975. "Identifying Metaphors." *Foundations of Language* 15: 315–38. Reprinted in Johnson 1981, 154–77.

Lonie, I. M. 1981. *The Hippocratic Treatises "On Generation," "On the Nature of the Child," "Diseases IV."* Berlin and New York: de Gruyter.

Lonsdale, S. H. 1993. *Dance and Ritual Play in Greek Religion*. Baltimore: Johns Hopkins University Press.

Loraux, N. 1975. "Hebe et andreia." *Ancient Society* 6: 1–31.

Lorimer, H. L. 1950. *Homer and the Monuments*. London: Macmillan.

Lowie, R. H. 1920. *Primitive Society*. New York: Boni and Liveright.

Lullies, R., and M. Hirmer. 1960. *Greek Sculpture*. New York: H. N. Abrams.

MacDowell, D. M. 1976. "Bastards as Athenian Citizens." *CQ* 26: 88–91.

———. 1978. *The Law in Classical Athens*. Ithaca: Cornell University Press.

———. 1989. "The *Oikos* in Athenian Law." *CQ* 39: 10–21.

MacLachlan, B. 1993. *The Age of Grace: Charis in Early Greek Poetry*. Princeton, N.J.: Princeton University Press.

MacLeod, M. D. 1967. *Lucian*. Vol. 8. Cambridge, Mass.: Harvard University Press.

Marconi, C. 1994. *Selinunte. Le metope dell'Heraion*. Modena: Panini.

Marinatos, S. 1967. *Kleidung, Haar- und Barttracht*. Archaeologia Homerica, part 1, chapter 1. Göttingen: Vandenhoeck & Ruprecht.

Marrou, H.-I. 1948. *Histoire de l'éducation dans l'antiquité*. Paris: Éditions du Seuil.

Massenzio, M. 1970. *Cultura e crisi permanente: La 'xenia' dionisiaca*. Quaderni di Studi e Materiali di Storia delle Religioni, no. 6. Rome: Edizioni dell'Ateneo.

McDonald, M. F. 1964. *Lactantius. The Divine Institutes*. Washington, D.C.: Catholic University of America Press.

McDonnell, M. 1991. "The Introduction of Athletic Nudity: Thucydides, Plato, and the Vases." *JHS* 111: 182–93.

Merkelbach, R., and M. L. West. 1967. *Fragmenta Hesiodea*. Oxford: Clarendon Press.

Metzger, H. 1951. *Les représentations dans la céramique attique du IVe siècle*. Paris: E. de Boccard.

Metzler, D. 1980. "Eunomia und Aphrodite." *Hephaistos* 2: 73–88.

Meyer, M. 1988. "Männer mit Geld." *JdI* 103: 87–125.

Millender, E. 1999. "Athenian Ideology and the Empowered Spartan Woman." In Hodkinson and Powell 1999, 355–91.

Miller, F. J. 1925. *Ovid: Metamorphoses*. London: W. Heinemann; New York: G.P. Putnam.

Miller, J. 1986. *Measures of Wisdom. The Cosmic Dance in Classical and Christian Antiquity*. Toronto, Buffalo, and London: University of Toronto Press.

Milne, M. J. 1945. "A Prize for Woolworking." *AJA* 49: 528–33.

Mitchell, W. J. T. 1986. *Iconology*. Chicago: University of Chicago Press.

Momigliano, A. 1950. "Ancient History and the Antiquarian." *Journal of the Warburg and Courtauld Institutes* 13: 285–315.

———. 1990. *The Classical Foundations of Modern Historiography*. Berkeley: University of California Press.

Moon, W. G., ed. 1983. *Ancient Greek Art and Iconography*. Madison: University of Wisconsin Press.

Mooney, G. W., ed. 1964. *The Argonautica of Apollonius Rhodius*. Amsterdam: A. M. Hakkert.

Moore, M. B. 1997. *Attic Red-figured and White-ground Pottery*. Athenian Agora, no. 30. Princeton, N.J.: American School of Classical Studies at Athens.

Moret, J.-M. 1990. "*Io apotauromene.*" *RA*: 3–26.

———. 1991. "Circé tisseuse sur les vases du Cabirion." *RA*: 227–66.

Morgan, L. 1985. "Idea, Idiom, and Iconography." *BCH* Suppl., no. 11: 5–19.

———. 1988. *The Miniature Wall Paintings of Thera*. New York: Cambridge University Press.

Morris, I. 1994. "Archaeologies of Greece." In *Classical Greece: Ancient Histories and Modern Archaeologies*, ed. I. Morris, 8–47. Cambridge: Cambridge University Press.

———. 2000. *Archaeology as Cultural History*. Oxford and Malden, Mass.: Blackwell.

Morrison, J. S. 1964. "Four Notes on Plato's *Symposium*." *CQ* 14: 42–55.

Mossé, C. 1991. "La place de la pallakê dans la famille athénienne." In Gagarin 1991, 273–79.

Murray, O. 1983. "Symposion and Männerbund." In *Concilium Eirene: Proceedings of the 16th International Eirene Conference*, eds. P. Oliva and A. Frolíková, 47–52. Prague: Kabinet pro studia recká, rímská a lat. CSAV.

———, ed. 1990. *The Greek City*. Oxford: Clarendon Press.

Murray, S. P. 1985. *The Joseph Veach Noble Collection*. Tampa, Fla.: Tampa Museum.

Münzen und Medaillen. 1971. *Sonderliste N*. Basel: Münzen und Medaillen A.G.

———. 1975. *Auktion 51*. Basel: Münzen und Medaillen A. G.

Mylonas, G. E., and D. Raymond, eds. 1953. *Studies Presented to David Moore Robinson on his Seventieth Birthday.* Vol. 2. St. Louis, Mo.: Washington University Press.

Nagy, G. 1999. *The Best of the Achaeans.* 2d ed. Baltimore: Johns Hopkins University Press.

Nauck, A., ed. 1964. *Tragicorum graecorum fragmenta.* Rev. ed. by B. Snell. Hildesheim: Georg Olms.

Nehamas, A., and P. Woodruff. 1989. *Plato, Symposium.* Indianapolis and Cambridge, Mass.: Hackett Publishing Co.

Neils, J. 2000. "Others within the Other: An Intimate Look at Hetairai and Maenads." In Cohen 2000, 201–26.

Nevett, L. 1999. *House and Society in the Ancient Greek World.* Cambridge: Cambridge University Press.

Newman, W. L. 1887. *The Politics of Aristotle.* Vol. 2. Oxford: Clarendon Press.

Nietzsche, F. [1873] 1911. "On Truth and Falsity in their Ultramoral Sense." In *The Complete Works of Friedrich Nietzsche,* ed. O. Levy, 171–92. London and Edinburgh: T. N. Foulis.

North, H. F. 1977. "The Mare, the Vixen, and the Bee." *Illinois Classical Studies* 2: 35–48.

Nussbaum, M. C. 1978. *Aristotle's de motu animalium.* Princeton, N.J.: Princeton University Press.

Oakley, J. H. 1982. "The Anakalypteria." *AA:* 113–18.

———. 1990. *The Phiale Painter.* Mainz am Rhein: P. von Zabern.

———. 1997. *The Achilles Painter.* Mainz: P. von Zabern.

Oakley, J. H., and R. H. Sinos. 1993. *The Wedding in Ancient Athens.* Madison: University of Wisconsin Press.

Ogden, D. 1996. *Greek Bastardy.* Oxford: Clarendon Press.

———. 1996a. "Homosexuality and Warfare in Ancient Greece." In *Battle in Antiquity,* ed. A. B. Lloyd, 107–68. London: Duckworth.

Olmos, R. 1990. *Vasos griegos. Coleccion Condes de Lagunillas.* Kilchberg and Zurich: Akanthus.

Osborne, R. 1985. *Demos: The Discovery of Classical Attika.* Cambridge: Cambridge University Press.

———. 1997. "Law, the Democratic Citizen and the Representation of Women in Classical Athens." *Past and Present* 155: 3–33.

———. 1998. "Sculpted Men of Athens: Masculinity and Power in the Field of Vision." In *Thinking Men. Masculinity and Its Self-representation in the Classical Tradition,* eds. L. Foxhall and J. Salmon, 23–42. London and New York: Routledge.

———. 1998a. "Men without Clothes: Heroic Nakedness and Greek Art." In *Gender and the Body in the Ancient Mediterranean,* ed. M. Wyke, 80–104. Oxford and Malden, Mass.: Blackwell.

Ostwald, M., trans. 1962. *Nicomachean Ethics.* New York: Macmillan.

Padgett, J. M. 1988. *The Painted Past.* Salt Lake City: Utah Museum of Fine Arts.

Page, D. L. 1951. *Alkman. The Partheneion.* Oxford: Clarendon Press.

———. 1962. *Poetae Melici Graeci.* Oxford: Clarendon Press.

Palaiokrassa, L. 1991. *To hiero tes Artemidos Mounichias*. Bibliotheke tes en Athenais Archaiologikes Hetaireias, no. 115. Athens: Athenais Archaiologike Hetaireia.

Pangle, T. L., trans. 1980. *The Laws of Plato*. New York: Basic Books.

Papaspyridi Karouzou, S. 1945. "Vases from Odos Pandrosou." *JHS* 65: 38–44.

———. 1957. "Ἡ τυφλὴ Ἄρχτος." *AE* 68–83.

Papoutsakis-Sermpetis, E. 1983. *Ho zographos tes Providence*. Athens: [s.n.].

Paradiso, A. 1986. "Osservazioni sulla cerimonia nunziale spartana." *Quaderni di Storia* 24: 137–53.

Parker, R. 1983. *Miasma*. Oxford: Clarendon Press.

Parker, R. 1984. *The Subversive Stitch: Embroidery and the Making of the Feminine*. New York: Routledge.

Pasley, M., ed. *Nietzsche: Imagery and Thought. A Collection of Essays*. Berkeley and Los Angeles: Methuen.

Pasquier, A., and M. Denoyelle, eds. 1990. *Euphronios, peintre à Athènes au VIe siècle avant J.-C.* Paris: Éditions de la Réunion des Musées Nationaux.

Patterson, C. B. 1986. "HAI ATTIKAI: The Other Athenians." *Helios* 13: 49–67.

———. 1990. "Those Athenian Bastards." *ClAnt* 9: 40–73.

———. 1991. "Marriage and the Married Woman in Athenian Law." In *Women's History and Ancient History*, ed. S. B. Pomeroy, 48–72. Chapel Hill: University of North Carolina Press.

———. 1991a. "Response to Claude Mossé." In Gagarin 1991, 281–87.

———. 1998. *The Family in Greek History*. Cambridge, Mass.: Harvard University Press.

Patzer, H. 1982. *Die griechische Knabenliebe*. Sitzungsberichte der wissenschaftlichen Gesellschaft an der Johann Wolfgang Goethe-Universität Frankfurt am Main, no. 19, no. 1. Wiesbaden: F. Steiner.

Payne, H., et al. 1940. *Perachora: The Sanctuaries of Hera Akraia and Limenia. Excavations of the British School of Archaeology at Athens, 1930–1933*. Vol. 1, *Architecture, Bronzes, Terracottas*. Oxford: Clarendon Press.

Pearson, A. C., ed. 1917. *The Fragments of Sophocles*. Cambridge: Cambridge University Press.

Peck, A. L. 1943. *Aristotle. Generation of Animals*. Cambridge, Mass.: Harvard University Press.

Pélékidis, C. 1962. *Histoire de l'éphébie attique des origines à 31 avant Jésus-Christ*. Paris: E. de Boccard.

Pender, E. E. 1992. "Spiritual Pregnancy in Plato's *Symposium*." *CQ* 42: 72–86.

Percy, W. A., III. 1996. *Pederasty and Pedagogy in Archaic Greece*. Urbana Chicago: University of Illinois Press.

Perdrizet, P. 1908. *Monuments figurés: Petits bronzes, terres-cuites, antiquités diverses*. Fouilles de Delphes, no. 5. Paris: A. Fontimoing.

Peredol'skaia, A. A. 1967. *Krasnofigurnye atticheskie vazy v Ermitazhe*. Leningrad: Sov. khudozhnik.

Perlman, P. 1983. "Plato *Laws* 833C-834D and the Bears of Brauron." *GRBS* 24: 115–30.

————. 1989. "Acting the She-bear for Artemis." *Arethusa* 22: 111–33.

Perrin, B. 1914–26. *Plutarch's Lives.* Cambridge, Mass.: Harvard University Press; London: W. Heinemann.

Peschel, I. 1987. *Die Hetäre bei Symposion und Komos.* Frankfurt am Main, Bern, New York, and Paris: P. Lang.

Petersen, F. 1892. "Funde," *RM* 7: 174–96.

Pettersson, M. 1992. *Cults of Apollo at Sparta: The Hyakinthia, the Gymnopaidiai and the Karneia.* Skrifter utgivna av Svenska institutet i Athen, no. 12 in 8°. Stockholm: Svenska Institutet i Athen.

Pfeiffer, R. 1949. *Callimachus.* Vol. 1. Oxford: Clarendon Press.

Philipp, H. 1968. *Tektonon Daidala.* Berlin: B. Hessling.

Piccaluga, G. 1966. "*Ta Pherephattes anthologia.*" *Maia* 18: 232–53.

Pirenne-Delforge, V. 1988. "Épithètes cultuelles et interprétation philosophique. À propos d'Aphrodite Ourania et Pandemos à Athènes." *AntCl* 57: 142–57.

————. 1994. *L'Aphrodite grecque: Contribution à l'étude de ses cultes et de sa personnalité dans le panthéon archaïque et classique.* Kernos Suppl., no. 4.

Pomeroy, S. B. 1997. *Families in Classical and Hellenistic Greece.* Oxford: Clarendon Press.

Prag, A. J. N. W. 1985. *The Oresteia: Iconographic and Narrative Tradition.* Chicago: Bolchazy Carducci; Warminster: Aris & Phillips.

Price, S. D. 1990. "Anacreontic Vases Reconsidered." *GRBS* 31: 133–75.

Prückner, H. 1968. *Die lokrischen Tonreliefs.* Mainz am Rhein: P. von Zabern.

Pryce, F. N. 1928. *Catalogue of the Sculpture in the Department of Greek and Roman Antiquities of the British Museum.* London: British Museum.

Raab, I. 1972. *Zu den Darstellungen des Parisurteils in der griechischen Kunst.* Frankfurt: Lang.

Rackham, H. 1959. *Aristotle, Politics.* Cambridge, Mass.: Harvard University Press.

Radt, S. 1977. *Sophocles.* Vol. 4 of *Tragicorum Graecorum Fragmenta,* ed. B. Snell. Göttingen: Vandenhoeck and Ruprecht.

Rasmussen, T., and N. Spivey, eds. 1991. *Looking at Greek Vases.* Cambridge: Cambridge University Press.

Reden, S. von. 1995. *Exchange in Ancient Greece.* London: Duckworth.

Redfield, J. 1982. "Notes on the Greek Wedding." *Arethusa* 15: 181–201.

Reeder, E., ed. 1995. *Pandora: Women in Classical Greece.* Baltimore, Md.: Walters Art Gallery; Princeton, N.J.: Princeton University Press.

Rehm, R. 1994. *Marriage to Death.* Princeton, N.J.: Princeton University Press.

Reho, M. 1990. *La ceramica attica a figure nere e rosse nella Tracia bulgara.* Rome: G. Bretschneider.

Reilly, J. 1989. "Many Brides: 'Mistress and Maid' on Athenian Lekythoi." *Hesperia* 58: 411–44.

Reinsberg, C. 1989. *Ehe, Hetärentum und Knabenliebe im antiken Griechenland.* Munich: C. H. Beck.

Reuterswärd, P. 1960. *Studien zur Polychromie der Plastik.* Bonniers: Svenska Bokforlaget.

Rhodes, P. J. 1981. *A Commentary on the Aristotelian* Athenaion Politeia. Oxford: Clarendon Press.

Richards, I. A. 1936. *The Philosophy of Rhetoric.* New York: Oxford University Press.

Richlin, A. 1992. *Pornography and Representation in Greece and Rome.* New York: Oxford University Press.

———. 1993. "Not before Homosexuality: The Materiality of the Cinaedus and the Roman Law against Love between Men." *Journal of the History of Sexuality* 3: 523–32.

———. 1997. "Towards a History of Body History." In Golden and Toohey 1997, 29–34.

Richter, G. M. A. 1936. *Red-figured Athenian Vases in the Metropolitan Museum of Art.* New Haven, Conn.: Yale University Press.

———. 1960. *Kouroi.* London: Phaidon Press.

———. 1965–72. *The Portraits of the Greeks.* 3 vols. and suppl. London: Phaidon Press.

———. 1968. *Korai.* London: Phaidon Press.

Ricoeur, P. 1977. *The Rule of Metaphor.* Toronto: University of Toronto Press.

———. 1978. "The Metaphorical Process as Cognition, Imagination, and Feeling." *Critical Inquiry* 5: 143–59.

Ridder, A. de. 1902. *Catalogue des vases peints de la Bibliothèque Nationale.* Paris: E. Leroux.

Ridgway, B. S. 1981. *Fifth Century Styles in Greek Sculpture.* Princeton, N.J.: Princeton University Press.

———. 1982. "Of Kouroi and Korai, Attic Variety." *Hesperia* Suppl., no. 20: 123–27.

———. 1990. "Birds, 'Meniskoi,' and Head Attributes in Archaic Greece." *AJA* 94: 591–612.

———. 1993. *The Archaic Style in Greek Sculpture.* 2d ed. Chicago: Ares.

Riedinger, J.-C. 1979. "Les deux *aidos* chez Homère." *RPhil* 53: 62–79.

Riley, D. 1988. *"Am I That Name?" Feminism and the Category of "Women" in History.* Minneapolis: University of Minnesota Press.

Robert, C. 1881. *Bild und Lied: Archäologische Beiträge zur Geschichte der griechischen Heldensage.* Philologische Untersuchungen, no. 5. Berlin: Weidmann.

———. 1919. *Archäologische Hermeneutik.* Berlin: Weidmann.

Roberts, S. R. 1978. *The Attic Pyxis.* Chicago: Ares.

Robertson, M. 1991. "Adopting an Approach: I." In Rasmussen and Spivey 1991, 1–12.

———. 1992. *The Art of Vase-Painting in Classical Athens.* Cambridge: Cambridge University Press.

Rodenwaldt, G. 1932. "Spinnende Hetären." *AA:* 7–21.

Rosen, R. M., and J. Farrell. 1993. *Nomodeiktes.* Ann Arbor: University of Michigan Press.

Rouse, W. H. D. 1902. *Greek Votive Offerings.* Cambridge: Cambridge University Press.

Roussel, D. 1976. *Tribu et cité.* Paris: Belles Lettres.

Roy, J. 1999. "*Polis* and *Oikos* in Classical Athens." *GaR* 46: 1–18.

Rubin, G. 1975. "The Traffic in Women: Notes on the "'Political Economy'" of Sex." In

Toward an Archaeology of Women, ed. R. R. Reiter, 157–210. New York and London: Monthly Review Press.

Sale, W. 1961. "Aphrodite in the *Theogony*." *TAPA* 92: 508–21.

———. 1962. "The Story of Callisto in Hesiod." *RhM* 105: 122–41.

———. 1965. "Callisto and the Virginity of Artemis." *RhM* 108:11–35.

———. 1975. "The Temple-legends of the Arkteia." *RhM* 118: 265–84.

Sandbach, F. H., ed. 1967. *Plutarch. Moralia*. Vol. 7. Leipzig: Teubner.

Saussure, F. de. 1916. *Cours de linguistique générale*. Eds. C. Bally and A. Sechehaye, with A. Reidlinger. Paris: Payot.

Scanlon, T. F. 1984. "The Footrace of the Heraia at Olympia." *AncW* 9: 77–90.

Schädler, U. 1996. "Spielen mit Astragalen." *AA*: 61–73.

Schaps, D. 1977. "The Woman Least Mentioned: Etiquette and Women's Names." *CQ* 27: 323–31.

Schefold, K. 1944. "Die Tyrannenmörder." *MusHelv* 1: 189–202.

———. 1978. *Götter- und Heldensagen der Griechen in der spätarchaischen Kunst*. Munich: Hirmer.

Scheibler, I. 1987. "Bild und Gefäss. Zur ikonographischen und funktionalen Bedeutung der attischen Bildfeldamphoren." *JdI* 102: 57–118.

Scheid, J., and J. Svenbro. 1996. *The Craft of Zeus*. Trans. C. Volk. Cambridge, Mass.: Harvard University Press.

Schettino Nobile, C. 1969. *Il Pittore di Telefo*. Rome: De Luca.

Schibli, H. S. 1990. *Pherekydes of Syros*. Oxford: Clarendon Press.

Schmidt, G. 1969. "Kopf Rayet und Torso vom piräischen Tor." *AM* 84: 65–75.

Schnapp, A. 1986. "Comment déclarer sa flamme ou les archéologues au spectacle." *Le genre humain* 14: 147–59.

Schneider, D. M. 1984. *A Critique of the Study of Kinship*. Ann Arbor: University of Michigan Press.

Schneider, L. A. 1975. *Zur sozialen Bedeutung der archaischen Korenstatuen*. Hamburg: Buske.

Schofield, M., and M. C. Nussbaum, eds. 1982. *Language and Logos; Studies in Ancient Philosophy Presented to G. E. L. Owen*. New York: Cambridge University Press.

Schrader, H. 1939. *Die archaischen Marmorbildwerke der Akropolis*. Frankfurt am Main: V. Klostermann.

Schultz, R. 1910. *Aidos*. Ph.D. diss. Rostock: R. Noske.

Schurtz, H. 1902. *Altersklassen und Männerbünde*. Berlin: G. Reimer.

Schweizer, T. 1990. "Männerbünde und ihr kultureller Kontext im weltweiten interkulturellen Vergleich." In Völger and Welck 1990, 1: 23–30.

Seaford, R. 1987. "The Tragic Wedding." *JHS* 107: 106–30

———. 1988. "The Eleventh Ode of Bacchylides: Hera, Artemis, and the Absence of Dionysos." *JHS* 108: 118–36.

Sealey, R. 1984. "On Lawful Concubinage in Athens." *ClAnt* 3: 111–33.

Sedgwick, E. K. 1985. *Between Men: English Literature and Male Homosocial Desire*. New York: Columbia University Press.

Segal, C. 1986. *Pindar's Mythmaking. The Fourth Pythian Ode.* Princeton, N.J.: Princeton University Press.

Sergent, B. 1986. *Homosexuality in Greek Myth.* Trans. A. Goldhammer. Boston: Beacon Press.

Settis, S. 1966. *ΧΕΛΩΝΗ: Saggio sull'Afrodite Urania di Fidia.* Pisa: Nistri-Lischi.

———. 1998. "Antropologi fra i Greci." *Rivista dei Libri,* May 28, 1998.

Shanks, M. 1996. *Classical Archaeology of Greece.* London and New York: Routledge.

Shapiro, H. A. 1977. "Personification of Abstract Concepts in Greek Art and Literature to the End of the Fifth Century B.C. Ph.D. diss., Princeton University.

———. 1981. *Greek Vases from Southern Collections.* New Orleans: New Orleans Museum of Art.

———. 1989. *Art and Cult under the Tyrants in Athens.* Mainz am Rhein: P. von Zabern.

———. 1992. "Eros in Love: Pederasty and Pornography in Greece." In Richlin 1992, 53–72.

Shapiro, H. A., and C. A. Picón. 1995. *Greek Vases in the San Antonio Museum of Art.* San Antonio, Tex.: The Museum.

Shorey, P. 1930. *The Republic.* London: W. Heinemann

Simon, E. 1963. "Polygnotan Paiting and the Niobid Painter." *AJA* 67: 43–62.

———. 1976. *Die griechischen Vasen.* Munich: Hirmer.

———. 1978. "Zwei Springtänzer—*Doio kybistetere.*" *AntK* 21: 66–69.

———. 1982. "Satyr-plays on Vases in the Time of Aeschylus." In *The Eye of Greece: Studies in the Art of Athens,* eds. D. Kurtz and B. Sparkes, 123–48. Cambridge: Cambridge University Press.

———. 1983. *Festivals of Attica.* Madison: University of Wisconsin Press.

Sissa, G. 1990. *Greek Virginity.* Trans. A. Goldhammer. Cambridge, Mass.: Harvard University Press.

———. 1990a. "Maidenhood without Maidenhead." In Halperin, Winkler, and Zeitlin 1990, 339–64.

———. 1999. "Sexual Bodybuilding: Aeschines against Timarchus." In *Constructions of the Classsical Body,* ed. J. I. Porter, 147–68. Ann Arbor: University of Michigan Press.

Smith, A. C. 1999. "Eurymedon and the Evolution of Political Personifications in the Early Classical Period." *JHS* 119: 128–41.

Smith, C. H. 1896. *Catalogue of the Greek and Etruscan Vases in the British Museum.* Vol. 3. London: British Museum.

Smith, R. R. R. 1988. *Hellenistic Royal Portraits.* Oxford: Clarendon Press.

Smyth, H. W. 1938. *Aeschylus.* Vol. 1. Cambridge, Mass.: Harvard University Press.

Snodgrass, A. M. 1974. "An Historical Homeric Society?" *JHS* 94: 114–25.

———. 1985. "The New Archaeology and the Classsical Archaeologist." *AJA* 89: 31–37.

———. 1987. *An Archaeology of Greece: The Present State and Future Scope of a Discipline.* Berkeley: University of California Press.

Sorabji, R. 1972. *Aristotle on Memory.* London: Duckworth.

———. 1982. "Myths about Non-propositional Thought." In Schofield and Nussbaum 1982, 295–314.

Sotheby & Co. 1993. *Greek Vases from the Hirschmann Collection.* London: Sotheby's.

Sourvinou-Inwood, C. 1971. "Aristophanes, *Lysistrata,* 641–647." *CQ* 21: 339–42.

———. 1979. *Theseus as Son and Stepson: A Tentative Illustration of Greek Mythological Mentality.* BICS Suppl., no. 40.

———. 1987. "Menace and Pursuit: Differentiation and the Creation of Meaning." In *Images et société en Grèce ancienne: L'iconographie comme méthode d'analyse,* eds. C. Bérard, C. Bron, and A. Pomari, 41–58. Cahiers d'archéologie romande, no. 36. [Lausanne]: Institut d'archéologie et d'histoire ancienne, Université de Lausanne.

———. 1988. *Studies in Girls' Transitions.* Athens: Karadamitsa.

———. 1990. "Ancient Rites and Modern Constructs: On the Brauronian Bears Again." *BICS* 37: 1–14.

———. 1995. *'Reading' Greek Death.* Oxford: Clarendon Press.

———. 1995a. "Male and Female, Public and Private, Ancient and Modern." In Reeder 1995, 111–20.

Stähler, K. P. 1983. *Eine Sammlung griechischer Vasen.* Münster: Archäologisches Museum der Universität.

Steiner, D. T. 1986. *The Crown of Songs: Metaphor in Pindar.* London: Duckworth.

———. 2001. *Images in Mind.* Princeton, N.J.: Princeton University Press.

Stern, J. P. 1978. "Nietzsche and the Idea of Metaphor." In Pasley 1978, 64–82.

Steuernagel, D. 1991. "Der gute Staatsbürger: zur Interpretation des Kuros." *Hephaistos* 10: 35–48.

Stevenson, T. 1998. "The 'Problem' with Nude Honorific Statuary and Portraits in Late Republican and Augustan Rome." *GaR* 45: 45–69.

Stewart, A. F. 1986. "When Is a Kouros Not an Apollo? The Tenea Apollo Revisited." In *Corinthiaca. Studies in Honor of Darrell A. Amyx,* eds. M. A. del Chiaro and W. R. Biers, 54–70. Columbia: University of Missouri Press.

———. 1990. *Greek Sculpture: An Exploration.* 2 vols. New Haven, Conn.: Yale University Press.

———. 1996. *Art, Desire, and the Body in Ancient Greece.* Cambridge: Cambridge University Press.

Stewart, F. H. 1977. *Fundamentals of Age-group Systems.* New York: Academic Press.

Stinton, T. C. W. 1976. "Iphigeneia and the Bears of Brauron." *CQ* 26: 11–13.

Stoddart, R. 1990. *Pindar and Greek Family Law.* New York and London: Garland.

Sutton, R. F., Jr. 1981. "The Interaction between Men and Women Portrayed on Attic Red-figured Pottery." Ph.D. diss., University of North Carolina at Chapel Hill.

———. 1989. "On the Classical Athenian Wedding: Two Red-figure Loutrophoroi in Boston." In *Daidalikon: Studies in Memory of Raymond V. Schoder, S.J.,* ed. R. F. Sutton, 331–59. Wauconda, Ill.: Bolchazy-Carducci.

———. 1992. "Pornography and Persuasion on Attic Pottery." In Richlin 1992, 3–35.

———. 2000. "The Good, the Base, and the Ugly: The Drunken Orgy in Attic Vase Painting and the Athenian Self." In Cohen 2000, 180–202.

Tarán, S. L. 1985. "ΕΙΣΙ ΤΡΙΧΕΣ: An Erotic Motif in the *Greek Anthology.*" *JHS* 105: 90–107.

Taylor, M. W. 1991. *The Tyrant Slayers.* Salem, N.H.: Ayer Co. Publishers.

Tazelaar, C. M. 1967. "ΠΑΙΔΕΣ ΚΑΙ ΕΦΗΒΟΙ." *Mnemosyne* 20: 127–53.

Theweleit, K. 1987–89. *Male Fantasies.* 2 vols. Trans. S. Conway with E. Carter and C. Turner. Minneapolis: University of Minnesota Press.

Thommen, L. 1999. "Spartanische Frauen." *MusHelv* 56: 129–49.

Thompson, W. E. 1972. "Athenian Marriage Patterns: Remarriage." *CSCA* 5: 211–25.

Thomson, G. 1938. *The Oresteia of Aeschylus.* Cambridge: Cambridge University Press.

Thorp, J. 1992. "The Social Construction of Homosexuality." *Phoenix* 46: 54–61.

Tiberios, M. A. 1989. *Perikleia Panathenaia: Henas krateras tou zographou tou Monachou 2335.* Thessalonica: Andromeda Books.

Tiger. L. 1984. *Men in Groups.* 2d ed. New York: Marion Boyars.

———. 1990. "Männerbünde aus soziobiologischer Sicht: Reaktion und Rezeption." In Völger and Welck 1990, 65–72.

Tillyard, E. M. W. 1923. *The Hope Vases.* Cambridge: Cambridge University Press.

Todd, O. J. 1922. *Xenophon. Anabasis.* London: W. Heinemann.

Torelli, M. 1984. *Lavinio e Roma.* Rome: Quasar.

Touchefeu-Meynier, O. 1968. *Thèmes odysséens dans l'art antique.* Paris: E. de Boccard.

———. 1972. "Un nouveau 'phormiskos' à figures noires." *RA* (1972): 93–102.

Touchette, L.-A. 1990. "A New Interpretation of the Orpheus Relief." *AA* (1990): 77–90.

Toutain, J. 1940. "Le rite nuptial de l'*anakalyptérion.*" *RÉA* 42: 345–53.

Truitt, P. 1969. "Attic White-ground Pyxis and Phiale." *BMFA* 67: 72–92.

Turner, M. 1987. *Death Is the Mother of Beauty: Mind, Metaphor, Criticism.* Chicago: University of Chicago Press.

Tyrrell, W. B. 1984. *Amazons: A Study in Athenian Mythmaking.* Baltimore: Johns Hopkins University Press.

Van Gennep, A. 1960. *The Rites of Passage.* Trans. M. B. Vizedom and G. L. Caffee. Chicago: University of Chicago Press.

Vatin, C. 1970. *Recherches sur le mariage et la condition de la femme mariée à l'époque hellénistique.* Bibliothèque des Écoles françaises d'Athènes et de Rome, no. 216. Paris: E. de Boccard.

Verdenius, W. J. 1949. "*Kallos kai megethos.*" *Mnemosyne,* ser. 4, 2: 294–98.

———. 1987. *Commentaries on Pindar. Mnemosyne* Suppl., no. 97.

Vérilhac, A.-M., and C. Vial. 1998. *Le mariage grec du VIe siècle av. J.-C. à l'époque d'Auguste. BCH* Suppl., no. 32.

Vermeule, E. 1979. *Aspects of Death in Early Greek Art and Poetry.* Berkeley: University of California Press.

Vernant, J.-P. 1974. *Mythe and société en Grèce ancienne.* Paris: Maspero.

———. 1990. *Figures, idoles, masques.* Paris: Maspero.

———. 1996. *Mythe et pensée chez les Grecs.* Paris: Découverte.

Vetta, M. 1983. *Poesia e simposio nella Grecia antica.* Rome: Laterza.

Vial, C. 1985. "La femme athénienne vue par les orateurs." In *La femme dans le monde méditerraéen,* ed. A.-M. Vérilhac, 1: 47–60. Lyon: G.D.R.-Maison de l'Orient.

Vian, F. 1965. "Melampous et les Proitides." *RÉA* 67: 25–30.

———, ed. 1974. *Argonautiques. Tome I: Chants I–II*. Paris: Belles Lettres.

Vidal-Naquet, P. 1986. *The Black Hunter*. Trans. A. Szegedy-Maszak. Baltimore: Johns Hopkins University Press.

———. 1989. "Retour au chasseur noir." In *Mélanges Pierre Lévêque. Annales littéraires de l'Université de Besançon* 377: 387–411.

Vickers, M., and D. Gill. 1994. *Artful Crafts*. Oxford: Clarendon Press.

Viret Bernal, F., F. Vallotton, A. Rogger, and C. Bron. 1992. "D'Héraklès à Guillaume Tell. Portrait d'un héros. Application de T.I.R.E.S.I.A.S." In *L'image en jeu*, eds. C. Bron and E. Kassapoglou, 173–88. Lausanne: Institut d'archéologie et d'histoire ancienne, Université de Lausanne; Yens-Sur-Morges: Cabedita.

Völger, G., and K. von Welck. 1990. *Männerbande, Männerbünde: Zur Rolle des Mannes im Kulturvergleich*. 2 vols. Ethnologica, no. 15. Cologne: Rautenstrauch-Joest-Museums fur Völkerkunde.

Wace, A. J. B. 1951. "Notes on the Homeric House." *JHS* 71: 203–11.

Wace, A. J. B., M. S. Thompson, and J. P. Droop. 1908–9. "The Menelaion." *BSA* 15: 108–57.

Wade-Gery, H. T. 1949. "A Note on the Origin of the Spartan Gymnopaidia." *CQ* 43: 79.

Waldner, K. 2000. *Geburt und Hochzeit des Kriegers*. Berlin and New York: de Gruyter.

Walker, H. J. 1995. *Theseus and Athens*. New York: Oxford University Press.

Warnock, M. 1978. "Nietzsche's Conception of Truth." In Pasley 1978, 33–63.

Watson, A. 1985. *The Digest of Justinian*, vol. 4, eds. T. Mommsen and P. Krueger. Philadelphia: University of Pennsylvania Press.

Waugh, L. R. 1982. "Marked and Unmarked: A Choice between Unequals." *Semiotica* 38: 299–318.

Waugh, L. R., and M. Halle, eds. 1984. *Russian and Slavic Grammar: Studies, 1931–1981*. Berlin: Mouton.

Waugh, L., and M. Monville-Burston, eds. 1990. *On Language. Roman Jakobson*. Cambridge, Mass.: Harvard University Press.

Weber, M. 1972. *Wirtschaft und Gesellschaft*. 5th ed. Tübingen: J. C. B. Mohr.

Webster, T. B. L. 1965. "Greek Vases in the Stanford Museum." *AJA* 69: 63–65.

Wehgartner, I. 1983. *Attisch weissgrundige Keramik*. Mainz am Rhein: P. von Zabern.

Weiss, C. 1989. "Phintias in Malibu und Karlsruhe." In *Greek Vases in the J. Paul Getty Museum. Volume 4*. Occasional Papers on Antiquities, no. 5, 83–94. Malibu, Calif.: The J. Paul Getty Museum.

West, M. L. 1985. *The Hesiodic Catalogue of Women: Its Nature, Structure, and Origins*. Oxford: Clarendon Press.

———, ed. 1978. *Hesiod: Works and Days*. Oxford: Clarendon Press.

———, ed. 1984. *Carmina Anacreontea*. Leipzig: Teubner.

———, ed. 1989. *Iambi et Elegi Graeci ante Alexandrum Cantati*. 2d ed. Oxford: Clarendon Press.

White, H. 1979. *Studies in Theocritus and Other Hellenistic Poets*. Amsterdam: Gieben.

Wickert-Micknat, G. 1982. *Die Frau.* Archaeologia Homerica, no. 3, chapter R. Göttingen: Vandenhoeck & Ruprecht.

Wikander, S. 1938. *Der arische Männerbund.* Lund: Ohlsson.

Will, E. 1955. *Korinthiaka.* Paris: E. de Boccard.

Willetts, R. F. 1962. *Cretan Cults and Festivals.* London: Routledge and Kegan Paul.

Williams, D. 1993. "Women on Athenian Vases: Problems of Interpretation." In *Images of Women in Antiquity,* eds. A. Cameron and A. Kuhrt, 92–106. 2d ed. Detroit: Wayne State University Press.

Williams, R. T. 1961. "An Attic Red-figure Kalathos." *AntK* 4: 27–29.

Winterling, A. 1990. "Symposion und Knabenliebe: Die Männergesellschaften im archaischen Griechenland." In Völger and Welck 1990, 2: 15–22.

Wittgenstein, L. 1960. *Preliminary Studies for the "Philosophical Investigations"; Generally Known as The Blue and Brown Books.* New York: Harper & Row.

Wolff, H. J. 1944. "Marriage Law and Family Organization in Ancient Athens." *Traditio* 2: 43–95.

Woodbury, L. 1978. "The Gratitude of the Locrian Maidens." *TAPA* 108: 285–99.

———. 1982. "Cyrene and the *Teleta* of Marriage in Pindar's Ninth Pythian Ode." *TAPA* 112: 245–58.

Wünsch, R., ed. 1967. *Johannes Lydus. Liber de mensibus.* Stuttgart: Teubner.

Young, D. C. 1968. *Three Odes of Pindar. A Literary Study of Pythian II, Pythian 3. and Olympian 7. Mnemosyne* Suppl., no. 9. Leiden: E. J. Brill.

Zancani-Montuoro, P. 1960. "Il corredo della sposa." *ArchCl* 12: 37–50.

Zevi, E. 1937. "Scene di gineceo e scene di idillio nei vasi greci della seconda metà del secolo quinto." *MemLinc* 6: 291–350.

Zimmer, G. 1987. *Spiegel im Antikenmuseum.* Berlin: Mann.

Zimmermann, K. 1980. "Tätowierte Thrakerinnen auf griechischen Vasenbildern." *JdI* 95: 163–96.

Zinserling, V. 1975. "Zum Bedeutungsgehalt des archaischen Kuros." *Eirene* 13: 19–33.

———. 1977. "Zum Problem von Alltagsdarstellungen auf attischen Vasen." In Kunze 1977, 39–56.

Zwierlein-Diehl, E. 1971. In R. Hampe et al., *Katalog der Sammlung antiker Kleinkunst des archäologischen Instituts der Universität Heidelberg. Neuerwerbungen 1957–1970.* Mainz am Rhein: P. von Zabern.

INDEX OF MONUMENTS

INDEX OF ANCIENT SOURCES

GENERAL INDEX

Achilles. See also *paiderastia*
 on Scyrus, 89–90, 119
 shield of, 88–89
 statue at Sigaeum, 116
Aegina, rape of, 43
Aethra, 26, 56
Aidos, 55
aidos, 7–8, 54–56, 272 n. 72. *See also*
 metaphor
andrias, 125–126
andreia, 8–9, 88, 92, 112–113, 124, 126,
 129, 132
Antigone, 192–193
antiquarianism, 3–4, 10
Aphrodite, 34, 49, 52, 187
 bearded, 109–111
 Cnidia, 163
 as maiden, 51
 toilet of, 18, 28, 46–47, 51, 52
 Urania, 106–107, 110–11
 Urania vs. Pandemos, 100–101, 107–
 108, 144, 147–148, 160
archaeology and history, 2–4
Ariadne, 58
Artemis, 46, 49, 58, 165
 as spinner, 58
astragaloi, attribute of youth, 15–16. *See*
 also games
Athena, 47, 49, 47
 as spinner, 58, 59

bath, scenes of, 47–50
 of Aphrodite, 50–51
 of Artemis, 49
 of Athena, 47
 of Europa, 48
 of Helen, 49
 of Nausicaa, 48
beard, terminology for
 ageneios, 135, 158
 geneion, 135, 137
 ioulos, 110, 135, 136
 hupene, 135, 136
beauty. See *hora; hebe*
Brauron, sanctuary of Artemis at
 Arkteia at, 168
 inventory lists of, 176
 Pelasgian raid on, 170

Callisto, 172–175
Calypso, 58
Charites, 15–16, 46, 49, 58
Chrysippus, rape of, 143–144, 148
Circe, 37, 58
collective representations, 5, 248 n. 21
concubine. See *oikos*
courtship
 of Agariste, 180
 of Helen, 30
 of Penelope, 20, 43, 51, 57
 scenes of, 30–31 (*see also* wool working)